Renoir's Portraits

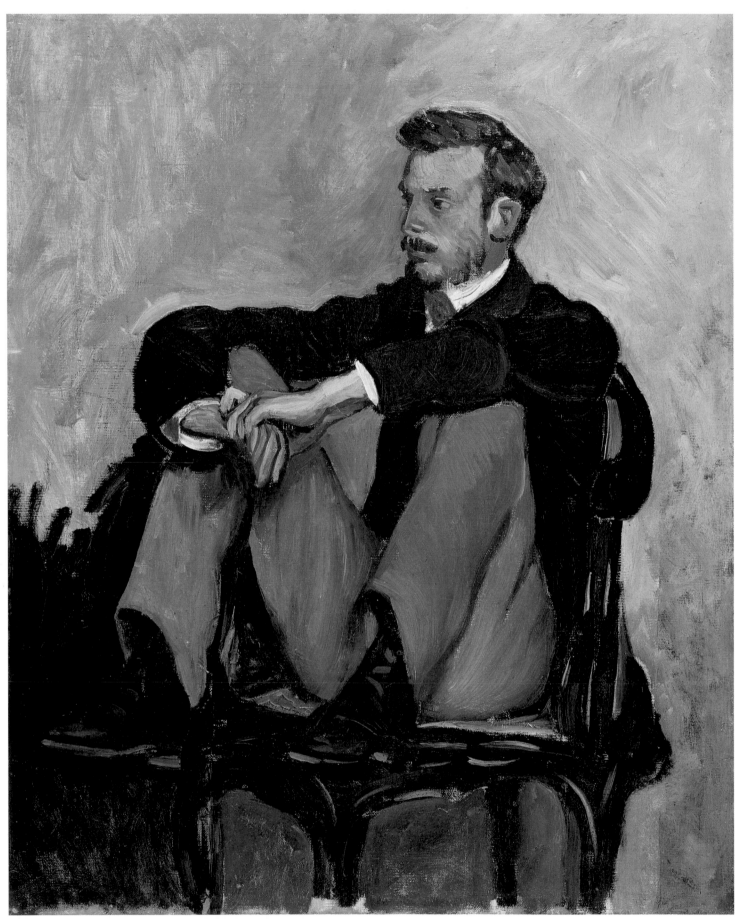

Frédéric Bazille, *Pierre-Auguste Renoir*, 1867. Musée d'Orsay, Paris

Renoir's Portraits

IMPRESSIONS OF AN AGE

COLIN B. BAILEY

with the assistance of John B. Collins

Essays by

Colin B. Bailey, Linda Nochlin, and Anne Distel

YALE UNIVERSITY PRESS
NEW HAVEN AND LONDON

in association with

NATIONAL GALLERY OF CANADA
OTTAWA

Published in conjunction with the exhibition *Renoir's Portraits: Impressions of an Age*, organized and circulated by the National Gallery of Canada.

ITINERARY

National Gallery of Canada, Ottawa
27 June – 14 September 1997

The Art Institute of Chicago
17 October 1997 – 4 January 1998

Kimbell Art Museum, Fort Worth
8 February – 26 April 1998

Published by Yale University Press, New Haven and London, in association with the National Gallery of Canada.

NATIONAL GALLERY OF CANADA
Chief, Publications Division: Serge Thériault
Editor: Usher Caplan
Picture Editor: Colleen Evans,
 with the assistance of Diane Watier
Indexer: Marcia Rodríguez

YALE UNIVERSITY PRESS
Design and Production: Gillian Malpass

Typeset in Bembo and Goudy by SX Composing DTP,
 Rayleigh, Essex
Film by Amilcare Pizzi S.p.A., Milan
Printed on Gardamatt and bound by Amilcare Pizzi S.p.A., Milan

French edition published in collaboration with
 Éditions Gallimard, Paris.

Canadian Cataloguing in Publication Data

Bailey, Colin B.
Renoir's portraits : impressions of an age.

Exhibition catalogue.
Issued also in French under title : Les portraits de Renoir.
Includes bibliographical references: p.
Includes index.
ISBN 0-88884-668-1

1. Renoir, Auguste, 1841–1919—Exhibitions. 2. Portrait painting, French—Exhibitions. 3. Portrait painting—19th century—Exhibitions. 4. Impressionism (Art)—France—Exhibitions. I. National Gallery of Canada. II. Title.

ND553 R46 A4 1997 759.4 C-97-986004-0

FRONT COVER: *Mademoiselle Legrand* (cat. no. 23), Philadelphia Museum of Art

BACK COVER: *Madame Georges Charpentier and Her Children* (cat. no. 32), The Metropolitan Museum of Art, New York

CONTENTS

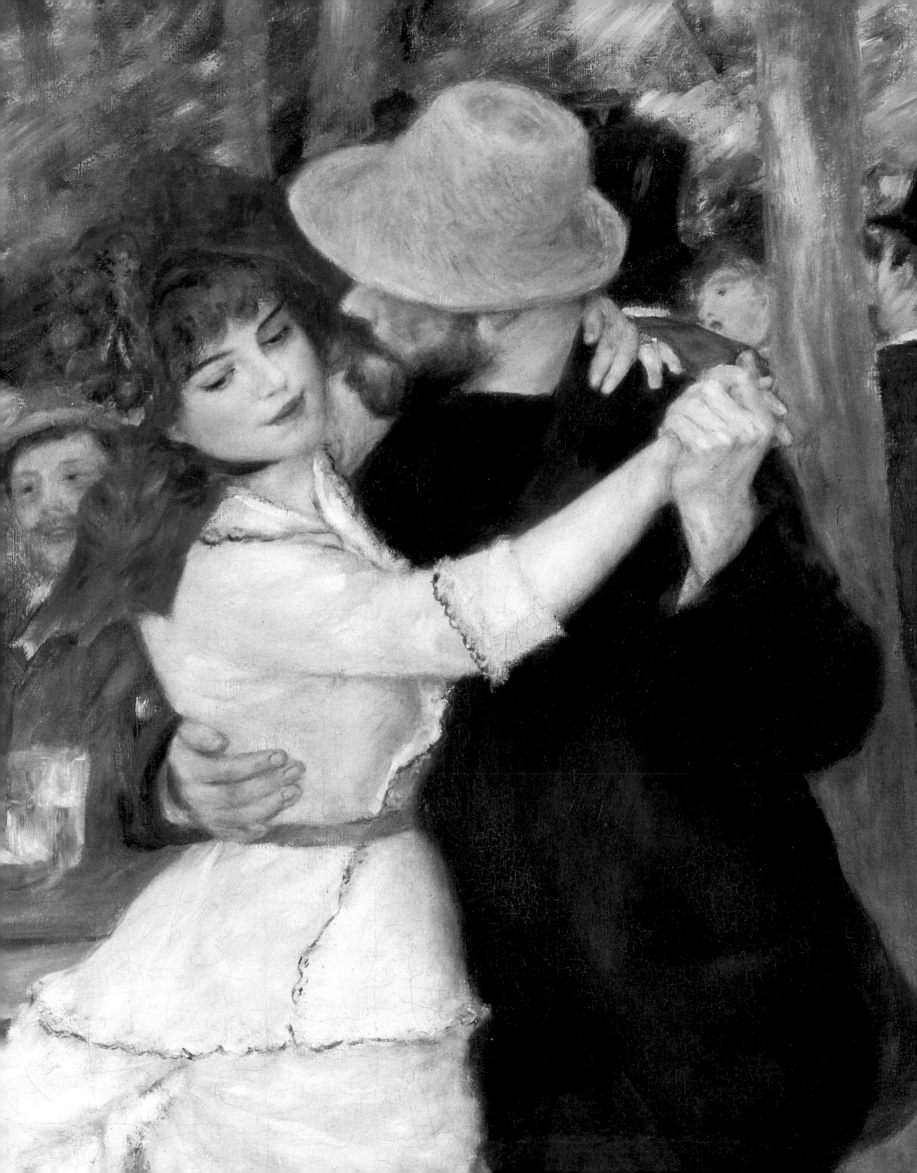

LENDERS TO THE EXHIBITION

BRAZIL
Museu de Arte de São Paulo Assis Chateaubriand 38

CANADA
National Gallery of Canada, Ottawa 59

FRANCE
Comédie-Française Collection, Paris 28
Durand-Ruel, Paris 64
Musée du Petit Palais, Paris 1
Musée d'Orsay, Paris 2, 5, 18, 21, 31
Musée National de l'Orangerie, Paris 54, 61

GERMANY
Gemäldegalerie Neue Meister, Staatliche Kunstsammlungen
 Dresden 10
Hamburger Kunsthalle, Hamburg 13
Nationalgalerie, Berlin 49

GREAT BRITAIN
Courtauld Institute Galleries, London 60
Southampton City Art Gallery 65

JAPAN
Nippon Television Network Corporation, Tokyo 69

RUSSIA
State Hermitage Museum, Saint Petersburg 30, 36, 51

SWEDEN
Nationalmuseum, Stockholm 4

SWITZERLAND
Stiftung "Langmatt" Sidney und Jenny Brown, Baden 27

UNITED STATES OF AMERICA
Albright-Knox Art Gallery, Buffalo, N.Y. 66
The Art Institute of Chicago 26, 35, 40, 46, 47
Columbus Museum of Art, Ohio 19, 55
The Chrysler Museum of Art, Norfolk, Va. 44
The Cleveland Museum of Art 3
The Detroit Institute of Arts 58
Fine Arts Museums of San Francisco 8
Fogg Art Museum, Harvard University Art Museums, Cambridge,
 Mass. 25
The J. Paul Getty Museum, Malibu, Calif. 37
Los Angeles County Museum of Art 63
The Metropolitan Museum of Art, New York 9, 32, 34, 68
Museum of Fine Arts, Boston 45
Museum of Art, Rhode Island School of Design, Providence 67
National Gallery of Art, Washington 15, 17, 20
The Nelson-Atkins Museum of Art, Kansas City, Mo. 48
Philadelphia Museum of Art 23, 50
The Robert B. Mayer Family Collection, Chicago 52
The Saint Louis Art Museum 6
Smith College Museum of Art, Northampton, Mass. 12
Sterling and Francine Clark Art Institute, Williamstown, Mass. 16,
 24, 39, 43, 56
Virginia Museum of Fine Arts, Richmond 57
Wadsworth Atheneum, Hartford, Conn. 14

ANONYMOUS LENDERS
7, 11, 22, 33, 41, 42, 53

Pierre-Auguste Renoir, *Dance at Bougival* (cat. no. 45), detail

MESSAGE FROM THE SPONSOR

Newcourt Credit Group takes great pleasure in supporting the presentation of *Renoir's Portraits: Impressions of an Age*, the first comprehensive examination of Renoir's portraiture since the artist's death. We are proud to be associated through this project with one of this country's most distinguished museums, the National Gallery of Canada.

This is an exhibition of great international significance. Assembled for our viewing are prized works from public and private collections throughout the world that reveal Renoir's extraordinary ability to paint the human form. His most memorable portraits, particularly those of family members, children, bohemian friends, and fellow artists, display his affectionate and engaging depiction of French life and set him apart from all other artists working in Paris during the Belle Époque.

For Newcourt Credit Group, it seems particularly appropriate to be involved with an exhibition devoted to the work of one of the founders of Impressionism. Renoir challenged the status quo. He established a new set of rules and defined a new way of looking at the world. These same attributes are mirrored in Newcourt's philosophy and the way we distinguish ourselves as one of North America's leading non-bank lending institutions.

Steven K. Hudson
President and CEO
Newcourt Credit Group

FOREWORD

We have every reason to feel that Renoir would have approved of an exhibition devoted to his portraits, an aspect of his production that has not received the attention it deserves. It was the genre by which the artist chose to be represented in the official Salon between 1864 and 1883 (and again, on his final appearance, in 1890), and portraits accounted for a substantial portion of his submission to the Impressionist exhibitions of 1876 and 1877. To his patron, Marguerite Charpentier, Renoir proposed an exhibition on this very subject – which he intended to show in the galleries of *La Vie Moderne*, her husband's recently launched art journal – early in 1880. "If those gentleman are willing," he wrote to her, "I should like to mount an exhibition devoted exclusively to my portraits: I believe that it will attract many people."

In 1880, for Renoir to have hoped that an exhibition of his portraits might "attract many people" was wishful thinking of the most flagrant kind. Not until June 1912 would such an undertaking be realized, and by then Renoir had more or less lost interest in the project (he was by now a wealthy and acclaimed artist). On Joseph Durand-Ruel's initiative, fifty-eight of Renoir's portraits – many of which rank among his finest, twelve of which are in the present exhibition – were assembled for display at Galeries Durand-Ruel in the rue Laffitte. *Portraits par Renoir* ran for two weeks and one day: Renoir was half-hearted, although he had helped secure certain loans; public and critical response was muted at best, and occasionally churlish.

The gradual improvement in the reception of Renoir's art during his lifetime and his consecration as the "greatest living artist" by the time of his death are subjects that have only recently begun to interest scholars of Impressionism, yet as we approach the end of the twentieth century, it is hard to imagine a time when Renoir's art could be anything less than universally beloved. Ironically, the flowering of popular acclaim for an artist now generally considered among the most accessible and joyful in the history of Western art has not spurred a particularly rigorous approach to his work. So tenacious is the myth of Renoir as a "natural painter"; so pervasive is our image of Renoir as a happy and uncomplicated artist; above all, such is the almost Puritanical reaction of recent generations of historians and critics (as opposed to the general public) to an art that is painterly, high-coloured, and astonishing in its virtuosity and sureness of touch that, with certain important exceptions, the literature on Renoir has been largely bereft of the more

exacting scholarship that has so broadened our understanding of Renoir's fellow Impressionists in recent years.

Colin B. Bailey, Chief Curator at the National Gallery of Canada, took up the challenge to redress this curious imbalance through the organizing of an exhibition of Renoir's finest portraits, spanning a period of more than half a century. As the principal author of the accompanying catalogue – handsomely co-published by the National Gallery of Canada with Yale University Press and Éditions Gallimard – he has also been responsible for amassing a great deal of new information, here presented for the first time. We are grateful to him, to Linda Nochlin and Anne Distel, authors of the accompanying essays, and to the staff of our three museums. To the Federal Council on the Arts and the Humanities we are grateful for indemnifying the exhibition during its American tour. We are especially thankful for the support of our corporate sponsors – in Ottawa, the Newcourt Credit Group, and in Chicago, Ameritech. Our greatest debt is to the lenders, both institutional and private, who have graciously permitted certain treasured works to travel. Without their generosity and commitment to this undertaking, *Renoir's Portraits* could not have appeared on the walls of three North American museums.

Writing in January 1910 to his protégé, the painter Albert André, Renoir – racked with arthritis, unable to work on his feet, but now embarked upon some of his most monumental figure paintings and portraits – confided a satisfaction and pleasure in his art that is all the more poignant for being so rarely expressed. "Painting," he wrote, "is a happy occupation, since it is capable of maintaining our illusions and bringing us joy." The comment suggests a keen awareness of the fragile but precious spirit that sustained Renoir's enterprise throughout his long career. It is this life-affirming and benevolent vision that is abundantly in evidence in each of the canvases selected for *Renoir's Portraits: Impressions of an Age*.

Shirley L. Thomson
Director, National Gallery of Canada, Ottawa

James N. Wood
Director and President, The Art Institute of Chicago

Edmund P. Pillsbury
Director, Kimbell Art Museum, Fort Worth

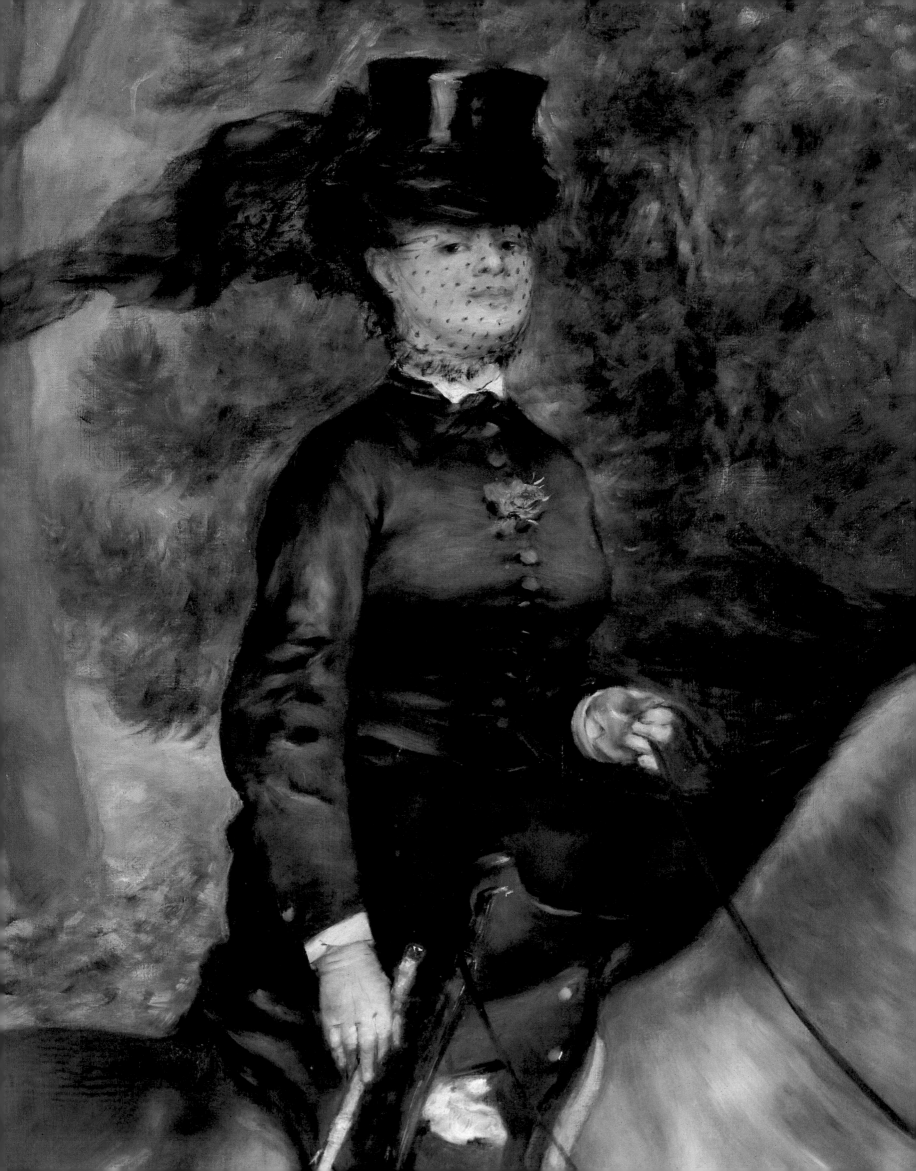

ACKNOWLEDGMENTS

The seed for this exhibition was sown more than eight years ago in discussions with Joseph J. Rishel, Senior Curator at the Philadelphia Museum of Art, whose enthusiasm for a project devoted to Renoir's portraits both spurred my thinking and sharpened my eye. It was during the last year of my tenure at the Kimbell Art Museum that the foundations for the exhibition were laid; and here I must acknowledge the perspicacity of Director Ted Pillsbury, who, in reviewing my proposal for a survey of Impressionist portraiture, reminded me of the advantages – both intellectual and practical – of the monographic format and encouraged me to concentrate exclusively on Renoir. Well launched though the project now was, every aspect of its organization – from identifying and negotiating loans, to researching, writing, and editing the accompanying catalogue – has been undertaken at the National Gallery of Canada, and I am deeply grateful to Director Shirley Thomson, whose commitment to *Renoir's Portraits* has been wholehearted and unwavering. I am also indebted to my colleagues in Senior Management, particularly Yves Dagenais, Deputy Director, Helen Murphy, Assistant Director, Communications and Marketing, Daniel Amadei, Assistant Director, Exhibitions and Installations, and Dennis Moulding, Comptroller, who have each worked tirelessly towards the successful realization of this project. For almost eighteen months I have been in regular contact with the Department of European Paintings at the Art Institute of Chicago, a partner in this exhibition as well as one of the principal lenders. Douglas W. Druick, Searle Curator of European Painting, and Associate Curator Gloria Groom have been unstinting in their enthusiasm and support, from which the project has gained immeasurably. Also at the Art Institute of Chicago, Dorothy Schroeder, Assistant Director for Exhibitions and Budget, and Greg Perry, Associate Director of Development for Special Projects, have been responsible for the application for Federal Indemnity and have coordinated the complex insurance arrangements for *Renoir's Portraits*. At the Kimbell Art Museum, Chief Curator Joachim Pissarro was most generous in helping me track down certain works in private hands.

My greatest debt of thanks is to the lenders – institutions as well as private individuals – who graciously consented to part with cherished paintings for almost a year. Each and every loan has been vigorously – but, I trust, not stridently – solicited, in many cases on more than one occasion. Certain crucial paintings were juridically unobtainable for this exhibition: portraits in the Barnes Collection, the Winthrop

collection at the Fogg Art Museum, the Oskar Reinhart Collection, and the Annenberg collection at the Metropolitan Museum of Art cannot be lent. These, along with other major works whose loan was denied, have been illustrated in colour in the opening essay of the catalogue. Three major portraits were cleaned and restored in preparation for this exhibition, and it is a pleasure to thank Marion Barclay, Chief of Conservation at the National Gallery of Canada, Claire Barry, Chief Conservator, Kimbell Art Museum, and M. Christian Paty, Paris, for their respective contributions. I want also to acknowledge Ann Collins, Consul General, Consulate General of Canada, Saint Petersburg, whose efforts on our behalf with our colleagues at the Hermitage were of critical importance.

I take this opportunity to thank Linda Nochlin, Lila Acheson Wallace Professor of Modern Art, Institute of Fine Arts, New York University, and Anne Distel, Conservateur en chef at the Musée d'Orsay and doyenne of Renoir studies, for their informative and elegant catalogue essays. To Linda Nochlin I am also grateful for having recommended Jane Becker, now a scholar of Eugène Carrière, to serve as the first research assistant on this project. Anne Distel has been unfailingly generous with information and advice, and has saved me from numerous errors. Over the course of the project I have also benefited from the work (published and unpublished) of several scholars. Without hesitation, John House placed at my disposal the research materials that he had gathered for the great Renoir retrospective of 1985–86. François Daulte, whose second volume of the Renoir catalogue raisonné is eagerly awaited, has responded to my many enquiries with characteristic generosity and promptitude. Caroline Durand-Ruel Godfroy not only undertook to secure essential loans for the exhibition, she also placed the extraordinary resources of the Durand-Ruel archives at our disposal. The invaluable documentation of press reviews of the eight Impressionist exhibitions, assembled in preparation for *The New Painting* (1986) and which will have been published by the time this catalogue appears, was generously made available to me in the early stages of my research; for this, I am extremely grateful to Charles S. Moffett and his *équipe*. Marc Le Coeur and Françoise Heilbrun allowed me to read drafts of their recent publications (on Charles Le Coeur and Paul Haviland respectively), so that their findings could be incorporated into my catalogue entries.

For more than two years *Renoir's Portraits* has consumed

Pierre-Auguste Renoir, *Riding in the Bois de Boulogne* (cat. no. 13), detail

the energies and taxed the ingenuity of my curatorial assistant John Collins, who has participated in every aspect of its organization, but has served principally as the most scrupulous and imaginative of researchers. His participation is acknowledged on the title page of this catalogue, but I take the opportunity of thanking him for the sterling quality of his work and the extraordinary level of his commitment to this undertaking. Much of the new information published here for the first time is the fruit of rigorous archival research undertaken on our behalf in Paris and the provinces by Marina Ferretti-Bouquillon and Robert MacDonald Parker. Not only did they compile complete dossiers on the sitters and their families, they also succeeded in tracking down descendants, obtaining photographs and memorabilia, and verifying myriad references unavailable in North America. If the catalogue has a value and "shelf life" independent of the exhibition itself, this is in no small part due to the contribution of my research associates. Finally, it has been a pleasure collaborating with John Nicoll and Gillian Malpass of Yale University Press, and Jean-Loup Champion of Éditions Gallimard, co-publishers of *Renoir's Portraits*. For the elegant design of the catalogue, we are indebted to Gillian Malpass, from whose sensitivity and clear-sightedness the book has benefited at every turn.

At the National Gallery of Canada, I am particularly grateful to Karen Colby-Stothart, Exhibitions Manager, who has overseen every aspect of this project with unfailing efficiency and good humour. For the most sympathetic and meticulous of editing – both verbal and visual – it is a pleasure to thank my colleagues in the Publications Division, and particularly Usher Caplan, Claire Rochon, and Colleen Evans (ably assisted by Diane Watier). Serge Thériault, Chief of Publications, has shepherded the manuscript to completion with the assurance of a seasoned but benevolent general and has ensured that the demands of a daunting production schedule were met at no cost to the quality of the book itself. Murray Waddington, Librarian, and his entire staff – but especially Peter Trepanier, Bonnie Bates, Maija Vilcins, and Anna Kindl – have placed the formidable resources of the Gallery's holdings at our disposal and have obtained, either through purchase or loan, almost every item of Renoiriana that has been requested. Ursula Thiboutot, Chief of Communications, has proved a tireless and unflagging advocate for the exhibition. The elegant installation of the exhibition in Ottawa is due to Ellen Treciokas, Designer, who was also responsible for all printed materials and ephemera relating to *Renoir's Portraits*. For their energy and enthusiasm I am most grateful to Anne Hurley, Head of Retail and Marketing for The Bookstore, and Sheila Weeks, The Bookstore's Manager of Operations. My friend and colleague Michael Pantazzi, Associate Curator of European and American Art, has been characteristically generous in sharing with me his unrivalled knowledge of nineteenth-century French art. I thank also Kate Laing, Head, Art Loans and Exhibitions, Monique Baker-Wishart, Education Officer, and Emily Tolot, Head, Special Events, for their contribution to the organization of the exhibition and its related programs in Ottawa. To Pauline Labelle, my Administrative Assistant, and Arline Burwash, Departmental Secretary, go heartfelt thanks for their essential support during the entire period in which *Renoir's Portraits* was conceived and brought to fruition.

My greatest debt, as always, is to Alan Wintermute, who has spurred me on in this undertaking from its very inception, and whose enthusiasm both for Renoir and for this exhibition have inspired and sustained me throughout the project. Boundless in his encouragement, he has also been the most careful (and demanding) of readers; what I owe to him is far greater than can be adequately expressed in these acknowledgements.

For their help in many ways it is a pleasure to thank the following: William Acquavella, Sharon Abbey, Ulf Abel, Anne Adams, Götz Adriani, Donald Anderle, Martha Asher, Linda Ashton, Joseph Baillio, Quentin Bajac, Geri Banik, Stephanie Barron, Claire Barry, Bernard Barryte, Lady Marina Bayliss, William L. Beadleston, Robert P. Bergman, Ulla Bergman, Marie Bernard-Meunier, Jean-Guy Bertauld, Jean Besnus, Yveline Cantarel-Besson, Heike Biedermann, Ulrich Bischoff, Delphine Bishop, Irène Bizot, Herbert Black, Mark Blichert, Sarah Bober, Laetitia Boehm, Jean Sutherland Boggs, Doreen Bolger, Arnaud de Borchgrave, Daniel Boulart, Mme. A. Boulart, Helen Braham, Philippe Brame, Janet F. Briner, Cheryl A. Brutvan, Rupert Burgess, Thérèse Burollet, Michel Buttiens, Jean Cadogan, the late comte Gilbert Cahen d'Anvers, comtesse Josephine Cahen d'Anvers, Isabelle Cahn, Sara Campbell, Görel Cavalli-Bijörkman, Claude Chambolle-Tournon, R. Chanaud, Martin Chapman, Danielle Chaput, Giles Chazal, Alison Cherniuk, Tasuku Chino, Alan Chong, Robert Clémentz, Melanie Clore, Michael Conforti, Philip Conisbee, Malcolm Cormack, James Cuno, Jean d'Albis, Anne d'Harnoncourt, Michel Dauberville, Guy-Patrice Dauberville, Diane De Grazia, Michel Déon, Julie Desgagné, Danielle Desmoulin, Michel Deverge, Peter Di Maso, Richard Dorment, Wolfgang Drange, Matthew Drutt, Wolf-Dieter Dube, Paul-Louis Durand-Ruel, Georges Dussaule, Teri J. Edelstein, Roy Engfield, Suzannah J. Fabing, Odile Faliu, Walter Feilchenfeldt, Larry J. Feinberg, Beth Figgers, Cheryl Gagnon, Marie Gallimard, Ernesto Silvio Galperin, Jean Gardair, Patricia Sherwin Garland, Kate Garmeson, Ivan Gaskell, Frank O. Gehry, Pierre Georgel, Oscar Ghez, Paul Girard, Maria Teresa Gomes Ferreira, Eugênia Gorini Esmeraldo, Mariko Goto, Wendy Gottlieb, Olle Granath, Denis Gravel, Deborah Gribbon, Charles de Gunzberg,

Mme Isabelle Hamel, Louis Hamel, Martha Hand, Susan Hapgood, Jefferson Harrison, William Hauptman, Margot Heller, Norine S. Hendricks, Meva Hockley, Anne Hoenigswald, Waring Hopkins, Charles Hupé, Joel Isaacson, Kazuo Ishikure, David Jaffé, Antoine Javal, Catherine H. Jordan, Jane Kallir, Robert Kaszanits, Steven Kern, Nada Kerpan, Rose Kerr, George Keyes, Jeremy K.B. Kinsman, Yosoji Kobayashi, Matt and Kyoko Kosaki, Albert Kostenevich, Brigitte Kueppers, Geneviève Lacambre, Gaetan Lafrance, Joe Lakkis, Mme. M.C. Lalance, Phyllis Lambert, Philippe E. Landau, Myron Laskin, Jr., Ronald Laskin, Larry Latkowcer, Florence Le Corre, Katharine C. Lee, Helmut R. Leppien, Irvin M. Lippman, Dominique Lobstein, Henri Loyrette, Ulrich Luckhardt, Marie Lugli, Alisa Luxenberg, Robert Maguire, Goli Maleki, Daniel Malingue, Alain Pieyre de Mandiargues, J. Patrice Marandel, Laure de Margerie, Laurier Marion, Nicole Maritch-Haviland, Luiz Marques, Nadine Massias, Nancy Mowll Mathews, Vladimir Matveyev, Ellen Mauer, Ceridwyn Maycock, Mrs. Robert Mayer, Jean-Claude Menou, Philippe Migot, Jean-Pierre Miquel, David Mirvish, Katsumi Miyazaki, Delphine Montalant, Philippe de Montebello, Paul Morisset, Hans Th. Mörtl, Linda Muehlig, Herta Müller, Jennifer Mundy, John Murdoch, Alexandra R. Murphy, Takako Nagasawa, Steven A. Nash, Jacques Naud, Leonard Nelson, Benoît Noel, Hajime Nonaka, Veronique Notin, Brigitte Olivier, Lynn Orr, Jennifer Paoletti, JoAnne Paradise, Peter Paret, Harry S. Parker III, Olaf Peters, Bernard Pharisien,

Claude Piening, Michèle Pierron, Mikhail Piotrovsky, Lionel Pissarro, Nicole Plamondon, Andrea Pophanken, Hans Porkert, Earl A. Powell III, Eva-Maria Preiswerk-Lösel, Wolfgang Pusch, David Raillot, Christian Renaudeau d'Arc, Michelle A. Rinehart, Christopher Riopelle, Marcia Rodríguez, Malcom Rogers, Anne Roquebert, Pierre Rosenberg, Daniel Rosenfeld, baronne Élie de Rothschild, Françoise Rouart, Jean Michel Rouart, Yves Rouart, Erich Rüba, Samuel Sachs II, Maria-Christina Sayn-Wittgenstein, David Schiff, Uwe M. Schneede, Douglas Schoenherr, Douglas G. Schultz, Peter Klaus Schuster, David Scrase, François Gérard Seligmann, George T.M. Shackelford, Tetsuji Shibayama, Richard Shone, Franklin Silverstone, Helen Simpson, Maria Helena Soares Costa, Carol Solomon-Kiefer, Mary B. Somerby, François Souchal, Andrée Stassart, Beate Stock, Gerard Stora, John A. Streckfus, Jeremy Strick, Penny Sullivan, Judy Sund, Peter Sutton, Shuji Takashina, Shinichiro Takeda, John Tancock, Denis Tessier, Alain Thomas, Betty Thurneyssen, Gary Tinterow, Carol Togneri, Klelia Topaloglou, Léo Tousignant, Sylvie Tremblay, Lora Urbanelli, Jennifer L. Vanim, Marie-France Vivier, Jean-Pierre Vuilleumier, John Walsh, Roger Ward, Keikichi Watanabe, Max Wemaëre, Barbara Ehrlich White, Linda Whiteley, Jörg Wille, Marc F. Wilson, Jennifer M. Winn, Mme Wisniewski, Susumu Yamamoto, and Frank Zuccari.

Colin B. Bailey

NOTE TO THE READER

The present catalogue consists of three essays and a series of entries on sixty-nine paintings. Supporting documentation and comparative illustrations for the entries are grouped at the back. These are followed by two appendices, a list of references and exhibitions, and an index.

The paintings in the catalogue are organized chronologically. Occasionally, two or more portraits of the same sitter separated only by a few years have been grouped together. Dimensions are those provided by the owner and are given in centimetres, height preceding width.

Further information on the individual paintings is provided in the supporting documentation at the back. Where François Daulte has catalogued a work under discussion (Daulte 1971), the Daulte number is shown, and where a work was included in the Renoir retrospective organized in 1985 by John House

and Anne Distel (House and Distel 1985), a House/Distel number is shown. The provenances of the catalogued paintings draw upon both these sources but also include, in many instances, new and unpublished information. Under Exhibitions I list only exhibitions that occurred during Renoir's lifetime, and under References I list works that are devoted primarily to the painting in question. Frequently consulted sources, such as Monneret 1978–81, White 1984, and Distel 1993, are not itemized specifically under References but are cited throughout the notes.

Unless otherwise stated, the medium for the catalogued works and the comparative illustrations is oil on canvas.

CBB

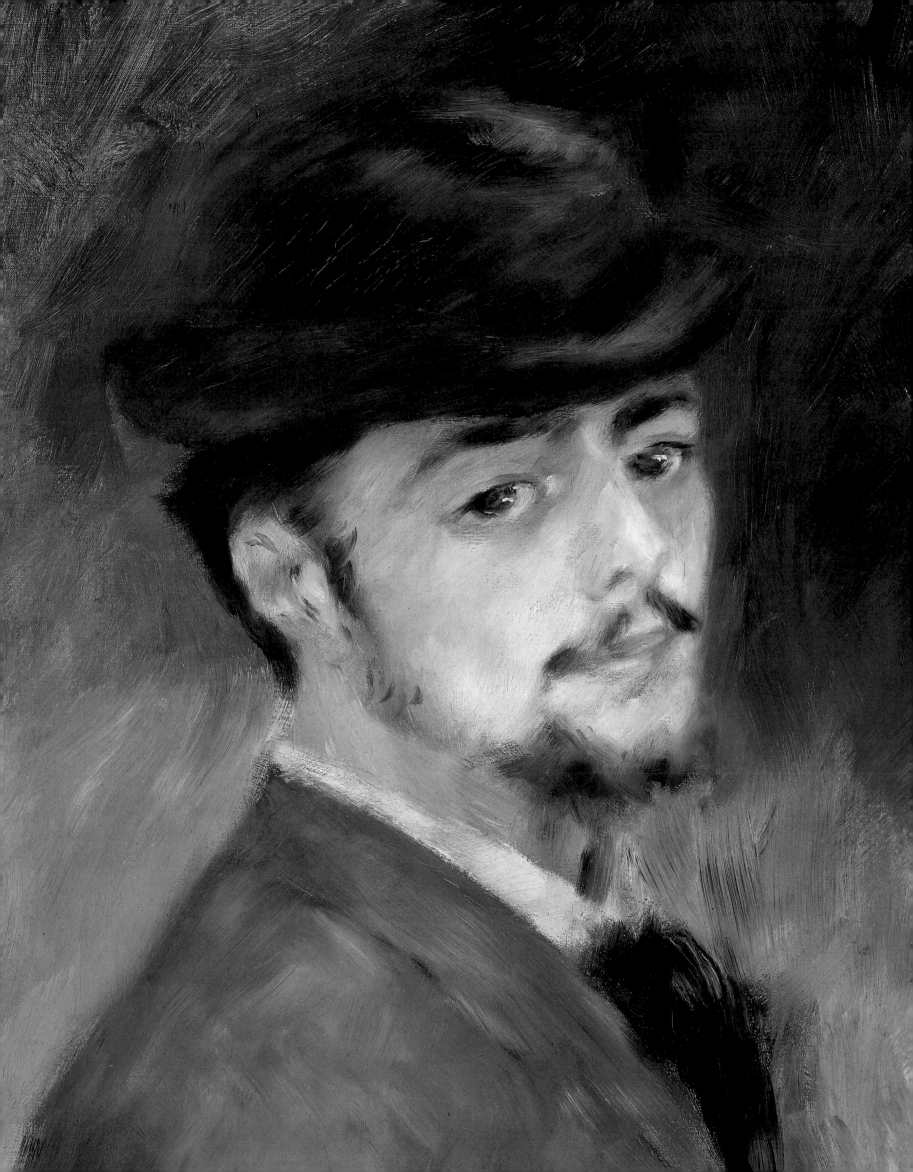

PORTRAIT OF THE ARTIST AS A PORTRAIT PAINTER

Colin B. Bailey

There are hardly fifteen art lovers in Paris capable of liking a painter who is not in the Salon. There are 80,000 who won't even buy a nose if the painter is not in the Salon. That is why, as little as it seems, I send two portraits to the Salon every year.[1]
– Renoir to Durand-Ruel, from Algiers, March 1881

"Monsieur Renoir, you have no integrity," said Degas reproachfully. "It is unacceptable that you paint to order. I gather that you now work for financiers, that you do the rounds with Monsieur Charles Ephrussi; next you'll be exhibiting at the Mirlitons with Monsieur Bouguereau!"[2]

In Renoir's figure painting, portraiture deserves a place unto itself. For no other artist has looked so deeply into his sitter's soul, nor captured its essence with such economy.[3]
– Georges Rivière, 1925

Briefly stated, Impressionist portraiture is a subject fraught with ambivalence, an unexpected aesthetic paradox. How, it may be asked, could the much studied Impressionist revolution, a genuinely radical and innovative artistic movement, spanning two decades and led by half a dozen artists, espouse a genre which, after religious painting, might be considered the least amenable to any divergence from accepted practice? How does the historian explain the phenomenon of reviled and rejected artists working within the conventions of the bourgeois art form par excellence?[4]

Consider, as preamble, Daumier's caricatures mocking the limitations of the earnest middle-class sitter, Baudelaire's "eternal bespectacled Eskimo."[5] "After all, it is rather flattering to have one's portrait at the Salon" (fig. 1); or again, "There's no getting away from it, that's my profile all right. But I don't understand why the artist has refused to include my spectacles and shirt collar" (fig. 2).

"Portraiture is the triumph of bourgeois art," claimed Théodore Duret in 1867.[6] A year later Zola complained that portraits were overwhelming the annual Salon, so numerous were they, because they were the only sort of painting that the benighted art-loving public had any interest in commissioning.[7] Yet, with the exception of Sisley, all the Impressionists painted portraits, sometimes as testimonies of friendships and allegiances, but just as often as commercial transactions, in exchange for ready money (both Monet and Renoir relied upon paid portrait commissions during the 1860s). That this most conventional of art forms attracted and, at certain times, sustained "les intransigeants," requires that the notion of a heroic artistic revolution played out before a philistine and uncomprehending public be modified yet again. Renoir, in old age, admitted as much: "It is the art lovers who make painting. French painting is as much the work of Monsieur Chocquet as Italian painting is the work of the Borgias and the Medicis . . ."[8] Yet, just as the Impressionists catered, at one level, to the conventional requirements for bour-

geois representation – namely, portrait painting – so did they also expand and redefine the genre, transforming it into a central component of the New Painting.[9] For Degas, Manet, and, to a lesser extent, Bazille – none of whom actually required commissions in order to live – portraiture functioned as a medium to explore the psychological terrain normally closed to the professional portraitist.[10] And it was the combination of poverty and ambition that led both Renoir and Monet to insert portraits of their familiars, in place of paid models, into their monumental paintings of Parisian leisure and modern life.[11]

Hegel's claim that the rise of portraiture marked the death knell of painting notwithstanding, critics responded more or less positively to the thriving demand for portraits, which appeared in increasing numbers in the Salons of the Second Empire and Third Republic. Although they did not count for three-quarters of the printed *livret*, as Zola claimed, it is fair to say that around one in five of the paintings on view at the Palais de l'Industrie in any one year were portraits; correspondingly, the second section of most Salon reviews would be devoted to them alone, and caricaturists had a field day (fig. 3).[12]

Portraiture was generally admitted to be a legitimate, difficult, and indeed noble undertaking – "une des plus hautes branches de l'art"[13] – since the painter went beyond the merely physical to achieve a psychological likeness, communicating the soul and character of the sitter. Academic pedagogy might insist that portraiture be protected from the contamination of the quotidian – "the greatest artist is not the one who enters our homes, wears our clothes, behaves as we do, speaks to us in our daily language and presents us with the image of our selves" – but such a stance was increasingly at odds with the naturalism inherent in the genre.[14] During the 1860s and 1870s it became an article of faith among the more progressive critics that portraiture could not be dissociated from the painting of modern life, and that its subjects might well be drawn from a wider pool of humanity than merely dignitaries and public figures. By the very nature of his craft, the painter of portraits "cannot isolate himself when he is observing, arranging, and judging the effects [of his sitter], and this requires that he maintain close ties with society."[15] Courbet's champion, the radical Republican Jules Castagnary (1830–1888)– who in his earlier criticism had denied all but "les hommes d'élite" the privilege of having their portraits painted – now urged a more democratic practice, since the portrayal of men and women "of various professions and of differing temperaments and characters" would leave posterity a lasting record of "la vie collective."[16]

The Naturalist aesthetic shared rather precariously by writers and painters around 1870 gave a privileged place to portraiture within the canon of modernity. "What is needed now are the special characteristics of the modern individual – in his clothing, in social situations, at home, or on the street," argued Edmond Duranty in a celebrated essay accompanying the second Impres-

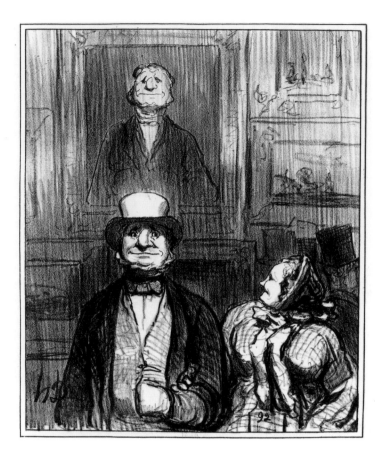

sionist exhibition of 1876.[17] The year before, in a brilliant passage, Zola – less willing to abandon the official terrain – had noted the potential of portraiture for the regeneration of contemporary art, as well as the inadequacies of its current practitioners:

> It goes without saying that portraits, these pictures of everyday life, should by their very nature represent the modern. But this is far from the case. Of course, the models are taken from life, but the artist nearly always strives to imitate the Old Masters: he tries to paint like Rubens, Rembrandt, Raphael, or Velázquez . . . Furthermore, artists have only one aim in mind: to please their sitters. You might say that their primary concern is to banish any trace of life whatsoever from their paintings, and so we are left with portraits that are nothing more than shadows – pale, glassy-eyed faces, with satin lips and porcelain cheeks.[18]

If it was primarily to landscape painting that progressive critics had looked for signs of a revitalization of the French school in the 1860s, portraiture also had a role to play in this renewal, since it brought the painter into contact with "life itself, modern life, in its daily permutations."[19]

Even within the less progressive terrain of the annual Salon, critics still uncertain about Manet and quite unsympathetic to the Impressionists did not hesitate to attack Cabanel and Bouguereau for their arid and excessive stylization, while warmly commending portraitists such as Carolus-Duran, Bonnat, Chaplin, and Bastien-Lepage. Thoroughly discredited, *ingrisme* was replaced by an official manner of portraiture that was relatively painterly, generally untroubled by finish, "positivist" in its transcription of costume and expression, and tolerant of chic modernity. It is against this sort of fashionable and commercial Parisian painting that Renoir chose to measure himself in the middle of his career.[20] While he might adopt similar pictorial solutions – Renoir was generally conservative in his compositions – his technical audacity set him apart from all other figure painters exhibiting in the Salon between 1878 and 1883 with the exception of Manet.

Nowhere is the precarious relationship between the conventional and the progressive, between the (largely) conservative expectations of a bourgeois clientele and the (largely) destabilizing ambitions of an Impressionist figure painter, of such pressing importance as in Renoir's portraiture. For no other artist of the nineteenth century bequeathed such an enduring and endearing image of elegance, comfort, and prosperity – one that, as Proust noted, was not to be found in the canvases of any of the more fashionable artists of the Third Republic: "Will not posterity, when it looks at our time, find the poetry of an elegant home and beautifully dressed women in the drawing-room of the publisher Charpentier as painted by Renoir, rather than in the portraits of the Princesse de Sagan or the Comtesse de La Rochefoucauld by Cotte or Chaplin?"[21] Since Renoir was the only Impressionist to achieve financial security through the practice of portraiture, as well as being the movement's pre-eminent figure painter, his pro–

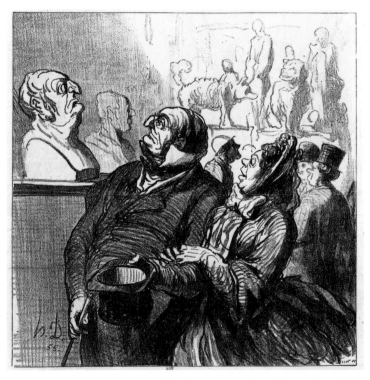

Fig. 2 Honoré Daumier, *Le Public à l'exposition*, 1864, lithograph. Bibliothèque Nationale, Paris. Captioned: "Il n'y a pas a dire, c'est bien mon galbe . . . mais je regretterai toujours que l'artiste ait eu l'entêtement de ne vouloir pas reproduire mes lunettes, non plus que mon faux-col!"

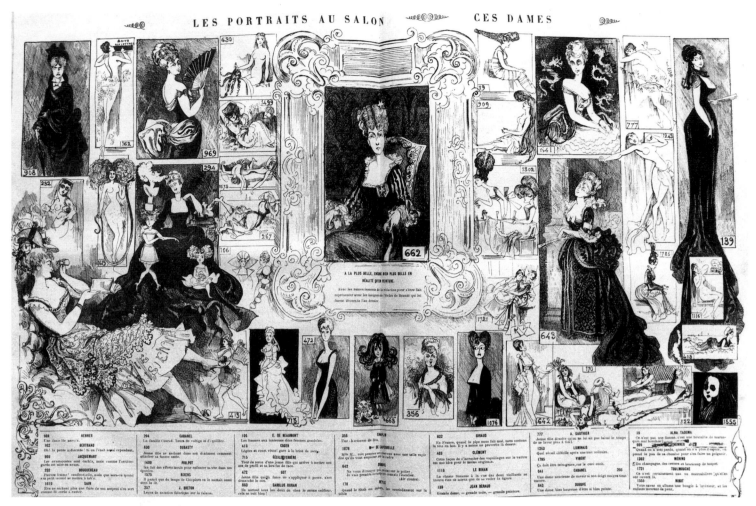

Fig. 3 *Les Portraits au Salon, ces dames*. From *La Vie Parisienne*, 28 May 1874

cedures and approaches to the genre are of particular interest. His best portraits are as fine as anything produced in the second half of the nineteenth century, and they provide a corpus of work of surpassing beauty that still remains to be thoroughly investigated.

Although Renoir, like Degas and Manet (and Monet in the 1860s), blurred the distinctions between the portrait and the tableau by posing friends in modern narratives that gave the illusion of being direct transcriptions of everyday life, between the mid-1860s and the mid-1880s he also worked as a portraitist in the conventional sense.[22] Narrowly defined, portraiture occupied Renoir at all stages of his early and middle career – from the dour and respectable effigies of family members painted in the 1860s, often surprisingly Victorian in feeling, to the extravagantly brushed canvases of the Impressionist decade, to the more solidly modelled, but no less brightly coloured, transitional works of the mid-1880s. During the last thirty years of his life, Renoir turned to the genre intermittently. In old age, his forms become more ample and his colours more generalized, but the artist touches new depths of affection and tenderness, and is capable of unexpected humour and wit. Renoir furthermore painted portraits in all formats, from the diminutive *Margot Berard* (cat. no. 34) to the towering portrait of his son Jean as a hunter (cat. no. 63), and in a variety of media, from pastel to oil on cement.

Rarely, but it does happen, a commissioned and completed work fails almost completely: the portrait of Caillebotte's homely mistress, *Mademoiselle Charlotte Berthier* (1883, National Gallery of Art, Washington),[23] and, most flagrantly, the disastrous portrait of "la dévorante Henriette," Madame Robert de Bonnières (fig. 4), wife of the influential journalist and friend of Mallarmé, whose salon on the avenue de Villars, "a sanctuary of Wagnerism," was recognized as "the meeting place for all talented newcomers."[24] "I can't remember ever having painted a picture that gave me more trouble," Renoir recalled of his commission from this society matron who kept her hands in cold water to preserve their pallor and who travelled to balls standing in her coach in order not to crease the folds of her gown.[25] The dealer Ambroise Vollard, who could do nothing with this portrait – a sort of failed Boldini – donated it to the Petit Palais, where it remains in storage.

Impolite though it may be to labour over the unredeemed portrait of Madame de Bonnières, it is nonetheless instructive as an anomaly. Renoir may have complained to Vollard of having to paint "those overbred females they call society women," but in the majority of cases he captured them with none of the constraint we find here, and succeeded in satisfying his sitter's demands for an acceptable presentation without compromising what might be

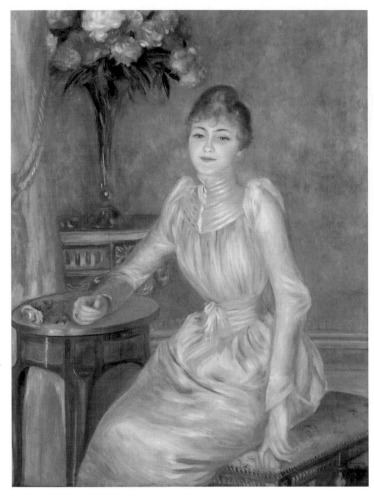

Fig. 4 Pierre-Auguste Renoir, *Madame de Bonnières*, 1889. Musée du Petit Palais, Paris

termed his own aesthetic integrity.[26] Since all commentators pointed out that painting was as natural to Renoir as breathing or eating, it can safely be assumed that portraiture required him neither to suffocate nor to starve.[27] Indeed, from the romantic Naturalist of the 1860s and the full-blooded Impressionist of the 1870s, painting family, friends, and supporters, Renoir emerges for a brief period between 1878 and 1884 as a society portraitist to rival Whistler or Sargent. Cézanne confided to Zola in the summer of 1880 that Renoir had recently picked up some very good portrait commissions, and it was to Renoir's studio that Mary Cassatt had initially directed her sister-in-law Lois in December 1882, the latter in search of a suitable full-length. Not liking what they saw, Lois and Alexander Cassatt approached Whistler in London the following April, waited three years for his portrait of Lois to be completed, and were disappointed with the results.[28]

Yet Renoir's portraits of the beau monde – particularly its children – are generally as affectionate and engaging as his portraits of bohemian friends and fellow artists. His "oeil bienveillant" operates a sort of aesthetic levelling in which actresses and circus performers are presented with the same charm and directness as chatelaines and society hostesses, in which the children of petit bourgeois clerks and shopkeepers are as commanding as the pampered offspring of provincial senators or the privileged sons and

daughters of bankers and doctors. It is this immensely reassuring and utopian vision of a shared and harmonious society that sets Renoir apart from any other figure painter working in Paris in that golden age. It also distinguishes him from Zola, the greatest Naturalist writer, whose novel *L'Assommoir* Renoir illustrated in 1878. "Zola imagined that he had described the common people once and for all when he said they smelled bad," Renoir confided to Vollard.[29] And whereas Renoir recalled the sensitivity of the families of Montmartre he had encountered on his trips to the Moulin de la Galette, he claimed that Zola had always spoken of them as "barbaric creatures."[30]

★ ★ ★

"Let him do no more portraits, let him remain a landscape painter!"[31] With characteristic perversity, Degas reversed the priorities for which Renoir was recognized by all critics during his lifetime. Noting that "Renoir excels at portraiture," Théodore Duret had stressed the importance of this genre in the artist's oeuvre as early as 1878, a year before *Madame Charpentier and Her Children* (cat. no. 32) was hung in a place of honour at the Salon.[32] Although Georges Rivière would later claim that Renoir disliked painting portraits, even of pretty women, in April 1877, at the time of his closest involvement with the artist, he is found advertising the painter's talents to female readers of the newly launched journal *L'Impressionniste*, urging the wives of good Republicans to overcome their husbands' resistance and commission Renoir to paint "a ravishing portrait that will capture every ounce of your charm."[33] Writing to Eugène Murer in April 1878, Pissarro referred warmly to Renoir as a "portraitiste éminent."[34]

Portraiture was an absolutely central concern of Renoir's in the first two decades of his career, and while it is not yet possible to determine the degree to which this activity occupied him in the last twenty-five years of his life, it is clear that he continued to paint portraits almost until the end. Renoir himself claimed to be "in a delirium of happiness" in January and February 1912 while painting Vollard's Creole mistress in Nice as a meridional Madame Récamier (fig. 5), and his final masterpiece in the genre,

Fig. 5 Pierre-Auguste Renoir, *Madame de Galéa à la méridienne*, 1912. Private collection

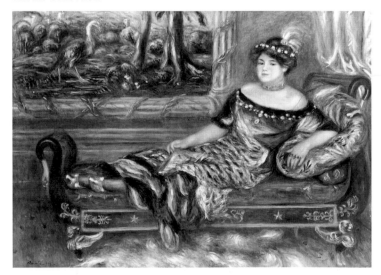

4

Ambroise Vollard as a Toreador (cat. no. 69), painted two years before his death, shows not the slightest diminution of his powers.[35] However, between 1864 and 1885 portraiture might well be said to dominate Renoir's oeuvre: of 397 finished compositions catalogued by Daulte, 164 are portraits and 161 are genre.[36] Submitting to every Salon but three between 1863 and 1883, and accepted in twelve of them (including the Salon des Refusés of 1873), Renoir was represented by portraits in 1865, 1873, 1879, 1880, 1881, 1882, and 1883.[37] After an absence of seven years, his *envoi* to the Salon of 1890 – and the last painting he would exhibit there, "assassinated" by its installation in a miserable corner of the Palais de l'Industrie – was *The Daughters of Catulle Mendès* (fig. 8).[38]

Portraiture played an equally important role in two of the three Impressionist exhibitions to which Renoir contributed of his own accord. Of the seventeen paintings exhibited at Durand-Ruel's gallery in April 1876, ten were portraits – "les portraits si fins et si vifs," as Castagnary commented in his review of the official Salon.[39] The following year, at the third Impressionist exhibition, Renoir included seven portraits among the twenty-one paintings he sent to the "immense appartement préparé ad hoc" on the first floor of 6 rue Le Peletier.[40] Already acknowledged as "le portraitiste du cénacle,"[41] Renoir's submission – which included the bust portraits of Mademoiselle Samary (cat. no. 29) and Madame Charpentier (cat. no. 31), as well as the portrait of Georgette Charpentier (fig. 6) commissioned the previous year – inspired the most perceptive assessment yet made of his talents. For the first time in print, an affinity was perceived with Renoir's beloved eighteenth century: "To discover a similar sort of portrait painting, one would have to go back to the spirited sketches of Fragonard, not for a comparable technique, but for a temperament that is so quintessentially French."[42]

Renoir also chose to show his portraits outside the Salon and the Impressionist exhibitions. For a second one-man exhibition at the offices of *La Vie Moderne*, planned for the spring of 1880 but never realized, Renoir informed Madame Charpentier that he hoped to have an exhibition devoted exclusively to portraiture: "I think it would be rather popular."[43] Twenty-one of the seventy paintings shown by Durand-Ruel in April 1883, in the largest exhibition of Renoir's work to date, were portraits. On the day that exhibition closed, Renoir's bust portrait of Mademoiselle Samary (cat. no. 29) was among the 355 portraits assembled by Charles Ephrussi at the École des Beaux-Arts for *Portraits du siècle*, an immensely popular survey described by one conservative critic as "la suite des portraitistes exposés quai Malaquais depuis Madame Vigée-Lebrun jusqu'à Monsieur Renoir."[44] Among the 25,000 visitors who saw the exhibition during its two-week run was Paul Gauguin, who, sixteen years later, from the distant island of Tahiti, would recall "ce beau portrait de Samary que j'ai vu autrefois."[45]

Finally, it seems fitting that the last exhibition devoted to Renoir during his lifetime in Durand-Ruel's Paris gallery should have reviewed his activity as a portraitist. Organized to compete with Monet's recent Venetian series on show at Bernheim-Jeune, *Portraits par Renoir* – fifty-eight works from all stages of his career, organized in less than a month, and on view for barely more than two weeks (5–20 June 1912) – carried a certain revisionist edge. By now, Renoir – widely considered the greatest living painter – was celebrated above all for his later work, the nudes and bathers

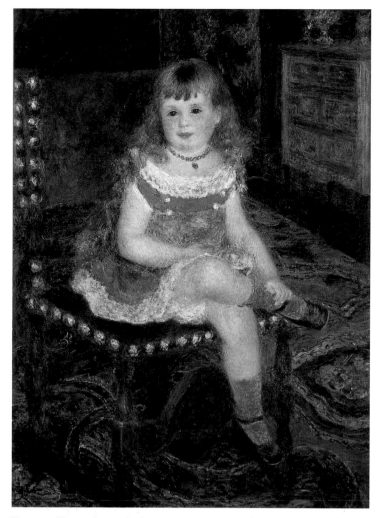

Fig. 6 Pierre-Auguste Renoir, *Georgette Charpentier Seated*, 1876. Bridgestone Museum of Art, Ishibashi Foundation, Tokyo

insensitively described by Mary Cassatt as "the most awful pictures . . . of enormously fat red women with very small heads."[46] Joseph Durand-Ruel justified mounting this portrait exhibition, which followed hard on the heels of his company's large survey of Renoir's recent work (27 April–15 May 1912), by claiming that it would reveal an unknown aspect of the artist to the public: "We intend to show that you are not only a painter of still lifes and nudes, but that, contrary to most people's idea of your talents, you are also a great portraitist."[47]

Although Renoir helped secure loans for the portraiture exhibition of June 1912, he initially resisted the project, Gabrielle informing Vollard that "the boss" had done what he could to prevent it from taking place.[48] Quite the reverse is true for Renoir's early and middle career, when he actively sought commissions for portraits and followed the advice given to him by his sister in the early 1860s "to be sensible and try his hand at doing portraits."[49] Renoir's development as a portraitist depended upon the discrete clusters of supporters and patrons with whom he was associated at different times between 1863 and 1885. At one level, his portraits are a record of social ascension, reflecting as they do the artist's attachment to various milieus within the Parisian lower-middle, middle, and upper-middle classes. In the 1860s, his sitters and sup-

porters were drawn primarily from his family, former fellow students of Gleyre's atelier, the Le Coeurs, the Darras. During the following decade, he turned to actresses and restaurateurs, and to collectors such as Chocquet, de Bellio, Murer, "a select group of art lovers with good taste, but not in the same league as the wealthy collectors who pay the highest prices."[50] Finally, between 1878 and 1884, through Duret and Charpentier, Renoir "arrived" at a clientele of wealthy, well-connected Protestant and Jewish financiers, whose patronage is considered in some detail below.

From early on, Renoir was quick to use all the means at his disposal to further his career as a portraitist. In the summer of 1868 he offered to paint a large full-length of Marie and Joseph Le Coeur, wife and son of his friend the architect Charles Le Coeur (cat. no. 18), perhaps with the intention of exhibiting it at the Salon of 1869. He would do the portrait for nothing, he explained, as long as the Le Coeurs paid for the canvas – "une toile de 120 fine [195 × 130 cm], très lisse, plusieurs couches."[51] Through Le Coeur, he was introduced to Prince Georges Bibesco (1834–1902) (fig. 7), a liberal Rumanian aristocrat whose *hôtel particulier* on the avenue de La Tour-Maubourg was designed by Le Coeur in the summer of 1868 and decorated by Renoir. A commission followed to paint the prince's portrait, for which Renoir

Fig. 7 Prince Georges Bibesco, 1866. Private collection, Paris

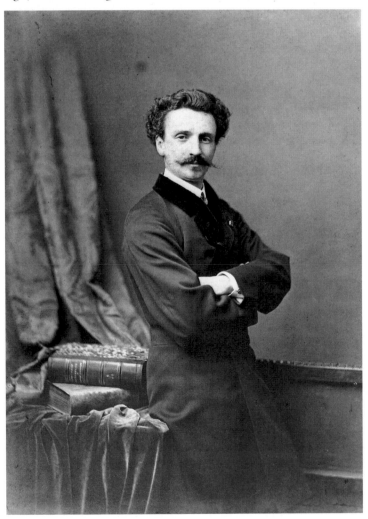

had high hopes.[52] Constrained by having to work from a photograph of the prince "en hussard rouge" (he was away campaigning in North Africa), Renoir disappointed Bibesco's mistress and her entourage, who failed to recognize "les yeux de feu du prince."[53] He had no better luck with the jury, who rejected this portrait when it was submitted to the Salon of 1869.[54] Undaunted, Renoir continued to canvas his friends for potential clients: Bazille was asked to remind Madame Mariani that Renoir hoped to paint her portrait on his return to Paris.[55]

From the following decade, there are similar instances of Renoir pressing for portrait commissions, an activity rather at odds with the carefree personality, generally unconcerned about money and easily taken advantage of, sketched by Rivière.[56] Renoir was unable to collect the money that Charpentier owed him in person, since he had agreed to lunch with a potential client.[57] He had twice tried to gain access to the comtesse Louis Cahen d'Anvers, he informed Charles Ephrussi, and urged him to write to her on his behalf to confirm the commission to paint the portrait of her daughter Alice.[58] Towards the end of April 1888, having just returned to Paris from Louveciennes, it was Renoir's idea to paint a full-length portrait of the daughters of Catulle Mendès (fig. 8) in time for the sixth Exposition Internationale in early May. He put the request quite bluntly in a letter to the poet, and on terms that could hardly be refused.[59]

By the late 1870s portraiture clearly enabled Renoir to achieve a certain measure of financial security, which in turn afforded him the independence and peace of mind to press forward in his ambitions as a figure painter. It also settled what Degas's father had called "la question du pot-au-feu dans ce monde."[60] Théodore Duret (1838–1927), who was introduced to Renoir by Degas in 1872 and owned fine examples of his early work, was categorical on this point. With the success inaugurated by his presence at the Salon of 1879 – where he exhibited the large portraits of Madame Charpentier and her children (cat. no. 32) and Mademoiselle Samary (cat. no. 30), as well as pastel portraits of Paul Charpentier and Théodore de Banville – Renoir's economic situation was transformed, virtually overnight: "He was rescued from the poverty in which he had almost always lived. Remuneration from these portraits would in time provide him with a sizeable income . . . But initially, they enabled him to make a living."[61]

Duret's melodramatic tone (he is writing a quarter of a century after the event) must be seen in the light of Renoir's failure to establish himself through the Impressionist exhibitions and sales of 1876 to 1878. Crucial here are the low prices of the second Impressionist auction of May 1877, in which sixteen of Renoir's paintings fetched a total of only 2,005 francs;[62] Renoir and Monet's decision to withdraw from the Impressionist exhibition of 1878, planned to coincide with the Exposition Universelle but finally abandoned, with Renoir showing at the Salon for the first time in five years and Monet claiming that another Impressionist exhibition would have prevented him from selling;[63] and the disastrous results of the forced sale of Hoschedé's collection in June 1878, where three Renoirs sold for 31 francs, 42 francs, and 84 francs respectively.[64] It was financial considerations such as these, as much as the factions within the Impressionist brotherhood, that encouraged Renoir to return to the arena of the annual Salon – "*l'officiel*" – and to return there as a portraitist.

Renoir was not alone in defecting from the exhibitions now advertised as by "a group of Independent artists" – by 1880

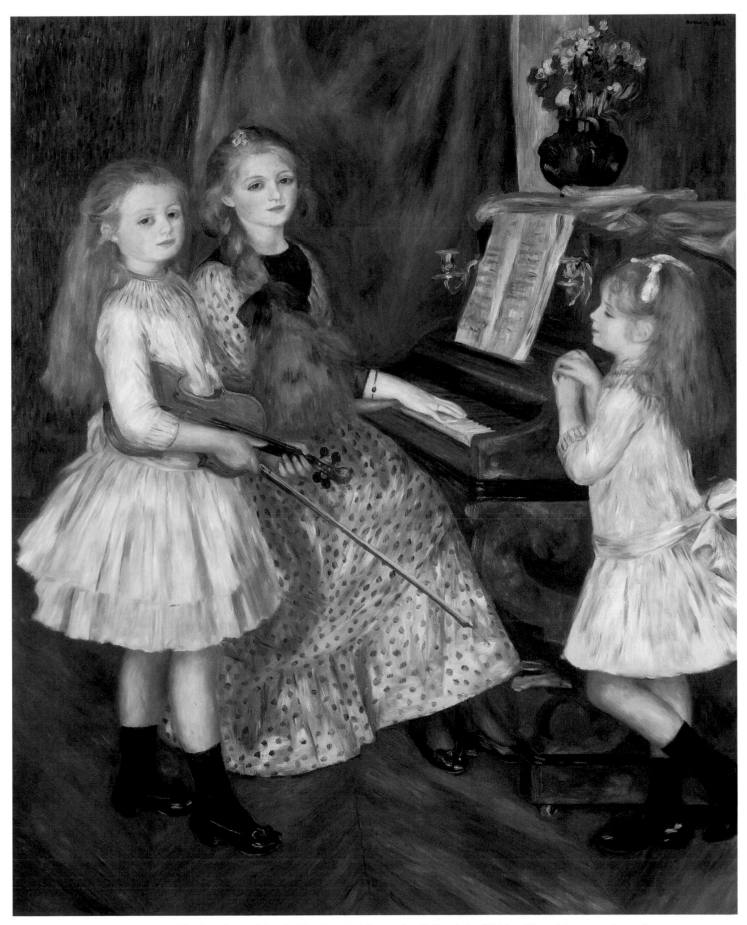

Fig. 8 Pierre-Auguste Renoir, *The Daughters of Catulle Mendès*, 1888. From the Collection of Walter H. and Leonore Annenberg

Monet, Sisley, and Cézanne were equally disenchanted – but he was the most committed to securing his reputation through official channels.[65] In one sense, portraits of the members of the Charpentier family and of the actress Jeanne Samary shown at the Impressionist exhibition of 1877 served as trial runs for the more formal productions that Renoir had completed by October of the following year, in good time for the Salon of 1879. Both the bust portrait of Madame Charpentier (cat. no. 31) and the full-length of her daughter Georgette, seated (fig. 6), are more summary in their handling and in a considerably higher key than the imposing *Madame Charpentier and Her Children* (cat. no. 32), which, thanks to the sitter's influence with certain members of the jury, was hung in a place of honour at the Salon of 1879.[66] Similarly, the radiant bust portrait of Jeanne Samary (cat. no. 29) – "une tête toute blonde et rieuse," generally accounted the success of the 1877 Impressionist exhibition[67] – was followed at the Salon of 1879 by a full-length of the actress in a ball gown (cat. no. 30), a painting of greater propriety, but impossible to see, since it was skied in one of the "dépotoirs" of the Salon, "high and badly hung."[68] Renoir's decision to paint Mademoiselle Samary full-length – the work, it should be noted, never belonged to her – was calculated to draw attention to his skills as a celebrity portraitist. It was one of the many effigies of fashionable young actresses that routinely appeared at the Salon, and it was exhibited the same year as Bastien-Lepage's acclaimed portrait of Sarah Bernhardt (fig. 181), Samary's rival at the Comédie-Française.[69] As the historian of that institution noted many years later, "When a young artist exhibits at the Salon the portrait of the creator of the most recent starring role, he too can be assured of becoming a star."[70] Renoir's choice of sitters and his manner of painting were tailored to conform to the expectations of the more enlightened Salon-goer. As Monet explained to Duret in March 1880, he had decided against sending one of the pictures on which he had been working to the Salon because it was "too much to his own taste"; rather than have it rejected, he replaced it "with something more sensible, more bourgeois."[71] Renoir can be seen to have approached his most ambitious portraits to date in precisely the same way.

Indeed, the care with which Renoir organized his submissions to the Salon between 1879 and 1883 confirms his determination to succeed in what Monet disparagingly called "ce bazar officiel."[72] He was increasingly uneasy about exhibiting with Pissarro and the younger artists he encouraged, such as Gauguin – "rester avec l'israélite Pissarro, c'est la révolution"[73] – and he could console himself that in returning to the official arena he was also following the advice of some of his most sympathetic critics. Both Duret and Castagnary had insisted that the Impressionists present themselves publicly in the Salon, and Zola, who approved of Renoir's decision, reminded his readers of "the admirable publicity that the official Salon provides for our young artists; in our society, it is only there that they can truly triumph."[74] If Renoir was being "pushed" by the Charpentiers, as Pissarro noted to Caillebotte as early as March 1878, it is not clear that they needed to do much pushing. For despite its many inconveniences – the "immense army of painters" that invaded the Palais de l'Industrie each year, the inequities of the jury, the privileges given to the "hors concours" and medal holders, the absurd system of hanging alphabetically[75] – Renoir made it perfectly clear to Durand-Ruel that he now had no interest in boycotting the Salon: "I do not

wish to waste my time bearing a grudge against the Salon. Nor do I wish to appear to have any reason to do so."[76]

Renoir took considerable pains to involve his new-found "protectors" – those who, in Duret's words, "having wished to help him, now undertook to commission portraits as a way of acting on his behalf" – in the organization of his entries to the Salon, with faintly comic results.[77] Madame Charpentier was dispatched to the Berards to confirm that the pastel portrait of their eldest daughter, Marthe (private collection), could be exhibited at the Salon of 1880; it could.[78] Charles Ephrussi (1849–1905) – the "benedictine dandy of the rue Monceau" and scion of a wealthy Jewish corn-exporting dynasty from Odessa, who, after arriving in Paris in 1872, devoted himself to the study of the Renaissance and the collecting of modern art – took charge of Renoir's submission to the Salon of 1881, and ensured that his mistress, Louise Morpurgo, the comtesse Cahen d'Anvers, lent both the portrait of her eldest daughter, Irène (fig. 10), and that of her two younger daughters, Alice and Elisabeth (cat. no. 38).[79] Ephrussi also commissioned Renoir to produce a drawing after the portrait of Irène Cahen d'Anvers (fig. 11) and published it in the issue of the *Gazette des Beaux-Arts* devoted to the Salon, even though the reviewer had not a word to say in the portrait's favour.[80] Not that Renoir, who had left Paris for Algiers in March 1881, had been entirely passive in this affair; as early as July 1880 he had informed Ephrussi that he wanted the portrait of Irène Cahen d'Anvers to be shown at the Salon the following year.[81]

Arrangements for the Salon of 1882, in which Renoir was finally represented by one work, the beautiful but diminutive portrait of Yvonne Grimprel (fig. 9), were even more chaotic, with Renoir, again en route to Algiers, sending frantic missives to Paul Berard (1833–1905), who had agreed to act as *commissaire*. Renoir's three letters (reproduced in Appendix I at the end of this catalogue) show that he had first wanted to exhibit *two* portraits: that of Yvonne Grimprel and another either of Paul Berard (fig. 51) or of a member of Berard's family.[82] In a second letter, Renoir reacts against the suggestion to exhibit his portrait of Ephrussi's brother Ignace (1848–1908) – "À tout prix, n'envoyez pas Ignace" – and urges Berard to send either the portrait of his eldest son André, or that of his wife, making it clear all the while that his preference is for the portrait of Paul Berard.[83] Once settled in Algiers, however, Renoir changed his mind: "Your portrait needs to be bottled away for a year. Don't pay any attention to what I said previously, just listen to Ephrussi. That super-bourgeois Jew has an eye for what is required at the (Beauty) Salon."[84] In the end, the choice is left to Berard, who sends nothing from his own collection. Yet, despite his wavering, on one issue Renoir had been categorical: "Do not send paintings, send portraits."[85]

Apart from Huysmans, only two critics discussed Renoir's submission to the Salon of 1881 in sufficient detail to confirm that he was indeed represented by "the portraits of those little Cahen girls."[86] *Yvonne Grimprel* must have been completely lost from view among the 2,722 canvases on show at the Salon of 1882, for it is nowhere mentioned in the press, and the same was true for *Madame Clapisson* (cat. no. 46), Renoir's single submission to the Salon of 1883.[87] With the appearance of *Madame Charpentier and Her Children* at the Salon of 1879, Renoir had been quickly welcomed back into the fold: critics crowed over the conversion of this "ancien intransigeant," and in *L'Artiste*'s review of the year published in December 1879 he was classified among the "por-

Pierre-Auguste Renoir, *Madame Georges Charpentier and Her Children* (cat. no. 32), detail

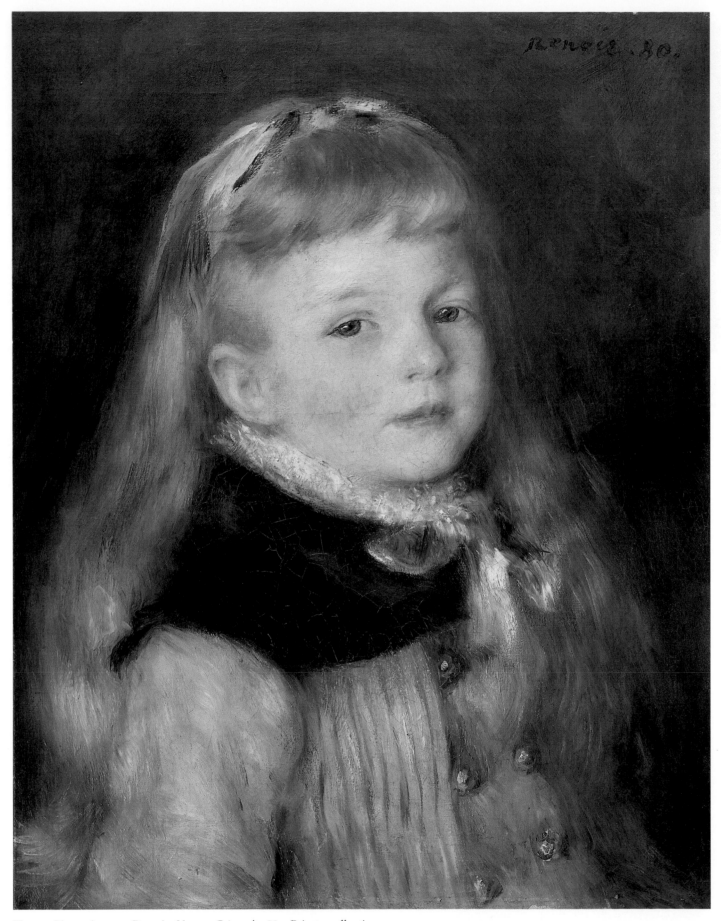

Fig. 9 Pierre-Auguste Renoir, *Yvonne Grimprel*, 1880. Private collection

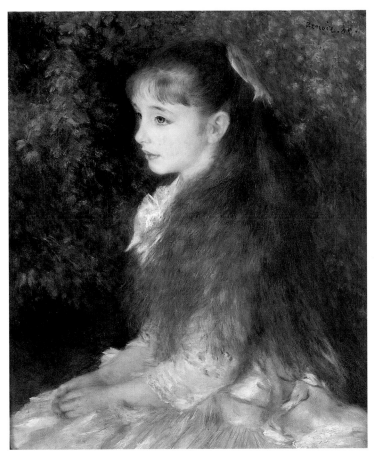

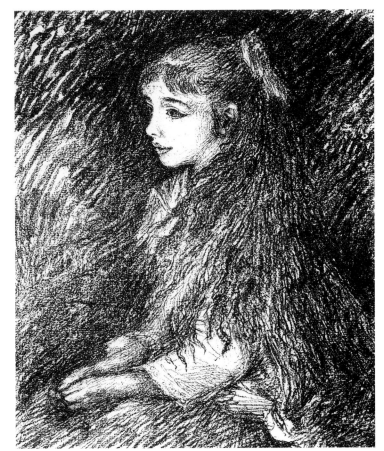

Fig. 10 Pierre-Auguste Renoir, *Irène Cahen d'Anvers*, 1880. Foundation E.G. Bührle Collection, Zurich

Fig. 11 Pierre-Auguste Renoir, *Irène Cahen d'Anvers*, 1881. From the *Gazette des Beaux-Arts*, July 1881

traitistes," rather than with Monet, Degas, and Pissarro in the camp of "les impressionnistes à outrance."[88] Yet, in the four years that followed, Renoir's commitment to the Salon was not altogether rewarded. As has been noted, even in 1879 the portrait of Mademoiselle Samary (cat. no. 30) had been poorly hung. At the Salon of 1880, Renoir was "fort mal placé," Zola reporting that his genre paintings were consigned to the circular gallery that abutted the garden courtyard, where they were rendered virtually invisible by the glare.[89] His portraits in the three subsequent Salons received hardly any attention in the press, and Renoir would always resent how poorly *The Daughters of Catulle Mendès* (fig. 8) had been hung at the Salon of 1890.[90] The "honours of the cimaise" were not forthcoming after 1879, and so it is with a certain poignancy that we find Renoir risking his relationship with Durand-Ruel in order to continue to exhibit at the Salon. Dangerously ill at L'Estaque in February 1882, Renoir did all he could to prevent Durand-Ruel from showing his works at the seventh Impressionist exhibition. In his delirium he claimed that Pissarro, Gauguin, and Guillaumin were out to ruin his career: "These gentlemen realize that I have made great strides because of the Salon. Now they cannot wait for me to lose all that I have gained and they will stop at nothing to bring me down."[91]

If Renoir had made "great strides," this had less to do with his success at the Salon, than with the cluster of well-placed patrons – largely Protestant and Jewish bankers – who supported his work

in the late 1870s and early 1880s. Most of them hesitated to sit to Renoir themselves, but they commissioned portraits of their families and introduced him to their friends, who in turn commissioned portraits of their wives and children. Here the focus shifts slightly from the Charpentiers, crucial though their support had been between 1876 and 1879. It was not primarily them that Jacques-Émile Blanche had in mind when he later recalled Renoir's success as a "portraitiste mondain" in the early 1880s.[92] For this well-connected twenty-year-old, there was a certain pleasure in seeing the rustic Renoir, whose table manners were the despair of his mother, taken up by "wealthy Jewish financiers" who hung his paintings "next to a Ricard, a Bonnat, a Baudry" and were "rather proud of their audaciousness," even if the portraits they commissioned "ended up in the laundry room or were given away to former governesses."[93] The critic and collector Charles Ephrussi (fig. 12), whom Renoir met through Deudon and Berard, and whom he introduced to the Charpentiers in December 1878, was Renoir's champion here.[94] According to the cynical Blanche, Ephrussi's friendship provided the artist with "a mondain clientele who had little faith in his talents but who had been assured that they would make a handsome profit by investing in Impressionist paintings."[95]

Through Ephrussi, Renoir apparently received a commission to paint the portrait of his brother Ignace, a work jocosely considered "slightly Cabanel" when it was unveiled "to everyone's

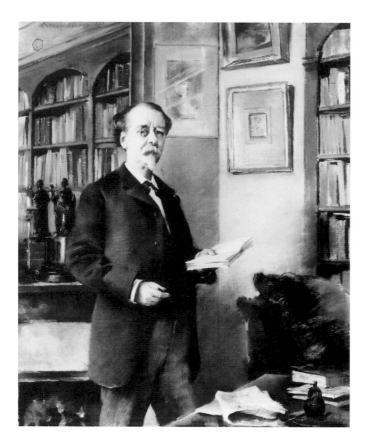

satisfaction";[96] the possibility of a commission (probably never realized) to paint the portrait of one of his "little nieces" (perhaps Elisabeth Fould, later the vicomtesse Joseph de Nantois [1881–1952]);[97] and, in July 1880, the commission to paint the portrait of "le bébé de Monsieur Bernstein," one of the sons of Manet's friend and Ephrussi's cousin Marcel (1841–1896).[98] In 1880 Renoir painted the portrait of Ephrussi's half-sister, Thérèse Prascovia Ephrussi (1851–1911) (private collection), wife of the banker Léon Fould (1839–1924), whose mother, Madame Eugène Fould, née Delphine Marchand (1812–1888), also sat to him in July of that year (fig 13). Her portrait, which Fanny Ephrussi considered "une merveille," was finished and paid for by August 1880.[99] As has been noted, Ephrussi had persuaded his mistress, the comtesse Louis Cahen d'Anvers, wife of the powerful Jewish banker, to have Renoir paint the portraits of her three daughters; *Irène Cahen d'Anvers* (fig. 10) was finished by August 1880, *Alice and Elisabeth Cahen d'Anvers* (cat. no. 38) in late February 1881, just before Renoir left Paris for Algiers.[100]

Ephrussi, who did not sit to Renoir – although he may have been the model for the gentleman in the top hat seen conversing in the background of *Luncheon of the Boating Party* (fig. 16) – was also a close friend of the man whose family provided Renoir with more sitters than any but the artist's own. The association between Ephrussi and Paul Berard (1833–1905) was elegantly acknowledged in the inscription that Renoir appended to his *Gypsy Girl* (cat. no. 33), one of the finest of the Renoirs in Ephrussi's collection.[101] Below his signature, he added "Wargemont 1879," referring to Berard's country estate just outside Dieppe, where Renoir was a regular visitor between 1878 and 1884.

A diplomat and financier, Berard was connected "with the great Protestant banking families who ruled the destinies of the Banque de France." According to Blanche, whose family summered at Dieppe, not far from Wargemont, Berard's "enormous influence . . . enabled Renoir to establish his reputation as a portraitist."[102] For Berard not only commissioned a series of incomparable family portraits, discussed later in this essay, but also acted as a conduit to other clients. His banking associate Georges Grimprel (1838–1910), who would have organized Renoir's entry to the Salon of 1882 had Berard declined, commissioned separate portraits of his three children, Yvonne (fig. 9), Hélène, and Maurice (fig. 14) in 1880, the first of which was exhibited at the Salon two years later.[103] It was in the "petit salon" at Wargemont in September 1881 that the composer Albert Cahen d'Anvers (1846–1903) (cat. no. 37), brother-in-law of Louise Morpurgo, sat to Renoir – like Ephrussi's *Gypsy Girl*, the portrait is inscribed "Wargemont," and we know from Deudon's correspondence that Ignace Ephrussi was Berard's guest at the time and that he too watched it emerge from Renoir's brush.[104] Berard introduced Renoir to his old friend Frédéric-Alexis-Louis, comte Pillet-Will (1837–1915), regent of the Banque de France, who declined to have the artist paint his portrait because his prices were too low.[105]

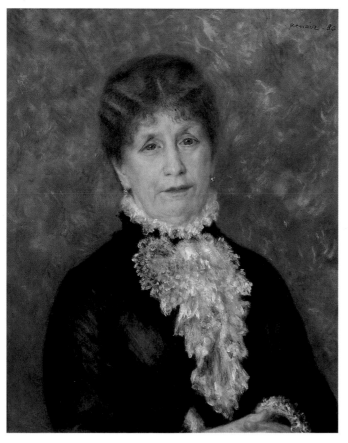

Fig. 13 Pierre-Auguste Renoir, *Madame Eugène Fould, née Delphine Marchand*, 1880. Private collection

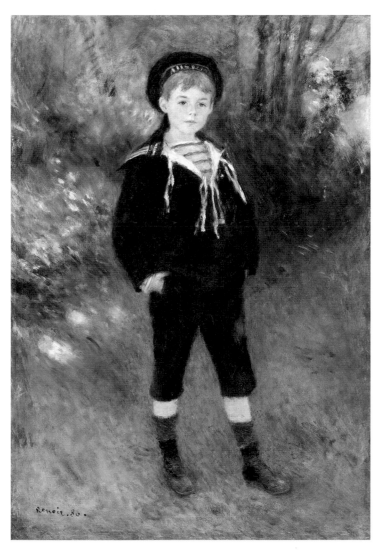

narratives that he "had been itching to paint for so long" might finally be realized.[108] After a particularly active summer – Renoir had accepted so many portrait commissions by July 1880 that he was beginning to "mistake one nose for the other"[109] – he had decided to start work on *Luncheon of the Boating Party*, since he could not be sure of having the funds later on; he confided to Berard from Chatou that such an undertaking was "enormously expensive," because of having to pay models.[110] Even so, it is not clear that in the making of any of these pictures Renoir was ever in a position to do without the assistance of friends and intimates who were prepared to pose for nothing.[111]

In fact, Renoir was following the course that was traditionally recommended to history painters, who were expected to turn to portraiture in order to help finance their more ambitious undertakings. "Portraits are the small change of history painting," noted Zola in 1876.[112] The commercial possibilities of portraiture were not to be overlooked, argued Burty, who encouraged artists to "use portraiture to subsidize the production of pictures whose eventual ownership is uncertain."[113] Bastien-Lepage might have been highly sought after as a portraitist, but Wolff remarked upon the number of enormous subject pictures found in his studio, unsold during his lifetime.[114] Ephrussi lamented that Paul Baudry – the artist who would soon replace Renoir in his affections – had been reduced to doing portraits to "earn his daily bread" after the decoration of the *grand foyer* of the Paris Opéra had more or less bankrupted him.[115] Renoir, as Rivière acknowledged, treated portraiture similarly: painting for money interested him "insofar as it allowed him to procure models in order to paint more pictures."[116]

The distinctions between genre and portraiture were blurred in Renoir's work early on, yet it is clear that he conceived of them as quite separate activities.[117] At some remove from his commissioned portraits, however informal, are the plentiful genre paintings of the 1870s that show provocatively posed young women in domestic, if ill-defined, settings. For both Duret and Blanche, these dishevelled but alluring figures appealed to the very men who might commission Renoir to paint the portraits of their wives and children.[118] Renoir's "preferred types" were "dressmaker's assistants, laundresses, milliners, the glistening flora of the working-class gutter," shown teasing their pets, abandoned in sleep, half-heartedly sewing, or gazing brazenly at the viewer, "like a panther sharpening her claws" (fig. 17).[119] Thus were the adolescents of Montmartre transformed into amiable Parisiennes, whose modernity and plebeian allure found favour both with Durand-Ruel and with Renoir's progressive collectors.[120] Often intimates of the artist – Lise Tréhot and Aline Charigot were his mistresses, as was Alma-Henriette Leboeuf, known as Margot – "Renoir's Mimis, Renoir's fleshy models at Montmartre," their very names suggesting a *nostalgie de la boue* distasteful to Proust's duc de Guermantes, were professionals who worked for an array of artists on the Right Bank.[121] Anna was Gervex's principal model; Suzanne Valadon – Degas's

For a brief period, as Blanche recognized, Renoir was courting the same clientele as painters with whom he is traditionally seen to have nothing in common whatsoever: "Since painting portraits was the only activity that paid well . . . a young Renoir, a young Bonnat, a young Carolus-Duran looked to the same clientele for commissions."[106] A little careless with chronology – by the 1870s Bonnat, "le roi de la ressemblance," was firmly established as the regime's official portraitist – Blanche was nevertheless right to muddy the waters of modernism by suggesting that Renoir's painting had found favour among the upper echelons of society well before his reputation was universally established.[107]

Nonetheless, Renoir's involvement with upper-middle-class supporters and his commitment to the Salon should not obscure the fact that it was precisely in the years between 1876 and 1883 that he also undertook his most impressive and ambitious multi-figured compositions of contemporary life, including *Ball at the Moulin de la Galette* (fig. 15), *Luncheon of the Boating Party* (fig. 16), *Dance at Bougival* (cat. no. 45), and *Dance in the City* and *Dance in the Country* (figs. 235, 237). The income from portraiture enabled him to rent additional studio space in Montmartre (1876–77) or hire models to pose in Chatou (1880–81) in order that the grand

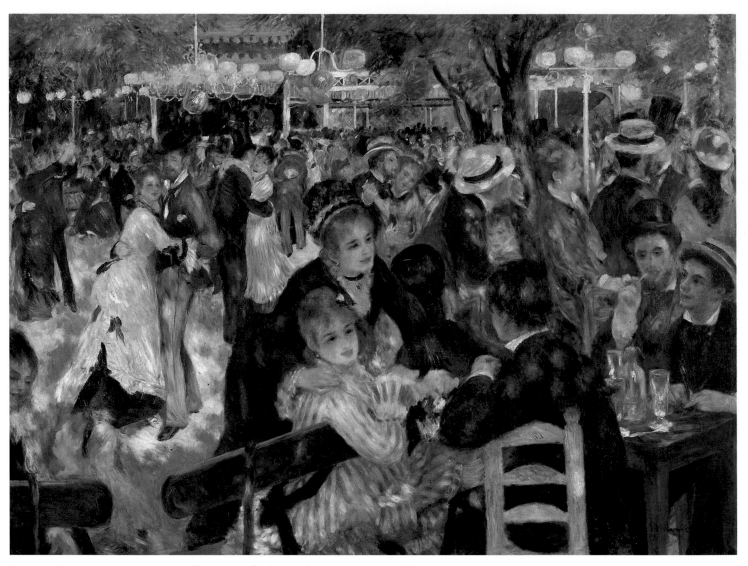

Fig. 15 Pierre-Auguste Renoir, *Ball at the Moulin de la Galette*, 1876. Musée d'Orsay, Paris

"terrible Maria" – earned her living mainly by posing for Puvis de Chavannes; Henriette Grossin, Renoir's favourite model after Lise Tréhot, would later achieve wealth and respectability as the stage actress Madame Henriot, but in the early 1870s she turned to modelling as a way of furthering her theatrical ambitions and paying the rent.[122]

For his multifigured "tableaux de moeurs" of the early 1880s, compositions that appropriated both the physical and poetic grandeur of history painting, Renoir again fictionalized from the live model, whose presence, while mediated, seems nonetheless to have been essential to him.[123] A muscular Caillebotte . . . Lhote and Suzanne Valadon dressed for a ball at the Jockey Club . . . the aspiring actress Jeanne Darlaud as a benevolent and demure elder sister – only marginally more particularized than the single figures of the 1870s, Renoir's *models* are distinguished from his *sitters* in the same way that genre, or the painting of modern life, is distinguished from portraiture. In order to immerse himself in the former, Renoir might seek income from the latter, but portraiture also demanded a different approach to the human figure that both refreshed and sustained him. Rivière recalled that as soon as *Ball*

at the Moulin de la Galette was finished, Renoir frequently left Montmartre to paint portraits.[124] As we have seen, Renoir's relative isolation at Chatou allowed him to devote himself to *Luncheon of the Boating Party* – "this damned painting . . . the last big picture I shall ever undertake" – despite many outstanding requests for portraits. As he wrote to Berard, "I shall sacrifice one more week on it and then I'll return to my portraits."[125] Only after having spent the entire summer of 1882 painting portraits *en plein air* could Renoir contemplate embarking upon the three life-size panels of dancers, again done without a specific client or location in mind.

If paintings such as *Ball at the Moulin de la Galette*, *Luncheon of the Boating Party*, and *Dance in the Country* resist the sharp focus of Renoir's portraiture,[126] his portraits from this period distil a comparable fiction, as Proust brilliantly pointed out in a passage that directly precedes his often quoted discussion of *Madame Charpentier and Her Children*. This painting, Proust argues, might well provide posterity with the lasting perfume of an elegant epoch, but as with nearly all of Renoir's fashionable sitters, the Charpentiers were socially of the second rank,

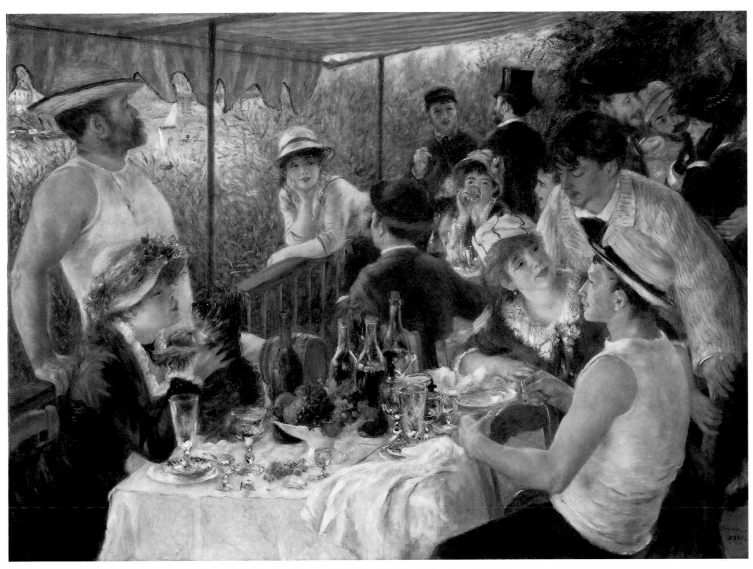

Fig. 16 Pierre-Auguste Renoir, *Luncheon of the Boating Party*, 1881. The Phillips Collection, Washington

. . . people in a relatively modest position, or who would seem to be so to people of real social brilliance (who are not even aware of their existence), but who, for that reason, are more within reach of the obscure artist's acquaintance, more likely to appreciate him, to invite him, to buy his pictures, than men and women of the aristocracy who, like the Pope and Heads of State, get themselves painted by academicians.[127]

Just as the Charpentiers, the Berards, and the Clapissons were unlikely candidates to represent for posterity the "real social brilliance" of Parisian society in the middle decades of the Third Republic, so Renoir was the painter least well-suited to assume the role of a "portraitiste mondain." Arriving in Dieppe wearing espadrilles and a fisherman's hat, sitting up front in Berard's carriage with the servants, with whom he was on familiar terms, Renoir rejected the rituals and behaviour expected of the Parisian portrait painter.[128] He disliked the obligation to attend his sitters *chez eux* – he told de Bellio that he dreaded having to spend all day on his feet painting Madame Charpentier – and he com-

plained to Duret about the amount of time that was wasted painting portraits.[129] He resented having to be away from his studio – to Murer he confided his irritation about spending an entire week at Nogent-sur-Marne "pour un portrait" – and he might leave a portrait unfinished rather than interrupt his routine.[130] His modest studio in the rue Saint-Georges (fig. 18), with its grey wallpaper and unframed paintings, stood in marked contrast to the fashionable (and commodious) atelier expected of the successful portraitist: even Manet's studio in the rue Saint-Pétersbourg was described by Zola as "très spacieux et meublé avec luxe."[131] By the 1880s, fashionable portrait painters "received" in their studios once a week, and Wolff described the gaggle of sitters and admirers who made their way every Thursday morning to Carolus-Duran's studio on the avenue Stanislas (fig. 19).[132] Octave Mirbeau mocked the affectations of the mondain portraitist in his account of the apocryphal Loys Jambois, whose sitters are introduced by a footman in livery and who paints the portrait of "une grande dame" to the accompaniment of an orchestra hired for the occasion and concealed behind screens.[133] Renoir liked to talk to

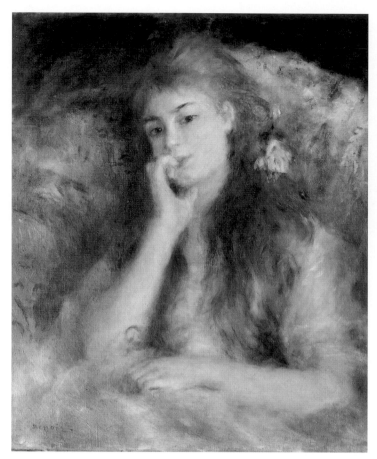

Fig. 17 Pierre-Auguste Renoir, *Young Woman Seated* (*La Pensée*), c. 1876–77. The Barber Institute of Fine Arts, University of Birmingham

Fig. 18 Pierre-Auguste Renoir, *The Artist's Studio, rue Saint-Georges*, 1876. Norton Simon Art Foundation, Pasadena, Calif.

his sitters, sang while he painted, and paid an annual rent of 900 francs for his studio.[134] Yet it is possible that his move to larger quarters in 1883 was prompted in part by the requirements of a thriving portrait practice. Berard observed in December of that year that after finally moving to the rue Laval, Renoir was overwhelmed by his "enormous studio," unable to work and "thoroughly discouraged . . . preoccupied by the large rent he has to pay and sorry that he left his little studio in the rue Saint-Georges."[135]

Renoir also executed his portraits a great deal more quickly than his fellow practitioners, and the speed with which the sittings were completed may not have been altogether to his advantage. Blanche claimed that Renoir was capable of painting a portrait in a single session, and that it was only to satisfy his sitters that he would ask for further appointments to "finish" the work.[136] Renoir's brother Edmond made the same point to John Rewald in 1943.[137] Since his clients expected several sittings, Renoir had to pretend "to retouch the picture, occasionally satisfying himself to perfect the background and certain details of the dress, without at all modifying the face."[138] Both Blanche and Edmond Renoir exaggerated a little. If in January 1882 Renoir, on his own admission, finished the bust portrait of Richard Wagner (Musée d'Orsay, Paris) in thirty-five minutes, this was an exceptional occurrence;[139] certainly, more than one sitting was needed for portraits of greater scale and greater finish. In the summer of 1868

Renoir had estimated that, with the sitters in front of him for one hour a day, he could complete the large full-length of Marie and Joseph Le Coeur in about two weeks.[140] The portrait of Albert Cahen d'Anvers (cat. no. 37) done at Wargemont was well underway by Wednesday 7 September 1881 and signed and dated two days later.[141] As has been noted, towards the end of April 1888 Renoir approached Catulle Mendès with a proposal to do a full-length portrait of his three daughters (fig. 8) to be shown at the Exposition Internationale scheduled to open on 6 May. Renoir must have worked on this, his most ambitious portrait since *Madame Charpentier and Her Children*, very quickly indeed; it was probably completed in about two weeks.[142] In June 1893, Renoir estimated that three sessions would suffice for the half-length of Madame Gallimard (cat. no. 52).[143] For the double portrait of Berthe Morisot and Julie Manet (cat. no. 53), done in the spring of the following year, he required the sitters' presence at his studio in the rue Tourlaque for two mornings or two afternoons a week for three weeks.[144] Compared to Zola's experience of falling asleep as he sat to Manet in February 1868, to Eva Gonzalès complaining of having to sit to Manet "day and night" while he reworked her portrait for the twenty-fifth time, or to the "hundred or so" sittings that Montesquiou was obliged to give Whistler between March 1891 and February 1892, Renoir proceeded expeditiously.[145] However, in demystifying the ritual of what Lois Cassatt called "the sitting business," he may not have

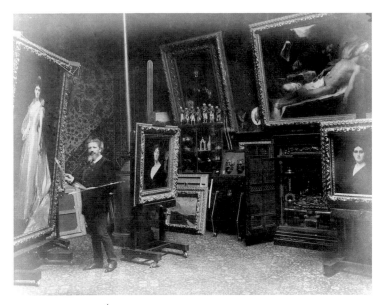

Fig. 19 Charles-Émile Auguste Carolus-Duran in his studio, c. 1890, photograph by E. Bénard. Private collection

inspired his patrons with complete confidence about his seriousness as a portraitist.[146]

Nowhere is the precariousness of Renoir's position as a "portraitiste mondain" brought out more clearly than in a review of the prices he was able to command as a portrait painter. It was well understood, as Duret pointed out to Pissarro in June 1874, that the Impressionists were not to compare themselves to artists who worked within the accepted conventions and for whom a thriving market was already established. By contrast, the "petit monde" who bought their paintings might well pay between 300 and 600 francs, but, he cautioned, "it will be a good many years before you can expect to sell your canvases for 1,500 to 2,000 francs."[147] In the 1860s, Renoir seems to have asked little more of his commissions for portraits than that they cover his expenses. His *Clown* (fig. 38) was acquired by the owner of the Café du Cirque d'Hiver for 100 francs;[148] he hoped to sell the "marriage portrait" of Sisley and Lise (fig. 30) for "une centaine de francs";[149] he had agreed to paint the portrait of Marie and Joseph Le Coeur for nothing.[150] By his own admission, Renoir could have earned a good deal more decorating blinds for export; his commissions cost about the same as an elaborate full-plate photograph, which sold at the fashionable studios of Disdéri and Adam-Solomon for 100 francs.[151]

The situation deteriorated in the 1870s. When Manet advised Berthe Morisot in 1872 to charge 500 francs for a pastel portrait, she could hardly believe it: "Cela me paraît énorme!"[152] Renoir shared Manet's belief in the value of Impressionist figure painting, and his optimism is confirmed by the prices at which he hoped to sell three of his principal paintings at the first Impressionist exhibition, which opened on 15 April 1874: *The Dancer* (National Gallery of Art, Washington) was estimated at 3,000 francs, *La Loge* (fig. 20) at 2,500 francs, and *La Parisienne* (fig. 149) at 3,500 francs.[153] In fact, four years later, Deudon acquired the first of these pictures, which had not yet found a buyer, for 1,000 francs; *La Loge* was sold to père Martin for 425 francs; and Henri Rouart picked up *La Parisienne* for 1,200 francs.[154] In general, Renoir's

portraits sold at sums that were well below these. Renoir recalled that he had painted the portraits of the restaurateur Alphonse Fournaise and his daughter Alphonsine (figs. 157, 206) for 200 francs each, and that he had seen *Madame Henriot "en travesti"* (cat. no. 19) marked down for sale at 80 francs.[155] In 1878, the pastry-cook and Impressionist collector Eugène Murer convinced Renoir to paint a set of bust-length portraits of himself (fig. 47), his sister, and his son Paul (cat. no. 27) for 100 francs each.[156] To give some sense of how low these prices were, it should be noted that a fashionable eighteenth-century print such as Delaunay's engraving after Baudouin's *Le Carquois épuisé* (fig. 21) sold at auction in Paris in April 1877 for 805 francs.[157]

Certainly, Renoir earned considerably more than this from his society portraits of the late 1870s and early 1880s. Vollard estimated that the Charpentiers paid "about 1,000 francs" for *Madame Charpentier and Her Children*; Duret, more reliable here, claimed that this portrait and the full-length *Marthe Berard* (fig. 22) each brought the artist 1,500 francs.[158] But even these figures, which did not increase greatly during the 1880s, remained well below market prices. Zola, attacking the influx of portraits at the Salon of 1875, noted that "each portrait, even by a mediocre artist, sells for between 1,500 and 2,000 francs, while those by the better known reach five, ten, twenty thousand francs."[159] The following year, he insisted that "no self-respecting artist produces a portrait for less than 10,000 francs."[160] In 1880, Renoir might write in

Fig. 20 Pierre-Auguste Renoir, *La Loge*, 1874. Courtauld Institute Galleries, London, Samuel Courtauld Collection

Williamstown, Mass.) and for *Mother and Child* (1881, Barnes Foundation, Merion, Pa.) – the two most expensive works among a group of nine North African and Neapolitan pictures that Durand-Ruel bought from Renoir on 22 May 1882 at a cost of 9,800 francs.[165]

For his portraits, Renoir's fees were altogether more modest. To a Professor Sbryenski, who inquired in June 1882 how much he charged for portraits of children, Renoir replied that his starting price was 500 francs, but that this sum was negotiable (he would do it for less, "ça dépend des difficultés").[166] In April 1888, he offered to paint a full-length portrait of the daughters of Catulle Mendès (fig. 8) for "500 francs, payable 100 francs a

Fig. 22 Pierre-Auguste Renoir, *Marthe Berard*, 1879. Museu de Arte de São Paulo Assis Chateaubriand

Fig. 21 Pierre-Antoine Baudouin, *Le Carquois épuisé*, c. 1775, engraving by Nicolas Delaunay. Private collection, Ottawa

excitement to Madame Charpentier that he had just "started a portrait for 1,000 francs," but it is clear that, even when he was taken up by Ephrussi and Berard, he could never command the prices of an established society portraitist.[161] Between 1879 and 1886 Chaplin, Carolus-Duran, Cabanel, and Bonnat were charging American sitters between 15,000 and 20,000 francs for a full-length portrait;[162] in February 1882 Renoir was paid 1,500 francs for the portrait of Alice and Elisabeth Cahen d'Anvers (cat. no. 38), his most expensive commission to date.[163]

Not only did Renoir's prices at the height of his activity as a portraitist of the beau monde remain low, they appear also to have been substantially lower than the prices Durand-Ruel was prepared to pay after 1880 for his more ambitious subject pictures. In November 1880, Durand-Ruel acquired Renoir's *Mussel Fishers at Berneval* (fig. 195), exhibited at the Salon earlier in the year, and *Dans la loge* (1880, Sterling and Francine Clark Art Institute, Williamstown, Mass.) from the dealer Dubourg for 2,500 and 1,500 francs respectively. *Sleeping Girl with a Cat* (fig. 23), also shown at the Salon of 1880, was purchased directly from Renoir in January 1881 for 2,500 francs.[164] This was also the price for *Girl with a Falcon* (1880, Sterling and Francine Clark Art Institute,

month"; he was still owed money at the end of November.[167] In July 1893, Renoir informed Edmond Maître that he would paint a replica of his portrait of Wagner (1882, Musée d'Orsay, Paris) for anything between 500 and 1,000 francs; Maître wrote to the lawyer commissioning the copy that by offering 600 francs he would "satisfy Renoir's soul."[168]

That Renoir's most expensive portraits never rose much above the price that a more conventional artist such as Henner had been able to command at the beginning of his career suggests the limitations of the support he could expect from the beau monde, whose tolerance for his increasingly brilliant yet solidly modelled figure painting was pretty much at an end by 1885.[169] In June 1882, Renoir had experienced difficulties with the commission of *Madame Clapisson,* "ce malheureux portrait qui ne vient pas." After making "this exquisite woman" pose out of doors in a summer dress, Renoir seems to have had both the weather and the sitter against him. He waited in vain for the sun, ended up with a half-finished canvas, and eventually suffered the humiliation of having the portrait rejected by her husband.[170] In an undated letter to Berard, probably written in the autumn of 1882, Renoir confided that before embarking on a second portrait of Madame Clapisson it was time to reevaluate his approach to the genre. Unimaginable as it may seem today, Durand-Ruel was also dissatisfied with the portraits of his children (cat. nos. 41–44), and Renoir was worried about losing his clientele.[171] Joking, but with an edge of irritation, he concluded: "I must return to the true path of painting and I've decided to enter Bonnat's studio after all. In a year or two I'll be earning 30,000,000,000,000 francs a year. And don't ever mention portraits in the sunshine to me again. A good black background, that's the ticket!"[172]

In December 1883, perhaps with this letter in mind, Berard wrote to Charles Deudon of the difficulty he was having in imposing Renoir on his friends. His most recent commission, the portrait of Lucie Berard (cat. no. 47), "so different from portraits of the kind that Henner paints," simply frightened people away: "I've gone to the expense of having a beautiful frame made for the portrait of Lucie, which I've hung in the best spot in my study, and Marguerite and I swoon with pleasure in front of it; but unfortunately for Renoir, we simply cannot get others to derive the pleasure that we do from his work."[173] In October 1888 Pissarro noted to his son Lucien that Renoir's "new manner" – his dry or *ingriste* style, by then already four years old – had met with complete incomprehension on the part of dealers and collectors, and that since his last exhibition at Durand-Ruel's, "by God, he's received no more commissions for portraits."[174] Three months later Renoir, "en train de paysanner en Champagne," admitted as much to Eugène Manet. Unless he was called back to Paris "by some good portrait commissions, which would come as a great surprise to me," he was only too glad to delay his return until his money ran out.[175]

It is clear that by the mid-1880s portraiture was no longer a major source of income for Renoir. After *Children's Afternoon at Wargemont* (cat. no. 49), painted in the summer of 1884, and the full-length portraits of the Goujon children, done a year later (cat. no. 51 and fig. 258), Renoir confined his portraiture closer to home. From then on, he concentrated almost exclusively on the members of his family and the extended household who took care of him, and, to a lesser extent, the dealers who vied for his attention.[176] Only seven of the one hundred and ten paintings that

Fig. 23 Pierre-Auguste Renoir, *Sleeping Girl with a Cat*, 1880. Sterling and Francine Clark Art Institute, Williamstown, Mass.

were assembled by Durand-Ruel in May 1892 for the most ambitious Renoir retrospective to date were portraits, and three of these were of the dealer's own daughters.[177]

Economics, aesthetics, and physical decline conspired to reduce Renoir's portraiture to a much more private undertaking after 1890; from this date commissioned portraits become increasingly rare in his oeuvre. More and more out of touch with Paris, his occasional mondain portraits, such as the frozen effigies of Misia Natanson (1904, National Gallery, London) and the poetess Alice Vallière Merzbach (1913, Musée du Petit Palais, Geneva), are, frankly, disappointing. And although, well into his sixties, Renoir was still capable of attending his sitters at their home, such visits were now made exceptionally and with increasing difficulty.[178] The revival of Durand-Ruel's fortunes after the crash of 1882–83 and his expansion into the American market, which Renoir had initially considered misguided, ensured that the artist would be subsidized at a time when he could no longer rely upon regular income from portrait commissions.[179] Renoir's efforts to move beyond "his Romantic period" – Pissarro's words – and his immersion in the call to order of the 1890s, with an increasing commitment to the female nude and to classical subject matter, marked a shift in his interest in picturing contemporary life.[180] In this sense, both the portraits and subject pictures of the mid-1880s

represent closure. In portraits such as those of Étienne Goujon (cat. no. 51), Marie Goujon (fig. 258), and the daughters of Catulle Mendès (fig. 8) Renoir is attempting to adapt the language of the *Great Bathers* (1884–87, Philadelphia Museum of Art) to the painting of his clients' children. Unlike the acceptable transference of style that had operated during the previous decade and that allowed him to maintain both aspects of his figure painting, Renoir's "new manner" – increasingly idealized, resistant to particularity – sought expression in subjects often far removed from the fabric of urban life, relegating commissioned portraiture to an occasional aspect of his production. Finally, although in January 1890 he could contribute only 50 francs to the subscription for Manet's *Olympia* (the previous summer he had been unable to send Monet anything at all),[181] as the decade progressed, Renoir's hard-won prosperity – a consequence of the gradual consecration of the Impressionists, both official and economic – allowed him to reject the constraints imposed by portraiture and approach the genre as a private, rather than commercial, activity.[182]

<div align="center">★ ★ ★</div>

"When he paints a portrait he asks his model to behave normally, to sit as she usually sits, to dress as she usually dresses, so that nothing smacks of constraint or artificial preparation."[183] Few would take exception to Edmond Renoir's comment, yet Renoir's spontaneity and naturalness are effects that he took some pains to achieve, and his efforts were wilfully obscured in the writings of his most ardent supporters.[184] From early on, as illustrated by his pen sketch for a proposed portrait of Marie and Joseph Le Coeur (fig. 24), Renoir had a firm idea of how he wanted to portray his sitters well before applying paint to canvas. From this unrealized portrait of Madame Le Coeur and her son, dated to the summer of 1868, to the rejected portrait of Madame Clapisson painted in the summer of 1882 (figs. 93, 94), to the magisterial portrait of the daughters of Catulle Mendès painted in 1888 (figs. 8, 25), Renoir seems to have employed this notational procedure for his more important, or more difficult, commissions.[185]

Renoir imposes a presentation on his sitters. But what models or types provided him with the appropriate blueprints for his portraits? In the 1860s and 1870s at least, the formats he preferred were conventional, old-fashioned even; indeed, it can be argued that Renoir emulated both Salon portraiture and commercial photography rather than following the researches of his fellow "actualistes" and Impressionists. In portraits such as *Alfred Sisley* (fig. 103), *Madame Massonie* (fig. 26), and *Pierre-Henri Renoir* (cat. no. 7), his sitters are placed firmly in the centre of the composition, full-square or at a slight angle to the spectator, and are portrayed with a generally serious though not forbidding expression. Renoir is at the other extreme from Degas, who by the end of the 1860s was seeking "to do portraits of people in familiar and typical attitudes, and especially to give their countenances the same range of expression as their bodies."[186] Furthermore, Renoir's sitters are painted against neutral or only vaguely defined backgrounds – as in *Lise Tréhot in a White Shawl* (1872, fig. 27), or *Alphonsine Fournaise* (1875, fig. 206), or *Madame Henriot* (cat. no. 20) – another egregious error that Duranty hoped would be remedied by the practitioners of the New Painting.[187] In one of

Fig. 24 Pen sketch by Renoir for a projected portrait of Marie and Joseph Le Coeur, from a letter to Charles Le Coeur datable to the summer of 1868. Private collection

Fig. 25 Pen sketch by Renoir for *The Daughters of Catulle Mendès*, from a letter to Catulle Mendès datable to April 1888. Location unknown

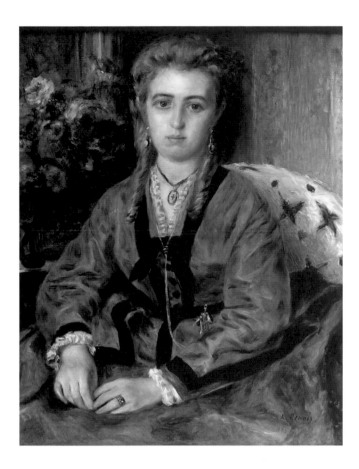

Fig. 26 Pierre-Auguste Renoir, *Madame Massonie*, 1870. Private collection, Japan

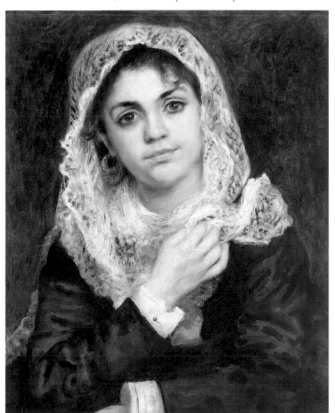

Fig. 27 Pierre-Auguste Renoir, *Lise Tréhot in a White Shawl*, 1872. Dallas Museum of Art, The Wendy and Emery Reves Collection

his first documented commissions, the half-length portrait of nine-year-old Romaine Lacaux (cat. no. 3) Renoir adhered quite closely to the standard formula for the portrayal of children, as is confirmed by a comparison with Flandrin's *Mademoiselle Maison* (1858, private collection), much acclaimed at the Salon of 1859, or Bouguereau's *Pauline Brissac* (fig. 28), painted the same year as *Mademoiselle Romaine Lacaux*.[188]

Not only does Renoir's compositional approach echo conventional portrait painting, it also relates to studio photography, and in particular the popular *cartes de visite* – commercial, inexpensive visiting cards that were all the rage in Paris during the 1860s and which influenced his development as a portraitist throughout the decade (fig. 29).[189] Renoir's well-known *Sisley and Lise* (fig. 30) – long thought to be a portrait of the Impressionist and his wife, but in fact a staged "marriage-portrait" of Renoir's mistress accompanied by his good friend – is modelled very much on celebrity *cartes* such as Disdéri's portrait of Pauline and Richard de Metternich (fig. 32), a photograph that Degas also knew well.[190] Renoir's portrait of Bazille (cat. no. 5), is also indebted to the standard photographic portrayal of artists at work, a genre with an established tradition, from Disdéri's *carte* of Léon Bonnat to Crémière's portrait of Ludovic-Napoléon, vicomte Lepic (fig. 31), a fellow student at Gleyre's atelier.[191] Even Renoir's seemingly casual portrait of Sisley (cat. no. 26), in which his technique is as free as it ever would be, has its roots in the conventions of the *carte*, where long exposure encouraged poses that could be held over time with little strain. The conventions of studio photography informed Renoir's portraiture early on, but photography was never a substitute for the human presence, and this is borne out by the posthumous portrait of Marie-Sophie Chocquet (fig. 33). Painted in 1876 from photographs taken more than a decade earlier – the girl had died in 1865 – Renoir's portrait of the four-year-old daughter of his great patron Victor Chocquet has considerable poignancy and personal significance, but little aesthetic distinction.[192]

Whereas the pose and presentation of Renoir's sitters might be conservative or appropriated, the paintings themselves look nothing like conventional portraiture of the last decade of the Second Empire and the early Third Republic (fig. 34). What distinguishes them from those of Renoir's Salon contemporaries is the extraordinary light with which they are imbued, "the natural light of day penetrating and influencing all things," which transforms and radicalizes Renoir's figures set in interiors, both in his portraiture and in his genre painting.[193] According to Mallarmé, painting demanded daylight, and therefore the artist was ill-advised even to attempt to reproduce the experience of daily life because "the chief part of modern existence is passed within doors." Instead, the artist should be concerned with capturing the "mental canvas" and reproducing our "beautiful remembrance," both of which filter out the "artificial prestige" of candelabra or footlights. This process of distillation is a "mental operation" critical to the creation of art.[194] The use of natural light, rather than

Pierre-Auguste Renoir, *Mademoiselle Romaine Lacaux* (cat. no. 3)

Fig. 29 (*right*) Portrait of a seated girl, c. 1860, *carte de visite*, photograph by A.A.E. Disdéri. Location unknown

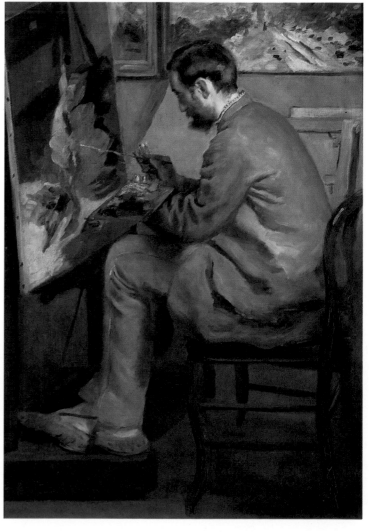

Duranty's concern with milieu and context, is at the heart of Renoir's practice as a figure painter, and it accounts for much of the bewilderment with which his early work was received. For Mallarmé's perceptive comment on *La Loge* (fig. 20) – "this scene is fantastically illuminated by an incongruous daylight" – could be applied to nearly all of Renoir's portraits.[195] And if it is almost impossible for us, today, to object to this "incongruous daylight," the flooding of daylight into these bourgeois interiors was all the more disturbing to Renoir's contemporaries because of the otherwise more or less conventional presentation of his sitters.[196]

Renoir, unlike Degas, was not interested in using accoutrements and accessories to explore the psychology of his sitters. The beguiling eight-year-old Marie-Adelphine Legrand (cat. no. 23) and six year old Jeanne Durand Ruel (fig. 39) are both shown against the patterned wallpaper of Renoir's own apartment in the rue Saint-Georges, the same setting for his much less innocent *Female Torso* (1873–75, Barnes Foundation, Merion, Pa.). When trappings of the middle-class home do intrude into his commissioned portraits – the exotic wall hangings in *Pierre-Henri Renoir* (cat. no. 7), the piano and pictures in the background of *Madame Hartmann* (1874, Musée d'Orsay, Paris) – they throw little light on the personality of the sitter, and are really nothing more than props. Here Renoir wilfully ignored Duranty's challenge that progressive painters attend to the contexts of domesticity in their portrayal of modern life:

> As we are solidly embracing nature, we will no longer separate the figure from the background of an apartment or the street. In actuality, a person never appears against neutral or vague backgrounds. Instead, surrounding him and behind him are the furniture, fireplaces, curtains, and walls that indicate his financial position, class, and profession.[197]

Only for a brief period in the early 1870s was Renoir perhaps tempted to tackle portraiture in this way. When his relationship with the sitter was more informal, his presentation might be

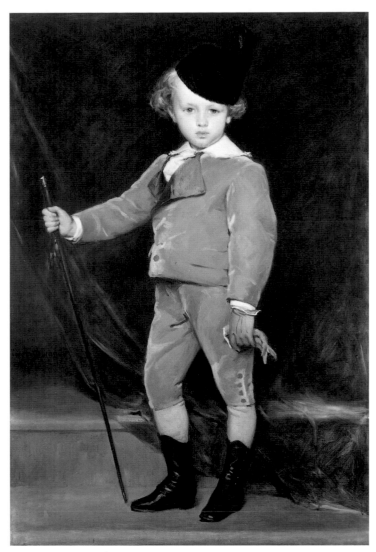

Fig. 34 Charles-Émile Auguste Carolus-Duran, *Hector Brame*, 1871. Private collection

Fig. 33 Pierre-Auguste Renoir, *Marie-Sophie Chocquet*, 1876. Private collection

equally so, and his portraits of Edmond Maître's mistress "Rapha" (cat. nos. 11, 12), as well as a series of superb paintings of Camille Doncieux, Monet's wife – resting in the garden with their son Jean (cat. no. 17), reclining like Goya's *Maja* (fig. 35), or reading (cat. no. 16) – succeed in integrating sitter and setting in a way that Renoir normally tended to avoid.

Indeed, with Duranty's manifesto in mind, it is interesting to note that as early as 1874 Renoir was taken to task by a generally favourable critic for the "vague, entirely conventional backgrounds" of his paintings, in this instance *The Dancer* (1874, National Gallery of Art, Washington), later acquired by Deudon.[198] That Renoir withheld information, that he failed to offer the Realists what they admired in Manet and Degas, has long discouraged careful inspection of his more ambitious figure paintings, portraits included. Yet even if Renoir's modernity is more ambivalent and less deliberately constructed than theirs, his canvases are not devoid of symbols and references: a gentler vision does not prevent the encoding of messages or the statement of allegiances.

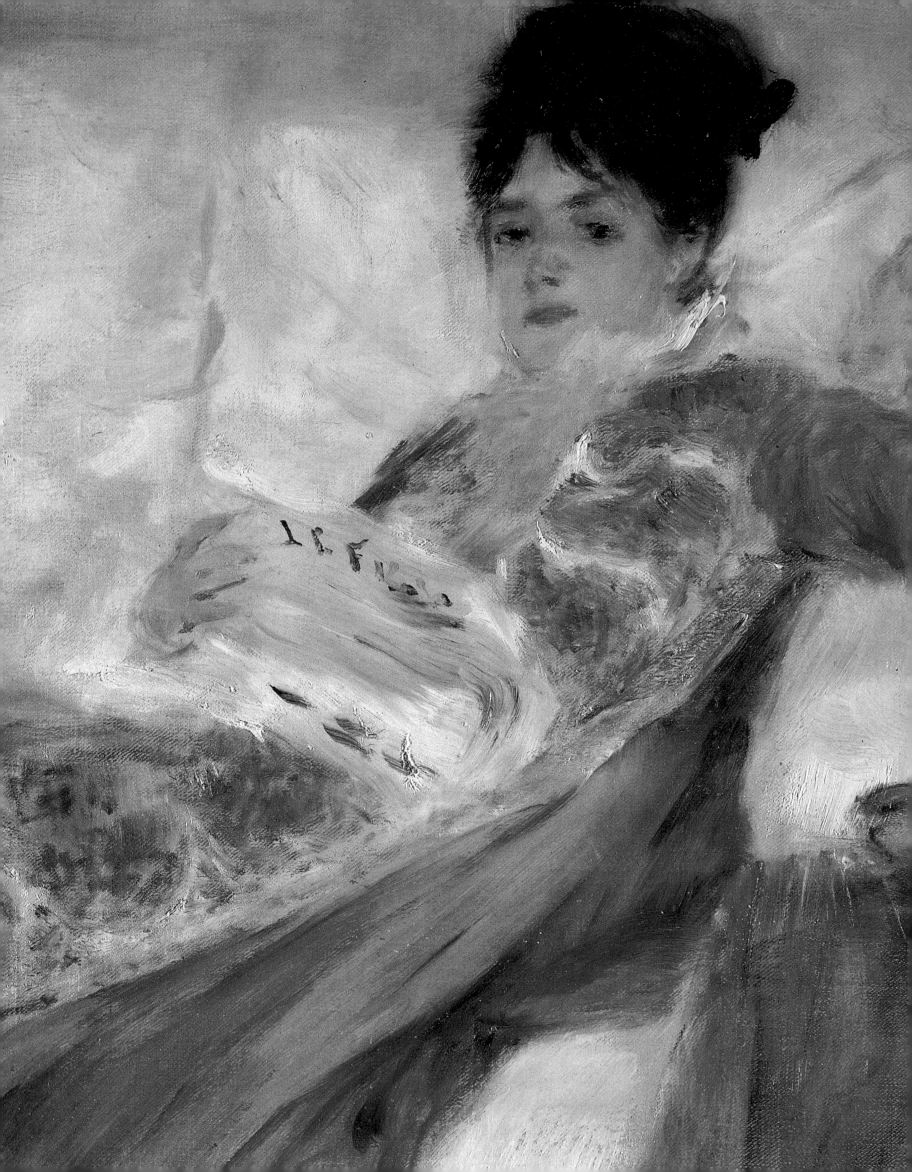

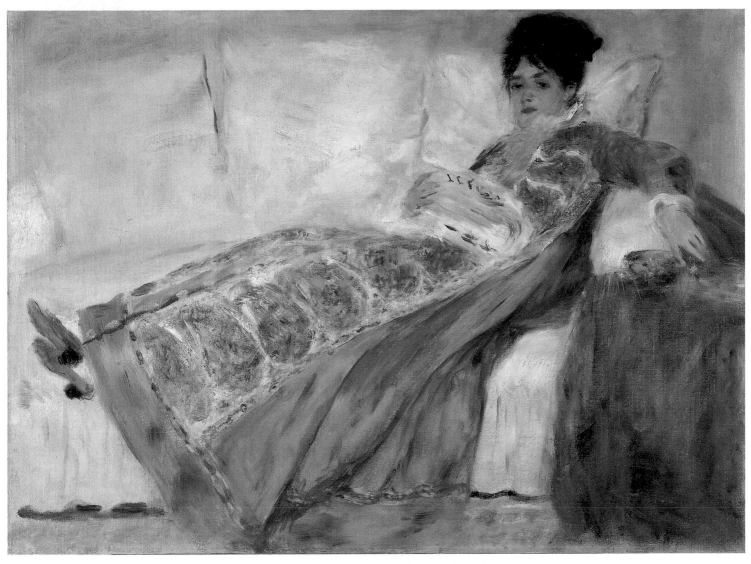

Fig. 35 Pierre-Auguste Renoir, *Madame Monet on a Sofa*, c. 1874. Calouste Gulbenkian Foundation, Lisbon

Thus, in *The Inn of Mère Antony* (cat. no. 4), in which the architect-turned-painter Jules Le Coeur, the painter Alfred Sisley, and an unidentified third figure finish lunch in a country inn frequented by artists and writers, Renoir pays homage to the modern movement in painting and literature. As is often noted, his large latter-day conversation piece is indebted to Courbet, whose *After Dinner at Ornans* could be seen at the Musée de Lille.[199] The prominence in the scene of a copy of *L'Événement*, a recently launched newspaper that published Zola's art criticism and was generally supportive of "les méchants" (Zola's term for Gleyre's former pupils) indicates the progressive sympathies of the younger group.[200] (Cézanne would show his allegiance in a similarly ambitious work, the portrait of his father, Louis-Auguste Cézanne [fig. 36], painted the same year.) Murals in the background glorify Henri Murger, whose *Scènes de la vie de bohème* had inspired the Romantics, from Balzac to Baudelaire. The mixing of classes, from Le Coeur, dressed in a worker's blue smock, to the Parisian Sisley, elegant in his felt hat and buckled shoes, is presented more sympathetically than in Manet's scenes of Parisian cafés and bars.

Indeed, the bonhomie of this meeting place is evoked with greater warmth than in the writings of the Realist authors Edmond and Jules de Goncourt, who had visited Mère Antony's a few years before and written unkindly of "the paintings scrawled all over the house . . . the dining room daubed with barracksroom caricatures and cartoons . . . the men wearing rough jackets and looking like thuggish workmen . . . eating lunch at three in the afternoon in the company of disreputable women with slippers and no hats."[201]

In the 1860s, Renoir is a tender Realist, whose observation of aspects of urban and suburban leisure, while keen, is also kind. In his full-length portrait of the acrobat-clown James Bollinger Mazutreek (fig. 38), apparently done on commission for the owner of the Café du Cirque d'Hiver, who was bankrupted before he could pay Renoir's fee of 100 francs, Renoir seamlessly fuses a variety of sources in the manner of the eighteenth-century French masters. As has recently been pointed out, the clown's pose is derived from Manet's *Mademoiselle Victorine en Espada* (Metropolitan Museum of Art, New York), a controversial work

adamantly refuses to paint the interior of a circus hall with anything like the appropriate lighting effects. Gaslight and, later on, electric light are banished from Renoir's world. For, as Rivière pointed out, Renoir "so despised the harsh artificial light that distorted both expression and gesture alike that he painted his acrobats and jugglers *en plein air*."[204]

In his portraits of individuals, Renoir often incorporates the sorts of references that Duranty insisted upon – "the surroundings that indicate the person's financial position, class, and occupation" – but with such discretion that they have generally gone unnoticed. In his portrait of Jeanne Durand-Ruel (fig. 39), we sense that the second daughter of the dealer Paul Durand-Ruel is posing a little nervously in her best boots and finest dress.[205] Renoir

Fig. 36 Paul Cézanne, *Louis-Auguste Cézanne Reading "L'Événement,"* 1866. National Gallery of Art, Washington, Collection of Mr. and Mrs. Paul Mellon

Fig. 37 James Bollinger Mazutreek, 1860. From Henri Thétard, *La Merveilleuse Histoire du Cirque* (Paris, 1947)

of 1862.[202] In his rather schematic portrayal of the well-dressed audience in the background, Renoir also introduces for the first time a figure that would become one of his most celebrated – the gloved Parisienne, bouquet in hand, who reappears gloriously in *La Loge* (fig. 20). Renoir documents the clown's apparel with the fidelity of a camera lens: from contemporary photographs it is clear how carefully he has reproduced the distinctive butterfly motif on Mazutreek's costume as well as his bush of hair, rising like a flame (fig. 37).[203] Yet, Renoir's *Clown* also falls into the tradition of the sad performer, distanced and detached from the respectable audience he entertains. Furthermore – and this would recur in his *Acrobats at the Cirque Fernando* (cat. no. 35) – Renoir

Fig. 38 Pierre-Auguste Renoir, *The Clown (James Bollinger Mazutreek)*, 1868. Rijksmuseum Kröller-Müller, Otterlo, Netherlands

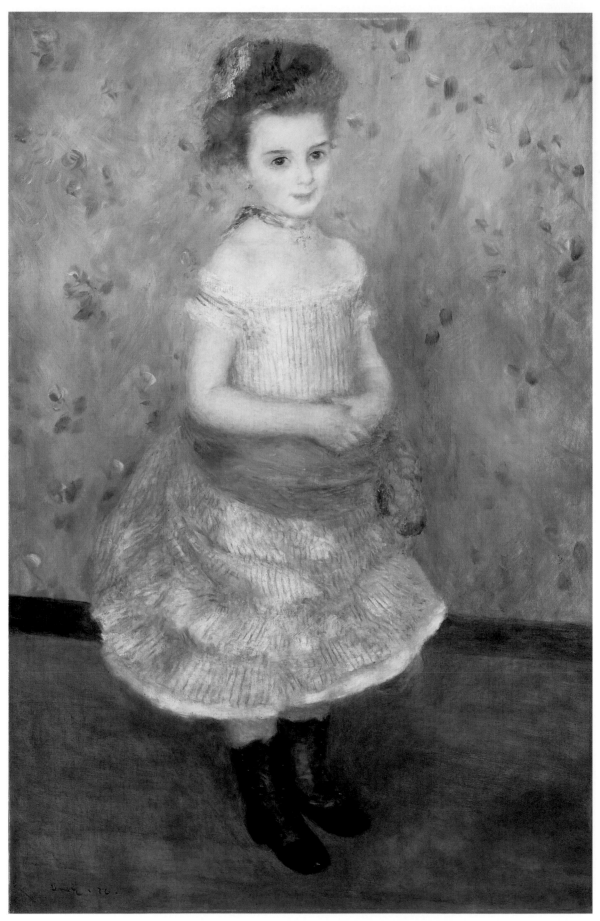

Fig. 39 Pierre-Auguste Renoir, *Jeanne Durand-Ruel*, 1876. The Barnes Foundation, Merion, Pa.

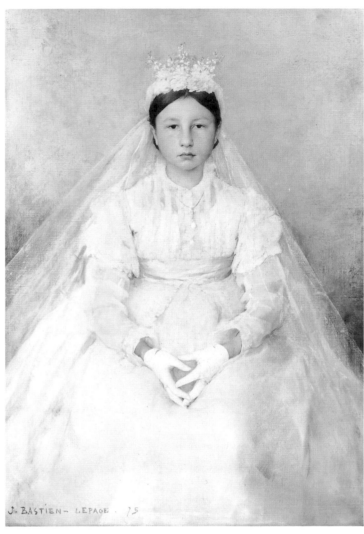

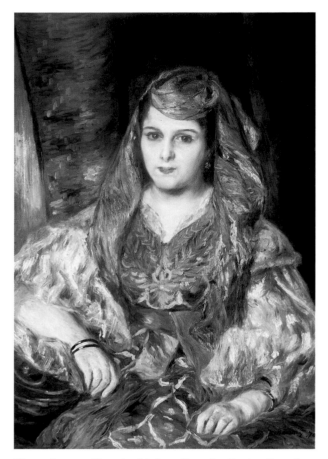

Pierre-Auguste Renoir, *Madame Stora in Algerian Dress* (cat. no. 8)

Fig. 41 Constant-Joseph Brochart, *Clementine Stora*, c. 1880, pastel. Private collection

Fig. 40 Jules Bastien-Lepage, *La Petite Communiante*, 1875. Musée des Beaux-Arts, Tournai

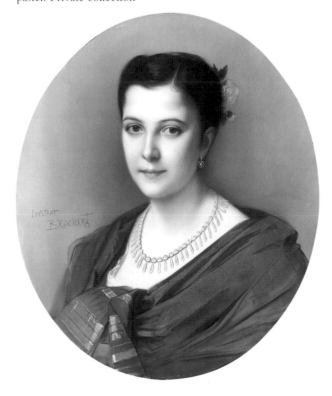

has taken considerable care in painting the golden cross on her blue-green choker, and since he is the most economical of painters this detail is not without significance. In many ways, the portrait of Jeanne Durand-Ruel may be compared to *The Dancer* of 1874, of which it was noted: "Below her boyish chest, a blue sash, a ribbon from first communion, comes down and flutters over the winged skirt of the ballerina."[206] Although, as is confirmed by a comparison with Bastien-Lepage's *Petite Communiante* (fig. 40), shown at the Salon of 1875, Jeanne Durand-Ruel is not wearing full communion apparel, her cross and communion ribbon are evocative of the devout Catholic household into which she had been born.[207] Her father, Paul Durand-Ruel, was both a committed monarchist and an ardent Catholic – Edmond de Goncourt was shocked to find a crucifix hanging prominently above his bed – and it may be assumed that he selected this particular pose and dress.[208] That Mademoiselle Durand-Ruel is shown in her "Sunday best," with its associated ritual and protocol, adds an unexpected religious dimension – albeit social, rather than sacred – to one of Renoir's early masterpieces.

Renoir operates similarly with *The Algerian Woman*, his portrait

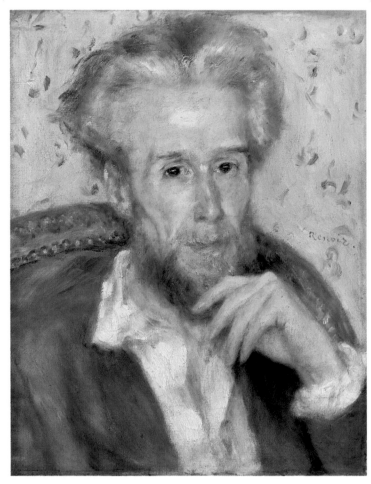

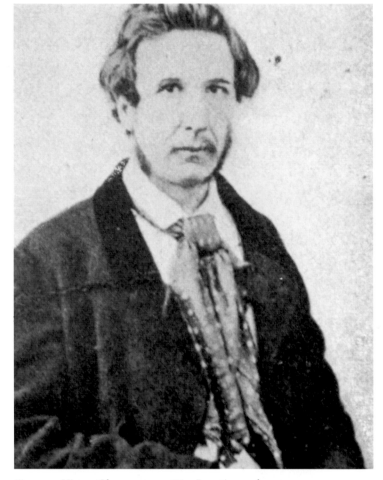

Fig. 42 Pierre-Auguste Renoir, *Victor Chocquet*, 1876. Oskar Reinhart Collection, "Am Römerholz," Winterthur

Fig. 43 Victor Chocquet, c. 1860. Location unknown

of Madame Clémentine Stora (cat. no. 8) – a burst of light in fancy dress, except that the dress, while fancy, is not completely fanciful. Madame Stora, née Rebecca Clémentine Valensin, was indeed born in Algiers, in 1851 (she is not yet twenty in Renoir's portrait), and with her husband Nathan was the proprietor of "Au Pacha," an antique shop on the boulevard des Italiens.[209] A later portrait by Constant Brochart of her and her third daughter, Lucie, born in 1876 (fig. 120), makes obvious reference to her North African heritage, but Renoir is both more discreet and more informative: he combines family history with advertising in presenting her as an Algerian woman and including an exotic rug, possibly a kilim, in the background.[210] Madame Stora had no particular affection for Renoir's portrait, which she considered "horrible" – her word, apparently – and which she sold to the painter Paul Helleu in 1894 for 300 francs, an extremely low price at a time when Renoir's paintings were beginning to acquire considerable market value.[211] She and her husband refused, however, to part at any price with another of Brochart's portraits of her (fig. 41), and it has remained in the possession of the family until this day.

That Renoir crafted such a joyous representation of a figure who cared little for his art is not the least of his achievements as a portraitist. However, his most affectionate portraits, which

Fig. 44 Eugène Delacroix, *Hercules Rescues Hesione*, 1852. Ordrupgaard-samlingen, Copenhagen

number among his greatest works, reveal a deeper bond between painter and sitter. Chief among his supporters at a time when his art was at its most radical and least understood was Victor Guillaume Chocquet (1821–1891) (fig. 42), a minor customs official some twenty years older than Renoir who, if not the first to

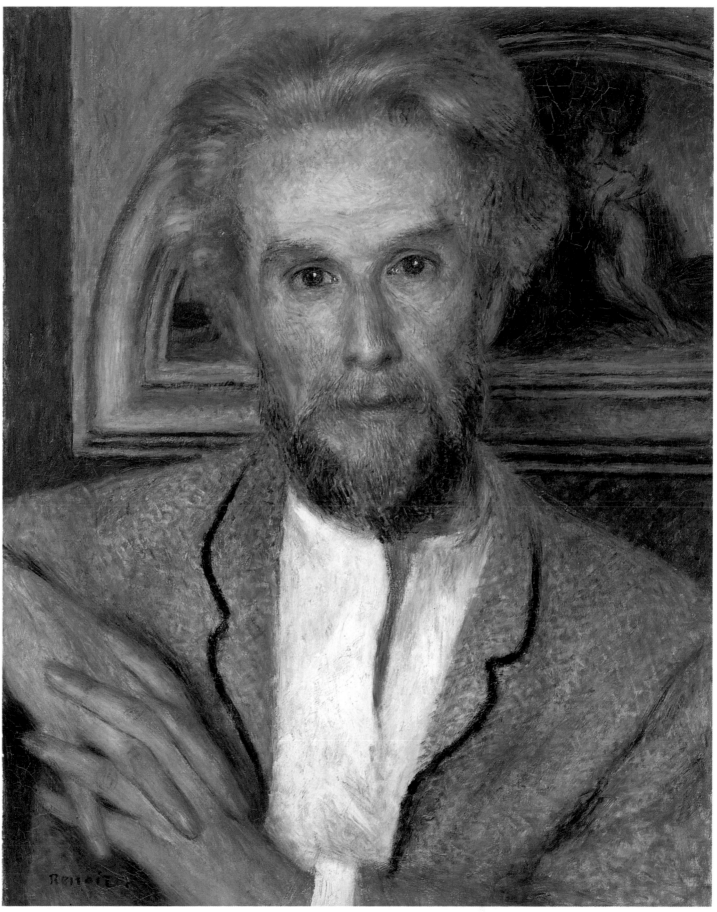

Fig. 45 Pierre-Auguste Renoir, *Victor Chocquet*, c. 1875. Fogg Art Museum, Harvard University Art Museums, Cambridge, Mass., Bequest of Grenville L. Winthrop

commission portraits from him (as Duret claimed), was far and away the most committed of his early patrons.[212] "Le père Chocquet" was no less passionate about Cézanne (to whom he had been introduced by Renoir) and owned over thirty paintings by him. This pairing of Renoir and Cézanne, which became a topos of modernist criticism by the beginning of the century but may seem puzzling today, was thus prefigured in one of the first collections of Impressionism ever assembled.[213]

Chocquet lent no fewer than six works by Renoir to the second Impressionist exhibition of 1876 – he also owned the reprise of Renoir's *Ball at the Moulin de la Galette* (1876, private collection, Japan) – and, in a gesture recognized at the time, was among the first to present his modern paintings in gilded frames. Both Renoir and Cézanne allude to this in their portraits of him, Renoir in particular capturing an innate elegance and sensitivity – "cet équilibre intellectuel qui vous caractérise" – that are somewhat at odds with the plain, heavy-set figure of the man himself (fig. 43).[214] And whereas the tell-tale wallpaper of Renoir's apartment provides the background for the portrait of Chocquet in the Oskar Reinhart Collection, in a second portrait of Chocquet (fig. 45), painted in the sitter's apartment in the rue de Rivoli, we see a framed sketch of Delacroix's *Hercules Rescuing Hesione* (fig. 44) – preparatory for one of the lunettes in the Salon de la Paix of the Hôtel de Ville (destroyed in 1871) and one of several paintings and watercolours by Delacroix in Chocquet's collection.[215] Chocquet's veneration of Delacroix was such that in March 1862 he had requested the artist to paint a portrait of his wife – Delacroix, now a grand old man of the Institut, had politely declined to paint the wife of a custom's official, claiming failing eyesight[216] – but when in the spring of 1875 the commission passed to Renoir, the younger artist found a charming device to allude to this episode. The rather stout Augustine-Marie-Caroline (1837–1899) (fig. 46) is shown sporting a sizeable ring – she stood to inherit an annual income of 50,000 francs and was fonder of jewellery than of painting[217] – but our attention is drawn to the painting on the wall behind her, Delacroix's sketch of *Numa and Egeria* (Musée du Louvre, Paris), preparatory to one of the pendentives in his decorative cycle for the Deputies Library at the Palais Bourbon and acquired by Chocquet in April 1865 for 657 francs.[218] In the background at the left Renoir also provides a glimpse of the fine Louis XVI furniture and framed pictures that again evoke Chocquet's presence in the company of his comfortable wife.

Next to Chocquet and the wealthy Impressionist Gustave Caillebotte, the collector most committed to Renoir in the mid-1870s was the political radical, pastry-cook and restaurateur, published poet and novelist, and would-be painter and pastellist Hyacinthe Eugène Meunier, known as Eugène Murer (1841–1906) (fig. 47), whose portrait Renoir painted for 100 francs in 1878.[219] In this work – a size 8 (46 × 30 cm), like the two portraits of Chocquet – the thirty-seven-year-old Murer appears as a sensitive if slightly melancholy figure, wistfully introspective, his coat and starched collar a little too large for his slight frame. In reality Murer was a passionate if rapacious and self-promoting art lover, and rarely has an artist crafted a more generous portrayal of such a difficult patron. In Pissarro's portrait of Murer, commissioned in the summer of 1878, he is shown as a bandit (fig. 48).[220]

After a brief passage in an architect's office and an apprenticeship with the pastry-cook and socialist Eugène Gru – the high point of which seems to have been a chance meeting with Balzac while delivering cakes to his house – Murer opened his own patisserie and restaurant in July 1870 at 95 boulevard Voltaire, above the Prince Eugène public baths.[221] It was here in the mid-1870s that he held weekly dinners to which he invited writers, musicians, and painters, including Renoir, Sisley, Pissarro, and Zola. In March 1867 Murer had married a seamstress, Marie-Antoinette Masson (1845–1872), then pregnant with his first child, Achille Eugène, who died in infancy. The couple lost a pair of twin daughters in June 1868 before having a healthy son, Paul, whose portrait Renoir would paint in 1878 (cat. no. 29).[222] Marie Antoinette died on 11 October 1872, at the age of twenty-six, and thereafter the widower Murer was helped both in his domestic and business affairs by his half-sister Marie Meunier, whom Renoir would always address as "Mademoiselle Marie" (fig. 50).[223]

By the spring of 1880 Murer could boast to Monet that "with the hundred paintings I own I am beginning to find myself rich in Impressionists," and indeed his collection of one hundred and twenty paintings included at least fourteen works by Renoir, all painted before 1879 and acquired for low prices.[224] With each of the Impressionists Murer drove a hard bargain. He rarely paid more than 100 francs for a painting, was happy to "lend" Pissarro 100 francs in exchange for five canvases in June 1879, and selected pictures by Sisley that were larger (and thus more expensive) than those of the format he had agreed to purchase.[225] But his attachment to the New Painting was unequivocal: as he noted many years later, "to buy his paintings is the greatest compliment that can be paid an artist."[226]

Like Chocquet, Murer seems to have stopped collecting modern art by the early 1880s, although unlike other pioneer collectors of Impressionism he showed some interest in the careers of younger artists like Gauguin and Van Gogh. In order to provide his sister with her marriage portion, he was obliged to dismantle his collection in the summer of 1896, managing to sell it for a great deal more than he had paid. Thereafter he gave up business to devote himself exclusively to the practice of art, exhibiting his own undistinguished paintings and pastels quite widely, and even persuading Vollard to show his latest work in February 1897.[227] Murer's continued admiration for Renoir, whom he considered "the greatest artist of our century," was by now something of an embarrassment, especially since he insisted on claiming him as his mentor and spiritual forebear. Much to Pissarro's amusement and Renoir's irritation, Murer publicly allied himself with the Impressionists, letting it be known in November 1895 that Renoir "had placed the paintbrushes in his very hand," and was "both his inspiration and his peer."[228] Renoir, in recounting his earliest memories of Murer to Vollard, remembered him simply as "the pastry-cook who became a painter."[229]

In May 1878, Chocquet and Murer were both included by Théodore Duret among the ten principal collectors of Impressionism.[230] Not mentioned by Duret at this time, as he had yet to own any Impressionist works, was Renoir's greatest patron, the Protestant banker and diplomat Paul-Antoine Berard (fig. 49).[231] It was the nonconformist and sceptical Berard, eight years older than Renoir, with a large family and a wide social acquaintance – each of whom was a potential subject for Renoir's brush – who played Maecenas to Renoir's Virgil. Berard and his wife, Marguerite Blanche, née Girod (1844–1901) – an "uncompromising Protestant" whose father too was a banker[232] – were the

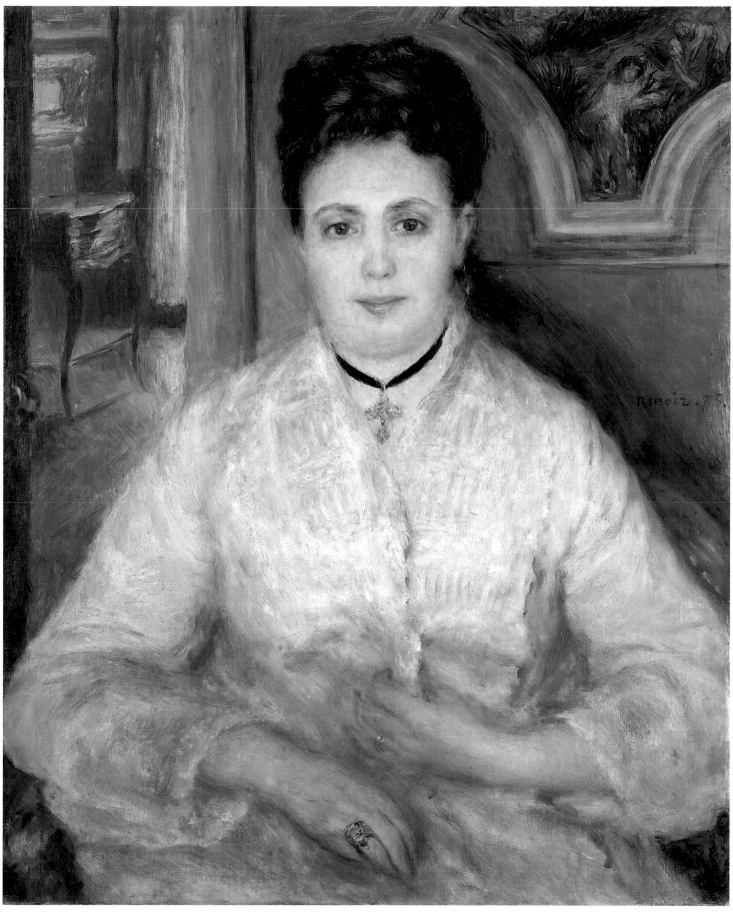

Fig. 46 Pierre-Auguste Renoir, *Madame Victor Chocquet*, 1875. Staatsgalerie Stuttgart

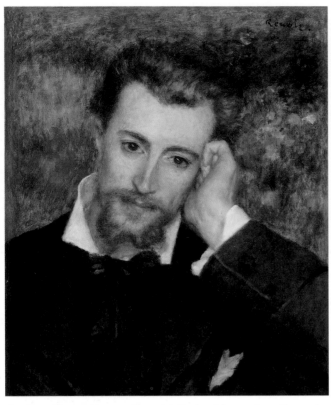

Fig. 47 Pierre-Auguste Renoir, *Eugène Murer*, 1877. From the Collection of Walter H. and Leonore Annenberg

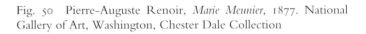

Fig. 49 Paul Berard, photograph by Eugène Pirou. Private collection

Fig. 48 Camille Pissarro, *Eugène Murer as a Bandit*, 1878. Museum of Fine Arts, Springfield, Mass., James Philip Gray Collection

Fig. 50 Pierre-Auguste Renoir, *Marie Meunier*, 1877. National Gallery of Art, Washington, Chester Dale Collection

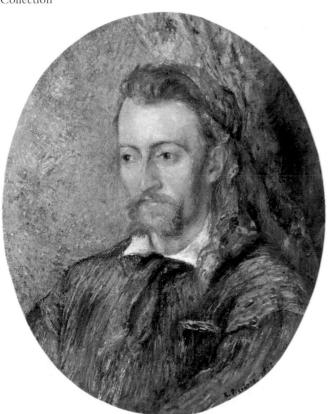

Fig. 51 Pierre-Auguste Renoir, *Paul Berard*, 1880. Private collection

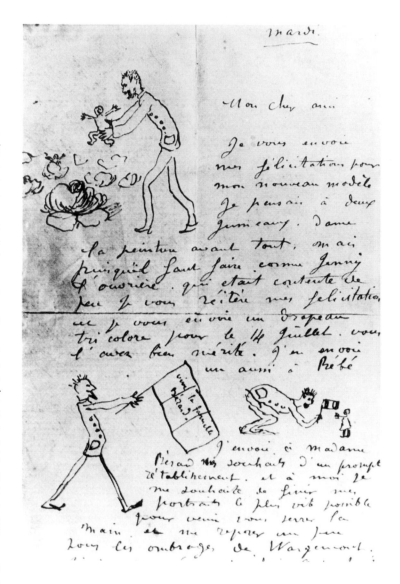

sort of people who might have appealed to Degas, although they
showed no interest in his art. Berard "looked like a gentleman of
the period of Louis-Philippe, gave sumptuous dinners, frequented
the *foyer de la danse* at the Opéra, and went to the races"; his wife
had a "visiting list that was so extensive" that "she always com-
plained of having to climb hundreds of stairs."[233] Berard's
mondain yet casual allure is perfectly caught in Renoir's portrait
of him smoking (fig. 51), in which he might well be one of the
"cigarettistes endurcis" espied in Madame Charpentier's salon by
Théodore de Banville.[234]

For it was there in the winter of 1878 that Renoir and Berard
probably met for the first time, introduced by Charles Deudon,
heir to a mining fortune, who also persuaded Madame Berard to
have Renoir paint a full-length portrait of their eldest daughter,
Marthe (fig. 22).[235] Berard began to invite Renoir to stay at his
country house at Wargemont, a village of three hundred inhabi-
tants some ten kilometres north of Dieppe – described by Mary
Cassatt as "a pretty place, an English park, rather isolated."[236] If
Renoir was "painter in ordinary" to Madame Charpentier, his
friendship with Berard was free of this sort of deference, despite
the enormous gulf separating the two men. They remained close
until Berard's death in April 1905, travelling together to Holland
as late as October 1898, long after Berard had stopped buying
Renoir's paintings.[237] And the warmth and spontaneity of their
friendship is nowhere better illustrated than in Renoir's delight-
ful letter of July 1880 congratulating Berard on the birth of his
youngest daughter Lucie (fig. 52), the artist's "latest model."[238]
Indeed, Renoir's portraits of the Berards, particularly the chil-
dren, constitute the most affectionate family album, ranging from
the comparatively sober portrait of Marthe, his earliest commis-
sion from Berard, and that of her brother André, the little school-
boy carrying his books (fig. 53) – both of which adhere to the
format of the studio photograph (fig. 54) – to the spontaneous
portrait of five-year-old Margot (cat. no. 34), her eyes red from
crying, and her hair appearing just as unruly as in a photograph of
her in more formal attire (fig. 197). In 1881 Renoir painted a
group portrait of all four children (cat. no.39), a canvas that has
been aptly termed a "secular chorus of disembodied angels" but
which has its source in Watteau's drawings (fig. 216).[239] Renoir's
grandest and most ambitious commission by far was the group
portrait of Berard's three daughters known as *Children's Afternoon
at Wargemont* (cat. no. 49), painted in the summer of 1884, "lit up
like a street lamp," in Blanche's rather dismissive phrase, but with
a slightly disturbing, overripe quality that anticipates Balthus.[240]
Blanche claimed that the Berard daughters were "savages who
refused to learn to write or spell," and Renoir hints at their wild
and unpredictable natures, despite their impeccably feminine
behaviour and dress.[241]

Berard's patronage went beyond the commission of his chil-
dren's portraits, although it is for these that he deserves to be
remembered. Renoir painted game panels, flower pieces, and
mythological overdoors as decorations for the château de

Wargemont.[242] The hilly countryside around Wargemont pro-
vided the subject for his greatest landscape, *Landscape at
Wargemont* (1879, Toledo Museum of Art), and he used the
château's grounds to finish off *Mussel Fishers at Berneval* (1880, fig.
195), his principal submission to the Salon of 1880 – a "seaside
picture" inspired by the Berards' private beach.[243] Berard intro-
duced Renoir to his elder brother Édouard Philippe (1823–1899),
chatelain of Graincourt, the property adjoining Wargemont, who
commissioned two distinguished portraits of his children: a rather
solemn portrait of Thérèse Berard (1866–1959) done in 1879,
which may be compared to a contemporary photograph of her
(figs. 55, 56), and a portrait of her nineteen-year-old brother
Alfred Louis Berard in 1881, dressed as a hunter (fig. 198).

It has already been noted that Berard, with Ephrussi, acted as a
conduit to members of the Protestant and Jewish banking com-
munity who patronized Renoir in this period, and that the por-
trait of Albert Cahen d'Anvers (cat. no. 37) was painted in the
"petit salon" at Wargemont, whose floral wallpaper threatens to
ensnare the composer in its purple tendrils (fig. 209). Renoir's
magnificent portraits of Cahen d'Anvers's nieces (cat. no. 38 and
fig. 10), his *envoi* to the Salon of 1881, have also been cited as

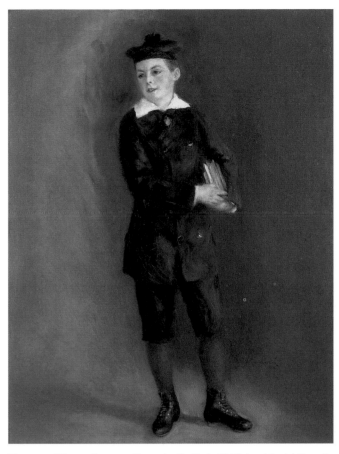

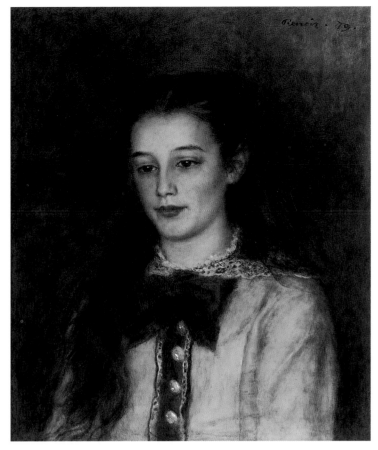

Fig. 53 Pierre-Auguste Renoir, *Le Petit Collégien* (*André Berard*), 1879. Private collection

Fig. 55 Pierre-Auguste Renoir, *Thérèse Berard*, 1879. Sterling and Francine Clark Art Institute, Williamstown, Mass.

Fig. 54 André Berard, c. 1880. Private collection

Fig. 56 Thérèse Berard, c. 1879. Private collection

masterpieces in the genre. Alice Ida Cahen d'Anvers (1876–1965), later Lady Townsend of Kut, recalled that it was only the pleasure of wearing the pink dress "en point d'Irlande" that made the experience of sitting to Renoir tolerable for her, but that Renoir's paintings were something of an anomaly in a household where Nattier's nymphs and Bonnat's portraits were more likely to be found hanging on eighteenth-century boiseries.[244] Indeed, both Bonnat and Carolus-Duran (but not Renoir) attended the ball given by her mother in March 1895 in honour of the young king of Serbia.[245] Her sister Elisabeth Cahen d'Anvers, born in 1874, died in March 1944 while being deported from Nazi-occupied France, a grim reminder that we are looking at portraits of the children of a prominent Jewish family, albeit one thoroughly assimilated into the upper echelons of Parisian society.[246] Renoir, like many Frenchmen of his class, was prone to anti-Semitic outbursts – far less virulent than Degas, he was a confirmed anti-Dreyfusard nonetheless – and after an altercation over payment for the portrait of Alice and Elisabeth Cahen d'Anvers, with Renoir apparently settling for less than he had expected, he wrote in some exasperation to Deudon: "As for the 1,500 francs from the Cahens, I must tell you that I find it hard to swallow. The family is so stingy; I'm washing my hands of the Jews."[247] A distasteful remark, certainly, and not an isolated one,[248] but none of Renoir's bigotry is perceptible in his portraits of these little girls, as radiant and affecting as anything in his oeuvre.[249]

★ ★ ★

The greatest of all Renoir's family portraits is *The Artist's Family* (fig. 58), a fitting work with which to conclude a discussion of Renoir's practice as a portraitist, since, rather like the finale of a Mozart opera, it weaves together many of the themes and issues touched upon in this essay. Painted in the spring of 1896, it became the centre-piece of the hastily organized *Exposition Renoir* at Durand-Ruel's that May. Renoir surely conceived *The Artist's Family* with a public institution in mind, and there are indications that he planned to bequeath it to the Louvre.[250] The largest portrait in his oeuvre, it shows Madame Aline Renoir, née Charigot (1859–1915), in a splendid but somewhat absurd hat, wearing gloves, and holding a fur-collared coat over her left arm, with eleven-year-old Pierre, her eldest son, in a sailor suit, leaning affectionately against her. Jean, her younger son, not yet two years old, is supported tenderly by Gabrielle Renard (1878–1959), nurse, housekeeper, and model. Behind Gabrielle stands a neighbour's daughter who gazes flirtatiously at Pierre, tossing back her chestnut hair. The family are posed in the woody courtyard of one of the pavilions at 13 rue Girardon, opposite the Château des Brouillards on the butte Montmartre, into which they had moved in October 1890.

The Artist's Family is a tour de force of monumental painting. Its origins are to be found in Velázquez's *Las Meninas*, a work that Renoir had seen on a visit to Madrid with Paul Gallimard in June 1892. Like Velázquez, Renoir endows his portrait with an iconicity that sets it outside time: here is the quintessential bourgeois family, tender, loving, healthy.[251] It is all these things, but it is also a work of consummate fiction and artistry. "Freshness," Mallarmé observed, "frequently consists – and this is especially the case in these critical days – in a coordination of widely scattered elements."[252] If we apply Mallarmé's dictum to *The Artist's Family*, it

Fig. 57 James Tissot, *The Artists' Wives*, 1885. The Chrysler Museum of Art, Norfolk, Va., Gift of Walter P. Chrysler, Jr., and the Grandy Fund, Landmark Communications Fund, and "An Affair to Remember," 1982

is possible to come nearer to a fuller appreciation of Renoir's powers of invention and mythmaking. For Renoir was not only responding to Velázquez, he was working in a genre that by the 1890s was already part of the canon of chic modernity; Tissot, in an unbearably mawkish work, had made artists' wives the subject of his painting of 1883–85 (fig. 57), in which behatted women are seen from every angle.[253] The very year that Renoir painted his *Artist's Family*, his younger competitor Jacques-Émile Blanche submitted to the Salon an equally large, if not equally impressive, portrait of the Norwegian artist Fritz Thaulow and his family (fig. 59), in which the artist's son also wears a sailor's costume and Frau Thaulow seems incongruously attired for outdoors.[254] The thirty-seven-year-old Madame Renoir does not have the fashionable ease of Tissot's ostriches, nor is she the deferential helpmate of Blanche's ambitious Salon entry. She is portrayed as a kindly but commanding matriarch, a position with which she seems a little uncomfortable. It is worth remembering that Aline Charigot was born to peasant stock in Essoyes in Champagne, had worked as a

Fig. 58 Pierre-Auguste Renoir, *The Artist's Family* (*Portraits*), 1896. The Barnes Foundation, Merion, Pa.

seamstress and artist's model in Paris, and shunned artifice and affectation. It was as a country girl that Renoir had chosen to present her a decade earlier, with ruddy complexion and rustic dress (cat. no. 50).[255] In his memoirs, Jean Renoir recalled that his mother was "determined to remain exactly as she had been born, the daughter of a wine-grower who could wring a chicken's neck, wipe a baby's bottom, and prune the vine," and it is this appealing, down-to-earth quality that is at the heart of Renoir's final portrait of her, done in 1910 (cat. no. 62).[256]

In *The Artist's Family*, Renoir is making a rather different statement. In June 1896, Gustave Geffroy noted that as soon as it was exhibited, everyone called this picture *Départ pour la promenade*: Renoir's family out for a Sunday walk.[257] In this epiphany of bourgeois married life – with Pierre in the sailor suit customarily worn by the sons of the well-to-do – Renoir is coming to terms with issues on which he had been ambivalent for some time: his wife, his marriage, his family. Pierre, his first son, had been born out of wedlock in March 1885. Renoir married Aline only in April 1890, and not until August of the following year did he introduce his wife and child to Berthe Morisot and her husband, good friends of his for half a decade. "I'll never be able to describe my astonishment at meeting this heavy woman," Morisot confided to Mallarmé in October 1891, "whom I had imagined, for reasons I cannot explain, more as a figure in one of his paintings."[258] Six years later, the nomadic Renoir seems finally to have come to terms with parenthood, property, and conjugality. On 1 July 1895, he had consented to have Jean, born the previous September, christened at the Église Saint-Pierre de Montmartre, although he insisted to the child's godfather: "We're doing the baptism without any fuss."[259] In February 1896, just before starting *The Artist's Family*, he had experienced real anxiety when Pierre fell ill with measles and Jean was at risk. Burning sulphur in the boys' bedroom, he informed Julie Manet: "Jean is superb at the moment, but I'm still worried. At his age measles are unbear-

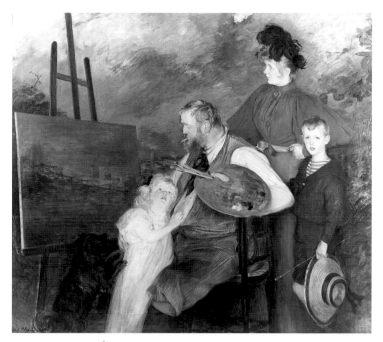

Fig. 59 Jacques-Émile Blanche, *Fritz Thaulow and Family*, 1895. Musée d'Orsay, Paris

able."[260] Indeed, with his immaculately attired and fully recovered brood about to set forth in what Geffroy considered "one of the finest groupings of human figures ever represented in painting," Renoir does more than come to terms with bourgeois values – he positively embraces them, with a sureness of touch, a peerless technique, and a depth of affection and good humour that resonate and give pleasure one hundred years later and will doubtless continue to do so into the centuries to come.[261]

1 "Il y a dans Paris à peine quinze amateurs capables d'aimer un peintre sans le Salon. Il y en a 80,000 qui n'achèteront même pas un nez si un peintre n'est pas au Salon. Voilà pourquoi j'envoie tous les ans deux portraits, si peu que ce soit" (Venturi 1939, I, 115).

2 "'Monsieur Renoir, vous n'avez pas de caractère! lui reprocha Degas . . . Je n'admets pas que l'on fasse de la peinture sur commande. Vous travaillez pour la finance, quoi? Vous ferez le tour des châteaux avec M. Charles Ephrussi, vous exposerez bientôt aux Mirlitons . . . comme M. Bouguereau!'" (Blanche 1927, 62-63). The Mirlitons was the name given to the fashionable Cercle de l'Union Artistique; in the 1870s and 1880s it held exhibitions in its elaborate top-floor galleries on the place Vendôme (Ward 1991, 605).

3 "Dans l'œuvre de Renoir, peintre de figures, il faut donner une place à part au portraitiste. Aucun autre n'a aussi profondément scruté l'âme de son modèle et n'en a exprimé l'essence en quelques traits concis" (Rivière 1925, 5).

4 For an introduction to this large topic see Boggs in *Degas Portraits* 1994, 17–85, and Loyrette in Tinterow and Loyrette 1994, 183–231. For a useful survey of the literature on Impressionist portraiture see Farr 1992.

5 "Éternel Esquimau porte-lunettes" (Baudelaire 1961, 1071, "Salon de 1859").

6 "Cependant le triomphe de l'art bourgeois est dans le portrait" (Duret 1867, 132).

7 "Le flot des portraits monte chaque année et menace d'envahir le Salon tout entier . . . Il n'y a plus guère que les personnes voulant avoir leur portrait, qui achètent encore de la peinture" (Zola 1991, 192, "Mon Salon" [1868]).

8 "Ce sont les amateurs qui font la peinture. La peinture française est l'œuvre de M. Cho[c]quet. Et la peinture italienne est l'œuvre de quelques Borgia, Médicis et autres tyrans" (Renoir 1981, 251).

9 Loyrette (Tinterow and Loyrette 1994, 193) notes that portraiture may have accounted for 45% of Degas's production between 1855 and 1876 and 25% of Manet's production between 1859 and 1870. Portraits, as opposed to genre, make up almost 50% of Renoir's figure painting between 1860 and 1885.

10 Boggs (*Degas Portraits* 1994, 18–19) points out that while portraiture may have accounted for as much as one fifth of Degas's entire oeuvre, only one conventional portrait commission – ironically, *General Mellinet and Chief Rabbi Astruc* (1871, Ville de Gérardmer) – may be said to have been brought to a successful conclusion. Boggs notes that "Degas seems to have made most of his portraits for his own enjoyment, free from the demands imposed by his patrons on the professional portrait painter."

11 Given the "enormous cost of hiring models," as Bazille regularly lamented to his mother (Bazille *Correspondance*, 96, 120, 187), it is not surprising that they resorted to using their mistresses in multiple poses. Camille Doncieux appears as all three raven-haired women in *Femmes au jardin* (1866–67, Musée d'Orsay, Paris) just as Lise Tréhot is painted from three different angles in *Parisian Women in Algerian Dress* (1872, National Museum of Western Art, Tokyo).

12 "Il me faudrait continuer ainsi pendant trois ou quatre pages, si je voulais signaler seulement les portraits convenables; les murs en sont tapissés et ils occupent trois quarts du livret" (Zola 1991, 337, "Le Salon de 1876"). A review of the proportion of paintings to designated portraits in the Salon confirms that Zola is indulging in customary hyperbole and would suggest that Burty's claim in *La République Française*, 27 May 1879, is far nearer the mark: "Jamais les portraits n'ont été aussi abondants qu'à ce Salon. Si on les comptait ils en formeraient bien le cinquième." The following figures are admittedly approximate: 1864 – 2,278 paintings, 266 portraits; 1870 – 2,991 paintings, 384 portraits; 1876 – 2,095 paintings, 359 portraits; 1879 – 3,040 paintings, 598 portraits; 1882 – 2,722 paintings, 536 portraits; 1887 – 2,521 paintings, 542 portraits.

13 Blanc 1880, 610.

14 "Le plus grand artiste n'est pas celui qui vient dans nos maisons revêtir nos costumes, se conformer à nos habitudes, nous parler l'idiome de chaque jour et nous donner le spectacle de nous-mêmes" (ibid., 615).

15 "L'artiste serre de près la nature, et ne s'isole pas de ces conditions d'observation, d'arrangement et d'effet qui doivent le maintenir en communication étroite avec la société" (Burty 1879).

16 "Représentés dans la diversité de leurs fonctions, de leurs tempéraments, de leurs caractères" (Castagnary 1892, I, 245, "Les Portraits" [1867]). Again anticipating Duranty's celebrated polemic of 1876, Castagnary took exception to Carolus-Duran's much admired equestrian portrait of the actress Sophie Croizette (fig. 131) at the Salon of 1873 because of its utter conventionality: "Il n'imagine pas qu'on soit tenu de peindre les gens chez eux, dans leur milieu moral, et, si l'on peut dire, dans leur atmosphère accoutumée" (ibid., II, 90, "Les Portraits" [1873]).

17 Moffett 1986, 44. "Ce qu'il nous faut, c'est la note spéciale de l'individu moderne, dans son vêtement, au milieu de ses habitudes sociales, chez lui ou dans la rue" (Duranty 1876, reprinted in Moffett 1986, 481).

18 "Les portraits, ces tableaux de la vie ordinaire, devraient évidemment, par leur caractère même, représenter le moderne. Il n'en est rien. Bien entendu, les modèles sont pris dans la vie, mais presque toujours l'artiste songe à imiter une école quelconque. Il veut peindre comme Rubens, Rembrandt, Raphaël ou Vélasquez . . . [les artistes] ne se soucient que d'une chose: plaire au modèle. On peut dire que leur grande affaire est d'effacer les traces de la vie. Leurs portraits sont des ombres, des figures pâles aux yeux vitreux, aux lèvres de satin, aux joues de porcelaine" (Zola 1991, 302–303, "Le Salon de 1875").

19 "Il faut cependant louer ceux qui entreprennent ainsi de représenter la vie même, la vie moderne, dans ses manifestations journalières" (Claretie 1874, 261, "L'Art français en 1872").

20 See Crespelle 1969, 74–85, Bréon 1988, 21–37, and Vaisse in *Degas Portraits* 1994, 118–127.

21 Proust 1981, III, 742. "La poésie d'un élégant foyer et de belles toilettes de notre temps ne se trouvera-t-elle pas plutôt, pour la postérité, dans le salon de l'éditeur Charpentier par Renoir que dans le portrait de la princesse de Sagan ou de la comtesse de La Rochefoucauld par Cotte ou Chaplin?" (Proust 1954, III, 722).

22 Daulte (1964, 75) estimates that Renoir painted over two thousand portraits, but as this also includes the innumerable portraits of his three children at the end of his career, the figure is of little use for our purposes.

23 On Anne-Marie Hagen, known as Charlotte Berthier, see *Caillebotte* 1994, 285, 360. She was only twenty when Renoir painted her portrait, and lived with Caillebotte from 1883 until his death in 1894.

24 "L'intérieur si vivant de ce jeune couple fut le carrefour où se confrontèrent les débutants talentueux" (Blanche 1928, 17). Henriette Arnaud-Gentil, comtesse de Bonnières de Wierre (1854–1906), *répétitrice* at the Schola Cantorum, was thirty-five when she sat to Renoir; according to Blanche, who also painted her portrait, she was an early patron of Rodin's, and sat also to Tissot, Helleu, Forain, and Besnard.

25 "Je ne me souviens pas d'avoir jamais fait de toile qui m'ait plus embêté!" (Vollard 1919, 134). The anecdote about Madame de Bonnière's arrival at the opera is told in Morisot *Correspondance*, 131. Blanche (1949, 229) describes "un visage dépourvu de beauté, mais savamment préparé à la crème simon, poudré de rose avec les pommettes saillantes."

26 "Je ne sais comment font les autres pour arriver à peindre des chairs faisandées. Ils appellent ça des femmes du monde!" (Vollard 1919, 11).

27 The stereotype of Renoir as a "natural" painter originates with Octave Mirbeau in his preface to *Renoir* 1913 (reprinted in Mirbeau 1993, II, 520): "Renoir peint comme on respire. Peindre est devenu pour lui l'acte complémentaire de regarder." See also Blanche 1921, 39: "La peinture était à Renoir un exercice, une fonction comme de respirer, de manger ou de boire."

28 Lindsay 1985, 14; Dorment and Macdonald

1994, 207–208. Mary Cassatt commiserated with her sister-in-law, who had still to take possession of Whistler's portrait in December 1884: "I am sorry you don't like it, you remember I commended Renoir but neither you or Aleck liked what you saw of his" (Mathews 1984, 186, corrected from a transcription of Cassatt's letter).

29 "Zola . . . s'imagine avoir peint le peuple en disant qu'il sent mauvais" (Vollard 1919, 94). According to Vollard, Renoir claimed always to have "detested" Zola's writing.

30 "M. Renoir parle de Zola: . . . il dit qu'il remarquait justement autrefois lorsqu'il allait souvent au Moulin de la Galette où se réunissaient toutes les familles de Montmartre combien il y avait de sentiments délicats chez ces gens dont Zola parlait comme d'êtres atroces" (Manet 1979, 150, entry for 20 January 1898).

31 "Qu'il ne fasse plus de portraits, qu'il reste paysagiste!" (Bernheim de Villers 1940, 86).

32 "Renoir excelle dans le portrait. Non seulement il saisit les traits extérieurs, mais, sur les traits, il fixe le caractère et la manière d'être intime du modèle" (Duret 1922, 186–187, "Les Peintres impressionnistes" [1878]). This observation is repeated, almost word for word, by Octave Mirbeau in "Notes sur l'art: Renoir" (1884): "Le portrait y tient une place importante, et Renoir excelle dans le portrait, cet art si difficile et profond, car non seulement il ne suffit pas de saisir les traits extérieurs, mais sur les traits il faut fixer le caractère et la manière d'être intime du modèle" (Mirbeau 1993, I, 89).

33 "Un portrait ravissant dans lequel on retrouverait le charme dont votre chère personne est inondée" (Rivière 1877b).

34 Pissarro Correspondance, I, 115.

35 "'Je paie cher,' me dit-il, 'le plaisir que j'ai avec cette toile, mais c'est si délicieux de se laisser aller à la volupté de peindre!'" (Vollard 1919, 258, Renoir on painting Madame de Galéa).

36 These figures are based upon the number of finished works between 1864 and 1885 – calculated at 397 – included in the first volume of Daulte's catalogue raisonné (which is restricted to figure painting between 1860 and 1890); for this period there are also 28 nudes and 9 decorations.

37 He would also have been represented by a portrait at the Salon of 1869, had his Prince Georges Bibesco (whereabouts unknown), painted the previous year, been accepted. Its rejection explains why Renoir exhibited only one painting at the Salon of 1869, his Summer (Study) (1868, Nationalgalerie, Berlin); see note 54 below.

38 "Le Portrait des Mlles Mendès, assassiné au Salon de 1890" (Alexandre 1892, 30), mentioned also by Wyzewa (1890, 28): "Juché dans le coin le plus obscur d'un obscur cabinet un portrait d'enfant [sic] de M. Renoir."

39 Castagnary 1892, II, 214, "Salon de 1876."

40 Robert 1877.

41 With heavy sarcasm, Arthur Baignères had written the year before in L'Écho Universel, 13 April 1876: "M. Renoir est le portraitiste du cénacle. Je ne crois pas qu'il porte ombrage à M. Carolus Duran." A more favourable comment came from Louis Fourcard (writing under the pseudonym Léon de Lora) in Le Gaulois, 10 April 1877: "Cet intransigeant . . . a sans contredit l'oeil et la patte du portraitiste."

42 "Il faut remonter aux vives pochades de Fragonard pour rencontrer, non pas des points de comparaison matérielle, mais des analogies de tempérament français s'appliquant à la peinture de portrait" (Burty 1877). It is worth noting that this anticipates by more than a decade Renoir's own explanation of his manner of painting as "Fragonard en moins bien" (Venturi 1939, I, 132, Renoir to Durand-Ruel, which should be dated to October 1888). The analogy soon atrophied into a fashionable cliché, as Proust observed: "Les gens de gout nous disent aujourd'hui que Renoir est un grand peintre du dix-huitième siècle" (Proust 1954, II, 327).

43 "Car j'ai l'intention d'y faire si ces messieurs consentent une exposition rien que de portraits ce qui attirerait beaucoup de monde, je crois" (Florisoone 1938, 34). Renoir's letter should be dated to early 1880, since he also asks Madame Charpentier for her opinion on a portrait that he will exhibit at the Salon of 1880.

44 Baignères 1883, 596.

45 Gauguin 1921, 19.

46 Havemeyer Archives, Metropolitan Museum of Art, New York, Cassatt to Mrs. H.O. Havemeyer, 11 January 1915.

47 "Nous tenons à montrer que vous n'êtes pas seulement un peintre de natures mortes ou de figures nues, mais que, contrairement à l'idée que bien de gens se font de votre talent, vous êtes un grand peintre de portraits" (Godfroy 1995, II, 105, Joseph Durand-Ruel to Renoir, 10 May 1912).

48 "Renoir a fait tout son possible pour éviter l'exposition des portraits, il n'a pu y arriver" (Hôtel Drouot, Paris, Bignon collection, 6 June 1975, no. 46, Gabrielle Renard to Vollard, 12 June 1912).

49 "D'être prudent et de faire du portrait" (Renoir 1981, 123).

50 "Un public d'amateurs choisis et de goût, mais qui ne vaut pas les amateurs riches payant les grands prix" (Pissarro Correspondance, I, 94, Duret to Pissarro, 2 June 1874). Duret's letter is in the Fondation Custodia, Paris.

51 Cooper 1959, 326.

52 "Il comptait sur ce portrait pour lui susciter des commandes et lui procurer quelques ressources" (Baudot 1949, 16).

53 Renoiriana 1919, 33; Baudot 1949, 16. Marc Le Coeur has informed me that Bibesco was in Algiers from February 1867 until October 1868.

54 "Le portrait de Georges Bibesco est refusé aussi, j'en suis bien fâchée car c'est vraiment malheureux pour ce pauvre Mr. Renoir" (private collection, Marie Fouqué, Jules Le Coeur's sister, to her husband, 12 April 1869). For this unpublished reference, I am grateful to Marc Le Coeur, who is preparing an article on Renoir and Bibesco.

55 Hôtel Drouot, Paris, 19 February 1982, no. 14, Renoir to Bazille, undated, late 1860s, in which Renoir, having already written to Madame Mariani himself, asks Bazille "de l'entretenir de son portrait pour quand je reviendrai ici."

56 "Il était si bien possédé par le démon de son art que tout le reste lui était indifférent, et qu'il n'eût voulu pour rien au monde s'embarrasser l'esprit d'une question d'argent" (Rivière 1921, 82).

57 "Je déjeune chez un monsieur pour une commande de portrait" (Florisoone 1938, 32, Renoir to Charpentier, undated, c. 1877–79).

58 "J'ai fait deux tentatives pour voir madame Cahen, je n'ai pas encore réussi" (Archives Durand-Ruel, Paris, Renoir to unnamed correspondent, in all likelihood Ephrussi, undated, c. 1880). See Distel 1989a, 60, for Fanny Ephrussi's letter of August 1880 to Charles Deudon noting that Ephrussi "a reçu une lettre de Renoir qui lui demande de bien vouloir écrire à Louise [Cahen d'Anvers] pour savoir à quelle époque il pourra faire le portrait d'Alice." This would also imply that Renoir initially expected to paint the portrait of each daughter individually and that the decision to paint the youngest daughters together may have been something of a compromise (see cat. no. 38).

59 See Bailey and Rishel 1989, 151, for Renoir's letter to Mendès, whose opening sentence sets the tone: "Mon cher ami, je suis revenu à Paris et je vous prierai de me dire de suite si vous voulez les portraits de vos jolis enfants . . . Vous voyez que c'est pressé."

60 Loyrette in Tinterow and Loyrette 1994, 186.

61 "C'était un changement de sa situation pécuniaire, qui le tirait de la misère, où il avait presque toujours vécu. Il avait obtenu de ces portraits une rémunération qui lui avait créé des ressources . . . Ils lui ont d'abord procuré le moyen de vivre" (Duret 1924, 66, 70). The point was also made by Pissarro to Murer in a letter of 27 May 1879: "[Renoir] a un grand succès au Salon. Je crois qu'il est lancé, tant mieux, c'est si dur la misère!" (Pissarro Correspondance, I, 133), and by Cézanne to Zola in a letter of 4 July 1880: "Renoir aurait quelques bonnes commandes de portraits à faire" (Rewald 1978, 194).

62 Duret 1922, 78, 96.

63 See the excellent account by Pickvance in Moffett 1986, 243–250.

64 Bodelsen 1968, 339–341. As Pissarro (Correspondance, I, 113) complained to Murer: "La vente Hoschedé m'a tué." Renoir's derisory prices were first published in Meier-Graefe 1912, 54, which seems to have escaped the meticulous Bodelsen.

65 For example, his request to Gambetta – either at Cernuschi's masked ball in October 1877, or at the Charpentiers – that he be appointed curator of a provincial museum at a salary of 200 francs per month (Vollard 1919, 98).

66 Particularly the Alsatian Henner, whom Renoir remembered as "un vieil ami de la maison" (Vollard 1919, 97). Henner, "qu'on veut nous faire avaler pour un Corrège moderne" (Pissarro Correspondance I, 127, August 1878), had painted a portrait of Georges Charpentier (private collection) in 1877 (Devillers 1886, 219; Rivière 1921, 170). As a result of the administrative reforms of 1879, he was one of ten members of the jury respon-

sible for admitting figure painters to the Salon (Monneret 1978–81, III, 242).

67 Zola 1991, 358, "Une exposition: Les peintres impressionnistes" (1877).

68 "Bien haut et bien placé pour une oeuvre d'une touche aussi délicate" (Renoir [Edmond] 1879a).

69 For a summary of the considerable iconography of Sarah Bernhardt see Bernier 1984. Renoir, who saw her perform in Dumas's *Dame aux camélias* (which he detested), took an instant dislike to her (Vollard 1938b, 195). By the end of the 1870s, portraits of Sarah Bernhardt at the Salon were something of a cliché: "Il y a d'ailleurs des gens qui déclarent qu'ils ne viendraient pas à un Salon où ne figurerait pas le nom de Mlle Sarah Bernhardt" (Lorr 1879).

70 "Quand un jeune artiste expose au Salon le portrait du créateur du dernier rôle à succès, il peut être, lui aussi, sûr à l'avance de son succès" (Dacier 1905, 110).

71 "L'une des trois est trop de mon goût à moi pour l'envoyer et elle serait refusée, et j'ai dû en place faire une chose plus sage, plus bourgeoise" (Wildenstein 1974–91, I, 438).

72 Ibid.

73 Venturi 1939, I, 122, draft letter to Durand-Ruel in Edmond Renoir's hand, dated 26 February 1882.

74 "Je vous engage à exposer: il faut arriver à faire du bruit, à braver et à attirer la critique. Vous ne pourrez arriver à tout cela qu'au Palais de l'Industrie" (Venturi and Pissarro 1939, Duret to Pissarro, February 1874, I, 33–34). "Il serait nécessaire qu'ils fussent au Salon pour confirmer de leur présence l'évolution accomplie et lui donner toute son importance" (Castagnary 1892, II, 214, "Salon de 1876"). "Il faut connaître l'admirable moyen de publicité que le Salon officiel offre aux jeunes artistes; avec nos moeurs, c'est uniquement là qu'ils peuvent triompher sérieusement" (Zola 1991, 417, "Le naturalisme au Salon" [1880]).

75 For a survey of Salon regulations in this period see Mainardi 1988, 31–40, and Mainardi 1993, 37–89.

76 "Je ne veux pas perdre mon temps à en vouloir au Salon. Je ne veux même pas en avoir l'air" (Venturi 1939, I, 115, Renoir to Durand-Ruel, from Algiers, March 1881). Indeed, as is clear from his petition that Murer published in the *Chronique des Tribunaux*, 23 May 1880, Renoir even tried to reform the Salon, proposing that the Naturalists and Impressionists (as he termed them) be given their own section and their own jury. On Renoir's "Projet d'exposition artistique" see Gachet 1956, 165–166. As Renoir recalled late in life to Walter Pach, potential clients such as the "rich banker" Pillet-Will would invariably choose a portraitist who had succeeded in the Salon, arguing that "if these portraits are bad, it is through no fault of mine, for I looked through the catalogue of the Salon and chose the painter with the most medals, just as I would do in buying my chocolate" (Pach 1912, 614).

77 "Et voulant lui venir en aide, ils se mirent en mesure de lui faire peindre des portraits, ce qui était le moyen d'agir en sa faveur" (Duret 1924, 62).

78 "Je vous serai bien obligé si vous avez un instant à vous de vouloir bien aller chez Monsieur Paul Berard 20 rue Pigalle, pour me dire si je puis envoyer le portrait de sa petite fille au Salon. Vous êtes annoncée" (Florisoone 1938, 34, Renoir to Madame Charpentier, undated, c. 1880). The pastel portrait of Marthe Berard is listed in the *livret* of the Salon of 1880 as "Nº 5704, Portrait de Mlle M.B."

79 In his review in *Le Siècle*, 14 May 1881, Henry Havard congratulated Renoir, "ce jeune peintre impressionniste," for his two remarkable portraits, describing the São Paulo picture in sufficient detail to lay to rest the vexed question of whether or not it actually appeared in the Salon of 1881 (it did): "Deux fillettes debout . . . leurs petites frimousses rieuses, leurs tresses blondes, leurs robes roses et bleues, composent un vrai bouquet et des plus frais et des plus brillants. L'autre portrait, un profil, est également fort intéressant." Ephrussi had listed these works in the *livret* as simply "Nº 1986, Portrait de Mlle XXX" and "Nº 1987, Portrait de Mlle XXX," which not only protected the privacy of the Cahen d'Anvers, but also succeeded in misleading the most attentive of Renoir's present-day historians; see House and Distel 1985, 224, Distel 1989a, 61, n. 20, and Distel 1993, 78.

80 *Gazette des Beaux-Arts* XXIV (1881), opposite page 40. Buisson (1881, 41) refers simply to "un intéressant portrait d'enfant par M. Renoir." On Ephrussi see the splendid article by Kolb and Adhémar (1984). Marguillier (1905, 354) remembered Ephrussi as one of Renoir's earliest promoters: "Il avait été en effet, un des premiers à comprendre et à soutenir l'effort de la jeune école du plein-air, notamment de Renoir, auquel, tandis que l'artiste était encore violemment discuté, il amenait des commandes." By the mid-1880s Ephrussi seems to have lost interest in the Impressionists, transferring his allegiances to Gustave Moreau and Puvis de Chavannes. Vollard (1919, 97) recorded Renoir's distasteful remark about Moreau painting with gold to impress the Jews, "jusqu'à Ephrussi, que je croyais, tout de même, un peu sensé!" Blanche (1927, 78) reproduces a letter of 1888 from Robert de Montesquiou, in which Ephrussi is referred to as Puvis de Chavannes's "manager." Ephrussi was transformed by Proust into Elstir's patron and protector ("une espèce de Mécène qui l'a lancé"), with the duc de Guermantes, who cannot remember his name, informing Marcel, mesmerized by what is clearly Renoir's *Luncheon of the Boating Party*, "le tableau populaire" (fig. 16), "c'est lui qui a fait acheter ces machines à Madame de Guermantes, qui est toujours trop aimable, qui a toujours trop peur de contrarier si elle refuse quelque chose; entre nous, je crois qu'il nous a collé des croûtes" (Proust 1954, III, 500).

81 "Charles a aussi reçu une lettre de Renoir qui lui demande de bien vouloir écrire à Louise . . . À ce qu'il semble, il désire exposer le portrait d'Irène au Salon de l'année prochaine et il a joliment raison" (Distel 1989a, 60, Ephrussi's sister-in-law Fanny to Charles Deudon, August 1880).

82 "J'ai l'intention d'exposer la petite Yvonne Grimprel et soit votre portrait, soit ce que vous voudrez de chez vous" (Archives Durand-Ruel, Paris, Renoir to Berard, from L'Estaque, undated, early March 1882).

83 "Mais j'aime votre portrait. Voilà mon avis. Si vous êtes trop combattu envoyez André . . . Une idée, pourquoi ne mettriez-vous pas Madame Berard. C'est très bien. C'est entendu" (Getty Center for the History of Art and the Humanities, Santa Monica, Calif., Special Collections, Renoir to Berard, from Marseilles, undated, early March 1882).

84 "Votre portrait a besoin encore d'un an de bouteille. Ne suivez pas mes conseils et écoutez Ephrussy. Ce juif plus que Bourgeois a l'oeil qu'il faut pour ce qu'on appelle le Salon (de coiffure)" (private collection, Renoir to Berard, from Algiers, undated, mid-March 1882, partially quoted in White 1984, 123–124).

85 "Surtout pas de tableaux des portraits" (Renoir to Berard, as in note 83 above).

86 On Easter Monday (18 April) 1881, Renoir had written to Duret: "J'aurai au Salon les portraits des petites Cahen. Je ne sais si ça fera l'effet déplorable de mon exposition de l'année dernière" (Florisoone 1938, 40). Huysmans (1883, 184, "Salon officiel de 1881") praised Renoir's portraits, "surtout celui d'une petite fille assise de profil, dont les cheveux ont une fleur de coloris telle qu'il faut remonter aux anciens peintres de l'École anglaise pour en trouver une qui l'approche," unquestionably a reference to the portrait of Irène Cahen d'Anvers. See also Chassagnol 1881: "On ne peut rêver rien de plus joli que cette enfant blonde dont les cheveux se déroulent comme un manteau de soie aux reflets changeants et dont les prunelles bleues s'imprègnent d'étonnements naïfs." On the portrait of Alice and Elisabeth Cahen d'Anvers see note 79 above and cat. no. 38.

87 The Salon *livret*, which listed this work as "Nº 2031, Portrait de Madame C . . . (forêt de Fontainebleau)," might lead one to conclude that Renoir's earlier, *plein-air* portrait had been exhibited. However, as Anne Distel has confirmed, the reference to Fontainebleau is a printer's error, and relates to Renié's entry, "Nº 2030, Bouleaux au soleil couchant-plateau de Bellecroix (forêt de Fontainebleau)."

88 Syène 1879b, 418.

89 "La lumière crue du grand jour, les reflets du soleil, leur font le plus grand tort" (Zola 1991, 426, "Le naturalisme au Salon" [1881]).

90 "Le jour où j'ai envoyé les petites Mendès on les ait mises sous le velum, où personne ne les a vues" (Moncade 1904, Renoir's first published interview).

91 "Ces Messieurs savent que j'ai fait un grand pas à cause du Salon. Il s'agit de se dépêcher à me faire perdre ce que j'ai gagné. Ils ne négligent rien pour ça, quitte à me lâcher une fois tombé" (Venturi 1939, I, 122, draft letter to Durand-Ruel in Edmond Renoir's hand, dated 26 February 1882).

92 Blanche 1931, 198.

93 "[Ils] consentaient à accrocher chez eux, à côté d'un Ricard, d'un Bonnat, d'un Baudry, les

effigies qu'ils commandaient à Renoir poussés par Charles Ephrussi et un peu fiers de leur audace. Ensuite ces toiles, d'un prix modique, monteraient à la lingerie, ou dans les cabinets de toilette" (Blanche 1933, 292). See also Dauberville 1967, 219, for a similar reminiscence regarding the portrait of Alice and Elisabeth Cahen d'Anvers, discovered "dans un sixième de l'avenue Foch."

94 Renoir probably first met Ephrussi at the home of Henri Cernuschi (1821–1896), the Milanese financier, militant Republican, and notable collector of Oriental antiquities. In 1876 Renoir had painted the portrait of Cernuschi's Japanese dog Tama for Duret (Sterling and Francine Clark Art Institute, Williamstown, Mass.); this suggests that his acquaintance with Cernuschi's circle – which included Deudon and Ephrussi – dates to before the celebrated costume ball of October 1877 to which he had begged an invitation from Duret, one of Cernuschi's closest friends (Kolb and Adhémar 1984, 30). Henry Morel, a novelist published by Charpentier, claimed in his review of the Renoir retrospective of April 1883 that Renoir had been introduced to Ephrussi by Chocquet, which seems unlikely, although in May 1881 Chocquet is known to have exchanged four small paintings by Sisley for a Monet in Ephrussi's collection (Rewald 1969, 60).

95 "L'amitié d'Ephrussi lui valait une clientèle mondaine, peu convaincue d'ailleurs de son talent, mais à qui l'on promettait un 'bénéfice énorme' sur l'achat des toiles impressionnistes" (Blanche 1927, 63).

96 "Je suis allé chez Ignace, j'ai trouvé le portrait accroché dans le salon à la grande satisfaction de tout le monde. Charles a trouvé que c'était un peu Cabanel" (Drouot Rive Gauche, Paris, Lettres et manuscrits autographes, 22 June 1979, no. 121-7, Renoir to unnamed correspondent, probably Berard, undated, c. 1880). The "Charles" referred to is, in all likelihood, Charles Deudon. The portrait's whereabouts are unknown.

97 "Il a même dit qu'il voulait me faire faire le portrait de sa petite nièce" (Hôtel Drouot, Paris, Autographes littéraires, historiques, artistiques, 11 June 1980, no. 108, Renoir to Berard, undated, in which he promises to visit Ephrussi, who had apparently spoken very highly of his work).

98 Either four-year-old Henry Bernstein (1876–1953), who would sit to Renoir as a grown man in 1910 (private collection, Japan), or his two-year-old brother Robert (b. 1878); see Bernstein Gruber and Maurin 1988, 12, and Groom 1993, 165–169. In an undated letter to Berard, probably July 1880, congratulating him on the birth of his daughter Lucie, Renoir noted: "J'ai commencé aujourd'hui le portrait de la mère de Mr. Leon Fouldt [sic] et après demain le bébé de Mr. Bernstein" (Archives Durand-Ruel, Paris; reproduced in Distel 1989b, 164). Manet painted Henry Bernstein in a sailor suit in August 1881, and Baudry painted a portrait of Madame Bernstein and her son in 1884 (Manet 1983, 474–476; Ephrussi 1887, 252, 273).

99 Renoir wrote to Léon Fould from Wargemont on 4 August 1880 acknowledging receipt of "le prix du portrait de Madame Foult [sic]. Vous savez que j'ai l'intention de la recommencer. Je ne vous en remercie pas moins et vous pri[er]ais d'agréer mes excuses de n'avoir pas mieux réussi. Mais à la revanche" (unpublished letter, private collection, graciously brought to my attention by the baronne Élie de Rothschild). It is clear that Renoir is referring here to the portrait of Madame Fould mère, because later in the same letter he refers to Fould's wife as "madame Léon."

100 Ephrussi's affair with Louise Morpurgo was salaciously followed by Edmond de Goncourt, who on 16 October 1878 noted their assignations at the hôtel Sichel, "où la Cahen d'Anvers, penchée sur une boîte de laque que lui fait admirer le jeune Ephrussi, indique à son amant le jour où il pourra venir coucher avec elle" (Goncourt 1956, II, 1265).

101 The finest being Les Deux Soeurs (cat. no. 40), which Durand-Ruel exhibited at the seventh Impressionist exhibition, but which was listed as belonging to Ephrussi in Renoir's one-man show of April 1883. By 1892 the painting had presumably been bought back by Durand-Ruel; in the catalogue of Renoir's exhibition of that year it is noted as in the collection of Joseph Durand-Ruel.

102 Blanche 1937, 36.

103 Daulte 1971, nos. 335, 336, 337.

104 Distel 1989a, 60.

105 Vollard (1919, 71) has the banker apologizing to Renoir in the following terms: "Ma situation m'oblige à avoir chez moi des tableaux des gens qui vendent cher. C'est pour cela que je dois m'adresser à Bouguereau, à moins que je ne découvre un peintre encore plus haut coté."

106 "Le métier de portraitiste étant encore quasi le seul rémunérateur . . . un jeune Renoir, un jeune Bonnat, un jeune Carolus cherchaient des commandes auprès de la même clientèle" (Blanche 1933, 292).

107 Both Renoir and Carolus-Duran painted portraits of Mélanie de Bussière, comtesse de Pourtalès; Henry Bernstein sat to Renoir, Manet, and Baudry; Bonnat painted the portrait of Louise Warshawska, wife of Albert Cahen d'Anvers (see cat. no. 37 and Luxenberg 1991, 150–151).

108 "Je fais un tableau de Canotiers qui me démangeait depuis longtemps" (Berard 1968, 54, Renoir to Berard, from Chatou, around September 1880). However, it is not strictly true, as Renoir claimed to Vollard, that the payment of 1,200 francs for a commissioned portrait, Mother and Children (1875–76, Frick Collection, New York), enabled him to rent the house in the rue Cortot, in whose garden he would paint Ball at the Moulin de la Galette (Vollard 1919, 72, 75). Mother and Children was in fact shown at the second Impressionist exhibition of 1876 as "La Promenade" and discussed by most critics as a painting rather than a portrait. While it certainly announced Renoir's ambitions to tackle the genre of society portraiture, the painting was posed for by models. White (1984, 50) argues that Nini Lopez posed for the mother, and Edgar

Munhall has kindly shown me correspondence from the descendants of the Salvatelli family who claim that Suzanne (1872–1946) and Marguerite Salvatelli (1870–1927), daughters of the director of a carriage rental business ("maison de chevaux et voitures"), were approached by Renoir to pose for the two little girls. While such identifications cannot be verified conclusively, they tend to confirm that the work was not a commissioned portrait.

109 Distel 1989b, 164, Renoir to Berard, July 1880.

110 "Je ne serais plus capable de faire les frais plus tard, c'est déjà très dur . . . J'ai conté mes malheurs à Deudon qui m'a approuvé, quand même les frais énormes que je fais ne me feraient pas finir mon tableau" (Berard 1968, 54, Renoir to Berard, from Chatou, September 1880).

111 All the male models for Luncheon of the Boating Party – Alphonse Fournaise fils, Lestringuez, Lhote, Caillebotte, Maggiolo, the baron Barbier, Ephrussi and Ephrussi's secretary Jules Laforgue (if these identifications are correct) would have donated their services gratis, as would Aline Charigot at this time. And with the exception of Suzanne Valadon, the other models for Renoir's dance series – Aline Charigot and Paul Lhote – were intimates of the artist.

112 "Les portraits sont la menue monnaie de la peinture historique" (Zola 1991, 335, "Le Salon de 1876").

113 "Les peintres pourront donc partager leur vie, demander aux portraits les ressources pour peindre le tableau dont le placement est toujours hypothétique" (Burty 1879).

114 Wolff 1886, 259; Aubrun 1985, 22–23.

115 "Le plus glorieux, mais le moins riche des artistes de France, demande à de nouveaux portraits le pain quotidien" (Ephrussi 1887, 199).

116 "La vente d'un tableau lui permit de se procurer des modèles pour en exécuter d'autres" (Rivière 1921, 82).

117 Following Boggs in Degas Portraits 1994, 42–50, portraiture may be said primarily to be concerned with the distinctive, the eccentric, the particular; genre with social character, environment, the circumstantial. This approach also seems to have held true for critics of the 1860s and 1870s – Duranty excepted. For example, Castagnary (1892, II, 89) described Manet's Bon Bock (1873, Philadelphia Museum of Art) as "un portrait qui se compose comme un tableau et qui exprime . . . les moeurs du personnage représenté." Rivière (1877c) praised Renoir's portrait of Georgette Charpentier (fig. 6) for "la pose enfantine, naturelle, abandonnée . . . le charme de cette petite fille aux grands yeux noirs, font du portrait de Mademoiselle Charpentier un véritable tableau."

118 "Les femmes qu'il a peintes avaient leur nom de famille, mais on ne s'est guère inquiété de les connaître sous cette sorte de nom" (Duret 1924, 78). Blanche (1937, 37) spoke of Berard's flirting with Renoir's models at his studio in the rue Saint-Georges.

119 "Ses modèles d'élection, trottins, blanchis-

seuses, modistes, flore mousseuse du ruisseau faubourien" (Blanche 1927, 238). "Un portrait de jeune femme à demi renversée et se mordillant l'ongle du petit doigt, distraction que Henry Heyne eût comparée à celle d'une panthère s'aiguisant les griffes" (Burty 1883).

120 Compare Zola's earlier characterization of *Lise* (1867, Museum Folkwang, Essen) as "une de nos femmes, une de nos maîtresses plutôt" (Zola 1991, 211, "Mon Salon" [1868]). From Berlin, Laforgue recalled in December 1881 at least two such paintings in Ephrussi's collection, "la parisienne aux lèvres rouges en jersey bleu, et cette très capricieuse femme au manchon, une rose laque à la boutonnière" (Laforgue 1896, 221). Berard owned *La Songeuse* (1879, Saint Louis Art Museum), which may have inspired Burty's comment cited above.

121 Gachet 1957, 85, 89–90; House and Distel 1985, 208–209; Blanche 1937, 53. "Cela a un côté canaille, pessimiste, qui me déplait" (Proust 1954, II, 501).

122 Rivière 1926, 925; Tabarant 1921, 626–627. On Madame Henriot see cat. nos. 19, 20. On Suzanne Valadon see cat. no. 45.

123 A fine insight into Renoir's use of the model is made in Meier-Graefe 1912, 24: "Il n'a, de fait, jamais peint sans modèle et aujourd'hui encore, le modèle doit être à l'atelier quand il veut travailler. *S'il le regarde, est une autre question*" [italics mine]. Blanche (1931, 205) noted that Renoir and Manet required "ce travail d'après nature" as much as Meissonier, if only "pour le jeu de la lumière sur la couleur des étoffes et de la chair."

124 "Le tableau du *Bal* achevé, Renoir quittait souvent Montmartre pour peindre quelques portraits, dont l'exécution avait été retardée par les vacances" (Rivière 1921, 151).

125 "Ce maudit tableau . . . je sacrifie encore cette semaine puisque j'ai tout fait et je reprendrai mes portraits. Ah! je vous jure que c'est le dernier grand tableau" (Berard 1968, 55–56, Renoir to Berard, from Chatou, September–October 1880).

126 It is hard today to accept the claim that they are "terriblement vécu, et fidèle comme les meilleures pages d'Émile Zola" (Silvestre 1883, 242).

127 Proust 1981, III, 742. "Gens modestes relativement, ou qui le paraîtraient à des gens vraiment brillants (qui ne connaissent même pas leur existence), mais qui, à cause de cela, sont plus à portée de connaître l'artiste obscur, de l'apprécier, de l'inviter, de lui acheter ses toiles, que les gens de l'aristocratie qui se font peindre, comme le Pape et les chefs d'état, par des peintres académiciens" (Proust 1954, III, 722).

128 Blanche 1927, 62.

129 "Quand je pense qu'il faut que je travaille demain toute la journée debout, je suis effrayé d'avance" (Nicolescu 1964, 257, Renoir to de Bellio, undated, probably September 1878). "Le temps que vous font perdre les portraits est incalculable" (Pierpont Morgan Library, New York, Tabarant collection, Renoir to Duret, 15 October 1878).

130 "Je pars demain matin pour Nogent-sur-Marne, toute la semaine, pour un portrait"

(Gachet 1957, 91, Renoir to Murer, undated, probably June 1880). In an undated letter that can be assigned to July 1887, Renoir complained to Durand-Ruel: "Je suis forcé d'aller bientôt à Boulogne-sur-mer finir un portrait" (Godfroy 1995, I, 58), referring possibly to the pastel portrait of Madeleine Adam (private collection).

131 Zola 1991, 348, "Le Salon de 1876."

132 Wolff (1886, 286–290) noted that Carolus-Duran had defied convention by refusing to take a studio in the more fashionable quartier Monceau and by receiving on Thursday rather than Friday morning ("c'est le vendredi qui a été adopté par la plupart des artistes pour les réceptions").

133 Mirbeau 1993, I, 307–311, "Portrait" (*Gil Blas*, 27 July 1886).

134 "Si vous voulez l'entendre – ô miracle! – chantonner quelque gai refrain . . . tâchez de le surprendre en train de travailler" (Renoir [Edmond] 1879b, reprinted in Venturi 1939, II, 338). Renoir remained at 35 rue Saint-Georges from 1873 to 1883; see Nicolescu 1964, 256, for his letter of 1878 asking de Bellio for a loan of 225 francs to pay his "terme," the quarterly payment, which gives an annual rent of 900 francs.

135 "Son vaste atelier l'épouvante et il ne peut rien y faire . . . Il reconnaît que le souci des gros termes de loyer à payer le ronge, et il regrette aujourd'hui d'avoir quitté son petit atelier de la rue Saint-Georges" (Distel 1989a, 62, Berard to Deudon, 12 December 1883).

136 "Ces 'commandes,' il les enlevait en quelques séances, souvent en une seule, feignant ensuite, pour satisfaire l'acheteur, de finir le portrait en d'autres séances" (Blanche 1921, 36).

137 "He worked with such a prodigious virtuosity that a portrait required just one sitting" (Rewald 1945, 181).

138 Ibid., 182.

139 "J'ai . . . bien employé mon temps, 35 minutes, ce n'est pas beaucoup" (Drucker 1944, 134, Renoir to unnamed correspondent, January 1882, recounting his experience of painting Wagner's portrait).

140 "Dans le jardin les jours où le temps sera gris et les jours où le temps ne sera pas gris de 6 heures à 7 heures du soir . . . avant une quinzaine j'aurai le temps de finir mes portraits" (Cooper 1959, 326, Renoir to Charles Le Coeur, summer 1868).

141 Distel 1989a, 61, n. 20. See cat. no. 37.

142 See Bailey and Rishel 1989, 42, for Renoir's undated letter to Mendès. This letter should be dated to before 25 April 1888; on that day Mallarmé wrote to Whistler that Renoir had just informed him of a change of plan, namely that the Exposition Internationale was to take place at Durand-Ruel's gallery, where it would open "bien probablement le seize" (Barbier 1964, 14–15).

143 "Je viendrai faire un portrait de madame Gallimard . . . si Madame Gallimard me refuse de poser pour une tête (trois séances) je ferai du paysage et c'est tout" (Archives Durand-Ruel, Paris, Renoir to Gallimard, undated, probably June 1893).

144 "Si vous vouliez me donner deux heures,

c'est-à-dire deux matinées ou après-midi par semaine, je pense pouvoir faire le portrait en six séances au plus" (Morisot *Correspondance*, 179, Renoir to Berthe Morisot, undated, probably April 1894).

145 *Manet* 1983, 282; Morisot *Correspondance*, 33–34; Munhall 1995, 69–70.

146 "The sitting business is a nuisance, and I am glad to be done with it" (Lindsay 1985, 61, Lois Cassatt to E.Y. Buchanan, June 1888).

147 "Je crois qu'avant d'arriver à vendre couramment mille cinq cent francs et deux mille il ne vous faille attendre encore bien des années" (Pissarro *Correspondance* I, 94, Duret to Pissarro, 2 June 1874).

148 Meier-Graefe 1912, 12.

149 "J'ai exposé Lise et Sisley chez Carpentier. Je vais tâcher de lui coller pour une centaine de francs" (Poulain 1932, 156, Renoir to Bazille, September–October 1869).

150 "Si vous consentez à ce que je vous demande il faudra que vous vous pay[i]ez la toile . . ." (Cooper 1959, 326, Renoir to Charles Le Coeur, summer 1868). These prices are consistent with those paid to Renoir's fellow "actualistes." In 1863 Courbet had charged Étienne Baudry, "grand propriétaire et amateur d'art," 200 francs to paint the portrait of his steward Corbinaud (Tabarant 1922, 32). In September 1868 Monet was paid 130 francs for the full-length portrait of Madame Gaudibert (Wildenstein 1974–91, I, 172). In May 1867 Bazille's hopes of earning 500 francs for the portrait of "une demoiselle fort riche" were dashed when the sitter's desire for friendship prevented him from accepting the fee (Daulte 1952, 53).

151 Meier-Graefe (1912, 14) was informed by Renoir that as a young man he had earned as much as 100 francs a day painting blinds "dix fois plus vite que les autres." On the price of full-plate photographic portraits of aristocrats and celebrities in the 1860s see McCauley 1994, 68.

152 Morisot *Correspondance*, 73, Manet also informing her "qu'il fallait lui faire payer très bien si je voulais être traitée avec considération."

153 Distel 1993, 40. The prices are from Roger-Marx's annotated catalogue of the first Impressionist exhibition.

154 Distel 1989a, 64; Vollard 1919, 64. For Renoir's receipt to Rouart for 1,200 francs, "prix d'un tableau intitulé Parisienne que je lui ai vendu," see Christie's, London, *Illuminated Manuscripts, Continental and English Literature*, 16 December 1991, no. 321.

155 Vollard 1919, 46, 101.

156 Renoir's initial asking price had been 150 francs, as Pissarro, who was also commissioned to paint a portrait of Murer, pointed out to the sitter in July 1878: "Si Renoir a baissé son prix c'est que vous lui avez fait une réduction" (Pissarro *Correspondance*, I, 115).

157 On the price of *Le Carquois épuisé* at the de Béhague sale see Dax 1877, 324.

158 "Je crois bien que ce fut dans les mille francs" (Vollard 1919, 100). "Le grand portrait de Mme Charpentier lui a été payé 1500 francs, les portraits peints pour les Berard ne lui ont été payés qu'à cette échelle" (Duret 1924, 66).

159 "Chaque portrait, même d'un peintre

médiocre, se vend quinze cents, deux mille francs, et les portraits d'artistes plus connus atteignent cinq, dix, vingt mille francs" (Zola 1991, 303, "Le Salon de 1875").

160 "Un artiste qui se respecte ne fait pas de portraits à moins de dix mille francs chacun" (Zola 1991, 335, "Le Salon de 1876"). This is the asking price of Machard's portraits in *Un amour de Swann*, which takes place between 1879 and 1881, with Madame Cottard praising his work as "idéal" – "évidemment elle ne ressemble pas aux femmes bleues et jaunes de notre ami Biche" – and expressing the commonplace assumption: "Je trouve que la première qualité d'un portrait, surtout quand il coûte 10,000 francs, est d'être ressemblant et d'une ressemblance agréable" (Proust 1954, I, 375).

161 "Aujourd'hui j'ai commencé un portrait de mille francs" (Florisoone 1938, 34, Renoir to Madame Charpentier, undated, c. 1880).

162 See Luxenberg 1991, 189, on Bonnat and Robert Garrett, president of the B & O Railroad; Osborne 1980–81, 3–12, on Leland Stanford, president of the Central Pacific Railroad, who commissioned Bonnat and Meissonier; and Lucas 1979, I, 496–500, 608–616, for examples of the prices paid by American sitters to the leading Parisian portraitists between 1880 and 1885 (in his journal entry for 22 November 1880 [ibid., 509] Lucas notes that Carolus-Duran "asked 15,000 ff for portrait en pied & 8,000 ff for head of child & 12,000 ff for portrait of Lady 3/4 length").

163 Schneider 1945, 99. White (1984, 108) incorrectly assumed that this referred to payment for the portrait of Albert Cahen d'Anvers.

164 Archives Durand-Ruel, Paris, "Journal 1880," 30 November 1880; "Journal 1881," 6 January 1881. See also House and Distel 1985, 218–219.

165 Archives Durand-Ruel, Paris, "Journal 1882," 22 May 1882, no. 2388, "Jeune fille à l'oiseau," 2,500 francs; no. 2389, "La Soeur aînée," 2,500 francs.

166 "Je prends généralement de 500 à . . . ça dépend des difficultés. Si ce prix vous paraît excessif j'irai voir l'enfant" (Bibliothèque Nationale, Paris, Département des Manuscrits, N.A.F., 24839/fol 503, Renoir to Sbryenski, 6 rue de la Borde, undated, postmarked 1882).

167 "Les 500 fr. payables 100 fr. par mois" (Bailey and Rishel 1989, 42, 151).

168 "Je vous communique sous le manteau la réponse que je reçois de Renoir dans le moment. Il me paraît qu'en lui offrant 600 f. vous rendrez son âme satisfaite" (Institut d'art et d'archéologie, Paris, Maître to Chéramy, 21 July 1893). Maître's letter is written on the verso of Renoir's response to Maître, who had evidently been asked to name his price: "Tant qu'au prix, que diable pourrai-je demander? Dites de 500 à mille, à votre choix." Renoir's first portrait of Wagner, from which he would paint Chéramy's copy, belonged to the ardent Wagnerian Robert de Bonnières, and it was directly from his house that Renoir arrived late for dinner at Berthe Morisot's on 9 September 1893, with this portrait tucked underneath his arm (Manet 1979, 18).

169 Henner remembered a client "qui lui avait commandé pour 1000 ff, ou à peu près, un de ses premiers portraits" (Durand-Gréville 1925,

153–154). Blanche (1921, 37), referring to the transformation of Renoir's technique after his "période italienne," noted that "il se servait du couteau pour aplatir la matière, repeignait par couches de "demi-pâtes," ponçait, grattait, s'efforçant de ne plus avoir cette dextérité si chère à ses clients-amis, *qui commencèrent à ne plus aimer du tout ce qu'il signait*" [italics mine].

170 "J'attends toujours le soleil. Je passe toutes mes journées à rentrer ma toile. Je ne sais quand j'aurai fini ce portrait qui n'est pas commencé. Je fais mettre tous les jours une robe printanière à une femme exquise, et tous les jours les mêmes choses" (Waemaëre-de Beaupuis 1992, no. 86, Renoir to Berard, 22 June 1882). In April 1883 the rejected portrait of Madame Clapisson was sent by Durand-Ruel with nine other paintings to an exhibition he had organized at Dowdeswell and Dowdeswell, 133 New Bond Street, London.

171 "Mon cher ami, ça ne va pas dans ce moment-ci. Il faut que je recommence le portrait de Madame Clapisson. J'ai fait un fort four. Durand n'est pas je crois très content des siens . . . il faut que je fasse attention, je ne veux pas me couler dans l'estime générale" (Archives Durand-Ruel, Paris, Renoir to Berard, undated, autumn 1882).

172 "Je veux rentrer dans la bonne voie – et je vais aller dans l'atelier de Bonnat. Dans un an ou deux je serai capable de gagner 30000000000000 f par an. Ne me parlez plus de portraits au soleil. Le joli fond noir, voilà le vrai" (ibid.).

173 "Je suis, d'ailleurs, épouvanté de la difficulté qu'on rencontre à faire accepter sa peinture. J'ai fait les frais d'un beau cadre pour le portrait de Lucie, je l'ai accroché en bonne place dans mon cabinet et Marguerite et moi nous pâmons de contentement devant lui. Mais hélas pour Renoir, nous ne pouvons faire partager notre satisfaction et ce portrait, si différent des portraits genre Hencker [sic], épouvante les gens" (Distel 1989a, 62, Berard to Deudon, 12 December 1883). As Anne Distel has noted, "Hencker" is probably a misprint for "Henner."

174 "Il ne trouve plus de portraits à faire depuis! Parbleu!" (Pissarro *Correspondance* II, 254, Pissarro to Lucien, 1 October 1888).

175 "Il n'y a que si mes moyens ne me le permettent pas que je me confinerai dans le poêle de l'atelier, à moins de fortes commandes de portraits ce qui m'étonnerait beaucoup" (Morisot *Correspondance*, 143, Renoir to Eugène Manet, 29 December 1888).

176 As Renoir, enrapturé by "les moues de Jean," explained to "mon cher Congé" on 1 February 1896: "Je vous assure que ce n'est pas une cynécure, [sic] mais c'est si joli et *je travaille pour moi, rien que pour moi*" [italics mine] (Getty Center for the History of Art and the Humanities, Santa Monica, Calif., Special Collections).

177 *Renoir* 1892, nos. 1 (*Portraits de Mlles D.R.*), 48, 50, 89 (*Portrait de Mlle M.D.R.*), 90 (*Portrait de Mlle J.D.R.*), 108, 110.

178 Examples of Renoir's by now infrequent portrait commissions would include his "holidaying" in September 1901 at the Adlers at Fontainebleau, "portraiturer les fiancées [of Joseph and Gaston Bernheim], charmant

d'ailleurs" (Archives Durand-Ruel, Paris, Renoir to unnamed correspondent, 4 September 1901); his visit to Munich in August 1910 to paint the portraits of Thurneyssen's wife and children (see cat. nos. 66, 67); and his travelling to Saint-Cloud to paint Joseph Durand-Ruel's wife Jenny in August 1911, where "il est très fatigué actuellement et travaille à peine une heure et demie par jour" (Godfroy 1995, II, 254, Joseph Durand-Ruel to unnamed correspondent). For the last twenty years of his life Renoir was largely inaccessible to a Parisian clientele: crippling arthritis forced him to follow a strict regime of wintering in the south, spending Easter in Essoyes, and residing in the city only between June and October.

179 "J'ai peur de vous voir perdre la proie pour l'ombre avec votre Amérique" (Venturi 1939, I, 138, Renoir to Durand-Ruel, 12 May 1887). While it is generally true that Renoir's travel after 1881 was made possible by Durand-Ruel's decision to buy pictures from him on a monthly basis, he was able to visit North Africa in March 1881 in part because of the commission to paint the portrait of Alice and Elisabeth Cahen d'Anvers. As he noted to Duret from Algiers on 4 March 1881: "J'ai fini les portraits des petites Cahen. Je suis parti aussitôt après et je ne puis vous dire si c'est bon ou mauvais" (Braun 1932, 11).

180 House in House and Distel 1985, 16–17, and House 1994, 24–26.

181 "Impossible de trouver de l'argent. Je suis désolé" (Geffroy 1924, I, 245, Renoir to Monet, 11 August 1889).

182 When Renoir's *Jeunes Filles au piano* entered the Luxembourg in April 1892, it was acquired for 4,000 francs, just over a quarter of the price paid for Bonnat's portrait of Cardinal Lavigerie (both Musée d'Orsay, Paris), purchased three months later for 15,000 francs (Mallarmé *Correspondance* V, 61–62; Luxenberg 1991, 173).

183 "Fait-il un portrait? Il priera son modèle de garder sa tenue habituelle, de s'asseoir comme il s'asseoit, de s'habiller comme il s'habille, afin que rien ne sente la gêne et la préparation" (Venturi 1939, II, 337). Edmond Renoir's text appeared in *La Vie Moderne*, 19 June 1879, accompanying the magazine's fifth exhibition, devoted to Renoir's pastels.

184 "Il peint comme l'oiseau chante, comme le soleil brille, comme les boutons fleurissent. Jamais on n'a créé avec moins d'artifice" (Meier-Graefe 1912, 3). "Il peint comme il boit, mange, respire" (Blanche 1933, 292).

185 Cooper 1959, 323. Berard (1968, 54) reproduces the drawing of Madame Clapisson in the garden, but not the letter of 22 June 1882 that it originally illustrated, for which see Wemaëre-de Beaupuis 1992, no. 86. For the *Daughters of Catulle Mendès*, Renoir informed the father in April 1888: "Je ferais les dessins chez vous et la peinture chez moi" (Bailey and Rishel 1989, 161). A similar division of labour may have obtained for grand commissions such as *Children's Afternoon at Wargemont*. Although no preparatory drawings have survived for this portrait, Renoir seems to have done some of the painting in Paris, away from his sitters. Writing in the early summer of 1884 from his new apartment at 37 rue Laval, he

joked to Berard (surely in a reference to this group portrait): "Je ne sais pas non plus si je dois apporter la grande toile pour effrayer les enfants" (Hôtel Drouot, Paris, *Autographes littéraires, historiques, artistiques*, 11 June 1980, no. 106, undated letter).

186 "Faire des portraits des gens dans des attitudes familières et typiques, surtout donner à leur figure les mêmes choix d'expression qu'on demande à leurs corps" (Tinterow and Loyrette 1994, 226, from Degas's notebook for 1869 to 1872).

187 "Le personnage . . . ne nous apparaît jamais dans l'existence, sur des fonds neutres, vides et vagues . . . notre point de vue n'est pas toujours au centre d'une pièce avec ses deux parois latérales . . . le personnage . . . n'est jamais au centre du toile, au centre du décor" (Duranty 1876, reprinted in Moffett 1986, 482). Renoir's figures are in fact often at the centre of the canvas.

188 Flandrin's *Mademoiselle Maison* is discussed in Tinterow and Loyrette 1994, 385–386; Bouguereau's *Pauline Brissac* appeared at Sotheby's, New York, 16 February 1994, no. 123.

189 McCauley 1985, 200–201. I am greatly indebted to Professor McCauley's work on photography during the Second Empire for much of what follows, although I disagree with her suggestion that the Lacaux family may have provided Renoir with a photograph of their daughter.

190 Ibid., 155–157.

191 Ibid., 80–81. The genre had a long life; see Paul Nadar's portrait of Caro-Delvaille (1907) in Néagu and Poulet-Allamagny 1979, 1, 199.

192 Duret 1922, 97. For the painting itself see, most recently, Sotheby's, New York, 24 April 1985, no. 33. The only other example that I have come across of Renoir working from a photograph is the anecdote relating to his full-length portrait "d'après une photographie" of Prince Georges Bibesco (see page 6 above).

193 Mallarmé 1876, reprinted in Moffett 1986, 30, commenting on Manet's *Le Linge* (Barnes Foundation, Merion, Pa.). The idea had been articulated only a month before by Zola in his review of the second Impressionist exhibition: the movement's most striking innovation – "le symptôme le plus révélateur" – is "le grand jour qui pénètre partout, ce sont les ateliers lâchant la peinture au plein air, sous les clairs rayons de soleil" (Zola 1991, 351, "Le Salon de 1876"). It should be noted that in 1868 Thoré had praised Manet's portrait of Zola (Musée d'Orsay, Paris) for "la lumière qui circule dans cet intérieur et qui distribue partout le modelé et le relief" (Bürger 1870, II, 532).

194 Mallarmé 1876, reprinted in Moffett 1986, 30.

195 Ibid., 33.

196 It should be noted, however, that by the 1870s there were dissenting voices against the fashion for Rembrandtesque backgrounds. Burty (1874) complained that the unmediated green background of Henner's portraits appeared "comme un fond banal de carte de visite." Huysmans criticized Bonnat's portrait of Victor Hugo at the Salon of 1879 for its "insane" lighting effects: "C'est ni le jour, ni le crépuscule, ni le Jablochkoff, c'est . . . une lumière passant sous des vitres brouillées et

remplies de poussière" (Huysmans 1883, 56); the Compagnie Jablochkoff had installed electric lighting at the Salon of 1879.

197 Moffett 1986, 44. "Et puisque nous accolons étroitement la nature, nous ne séparerons plus le personnage du fond d'appartement ni du fond de rue. Il ne nous apparaît jamais, dans l'existence, sur des fonds neutres, vides et vagues. Mais autour de lui et derrière lui sont des meubles, des cheminées, des tentures de murailles, une paroi qui exprime sa fortune, sa classe, son métier" (Duranty 1876, reprinted in Moffett 1986, 482).

198 "Malheureusement perdu dans un fond vague, tout de convention" (Chesneau 1874).

199 House and Distel 1985, 185.

200 Zola 1991, 103, "Mon Salon" (1866).

201 "La maison est salle de peinture . . . la salle à manger, toute peinturlurée de caricatures de corps de garde et de charges de Murger . . . trois ou quatre hommes . . . l'aspect de mauvais ouvriers en vareuses, déjeunant à trois heures de l'après-midi avec des femelles vagues de la maison, qui viennent là en cheveux et en pantoufles du Quartier Latin" (Goncourt 1956, I, 1306, entry for 28 July 1863).

202 Tinterow and Loyrette 1994, 454.

203 Jellema-van Woelderen 1966–67, 46–49.

204 "Au cirque, l'éclairage incertain rend les visages grimaçants, déforme les gestes, et que Renoir répugnait à cette déformation caricaturale. Il a peint *les jongleuses*, cependant, des acrobates, mais vues au jour, en plein air" (Rivière 1921, 146).

205 See Distel in *Barnes* 1993, 48.

206 Moffett 1986, 141. "Au-dessous du buste garçonnier une ceinture bleue, une ceinture de première communion, descend et papillonne sur la jupe envolée de la ballerine" (Prouvaire 1874).

207 Aubrun 1985, 94–98.

208 "Un curieux habitacle d'un marchand de tableaux au XIXᵉ siècle, c'est celui de Durand-Ruel . . . avec une chambre à coucher ayant au chevet du lit un crucifix" (Goncourt 1956, IV, 269, entry for 13 June 1892).

209 Archives de Paris, V4E/1047, "Acte de mariage," 11 June 1868, Nathan and Clémentine Stora, in which she is identified as "Rebecca Clémentine Valensin, née à Alger le 24 Avril 1851."

210 In his discussions with Vollard, Renoir had referred to her as the wife of a rug dealer (Vollard 1919, 50).

211 Gimpel 1963, 70, entry for 6 September 1918. Vollard (1919, 50) confirms that the painting was sold for 300 francs.

212 Duret 1922, 96. See Rewald 1969 for an unsurpassed account, and Distel 1989b, 125–139. Chocquet may have been introduced to Renoir's work by Philippe Burty (1830–1890), a friend and fellow-admirer of Delacroix, who wrote the preface to the catalogue of the first Impressionist auction of 23 March 1875, which Chocquet attended but at which he made no purchases. Renoir recalled that Chocquet wrote on the evening after the sale asking him to paint the portrait of his wife (Daulte 1971, no. 142), the first work by Renoir to enter his collection (Vollard 1919, 77).

213 See, most recently, *Cézanne* 1995, 164–172,

539–549, 571.

214 Rewald 1969, 54, Cézanne to Chocquet, 11 May 1886.

215 Johnson 1981–89, V, 155.

216 Joëts 1935, 125.

217 See Rewald 1969, 58, quoting Duranty's letter to Zola written in the summer of 1878 informing him that "la femme [de Chocquet] m'a-t-on dit aura un jour cinquante mille livres de rente." Robert de Flers (Gangnat 1925) relates the anecdote of Chocquet presenting his wife with a ring in order to reconcile her to one of his more expensive acquisitions (in this case, Delacroix's *Bride of Abydos*).

218 Johnson 1981–89, V, 50–51. In a similar vein, Rivière (1921, 38–40) recalled Chocquet laying his collection of Delacroix's drawings and sketches on the carpet of his salon for Cézanne to study, "et ces deux êtres supersensibles, à genoux, penchés sur les feuilles de papier jauni qui pour eux étaient autant de reliques, se mirent à pleurer."

219 Distel (1989b, 207) was the first to publish Murer's date of birth accurately, since "l'homme éternellement jeune" seems to have lied about his age to friends and biographers alike. His future brother-in-law, Doucet (1896), gave his birth as 20 May 1847; in Curinier 1899–1905, II, 288, it is given as 20 May 1845. Reiley Burt (1975, 54) notes that he was born in "1846 or 1847." Although Murer's epitaph at Auvers gives the year of his birth as 1846 and Gachet (1956, 146) insists upon this date, a more reliable source is Murer's birth certificate, according to which he was born out of wedlock on 14 May 1841 in Poitiers and christened simply Hyacinthe Eugène (Mairie de Poitiers, No. 266, "Acte de naissance," 15 May 1841, "Hyacinthe Eugène, naturel"; information repeated in Archives de Paris, 5MI3/578, no. 259, "Acte de mariage," 26 March 1867, Hyacinthe et Masson). On 5 August 1872 he was legally recognized by his parents Antoine Meunier and Marie-Thérèse Pineau, "négociants" living at 125 boulevard Voltaire (Archives de Paris, 5MI3/254, "Registre des naissances," 11ᵉ arrondissement).

220 House and Distel 1985, 22; Distel 1989b, 207–215; Bailey and Rishel 1989, 33–35, 144–146. Monet shared Pissarro's view: after agreeing to sell Murer four paintings "size 10 or 15" for 200 francs in December 1877, he was dismayed at the lengths to which Murer would go to take possession of these canvases. Nine months later, Monet reacted angrily to his patron's threats, the paintings having still not been delivered: "Qu'il vous suffise de savoir que je ferai en sorte de vous donner le plus tôt possible, afin de faire cesser au plus vite toute espèce de rapports entre nous" (Wildenstein 1974–91, I, 434-435, Monet to Murer, 6 September 1878).

221 Doucet 1896. The building at 95 boulevard Voltaire is listed as "immeuble à usage de bains publics (les bains du Prince Eugène)" (Archives de Paris, D1P4/1128, "Bail," 1 July 1870).

222 Archives de Paris, 5MI3/578, no. 259, "Acte de mariage," 26 March 1867, Eugène Hyacinthe, patissier, and Marie Antoinette Constance Masson, couturière; ibid.,

5MI3/578, no. 2940, "Acte de naissance," Achille Eugène, 6 August 1867; ibid., 5MI3/580, no. 1694, "Acte de naissance," Eugénie Hyacinthe, 16 June 1868 (died 2 July 1868).

223 In 1877 Renoir painted two portraits of Marie Meunier (Daulte 1971, nos. 248, 249). Pissarro's 1877 pastel portrait of her is reproduced in Reiley Burt 1975, 57. For Renoir's letters to Mademoiselle Marie see Gachet 1957, 105–106, 109. Renoir also designed curtains, carpets, and fabrics for the Murers (ibid., 94).

224 "Avec les cent que je possède je commence à me trouver assez riche d'impressionnistes" (Gachet 1957, 161). See Vollard 1919, 48, where Renoir claims that he sold eleven paintings to Murer as a job lot for 500 francs, including The Harem (1872, National Museum of Western Art, Tokyo), Alfred Sisley (cat. no. 26), and The Arbour (1876, Pushkin State Museum of Fine Art, Moscow).

225 Bailey and Rishel 1989, 34, 151–152.

226 "Le plus beau compliment que l'on puisse faire à un artiste, c'est de lui acheter ses tableaux" (Reiley Burt 1975, 92).

227 Curinier 1899–1905, II, 288, for Vollard's exhibition of Murer's Trilogie des mois – "vaste et délicieux poème de lumière" – a series of thirty-six paintings acquired by the marquis de Grandru.

228 "Renoir lui a mis les brosses à la main; Renoir a été à la fois et son inspiration et son émule. Et pendant dix ans, le maître et l'élève, deux maîtres, ont marché la main dans la main" (quoted in Pissarro Correspondance, IV, 133; this passage comes from the highly favourable review, probably written by Murer himself, in L'Art International of Murer's exhibition of 172 pastels and watercolours at the Galerie La Bodinière, 18 rue Saint-Lazare, held from 23 November to 13 December 1895).

229 "Un pâtissier qui est devenu peintre" (Vollard 1919, 50).

230 Duret 1922, 186, originally in Duret 1878, 9.

231 See House and Distel 1985, 22–23, and Distel 1989b, 162–169.

232 Blanche 1937, 37.

233 Ibid., 36–37.

234 Banville 1879.

235 Duret 1922, 98–99; Berard 1956, 239; Distel 1989a, 60. Berard was also a friend of Chocquet, whom he invited to Wargemont in September 1880. See Berard 1968 for Renoir's letter from Chatou: "Vous m'avez fendu le coeur en me disant que j'avais raté bien peu le père Choquet. J'étais rue de Rivoli quand il était à Wargemont." Roger-Milès (1905, 8) noted that Berard "était de la race des fervents de la beauté – tel M. Chocquet dont il fut

l'ami."

236 Mathews 1984, 199.

237 Manet 1979, 198.

238 For the full letter see Distel 1989b, 164.

239 Rosenblum 1988, 45.

240 "Éclairé comme une lanterne" (Blanche 1933, 292).

241 Blanche 1937, 37–38.

242 Berard 1938. That Renoir continued to produce decorations for Wargemont into the 1890s is borne out by his request for the measurements of an overdoor he was to paint: "Si vous ne le mettez pas sur la porte, vous le mettrez autre part, ne vous en inquiétez pas" (Autographes T. Bodin, June 1982, no. 199, Renoir to Berard, from Pont-Aven, October 1892).

243 Blanche 1937, 36.

244 Jullian 1962.

245 Gaulois 1895.

246 Daulte 1971, 410.

247 "Quant au quinze cents francs des Cahen, je me permettrai de vous dire que je la trouve raide. On n'est pas plus pingre. Décidément je lâche les Juifs" (Schneider 1945, 99, Renoir to Deudon, 19 February 1882). Ironically, this was Renoir's best paid commission to date.

248 For an example of "l'éternelle discussion sur l'affaire Dreyfus" see Renoir's comments in Manet 1979, 148–156 (15 January–17 March 1898). The following year saw a particularly unpleasant outburst against Duret, "un homme qu'on ne peut plus recevoir," for his support of the Bernheims, "horribles juifs" (Hôtel Drouot, Paris, Lettres autographes, 16 February 1979, no. 79, Renoir to Berard, undated, c. March 1899).

249 In his treatment of Jewish sitters, Renoir's "benevolent eye" makes no distinction in practice, despite comments that betray a more or less open anti-Semitism. Thus "israélite" Pissarro is given pride of place in The Artist's Studio, rue Saint-Georges (fig. 18), and Renoir finds the Bernheim fiancées "charming" when he paints their portraits in September 1901. Renoir's Jewish sitters, who include not only the Cahen d'Anvers, the Foulds, the Nunès, but also his sister-in-law Blanche Renoir, Madame Stora, and the Mendès daughters (who were Jewish on their father's side), cannot be distinguished typologically from his other patrons and friends.

250 Joseph Durand-Ruel informed Albert Barnes in February 1915 that Renoir had "always refused to part with it. I believe he wants to give it to the Louvre after his death" (Riopelle in Barnes 1993, 79). See also Geffroy 1900, 192: "Qu'on le sache bien, le Départ pour la promenade sera une date dans l'histoire de l'art de ce temps et ne devrait quitter l'atelier de Renoir

que pour entrer au Luxembourg." Geffroy's prophecy, made on 20 June 1896, proved ill-founded, and The Artist's Family was eventually acquired by Barnes in February 1927 for $50,000.

251 In what follows, it is clear that I take the opposite view from Christopher Riopelle in Barnes 1993, 79, where the painting is read as celebrating "Renoir's hard-won freedom, however illusory, from the weight of bourgeois convention." I am nonetheless indebted to Riopelle's entry on this picture, the most thorough to date.

252 Mallarmé 1876, reprinted in Moffett 1986, 29.

253 Wentworth 1984, 162; Harrison 1991, 146–147.

254 Blanche (1949, 246) recalled that Renoir was present at one of the sittings (which took place in the summer of 1895) and congratulated him on his "modèles épatants," advising him, "Surtout ne reprenez pas. Moi c'est ma manie, et je gâche tout, le lendemain."

255 Vollard (1919, 9) noted that upon first meeting Aline Renoir in 1895 he was reminded of "toute la rondeur et la bonhomie de certains pastels de Perronneau."

256 "Elle tenait à rester ce qu'elle était, une fille de vignerons sachant saigner un poulet, torcher un enfant et tailler la vigne" (Renoir 1981, 283).

257 "Portraits, qui est déjà désigné par tous comme un Départ pour la promenade" (Geffroy 1900, 189–190).

258 House and Distel 1985, 302, 304. "Je n'arriverai jamais à vous peindre mon étonnement devant cette personne si lourde que, je ne sais pourquoi, je rêvais toute semblable à la peinture de son mari" (Morisot Correspondance, 163).

259 "Nous faisons ce baptême sans cérémonies" (Godfroy 1995, 1, 97). In the light of Jean Renoir's baptismal record of 1 July 1895 (Archives de l'Archevêché, Paris), this letter should be dated towards the end of June 1895.

260 "Je vais faire brûler du souffre dans sa chambre. Jean est superbe jusqu'à présent mais j'ai toujours peur. À son âge une rougeole est insupportable" (Drouot Rive Gauche, Paris, 7 December 1979, no. 149, Renoir to Julie Manet, late February 1896, before the opening of the Morisot retrospective at Durand-Ruel's, 4 March 1896).

261 "Bien un des plus beaux groupements d'être humains qui aient été représentés par la peinture" (Geffroy 1900, 190). For an unexpected condemnation of this painting see Meier-Graefe 1929, 259–261, where it is considered "eins der verfehltesten Bilder des ganzen Werkes."

IMPRESSIONIST PORTRAITS AND THE CONSTRUCTION OF MODERN IDENTITY

Linda Nochlin

In Degas's portrait *Place de la Concorde*, subtitled *Vicomte Lepic and His Daughters* (fig. 60), the protagonist, Ludovic-Napoléon Lepic – aristocrat, artist, museum curator, and *père de famille* – strolls across the foreground of the painting. The vicomte's top hat is set at a jaunty angle; his cigar is thrust between his lips, his furled umbrella beneath his arm. Accompanied by his two well-dressed little daughters, Eylau and Janine, and his equally well-bred borzoi, Albreckt, he seems to dominate this urban space – the heart of elegant Paris – without even having to think about it. At the left margin of the picture, the fragmentary figure of a well-dressed gentleman with a walking stick, recently identified by Albert Kostenevich as Degas's friend Ludovic Halévy, turns to take in the group.[1]

For many who have considered this work, the vicomte Lepic represents the typical – of course, masculine – *flâneur*, at once a dominator and observer of the public space through which he so confidently strides. Anthea Callen, for example, in her recent study of Degas, *The Spectacular Body*, declares that "in a work like *Place de la Concorde* . . . it is the public role, the activity of the aristocrat as *flâneur* which is precisely what gives his persona meaning: his studied leisure (his leisure to study) is the sign of his social position and wealth."[2] This may be a plausible interpretation of the painting. But certainly, other, more complex and ambiguous readings of this extraordinarily contradictory portrait-image are possible, indeed are demanded by specific features of its pictorial structure.

As has often been remarked, there is no single unified direction of movement in the composition: the vicomte walks to the right, the daughters seem to be turning to the left, the dog moves parallel to the picture plane, and the "passerby" turns to the right. The movement of the painting is at once disjunctive and centrifugal: the figures move not only counter to each other, but also *away* from the centre to the very margins of the canvas. A large part of the image is given over to empty space – that subtly shimmering, circular spread of variegated beiges that represents the pavement.[3] Even those elements that seem to move together, like the horse and carriage in the rear left, are, as Kostenevich points out, actually moving in opposite directions, the horse to the right, the carriage out of the picture space to the left.[4] Connection, coherence, interrelationship, if they are present at all, are fortuitous rather than narrative or expressive, established by seemingly chance conjunctions of formal elements: the red in the woman's skirt in the rear "accidentally" pulling our eye to its echo in the red rosette of the Légion d'Honneur in the vicomte's buttonhole in the foreground; the multicoloured, openly painted cravat of the bystander merging indistinguishably with identical strokes indicating the passengers in the carriage; Lepic's top hat picking up the similar shape of the doorway to the Tuileries Gardens in the rear centre; the umbrella handle passing beneath and creating

an accidental connection with the daughter at the right; the rather snoutlike profile of the little girl slyly echoing the more elongated muzzle of the dog.

It is clear that *Place de la Concorde*, far from being a traditional portrait, is not simply a representation of the vicomte Lepic and his children, but also a portrait of members of a specific class, in a specific location in Paris, at a particular moment in history. Degas makes discreet reference to the recent loss of Alsace to the Germans after the Franco-Prussian War: the vaguely adumbrated statue of Strasbourg in the Tuileries is decked out with mourning banners.[5] The painting, then, hovers lightly on the border of genre, despite the lack of any narrative thread that would connect the characters to each other, as in traditional genre painting: it arouses expectations of conventional meaning which it then refuses to fulfil.

How are we meant to interpret this putative portrait? Is it relevant to note the achievements of the actual "subject," who was, among other things, a prolific and technically skilled printmaker and an exhibitor in the first and second Impressionist exhibitions? Does it help in understanding the portrait to be aware of the vicomte's interest, shared by his friend Degas, in the so-called "science" of physiognomy and in evolutionary theory, interests which Lepic had demonstrated in his almost contemporary work for the ethnographic Musée de Saint-Germain?[6] (Both physiognomy and the theory of evolution maintained that the analogies between animal and human expressions argued their common origin, thereby demoting mankind from its unique position in the great chain of being as possessor of a God-given soul.)

Is it possible to assert that the image *as an image* demonstrates unequivocally the confident domination of urban space by the privileged male *flâneur*, or are there not rather signs of psychological ambivalence, social stress, and alienation built into the very composition of the work? Is there not a sense of emptiness at the core of the painting, a lacuna at its structural heart, so typical of many of Degas's works (and often associated with scenes of antagonism between the sexes)?[7]

In relation to this centrifugal emptiness in *Place de la Concorde* and the concomitant sense of psychological uneasiness, even distress, that it creates, it is perhaps worth noting that at just this historical moment, sociologists and urban planners were identifying and naming the phenomenon of fear of urban open spaces: agoraphobia. In 1889, Camillo Sitte, the Viennese urbanist, in his *Art of Building Cities*, wrote specifically of a modern nervous illness which he termed *Platzangst* – literally, the "fear of the *place*," the fear of empty, open public squares.[8] Even earlier, in 1871, Carl Westphal, one of the founders of German psychiatry, had discussed the cases of three male patients complaining of a condition whose primary symptom was anxiety about walking across open spaces or through empty streets.[9] According to the urbanist

Fig. 60 Edgar Degas, *Place de la Concorde* (*Vicomte Lepic and His Daughters*), 1875. State Hermitage Museum, Saint Petersburg

Thomas McDonough, "agoraphobia was neither a condition of the poor nor of women – it was a predominantly male, bourgeois phenomenon, making it an even greater threat to urban stability."[10] By pointing out that the identification and definition of agoraphobia coincides very closely with the painting of this picture, I do not mean to suggest that Degas in any way meant this painting to be a demonstration of a particular psychological condition. I simply want to indicate that notions of the modern city as anomic, inimical to and undermining of masculine authority and confident subjecthood generally, should be seen historically to inflect and indeed call into question the evidences of triumphant "*flâneurisme*" as they are inscribed in Degas's painting of his friend. One might say that it is no coincidence that the phenomenon of agoraphobia and that of the *flâneur* occur under the same historical and social circumstances: the growth of the modern city, with all its multiple contradictions.

Finally, I should like to consider the rather ambiguous role of photography in Degas's portrait of the vicomte Lepic. It is undeniable that photography had a considerable impact on portraiture in the later nineteenth century, both in terms of actual influence and as a portrait medium in its own right. Degas himself exhibited considerable interest in photography and made more than a

few photographic portraits later in his career. Indeed, one can already feel the photographic impulse in the blurred contours and rather self-consciously stiff "held" poses of another of Degas's representations of the Lepic family, the more conventional portrait *Ludovic Lepic and His Daughters* (c. 1871, Bührle Collection, Zurich). Furthermore, as Kostenevich has astutely pointed out, photographs like the one of Lepic's dog probably played a role in the construction of this image of the vicomte in the place de la Concorde.[11] But the usual tendency to accept photography as an "influence" on the older art of painting should be avoided in this particular instance. In 1875, photography would have been incapable of encapsulating the bold movement, wide angle, and "stop action" effect inscribed in *Place de la Concorde*.[12] What is more interesting here is that it also had a liberating effect on artists in a negative sense: the studio portrait photograph, especially the popular *carte de visite*, could substitute for more conventional, static means of registering a unique human image, leaving the field wide open for freewheeling variations of the portrait mode on the part of innovative artists such as Degas and his friends.

In a way, photography *forced* a certain innovativeness on ambitious artists. Today we cannot easily envision a world without the mass production and consumption of images – specifically, images

of ourselves, our families, and our friends in the form of the snap-shot, the wedding picture, or the class photograph – any more than we can envision a world without the mass production of clothing or other consumer products. The easy availability of images is so much a part of our experience that we cannot even imagine a situation in which a portrait might be a once-in-a-life-time experience rather than an ongoing, multiple record of personal appearance and situation. The Impressionists lived in and reacted to a world in which the richness of individual and communal memory itself was being replaced by a plethora of cheap visual imagery.

Degas's *Place de la Concorde* is a remarkable portrait, offering itself to a wide variety of interpretive strategies – but is it a portrait at all? It is certainly different from the conventional single portrait, and it is hardly a family portrait in the usual sense of the term. Although the principal subject of the painting was indeed a friend of Degas's who must have been willing to participate in the portrait's creation, it is not a commissioned portrait, a work in which, as Harry Berger has described it, both sitter and painter arrive at a joint decision about the image to be produced.[13] *Place de la Concorde* reminds us that Impressionist portraits should not on the whole be considered as portraits in the traditional sense, but rather should be seen as part of a broader attempt to reconfigure human identity by means of representational innovation, at times working within, at times transforming, and at times subverting this time-honoured and seemingly unproblematic, indeed self-explanatory, pictorial genre.[14] Over and over again, in examining the range of Impressionist portraiture, I have found myself forced to ask whether or not a certain image *is* in fact a portrait and, at the same time, to question the definition of the portrait genre itself.[15] Is Degas's *At the Races in the Countryside* (fig. 82), for instance, a family portrait or a racing scene – or both? Is Manet's *Masked Ball at the Opéra* (fig. 74) a lively view of contemporary night-life in Paris or a group portrait of Manet's friends, posed for in his studio – or is it something lying ambiguously between the two possibilities?[16] Is Degas's so-called *Sulking* (1869–71, Metropolitan Museum of Art, New York) to be considered a genre-scene posed for by his favourite model of the time, Emma Dobigny (who also posed for a meditative portrait), and his friend the critic Edmond Duranty (also an outright portrait subject on another occasion), or to be judged as a recognizable portrait of these subjects: in other words, are they "sitters" (portrait subjects whose identities are maintained or reinforced) or are they "models" (figures hired by the artist to pose for him, usually with their actual identities erased or transformed)?

<p style="text-align:center">★ ★ ★</p>

For the Impressionist portraitist of the 1860s and 1870s, the question was not merely that of liberating portraiture from restrictions of categorization, but also of overturning the conventions of the portrait pose. The strictures governing the portrait pose have, historically, always been connected to the matter of decorum.[17] In other words, the portrait subject's pose has always been a moral as well as a formal issue, central to the establishing of the social and personal identity of the sitter. And in portrait tradition, this identity has generally been conceived of as a dignified one, morally and posturally upright. When the posture changes – when the young Renoir chooses to be portrayed with his feet propped up

Fig. 61 Édouard Manet, *Lady with Fans* (*Nina de Callias*), 1873–74. Musée d'Orsay, Paris

on a chair and his head turned to one side as though thinking of something quite different than posing for his friend Frédéric Bazille (frontispiece); when Monet permits this same artist to represent him lying helplessly in bed beneath a device to drip water on his injured leg (*The Improvised Field Hospital*, 1865, Musée d'Orsay, Paris); when Monet poses for Renoir in a broadly painted close-up view, his beard shaggy, his hat on his head, his pipe clenched in his mouth as he concentrates on the ruffled pages of his newspaper (fig. 137); or when Nina de Callias, a woman prominent in Parisian intellectual and artistic circles, collaborates with Manet in constructing an image of herself sprawled out on a couch against a background of Japanese fans, looking quizzically out at the viewer instead of sitting properly erect and gazing blandly into empty space (fig. 61) – then certain moral as well as formal expectations are violated. The casually posed Renoir and his portraitist are announcing their membership in an artistic, youthful, and renegade fraternity in which good posture is no longer a requirement. Violation of the rules of portrait posture suggests insubordination on other fronts as well. Even such an apparently innocuous out-of-doors portrait as Degas's of Eugène Manet stretched out on the ground in an undefined landscape setting (1874, private collection)[18] suggests a startling departure from previous portrait decorum controlling the representation of the haute bourgeoisie, as well as a sense of detachment or even of alienation from a justifying context. In a very different way, Degas's portrayal of his friend Henri Rouart stiffly pinned before the facade of his factory (c. 1875, Carnegie Museum of Art, Pittsburgh) might be said to overemphasize the traditional category of the *portrait d'apparat* by making the factory seem to possess or at least dominate its owner.

<p style="text-align:center">★ ★ ★</p>

One possible way to begin examining the young Impressionists' innovative ideas in the realm of portraiture is through the theme of the artist's studio. The topos of the artist at work in his studio, either alone or with friends, fellow artists, and supporters, has traditionally been used as a statement of purpose and achievement by

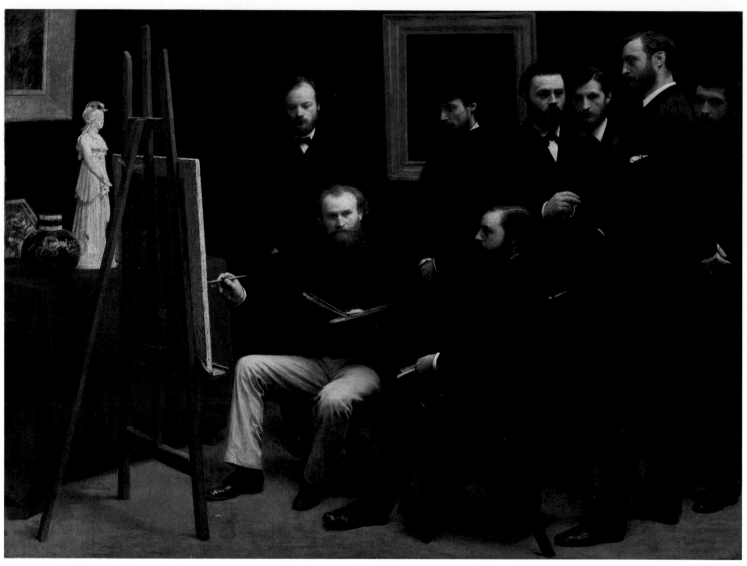

Fig. 62 Henri Fantin-Latour, *A Studio in the Batignolles*, 1870. Musée d'Orsay, Paris

ambitious artists. Within the nineteenth century, a whole range of possibilities was offered, from the relative formality of Boilly's artistic group portrait, *A Reunion of Artists in Isabey's Studio* (Salon of 1798, Musée du Louvre, Paris), to the outright provocation and meaningful antitheses of Courbet's *Painter's Studio* (1855, Musée d'Orsay, Paris), subtitled a "real allegory," to the programmatic naturalism of Fantin-Latour's *Studio in the Batignolles* (fig. 62), in which Scholderer, Renoir, Astruc, Zola, Maître, Bazille, and Monet are rather self-consciously gathered around Manet, who is busy at his easel, apparently working on a portrait of Astruc.[19]

With its deliberate informality and apparent lack of programmatic intention, Frédéric Bazille's group portrait of artists in their habitat, *The Studio in the rue La Condamine* (fig. 63), marks a new departure. The casually posed inhabitants of Bazille's studio are saying something about the condition of innovative art and artists that is quite different from the implications of Boilly's more artificed and elegant arrangement of his cast of characters. None of the young artists present is made to seem aware of the fact that he is being portrayed – no one is posing, and all seems haphazard, as

though the viewer has just happened on a group of artists (not all of them securely identified) visiting their friend and colleague. The group includes the tall Bazille at his easel, painted in by Manet (an act emblematic of the cooperative relation among the artists); to Bazille's left, Manet himself, gesturing; either Monet or Astruc to Manet's left; Zola or Monet on the stairs, with Sisley or Renoir looking up from below; and Edmond Maître playing the piano. On closer consideration, this composition is, of course, seen to be as predetermined as any other studio group. And, like Courbet's *Painter's Studio*, Bazille's painting (no matter how different it may be in other ways) is conveying a message, in visual terms, about the values espoused by the artists in it – aesthetic values as well as moral and social ones. The topos of the artist's studio always implies a subtext that says, in effect: "We are the chosen; the way this is painted is the way painting ought to be; the way we are gathered has special meaning in terms of the social relationships among artists and in terms of how the artist relates to his public." In this respect, one might note that Bazille's world of creation is still markedly male. The only women present in his

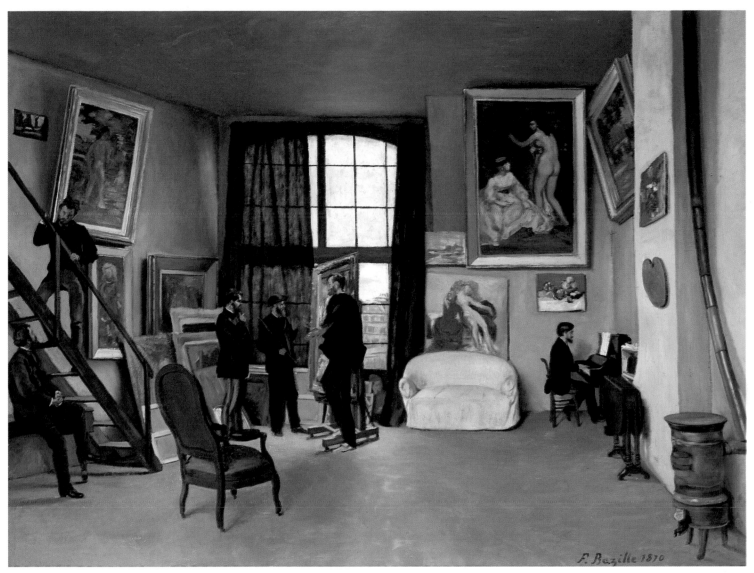

Fig. 63 Frédéric Bazille, *The Studio in the rue La Condamine*, 1870. Musée d'Orsay, Paris

Studio are nudes on the wall, his *Bathers* and *Toilette*, countered by his more unusual male nude, *Fisherman with a Net*, at the left.

It is striking that genius is not singled out, as it so markedly is in Courbet's image, but instead is more randomly distributed within a context of group activity, a self-selected fraternity of innovators. The making of art is represented as perhaps an everyday affair, but nonetheless an understatedly distinguished one: the young artists unselfconsciously paint, play the piano, chat. This informality is continued in the series of *plein-air* portraits Manet and the Impressionists made of each other in the decade of the '70s: Renoir's informal, loosely brushed representation of Monet painting in his garden at Argenteuil (cat. no. 14); Manet's colourfully sketchy canvas of Monet, in summery white, painting in his floating studio at Argenteuil, while Camille looks on from the protection of the awning (1874, Bayerische Staatsgemälde Sammlungen, Munich); and the same artist's picture of Monet working in his garden, rather than at his easel, accompanied by Camille and their son, the family relationship and the bucolic set-

ting wittily underscored by the rooster, mother hen, and chick in the foreground (fig. 144).

<p style="text-align:center">★ ★ ★</p>

Much has been made of how differently male and female sitters are represented in Impressionist portraiture, and no doubt such differences exist. The Impressionist painters, both male and female, could no more escape entirely the dominant ideology of their time governing the behaviour and appearance of men and women than could any of their contemporaries.[20] Far more interesting, I believe, are the ways in which Impressionist portraiture at times challenged gender-based stereotypes, consciously or unconsciously, and at other times emphasized differences *among* male sitters and *among* female sitters as opposed to the more conventional differences *between* males and females. For example, the subtle challenge of representing the act of listening to music might seem to call for a sitter whose gender matched the implicit pas-

Fig. 64 Edgar Degas, *Madame Camus in Red*, 1870. National Gallery of Art, Washington

sivity and receptivity of the act itself: that is, a woman. Yet Degas, who on several occasions depicted a sitter listening to music, by no means restricted this type of scene to female subjects. If, in *Madame Camus in Red* (fig. 64), the sitter is shown as though absorbed in listening, a relatively passive condition, she is nevertheless alert and attentive. (It is relevant to note that in *Madame Camus at the Piano* [1869, Bührle Collection, Zurich], Degas had also represented this talented musician seated at her instrument as though preparing to perform music as an active participant as well as merely reacting to it.) *Madame Camus in Red* suggests the sensuously enveloping mood of the deep musical experience through a kind of synaesthesia – the heavy, misty, orange atmosphere of the image; the relative emptiness of the background space, suggesting sound rather than substance; and the repetition of rhythmic, curvilinear forms in the background hanging, the figure, the fan, and the sinuous contour of the statuette reiterated by its shadow on the wall. This atmosphere of sensual exoticism

is heightened by the blackamoor figure, which contrasts with the sitter, projecting a potent touch of masculinity within the soft glow of the *contre-jour*.

Degas also represented male sitters in a similar condition of attentive receptivity. More than once, he portrayed his father listening to the singer Pagans, in images which suggest that difference *within* gender categories can at times be as telling in portrait construction as difference *between* these categories. In *Lorenzo Pagans and Auguste De Gas* (fig. 67) it is the contrast between masculine youth and masculine age, and between active playing and passive listening, that is at stake.[21] The vital young performer dominates the foreground of the picture with his singing and strumming; the vigorous diagonal of his guitar passes in front of and more or less holds in place the subordinate, frailer figure of the aged Degas *père*, whose bowed head is enframed by the glowing white rectangular halo of the open sheet music behind it. One might also consider the implications of Degas's double portrait of

Fig. 66 Edgar Degas, *Édouard Manet and His Wife*, 1865. Kitakyushu Municipal Museum of Art, Japan

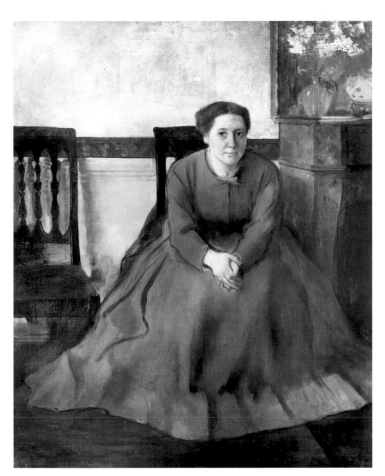

Fig. 65 Edgar Degas, *Victoria Dubourg*, c. 1868–69. Toledo Museum of Art, Bequest of William E. Levis

Fig. 67 Edgar Degas, *Lorenzo Pagans and Auguste De Gas*, c. 1869. Musée d'Orsay, Paris

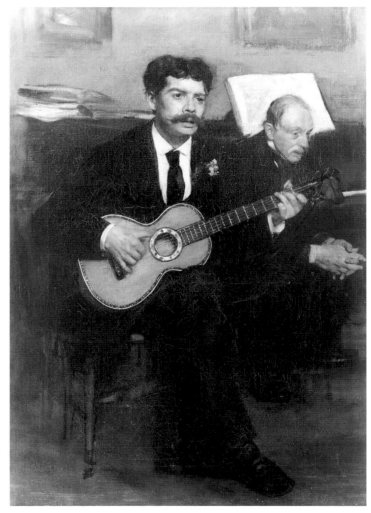

Manet listening to his wife Suzanne at the piano (fig. 66) – a painting unfortunately mutilated by Manet, who felt that Degas had distorted his wife's features. Here, it is the famous artist who is depicted passively listening, in an unflatteringly unselfconscious pose. There is no sign of his importance as the leader of the avant-garde painters of his time or of his reputation for understated dandyish elegance. On the contrary, Manet is depicted in a moment of total absorption – sprawled out in an inelegant pose that emphasizes his *embonpoint*, with his head in his hand and his foot drawn up beneath his stocky body.

Nor did Degas by any means subsume all of his woman sitters within a single category of femininity. In *Victoria Dubourg* (fig. 65), the female artist leans forward assertively towards the spectator from the centre of the canvas; her glance is actively alert and intelligent, and her competent hands are a major focus of the composition. This pose must surely be contrasted with the meditative stillness and marginal position of the putative figure of Madame Paul Valpinçon in *Woman Leaning near a Vase of Flowers* (1865,

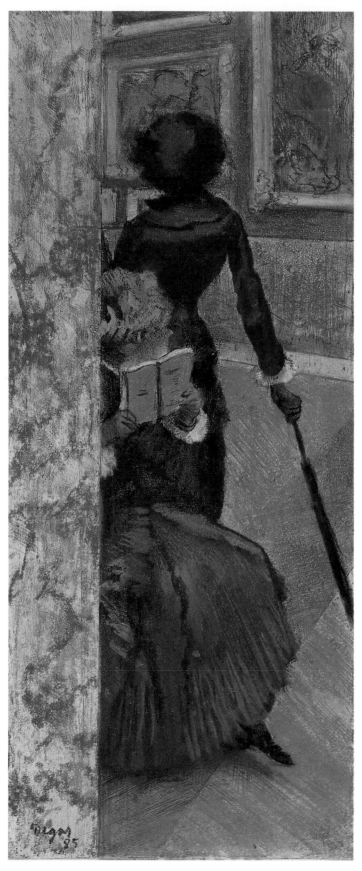

Fig. 68 Edgar Degas, *Mary Cassatt at the Louvre*, 1885, etching, aquatint, drypoint, and crayon électrique, heightened with pastel. The Art Institute of Chicago, Gift of Kate L. Brewster Estate

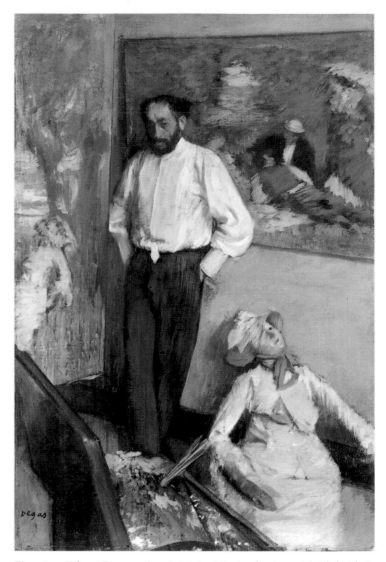

Fig. 69 Edgar Degas, *An Artist in His Studio* (*Henri-Michel Lévy*), c. 1878. Calouste Gulbenkian Foundation, Lisbon

Metropolitan Museum of Art, New York). True to the doctrines of Edmond Duranty, who maintained that "a back should reveal temperament, age, and social position," Degas makes us aware of the judging attentiveness of his artist friend Mary Cassatt by the juts and angles of her back-view pose in the various versions of *Mary Cassatt at the Louvre* (fig. 68) – a pose quite different from that of her sister Lydia in the same images, seated and rather vapidly absorbed in the catalogue.[22]

What is conspicuously missing from the portrait repertory of the Impressionists, male and female, is the woman artist *as* artist, shown in the act of painting, or at least within the studio context. Although Manet represented Berthe Morisot again and again, it is never in her role as a painter. If Degas hints at Dubourg's or Cassatt's professional occupation in his painted or graphic representations of them, he merely hints: he does not make their working lives explicit, as in his portraits of James Tissot (1867–68, Metropolitan Museum of Art, New York) and Henri Michel-Lévy (fig. 69), both represented in their studios and surrounded

by evidences of their work.[23] Renoir, in one of his most beautiful early portraits, *Frédéric Bazille Painting "The Heron"* (cat. no. 5), conceived in tones of grey, beige, and brown, yet somehow richly colourful, represents his artist-friend hard at work painting a dead heron, his palette tensely raised in his left hand, his brush deftly probing the canvas in his right, with a snow-scene by Monet on the wall behind him, making this a token of artistic friendship as well as the portrait of a working artist. Perhaps the sole exception is Manet's extremely artificed *Eva Gonzalès* (National Gallery, London), an image of his only official pupil in the guise of a Goya prototype, dressed in snowy white and holding a maulstick. Although Morisot and Cassatt both created self-portraits, they never revealed their identity as painters within their self-representations, settling instead for more conventional appearances.

Of course, the mere fact of representing the artist in his studio does not necessarily convey the idea of triumphant creative activity, nor are male artists inevitably represented in situations of casual optimism. Take, for example, Degas's portrait of Henri Michel-Lévy mentioned above. Here the artist is represented neither at work, nor confidently leaning out toward the viewer, as in Degas's earlier portrait of his friend James Tissot. Indeed, the nearest analogue for this gloomily introspective sitter – his head cast down, his hands thrust into his pockets – is Delacroix's pensive *Michelangelo in His Studio* (1850, Musée Fabre, Montpellier), where the Renaissance giant, in a melancholy attitude perhaps traceable to Dürer's famous *Melancolia I* (1514), is represented as overwhelmed by the grandeur of his own creation. Like Delacroix's Michelangelo, Degas's Michel-Lévy seems discouraged by the (admittedly less ambitious) evidences of his own *plein-air* painting, exhibited behind his drooping figure on the studio walls. The unused paint box and the crusted palette and brushes in the foreground, as well as the somewhat parodic touch of the floppy female lay-figure decked out in contemporary finery and propped up on the floor, add to the sense of futility and discouragement projected by this image of the artist in his studio.

★ ★ ★

The Impressionist group was unusual in that it included within its ranks two prominent women artists, Berthe Morisot and Mary Cassatt. Both of these women were faithful exhibitors in the group exhibitions, Morisot showing seven times with them and Cassatt four. Both were active as portrait painters within the Impressionist circle and tended to favour sitters of their own sex. Cassatt in particular created a wide variety of female portrait types, ranging from the classical formality of Mrs. Riddle to the more down-to-earth intimacy of the portrait of her mother reading. Here again, this time in the work of a woman artist, difference is established within gendered categories rather than between them. For Cassatt, gender itself was not the determining factor in portrait structure and expression, despite the restrictions placed on women artists and on the representations of women sitters during the period.[24] While it is true that portraying a female subject might set limits on what could or could not be depicted in the portrait image, it did not determine just how the portrait might be constituted. Two of Cassatt's portraits are especially revealing in this respect.

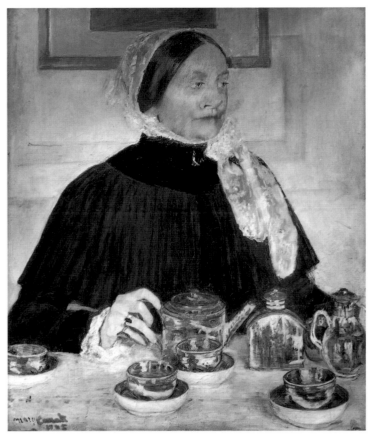

Fig. 70 Mary Cassatt, *Lady at the Tea Table*, 1883–85. The Metropolitan Museum of Art, New York, Gift of Mary Cassatt, 1923

Lady at the Tea Table (fig. 70) is one of the most remarkable American portraits of the nineteenth century. A subtle combination of strength and fragility, the painting represents Mrs. Mary Dickinson Riddle, Cassatt's first cousin once removed. The sitter, who had a certain reputation as a great beauty, rejected the work, apparently because she and her daughters felt that it was not flattering enough. And indeed, it is not a flattering portrait, in the sense that one of John Singer Sargent's commissioned portraits of upper-class female sitters may be said to be flattering. The pose is rigid, the costume and decor severe. The telltale signs of age, especially around the mouth and chin, are noted, if not exaggerated. The wonderfully quirky nose – with its sharp tip slightly enhanced by a dab of white highlight, and the horizontal flare of the nostril – is anything but classic in its idiosyncratic structure. What Mrs. Riddle has is *character*, something as different from the slightly vapid elegance of Sargent's sitters as it is from the explosive primitivism of Van Gogh's almost contemporary portrait of Augustine Roulin, *La Berceuse* (1889).

Cassatt paid attention to the lives of a restricted and privileged circle of women who could afford to spend their days enjoying genteel accomplishments, mutual entertainment, and mild leisure activities – women who did not have to work, and who, on the whole, were engaged in the arts merely on an amateur level. Cassatt herself was divided about women's role: she herself aspired unswervingly toward professionalism and the serious work it entailed; but she nevertheless honoured the feminine sphere of

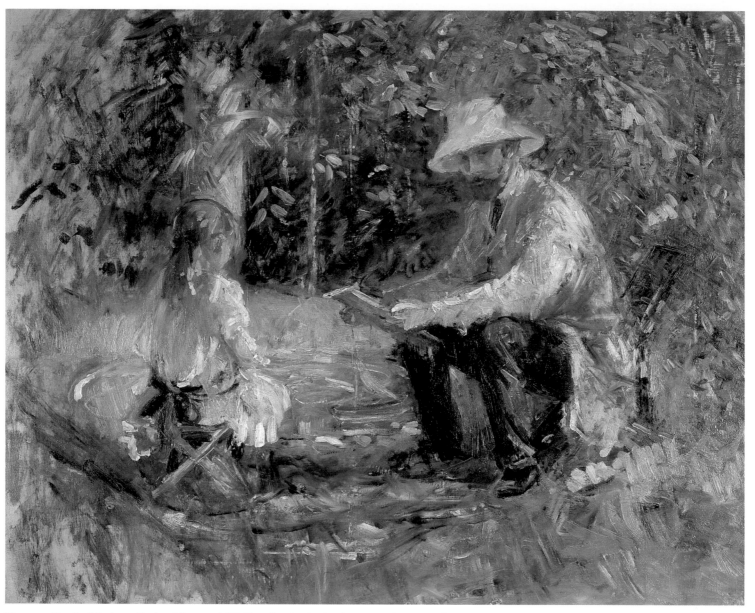

Fig. 71 Berthe Morisot, *Eugène Manet and His Daughter in the Garden*, 1883. Private collection, Paris

activity, the world of family, friends, and decorous sociability. The subject of afternoon tea seems to have attracted her more than once. Perhaps it epitomized for her that other kind of work – or, more accurately, art – that leisure-class women engaged in while running fairly complicated, large-scale households: the art of organizing domestic ceremonies. In *Lady at the Tea Table*, tea is represented as a sort of ritual occasion. One can imagine that Cassatt saw her sitter's vocation – setting the table, arranging her decor, dressing in style, running her household with a sure grasp and keen aesthetic sense, building a seemly and even exquisite atmosphere – as analogous to her own task of painting a portrait.

Like Poussin's great *Self-portrait* of 1650 in the Louvre, which Cassatt surely knew, this portrait is a painting about art and the making of art. Like Poussin, she sets off her sitter's head in a series of enframements that at once rivet it in place and at the same time call attention to the relation between the rectangles within the

picture – one of which is, itself, a framed picture – and the rectangular shape of the canvas support. A similar use of the frame to provide compositional stability and self-reference is to be found in Degas's *Bellelli Family* (fig. 81), where Laura Bellelli offers a striking analogue to the figure of Mrs. Riddle in both her dignified pose and her dark pyramidal shape. (Degas used the painting-within-a-painting motif again, with quite different implications, in his portrait of Tissot.)

Oddly enough, it is a painter whom Cassatt seems not to have admired strongly whose work offers the best analogy for her sense of the frame within the frame in her work. Cézanne, in his 1877 portrait of Victor Chocquet (Columbus Museum of Art), locks the figure in place with exactly the same tight-knit planar grid that Cassatt constructs for her portrait of Mrs. Riddle, although he emphasizes it more through constant reiteration. Cassatt, on the contrary, softens any impression of pictorial geometry through

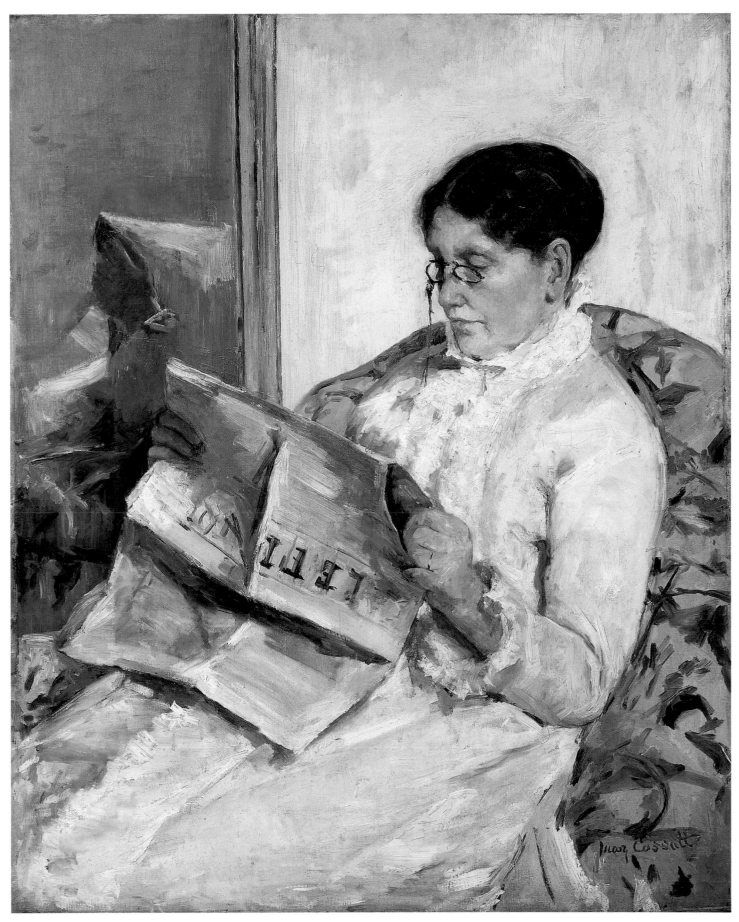

Fig. 72 Mary Cassatt, *Mrs. Cassatt Reading "Le Figaro,"* 1883. Private collection, Washington

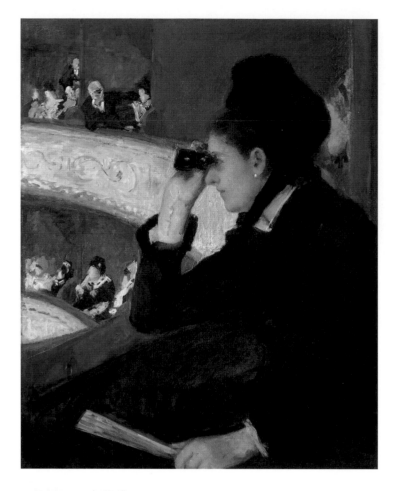

Fig. 73 Mary Cassatt, *Woman in Black at the Opera*, c. 1879. Museum of Fine Arts, Boston, The Hayden Collection

blankly into space, in disembodied profile, an object within a world of objects, but rather in solid three-quarter view, and reading with great concentration. Nor is it some fluffy novel she has in her hands, but the rather serious "Le Figaro," its title prominent if upside down in the foreground.

In her classic text "Motherhood according to Bellini," the French theorist Julia Kristeva meditates on the Virgin's body, its ineffability, the way it ultimately dissolves into pure radiance.[26] Elsewhere, she and other French psychoanalytically oriented feminists stress the maternal body as the site of the pre-rational, the incoherent, and the inchoate. Cassatt's portrait inscribes a very different position vis-à-vis the maternal figure: this is a portrait-homage not to the maternal body, but to the maternal mind. One might say that finally we have a loving but dispassionate representation of the mother not as nurturer but rather as *logos*. It matters little whether the real Mrs. Cassatt was an intellectual or not (for all we know, she may have been absorbed in the racing news); it is the power of the representation that counts. Instead of the dazzling, disintegrative, ineffable colourism with which Kristeva inscribes the maternal body according to Bellini, Cassatt reduces the palette of the maternal image to sober black and white, or its intermediary, grey – the colours of the printed word itself.

Mrs. Cassatt's black-framed pince-nez – the instrument of visual power – is prominent, reiterating the black of the printed page below and the hair above. The eye, of course, is the sense organ most closely associated with mental activity, which in the nineteenth century was often regarded as a form of masculine power. Cassatt had similarly associated femininity and the active gaze several years earlier, in her *Woman in Black at the Opera* (fig. 73). There her young woman, armed with opera glasses, is all activity, almost aggressive-looking. She holds the glasses – prototypical instruments of masculine specular power – firmly to her eyes, and her tense silhouette suggests the concentrated energy of her assertive visual thrust into space.

★ ★ ★

Both Manet and Degas created scenes of contemporary life that are not explicitly portraits but which base their appeal on the portrait's specificity. Friends and acquaintances posed for the artists and remain recognizable in these "hidden portraits." Perhaps it is stretching the term to call Manet's *Déjeuner sur l'herbe* (1863, Musée d'Orsay, Paris) a portrait of his brothers and Victorine Meurent without her clothes, or to call *The Balcony* (fig. 79) a portrait of the painter Berthe Morisot, the violinist Fanny Claus, and the landscape artist Antoine Guillemet; nevertheless, these great works are enriched in specificity and contemporaneity by the presence of identifiable friends as models. Certainly, the title of Manet's painting of Victorine Meurent as a bullfighter, exhibited at the Salon des Refusés of 1863, makes explicit both the portrait aspect of the image and the element of patent masquerade, which, in addition, involves a piquant and even scandalous gender

strategies of texture and colour, playing the blue and white drip patterns of the Chinese Export tea set, so strikingly deployed in the foreground, against the differentiated swirls and textures – also blue and white – of the delicate, transparent lace coiffe of the sitter. The glitter of the porcelain is picked up, in a different modality, by the subdued glow and colouristic striation of light playing on the sitter's face. Indeed, the painting could, with perfect justice, in a Whistlerian vein, be thought of as a "Symphony in Blue and White."

Women painters are often associated with the theme of motherhood. Both of the prominent women Impressionists, Cassatt and Morisot, produced highly successful images of mothers with their children: Cassatt's *Emmie and Her Child* (1889, Wichita Art Museum), for example, or Morisot's *The Cradle* (1872, Musée d'Orsay, Paris). But within this more or less conventional realm of parent-child representation, both women produced portraits that were anything but conventional. Among Morisot's paintings is a portrait of her husband, Eugène Manet, playing with their daughter Julie in the garden (fig. 71), and an unforgettable image of Julie being fed at the breast by her "second mother," the wet-nurse (1879, private collection).[25] Equally innovative is Cassatt's depiction of her own mother *without* child, in *Mrs. Cassatt Reading "Le Figaro"* (fig. 72). Like Whistler's famous painting of his mother, with which it shares a certain formal emphasis, Cassatt's portrait too could be called "A Symphony in White," playing as it does on a subtle scale of whites tinged with grey. However, Cassatt's mother, unlike Whistler's, is represented not staring

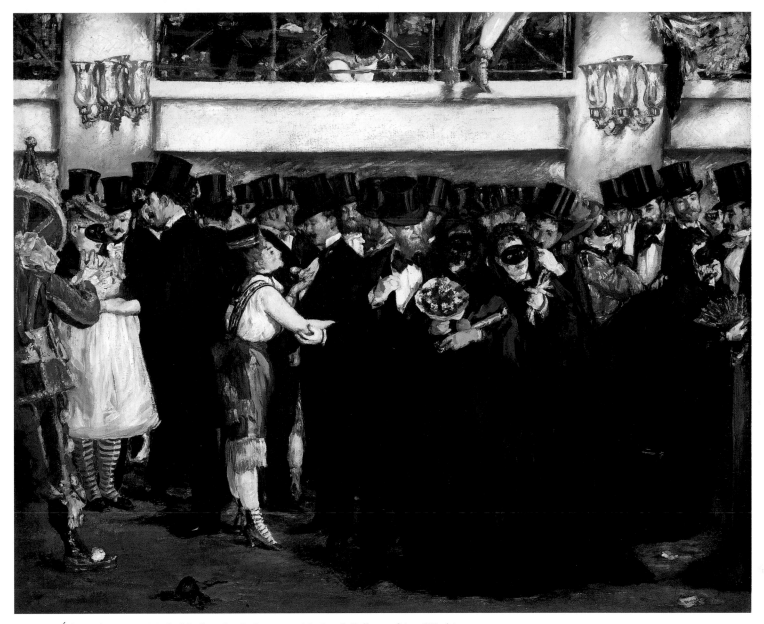

Fig. 74 Édouard Manet, *Masked Ball at the Opéra*, 1874. National Gallery of Art, Washington

switch. Manet understood that providing the accent of truth in works like *Masked Ball at the Opéra* (fig. 74) and eliciting the viewer's sense of identification with a scene could not be obtained through the use of professional models but only by portraying unique individuals of the proper class. His biographer Théodore Duret assures us that the friends and acquaintances of Manet who served as his models (Duret himself among them) were all "men of the world" and that the artist insisted they keep their habitual postures and expressions. "The men," Duret writes, "have their hats placed on their heads in the most varied ways possible. This was not the result of an imaginative arrangement but actually the way all these men really wore their hats. Manet asked them, 'How do you put on your hat when you're not thinking about it? All right – when you pose, put it on that way, without premeditation.'" So anxious was Manet to capture real life, Duret con-

tinues, that he used a different model for each of the supernumeraries in the back row of *Masked Ball at the Opéra*, even though only a part of a head or a shoulder might be visible.[27] As a result, we are unable to identify more than a few of the many figures in the painting, some of whom are represented by nothing more than an ear or a top hat. But the image as a whole throbs with a sense of individual vitality: it evokes the odd feeling one has when encountering a familiar face and not quite being able to remember the person's name.

Degas deploys the same strategy in his modern genre paintings, posing friends and acquaintances rather than paid models, although we are not necessarily supposed to be aware of their identities. In *In a Café* (fig. 75), the actress Ellen Andrée and Degas's friend the artist Marcellin Desboutin – the latter also posed for Manet's *The Artist* (fig. 78) around the same time –

Fig. 75 Edgar Degas, *In a Café* (*The Absinthe Drinker*), 1875–76. Musée d'Orsay, Paris

enact the roles of two louche characters in the setting of the Café de la Nouvelle-Athènes. Perhaps "acting" is a more appropriate term to use than "posing," especially for the poignant female figure whose heavy-lidded eyes, down-sloping shoulders, and splayed feet clearly show the effects of her condition. Even the application of the paint for the figures is loose and thin, and the looming shadows on the wall behind add to the vaguely sinister mood of the composition, into which we are led by a series of sharp diagonals. Perhaps the fact that the actors are recognizable gave this scene of the "lower depths" a certain added frisson, an aura of make-believe depravity more unsettling than the real thing.

Very different in mood and in its deployment of friends as models in a scene of contemporary life is Renoir's *Luncheon of the Boating Party* (fig. 16). Unlike Manet's sardonic *Masked Ball at the Opéra* or Degas's overtly shady *In a Café*, Renoir's painting is a multifigured celebration of the pleasures of modern existence. "An image of unalloyed happiness," as John Russell dubbed it in a recent review of the painting, it is indeed "blessed with a vast and contagious conviviality," portraying "a completely harmonious world: pain and self-doubt play no part in it, nor do cruelty and rejection . . . What Renoir had in mind was a charismatic tumble of images and impressions that would fall into place as a classless Who's Who of people known to him."[28] The same Ellen Andrée, the actress and model who had figured

as the melancholy café denizen in Degas's painting, is smartly dressed, alert, and adorably flirtatious in Renoir's painting. The cast of characters includes Aline Charigot, Renoir's future wife, making eyes at the lap-dog seated on the table to the left; the wealthy and gifted painter Gustave Caillebotte, bare-armed, straw-hatted, and full of masculine sex-appeal, in the right foreground; and Alphonse Fournaise, Jr., son of the restaurant owner, equally appealing, leaning back on the railing to the left, dressed in the same casual bare-armed rower's outfit (so flattering to the well-turned male bicep!) worn by Caillebotte. The pleasures of food, wine, flirtation, conversation, and the out-of-doors are enhanced by those of friendship in this image, although its primary identification has never been that of the group portrait *per se*.

⋆ ⋆ ⋆

One of the time-honoured goals of traditional portraits – especially those of the Protestant North and, above all, the Dutch painters of the seventeenth century and their followers – has been to capture not merely the external appearance of the sitter but his or her so-called "inner life" as well. Rembrandt, in his portrait of Jan Six, for example, is said to have captured far more than Six's mere likeness. "Thus Rembrandt observed him and thus revealed his innermost being," declares one authority.[29] In the nineteenth century, Eakins's sitters, mainly the female ones, inherit this task of expressing inner feeling. Of course, what the critics and we are really talking about, when we speak of capturing the soul of the sitter as opposed to a mere surface recording, are the pictorial signs of spirituality. These signs are produced by certain effects of the brush on canvas. The painter creates these signs – nuanced shadow, thin veiling glazes, or compositional elements like asymmetrical features or a tilted head – and the viewer accepts them as the pictorial code for signalling the presence of inwardness.

A vanguard painter of the mid-nineteenth century like Manet rejected this concept of interiority in his portraiture, constructing modern identities solely on the basis of form on surface. Notions of "depth" and "profundity" were foreign to his way of thinking. Often, his references to models from the art of the past or from exotic cultures served to reveal that his portraits, like the rest of his production, had more to do with the artifices proper to art than to the supposed revelation of truth about the nature of inner life – whether the sitter's or the portraitist's. His famous portrait of Zola (fig. 76), for example, depicts his friend and supporter as an object among objects, a surface amid elegantly deployed surfaces. This is a thoroughly aesthetic painting rather than an investigation of the sitter's inner being or character. Indeed, the very objects that may be said to characterize the traditional *portrait d'apparat* – in this case, the Japanese screen at the left, the Japanese print of a sumo wrestler, the engraving after Velázquez's *Los Borrachos*, the photographic reproduction of Manet's *Olympia*, and the casually displayed books (which include prominently

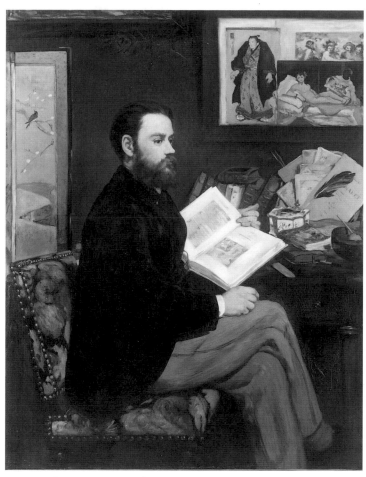

Fig. 76 Édouard Manet, *Émile Zola*, 1868. Musée d'Orsay, Paris

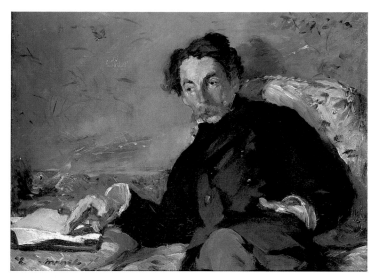

Fig. 77 Édouard Manet, *Stéphane Mallarmé*, 1876. Musée d'Orsay, Paris

Fig. 78 Édouard Manet, *The Artist* (*Marcellin Desboutin*), 1875. Museu de Arte de São Paulo Assis Chateaubriand

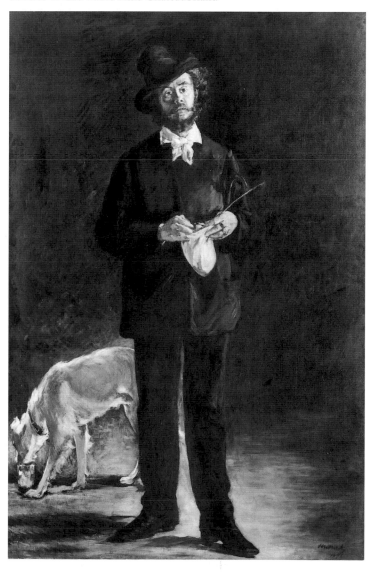

among them Zola's recently published defense of Manet and Charles Blanc's illustrated *Histoire des peintres*) – have more to do with Manet and his new artistic enterprise than with Zola, although the artist honourably swivels Olympia's eyes towards her literary defender and crowns him with the peacock feather of fame.[30] Manet's later portrait of his friend the poet and critic Stéphane Mallarmé (fig. 77) conveys an even greater sense of surface lightness, of defiant painterly brio, poetic gesture caught on the wing; here, one might say that surface play creates its own profundity, if this were not too paradoxical a formulation. The writer Georges Bataille, discussing this painting with fervour, speaks of its "buoyancy of flight, the subtlety that alike dissects form and phrase," and declares it "the most complete image of the child's play that ultimately is man, once he achieves weightlessness."[31] One is made aware, in this relatively object-free image, of the evanescence of experience, by the asymmetrically tilted pose, the deftly adumbrated wisp of cigar-smoke at the left, and the deliberately elliptical deployment of wide, almost crudely self-revelatory swatches of paint (the forefinger protruding from a summary cuff in the foreground, the upcurled thumb to the right, the silken sheen of a moustache, the scattered patterning on a Japanese screen in the background). Once more, though very differently than in the Zola portrait, surface is everything; depth, weight, profundity in the conventional sense, are absent from modern creation. Manet's portraits of his biographers Antonin

Proust and Theodore Duret reject any pretence of character-probing in favour of an imagery of pure appearance; at most, we are presented with the definition of a type – the modern dandy in all his understated glory. In both instances, this modernity is projected against a screen of traditional art: the austere portrait motifs of Goya and Velázquez that had so impressed the artist when he first saw them in Madrid in 1865. Yet one is made aware of these references not in terms of passive "influence," but as an active device in the creation of a new way of presenting the modern subject.

It is no accident that Manet poses an artist friend (Marcellin Desboutin) *as* an artist, and actors (Rouvière, and later Faure) *as* actors. Identity is confirmed by enactment, a kind of excessive role-playing in pictorial terms, while the contemporaneity of the modern sitters – more accurately, "standers" – is set in relief against the art of the past. In *The Artist* (fig. 78), the full-length figure of Marcellin Desboutin is posed in suitably "bohemian" loose black jacket and trousers, flowing white neckerchief, and battered stove-pipe hat. He faces his audience frontally, or rather is confronted by it, somewhat in the manner of Watteau's *Gilles*, although the actual precedent may well be Velázquez's "Philosopher" series. The artist is engaged not in painting, but in filling his pipe; behind him, a shaggy blond dog drinks out of a glass of water, suggesting, among other things, that art is a trick performed under the pressure of necessity.

In *The Tragic Actor* (1865–66, National Gallery of Art, Washington) and *Faure as Hamlet* (1877, Museum Folkwang, Essen), both men are represented in the role of Hamlet, clad in black hose, doublet, and cloak, and caught in a moment of rhetorical gesture. In both paintings, the pictorial referent is obvious: Velázquez's *Pablillos de Valladolid*, then thought to be a portrait of an actor, in the Prado. The totally neutral, delicately nuanced, and horizonless background, the confrontational pose, the suggestion of space created by a little ledge of shadow beneath the subjects' feet – all of these features refer back to Velázquez's memorable canvas. Manet, on seeing it in 1865, had written: "The most astonishing example in [Velázquez's] splendid oeuvre, and perhaps the most astonishing piece of painting ever done, is the painting listed in the catalogue as *Portrait of a Famous Actor in the Time of Philip IV*. The background vanishes, and atmosphere envelops the good man, a vital presence dressed in black."[32] Here, the actual personality of the modern portrait subject is distanced by at least two devices of artifice: reference to the art of the past and the masquerade of theatrical performance. Manet's ever foregrounded references to the painting *as* a painting may be said to constitute a third such distancing device.

In a "hidden" group portrait like *The Balcony* (fig. 79), it is once more the extreme artifice of this scene of modern life that strikes us, an artifice arising from the mask-like intensification of the faces, the stiffness of the poses, and the references to Goya's *Majas on a Balcony* (1808–12, Metropolitan Museum of Art, New York)[33] and, more diffidently (in the dimly adumbrated figure of the youthful Léon Leenhoff carrying a ewer in the background), to Delacroix's second version of *Women of Algiers* (1847–49, Musée Fabre, Montpellier). Yet nowhere is distance from nature, and the play between "art" and "reality," more brilliantly demonstrated than in the wide range of greens that Manet deploys in this work, from the harsh, industrial pigment of the balcony railing (establishing the front plane of the image with linear intensity), to

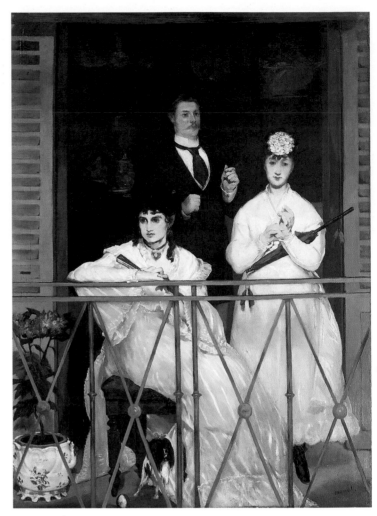

Fig. 79 Édouard Manet, *The Balcony*, 1868–69. Musée d'Orsay, Paris

the more faded green of the horizontally articulated shutters, to the brighter green of Fanny Claus's tasselled umbrella, to the green ribbon about Berthe Morisot's neck, and finally to the rather pathetic "natural" green of the potted plant marginalized behind bars in the left-hand corner. Manet has at once problematized the traditional understanding of portraiture as the capturing of natural appearances (through the mask-like transformation of the sitters' physiognomies into recognizable types – the femme fatale, the artist-dandy, the naive soubrette) and, in terms of colour, has gone so far as to subvert the time-honoured notion of green as the colour of nature.

★ ★ ★

In his study of sixteenth- and seventeenth-century Dutch portraiture, the great Austrian scholar Alois Reigl saw the group portrait as progressing over time to ever greater compositional unity and expressive coherence.[34] Such progress is reversed, if not completely nullified, in most Impressionist group portraits, where it is fragmentation and separateness that determine the compositional strategy, and where the group appears to be no more than the sum of its disconnected parts. Even so innocent a work as Bazille's

bucolic *Family Reunion* (1868–69, Musée d'Orsay, Paris) refuses the false imposition of unity so important in the "evolved" Dutch company portraits of the seventeenth century. In Manet's famous group portrait of the literary and artistic luminaries of his time, *Music in the Tuileries* (fig. 80), the separate subgroups are not meant to add up to a single expressive totality. The centre of the composition is empty and is in fact treated with the highest degree of unclarity.

No other artist went so far in recasting the issue of the family in portraiture, or, indeed, in constructing new ways of representing modern relationships – of the family, couple, or professional group – than Degas. His ambitious early work *The Bellelli Family* (fig. 81) seems at first to be a conventional, if unusually well painted and composed, family portrait. It is only gradually that one notices a minor but striking anomaly: the existence of half a small dog moving out of the painting to the right. The dog must have been a last-minute addition: it does not appear in the final compositional study (Lemoisne no. 64, Ordrupgaardsamlingen, Copenhagen). It is possible that Degas's main reason for putting it in was a formal one: to fill up an awkward empty space in front of the figure of Gennaro Bellelli, who might otherwise seem outweighed by the three-figured group at the left. Yet a formal intention does not nullify a signifying result. With a wave of its fluffy tail and a kind of airy, heedless, cheeky *je m'en foutisme*, entirely at odds with the seriousness of the painting as a whole, this canine hind part works to undermine all the solemn balance and traditional formality of Degas's monumental, tensely harmonized family-group structure. The dog's vector is, in the extreme, centrifugal – in contrast, for example, to the reassuringly anchored position of Porthos, the Newfoundland, who is wholly present in the more cheerful and relaxed bourgeois family group in Renoir's *Madame Charpentier and Her Children* (cat. no. 32).

Yet it is not really the dog I wish to discuss – Degas, incidentally, is said to have hated dogs – but rather the relatively covert contraversion of what one might call conventional bourgeois – or more specifically, haut bourgeois – family values, such as those represented in the Charpentier family portrait and many others of the period. Degas was well aware of the strains existing between Gennaro Bellelli and his wife, Laura (who was the sister of Degas's

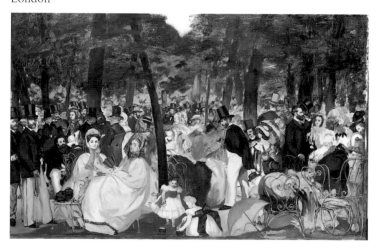

Fig. 80 Édouard Manet, *Music in the Tuileries*, 1862. National Gallery, London

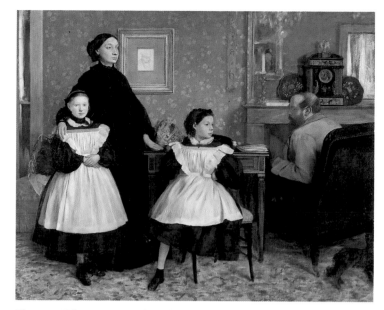

Fig. 81 Edgar Degas, *The Bellelli Family*, c. 1858–60. Musée d'Orsay, Paris

father). At the same time, he evidently wanted the portrait of the Bellellis to be a major painting with a dignified structure and a sense of tradition. The tensions that must have been affecting Degas personally – his conscious or unconscious awareness of animosity between husband and wife, the perhaps unacknowledged strength of his feelings for his aunt – and the consequent insertion of the signs of dissension and instability into the superficially harmonious fabric of his representation are what make the portrait interesting and disturbing to the modern viewer. *The Bellelli Family* (originally referred to simply as "Portrait de famille" when it was first exhibited at the Salon of 1867) is as much a painting about the contradictions riddling the general idea of the haut bourgeois family in the middle of the nineteenth century as it is a family portrait *tout court*.[35]

Within the complex web of meanings constituting *The Bellelli Family*, both temporal and spatial considerations play their role. On the one hand, Degas has presented the family diachronically, as a hierarchical continuum of generations: grandfather René, then the parents, followed by Giuliana and Giovanna. And as the presence of the recently deceased grandfather is indicated simply by an image on the wall, so the presence of the unborn next generation is merely hinted at in the costume and stance of Laura. References to the aristocratic tradition of portraiture – that of Van Dyck and Bronzino – and the conscious balance and geometric ordering of the composition suggest that it is not just to any past that the young artist wishes to connect his family. The high tone of this reference to family continuity is complicated by synchronic tensions. The stately order of inheritance and succession is interrupted and called into question by contemporary disharmonies characteristic of the haut bourgeois family of Degas's time. Interestingly, these tensions are, in pictorial terms, represented not merely by the slumped figure of Gennaro and the over-erect Laura, but perhaps even more acutely by the figure that both separates and connects them, the awkwardly and unstably posed Giuliana.[36]

Nothing would appear to be further from the monumental seriousness of this formal representation of a family group than Degas's lighthearted outdoor scene *At the Races in the Countryside* (fig. 82). Yet it too, in its way, is a family portrait, even if a far less overt and conventional one; indeed, in a letter to James Tissot, Degas referred to it as a picture "of the family at the races."[37] The family in question is that of his friend Paul Valpinçon, seated in the carriage in the foreground; seen with him are his wife, their baby son Henri, their fashionable bulldog, and (perhaps the star of the occasion) the wet-nurse, her left breast bared, depicted in the very act of feeding their son and heir. Like his mother and nurse, the infant is carefully shaded by the white parasol – only his dimpled legs are exposed to the light. Here is a modern scene of upper-middle-class family pleasure, a new sort of family portrait which is at the same time an image of a whole milieu. The elegant but static horses in the foreground contrast with the smaller racing steeds in the background, silhouetted in a traditional flying gallop against the green lawn that spreads like a carpet behind the protagonists. At once casual and deliberate, calling up memories of English sporting prints as well as contemporary French sporting practice, *At the Races in the Countryside* is a tribute to the artist's friends and also a reminiscence of an outing to the races at Argentan near the Valpinçons' home in Normandy.[38]

Yet Degas, a keen investigator of modern life in all its appearances, did not restrict his group portraits to family subjects, no matter how inventive these might be. Public life was also there to be investigated. The worlds of entertainment and business challenged him, most notably in two remarkable group portraits characterized by very different subjects and approaches. The first of these, *The Orchestra of the Opéra* (fig. 83), is, like Bazille's *Studio*, a group portrait of practising artists that is very different from the "serviceable" representations of creative leaders such as Fantin's *Studio in the Batignolles*. The frieze of solid middle-aged men, each absorbed in his musical effort, is played in a kind of theatrical *contre jour* against the pinkish luminosity of the disembodied dancers behind – the dancers have no heads, the players have no legs. But this is not in reality a portrait of a "corporate body," as the Dutch group portraits were: only a few of the

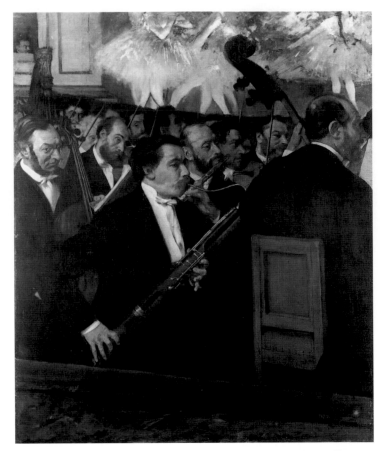

Fig. 83 Edgar Degas, *The Orchestra of the Opéra*, c. 1870. Musée d'Orsay, Paris

depicted sitters were actually members of the orchestra, or indeed musicians at all.[39] So it is a portrait of members of the orchestra posed for by others – an artificial Realist construction, as it were, as deceptive as it is convincing.

Still a different sort of composition – one emphasizing spatial recession – is deployed for a different type of group portrait, in this case representing members of Degas's family and, at the same time, the activity of a modern commercial enterprise. *Portraits in an Office (New Orleans)*, more commonly known as *The Cotton Market at New Orleans* (fig. 84), painted on the artist's trip to the United States in 1873, shows Degas's maternal uncle Michel Musson, in the foreground, examining a sample of cotton. Behind him are Degas's brothers René, reading the *Daily Times-Picayune*, and Achille, leaning against the counter. Other members of the firm or associated figures are scattered through the receding space of the picture. Prominent in the right foreground is the cashier, John Livaudais, looking over a large register. Degas originally had in mind a spinner in Manchester as his ideal purchaser, and one can see why. If ever there was a specific (at first sight, almost illustration-like) image of an aspect of the modern textile business, this busy but uncrowded and apparently realistic painting is it. Yet, on closer examination, this group portrait, like *The Orchestra of the Opéra*, is far from literal in its realism, even if, to borrow the words of a contemporary critic, "it is bourgeois" and "seen in a way that is accurate and correct."[40] All the sensuous appeal of the painting is displaced to the centre of the image,

Fig. 82 Edgar Degas, *At the Races in the Countryside*, 1869. Museum of Fine Arts, Boston, Arthur Gordon Tompkins Residuary Fund

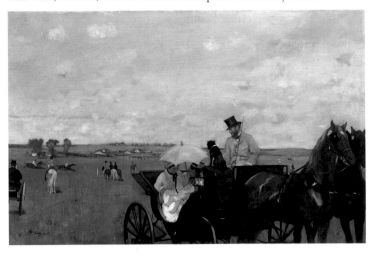

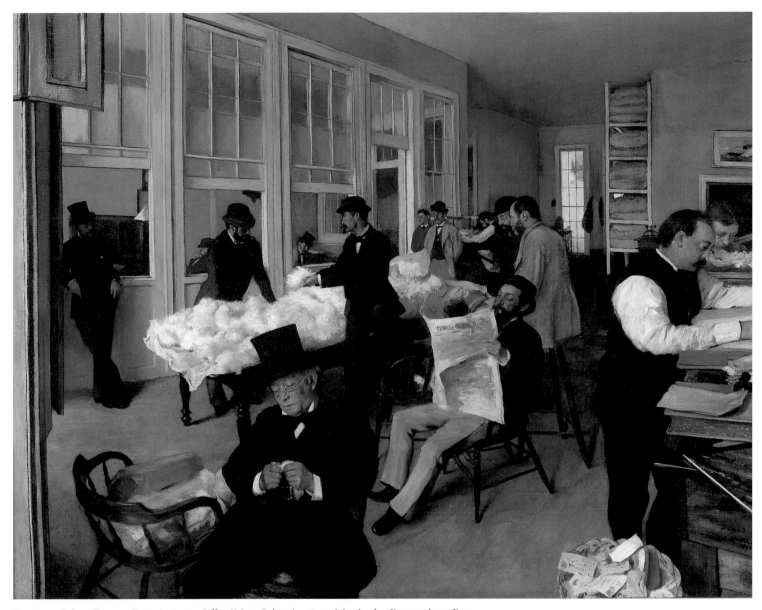

Fig. 84 Edgar Degas, *Portraits in an Office* (*New Orleans*), 1873. Musée des Beaux-Arts, Pau

where, laid out like a body on the long table, the raw cotton, fluffy, tufted, richly painted, formless and weightless, offers at once the iconographic point of the painting and the antithesis of the Realist matter-of-factness of the male characters portrayed within it. One might even go further and say that the cotton – in its sensuality, in the way it is touched and gazed at – takes the place of the (totally absent) feminine, providing the same sort of oppositional foil to the male protagonists that the dancers' pale, diaphanous legs offer to the male sitters in *The Orchestra of the Opéra*. Equally original is the buildup of objects and stuffs, almost abstract in its intensity yet totally suited to the Realist specificity of the occasion, starting in the right corner with the wonderful wastebasket and its collection of varicoloured papers, continuing above it and to the right in the gorgeous striations of the ledger-cover leading the eye in on a diagonal, and then moving on to the table where Livaudais is working, neatening up in the horizontal

of the ledgers and, perhaps not incidentally, in the whiteness of the cotton, now in its finished condition, in his shirt sleeves.

★ ★ ★

Historically, the portrait worked toward establishing difference within the category of similarity. That is to say, the signifiers of individual uniqueness are called on to define the specificity of *this* particular member of an equally specific class or group of individuals. One must be able to respond to the dignity and importance of this personage as part of an equally dignified, socially elevated class or subclass – as defined by pose, costume, accoutrements, expression – and at the same time seek out the unique flare of a nostril, the particular way a garment responds to the sitter's body, the eloquence of the hands, and so forth. The traditional task of physiognomy was to deliver both categories of information to the

71

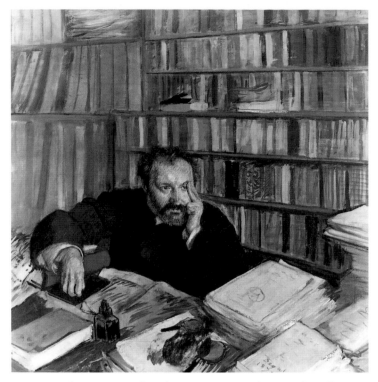

Fig. 85 Edgar Degas, *Edmond Duranty*, 1879. The Burrell Collection, Glasgow

viewer. Duranty, writing in *La Nouvelle Peinture*, demanded nothing less.[41]

Degas may indeed, as Anthea Callen suggests, have been interested in the new "scientific" theories of human typology of his time.[42] These theories recast the time-honoured categories of physiognomy (the study of permanent human facial features) and pathognomy (the study of momentary facial expression), as undertaken by LeBrun in his *têtes d'expression* in the seventeenth century, in more precise and empirical form. Degas and Duranty were both amateurs of a modified version of Lavater's eighteenth-century attempt to establish a correlation between human appearance and character. In his 1867 essay "Sur la physionomie," Duranty attempted to construct a grammar of "modern observation" based on the analysis of physical, social, and racial characteristics.[43] Degas himself wrote in his notebook: "Make of expressive heads (academic style) a study of modern feeling – it is Lavater, but a more relativistic Lavater, so to speak, with symbols of today rather than the past."[44]

Yet, paradoxically, it is the very attempt to attain to a scientific accuracy in his portraits that makes them deviate from a simple typological representation. Degas's portraits – of Duranty (fig. 85) and of Diego Martelli (fig. 86), for example – inscribe subtle and incisive differences within the framework of physiognomic or social typology. In Degas's understanding of it, modern individualism consists precisely in that telling deviation from the standard type established by the relatively crude formulae of even the most up-to-date physiognomists. Thus, in his portraits of Duranty and Martelli, while representing what might be thought of as the modern critic or intellectual *in situ*, the artist deliberately locates these two very different personalities in totally different settings,

which in turn create different expressive effects. Although a high viewpoint is established for both subjects, Duranty, intense and febrile, seems to invite a more head-on confrontation. The author, best known for his pamphlet *La Nouvelle Peinture*, written on the occasion of the second Impressionist exhibition in 1876, is at once defined and at the same time entrapped by the colourful rows of books that surround him, marching horizontally on the shelves behind and more casually laid out in space-establishing, dynamic diagonals in the foreground. Between these two bibliographical borders Duranty sits, his two fingers pressed to his head at eye level, as though emphasizing both the act of thinking and the act of seeing. Even the medium, pastel and tempera, is applied with a kind of dry, elegant energy. Diego Martelli, in the Edinburgh version of his portrait of 1879, is seen from an even higher vantage point, one calculated to emphasize his squat stature and rounded contours. Indeed, he might be said to be a typical "endomorph," in the typology established in our own century by William H. Sheldon to correlate physiological types with psychological categories.[45] A sense of comfortable informality is established both by the pose and by the fact that the subject is in shirtsleeves: Martelli is constructed to emphasize the contemplative rather than the confrontational nature of his character. His arms, folded across his chest, are supported by his ample belly; his plump legs, straining against the cloth of his trousers, are crossed and tucked under his body, whose weight is emphasized by the relative frailty of the folding stool on which he sits. Throughout the setting, Degas places the round against the infor-

Fig. 86 Edgar Degas, *Diego Martelli*, 1879. National Gallery of Scotland, Edinburgh

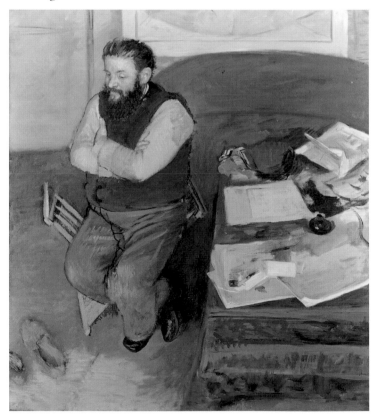

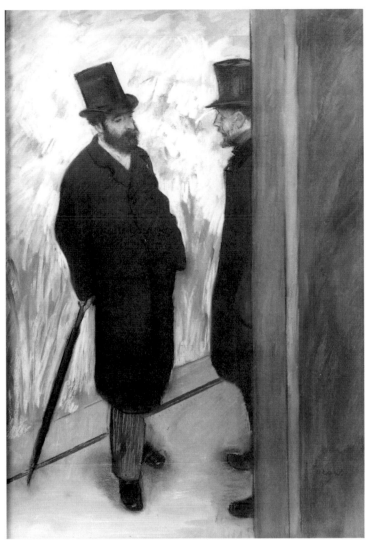

Fig. 87 Edgar Degas, *Portrait of Friends in the Wings* (*Ludovic Halévy and Albert Cavé*), 1879. Musée d'Orsay, Paris

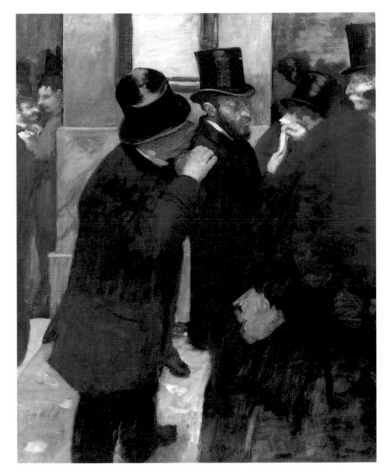

Fig. 88 Edgar Degas, *Portraits at the Stock Exchange*, c. 1878–79. Musée d'Orsay, Paris

mally scattered. Here are no marching rows of books, but ruffled papers and objects haphazardly spread on the table in the foreground. The rounded back of the sofa in the background echoes both the rounded contour of the mysterious image on the wall and the outlines of the sitter's body. The pair of red-lined carpet slippers at the left, one partly cut off at the margin of the canvas, add another touch of informal heterogeneity to the composition. Although both portraits were created at the same time, and although both subjects were writers and critics, there is no sense that they conform to a similar type or character: on the contrary, it is uniqueness and difference that are emphasized by every aspect of the formal structure of the images in question.

Even when it comes to a so-called "racial" category, that of the Jew, where one might expect to find stereotyping and (given Degas's overt anti-Semitism at the time of the Dreyfus affair) even outright hostility, Degas does not resort to caricature, but rather emphasizes the specificity of the sitter and the situation. What is striking is the difference he establishes among his – admittedly rare – Jewish sitters. *Portrait of Friends in the Wings* (fig. 87), a work in

pastel and tempera on paper, represents Ludovic Halévy, the artist's boyhood friend and constant companion. Halévy, a well-known writer, librettist, and man-about-town, is shown backstage at the Opéra with another close friend, Albert Boulanger-Cavé. The image is a poignant one. Halévy leans with a kind of resigned nonchalance against his furled umbrella, in a mood of isolation and inwardness that suggests an empathy between the middle-aged artist and his equally mature subject.[46] The brilliant colour of the painted backdrop – slashed on in visible strokes of green, white, and yellow – serves as a foil to set off the sense of world-weariness established by the silhouetted figure. Halévy himself commented on this discrepancy between mood and setting in the pages of his journal: "Myself, serious in a frivolous place: that's what Degas wanted to represent."[47] Halévy was a Jew – a convert to Catholicism, to be sure, but a Jew nevertheless – and, when the time came, a staunch Dreyfusard. No one looking at this sympathetic, indeed empathetic, portrait could have surmised that Degas was (or would become) an anti-Semite, that he would cast himself as a virulent anti-Dreyfusard, and that within ten years he would pay his last visit to the Halévy home, which had been like his own for many years, never to return, except briefly to pay his final respects following Ludovic's death in 1908.[48]

But in another representation of a Jewish subject, *Portraits at the*

Stock Exchange (fig. 88), almost contemporaneous with the Halévy portrait, the situation is more ambiguous. The work represents the Jewish banker, speculator, and patron of the arts Ernest May on the steps of the Paris stock exchange in company with a certain Monsieur Bolâtre.[49] At first glance, the painting seems quite similar to *Friends in the Wings*, even to the way Degas has employed brightly streaked paint on the dado at the left to set off the black-clad figures. But if we look more closely, we see that this is not the case. The gestures, the features, and the positioning of the figures suggest something quite different from the empathetic identification in the Halévy portrait. What they suggest is "Jewishness," in an unflattering if relatively subtle way. If *Portraits at the Stock Exchange* does not sink to the level of anti-Semitic caricature, it nevertheless draws from that source of visual stereotype. The subtlety of the reference owes something to the fact that it is conceived as a "work of art" rather than as a "mere caricature." It is not so much May's Semitic features as Bolâtre's gesture that I find disturbing – what might be called the "confidential touching" – that and the rather strange, close-up angle of vision from which the artist chose to record it, as if to suggest that the spectator is spying on rather than merely looking at the transaction taking place.

At this point in Degas's career, gesture and the vantage point from which gesture was recorded were everything in his creation of an accurate, seemingly unmediated, imagery of modern life. "A back should reveal temperament, age, and social position, a pair of hands should reveal the magistrate or the merchant, and a gesture should reveal an entire range of feelings," Duranty declared in his discussion of Degas in *La Nouvelle Peinture*.[50] What is "revealed" here, perhaps unconsciously, through May's gesture, as well as in the unseemly, inelegant closeness of the two central figures and the demeanour of the vaguely adumbrated supporting

cast of characters (like the odd couple, one with a Semitic nose, pressed as tightly as lovers into the narrow space at the left edge of the picture) – is a whole mythology of Jewish financial conspiracy. Bolâtre's half-hidden head tilted to afford greater intimacy, the plump white hand on the slightly raised shoulder, the stiff turn of May's head, the somewhat emphasized ear picking up the tip – all this suggests "insider" information to which "they" are privy, from which "we," the spectators (understood to be gentile) are excluded.

I am, of course, pointing to significances inscribed for the most part unconsciously or only half-consciously in this vignette of modern commerce. If the reading seems exaggerated in its implications, one might compare the gesture uniting the Jewish May and his friend with any of those in Degas's portraits of members of his own family who were also engaged in commerce. In *The Cotton Market at New Orleans*, for example, there is not the slightest overtone of what might be considered the "vulgar familiarity" of the gesture of May and Bolâtre.[51]

★ ★ ★

It is clear that in their attempt to reconfigure modern identity, the Impressionists, including Manet, deployed a wide range of pictorial strategies. If the presence of modernity was often signalled by fragmentation, ambiguity, and artifice, merely listing these characteristics hardly accounts for the richness, vitality, and often startling originality of the individual examples. A portrait by Bazille, Renoir, Cassatt, Morisot, Degas, or Manet can still move us with its innovative intensity, its unexpected nuance, its disruptive intervention within the codes of the conventional, not to mention its sheer pictorial freshness of approach.

NOTES

1 Kostenevich 1995, 71–72. Kostenevich's analysis of the painting, as well as the information he provides about the vicomte Lepic himself, is the richest available. For the most recent investigation of Degas as a portraitist, with a series of essays on individual portraits, see *Degas Portraits* 1994.

2 Callen 1995, 174–175. On the subject of the *flâneur* and his representation, see also Pollock 1988, 50–90. On the absence of the *flâneuse*, see Wolff 1990, 34–50, and 1995, 88–114.

3 This sense of circular movement swinging around or away from a central point is even more marked if one stands before or moves in front of the painting itself. The only such sense of pictorial space swinging around a central pivot that I can think of is that created by Rembrandt in his etching *The Goldweigher's Field*, where the field seems to rotate around a church spire in the centre of the composition.

4 Kostenevich 1995, 72.

5 Ibid., 72.

6 For a discussion of the relation between Lepic and Degas, and possible influences, see Druick and Zegers in *Degas* 1988, 205: "Degas's physiognomic investigations indeed reflected the current related interests . . . in evolutionary theory and the scientific reconstruction of man's history. Lepic, the experimental printmaker who introduced Degas to monotype, was also an ardent amateur of French prehistory who, by 1874, had created several 'reconstructions' of prehistoric man and animals for the recently founded ethnographic Musée de Saint-Germain."

7 For discussion of this issue within the wider framework of Degas's anti-narrative strategies see Sidlauskas 1993, 697–712.

8 Sitte 1945, 28.

9 For a detailed analysis of these cases of male agoraphobia and the formulation of the notion of agoraphobia itself see Westphal 1871, 136–161. A commercial traveller, for instance, told Westphal that "in Berlin, the Dohnofsplatz is the most unpleasant for him; when he attempts to cross the corresponding square he feels as if the distance were great, that he would never make it across" (quoted in Westphal 1988, 60).

10 Thomas McDonough, "The Architecture of Agoraphobia," unpublished paper, New York University Institute of Fine Arts, 1995. See also Sennett 1994, 255–257.

11 Kostenevich 1995, 79, fig. 8.

12 For a specific analysis of the gap between the photography of the period and the compositional strategies of Degas's painting see Varnedoe 1990, especially page 49: "The advent of snapshot photography came later, a crucial decade or so after Degas's innovations."

13 See Berger 1994, 86–120.

14 There are not many large-scale attempts at investigating the portrait as an entity in a long historical trajectory. Brilliant's *Portraiture*
(1991) constitutes a lone recent attempt in this direction. For a good general study of the Impressionist portrait see Melissa McQuillan's *Impressionist Portraits* (1986).

15 In deciding whether a given work is a portrait or a genre painting, is the question merely taxonomic or in fact morphological? For an interesting discussion see Smith 1987, 407–430.

16 In this essay I am regarding Manet (who was considered a leader of the group, shared many of their goals, and was a close friend of members of the circle) as an Impressionist, though since he never exhibited with them, he is technically not a bona fide Impressionist.

17 On the relation of gesture and pose to issues of decorum in Dutch painting see Smith 1987.

18 *Degas Portraits* 1994, 262, no. 115.

19 The work was caricatured by Bertall as "Jesus Painting among His Disciples, or The Divine School of Manet, a religious picture by Fantin-Latour," and the caricaturist was not so wrong in his interpretation of the pious atmosphere of the large-scale group portrait, which includes a statuette of Pallas Athena as well as a meaningful Oriental vase to the left. For an illustration of Bertall's caricture see Rewald 1973, 196.

20 On gender representation see especially Callen 1995.

21 In *Degas Portraits* 1994, 26, the painting is dated c. 1871–72. There is another, almost contemporary version in which Pagans is shown in profile, dominating the foreground (Museum of Fine Arts, Boston), as well as a much later version of c. 1895 (Scott M. Black collection), done after the death of both sitters. The contrast between male youth and age is depicted somewhat differently, but is still present, in the two variants.

22 But see the very different, more negative interpretation of this pose and of Degas's various images of Cassatt in Callen 1995, 184–198.

23 It is interesting to note that in the portrait of Mademoiselle Dubourg Degas eliminated the picture that was adjacent to the sitter's head, "which, as in the Tissot portrait, would almost certainly have been closely tied to the sitter's activities and tastes. He erased it, and thereby suppressed all explicit reference to Mlle Dubourg's vocation" (*Degas* 1988, 142).

24 For the best general discussion of these restrictions and conventions within Impressionist painting see Pollock 1988.

25 See Nochlin 1988, 37–56.

26 Kristeva 1980, 237–270.

27 Duret 1919, 110–111.

28 Russell 1996, 37.

29 Otto Benesch, quoted in Berger 1994, 88.

30 For a full analysis of this portrait, as well as the observation that Olympia in the painting turns her eyes towards Zola, see Reff 1975, 34–44.

31 Bataille 1955, 25.

32 Moreau-Nélaton 1926, I, 72, Manet to Fantin-Latour. See *Manet* 1983, 231–232.

33 See Goya 1996, 64, 65.

34 This theory was propounded, of course, in relation to Dutch group portraits of the sixteenth and seventeenth centuries. See Reigl 1964.

35 For the history of the portrait and the identification of its subject, see the excellent analysis
in *Degas* 1988, 77–85. For the classic analysis of the painting and Degas's relation to the family see Boggs 1955, 127–136, and the revision of that article in Finsen 1983, 14–19.

36 For a more extended analysis of *The Bellelli Family* see Nochlin 1992, 43–46.

37 Quoted in *Degas* 1988, 157.

38 See *Degas* 1988, 157–158.

39 Included in the composition are the composer Emmanuel Chabrier (in the box at the left), the cellist Pilet, the Spanish tenor Pagans, a stage director at the Opéra named Gard, and (pensively playing the violin) the painter Piot-Normand. Although there are also some genuine orchestra members depicted, such as Dihau himself, it is indeed "a somewhat eclectic orchestra" (*Degas* 1988, 161).

40 Louis Enault, quoted in *Degas* 1988, 186. My identifications are taken from the excellent entry on the painting in this catalogue.

41 Duranty 1876.

42 Callen 1995, especially 1–31.

43 See the excellent discussion of this by Druick and Zegers in *Degas* 1988, 205.

44 Ibid. On Lavater and portraiture see Stemmler 1993, 151–168.

45 See Sheldon 1940.

46 The pose is vaguely reminiscent of that established for the various "portraits" Degas made of Mary Cassatt at the Louvre at about the same time, except that Mary Cassatt, leaning on her furled umbrella, is seen from the back. For the Cassatt portraits, see *Degas* 1988, 320–24. For further information about Ludovic Halévy and Degas's relation to him see Nochlin 1987, 96–106, and especially n. 8.

47 "Les Carnets de Ludovic Halévy," *Revue des Deux Mondes* 42 (1937), 823.

48 For a moving account of this last visit see Halévy 1964, 104–105.

49 On Ernest May see Nochlin 1987, 113, n. 17, and *Degas* 1988, 316–318.

50 Moffett 1986, 44.

51 There is a third portrait by Degas in which the issue of Jewish identity enters: the double portrait of *General Mellinet and Chief Rabbi Astruc* (1871). Although I have always considered this a straightforward and more or less objective portrait of the rabbi, his relatives saw it as a gross anti-Semitic caricature of the "fine features" of the sitter. Astruc's son wrote of it: "This painting is not a work of art – it is a pogrom" (*Degas* 1988, 166). To me, his features – the aquiline nose, the rather full lips – look much like those of any other Frenchman, as does his black beard, characteristic of the period. It is interesting that several of Cézanne's self-portraits, especially the well-known one of 1879–82, which graced the cover of the 1968 paperback edition of Rewald's biography of the artist, have been denominated "Jewish" or "rabbinical" more than once, with both positive and negative implications. For instance, the journalist James Hunecker in 1909 described the Cézanne self-portrait as a "Shylock in a gaberdine, broad-brimmed hat, and patriarchal beard." I am grateful to Steven Z. Levine for this information, from his talk at the Cézanne symposium in Philadelphia in June 1996 ("Eye and I in the Self-portraits of Cézanne," unpublished).

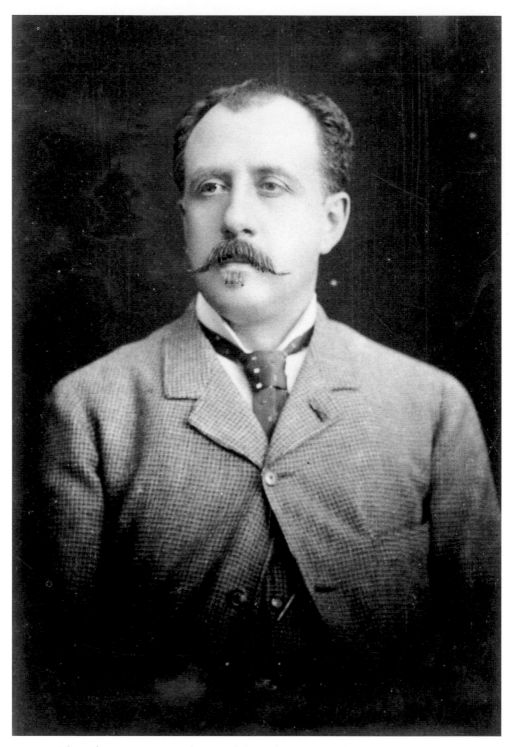

Fig. 89 Léon Clapisson, c. 1875, photograph by Délié. Private collection

LÉON CLAPISSON: PATRON AND COLLECTOR

Anne Distel

When it entered the collection of the Art Institute of Chicago in 1933, Renoir's portrait of Madame Clapisson (cat. no. 46) brought its subject a degree of celebrity far greater than that enjoyed by her husband, who had commissioned the painting in the first place.[1] Art historians have long known that Léon Clapisson (fig. 89) was a middle-class Frenchman of independent means who collected Impressionist art,[2] and whose tastes could be judged from the catalogues accompanying the two sales of works from his collection – the first in 1885, during his lifetime, the other in 1894, following his death.[3] He was also part of the group led by Claude Monet who purchased *Olympia* from Manet's widow in 1890 and presented it as a gift to the State.[4] Clapisson thus emerges as an avid collector at the very dawn of Impressionism. Interest in him has now been rekindled by the chance discovery of two notebooks in which he recorded his purchases of paintings and drawings from 1879 until his death in 1894.[5] This essay sets out to add Clapisson's name to the list of patrons and collectors who fostered the early development of Impressionism – an honour roll that includes among its more prominent members Dr. Paul Gachet and the baritone Jean-Baptiste Faure, as well as some of the painters themselves, notably Degas and Caillebotte. Such a list would be incomplete if it did not also take into account certain secondary figures, those middle-class art lovers of relatively limited means, possessed of an adventurous and speculative spirit (though never really eccentric in their tastes), whose names have been saved from oblivion only by the many *catalogues raisonnés* that trace the provenance of individual works. Léon Clapisson is such a figure. The surviving documentation on him is unfortunately quite sparse, but it is now possible to provide at least a brief sketch of his life.[6]

The son of Louis Clapisson (1808–1866) (fig. 90) and Marie Catherine Bréard (1816–1892), Louis Aimé Léon Clapisson was born in Paris on 26 November 1836.[7] His father enjoyed considerable renown as a musician and composer, though his reputation began to decline gradually after his death. In his own day, encyclopedias had paid tribute to Louis Clapisson *père* as an eminent member of the Institut, professor at the Conservatoire de Musique, *chevalier* of the Légion d'Honneur, and an accomplished composer of operettas (the most famous being *La Fanchonnette*, first staged in 1856).[8] Today he is remembered mainly as the man who was admitted to the Académie in 1864 over Hector Berlioz and who was responsible for the museum of musical instruments at the Conservatoire. Clapisson *père* was himself a collector of early instruments, constantly on the lookout for items of unusual origin or of exquisite quality.[9] He became the curator of his own collection, which was kept in his cramped apartment at 15 rue du Faubourg-Poissonnière (the apartment came with the post at the Conservatoire), selling it to the State in 1860–61.[10] Born in Naples, of a father who was an impoverished musician, Louis Clapisson's early years had been marked by hardship and peril, but

he emerged rich and successful, thanks not only to his strong drive but also to several strokes of good luck. By the end of his life he was unfortunately mired in debt[11] – ruined for the most part by his exorbitant purchases of musical instruments – but would be remembered no less as a bon vivant with more friends than enemies.[12] He died on 19 March 1866 at the age of 58, and was survived by his widow, his son Léon, and a second son, Henri Lucien, born 24 July 1848 (still a minor and boarding at the Lycée Napoléon). Léon, a businessman, already married, now became head of the family.[13]

Léon Clapisson thus had the good fortune to be born into a milieu of creative artists – chiefly musicians, though the great Delacroix makes an appearance too[14] – in which there was a highly developed appreciation of objects of beauty. Of his earlier years relatively little is known. He was presumably well educated, since he held a bachelor of letters degree, though we do not know

Fig. 90 Louis Clapisson, 1860–65, photograph by Nadar. Caisse Nationale des Monuments Historiques et Sites, Paris

Fig. 91 Valentine Clapisson, c. 1875, photograph by Tourtin. Private collection

Pierre-Auguste Renoir, *Madame Clapisson* (cat. no. 46)

if he went on to pursue further studies.[15] The single notable fact from his early life is that on 28 March 1861 he volunteered for a seven-year period of military service with the 3rd regiment of the Zouaves. He was sent directly to Algeria, where he remained until the spring of 1864, at which point he was discharged and returned to France.[16] What is most surprising here is his choice of regiment: the Zouaves (originally a fierce corps of indigenous Algerian soldiers who had helped France conquer Algeria) consisted, at the time, of peasants, labourers, and artisans – certainly, young *bacheliers* were a rarity among them. Since his father did not have the means to provide a replacement for his son's military service, and considering that his grandfather had served as an officer under Napoleon, Léon may well have chosen the Zouaves to satisfy a taste for adventure. Here, his path was similar to that of the young Claude Monet, who enlisted in the *chasseurs d'Afrique*, joining his corps in Algeria in June 1861 but remaining there only one year, thanks to his aunt, who paid for his discharge. Clapisson thus spent three years in the famous Zouave uniform, with its blue jacket, billowy ruby-coloured Moorish trousers, leather gaiters, turban, and red skullcap.

Back in Paris, he went into business, and soon married Valentine Billet (fig. 91), a young woman aged "fifteen years and seven months" and the daughter of a retired stockbroker, Henri Billet, who lived at the château de Cernay-Ermont in Sannois, near Paris.[17] When war broke out with Prussia in 1870, Léon returned to military service, this time with the Garde Nationale. His outstanding bravery in the famous offensive at Montretout during the siege of Paris in January 1871 earned him election to the Légion d'Honneur the following year.[18] After the war, he resumed his business activities in the stock market,[19] living for a time in Paris[20] before settling in Neuilly-sur-Seine, where in 1881 he purchased a magnificent *hôtel particulier* at 48 rue Charles-Laffitte on the corner of the boulevard des Sablons (fig. 92).[21] Into this house came his wife Valentine, his elderly aunt Aglaé Bréard, his nephews Louis and Lucie (then aged five and seven, the children of his brother Lucien, who had left France to run a cement business in Rio de Janeiro), his sister-in-law Eugénie Billet with her baby, Léon Henri Prignot, and three servants.[22] Since the walls of such a large residence could hardly be left bare, it was perfectly natural for him to have begun collecting – he did so in March 1879, the date inscribed in his first notebook. Before long, Léon Clapisson's name would begin to appear as a lender to important exhibitions; he was not the type to seek anonymity. One of the paintings in his collection, a Corot landscape with figures, was reproduced in the 17 April 1880 issue of *La Vie Moderne*, the magazine put out by the famous Parisian publisher of Naturalist novels Georges Charpentier; next to the reproduction appeared a long poem by Ernest d'Hervilly entitled *Soir d'un beau jour*, dedicated to Clapisson.[23] The names of Georges and Marguerite Charpentier (see cat. nos. 31, 32) are linked with

Manet, Renoir, Monet, and Sisley, and we can safely assume that Clapisson was already in touch with some of the most adventurous players in the Paris art scene.

Revealing as all this may be, we do not know for certain what prompted Léon Clapisson to purchase paintings and drawings. Like so many other collectors, he was doubtless driven by a wish to be noticed and an appetite for speculation, as well as by a real love of art. Through the recent discovery of his two notebooks, we also have a sense of the wide range of works that appealed to him, and we can chart quite precisely how his collection evolved over time. What emerges very clearly is that most of his purchases were made between 1880 and 1882, with selective reselling in 1885, 1891, and 1892, and that relatively few works were acquired after 1885.

As we scan the two hundred or so titles of paintings and drawings in the notebooks and in the 1894 sale catalogue (running the gamut from masterpieces to trifles), it is clear that Clapisson's collection was above all a collection of "modern" art. While he began with more classic pieces (by Delacroix and Corot, for example, as well as the Barbizon School and the Realists), he gradually moved on to works by the Impressionists, along with a variety of other artists. The small number of eighteenth-century paintings and drawings by Lancret, Bachelier, Boucher, Descourtis, Fragonard, and Tiepolo are secondary – Clapisson was not particularly moved by this type of art, although it was very much in vogue at the time, and championed by the Goncourts. Purchased cheaply, these works also had the lowest resale value, undoubtedly on account of their inferior quality. The rest of the collection initially consisted of works by nineteenth-century artists, including the masters (Corot, strongly represented, as well as Delacroix and Millet, of whom Clapisson owned some important works) and their emulators (Daubigny, Dupré, Diaz, Gassiès, Harpignies, Jacque, Jacquemart, Jongkind, Lavieille, Théodore Rousseau). We find a small selection of Orientalists (Decamps, Dauzats, Fromentin) and a Realist group featuring Barye, Bonvin, Tassaert, Troyon, and Vollon, along

Fig. 92 The Clapissons' *hôtel particulier* (now destroyed) at 48 rue Charles Laffitte in Neuilly-sur-Seine. Private collection

with Courbet (one of whose paintings Clapisson lent to the artist's posthumous retrospective in 1882) and Couture. It was principally the works of these artists that Clapisson sold in 1885, just as he was beginning to collect Impressionist canvases, in keeping with a trend discernible in the 1870s: collectors such as Ernest Hoschedé and the singer Jean-Baptiste Faure had also built collections centred on the "École de 1830," only to dispense of them and invest instead in Manet and the Impressionists.[24]

This overview needs to be nuanced somewhat, for Clapisson clearly derived pleasure from a wide variety of artists. Appreciating the anecdotal and the picturesque, he was perfectly comfortable with paintings by Antigna, Charlemont, Le Blant, Luminais, Morin, Roybet, Serret, Alfred Stevens, and Vibert. At the same time he delighted in landscapes – perhaps as souvenirs of places he had visited – purchasing works by painters as diverse as Boggs, Brun, Dumoulin, Jourdain, Loir, Pelouse, Raffaelli, Renouf, Roqueplan, and Vignon (though not, curiously, Boudin). He owned works by all the leading Impressionists except Cézanne and Guillaumin, and even possessed a painting by Gauguin.[25] Also to be found in his lists (in no particular order) are, somewhat surprisingly, Munkácsy (if we have read it correctly), Meissonier, Gustave Moreau, Rops, Fantin-Latour, Lhermitte, Breslau, Besnard, and Cazin. All of these artists would have been familiar to Clapisson from the exhibitions that he undoubtedly attended at Georges Petit's gallery and at other Paris dealers such as Durand-Ruel, Beugniet, Portier, Boussod et Valadon (managed by Theo van Gogh, brother of the painter), and Brame. He preferred to buy from dealers rather than directly at the Hôtel Drouot, where he was rarely seen bidding. A man of eclectic tastes, he did not think twice about spending several hundred francs for a small watercolour by a young artist who might have been recommended to him, nor did he hesitate to spend large sums of money on major works.

Clapisson's sale of 1885 did not realize the profits that he had hoped for, nor did the resale prices, which were often lower than the original purchase prices, always reach the collector's own estimates. Besides being a neophyte, Clapisson also experienced a run of bad luck. Alfred Robaut, Corot's cataloguer, refers to a fake Corot that Clapisson bought at auction.[26] An entire series of drawings by Daumier in the 1894 sale were sold by Durand-Ruel "without guarantee."[27] This may partly explain why Clapisson came to prefer living artists over dead ones, and why, like others before him, he turned to the dealer Paul Durand-Ruel for his first Impressionist works.

While it has not been possible to establish the purchase date for each and every Impressionist work in Clapisson's collection, it can be established that a large number were bought from Durand-Ruel between May and July of 1882.[28] Clapisson was a typical Durand-Ruel client – comfortably middle-class, a lover of painting, willing to leave the beaten path, and trusting his dealer to serve him well. In fact, he made his purchases and exchanges with such regularity that, according to Pissarro (repeating a confidential remark by Durand-Ruel), he had become the dealer's "front man" in a transaction with Monet.[29] Faithful to the end, Clapisson enlisted Durand-Ruel's services to resell the collection, as did his widow after him.

Clapisson's name is associated in print with the Impressionists for the first time in 1881, in the catalogue of the sixth group exhibition, where he is mentioned as the lender of *La Moisson*, a

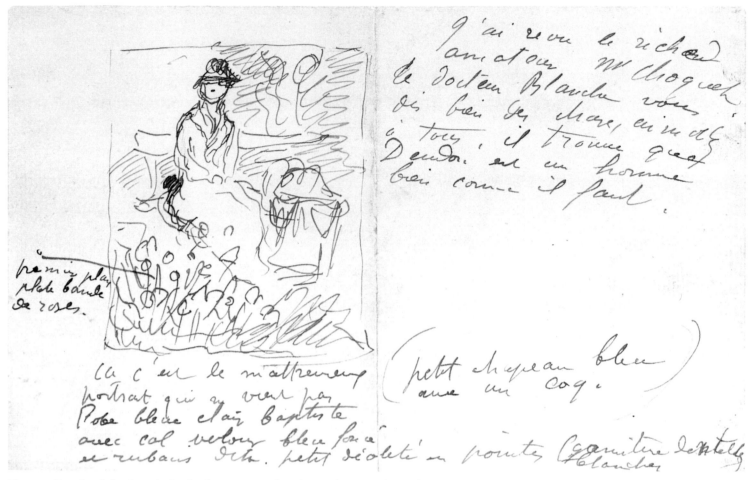

Fig. 93 Pen sketch by Renoir for the first portrait of Madame Clapisson, from a letter to Paul Berard, 22 June 1882. Private collection

gouache by Pissarro. The work cannot be identified with certainty, and where it was purchased is unknown. One thing that is clear, however, is that Pissarro knew Clapisson well: in a moment of great financial difficulty, in 1887, the artist seems to have counted on being able to sell him a recent work "on the sly," which is to say, without going through Durand-Ruel or another intermediary.[30]

The circumstances of Clapisson's discovery of Renoir are, in fact, well known. Durand-Ruel's records show that on 25 and 30 May 1882 Clapisson bought three works with an Algerian theme, which Renoir had just deposited with the dealer; he was only prevented from buying a fourth by Durand-Ruel himself.[31] Clapisson had already purchased works by Cassatt, Manet, and Monet from Durand-Ruel, and the Renoirs may have appealed to him in part because of their subject matter. On the combined advice, apparently, of Durand-Ruel and the Charpentiers,[32] Clapisson then asked Renoir to paint a portrait of his wife, for which he paid 3,000 francs, a considerable sum, though modest in comparison with the prices charged by more fashionable portraitists. The commission did not run smoothly. A first portrait, painted by Renoir in June 1882, in which the "exquisite" Valentine posed patiently in her garden next to a bed of roses (figs. 93, 94), turned out, in his words, to be "a total flop" and was rejected.[33] Quite distraught, Renoir, who was struggling with

health problems and worrying about his move to a new studio, undertook a second portrait (cat. no. 46). With the example of Bonnat in mind – an established portraitist very much in vogue – he wrote to the collector Paul Berard: "Don't ever mention portraits in the sunshine to me again. A good black background, that's the ticket!"[34] Even though its background was not completely drowned in the flattering mists of bitumen that abounded in contemporary academic painting, this second portrait proved a success. It was shown at the Salon of 1883, and Clapisson presumably forgave Renoir for the initial "fiasco."

Perhaps by way of offering his apologies, Renoir also painted a charming little portrait of the Clapissons' young nephew Henri Prignot (fig. 96).[35] This latter work provides us with yet another interesting link: the doctor who delivered the child was none other than Albert Filleau (1840–1894), a well-known devotee of the New Painting whose collection attracted many admirers, including Ambroise Vollard, who – thanks to Félicien Rops – first became acquainted with Impressionism through it.[36] One wonders, did Filleau also introduce Clapisson to Impressionism, or was it perhaps the other way around? Whichever the case, these relationships explain the presence in Clapisson's collection of works not only by Rops (fig. 98), a mutual friend,[37] but also by Albert Lebourg. In his 1923 monograph on Lebourg, Léonce Bénédite described how the artist was introduced by his dealer,

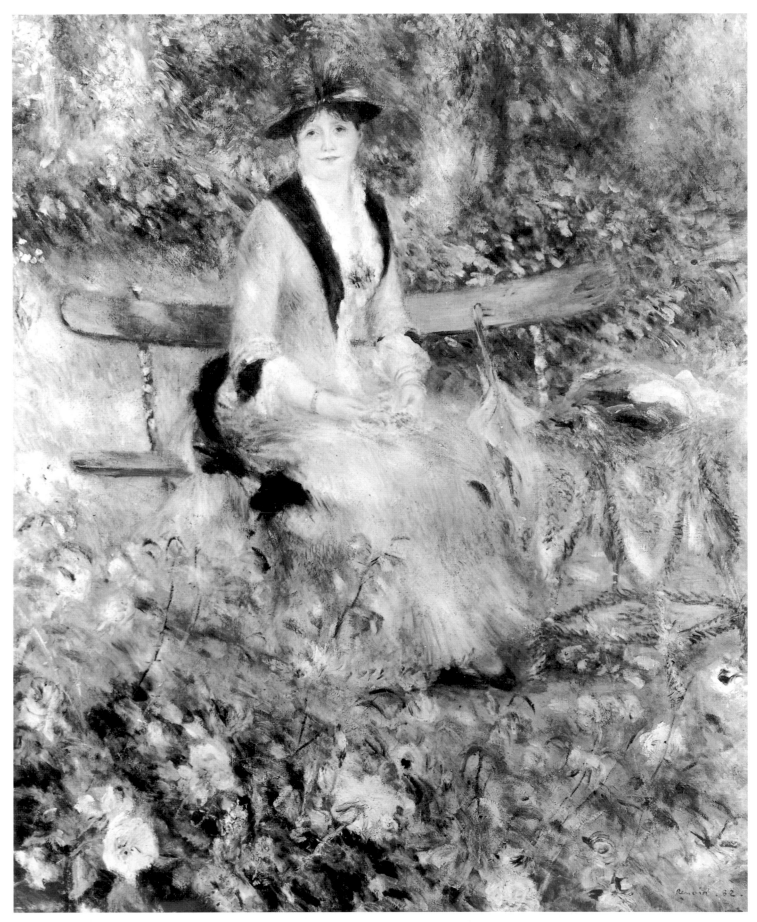

Fig. 94 Pierre-Auguste Renoir, *Femme dans les fleurs (Dans les roses)*, 1882. Private collection

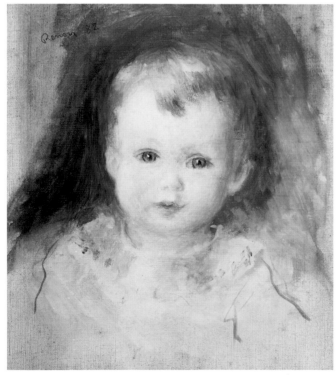

Fig. 95 (*above left*) Page from the notebook of 1882 recording purchases by Léon Clapisson of works by Renoir. Private collection

Fig. 97 (*above right*) Page from the notebook of 1879 recording purchases by Léon Clapisson of works by Renoir. Private collection

Fig. 96 Pierre-Auguste Renoir, *Henri Prignot*, 1882. Kunstmuseum, Saint Gall

Fig. 98 Félicien Rops, book-plate for Valentine Clapisson, etching, published in *La Plume*, 15 June 1896

Portier, to Filleau, at whose home he subsequently met Clapisson, who in turn became an enthusiastic collector of his works.[38] Clapisson and Lebourg may also have been drawn to one another by their common interest in North Africa: Lebourg had lived in Algeria for a long time. Bénédite also tells us that it was at Clapisson's home that Lebourg was first introduced to Georges Charpentier.

Like most art lovers of his generation, Clapisson owned works by Manet – two titles, *Un jardin* and *La Jetée de Boulogne*, appear in his collection – but given the artist's untimely death it is very unlikely that they would have met. Clapisson did not buy anything at the atelier sale in February 1884, but he had lent *Un jardin* (fig. 241), one of the most beautiful of Manet's late landscapes, to the artist's posthumous retrospective at the École des Beaux-Arts the month before. On the other hand, he was well acquainted with Claude Monet, and owned no fewer than ten outstanding paintings by him,[39] including at least one that he bought directly from the artist, in 1886, with Durand-Ruel's consent. Some of Clapisson's Sisleys were probably also purchased directly (he held on to many of them until the end of his life), but there is no evidence of any direct relations between the two men.[40] It is worth noting that Clapisson purchased works by the two female members of the group, Mary Cassatt and Berthe Morisot. His collection even included two pastels by Caillebotte – remarkable in its

way, since the artist sold very little of anything in his lifetime. Finally, Clapisson also bought works by all the minor artists who exhibited in the Impressionist shows, including Cals, Piette (a friend of Pissarro), Charles Tillot, Eugène Vidal, and Victor Vignon; he also owned a work by Raffaelli. However, this fascinating collection was not to endure: from 1891, barely ten years after starting it, Clapisson set about dismantling it.

Why he decided to do so remains unclear. Was he short of money? Did he lose interest in his paintings? Or could it have been related to some vague agreement with Durand-Ruel? The fact is that on 19 May 1891 the dealer paid him 20,000 francs for seven works by Monet and two by Degas,[41] almost doubling Clapisson's original investment. The following year, on 21 April 1892, Durand-Ruel purchased two Manets, two Monets, two Pissarros, three Renoirs, one Morisot, and three works by Degas, all for 30,000 francs, yielding a similar return for the collector.[42] Then, on 12 March 1894, Léon Clapisson died suddenly in his home in Neuilly, at the age of 57. His widow placed all the remaining works for sale, with the exception of Renoir's portrait of her, which she would not relinquish to Durand-Ruel until 1908, when pressed for cash.[43] On 28 April 1894, the remainder of the collection was auctioned at the Hôtel Drouot. Clapisson's name was not mentioned, but those in the know were well aware that the works had belonged to him. Since some of the finest paintings had been dispensed with in previous sales, those that were left were somewhat unremarkable – so much so that Durand-Ruel, who acted as appraiser, felt the need to make the sale more enticing by adding at least one Monet from his own stock (*Les Pins*, 1888) along with two of the Renoirs that he had bought back from Clapisson in 1892.[44] Durand-Ruel purchased a number of works himself, notably some Sisleys, a Renoir, a Pissarro, the two Caillebottes (on instruction from the artist's brother), and the Gauguin, since bidding on these remained low. Other dealers were present, including Brame, Montaignac, Tempelaere, Gérard, Delineau, and Bernheim-Jeune, as well as a number of collectors, most notably Dollfus, Faure, Feydeau, Sainsère, and Viau.

And so with these routine transactions Léon Clapisson's adventure came to an end. The year 1894, which saw the death of Georges de Bellio and Gustave Caillebotte, early patrons of the Impressionists, was also the year in which the critic Théodore Duret sold his collection (Degas, incensed at seeing his works on the auction block, prophesied financial doom for Duret). But it was also the dawn of a new era: thanks to the Caillebotte bequest, and despite the controversy surrounding it, the Impressionists had forced open the doors of the French national museums. And their work has met with steadily increasing admiration and commercial success to this day.

1 The sitter's name was first published by Vollard (1919, 92–93) and then by Rivière (1921, 200), in both cases without a reproduction of the painting. Vollard (1918b, I, no. 354) reproduced Renoir's first portrait of Madame Clapisson (fig. 94), painted in 1882 and rejected by the client, with the caption "Portrait de Mme Clapisson 1880" (known, variously, as *Sur le banc*, *Femme dans les fleurs*, and *Dans les roses* [Daulte 1971, no. 428]). Slightly later, Durand-Ruel's photograph of the Chicago portrait was reproduced as "Portrait de Mme C." (but with an incorrect date) in both André 1923 and Fosca 1923.

2 See Daulte 1971, 411, and the article on Clapisson in Monneret 1978–81, I.

3 Hôtel Drouot, Paris, 14 March 1885, *Catalogue de tableaux modernes par Barye, Boggs, Bonvin, Charlemont, Corot, Courbet, Couture, Daubigny, Diaz, J. Dupré, Harpignies, Jacquemart, Jongkind, Luminais, De Pene, Th. Rousseau, Alfred Stevens, Tassaert, composant la collection de M. C . . .* ; Hôtel Drouot, Paris, 28 April 1894, *Catalogue de tableaux modernes, pastels, aquarelles et dessins anciens composant la collection de M. X*

4 See Geffroy 1922, "Dossier de l'*Olympia*," and Distel 1990–91, 44–50.

5 During a lecture that I delivered in 1985 in connection with the Renoir exhibition in Paris, I mentioned my interest in the Clapissons, and as a result I was put in touch with the descendants of Léon Clapisson's brother Lucien. It was thus that the existence of the notebooks, which had been handed down as heirlooms, came to light. I would like to express my thanks to all the family members – especially Madame Meunier, Madame Houery, and Monsieur François Hurard – for their generous help and for their kind permission to publish the contents of the notebooks in Appendix II below. My only regret is that Madame Françoise Hurard, recently deceased, was not able to see the final version of this essay, which she so graciously encouraged.

6 To economize on notes, I refer the reader to the main primary sources that have been consulted: birth, marriage, and death certificates at the city archives of Paris, Sannois, Neuilly-sur-Seine, and Le Chesnay; the Archives de la Légion d'Honneur, Archives Nationales, Paris, LH/541/50; the Service Historique de l'Armée de Terre, Vincennes, dossier 29909, and records of the 3rd regiment of the Zouaves, vol. 13, no. 12782; electoral and census lists, Paris and Neuilly-sur-Seine; cadastral records for Léon Clapisson's Paris lodgings (Archives de Paris, series D1P4, rue du Faubourg-Poissonnière and rue d'Hauteville); and the *Didot-Bottin* and *Tout Paris* city directories. I would like to thank Brigitte Lainé, chief curator of the Archives de Paris, for her assistance, and also Marina Ferretti, who generously made available her research findings. Despite the diligent and much appreciated efforts of the Neuilly-sur-Seine archivists, it was impossible to find any records of the fiscal attestation of Léon Clapisson's estate (they were presumably destroyed). However, it did prove possible to consult such records for Clapisson's father (Archives de Paris, DQ7/10682), and also to examine his father's very revealing estate inventory (Archives Nationales, Paris, Minutier Central, XCII/1346, Maître Lamy, notary, 8 May 1866). Léon Clapisson's last will and testament (Archives Nationales, Paris, Minutier Central, XCII/1545), discovered thanks to Maître Jacques Fontana, the successor to Maîtres Lamy and Henri Eugène Fontana, is extremely brief; drawn up on 30 June 1866, it simply names his wife Valentine Billet as his sole heir. Furthermore, no inventory of the estate was ever taken, which makes his notebooks all the more indispensable for reconstituting his collection.

7 As a result of an error made during the reconstitution of the birth, marriage, and death records in the Paris city archives, damaged by fire during the Commune, one finds repeated in numerous official documents that Léon Clapisson's date of birth was 26 December 1836. However, the oldest known birth certificate, dated 20 April 1865 and supplied at his marriage, establishes that he was born 26 November 1836 at 10 rue de la Grange-aux-Belles (10th arrondissement, previously 5th) at the home of his maternal grandfather, Jean Marie Léon Bréard, a retired lieutenant-colonel and *officier* of the Légion d'Honneur. Léon Clapisson seems to have been unlucky with regard to his civil status records: his death certificate erroneously has him named Léon Marie, which had to be corrected to Louis Aimé Léon in a later attestation.

8 Larousse's *Dictionnaire universel* (1866–90, IV) contains a substantial and laudatory entry on Louis Clapisson by Félix Clément. On the other hand, *La Grande Encyclopédie* (c. 1890, XI) supplies only a brief and derogatory entry on Clapisson by A. Ernst.

9 The contents of Clapisson's estate included a sixteenth-century Italian spinet, "toute couverte de sculptures d'ivoire, incrustée de pierreries" (*Chronique des arts et de la curiosité*, 6 May 1866, 143), later sold by his widow to the future Victoria and Albert Museum in London. Louis Clapisson apparently had in his study just one painting worthy of mention, "un petit tableau sur bois de forme ronde représentant une marine de Joseph Vernet," which was auctioned off for the paltry sum of 10 francs.

10 This aspect of Louis Clapisson's life has recently been examined very thoroughly in Gétreau 1996, 91 ff., 117–127.

11 An examination of his estate (see note 6 above) is very revealing: the assets barely cover the debts. The State purchased Clapisson's collection for 20,000 francs in 1861 and assigned him the post of curator, clearly a favour to help a composer in grave financial straits. In 1864 Clapisson was reproached for having made a contribution to his museum when he could ill afford to do so (Archives Nationales, Paris, AJ37/321/6C). Louis Clapisson did not inherit a family fortune. His wife, Marie Catherine Bréard, known as Ketty, born in Libourne, belonged to a family from Saintes in the Charente who, while not particularly wealthy, were still proud of their ties to nobility (hence the name "de Bréard" used by Marie Catherine, notably on her tombstone in Montmartre Cemetery, and by her unmarried sister Aglaé).

12 Louis Clapisson's "arch-enemy" was the young Bizet, who composed a pastiche entitled "L'Enterrement de Clapisson" (Gétreau 1996, 121). This enmity, passed on to his son Jacques Bizet, and in turn to Jacques's friend Marcel Proust, resurfaces in the latter's derision of Clapisson through one of his characters, Odette, who wishes to go to Bayreuth for Wagner but cannot distinguish "entre Bach et Clapisson" (Proust 1954, II, 301).

13 Louis Antoine Clapisson's obituary by Timothée Trimm, in *Le Petit Journal*, 22 March 1866, mentions that his eldest son was married and known for his "opérations financières."

14 "Dîné chez Perrier avec Halévy, Auber, Clapisson très aimable et très prévenant" (Delacroix *Journal*, II, 477, entry for 15 November 1856).

15 A certified copy of his diploma, awarded 7 August 1855, is in his military dossier.

16 His military and Légion d'Honneur dossiers contain a summary of his military career recorded on 23 August 1864: "Entré au service du 3e régiment de zouaves comme engagé volontaire le 28 mars 1861 à la mairie du 9e arrondissement de Paris (Seine) pour sept ans; arrivée au corps le 17 avril 1861, zouave de 2e classe; caporal le 24 octobre 1861; sergent-fourrier le 1er mai 1862; sergent le 19 juillet 1863; incorporé au 72e de ligne par voie de simple immatriculation. Exonéré du service le 27 avril 1864; a reçu un certificat de bonne conduite. Campagnes: embarqué à Marseille le 12 avril 1861; débarqué à Philippeville le 14 dudit; Afrique: 1861, 1862, 1863, 1864 au 26 avril. Était libérable le 28 mars 1868."

17 Marie Henriette Valentine Billet was born on 20 October 1849 in Paris, at 5 rue d'Anjou-Dauphine. She was the daughter of Virginie Marie Éléonore Louise Roch, a woman of independent means, who was nineteen at the time of Valentine's birth. Her father, Henri Hippolyte Sophie Romain Billet, legally recognized her as his daughter in a document presented to Maître Potier, a Paris notary, on 24 April 1865, at the time of the girl's marriage.

Henri Billet married Alexandrine Gouverneur, who bore him a daughter, Eugénie, on 16 May 1857, and Valentine was made godmother. The two half-sisters remained very close for the rest of their lives. Henri Billet gave his daughter a generous 110,000-franc dowry (guaranteed by his château) and a 7,000-franc trousseau. Léon Clapisson contributed a 5,000-franc trousseau and 50,000 francs in cash, proof of his already substantial earnings. Among the groomsmen were the marquis de Saint-Georges (1799–1875), the librettist for Louis Clapisson's *La Fanchonnette*, and, most notably, Camille Doucet (1812–1895), Directeur de la Surintendance aux Beaux-Arts et de l'Administration des théâtres au ministère de la Maison de l'Empereur. I am most grateful to Marie-Christine Key and Patrice Planchon, notaries in Sannois, for allowing me to examine the Clapissons' marriage contract.

18 Decree dated 18 January 1872. His Légion d'Honneur dossier enumerates his ranks in the Garde Nationale, 2nd regiment in Paris, where he was promoted from *lieutenant* to *capitaine* of the 7th battalion. After the war, in 1875, he was assigned to the 11th territorial regiment of the infantry, with the rank of *lieutenant*, and resigned 31 March 1877. The fact that he served in the Garde Nationale proves that he was financially stable by 1870.

19 It is difficult to determine the exact nature of Clapisson's business dealings. In official documents he is generally referred to as a "rentier," a man of independent means. On his marriage certificate he is described as "interessé d'agent de change," though the words are crossed out. We know that he was not actually registered as a stockbroker, as there is no record of the required initial deposit. His father-in-law had been a stockbroker, and Léon Clapisson presumably moved in the same circles, well described by Zola in his notebooks for *L'Argent* (Mitterand 1986, 61–93). Attached to a notarized document dated 15 November 1887 is a note written in Clapisson's hand under the heading "E. Nathan, agent de change, successeur de A. Gavet, 11 rue du Quatre Septembre" (Archives Nationales, Paris, Minutier Central, XCII/1454); Clapisson was presumably an associate of Nathan's. An 1891 census record refers to him as a "courtier de banque."

20 In October 1871, he signed a lease (the annual rent of 1,800 francs indicates a substantial income) for an attractive apartment at 83 rue d'Hauteville, in the 10th arrondissement (Archives de Paris, D1P4 1862). There he is designated as an "artiste," which is surprising, but may be the result of some confusion with his father.

21 The first reference to his Neuilly address, at 47 rue Charles-Laffitte, is found in his military dossier on a request made out to the Ministre de la Guerre in September 1874. At the time, he was the tenant of a certain Veuve Marie. On 5 May 1881 he purchased the *hôtel particulier* at 48 rue Charles-Laffitte for 200,000 francs from a couple by the name of Heiss, with a loan of 70,000 francs from the Crédit Foncier de France to be repaid over a period of fifteen years (Archives Nationales, Paris, Minutier Central, XCII/1445). The *hôtel particulier* was destroyed

sometime between 1953 and 1965, and replaced by a modern building. It is interesting that after Clapisson's death it became the residence of the collector Charles Comiot, who gave three important works to the Louvre in 1926, including paintings by Renoir and Degas.

22 Census of 1881. The Clapissons evidently did not have any children at this time. However, an undated note, probably from about 1877, attached to Clapisson's military dossier, includes a reference to "Clapisson Léon rue Charles-Laffitte 47 à Neuilly, rentier, marié, père d'un enfant, bonne réputation, Conduite régulière." The child mentioned here presumably died young; no further information on it has surfaced. Clapisson's mother was still residing in the apartment that had come with her husband's post at the Conservatoire, where she had raised her children before the war. She would draw Louis Clapisson's salary in the form of a widow's pension until her death on 27 August 1892 at 21 rue Singer in the 16th arrondissement of Paris.

23 *La Vie Moderne*, 17 April 1880, 254. The page is headed "Les collections privées," and the drawing captioned "Paysage de Corot, collection de M. Clapisson, dessin de Tony Faivre." Clapisson also owned a small work by Tony Faivre (see Appendix II below). Ernest d'Hervilly (1839–1911) is one of the long-forgotten guests in Fantin-Latour's famous *Coin de table* (1872, Musée d'Orsay, Paris), seated beside Rimbaud and Verlaine. Corot's painting, which is not listed in Clapisson's notebooks, is published in Robaut 1965, no. 2209.

24 See Faure sale, Hôtel Drouot, Paris, 7 June 1873, and Hoschedé sale, Hôtel Drouot, Paris, 13 January 1874.

25 Clapisson may have met Gauguin, who had been working for a stockbroker. Gauguin wrote Clapisson's name in his notebook in connection with a painting entitled "Dindons" (see Huygue 1952, 225, and Wildenstein 1964, no. 276), but this work is not mentioned in Clapisson's notebooks. Gauguin also listed Clapisson's name in connection with a *Vue de Pont-Aven*, but then the name is crossed out and replaced with that of another collector, Dupuis. As well, Clapisson is mentioned in a letter from Gauguin to Theo van Gogh, the dealer who served as intermediary between them: "Pour Mᵣ Clapisson je ne suis pas étonné qu'une affaire soit difficile à terminer avec lui, je connais les habitudes de ces financiers" (Gauguin *Correspondance*, no. 192). This sarcastic remark also explains the confusion as to which work was actually sold by Theo.

26 "M. Haro, un autre pseudo expert . . . qui vendit un jour à l'hôtel une certaine peinture de Philippon, comme un Corot vrai, à M. Brame autre expert (?) qui l'acheta 5.000 F pour M. Clapisson" (A. Robaut, quoted in Bazin 1942, 73).

27 Transcript of the 1894 sale (Archives de Paris).

28 See Appendix II below. I wish to thank Caroline Durand-Ruel Godfroy and France Daguet for providing much information on Renoir, gathered in preparing the 1985–86 Renoir exhibition seen in London, Paris, and Boston. I am also extremely grateful for their assistance in this new study. I would also like to

extend my thanks to Henri Loyrette, who was kind enough to check numerous references to Degas.

29 Pissarro *Correspondance*, II, 65, Pissarro to his son Lucien, 30 July 1886.

30 ". . . à la bande à M. Clapisson" (Pissarro *Correspondance*, II, 198, Pissarro to his son Lucien, 28 August 1887).

31 "Ce Monsieur vient d'acheter à Durand la petite mosquée, mon petit domestique kabile et un buste de négresse; il voulait acheter la jeune fille en algérienne, Durand n'a pas voulu" (Archives Durand-Ruel, Paris, Renoir to Berard, undated, early June 1882; see Hôtel Drouot, Paris, *Autographes littéraires, historiques, artistiques*, 11 June 1980, no. 104). The painting Clapisson wanted to buy is *Jeune fille en algérienne* (Daulte 1971, no. 367). For details on the works he purchased see Appendix II below.

32 Vollard (1919, 92–93) and Duret (1924, 70) considered the friendship between Madame Clapisson and Madame Charpentier to have been the decisive factor in Renoir's being chosen. Madame Charpentier, born in 1848, was just a year older than Madame Clapisson. Moreover, in a letter to Paul Berard dated 22 June 1882 (partially reproduced in fig. 93) Renoir remarks that he is doing a full-length pastel portrait of the Charpentiers' youngest daughter at the same time as Madame Clapisson's portrait. Durand-Ruel had already planned to commission Renoir to paint the portraits of his five children (cat. nos. 41–44). On Renoir's relationship with the Charpentiers see also Colin Bailey's essay above.

33 See the letter of 22 June 1882 from Renoir to Paul Berard, with its accompanying sketch (fig. 93), and the undated letter to Berard, Hôtel Drouot, Paris, 16 February 1979, no. 68. As John House has noted (House and Distel 1985, no. 70), Renoir kept the first portrait and from 1883 attempted to sell it through Durand-Ruel. See also cat. no. 46 in the present catalogue.

34 See the undated letter to Berard cited in note 33 above.

35 See Appendix II below. It is through family tradition that the small portrait is identified as that of Henri Prignot, born 8 March 1881 in Neuilly at 48 rue Charles-Laffitte (i.e., at Léon Clapisson's home), the son of Marie Constant Robert Prignot, a draughtsman, aged thirty-two, and Eugénie Billet (Madame Clapisson's half-sister), aged twenty-three, with no profession, married 18 May 1880 and divorced 17 November 1886. Witnesses to the birth were Léon Clapisson, Dr. Albert Filleau (who delivered the baby), and Charles Henri Frédéric Bex, a stockbroker (further confirming Clapisson's involvement in that milieu). We know from the epitaph on the Clapisson family vault in Montmartre Cemetery that Henri Prignot died at an early age, in 1905. I have identified Renoir's portrait of the child, housed in the Kunstmuseum in Saint Gall, through a pastel copy kept by the family after the original was sold.

Proof of continued relations between Renoir and Clapisson is provided in a letter to Monet (then in Belle-Île), dated 15 October 1886, in which Renoir writes tongue-in-cheek of how he is hoping to sell one of the landscapes he had

painted recently in Brittany: "Clapisson m'a toujours embêté avec la mer sauvage. Il sera content de voir des études de ce coin là" (Charavay catalogue, no. 770, October 1980, no. 87). Clapisson did not buy any of Renoir's new works, but he did own Monet's *Mer sauvage*, which he acquired slightly later (see Appendix II).

According to his notebooks, Clapisson purchased only one other Renoir beyond the five already mentioned: *Matinée de printemps*, now in the Musée des Beaux-Arts in Algiers. But there are several other Renoirs that Madame Clapisson sold back to Durand-Ruel (in partnership with Vollard and Bernheim-Jeune) on 28 October 1915, after her husband's death: *Tête de jeune fille au chapeau de paille* (Daulte 1971, no. 430), *Paysage, effet d'automne* (a watercolour), and *Roses*. These were all minor works, and they may have simply been gifts from the artist. One last piece by Renoir has been associated (erroneously, it seems to me) with Léon Clapisson: an alleged portrait of the collector (Daulte 1971, no. 431) that appeared most recently at Sotheby's, London, 26 June 1985, no. 111, with its provenance incorrectly listing the painter Derain.

36 See Blot 1934, 5–6. Blot describes Filleau as a political friend of his father and a supporter of the député Eugène Spuller (fig. 167), and he acknowledges Filleau as the person who introduced him to Impressionism. Vollard (1937, 39–40) knew Dr. Filleau from early on; he was introduced to him by Rops.

37 In November 1894 Rops wrote sorrowfully of the death of his friends: "La délicieuse exquise et savante Mathilde Godebska, Malassis, Dubois, Filleau, Camuset, Gouzien, Clapisson, Schaunard" (quoted in Delevoy et al. 1985, 233).

38 Bénédite 1923, 86–90.

39 In one of his notebooks (Musée Marmottan, Paris, MM5160/3), Monet wrote down Clapisson's address, "Clapisson 48 rue Charles-Laffitte Paris Neuilly," and in another (MM5160/5) he recorded a sale to him, "1886 Clapisson tulipe 1 500" (see Appendix II). In a letter of 25 February 1888 to the critic Gustave Geffroy concerning the paintings he should reproduce, Monet points out: "Il y a également M. Clapisson, fils du musicien qui a pas mal de tableaux de moi. Van Gogh [the dealer, Theo, brother of the artist] qui le connaît bien pourra lui demander pour vous en lui expliquant le but" (Wildenstein 1974–91, no. 2732, [842a]).

40 Caroline Durand-Ruel Godfroy has indicated that Clapisson purchased two of Sisley's works from Durand-Ruel in 1882, *Saint-Mammès et les côteaux de la Celle*, for 1,500 francs, and *Paysage temps orageux*, for 1,000 francs (*Sisley* 1992, 48, 59, n. 23). For the latter, whose vague title is not recognizable on Clapisson's lists, see Daulte 1959b, no. 317. Clapisson did not sell back any of Sisley's works to Durand-Ruel in 1891 or 1892, perhaps because the dealer was no longer handling Sisley at that time.

41 Archives Durand-Ruel, Paris, "Journal," 19 May 1891, folio 171. See Appendix II.

42 Archives Durand-Ruel, Paris, "Journal," 21 April 1892, folio 284. See Appendix II. Since all prices are listed, it is possible to measure the increase in value of each artist's work, Degas's naturally being the most expensive.

43 The portrait was sold on 12 November 1908 for 15,000 francs, yielding a good return. See note 35 for other works that remained in Madame Clapisson's possession. Valentine Clapisson left Neuilly after her husband's death, living subsequently in Noisy-le-Roi, in Versailles (Villa La Fanchonnette, boulevard de la Porte-Verte, and 4 avenue Mirabeau), and in Chesnay (28 rue Saint-Joseph), where she died on 30 August 1930 at the age of 80.

44 The transcript of the sale of 28 April 1894 (Archives de Paris, D48 E3C79, no. 7981) reveals that it was carried out in Durand-Ruel's name, without Valentine Clapisson's name appearing. Monet's *Les Pins* (Wildenstein 1974–1991, no. 1190) and two Renoirs (Daulte 1971, nos. 400, 406) – numbers 20, 25, and 26 in the sale catalogue – were sold to Durand-Ruel, "propriétaire vendeur," and their prices, the highest in the sale (adding up to one third of the total), were deducted from the overall amount. It seems likely that number 21, *Les Fonds de Varangeville* (1882) by Monet (Wildenstein 1974–1991, no. 797), which is not on Clapisson's lists, was also added from Durand-Ruel's stock, but was sold at a high price to Montaignac, Petit's agent (and Durand-Ruel did not choose to buy it back). The two works by Monet had been lent by a certain Guillemard to the *Claude Monet – Auguste Rodin* exhibition at Georges Petit's gallery in 1889. The proceeds amounted to 30,107 francs, of which Valentine Clapisson received 26,657 francs after expenses were deducted (Archives Durand-Ruel, Paris).

Léon Clapisson spent slightly over 400,000 francs on works of art in his lifetime, twice what he paid for his *hôtel particulier* in Neuilly. It is an enormous sum, considering that a contemporary Parisian household was thought to be comfortable with earnings of 10,000 francs per year. If we deduct from this the known amount of money realized for works that were sold in 1885, 1891, 1892, and 1894, totalling slightly under 150,000 francs, we are left with 250,000 francs for works whose ultimate resale prices are unknown to us but which were initially purchased for approximately that amount. Assuming Clapisson did not sell these works at a loss, he may have done no more than recover his original capital. All in all, the investment was not especially profitable, even if some gains were occasionally made, particularly on the Impressionist works, which originally must have seemed the least likely to be "blue-chip."

CATALOGUE

Forty-three Portraits of Painters in Gleyre's Atelier c. 1856–68
Collective work with contributions by Renoir and Émile Laporte c. 1862–63

117 × 145 cm
Musée du Petit Palais, Paris

THIS COMPOSITE GROUP PORTRAIT of forty-three students of the atelier of Charles Gleyre (1806–1874), painted by many hands over a period of twelve years (the earliest can be dated to 1856, the latest to 1868)[1] is notable for two reasons. It includes the first painted portrait of Renoir, aged twenty-one – clean-shaven, he is third from the left on the fourth row down – as well as one of the first by him: the portrait of his "ami intime" Émile-Henri Laporte (1841–1919), seen facing Renoir in profile, sporting a russet beard and starched white collar.[2] Directly above Renoir is a portrait of Alfred Sisley, which may also have been painted by him.[3] To the right of Sisley is the commanding presence of the most aristocratic of Gleyre's students, Ludovic Napoléon, vicomte Lepic, Degas's future collaborator and model (fig. 60).[4] And below Renoir, second from the left, is a bearded figure, traditionally identified as Eugène Baugniès, who bears a striking resemblance to Bazille.[5]

With its origins in the drawn and lithographed studio portrait of the 1820s – pictorial forebears would include Colin's *Atelier de Girodet* and depictions of Gros's studio – *Gleyre's Atelier* is pendant to a less finished canvas of identical dimensions portraying forty-five painters from Paul Delaroche's atelier (fig. 99) of whom only nine can be identified with any certainty.[6] Both paintings belonged to the "peintre-décorateur" Paul Albert Baudouin (1844–1931), seen in the top right-hand corner of *Gleyre's Atelier*. After studying with Gleyre in the mid-1860s, Baudouin went on to work with Puvis de Chavannes and to enjoy fame as the reviver of fresco painting in France in the last decades of the Third Republic; his mural commissions include the peristyle of the interior courtyard of the Petit Palais (1906–10).[7] It is Baudouin who provided the names of thirty-four of the sitters and twenty-two of the painters who collaborated on *Gleyre's Atelier* – his inscriptions are written on the back of the canvas – and, as has been confirmed by William Hauptman's magisterial study of this painting, his identifications are for the most part incontrovertible.[8]

In this array of largely well-coiffed, properly dressed young men[9] – one shown posthumously (the unknown figure just right of centre with a halo around his head), another assuming the guise of a model (the naked Edmond de Pury) – an entire generation of ardent would-be painters is captured for posterity. Yet the group assembled here represents only a fraction of the six hundred students who passed through Gleyre's atelier between 1843 and 1874: no women are included, nor are any of the English or American students.[10] If the atelier was renowned in its day for

having produced the leading exponents of the neo-grec manner of which Gleyre himself was past master – both Gérôme and Hamon studied with him – more recently it has gained notoriety as the training ground and meeting place of the future Impressionists Renoir, Bazille, Sisley, and Monet (the latter not pictured in this group portrait).[11] By the late 1850s Gleyre, whom Renoir remembered as "un fort estimable peintre suisse," was recognized both as a successful teacher, whose students were winning the Prix de Rome with some regularity, and as a liberal, somewhat eccentric character, who refused to accept a fee from any of his pupils.[12] Those who studied with him were required to contribute ten francs a month; this paid for the hire of a model, who generally posed once a week on Monday, and went towards the rent of the studio, which from 1859 was at 69 rue Vaugirard.[13]

Following the *succès d'estime* of his *Lost Illusions* (Musée du Louvre, Paris) at the Salon of 1843, Gleyre – who was neither an Academician nor a teacher at the École des Beaux-Arts – had inherited the studio of Paul Delaroche after the latter's removal to Rome, and he soon established a thriving practice. The purpose of private ateliers was to prepare students for the competitive *concours des places* held at the École des Beaux-Arts twice a year, which offered "advanced pupils a locale in which to practice under the eye of a rota of masters."[14] With sufficient training, students could eventually sit for the Prix de Rome. "Beloved by all who came into contact with him," Gleyre might be an attentive, discreet, and generous teacher – unlike Delaroche, he corrected his student's errors as quietly as possible in order to avoid embarrassing them – yet the training he offered was both rudimentary and conventional.[15] As in all private ateliers, the emphasis was on drawing, either from the live model or from plaster casts. Gleyre also encouraged drawing from memory, and gave his pupils biblical or classical compositions as preparation for the École's exams. Two of Renoir's earliest figure studies (fig. 101) show him to have been an accomplished if unexceptional student.[16] As Bazille informed his parents, one was not allowed to touch a paintbrush until command of the drawn figure was thoroughly mastered, in his case a matter of four months of regular instruction.[17]

Renoir's passage in Gleyre's studio, which seems to have been an embarrassment to some of his later supporters, was meant to prepare him for the *concours des places* at the École des Beaux-Arts, and it did so effectively.[18] Registered as a pupil of Gleyre's by November 1861, Renoir was admitted to the École des Beaux-Arts the following April, placing sixty-eighth out of eighty. He came fifth out of eight in the *concours de perspective* of 18 April 1862, and last out of ten in the *concours de figure peinte* of August 1862, the subject of which was "Joseph Sold into Slavery by His Brothers."[19] Renoir did not sit for the winter *concours des places* – from 1 October until 31 December 1862 he was away doing his military service – but the following April he competed again and came twentieth out of eighty-four. In August 1863 he again entered the *concours de figure peinte* – the subject this year was "Ulysses in Alcinous's Palace" – at which he did only marginally

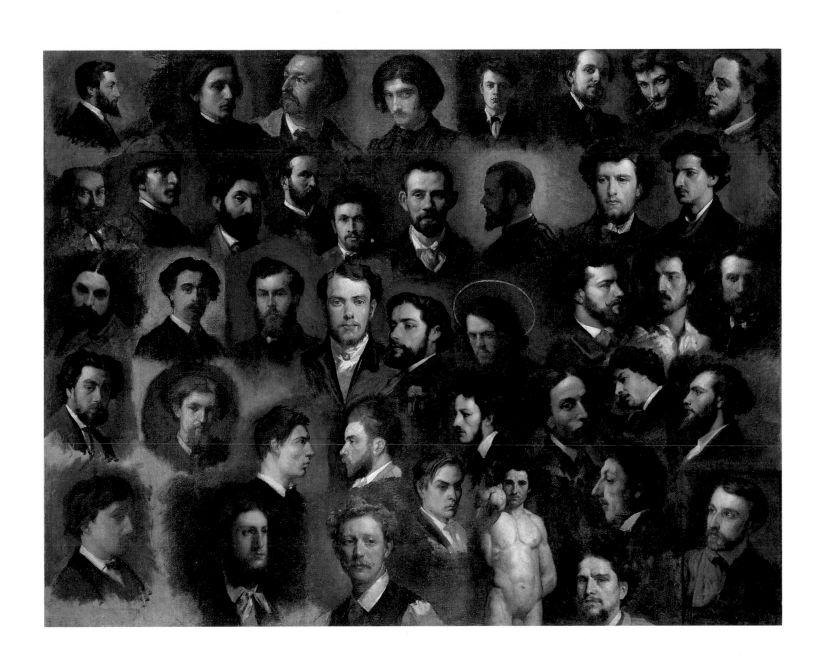

better than in his previous attempt, coming ninth out of eleven. He did not sit for the *concours des places* the following March because he was again away on military service between January and March 1864.[20]

As might be suspected from the more or less indistinguishable styles of the forty-three portraits by some twenty-two different hands, Gleyre's training provided an acceptable standard of technical proficiency based on orthodox principles. His pedagogy may well have been generous, but it is anachronistic to see him as "preoccupied with developing his pupils' original qualities."[21] He did not offer advanced training in any form, and he certainly did not encourage his pupils to sketch outside the precincts of the studio *en plein air*.[22] Although antagonistic towards officialdom – he refused to exhibit at the Salons of the Second Empire and he turned down the Légion d'Honneur – Gleyre was recognized as an implacable opponent of both Romanticism and Realism.[23] He could not accept that modern life might provide subjects "worthy of the employment of the painter"; his was "the true school of poetry and style . . . and no one better evoked the Greeks than he."[24]

Furthermore, Renoir's success in Gleyre's studio and at the École des Beaux-Arts between 1861 and 1864 suggests that his early development was more complex than is implied by a heroic history of early Impressionism. Renoir's training was a curious mixture of the artisanal and the academic. He gained experience as a colourist by painting blinds for export to the Jesuits and by decorating porcelain for the domestic market; he succeeded in Gleyre's studio, while also painting ill-digested pastiches of Boudin and Diaz, and providing a steady supply of bituminous landscapes in the manner of Théodore Rousseau, the sale of which subsidized his immersion in the École's curriculum.[25]

That Renoir's initiation into the vanguard of French painting was more ambivalent than he chose to remember is confirmed by closer inspection of *Gleyre's Atelier* itself. The friendships with Sisley, Bazille, and Monet that would determine the course of his painting after 1864 have yet to be established. Renoir, it should be remembered, was a year ahead of his future companions-in-arms: he had entered Gleyre's studio in November 1861, while Sisley started in October 1862, Bazille in November 1862, and Monet, with some hesitation, in December 1862.[26] Furthermore, between October and December 1862 Renoir was undergoing the first stint of his military service and so was absent from Paris.

In fact, in 1861–62 Renoir's closest affiliation was with the obscure painter Émile-Henri Laporte, to whom he later gave credit for his having joined Gleyre's atelier in the first place.[27] Son of Henri-Émile Laporte, a casemaker ("gainier") and Zélie Menut, a dressmaker's assistant, Laporte had met Renoir in the late 1850s when both were students at the free École de Dessin in the rue des Petits-Carreaux, a municipal drawing school that Laporte would later go on to direct.[28] Brought up by his grandparents in Colmar and Troyes, Laporte had returned to Paris at age thirteen to take up an apprenticeship as a copperplate engraver, which he abandoned to enter Gleyre's atelier.[29] In 1862 Renoir is documented as sharing an apartment with Laporte at 29 place Dauphine, the family residence, and two years later would paint a second portrait of him (fig. 100) as well as one of his sister Marie-Zélie (fig. 105).[30] It seems likely that between 1860 and 1864 Renoir was closer to Laporte than to any of his more famous fellow students – Laporte's niece later wrote that Renoir "visited the family almost every day" and made them a present of one of his flower still lifes – yet the two artists soon lost contact, and it was only through the efforts of Vollard and Ellen Andrée half a century later that Laporte made a brief reappearance in the Renoir literature.[31] Yet Renoir's adept bust portrait, his most accomplished portrait to date, has both aesthetic and historical significance. He confided to Rivière that, as a student, such a task had seemed beyond him: "I thought I would never be able to draw a head, so difficult did this seem to me."[32] A modest victory then, and one that augured well.

2 *William Sisley* 1864

81 × 65 cm
Musée d'Orsay, Paris

LATE IN LIFE Renoir recalled that after leaving Gleyre's studio he had been advised by his sister to turn to portraiture as a way of earning an income from painting: "And that is just what I did. Except that my models were my friends and I did their portraits for nothing."[1] Among the finest of these early commissions are Renoir's portraits of his friend and fellow student Alfred Sisley (fig. 103) and his father, William Sisley (1799–1879), both of which were painted at the same time.[2] Who exactly was responsible for the commission is unknown, although it was obviously Renoir's decision to submit the portrait of William Sisley to the Salon of 1865.[3] And if this relatively austere portrait was intended to encourage potential clients, it is not altogether clear that it achieved its goal, since the painting was mentioned by not a single critic.[4]

Renoir's "perspicacious early portrait" captures the shrewd and somewhat forbidding character of the sixty-five-year-old Protestant businessman who had moved from London to Paris in 1839 (the year of Alfred Sisley's birth) and who, by 1860, was established as one of the "notable merchants" of the 10th arrondissement.[5] Born in Dunkirk on 6 December 1799 to an English father who would marry three French wives, William Sisley descended from generations of "desperate and daring smugglers" in Romney Marsh, Kent.[6] His wife (and cousin) Felicia Sells (1810–1866), whom he married in March 1827, was the daughter of the keeper of the debtor's prison in Dover Castle, who had previously been a saddler and a smuggler.[7] By the 1830s, William had shed such embarrassing ancestors. As part-owner of Thomas Sisley and Company, with a warehouse in Watling Street behind Saint Paul's Cathedral, he prospered importing French goods to London. In 1839 the Sisleys and their three children crossed the Channel, and they are first documented as living at 39 rue des Bornes in Paris's 11th arrondissement, where Alfred was born on 30 October.[8] William Sisley et Compagnie was established in April 1841, and its premises were registered at 1 passage Violet, in the 10th arrondissement, from 1845 to 1847. From 1848 to 1872 the business was located at 3 passage Violet, with the family living in the 9th arrondissement at 43 rue des Martyrs between 1859 and 1865 and at 13–15 rue Moncey from 1865 until the outbreak of the Franco-Prussian War.[9]

It is now generally assumed that William Sisley, who is listed simply as "négociant commissionaire" in the *Annuaire-Almanach du Commerce*, traded in luxury articles with a specialty in imported gloves; the claim that he manufactured artificial flowers and had clients in South America seems to be pure fiction.[10] Like Bazille's family, Sisley was sufficiently affluent to provide his youngest son with an income during his student years. His second daughter, Aline Frances (1834–1904), who would come to own Renoir's portrait of her father, made a successful marriage to Théodore-Lucien Leudet, a doctor who attended Sarah Bernhardt.[11] However, the dislocation caused by the Franco-Prussian War led to losses from which Sisley *père* was unable to recover.[12] In his

seventies, he left Paris for the village of Congy, where he was looked after by a *gouvernante*. Alienated from his children and by now possibly deranged, he lived in retirement on a modest income from a life insurance policy. This and a piece of furniture valued at 170 francs, his only possessions of any significance, were bequeathed to his half-brother, Thomas, upon his death on 5 February 1879 at the age of seventy-nine.[13]

Sisley's first biographer recorded that his father had been "displeased with his son's preference for painting rather than serious business activities and had abandoned him to the vagaries of a bohemian existence."[14] While it would be tempting to see Renoir's stern patriarch as a disapproving *père de famille*, William Sisley's rupture with his youngest son actually occurred over Alfred's liaison with Marie-Adélaïde-Eugénie Lescouezec, an artist's model and florist five years his senior, who bore his first child in June 1867.[15] Only then did Sisley withdraw the financial support that had allowed his son to study as a painter without seeking additional employment.

In 1864, the year in which Renoir dated his portrait of William Sisley, such family tensions were still far off. That William sat to Renoir and allowed his portrait to appear at the Salon of 1865 suggests some tolerance of the kind of artistic ambitions that his son shared. In January 1864 another fellow student from Gleyre's atelier, the American Daniel Ridgway Knight (1839–1924), recently returned to Philadelphia, wrote warmly to Sisley asking him to send "pictures of the whole family," concluding, "I can never forget the real English hospitality of your house and the kindness of your father to a stranger."[16]

The most striking characteristic of Renoir's portrait of William Sisley is its uncanny likeness. Comparison with a studio photograph, surely taken around the same time (fig. 104), confirms the veracity of Renoir's brush as well as the kinship of his approach with the conventions of portrait photography.[17] While I am not suggesting that Renoir made use of this photograph of William Sisley, it is clear that his sitter is wearing identical daily business attire. Frock-coat, waistcoat, silk cravat, starched collar – even the same elegant tie-pin may be seen, placed somewhat lower in the photograph than in the painting. Renoir is also scrupulous with regard to Sisley's long side-whiskers and pugnacious chin (although the sitter is rather more ferocious in the photograph), and he does not hesitate to appropriate a pose similar to the photographer's. Sisley holds his spectacles in his right hand – he is about to put them on? – a well-established mannerism to suggest that something has just caught the sitter's attention.

Direct and frontal in presentation, subdued in tonality, and painterly in handling (for example, in the dabs of impasto that make up Sisley's grey hair and the touches of red added to the flesh tones of his face and hands), Renoir's commendable Salon portrait compares well with contemporary examples by Baudry and Henner, but at this point has less in common with Manet or Fantin.[18] The young artist's inexperience is also manifest. The build-up of shadows on Sisley's right cheek is slightly maladroit, and Sisley's corpulence is not always convincing. But in his rich handling of the sitter's apparel, whose folds and creases are lovingly described, Renoir applies ivory black with a sureness of touch that would doubtless have won his teacher's approval.[19]

3 *Mademoiselle Romaine Lacaux* 1864

81 × 65 cm
The Cleveland Museum of Art
Gift of the Hanna Fund

IN 1864 RENOIR MADE the transition from student to promising young painter. His *Esmeralda*, a Romantic subject picture inspired by Victor Hugo's *Notre-Dame de Paris*, was accepted at the Salon – his submission the previous year had been rejected – and he received his first commissions for portraits.[1] Of these, *Romaine Lacaux*, if not altogether successful in its deployment of accoutrements, is by far the most beautiful. Striking for the absolute concentration with which this "little bourgeois infanta" presents herself, the work has been justly admired since it was first published in 1928, although the silence of Renoir's contemporary biographers helped ensure that the sitter remain shrouded in obscurity.[2]

Building upon Anne Distel's research, it is now possible to present a more complete, if still rather bloodless, biography of Renoir's attractive nine-year-old.[3] Romaine Louise Lacaux, named for her maternal grandmother, was born on 10 May 1855 and baptized four days later at the Église Sainte-Marguerite in the 11th arrondissement.[4] She was the daughter of Paul Adolphe Lacaux (1816–1876), an enterprising manufacturer of earthenware goods – he is listed in the documents as "fabricant de poteries de terre" – and Denise Léonie Guénault (1823–1909), daughter of another well-established earthenware manufacturer.[5] Three weeks before his marriage to Denise Léonie on 26 April 1842, Paul Adolphe had purchased property at 27–29 rue de la Roquette – consisting of a three-storey house and workshops for the fabrication of earthenware – for the considerable sum of 40,000 francs.[6] Since his future wife's family had their premises at 31–33 rue de la Roquette, the impending union sealed the business relationship between these two producers of earthenware goods, and indeed until 1873 Lacaux-Guénault, "fabricant de poteries de terre," was listed as among the more substantial enterprises in the 11th arrondissement.[7]

In July 1843, the Lacaux had their first child, Nicolas François (1843–1906); their second child and only daughter, Romaine Louise, was born twelve years later.[8] For the first thirty years of their marriage, the Lacaux occupied a relatively modest apartment on the second floor of 27 rue de la Roquette – above the shop, as it were – and it is far more likely that it was here, and not on holiday in Barbizon, that nine-year-old Romaine Louise sat to Renoir in 1864.[9]

After undertaking improvements to their property in 1866 – the courtyard of 27 rue de la Roquette was cleared, the building transformed into a factory for *articles de poterie*, and a number of units set aside for rental – Romaine's father sold his business in 1873 to Jean Louis Briffault, who used the premises to manufac-

ture ovens and stoves.[10] Now in retirement, Paul Adolphe moved his family to 60 rue des Tournelles in the 3rd arrondissement, where he is listed simply as a *rentier*, and it is here that he died three years later.[11]

In April 1883, at the age of twenty-eight, Romaine Lacaux married François Martial Lestrade (born 17 April 1850), the son of a baker from Auch, who gave his profession at this time as an "employé de commerce."[12] Three years later the couple opened a general store at 5 rue Geoffroy-Marie in the 9th arrondissement, where they lived in a spacious apartment on the first floor.[13] The Lestrades had two children: a son, Francis Eugène, born in March 1886, and a daughter Pauline, born three years later on 23 January 1889. Nothing more is known of the family until the tragic death of all its members during the First World War. Francis Eugène, "lieutenant au 2ᵉ régiment de marche," was killed on duty in Champagne on 26 September 1915, "mort pour la France."[14] His parents and sister all died together on 8 March 1918 when a bomb fell on their house in the rue Geoffroy-Marie. All three were listed as "victimes d'un bombardement aérien."[15]

Renoir's ties with the Lacaux in the early 1860s are impossible to document with any certitude. There is no evidence that they were friends of his parents, although it has been reasonably suggested that as a decorator of porcelain plates, Renoir might have come into contact with manufacturers of domestic goods such as the Guénaults and the Lacaux.[16] The godfather of Romaine's elder brother produced faience, and at least two major porcelain manufacturers are listed in the rue de la Roquette.[17] In the early 1860s Renoir's clients were often petit bourgeois artisans facing the challenge of industrialization, and it is notable that his portrait of Marie-Zélie Laporte (fig. 105), daughter of a successful casemaker, painted in the same year as that of Romaine Lacaux, employs a similar frontal presentation and pose.

Although Renoir knew Marie-Zélie and her family quite well, his relationship with the more prosperous Lacaux was in all likelihood less familiar. Nonetheless, he arrived at a remarkably sensitive and unsentimental portrayal of their self-assured nine-year-old daughter, resplendent in an aureole of clear, white light. Romaine Lacaux engages the viewer with an intensity and directness as yet unprecedented in Renoir's oeuvre. Sitting on a wooden chair that is palpably too small for her, she is attired in a belted dress of *mousseline de soie*, with her white blouse slightly askew, and wears coral and gold earrings. Her fingers, knotted a little nervously, rest upon a bed of flowers.

Renoir has drawn promiscuously on potentially discordant traditions – the *carte de visite* (fig. 29), the Baroque *portrait d'apparat*, the more polished Salon prototype – and yet, for all this, as Kermit Champa has justly observed, spatial construction almost eludes him.[18] Foreground and background are collapsed, and the arrangement of what appear to be flowers behind the sitter hovers uneasily between the chair and the patterned wallpaper that continues behind the semi-transparent white drapery, itself adjusted several times. But it is precisely in details such as these, as

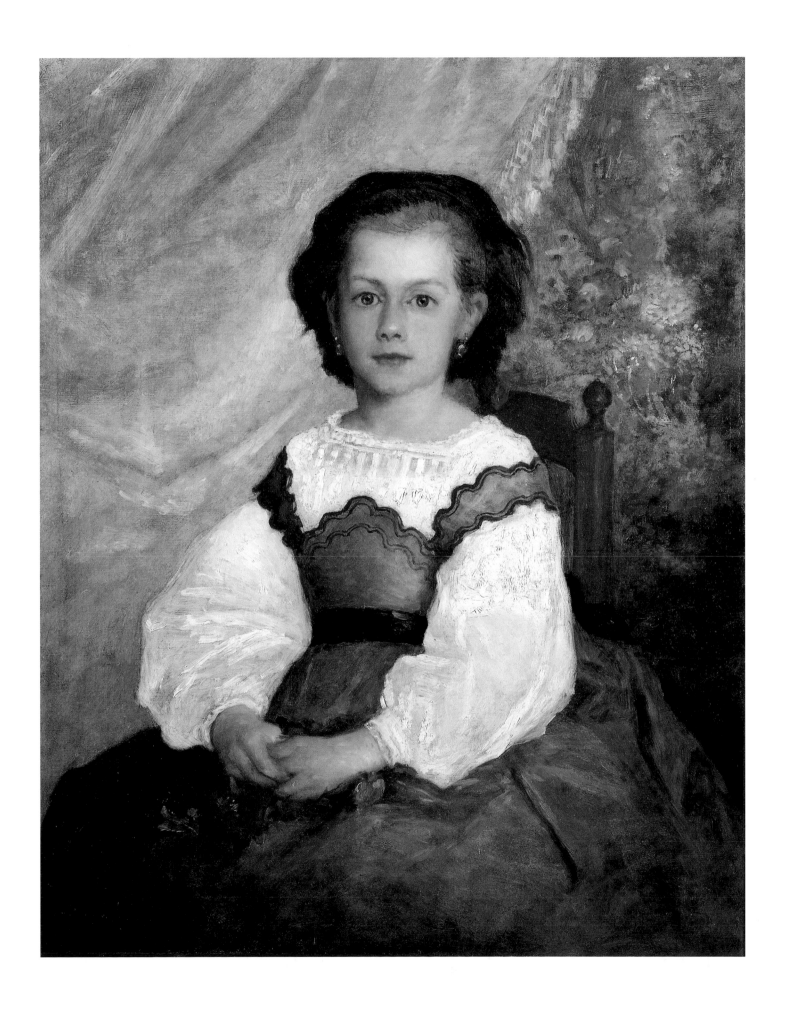

well as in the bravura attempt to render the white undergarment beneath Romaine's blouse and the flesh of her arms through her silk sleeves (brilliantly achieved for the left arm, less successful for the right) that Renoir surpasses all of his previous work. The variations of touch – the heavily impasted sleeves and bodice, the pink-grey washes that give rhythm to her skirt, the scraping and reworking of the flowers in the background – compromise neither the solidity of Renoir's modelling nor his extraordinary luminosity, both of which make a first appearance in this work.

As Henri Loyrette has pointed out, a rehearsal of the various sources for *Romaine Lacaux* – from Ingres to Corot, Velázquez to Whistler – is of little help in accounting for the wide-eyed brilliance of Renoir's commissioned portrait.[19] A contemporary source that has gone unnoticed suggests an unexpected early kinship with Degas: both artists had copied in the Louvre in the early 1860s.[20] *Romaine Lacaux* is a distant cousin to Degas's *Nathalie Wolkonska* (1860–61, fig. 106), who is also posed against floral wallpaper: both young girls are sympathetic, alert, and thoroughly self-possessed.[21] Finally, the manner in which Renoir signed this work throws additional light on his ambitions at this time. The capitalized signature to the right of the black bow behind the sitter's skirt – used again the following year in the portrait of Mademoiselle Sicot (National Gallery of Art, Washington) – is a gentle reminder that Renoir still considered himself a pupil of Gleyre.[22]

195 × 131 cm
Nationalmuseum, Stockholm

BALANCING PLATES AND CUPS with the debris of a recently finished meal, a serving girl in a grubby apron clears the table. Next to her, a tall bearded figure in the blue smock customarily worn by peasants and workers rolls a cigarette from the pouch of tobacco cradled between his hands. Like the seated, clean-shaven fellow next to him, he is absorbed by the remarks of the bearded man in a cream felt hat, seen in profile, who completes this frieze of figures set at some remove from the picture plane. One hand in his pocket, the figure on the far right gestures with the other to emphasize a point made in conversation. Wedged between him and his seated companion, an older woman in lost profile, her hair covered by a spotted kerchief, attends a group we cannot see. The wall behind her is covered with caricatures of four figures, and directly above the standing man can be seen the verse of a song with its accompanying musical notation. A wooden crossbeam at right suggests both the lowness of the ceiling and the rusticity of the setting.

"I shall always remember the excellent Mère Antony and her inn at Marlotte, a real village inn," Renoir told Vollard in 1918.

> As the subject of my painting I took the public room which doubled as the dining room. The old woman in the headscarf is Mère Antony herself; the splendid girl serving drinks is the servant Nana; the white poodle is Toto, who had a wooden leg. I posed some of my friends around the table, including Sisley and Le Coeur. As you can tell from my painting, the walls were covered with murals – the unpretentious but quite respectable handiwork of some of the inn's regular clientele. I myself did the silhouette of Murger that is reproduced in the upper-left corner of my painting.[1]

Renoir went on to explain that the murals were whitewashed at the request of Henri Regnault, another visitor to Marlotte, who offered to provide more elevated decoration. When he failed to do so, Mère Antony resorted to hanging Renoir's group portrait in a place of honour: "How pleased I was to have a work of mine exhibited. It seemed like glory already."[2]

Written more than half a century after *The Inn of Mère Antony* was painted, Renoir's vivid account, not without its inaccuracies, still serves as the essential starting point for a consideration of his most ambitious figure painting to date, a large-scale work that is "both a group portrait and a scene of modern life."[3] Whereas the two women and the poodle Toto present no difficulties, the three male figures have been variously, and often implausibly, identified. Monet, Pissarro, Franc-Lamy, and Renoir himself have all been nominated as candidates for inclusion, though not one of them makes an appearance here.[4] It is now generally agreed that the man rolling a cigarette is the wealthy thirty-four-year-old architect-turned-painter Jules Le Coeur (1832–1882) (fig. 107), who in April 1865 had acquired a house and studio at Marlotte – a village of some five hundred inhabitants on the southern edge of the forest of Fontainebleau – and with whom Renoir and Sisley stayed at various times in 1865 and 1866.[5] The seated figure whose conversation animates the scene is undoubtedly Alfred Sisley; he exhibited two landscapes of Marlotte at the Salon of 1866.[6] Anne Distel was the first to provide a clue to the identity of the full-faced clean-shaven figure when she noted that in August 1905 the bronze-caster and part-time dealer A.A. Hébrard, who was hoping to sell *The Inn of Mère Antony* to the prince de Wagram, listed the *dramatis personae* of Renoir's canvas as "the painters Bos, Le Coeur, and Sysley [sic]."[7] Although Distel was unable to trace a painter by the name of Bos in any of the catalogues or registers of the Salon for that period, two painters of this name are known, the Leiden landscapists and *animaliers* Gerardus Johannes Bos (1825–1898) and his brother Christiaan Bos (1835–1918).[8] Obscure though these painters are, the candidacy of one or the other as the model for the third man in Renoir's group portrait appears less outlandish when it is remembered that Le Coeur's first wife, Marijann Bowens van der Boijen, who had died in childbirth in November 1862, was Dutch.[9]

Renoir also told Vollard that he had painted *The Inn of Mère Antony* in 1865, a date he presumably repeated to Meier-Graefe, who, in order to accommodate the evidence of the signature – "RE[NOIR] 1866" – claimed that the painting was started in 1865 and completed in January–February of the following year.[10] In fact, as Douglas Cooper ingeniously demonstrated, *The Inn of Mère Antony* dates quite precisely to the early summer of 1866, where it appears as the culmination of Renoir's experiments during his most productive period thus far.[11] Once this group portrait is moved from January–February 1866 to four or five months later, it becomes clear that it was undertaken in the aftermath of Renoir's dispiriting experience with the jury for the Salon of 1866 who had rejected his life-size *Figures in a Landscape* (whereabouts unknown) but had accepted a landscape done at Marlotte, which he in turn withdrew from exhibition.[12] Retreating from Paris to Marlotte in April, Renoir seems to have thrown himself into painting landscapes inspired by Diaz and Courbet, the most notable of which, *Jules Le Coeur in the Forest of Fontainebleau* (1866, Museu de Arte de São Paulo), was executed almost entirely with a palette knife.[13] By mid-May he returned to painting with the brush – he confided to Le Coeur that he had discovered "la vraie peinture" – and the more freely handled *Large Vase of Flowers* (1866, Fogg Art Museum, Cambridge, Mass.) and *Inn of Mère Antony* sustained him for the rest of the summer.[14]

Thus Renoir's first monumental group portrait – neither a commissioned work, nor a painting for the Salon – was conceived in the spirit of a *refusé* and owes much to the examples of Courbet and Manet, two more celebrated recalcitrants. As has often been noted, *The Inn of Mère Antony* shares elements of composition and mood with Courbet's *After-Dinner at Ornans* (1848–49, Musée des Beaux-Arts de Lille), but more as tribute than in emulation.[15] In its deployment of blacks, browns, and greys, its suppression of half-tones, and the exquisitely variegated whites that describe Nana's apron, the starched tablecloth, the porcelain cups with their red rims, and the crumpled newspaper, Renoir's magisterial group portrait looks to Manet, whose *Fifer* (Musée d'Orsay, Paris), also rejected from the Salon of 1866, Renoir copied.[16] A source closer to home, and considerably more banal, is Firmin-Girard's *Hot Day at Marlotte* (fig. 108), a group portrait *in petto* painted the previous year that shows Renoir's host Jules Le Coeur in the company of the more conventional painters Henri Charles Oulevay, Paul Vayson (a fellow former pupil of Gleyre's), and Guillaume Tasset.[17]

97

Renoir referred affectionately to *The Inn of Mère Antony* as "ma grande tartine" – his screed or harangue – and indeed the levels of discourse on which this monumental but seemingly casual group portrait operates situate him unequivocally in the orbit of Courbet and Manet. As always with Renoir, the directly observed is rarely as transparent, or as simple-minded, as is generally assumed. Thus, whereas Courbet's post-prandial conversation piece is firmly anchored by the firelight of evening, Renoir's *Inn of Mère Antony* is infused with a blond, even light that suggests luncheon. Yet it is clear from various accounts of the artists who worked in the forest of Fontainebleau and lodged at Barbizon, Chailly, or Marlotte, that the summer days were normally spent out of doors, working under a parasol, with a lunch packed for the occasion.[18] "Dinner was the great event of the day" – returning to the inn at sunset in expectation of a hearty meal, "they threw off their hats, tied their dogs to the foot of the chair, and behaved just like older children in a refectory but with the appetites of men refreshed from a day spent in the bracing air of the forest."[19]

The daylight that permeates Mère Antony's inn also allows Renoir to settle scores on his own terms. As has been noted, a newspaper with its title quite legibly inscribed is placed near Sisley's lap at the table's edge.[20] *L'Événement*, while sharing the name of a fiercely Republican journal founded in August 1848 by Victor Hugo, was in fact a recently launched and rather fashionable newspaper that Duret remembered as having been especially popular with the cultural beau monde.[21] Founded in October 1865 by Hippolyte de Villemassant, editor of *Le Figaro*, it folded just over a year later, but became notorious in its own day – and celebrated in ours – for having published the earliest criticism, both literary and artistic, of the twenty-six-year-old Émile Zola.[22] Zola's article on Manet caused a scandal, appearing as it did in the context of a review of the Salon that had rejected both of the painter's submissions, and obliged its author to tender his resignation as art critic, which was accepted on 20 May 1866.[23] Although he had yet to defend Renoir in print, Zola's kind words for Monet's *Camille* (1866, Kunsthalle Bremen) served that artist well. On 22 May, Monet informed Amand Gautier that his aunt and patron, the wealthy Madame Lecadre, had been delighted by such good press: "She had received the copy of *L'Événement* that you sent her from no fewer than three other people."[24] Renoir's inclusion of the journal that had briefly published Zola's commentaries in support of his fellow *actualistes* was both an expression of solidarity as well as a tacit affirmation of the power of the press – the first of several such covert manifestos in his work.[25]

Renoir's discreet metonymic reference to Zola is accompanied by a more expansive homage to Marlotte's most famous citizen. The bowler-hatted figure on the wall at upper left, whose eyes are also turned in Sisley's direction, is Renoir's own caricature of Henri Murger (1822–1861), the inebriated inventor of bohemia, who had settled permanently in Marlotte in 1855, bringing "an entire Parisian colony" in his wake.[26] Murger was later remembered by Alphonse Daudet as having "a large, sad face, reddened eyes, and a thinning beard – the signs of weak Parisian blood – a rifle always on his shoulder, pretending to hunt."[27] Not only is Renoir's caricature quite to the point in its likeness and inclusion of attributes (fig. 109), it is also accompanied by the lines "Musette qui n'est plus elle / Disait que je n'étais plus moi," a verse from his hit musical *La Vie de Bohème*.[28]

Renoir's appropriation of his own popular imagery establishes an interesting dialogue between high and low art, but it also records a distinctive feature of artists' inns such as Mère Antony's, the Auberge Ganne in Barbizon (where Sisley had stayed in 1861), or the Cheval Blanc in Chailly (whose guests included Carolus-Duran as well as Monet and Bazille).[29] Such "picturesque, jolly inns . . . the very weekend-cottages of art,"[30] were routinely decorated with free and occasionally licentious daubs done by their guests "on rainy days when one could not go out and paint in the forest."[31] The Goncourts, who made annual forays to such hostelries in preparation for their novel *Manette Salomon*, and who visited Marlotte on several occasions, may even have seen Renoir's original caricature of Murger, or one very much like it. Recording their stay in "the ignoble phalanstery of Murger's harem," on 8 August 1863, they noted among "the disgusting paintings and scribblings" that soiled the walls "an abominable and stupid caricature of Murger wearing a smock and carrying a gun in his arms."[32]

The Goncourts grew to despise the rusticity and enforced camaraderie of establishments such as Mère Antony's, as does the hero of their novel *Manette Salomon*, published in the very month that Renoir was likely putting the finishing touches to his picture. At first charmed by "ce lazzaronisme en plein air," the Paris painter Coriolis quickly becomes disenchanted with "the inadequate living conditions, the wretched amount of water and linen available for washing, the towels that were at least eight days old."[33] The Goncourts also lamented the commercialization of artists' colonies such as Marlotte. No longer the preserve of the painter, these villages were being infiltrated by "the bourgeois, the city gentleman, the eager holidaymaker on a budget," each of whom wanted to observe "that strange specimen, the artist, to watch him eat, to catch a glimpse of him at ease, in his unguarded slovenliness."[34] Renoir accommodates these overlapping worlds with far greater warmth and humanity than the Goncourts, yet, ironically, his self-assured bohemian rolling a cigarette and attired in peasant's clothing – Jules Le Coeur – is the very sort of well-to-do "intruder" whom the Goncourts considered responsible for ruining Marlotte.

Cézanne's biographer, Joachim Gasquet, recalling his first encounter with *The Inn of Mère Antony* at the Venice Biennale of 1910, was moved not only by the impassioned conversation of the protagonists, but also by what he considered an intimation of impending social unrest: "One could almost feel the presence of 'the people' lurking behind the faces of these artists in their ardent discussions, just as the room seemed to fill with the invisible beckoning cry of the strike, of catastrophe, or of salvation."[35] Surely *The Inn of Mère Antony* had no such explicit political agenda, but Gasquet's unexpected reaction to the imposing masculinity of Renoir's group portrait, a work that is so much more forthright than the Goncourts' prurient and condescending portrayal of artists in the country, draws attention to the essential radicalism of Renoir's enterprise. For, unlike his subsequent history paintings of modern life, with their joyous civilities and harmonious integration of class and gender, *The Inn of Mère Antony* adheres to more traditional notions of distinct communities. In its sympathetic and detached presentation of the masculine sphere, it distils a sociability and concentration of relationships that would be surpassed only by Cézanne's *Cardplayers*.[36]

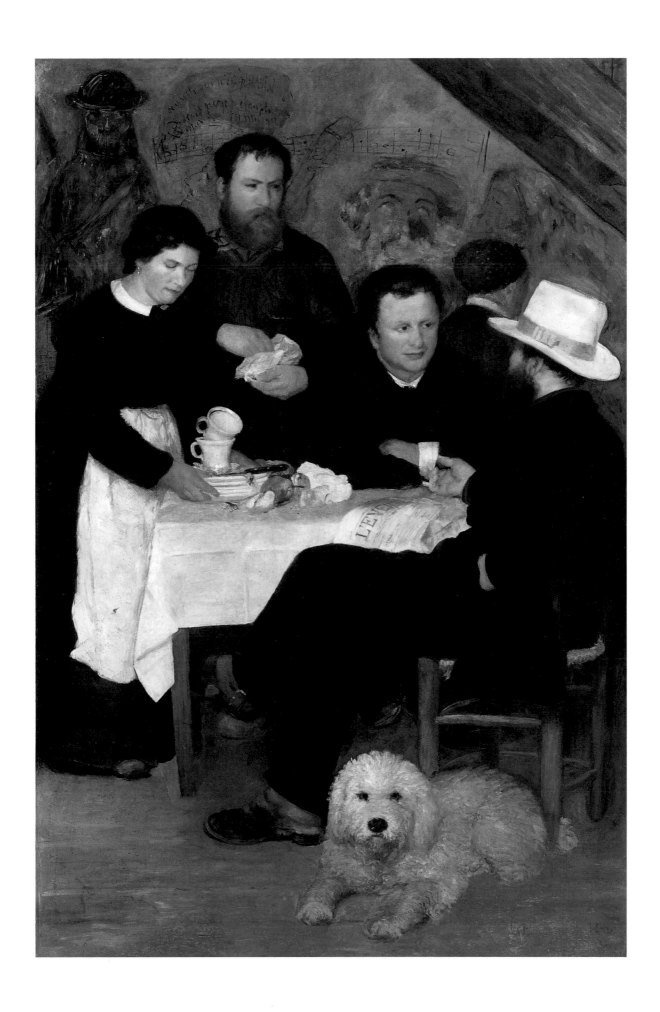

5 *Frédéric Bazille Painting "The Heron"* 1867

105 × 73.5 cm
Musée d'Orsay, Paris

RENOIR'S AFFECTIONATE PORTRAIT of his fellow artist and one-time landlord was painted in Bazille's studio at 20 rue Visconti, near the École des Beaux-Arts, in November–December 1867.[1] This was the studio into which Bazille had moved in July 1866 and from which he would decamp at the end of December 1867, shortly after Renoir's portrait was executed. In January 1868 Bazille sublet the apartment in the rue Visconti and took up residence in an "immense studio" at 9 rue de la Paix in the Batignolles, the subject of his own celebrated group portrait, *Studio in the rue La Condamine* (fig. 63), painted two years later.[2]

Rarely is it possible to date Renoir's portraits with such precision, and the key here is the *Still Life with Heron* (fig. 110) upon which Bazille is seen to be working with such intensity. Bazille refers to this canvas (signed and dated "1867") in a letter to his father written apparently in late November. "For the past two days I've been painting two large still lifes. I'm not completely satisfied with them, but the one with the big grey heron and jays is not too bad."[3] Sisley was also present at this session, and on a canvas of similar dimensions he painted the same arrangement in a horizontal format that truncates the table and gives greater prominence to the oilcloth that Bazille had placed underneath the dead birds (fig. 111).[4] Not only did this cloth protect the floor, it established the dominant cold tonality for both still lifes, Bazille perhaps unconsciously taking his lead from Monet's "snowscapes," several of which had been left with him for safekeeping.[5]

A non-paying co-occupant of the studio in the rue Visconti since July 1866, Renoir acknowledges Bazille's hospitality in this most tender of portraits. The tall, lanky Jean-Frédéric, just twenty-six – with his "curly hair, his light beard, his straight and rather pronounced nose, and his dark eyes prepossessing in their haughtiness"[6] – is shown crouching over the large still life, casually attired in a beige-grey painter's smock and collarless shirt, his slippers resting on the foot of the easel. Deep in concentration, he applies touches of white paint that drip from his long, finely pointed brush. On the wall behind him hang a framed landscape, whose subject cannot be identified, and a larger, unframed village scene that Anne Distel was the first to recognize as one of the snowscapes painted by Monet in Honfleur in February 1867.[7]

Autumnal in palette, painted in caressing greys, pinks, browns, and ochres, Renoir's portrait of Bazille, along with the still lifes by Bazille and Sisley, constitute a trio of essays in the style of Édouard Manet – tacit confirmation of the older artist's influence over this group of Gleyre's former students.[8] Comparison with *The Inn of Mère Antony* (cat. no. 4), painted the previous year, also confirms that Renoir's forms are now softer and more pliant, his

volumes more convincing. In the portrait of Bazille we are witnessing the emergence of what Meier-Graefe considered Renoir's greatest strength, the "plastic plenitude of his figures," a phrase whose ungainliness belies its acuity.[9]

The portrait is also full of references that bear witness to a fairly recent *esprit de corps* linking Renoir, Bazille, Sisley, and Monet.[10] Given that Manet owned this work until 1876, and that he was responsible for its inclusion in the second Impressionist exhibition, the portrait of Bazille assumes almost totemic significance.[11] It stands as a symbol of the increasing solidarity among the renegades of Gleyre's atelier whose ambitious figure paintings were rejected from the Salon of 1867 and who sought alternative exhibition space in the early summer of that year (the project failed for lack of funds, but by May the impoverished young artists had raised 2,500 francs).[12] Renoir's portrait of Bazille also communicates a shared admiration for Monet, whom Bazille considered "the strongest of them all." Hence the snowscape floating like a nimbus above the sitter's head.[13]

Renoir's portrait reflects other concerns of its sitter, notably his growing dissatisfaction with an apartment he now considered too small. Unlike Bazille's airy *Studio in the rue Visconti* (Virginia Museum of Fine Arts, Richmond), painted six months earlier, Renoir's portrait conveys a sense of constriction, almost of claustrophobia, as if Bazille were in confinement.[14] Such an effect is all the more apparent when this work is compared with Degas's contemporaneous portrait of Tissot (Metropolitan Museum of Art, New York), suggestive also of the different milieus in which these progressive artists moved in the 1860s. Next to Degas's urbane and melancholic Tissot, Renoir's Bazille is a jobbing painter who dirties his hands.[15]

Indeed, Renoir rusticates the elegant, well-groomed Bazille (fig. 112) – something of a dandy who worried about thinning hair and despaired at the quality of the laundry – by portraying him in a rumpled costume spattered with paint.[16] This is in marked contrast to the manner in which Bazille chose to portray himself two years earlier. In his brooding *Self-portrait* (fig. 113) he is shown impeccably dressed, with starched collar and clean cuffs, but anguished, possibly overwhelmed. Also absent from Renoir's portrait is the large multicoloured palette that Bazille clutches like a fan in the *Self-portrait* and that reappears in two of his studio paintings.[17] Instead, Renoir has him holding a rectangular palette – "une palette carrée" – invented for use on easel paintings but small enough to be packed away in the portable paintboxes used for working *en plein air*.[18]

Such is the restricted tonality of Renoir's portrait that Bazille is hardly in need of a palette of greater size. Indeed, the rigour of Renoir's composition is unremitting: overlapping geometrical forms compress the space and render the studio airless. Yet the mood of the painting is heartrending in its tenderness, a pictorial affirmation of the friendship between the two men. Unlike Monet, whom Bazille practically idolized but who in turn demanded both personal and financial commitment and brooked

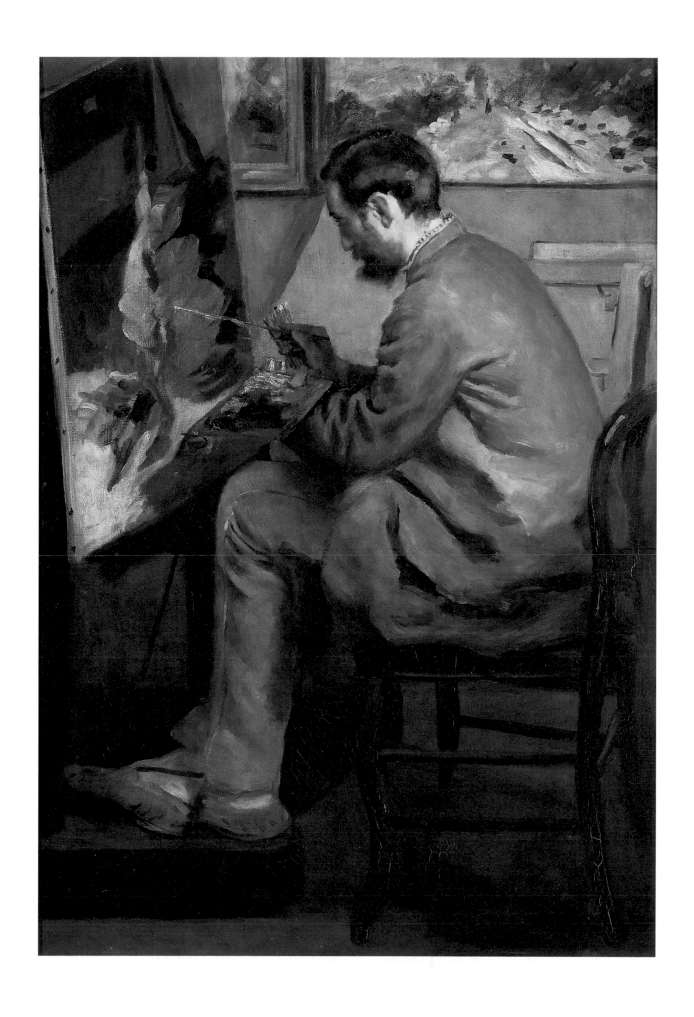

no disagreement, Renoir enjoyed a less complicated relationship with Bazille. In their letters they refer to each other as "tu," whereas Monet always retained the more formal usage. Bazille might be summoned to Chailly in August 1865 "simply to be of use to Monet," just as he was the recipient of increasingly desperate requests for money in the summer of 1867, when Camille was about to give birth to their first child.[19] Renoir's allusion to this episode in a letter of August 1868 – "As for me, you can rest assured that I've neither wife nor child and I'm not likely to have either at the moment" – captures the tone of their relationship: jovial, forthright, independent.[20]

Just as Renoir's portrait of Bazille is part of a cluster of works that bear witness to an emerging artistic movement, so is it also the most notable of a series of homages painted in 1867 that anticipate Van Gogh and Gauguin's celebrated exchange of portraits some twenty years later. In the spring of 1867 Bazille had painted a remarkably alert portrait of Renoir perching on a chair (see frontispiece), dapper in jacket and tie; in April, he was at work on a portrait of Monet for their "exposition particulière"; his little portrait of Sisley smoking a pipe, destroyed in the Second World War, also dates from this year.[21]

And it would appear that Monet returned the compliment, possibly at the same time that Renoir and Sisley were painting in the rue Visconti. In a letter of December 1868 from Étretat, asking Bazille to send him any unused canvases that he might have left in his studio, Monet refers to a pair of unfinished paintings, "abandoned things such as the full-length portrait of you, and another canvas, size 60, in which I did some bad flowers."[22] Monet's "abandoned full-length" of Bazille – a pendant to Renoir's? – was doubtless painted over, and will perhaps one day come to light in an X-radiograph revealing the familiar features of this generous sitter, "whose charming nature and constant friendship" sustained the Impressionist movement at its very origins.[23]

61 × 45.7 cm
The Saint Louis Art Museum

RENOIR'S UNSENTIMENTAL PORTRAIT of his seventy-year-old father is a fitting epitaph to this "little tailor" from Limoges who ended his years as a modest *rentier* with a well-stocked cellar in the hamlet of Voisins-Louveciennes.[1] Léonard Renoir (7 July 1799–23 December 1874) was the eldest of nine children born to François Renoir (1773–1845), a maker of wooden shoes ("sabotier"), and Anne Regnier (1770–1857), the daughter of a carpenter, who were married in Limoges in December 1795.[2] Although François Renoir had been abandoned at birth, there is no evidence to support the family legend, recorded by Vollard and by Jean Renoir, that he was the illegitimate offspring of a nobleman whose family had perished during the Terror.[3] Rather, Léonard's parents were illiterate artisans who set up shop in Limoges, and whose children were destined to enter the trades that flourished in this *ville perdu* of 30,000 souls, celebrated above all for its manufacture of textiles and porcelain.[4] Léonard became a journeyman tailor (on his exemption from military service he is listed as "tailleur de habits") and completed the tour de France required of companion guild members. In November 1828 he married Marguerite Merlet (1807–1896), a dressmaker's assistant and daughter of a tailor from Saintes, whom he brought back to the town of his birth.[5]

Léonard Renoir and Marguerite Merlet lived in Limoges between 1829 and 1845. Four of their five children were born there (not counting two lost in infancy): Pierre-Henri (February 1832), Marie Elisa (February 1833), Léonard-Victor (May 1836) and Pierre-Auguste (February 1841). Following the death of Léonard's father in May 1845, the forty-six-year-old tailor moved his family to Paris, and it was there in an apartment in the rue de la Bibliothèque that his last child, christened Victor-Edmond, was born in May 1849.[6] During the twenty-three years that they lived in Paris, the Renoirs moved only once. In 1854–55 they took occupancy of an apartment on the fifth floor of 23 rue d'Argenteuil, a building listed as having "thirty-three rental units for small businesses."[7]

It was here that Léonard established himself as a bespoke tailor, "un tailleur à façons." His work bench, with the addition of a mattress, doubled as Pierre-Auguste's bed until the family was in a position to rent an extra room on the sixth floor in 1858.[8] In the absence of solid information, it seems reasonable to suppose that Léonard Renoir, assisted no doubt by his wife, was able to earn a modest living making men's suits to measure. In one sense, he had moved to Paris at the worst possible time. In the 1840s and 1850s tailoring was being transformed through the rapid growth of ready-made clothes (*confection*), which counted for one third of the Parisian market by 1847 and which would eventually render obsolete the trade of the master tailor working from his home without a shop and employees.[9]

If Léonard Renoir was hardly crushed by the competition of the entrepreneurs and department stores, he did not achieve great wealth as a bespoke tailor. The impression given by Jean Renoir – who was born twenty years after his grandfather died, but whose account is based upon information provided by Renoir himself – is of a taciturn, hard-working man, respected if a little feared by his children, who provided his family with sufficient means to see the elder sons established in respectable Parisian trades, and who could be tolerant of the artistic aspirations of the younger ones.[10] Renoir vividly remembered his father in the customary pose of a tailor, "sitting cross-legged like a Hindu, surrounded by rolls of cloth, samples of material, scissors, and spools of cotton." He might have been describing a caricature by Gavarni (fig. 114).[11]

But it was not as a tailor that Renoir chose to present his father in a portrait that is bereft of any attributes that might throw light on the sitter's "financial position, class, and profession."[12] Gaunt and unwelcoming, a little suspicious of his son's scrutiny – and by implication, of ours – since July 1868 Léonard had been living with his wife in retirement at 22 rue des Voisins in the hamlet of Voisins-Louveciennes, just north of the more fashionable Louveciennes, with its "excellent air, abundant springs, delightful walks . . . and a multitude of villas."[13]

Renoir certainly captured the "grave and silent man" who "even in his private life was never known to depart from his customary solemnity."[14] One of his earliest biographers went so far as to claim that Renoir had given his father "the appearance of a magistrate, with a certain nobility."[15] Nobility seems less apt here than austerity. Within its restricted tonal range, Renoir's handling is looser and more liquid than in his portraits of the previous year, and his brushwork is more animated. Despite the conventional frontal pose, Léonard Renoir is portrayed slightly off centre, at an oblique axis.[16] He even appears a little dishevelled: his hair is untidy and his cravat refuses to hang straight. Increasingly, one gains the distinct impression of energy barely held in check, as if the experimentation that Renoir had just embarked upon at La Grenouillère could not but reassert itself in this more traditional exercise. The portrait of Léonard Renoir, it should be remembered, was in all likelihood executed between July and September 1869 when Renoir, penniless, was living at home and travelling each day to paint with Monet in nearby Bougival.[17]

One final observation: the prominent signature and dating above Léonard's left shoulder, somewhat unexpected in a family portrait, might suggest that Renoir also had a public forum in mind. It is known that in October 1869 he exhibited a number of recent works, among them *Lise with a Parasol* (1867, Museum Folkwang, Essen) and *Alfred Sisley and Lise Tréhot* (1868, fig. 30), at the premises of his colourman Carpentier at 8 boulevard Montmartre.[18] Had it been included, the portrait of Léonard Renoir would have demonstrated with considerable aplomb Renoir's capacity to renew the genre of the simple bust portrait.

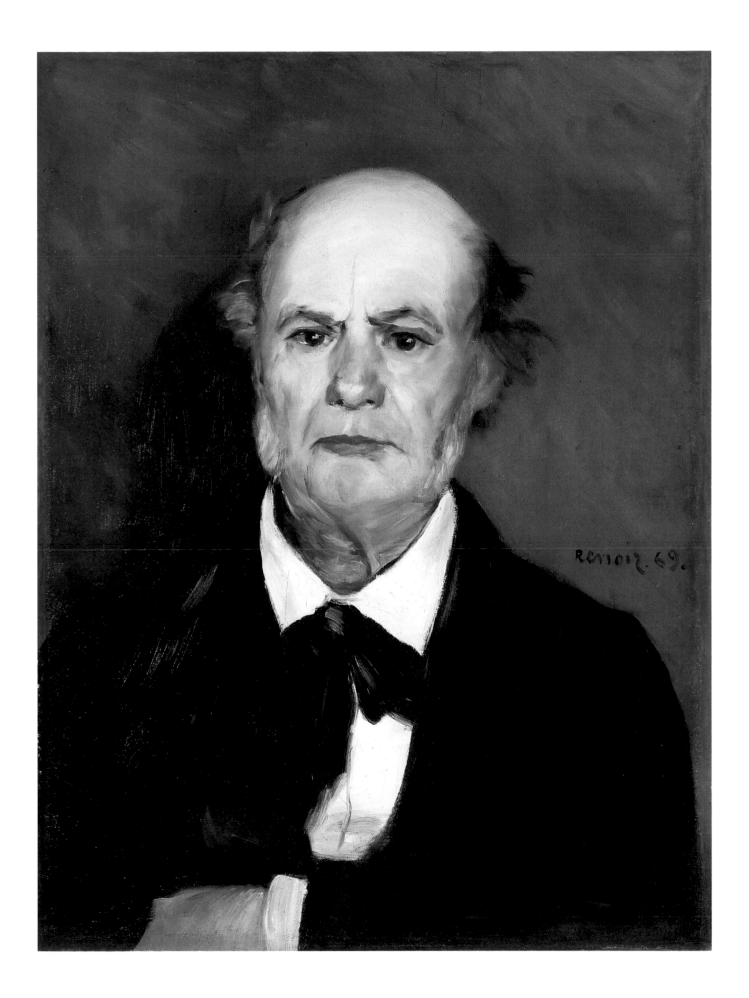

81 × 64 cm
Private collection

U<small>NTIL HE HAD SONS</small> and nephews of his own, Renoir – unlike Degas – generally refrained from co-opting members of his family to model for him or sit for their portraits.[1] On the rare occasions that he did so – confined to the final years of the Second Empire – the results were surprisingly formal, even austere. For candid though they are, Renoir's portraits of his father (cat. no. 6) and eldest brother can hardly be considered intimate. The viewer is encouraged to keep his distance.

With his elegant black frock-coat and resplendent side-whiskers, the thirty-eight-year-old Pierre-Henri Renoir (1832–1909) might easily be mistaken for a Victorian worthy. A contented man, whose waistcoat is already a little tight for him, he sits upright in a plush velvet armchair placed against an exotic wall hanging, among whose arabesques can be discerned a bird of paradise. Situated somewhat ambiguously in the background, at left, is a red tufted armchair over which a coloured shawl or piece of fabric has been draped. Pierre-Henri looks past the viewer with barely the hint of a smile; he holds a golden watch chain decorated with black onyx in his right hand, while keeping the other hand in his pocket. From around his neck, a black silk ribbon, to which is perhaps attached a monocle or pair of spectacles, falls across his waistcoat.

With its recently identified pendant, *Madame Pierre-Henri Renoir* (fig. 115), whose background and accoutrements suggest a contiguous domesticity, Renoir's portrait of his eldest brother must have been painted before August 1870, when the artist was drafted to Bordeaux at the outbreak of the Franco-Prussian War.[2] The pair of pictures follows the convention of marriage portraits "en regard" – like Ingres's *Monsieur Leblanc* and *Madame Leblanc* (1823, Metropolitan Museum of Art, New York) – with Renoir's female sitter deferring to her spouse. Although in the treatment of his brother's black jacket and dark-grey trousers Renoir declares himself a follower of Manet, the warmth of his palette and the russet tonality of the composition are indebted to Delacroix, whose influence Meier-Graefe considered resurgent at this time.[3]

Born on 11 February 1832 in the rue des Arrenes in Limoges, Pierre Henry, as he was christened, was the third child of Léonard Renoir and Marguerite Merlet, but the first to live beyond infancy.[4] The eldest of their five surviving children (four sons and a daughter), he trained as a medallist and gem-engraver under Samuel Daniel (1808–after 1864), who had designed the private seals of Charles X and the duc and duchesse de Berry.[5] Renoir remembered his brother as a "marvellous engraver" who encouraged him in the early years of his career and passed on work when he could.[6] In fact, Pierre-Henri was something of an authority on the engraving of interlaced ornaments (*guilloche*) – his first manual of monograms, published in 1863 (fig. 116), was translated into English four years later[7] – and he moved in circles that included such prominent jewellers as Louis Aucoc, at whose family firm, established in Paris since 1821, René Lalique would later undergo his apprenticeship.[8] A measure of Pierre-Henri's prominence in his field is Zola's mistake in attributing *Lise with a Parasol* (1867,

Museum Folkwang, Essen) to "Henri Renoir" – thereby confusing the as yet unknown artist with his more established elder brother.[9]

On 18 July 1861 Pierre-Henri married Blanche Marie Blanc (1841–1910?), the natural daughter of Joséphine Blanche, a seamstress, and the aforementioned Samuel Daniel, "son tuteur datif," at whose premises at 58 rue Neuve Saint-Augustin she was living at the time.[10] By 1879 Pierre-Henri had taken over Daniel's practice, and in 1888 he would in turn pass the business to a Monsieur Sylla, "graveur héraldique et guillocheur."[11] Pierre-Henri and Blanche Renoir then retired to a villa in Poissy, where he continued to publish manuals on the art of the monogram,[12] and where the couple, who were childless, lived in relative comfort, employing a servant named Cesarine Brayeul.[13] Pierre-Henri died at the age of seventy-seven on 9 October 1909, apparently after having been served one of Blanche's particularly copious meals. It seems reasonable to assume that his wife died a year later, since Blanche's name disappears from the Poissy census records after 1911.[14]

The Pierre-Henri Renoirs occupy a special place in Jean Renoir's memoirs, since they were the first to introduce the future film director, aged seven or eight, to the vaudeville and café-concert: "It is thanks to them that I came to know the delightfully bawdy repertory of those turn-of-the-century singers, not to mention the melodramas that were still being performed at the Théâtre-Montmartre."[15] Jean Renoir's account of the couple's cosy domesticity in Poissy – in a villa whose parquet floors and Renaissance furniture from Dufayel's were "waxed and polished until they shone like mirrors" – is both vivid and engaging, but, as I have pointed out elsewhere, he is an unreliable biographer.[16] Jean Renoir has his uncle working for the celebrated silversmith Odiot after being apprenticed to a "Monsieur David, orfèvre de la rue des Petits-Champs," whose daughter, Mademoiselle Blanche, he will eventually marry, despite the difference of their religion ("the Davids were Jewish").[17] Archival and documentary evidence has established that at no time did Pierre-Henri work for Odiot, that his first *patron* was Daniel, "graveur-guillocheur," not David, and that it was Daniel's illegitimate daughter Blanche Marie Blanc whom he would marry in July 1861.[18] But with these small details corrected, Renoir's testimony remains valuable, not least in the suggestion that his aunt Blanche, of whom the artist left such a sympathetic portrait, was Jewish.

Jean Renoir also credited his uncle with introducing Renoir to Oriental art in the late 1860s: "Henri took my father to an exhibition of lacquered objects and china brought to France by a partly diplomatic and partly commercial mission."[19] Renoir had been only mildly impressed by the vases and statuettes on display, but was more taken by the Ming porcelain, something that Pierre-Henri could not understand since he had "already succumbed to the latest craze."[20] In the portraits of his brother and sister-in-law, Renoir alludes to the couple's enthusiasm for *japonisant* decoration, but insists primarily on their bourgeois respectability.[21] Yet in portraying the gem engraver and son of a tailor with such confidence and assurance, Renoir was also colluding in a fiction of sorts. *Pierre-Henri Renoir* invites comparison with Whistler's portrait of Thomas Carlyle (1872–73, Art Gallery and Museum, Glasgow), a truly eminent Victorian.

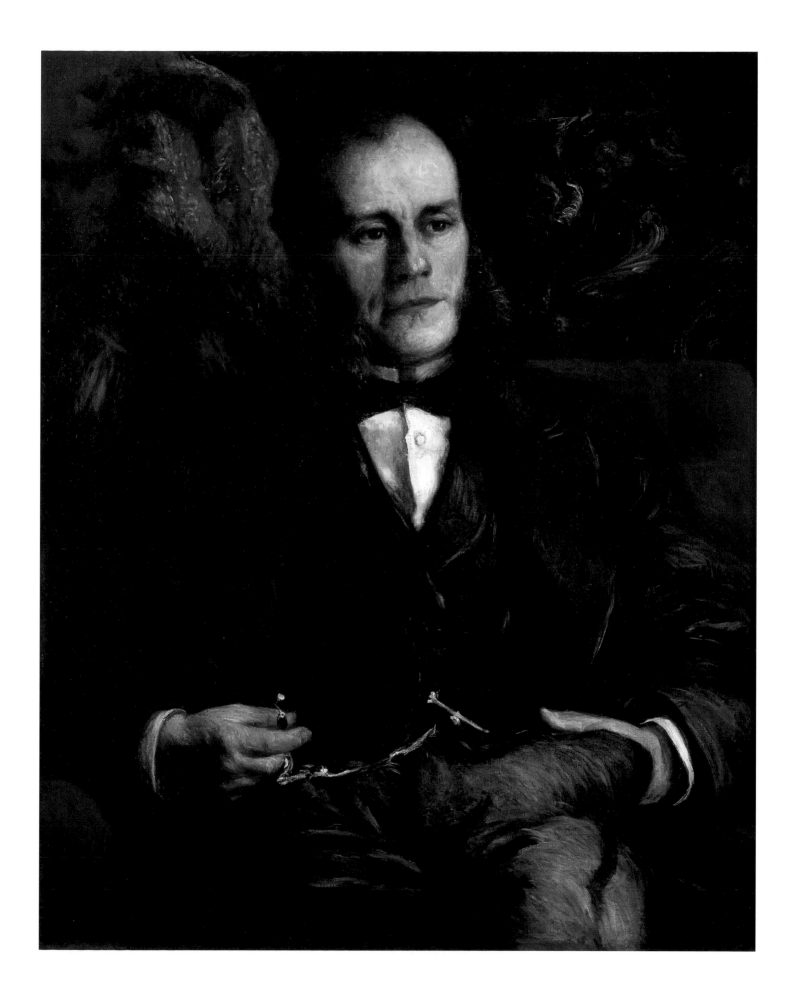

8 *Madame Stora in Algerian Dress*
 (*The Algerian Woman*) 1870

84.5 × 59.6 cm
Fine Arts Museums of San Francisco
Gift of Mr. and Mrs. Prentis Cobb Hale
in honour of Thomas Carr Howe, Jr.

PAINTED BETWEEN JANUARY AND AUGUST 1870 – before
Renoir's mobilization following the outbreak of the Franco-
Prussian War – *Madame Stora in Algerian Dress* was the artist's most
exuberant portrait to date, its "rainbow palette" and proto-
Impressionist facture cohering in a bravura performance of which
only the sitter seems to have been less than admiring.[1] With
Woman of Algiers (fig. 117), exhibited to some acclaim at the Salon
of 1870, and *Parisian Women in Algerian Dress* (National Museum
of Western Art, Tokyo), rejected by the Salon of 1872, it bears
witness to Renoir's intense, but short-lived, apostasy from
Courbet and Manet in favour of Delacroix, an artist whom he
would venerate all his life but whose influence would not be so
potent again.[2] The portrait of Madame Stora also reflects Renoir's
affection for a conservative, even outmoded, Orientalism: in
1870, he is drawn to North Africa, not to Japan.[3]

Renoir's "femme d'Alger" in this instance is the nineteen-
year-old Rebecca Clémentine Valensin (24 April 1851–July
1917), daughter of Moïse Abram Valensin, a maker of travel
goods, and his wife Fortunée Dayan. Born in Algiers, Rebecca
Clémentine and her parents were living in Frankfurt by 1868. In
June of that year, they assembled at the mairie of the 9th
arrondissement in Paris for her marriage to Nathan Stora
(1839–1892/93), an antique dealer (also born in Algiers) special-
izing in North African goods. Stora's shop at 24 boulevard des
Italiens (fig. 118) occupied part of the ground floor of an impos-
ing *hôtel particulier* on the corner of the boulevard des Italiens and
the rue Taitbout.[4] His first landlord – whom he most assuredly
never met – was Richard Seymour-Conway (1800–1870), fourth
Marquess of Hertford (and founder of the Wallace Collection),
whose mother had left the building to him after her death in 1856;
among Stora's co-tenants was the Egyptian-born Khalil-Bey
(1831–1879), the first owner of Courbet's notorious *Origins of the
World* (1866, Musée d'Orsay, Paris).[5]

Little is known of the Storas' life in Paris. The witnesses at their
wedding were all North African expatriates who styled them-
selves "businessmen."[6] The couple had three daughters and one
son in fairly regular succession, each of whom was born at 24
boulevard des Italiens.[7] Nathan's antique shop prospered, and he
developed an expertise in Oriental rugs. His son Moïse Maurice,
who took over the family business, shocked the seasoned art
dealer René Gimpel in September 1924 by offering a sixteenth-
century Persian carpet for sale at half a million francs.[8]

Renoir told Vollard that he had painted the portrait of Madame
Stora in a studio in Paris, although both the costume in which she
is dressed as well as the kilim that hangs in the background sug-
gest a more domestic setting, perhaps the *arrière-boutique* of her
husband's antique shop, the appropriately named "Au Pacha."[9] In
fact, Renoir's imagery is pertinent on several levels. Despite the

flamboyance of the handling, Rebecca Clementine's blue and
gold headdress and robes are remarkably similar to those in
Cordier's *Juive d'Alger* (fig. 119), a polychrome gilt bronze bust
shown at the Salon of 1863 and again at the Exposition
Universelle of 1867.[10] The headdresses are more or less identical
in form; both bodices are decorated with arabesque scroll-work;
both costumes are belted and high-waisted. Renoir presents his
sitter in the formal dress of an Algerian Jewess, a subject that had
been treated by Delacroix and Dehodencq, and also attracted
Madame Stora's favourite painter, Benjamin-Constant.[11] Missing
in Renoir's portrait are the large hoop earrings that customarily
completed the ensemble; these reappear in Brochart's portrait of
Clementine Stora and her third daughter, Semha Lucie, painted
in the late 1870s (fig. 120).[12]

How and where Renoir met his sitter and her husband is not
known, although it is clearly established that the Storas had little
affection for his portrait, which is quite unlike the tepid, conven-
tional work that they normally commissioned (fig. 41).[13] In
September 1918, Gimpel was told that Renoir had met the
"beautiful Madame Stora in a watering place, some thirty years
ago."[14] The only "watering place" that Renoir frequented in
1870 was La Grenouillère, and if it was indeed there that he had
been introduced to his model and her husband, the intermediary
may well have been Prince Georges-René Bibesco (1834–1902)
(fig. 7), who reportedly accompanied Renoir on his earliest visits
to this fashionable bathing spot.[15] Bibesco had spent eighteen
months on military service in Algiers, and while there is no evi-
dence to connect the Rumanian aristocrat with the North African
merchant, both the Valensin (or Valensi) and Stora families were
well-established Sephardic Jewish dynasties, some of whose
members he might well have encountered prior to his return to
Paris in October 1868.[16]

Whatever the explanation for this unexpected connection, one
can only marvel at the result: a richly impasted, golden-hued por-
trait, quite unfettered in its handling – much freer than in
Renoir's Salon painting – and exceptionally luminous. The "bru-
tal freedom of brushwork" that impressed Houssaye in Renoir's
Algerian Woman[17] is given even greater licence here, and the
strokes and dabs of paint that describe the sleeves of Madame
Stora's dress, the unfurling silks of her headdress, and the pattern-
ing of the kilim in the background are as abbreviated as anything
Renoir had painted at La Grenouillère the previous summer.

For Meier-Graefe, Renoir's immersion in Delacroix consti-
tuted the crucial experimentation of 1870 and precipitated the
artist's coming of age as a colourist.[18] In the 1890s, however, an
early work such as the portrait of Madame Stora was considered
something of an embarrassment by its author, who did not under-
stand why collectors were so eager for paintings in his "manière
ancienne."[19] If the portrait of Madame Stora was thus disavowed
by both artist and sitter, it fared better with two painters of radi-
cally opposing temperaments and styles. Having been acquired
from the Storas for 300 francs by Paul Helleu, the portrait of
Madame Stora first came to public attention as one of three paint-
ings by Renoir in the retrospective of French Orientalists held in
Marseilles in May 1906. It was lent to that exhibition by Claude
Monet.[20]

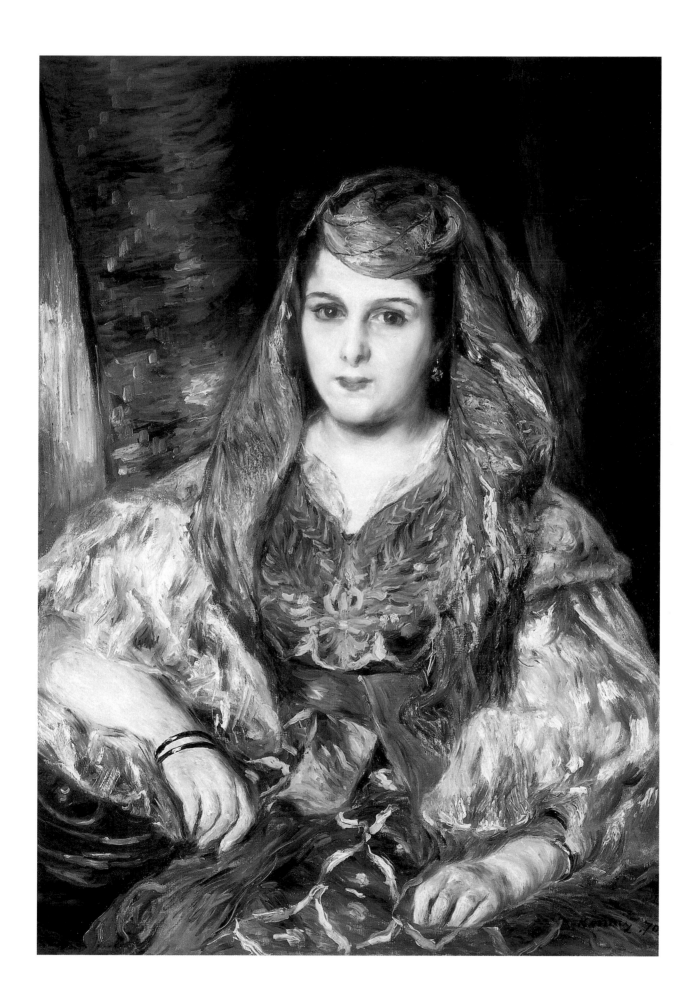

9 *Madame Marie Octavie Bernier* (formerly
 called *Madame Darras*) 1871

 78.9 × 62.2 cm
 The Metropolitan Museum of Art, New York
 Gift of Margaret Seligman Lewisohn,
 in memory of her husband, Samuel A.
 Lewisohn, and of her sister-in-law,
 Adele Lewisohn Lehman, 1951

10 *Captain Édouard Bernier* (formerly called
 Captain Paul Darras) 1871

 81 × 65 cm
 Gemäldegalerie Neue Meister,
 Staatliche Kunstsammlungen Dresden

Renoir was called up for duty on 26 August 1870 and mobilized in the fourth platoon of the 10th *chasseurs à cheval*, a light-cavalry regiment stationed in Libourne, twenty-seven kilometres northeast of Bordeaux.[1] Although he did not see action during the Franco-Prussian War, he fell gravely ill from dysentery and suffered a complete nervous collapse. He was granted leave to convalesce with an uncle in Bordeaux, and following the armistice of 28 January 1871 rejoined his regiment at Vic-en-Bigorre, a garrison town in the Hautes-Pyrénées, fifteen kilometres north of Tarbes. There he was apparently responsible for training remount horses, a task for which he had little experience.[2] Renoir was demobilized on 10 March 1871, but did not return to Paris until April, the month inscribed beside his signature on the portrait of Rapha Maître (cat. no. 11).

Renoir painted next to nothing during his seven months in the army, an aberration that suggests the seriousness of his physical and mental condition. Only the present portraits, traditionally identified as depicting Captain Darras and his wife, have been related to the artist's experience of military life, and they have generally been dated to the autumn of 1871, following Renoir's return to a normal routine in Paris.[3] Given that Madame Darras would pose the following year for the figure of the Amazon in Renoir's *Riding in the Bois de Boulogne* (cat. no. 13), and that her husband was a good friend of Prince Bibesco and the Le Coeurs, the identifications of the companion portraits now in New York and Dresden have never been questioned.[4] It should be noted, however, that Renoir's earliest historians were less cavalier in assigning names to faces. The "Portrait of Captain Darras" was first exhibited in Dresden in May 1926 as simply *Offiziersbildnis* ("Portrait of an Officer"). In the edition of Meier-Graefe's monograph on Renoir that appeared in 1929 it was entitled "Portrait of an Officer, perhaps Darras."[5] Its mate, first published in January 1920 by Gustave Geffroy as "La Dame en noir," was exhibited in New York the following year as "The Lady in Black."[6] Only after it entered the collection of Adolph Lewisohn in 1921 did the latter acquire the title of "Madame Darras,"[7] following which the companion painting in Dresden had its title amended accordingly, though with slightly more caution.[8]

In fact, there exists a considerable body of evidence to challenge the assumption that these pendant portraits represent Captain Paul-Édouard-Alfred Darras (1834–1903) and his wife Henriette Oudiette (1837–1910). Discovery of supporting archival material confirms what is strongly suggested by a closer inspection of both the published sources and the captain's costume itself, namely, that Darras and his wife are not the sitters of this portrait commission.[9]

In September 1897, Julie Manet recorded one of Renoir's rare accounts of his experience during the Franco-Prussian War and the consequent upheavals in Paris. He told her that at the end of the war he spent "two months in a château," where he was "treated like a prince," riding horses every day and teaching his hosts' daughter to paint.[10] Jean Renoir expanded upon this reminiscence, claiming that his father had worked in the remount depot in Bordeaux under the supervision of a sympathetic captain who brought Renoir south with him and invited him to stay with his family in Tarbes after peace was declared.[11] That Renoir was living in the south at this time is confirmed by his exceptionally intimate letter of 1 March 1871 to Charles Le Coeur, written from Vic-le-Bigorre, the town just north of Tarbes in which the 10th *chasseurs à cheval* was garrisoned.[12]

Having placed Renoir in and around Tarbes in March 1871, one must now examine the captain's costume more closely. Despite the freedom of handling in the background, which is little more than scumbling over primed canvas, the sitter's apparel and physiognomy are rendered with Renoir's customary verisimilitude. His blue-black dolman has three vertical rows of silver buttons; the belt, slung diagonally across his chest, has its studs spaced more widely. Although difficult to make out in even the most faithful reproduction, the brandenburgs that decorate his dolman form a series of nine horizontal ridges that continue almost to the level of the medals.[13] Easier to recognize are the officer's red trousers, with their double-banded stripe, and the two military decorations: the five-sided cross of the Légion d'Honneur that hangs from a red ribbon and the Médaille Militaire suspended from a yellow ribbon edged with green. The latter was awarded only to non-commissioned officers.

Returning to the published provenance of both portraits, we find that the first name to appear in the sequence of buyers and sellers is a certain "Bernier," who on 24 and 26 July 1919 sold the paintings separately to Durand-Ruel. The entries in Durand-Ruel's register for these days record the purchase from Bernier of "un portrait de femme" for 10,000 francs and "un portrait de capitaine d'infanterie" for 5,000 francs. Darras was not the vendor, nor is his name included in either title, yet Bernier's name has subsequently gone unmentioned.[14]

Édouard Bernier (21 November 1822–13 September 1880) was a professional soldier who had come up through the ranks. At twenty-three, he joined the 10th *chasseurs à cheval* – Renoir's future division. After serving in North Africa between 1849 and 1851 with the 4th *chasseurs d'Afrique* and enrolling briefly in the 2nd *hussards*, he returned to his former regiment in June 1852, and remained attached to it for the next twenty years. In the 1860s Bernier was promoted regularly, if gradually: he became provisional *capitaine* in November 1870, and on 9 December 1870 he finally received the full commission of *capitaine d'habillement*, responsible for the presentation and outfitting of his troops.[15]

As a non-commissioned officer, Bernier had been awarded the Médaille Militaire in June 1856 (an honour which was noted in his marriage contract the following year), and on 14 August 1865

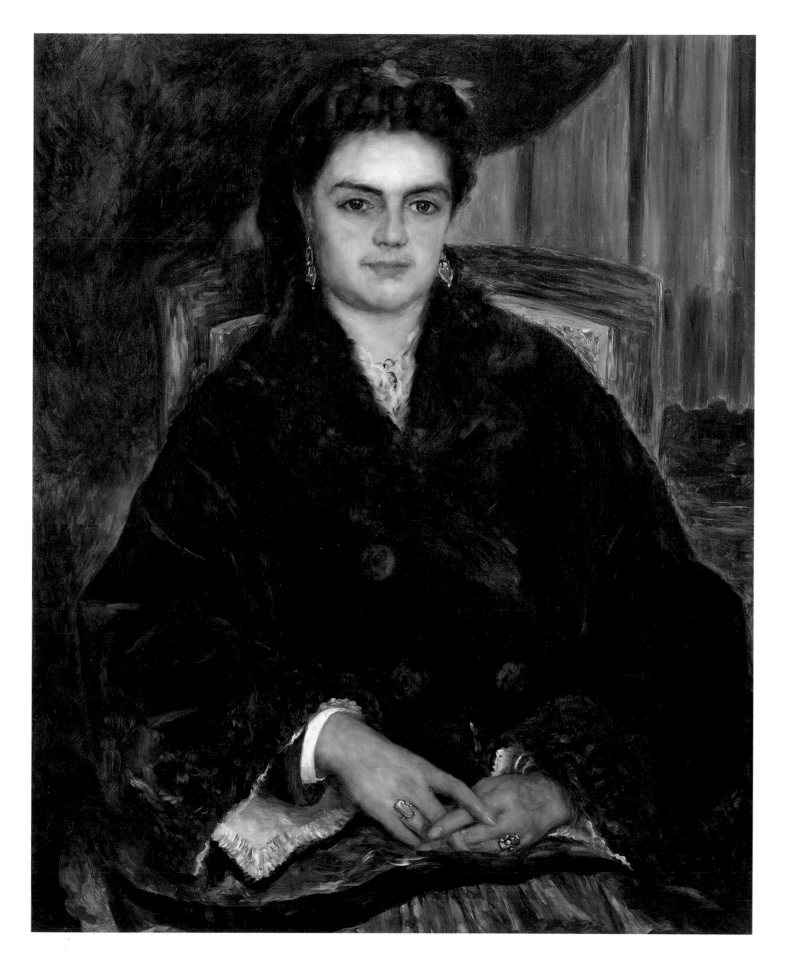

he received the Légion d'Honneur. He participated in the assault on the Prussian army at Metz in July–August 1870; his regiment was routed at Forbach and retreated to Rambouillet. In September 1870 he returned to Vic-en-Bigorre for the remainder of the war, and it was there that Renoir came under his command.[16] In April 1872, with twenty-six years and ten months of service, Bernier petitioned to be allowed to retire from the army on full pension. His request was granted, and he, his wife, and their two children settled first in Marmande, near Agen (Lot-et-Garonne), before moving north to Saint-Saens, midway between Rouen and Dieppe, where he died in September 1880.[17]

Born in the village of Juvelise in Lorraine to François Bernier, a schoolteacher, and Madeleine Gérard, Édouard had moved south with his regiment. At the time of his marriage on 29 October 1857 to Marie Octavie Stéphanie Laurens (2 April 1838–11 November 1920) from Toulouse, he and his bride were living in Tarbes, where her widowed father, Théodore Napoléon Laurens, was employed as a *conducteur* in the administration of the Ponts et Chaussées. Marie-Octavie's mother, Suzanna Evalina Despeyroux, had died in Corsica in April 1851.[18]

Although he would be of service to Renoir in the winter of 1872, during the Franco-Prussian War Darras saw duty in an entirely different part of the country. Captured by the Prussians at Metz in October 1870, he returned to Paris in the exchange of prisoners of January 1871 and entered the *armées du nord* under General Faidherbe. He assisted General du Barrail in the second siege of Paris and was active in the suppression of the Commune.[19] At no point during the eight months of Renoir's military service did the two men come into contact with one another.[20]

Darras had been a product of the École de Saint-Cyr, the elite military academy from which he graduated ninth in his class in October 1856, receiving the commission of *sous-lieutenant*. He was assigned to the infantry, would become staff officer (*état-major*) to General du Barrail in 1865, with the brevet of *capitaine de l'infanterie*, and was made *chevalier* of the Légion d'Honneur in August 1863, rising to *grand officier* in May 1899.[21] As a commissioned officer, he was not eligible for the Médaille Militaire, and as a *capitaine d'infanterie* his uniform was quite different in appearance to the one worn by the sitter in Renoir's portrait, which conforms to the style of the costume of a *capitaine de cavalerie*. Photographs of Darras from the 1880s show a single line of buttons running down the centre of his dolman, and the ornamental facings on his sleeves are of a different design from those in the costume worn by Renoir's captain (fig. 121). Finally, all photographs of Darras show him wearing but one military decoration, that of the Légion d'Honneur (fig. 122).[22]

In his *Text Book of Photography* published in 1864, Disdéri established as an article of faith that the artist, however inventive, must always adhere to the strictest truth in his portrayal of military sitters. This was the one area in which no licence was allowed the photographer: "When the person wears a military uniform, or an official dress, here the exact reproduction of the costume is an essential condition to the likeness."[23] The young John Shirley Fox, future R.B.A., recalled a morning in Lecomte-Vernet's studio in the Institut when "the master" was at work on the portrait of Marshal Canrobert. On days when the sitter could not attend in person, he would send one of his orderlies, "who sometimes had to pose in his uniform."[24] It is inconceivable that Renoir would have fabricated a style of uniform or invented a second honour, or that Darras would have permitted him to do so.

With the Darras rejected as Renoir's sitters, the more modest – and more obscure – Berniers assume their rightful place as the couple represented in this pair of pendant portraits. Painted in March or April 1871, while Renoir was their guest in Tarbes, the portraits of Édouard and Marie Octavie Bernier are affectionate, straightforward depictions of members of the provincial bourgeoisie – an officer and his wife who might have sat to Courbet (the Communard's influence hovers over both works). No photographs exist of Bernier in uniform, but his costume has been identified as that worn by a *capitaine de la cavalerie de la ligne*, and the two military decorations – the Médaille Militaire and the Légion d'Honneur – match those listed in his records.

In his portrayal of Captain Bernier especially, Renoir's composition – as opposed to his colourism – is conventional, not to say *retardataire*. As *capitaine d'habillement*, Bernier is appropriately seated on his military greatcoat – on whose lining he rests his right hand; he is posed out of doors against a turbulent grey-black background, symbolic of nature's forces. Here again Renoir was following a fairly well-established formula for the photographic representation of military men. Unlike the philosopher or man of letters, who should be shown indoors "in interior light distributed in tranquil masses," Disdéri had insisted that the soldier required a quite different treatment: "the open air, plenty of light – no mysterious half tones, the body firmly posed, without anything vague or uncertain."[25]

In contrast to her husband, Madame Bernier – a little over-dressed perhaps – is presented in the protective yet comfortable ambient of home. Her sumptuously lined fur pelisse and rather prominent jewellery suggest a certain opulence, while her dark-eyed Corsican good looks may have reminded Renoir of his absent mistress Lise Tréhot. The blacks of Madame Bernier's fur collar and mantle are of a richness worthy of Manet.

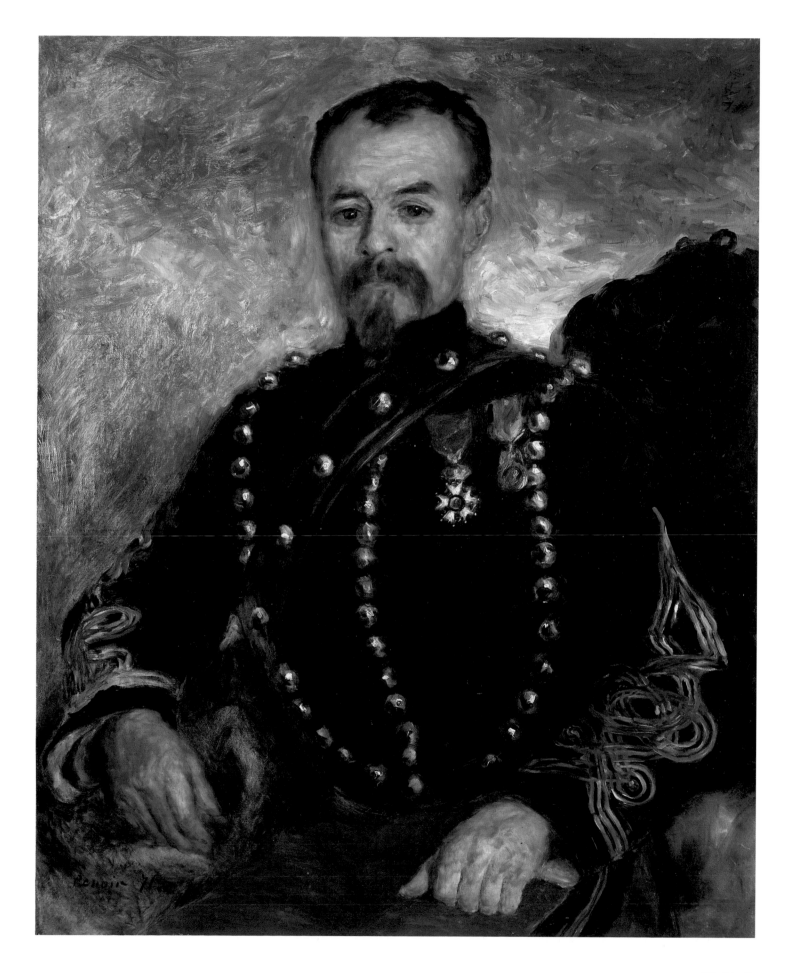

11 *Rapha Maître* 1871

130 × 83 cm
Private collection

12 *Rapha Maître* c.1871

37.4 × 32.3 cm
Smith College Museum of Art,
Northampton, Mass.

FOLLOWING DEMOBILIZATION from the 10th *chasseurs à cheval* on 10 March 1871 and a brief stay in the Hautes-Pyrénées with the Berniers (cat. nos. 9, 10), Renoir returned to Paris after an absence of seven months.[1] His first painting of any significance, executed in April 1871 "en pleine Commune," was *Rapha Maître* (cat. no. 11) – by far the most ambitious and accomplished work he would produce that year.[2] Part portrait and part subject picture, painted with a joy in the materials of his art that is palpable,[3] it marked the artist's complete rehabilitation after a period of military service that had been both "morally and physically destructive."[4]

Dressed in the latest fashion (fig. 123), her lace and silk ensemble a cavalcade of swirls and frills, Rapha Maître looks out of the window, past the iron birdcage that houses four budgerigars (two green, two white) and a tray of water. The corner of the highly patterned interior in which she stands has been transformed into a makeshift conservatory, with purple pansies under the birdcage, an arum lily about to bloom, and a crescent of red hyacinths that mirrors the folds of her dress and whose crimson highlights are reflected in the creams and yellows of her skirt. The Japanese fan that she holds with both hands is a prop that also appears in the *Still Life with Bouquet* (fig. 124), painted at the same time.[5] Yet such is the array of decorated surfaces – the floral curtains by the window, the trellis design of the wallpaper, the coloured cover of the birdcage, the spray of indoor flowers in bloom – that the *uchiwa* fan scarcely draws attention to itself.

Taking his lead from Renoir perhaps, Meier-Graefe was dismissive of this early masterpiece, describing it as "only the envelope of a Renoir, without the substance of a Renoir," but with "the effects of an Alfred Stevens."[6] The comparison with Stevens was apt (fig. 125), since Renoir was working within the conventions of a genre established during the 1860s – the Parisienne with fashionable accoutrements – that would spawn innumerable dreary pastiches of Chardin and Greuze in the following decade.[7] Yet in mood and technique Renoir is closer to Manet, who was much on his mind at this time.[8] With its richly impasted surfaces (in the modelling of Rapha's dress, the paint is handled almost like plaster) and in its resistance to mawkish sentiment or anecdote of any kind, *Rapha Maître* is a variation on the master's *Woman with a Parrot* (1866, Metropolitan Museum of Art, New York), less combative than Manet's staring model certainly, but no more welcoming.[9]

In fact, with "April 1871" boldly inscribed in the lower-right corner, the painting is itself a manifesto of sorts. It is Renoir's Commune painting, and its date takes on the significance of a memorial. In his discussions with Vollard some forty years after

the event, Renoir could make light of his experience of Paris under siege, but it is clear that this had been a dangerous and oppressive time for him.[10] Unable to visit his family in Louveciennes except by permission, faced with being forced to march with the Garde Nationale against the Assemblée Nationale at Versailles, Renoir kept a low profile during the month of April, wandering the streets in the evenings only, to the unending sound of cannon fire and bombing.[11] By the middle of the month, barricades were being erected in the place de la Concorde against possible attack from Versailles, gunboats were lining the Seine, and the smell of gunpowder hovered on the Quai Voltaire.[12] Edmond de Goncourt noted that Paris was "like a town that has contracted the plague," so empty had it become and so swiftly was the bourgeoisie leaving.[13] The mood of the city was anxious and expectant, with bitter fighting taking place at Neuilly and Auteuil, and shells damaging the Arc de l'Étoile on 7 April and penetrating as far as the avenue de l'Alma five days later.[14] Renoir's *Rapha Maître* cannot be said to reflect this social dislocation in any obvious way, but painted at a time of extreme uncertainty (Goncourt's journal for 2 April announced the beginning of civil war[15]), its celebration of fashionable domesticity might be interpreted as nostalgic at least. The profusion of brightly coloured spring flowers, for example, acquires a certain poignancy when we read that Edmond de Goncourt could find only "a few miserable little potted plants at the flower market," and that these, to his disgust, were being carried off "by workers chewing on their bread."[16]

In all likelihood, the unseen window that beckons to Rapha in Renoir's painting looked onto the rue Taranne and would be damaged during the "semaine sanglante" of 21–28 May. The tenant of that apartment, and the friend for whom the portrait was painted, was Edmond Maître, who informed his father on 3 June 1871 that the faubourg Saint-Germain had been reduced to a series of "ruined streets, with corpses all around," but that 5 rue Taranne had survived the devastation with the loss of only a single window.[17] Louis-Edmond Maître (23 April 1840–29 May 1898),[18] eldest son of a prosperous lawyer from Bordeaux, had come to Paris in 1859 to train for the bar, but by February 1864 had accepted the first of a series of a minor posts in the city's bureaucracy that left him free to pursue his interests in avant-garde painting, poetry, and music.[19] "A dilettante who, had he been blessed with a great fortune, would have been the most discriminating of patrons," Maître was Bazille's boon companion and a close friend of Fantin-Latour (with Manet, he was a witness at his wedding in November 1876).[20] The only "outsider" to appear in Fantin's *Studio in the Batignolles* (1870, fig. 62) – the celebrated group portrait honouring Manet – Maître was also an ardent Wagnerian and a great admirer of Rimbaud.[21] An enigmatic voluptuary whose last years were blighted by paralysis and blindness, he had been the subject of Bazille's finest portrait; Renoir, by contrast, portrayed him more laconically (1871, private collection).[22]

It is clear from his death certificate that Maître never married, but his mistress for over thirty years was Camille, known as Rapha – "Madame Edmond Maître to the concierge" – a girl of Belgian origins whom he had met as a student and who remained at his side until his death.[23] Her full name and age unknown, this figure would have remained completely mysterious were it not for the testimony of Jacques-Émile Blanche, who had known Maître

114

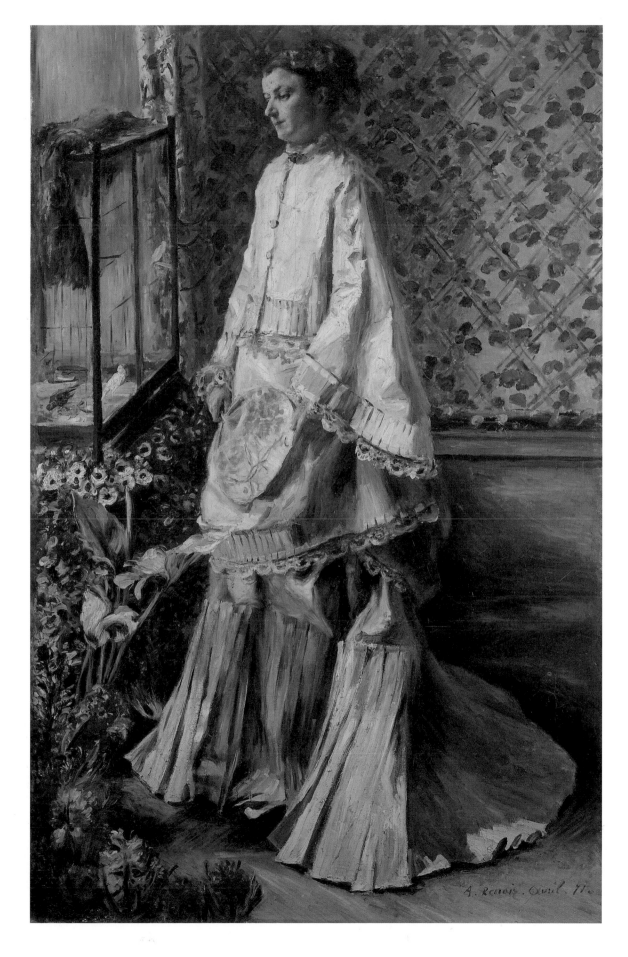

from the age of nine and clearly idolized him; it was to Maître that Blanche dedicated *Les Arts plastiques* (1931).[24] In *Aymeris*, Blanche's *roman-à-clef* written on the eve of the First World War but not published until 1922, Maître appears as Léon Maillac, mentor to the young portraitist Georges, and Camille as Florette, the querulous harpy with whom he has shared his bed for over thirty years.

Blanche was a prig and a snob, and without the slightest affection for Camille, "an old companion who had stuck to Maître since meeting him at the pension in which he had boarded in his student days."[25] If, in his memoirs, he referred to her as a "horrible shrew" who complained about having to tend the ailing Maître, in *Aymeris* he is unsparing in his description of Florette as a "sour-tempered slattern . . . with the voice of a fishwife."[26] Jaundiced though Blanche's testimony is (his most vivid recollections of Maître and his "sordid house" in the rue de Seine date from the 1890s), it is valuable in confirming the identity of the model of Renoir's portrait.[27] In noting that *Rapha Maître* hung next to one of Renoir's rare male nudes, *Boy with a Cat* (fig. 126), Blanche also raised the intriguing possibility that these two "masterpieces" (his word) may have related to each other as pendants – they are of similar but not identical dimensions – even though in execution they were separated by a period of three years.[28]

Of Renoir's relationship with Rapha nothing is known. She had the dark-eyed energy that appealed to him, and he painted two head studies of her, neither preparatory works nor commissioned portraits, whose format and intimacy suggest friendship.[29] The more intense of the two is the portrait at Smith College (cat. no. 12), signed at upper left long after it was painted, in which Rapha's head and tiny shoulders are seen slightly from below and rendered in such "close up" that she appears to be shrinking from the artist's gaze. Dressed in a black-and-white-check suit of vaguely tartan design, her collar held in place by a garnet brooch, Rapha rests her head against an embroidered white cushion whose patterning reinforces the dynamism that Renoir's brush has established throughout this composition. More oily and

"tachiste" than the granular, thickly encrusted full-length, the handling of the Smith portrait of Rapha is not unlike that of Renoir's *Madame Stora in Algerian Dress* (cat. no. 8), and it is possible that this unsentimental head may date to the summer of 1870, in the months prior to his mobilization, when Renoir had been living intermittently in Maître's apartment in the rue Taranne.[30]

In *Aymeris* Blanche presents us with the distasteful spectacle of Florette imploring Maillac's family and friends to take care of her after his death: "After all, I washed and cleaned him day and night as one would a dotard."[31] Camille seems unlikely to have received satisfaction on this point, since Maître's estate, valued at just over 10,000 francs, was divided among his father, three brothers, and four half-brothers and half-sisters, most of whom renounced their claims.[32] His family did, however, leave her in possession of Renoir's portraits, which she promptly sold to Durand-Ruel for modest sums: the full-length for 1,000 francs and the head for 250 francs.[33]

In later years Renoir himself expressed a surprising aversion towards his early portraits and figures – of the related *Woman with a Parrot* (1871, Guggenheim Museum, New York) he wrote in March 1912 that such paintings were "croûtes," things of no value – but a younger generation did not share his disdain.[34] Proust may have been inspired by the full-length *Rapha Maître* in his description of Odette de Crécy's "narrow vestibule" as "papered with a garden trellis, with a rectangular tub of chrysanthemums running the entire length of one wall."[35] Matisse would pay a double tribute to this painting by including the lower half in both versions of *Auguste Pellerin* (figs. 127, 128) – his portrait of the manufacturer of Tip margarine, who owned ninety-two Cézannes by the time of his death and who had recently acquired Renoir's full-length.[36] Yet it seems fitting that the last word be given to Edmond Maître, whose enthusiasm for Renoir never wavered, and who elegantly alluded to the two portraits of his mistress when he wrote that "Renoir's work, so diverse, so refined, will turn the heads of the connoisseurs in years to come."[37]

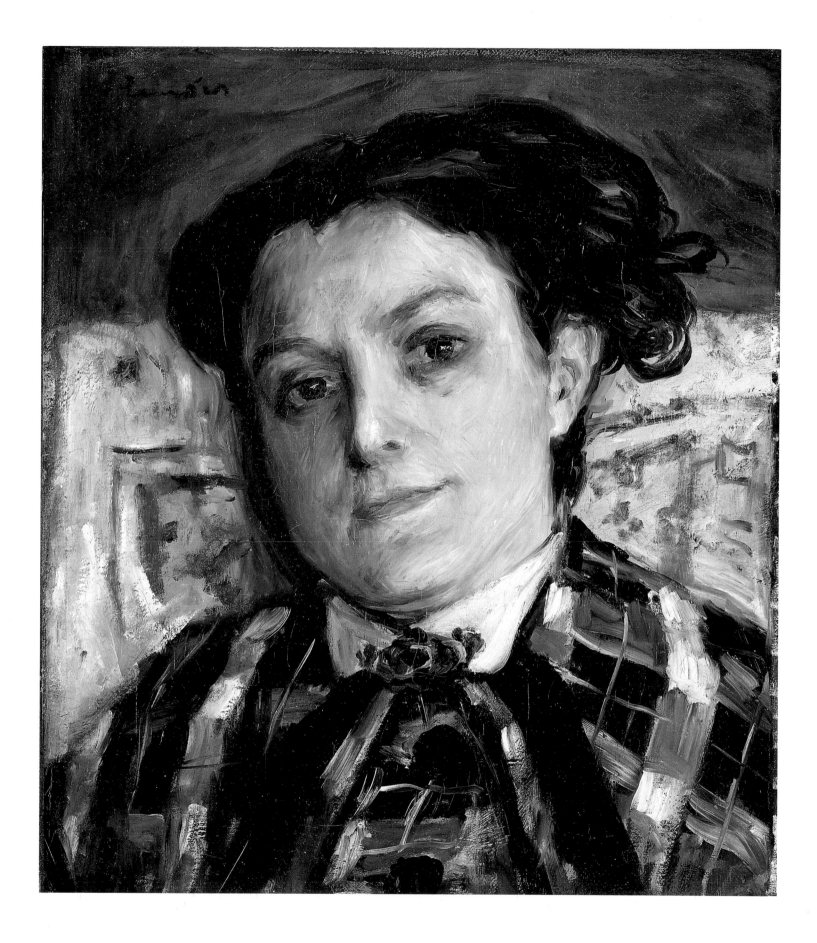

cat. no. 12

261 × 226 cm
Hamburger Kunsthalle, Hamburg

REPLYING ON 28 JANUARY 1913 to a request from Alfred Lichtwark, director of the Kunsthalle in Hamburg, for information on their newly acquired *Riding in the Bois de Boulogne* – which had fetched 95,000 francs at the Rouart sale of 9–11 December 1912 – Renoir produced a terse, but succinct, recollection of the conditions surrounding the creation of his largest, if least universally beloved, work.

> About the history of this painting, it's fairly simple. My friend Darras, aide-de-camp to General du Barail, kindly let me use one of the rooms of the École Militaire as well as the riding school, so that I could study horses in motion. In those days, I did not attach a great deal of importance to my work, which was in any case little appreciated, and I have since lost all the preliminary studies for this painting, which were done in the Bois de Boulogne. It was Madame Darras who posed for the Amazon.[1]

A similar account, published by Vollard six years later, adds precious information. Renoir remembered starting this work "in the first days of winter"; he did not complete it until early in the new year; his studio in the École Militaire was the Salle des Fêtes. He also recalled painting other large canvases at this time, including *La Source* (Barnes Foundation, Merion, Pa.), normally dated to 1875, as well as a military subject, *The Trumpeter of the Mounted Guard*, of which no trace remains. Finally, it was noted that the painting had been submitted to the Salon of 1873 and rejected.[2]

As both of these accounts make clear, *Riding in the Bois de Boulogne* was something of a family affair. Captain Paul-Édouard-Alfred Darras (1834–1903), an accomplished topographical painter whose watercolours were accepted at the Salon of 1873, was able to provide Renoir with a large "studio" in the École Militaire, because, as a staff officer, he and his wife were themselves living there at this time.[3] The use of one of the abandoned reception rooms must have served Renoir almost as well as the opportunity to observe horses at first hand in the company of a distinguished equestrian. Darras's thirty-five-year-old wife, Henriette, née Oudiette (1837–1910) (fig. 129), played her part as a fashionable Amazon. Wealthier than her husband – at the time of her marriage to the impecunious Darras in February 1859 it was her dowry that had provided the basis of the couple's income – this daughter of a plaster manufacturer from the outskirts of Dijon was nevertheless hardly known to frequent the beau monde in the early years of the Third Republic.[4] Similarly, the boy accompanying her on a pony – whom most critics took to be her son – was modelled for by the thirteen-year-old Joseph Le Coeur (1860–1904), second child of the architect Charles Le Coeur, whose portrait would be painted by Renoir the following year (cat. no. 18).[5] It was probably the Le Coeurs who were responsible for introducing Renoir to Darras and his wife: their lasting friendship is attested to by the presence of Renoir's preliminary study for *Madame Darras as an Amazon* (fig. 130) in the Le Coeurs' collection until 1924.[6] Charles Le Coeur was one of the witnesses at

Captain Darras's death in June 1903; by this time, Renoir had long lost touch with both families.[7]

In its way, *Riding in the Bois de Boulogne* is as megalomaniacal a painting as Monet's *Luncheon on the Grass* (1865–66, left and central panels, Musée d'Orsay, Paris). Emboldened rather than thwarted by the rejection of his *Parisian Women in Algerian Dress* (National Museum of Western Art, Tokyo) the previous year, Renoir now tackles a genuine Parisian subject on a canvas almost twice the size of his last Salon entry, and he is prepared to suffer the indignities of a second trial by jury in submitting this work to the Salon des Refusés – euphemistically called "l'exposition des oeuvres non classés" – held between May and June 1873 in a makeshift pavilion opposite the Palais de l'Industrie.[8] His desire for public recognition as a figure painter working at this point in a style closer to Manet than to Monet is nowhere better illustrated than in this reckless undertaking, a hybrid composition – part portrait, part genre – and of a scale normally reserved for allegories of royalty.

Riding in the Bois de Boulogne was acquired in April 1874 for 2,000 francs by one of Renoir's fellow participants at the Salon des Refusés, the industrialist and discerning collector of Impressionist paintings Henri Rouart (1833–1912).[9] Rouart's perspicacious acquisition resulted in the virtual disappearance of a work whose scale – then as today – made its inclusion in exhibitions problematic. Hanging high on the walls of Rouart's studio in his *hôtel particulier* at 34 rue de Lisbonne, it was the single "grand absent" in the first major retrospective devoted to Renoir during his lifetime – Durand-Ruel's exhibition of one hundred and ten works held in May 1892 – and mourned as such by Arsène Alexandre.[10]

"His works might assume more brilliance and more grace, or rather a different sort of brilliance and grace, but one can hardly imagine him painting anything more powerful or more harmonious."[11] In fact, Alexandre's enthusiasm had been shared by all contemporary critics sympathetic to Renoir's cause. In 1873, Burty praised the solidity of his draughtsmanship and the successful rendering of horses in movement, a rarity even in the official Salon; and Castagnary admired Renoir's audaciousness and the conviction with which he had rendered "the beatitude of being transported, of cleaving through the wind."[12] In May 1892 Alexandre wrote that Renoir's Amazon, "with her fine skin blooming tenderly beneath the soft blue veil . . . was one of the most accurate as well as the most seductive creations of modern art."[13] Julie Manet, visiting Rouart's collection in January 1898, marvelled at the "astonishing movement" of the horses, the grace of the Amazon, the delightful background: "one had never seen anything like it by Monsieur Renoir."[14]

Yet appreciation of Renoir's delicate coloration or ambitious draughtsmanship has not been shared in our own day by historians who have preferred to follow Meier-Graefe in classifying *Riding in the Bois de Boulogne* as a step backwards, a diversion from the path to Impressionism.[15] For Rewald it was "a huge but somewhat conventional painting."[16] Barbara White considered it Renoir's "last Academic Realist work," a curious muddling of categories.[17] Even Robert Herbert, the first to examine carefully the resonances and topicality of Renoir's subject matter here, dismissed the painting itself as "awkward and unconvincing . . . full of compromise . . . pretentious."[18]

If Renoir is tackling a subject more properly the province of Degas, and on a scale that might well seem preposterous, it is

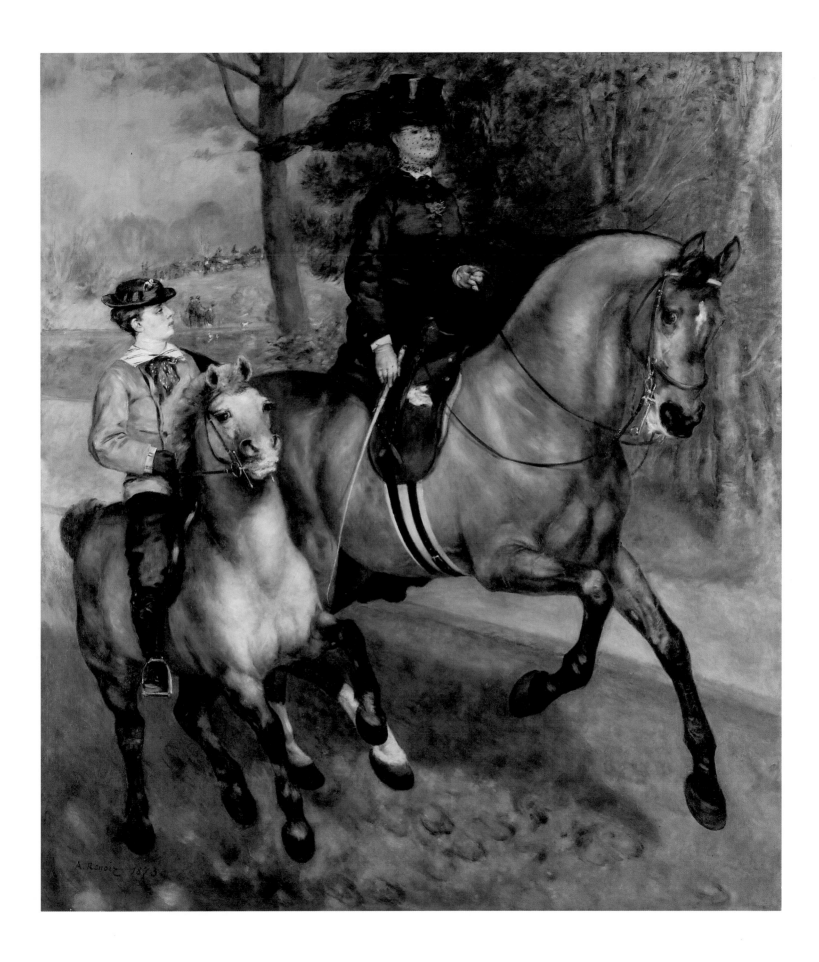

worth considering the ambition of his enterprise and the complexity of his pictorial agenda before passing judgement on what is assuredly a flawed, if magnificent, wrong turning. Renoir's determination to gain some understanding of animal locomotion and to render equine movement without recourse to the clichés of military painting placed him in the vanguard of Naturalist experimentation. He is an unlikely cohort of the British photographer Eadweard Muybridge, whose investigations into the movement of horses in Palo Alto, California, were taking place at precisely this time.[19] Yet even if Muybridge's photographs had been available to Renoir, it is unlikely that he would have consulted them. He would surely have agreed with Manet's comment to Berthe Morisot: "Not being in the habit of painting horses, I copied mine from those who knew best how to paint them."[20] Renoir turned to Delacroix and Rubens (Velázquez's equestrian portraits were not available to him in Paris), studying the lunging horse that chases Heliodorus from the Temple in the mural at Saint-Sulpice, and appropriating the general framework of his composition from Rubens's *Capture of Juliers* (Musée du Louvre, Paris) in the Medici cycle. As Isaacson has noted, Renoir also looked to journalistic illustration for a subject more properly the province of popular imagery. Amazons and their accompanying chevaliers were a common subject in the ephemeral press, and Renoir would doubtless have seen illustrations such as Morin's *Un temps de galop au Bois de Boulogne* (fig. 132).[21]

Yet a compilation of sources, high and low, goes only so far in penetrating Renoir's equestrian painting, just as it tends to obscure the mythmaking that is at the heart of this monumental enterprise. For *Riding in the Bois de Boulogne* is Renoir's first large-scale urban work to be presented to a Parisian public. Its subject is high life and privilege; it makes a calculated appeal to fashion and, perhaps, to snobbery; it is a record of the distance travelled from bohemia to the Bois de Boulogne. And for all these reasons, it fails.

Impeccably attired in the black suit and top-hat and veil of a fashionable Amazon, Madame Darras is shown riding side-saddle in one of the pathways reserved for horsemen in the Bois de Boulogne. Hoof marks, but not those of carriage wheels, are visible underneath the splayed legs of the dappled horse and the pony who is having some difficulty keeping up. The stretch of water in the background and the tiny carriages in the far distance identify this allée as one of those that converged on the serpentine lakes in the heart of the Bois de Boulogne. Like his earlier *Skaters in the Bois de Boulogne* (1868, private collection, New York), Renoir's equestrian picture pays homage to the most spectacular of Haussmann's developments in Second Empire Paris.[22] "Once a forest abounding with game, the resort of duellists, persons suicidally disposed, and robbers, [the Bois de Boulogne] is now a beautiful park covering 2,250 acres."[23] Baedecker was rarely so poetic, but it was the case that between 1852 and 1858 the former royal forest was transformed out of all recognition by the planting of 400,000 trees, the creation of two artificial lakes – one seen in the background here – the establishment of a racetrack at Longchamps, a zoo, botanical gardens, and an amusement area at the Pré Catelan. By the 1860s, the Bois was the pre-eminent pleasure garden of Paris, a place to see and to be seen, with its own rigorously codified protocol and set of rituals.[24]

Among the activities most favoured by the aristocracy of Second Empire Paris was the early morning ride in the Bois, so planned to avoid both the heat and the thronging masses who descended upon the lakes every afternoon. An English observer noted in 1865: "The ladies have started a new fashion since the hot weather set in, and go early in the morning. Princess de Bauffremont on a dark bay mare, the Duchess of Fitzjames and her two sons . . . may be seen almost every morning enjoying a canter in the shady allées of the Bois."[25] By the 1880s, the allée des Poteaux, "exclusively reserved for the use of riders on horseback," was frequented by up to twelve hundred people a day at the height of the season. Accordingly, it became an article of faith that society enjoyed the Bois only in the mornings: "It is in the mornings that one rides, either on horseback or in the carriage, and this every day without exception in order to bring red to ones cheeks. There are women of the highest rank whom nothing will prevent from being at the Bois at eight in the morning."[26] As Philippe Burty noted in 1873, Renoir had captured the colour rising to the cheeks of the boy who accompanies his mother in her morning ride – "la promenade du matin" – at the Bois de Boulogne.[27]

Thus, Renoir's most monumental scene of Parisian leisure to date is also his most patrician. And as in his later multifigured compositions set in Montmartre and Chatou, it is one in which his models assume guises that are fictional. Henriette Oudiette might be the wife of an admired staff officer, but Darras's fortune was modest, as his commanding officer noted, and he could not afford to keep a horse that did justice to his equestrian skills.[28] The beautifully dressed Joseph Le Coeur (the Darras were childless) resembles the depraved adolescent Maxime in Zola's *La Curée* – "with his fine shoes, well-fitting gloves, splendid cravats, and unforgettable hat" – rather than the son of a solid middle-class architect.[29]

In fact, Renoir is tackling a genre more properly the province of fashionable society painters. Manet painted Marie Léfebure *en Amazone* (Museu de Arte de São Paulo) at this time, but for Renoir's contemporaries the more apposite comparison was with Carolus-Duran's highly acclaimed portrait of his sister-in-law Mademoiselle Croizette (fig. 131), the success of the official Salon of 1873, with which Renoir's *Riding in the Bois de Boulogne* was both favourably and unfavourably compared.[30] Sarah Bernhardt's chief rival at the Comédie-Française at this time, Sophie Croizette might look as if she could not take one step backwards without falling straight into the sea, but the static pose and elegant presentation of Carolus-Duran's portrait of her – reminiscent of the equestrian *carte de visite*, with its horizontal format and formal garden as background – conformed to the requirements of an acceptable Parisian chic that Renoir was far from being able to satisfy.[31]

Renoir would paint the portraits of actresses soon enough, but in 1872–73 his aspirations were rather to create an authentic vision of modern life. Paradoxically, he was poorly served by subjects of Parisian high life. In *La Curée*, published as a book at the very time that Renoir began work on *Riding in the Bois de Boulogne*, Zola had treated the Bois as a locus for mondain intrigue and sexual dalliance.[32] His novel opens, unforgettably, with a litany of infidelities discussed during the long journey back to Paris in a traffic jam of carriages returning from their afternoon tour of the lakes. Renoir's sympathies are elsewhere. Unlike the journalistic illustrations with which his giant canvas is compared, his painting is without the slightest hint of gallantry or intrigue. The modernity he strives to capture – formulated by Baudelaïre,

made the subject of high art by Manet – proves elusive. For Baudelaire, modernity was an ethical and not merely topographical construct. Multivalent, it was inclusive, from "costume and coiffure, down to gesture, glance, and smile (each age has a deportment, a glance, and a smile of its own)."[33] The painter of modern life could no longer separate woman from her environment; indeed, in her various incarnations, woman became a subject worthy of the most intense scrutiny: "Where is the man who, in the street, at the theatre, *or in the Bois*, has not in the most dis-

interested of ways enjoyed a skilfully composed toilette, and has not taken away with him a picture of it which is inseparable from the beauty of her to whom it belonged, making thus of the two things – the woman and her dress – an indivisible unity?"[34]

In the end, it was Rabelais and not Baudelaire whose vision of community and society nourished Renoir. The morning ride in the Bois de Boulogne was part of an alien sociability to which Renoir, here a reluctant and uneasy *flâneur*, could respond only as an outsider.

46 × 60 cm
Wadsworth Atheneum, Hartford, Conn.
Bequest of Anne Parrish Titzell, 1957

"MY STUDIO? But I've never had a studio! And I do not understand why anyone should want to lock themselves away in a room. To draw, yes; but to paint, no!"[1] Anticipating Monet's outburst by seven years, Renoir's lambent canvas of Monet painting *en plein air* before a bush of high-coloured dahlias bears eloquent witness to a central tenet of Impressionism as well as one of its most persuasive myths: the artist before Nature, spontaneously recording what he sees. *Claude Monet Painting in His Garden at Argenteuil* was probably painted in late August or early September 1873 – the time of Renoir and Monet's *rapprochement* and the period at which the dahlias would have been at their most abundant.[2] It is the only painting done at Argenteuil that Renoir remembered in any detail,[3] and as Anne Distel has noted, it does more to "evoke the friendship that existed between Monet and Renoir than could any commentary."[4]

Claude Monet Painting in His Garden at Argenteuil is a record of the artist's second summer at 2 rue Pierre Guienne, a villa with a spacious garden previously rented by the Realist painter Théodule Ribot.[5] Known as the Maison Aubry, the property lay near the railroad station in the most picturesque section of Argenteuil, a town whose population had doubled to 8,000 by the time that Monet and his family moved there. Fifteen minutes from the Gare Saint-Lazare, Argenteuil was a favoured sailing centre for Parisians.[6]

The painting is a work of extraordinary delicacy and detail. Monet, wearing his round hat and dark-blue jacket with its black velvet collar (the cuff of his right sleeve and his shirt collar are indicated by the merest slivers of white), is shown with nearly all the tools of his trade. His portable paint box and folded parasol are placed on the ground by his feet; he balances a rectangular palette on his left arm, while holding several long paintbrushes in his left hand; on the lightweight easel, also portable, can be seen a canvas of landscape format, primed with a white ground. Monet is portrayed painting in front of a thicket fence that can barely restrain the tumultuous array of red, yellow, and white dahlias. Behind them, at left, is a two-storey house with an attic window, flanked by a tree in full bloom. In the background at right are several of the older villas in the rue Diane and the rue Pierre Guienne to the south of Monet's property.[7] In front of what might possibly be a shop (the white walls and blue frontage of the second house from the right) can be discerned the tiny figure of a man dressed not unlike Monet.

Renoir's handling is at its most animated here. Touches of salmon-pink resonate throughout the sky and trees in the background, just as dabs of orange activate the surface of the flowering bushes throughout. But all this is at no cost to the planar organization of a painting that conveys a sense both of rampant nature and of the compact, indeed confining, environment of closely massed brick and stucco villas. In fact, Renoir seems consciously to have adopted Monet's flickering, variegated brushwork in a canvas that has obvious affinities with the latter's own

Corner of the Garden in Argenteuil (fig. 133), signed and dated 1873 and probably painted at more or less the same time.[8] In Monet's composition the flowering dahlias are overwhelming: they obscure the two-storey house, now positioned just right of centre, and they dwarf the properly attired figures – Camille and Renoir? – seen walking by the thicket fence on the far edge of the garden.

Similar only at first sight, the two paintings can be seen in terms of distinct polarities. Unlike Monet and Renoir's views of the duck pond or the railway bridge at Argenteuil, their garden scenes were not painted side by side; in each the garden is recorded from a different angle. Monet's composition, with its absent fence and windswept vegetation, stresses the seigniorial over the suburban; his *Corner of the Garden in Argenteuil* is a modern *fête champêtre*, with the neighbouring villas ruthlessly excluded from view. Renoir, more faithful to the topography of Argenteuil, does not excise the surrounding architecture, nor does he ignore the lack of privacy characteristic of suburban living, however gracious.[9] With its thicket fence, its boundaries between neighbours, and the other houses not far beyond, his painting hints at the artificiality of Monet's *hortus conclusus* and the exiguity of his rented property.

Renoir and Monet have approached this corner of the garden with quite different expectations. Not only is there a staged quality in Renoir's portrayal of Monet working out of doors – he is equipped for a long day in the countryside, not merely a trip down the garden path – but it is also fair to ask whose garden is being painted. Monet's many garden views done at the Maison Aubry between 1872 and 1874 invariably suggest an ordered, spacious realm, one that is protected by closed walls from the noisy suburb without. From whatever angle, Monet's garden – with its manicured flower-beds, *japonisant* pots, and occasional unkempt corners – is normally represented as a site of calm, even formal, retreat. Exceptionally, his *Corner of the Garden in Argenteuil* approaches the garden from the opposite point of view. In the light of Renoir's version, it has even been suggested that Monet has enlarged the flower-bed and removed it from his neighbour's property to represent it as his own.[10]

Renoir quietly punctures Monet's vision of gentility in the suburbs. Standing outside the garden, to which the thicket fence denies access, it seems reasonable to assume that he has shown Monet painting not his own garden but that of a neighbour. The question must remain moot, since the Maison Aubry at 2 rue Pierre Guienne was demolished in 1913 when the street was renamed boulevard Karl Marx (a change of address unlikely to have appealed to either Monet or Renoir).[11]

If Monet's *Corner of the Garden in Argenteuil* is more romantic than it initially appears, so Renoir's *Monet Painting in His Garden at Argenteuil* is less spontaneous than such confident and shimmering brushwork would imply. His preparatory pastel portrait of Monet in painter's costume, seen head-on but without brushes or palette (fig. 134), suggests that Renoir perhaps worked out his composition beforehand, studying Monet from different angles before committing to the final *mise en scène*.[12] Furthermore – and following a suggestion first made by John House in 1994 – it can now be shown that *Monet Painting in His Garden at Argenteuil* is painted over an entirely different composition.[13] The ridges of paint underneath the present composition, clearly visible to the naked eye, are the brushstrokes of an earlier painting, vertical in format, of Camille Monet wearing a summer bonnet (fig. 136).

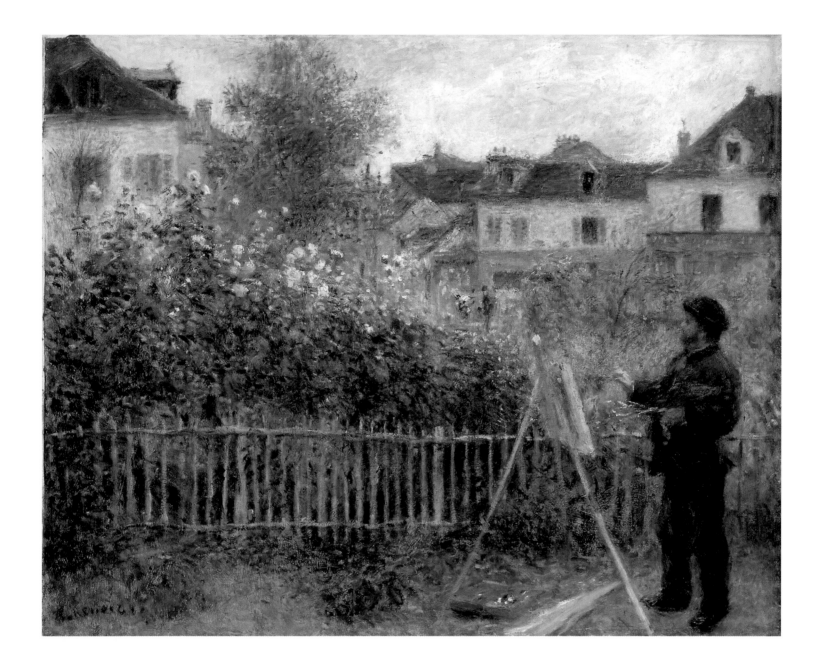

The wide-brimmed hat trimmed with ribbons at the top is not unlike the one she wears in *The Reader* (*Springtime*) (fig. 135).[14] This bust-length portrait of Camille, looking to her left and placed slightly off centre, would have been the only instance in which Renoir allowed himself such proximity to his host's wife: in his other portrayals of her, he keeps a more respectable distance (see cat. nos. 16, 17). Yet the cropping of Camille and the pre-

sentation of her gazing past the viewer are uncharacteristic of Renoir's approach to his sitters and raise the possibility that this composition itself may have been cut down from a larger work that had been abandoned. If so, House's question remains pertinent: was Renoir painting over a study by Monet of his wife that Monet had discarded, or did he replace his own close-up of Camille with a virtuoso rendering of her husband at work?[15]

15 *Claude Monet (The Reader)* 1873–74

61 × 50 cm
National Gallery of Art, Washington
Collection of Mr. and Mrs. Paul Mellon

Between 1873 and 1875 Renoir painted several informal but deeply felt portraits of Claude and Camille Monet (always separately – the couple was never shown together) that communicate not only his affection but his growing admiration for Monet, "the heart and soul of the group."[1] This portrait in the National Gallery of Art in Washington and another of similar dimensions in the Musée Marmottan in Paris (fig. 137) both show Monet smoking as he reads, and they may well have been painted on the same occasion. Although he is hatless in the Washington picture, his costume is buttoned to the neck in both, and in both he is seated in a dark interior with no indication of the source of the strongly defining light.

The Marmottan picture, known as *Claude Monet Reading*, in which the artist is shown reading a newspaper, was painted as a companion to a portrait of Camille (fig. 138) that is less thoroughly worked up and betrays an indecisiveness – in the sitter's pose and expression, in the handling of the background – nowhere discernible in the more resolute portrait of her husband. These pendant portraits were owned by Monet and remained in his family until they were donated by Michel Monet with the rest of his collection to the Musée Marmottan in 1966.[2]

Shortly after it was painted, *The Reader* was acquired by Jean Dollfus (1823–1911), scion of an Alsatian industrial dynasty and a discriminating collector of Impressionist pictures in the 1870s.[3] Dollfus probably paid no more than 150 francs for the work, which sold for 12,000 francs in March 1912.[4] In his sale catalogue, *The Reader* was published as a portrait of Alfred Sisley and dated to 1876, and it is as such that it appeared in the third edition of Duret's *Les Peintres impressionnistes* in 1922.[5]

Despite this curious error, inexplicable to modern eyes, these portraits of Monet reading would seem unproblematic. Both are signed "A. Renoir," a form of signature that the artist would continue to use until 1874; both are quite thickly worked in a relatively muted palette; and in both a proto-Impressionist handling is evident, with Renoir taking great pleasure in painting the blue smoke of Monet's pipe and in enlivening the surfaces of his beard, face, and hand with dabs of orange, pink, yellow, and blue. Until very recently, the traditional dating of both portraits to 1872 had gone unquestioned, and the works have become symbols in the mythology of an emerging Impressionist brotherhood.[6]

In fact, each painting seems to have been thoroughly reworked, as in the case of *Claude Monet Painting in His Garden at Argenteuil* (cat. no. 14). Careful inspection of the canvases – or even close examination of good reproductions – reveals the presence of underlying brushstrokes, particularly noticeable in the lower-left quadrant of the Marmottan picture, where they describe an alternative composition that Renoir seems to have effaced. That he should have reused his canvases at this time is not surprising, but it has been documented in relatively few examples for the 1870s. The Washington portrait, while it also shows signs of considerable revision, does not have an underlying com-

position detectable through X-radiography. Examination of the Marmottan portrait will reveal whether it is painted over a different composition, or whether the underlying image served as a trial run. These investigations add considerably to our appreciation of the experimental nature of Renoir's work in the early 1870s.[7]

If the physical condition of these portraits still has information to reveal, their traditional dating is also open to revision. It seems highly unlikely that they could have been produced in 1872, and a later dating to the second half of 1873, or possibly early 1874, has implications beyond the connoisseurial. Although Renoir had worked alongside Monet prior to the Franco-Prussian War, it took some time for their former intimacy to be reestablished after the Monets returned to Paris in October 1871. Claude, Camille, and Jean moved almost immediately to Argenteuil, where they rented a house with a large garden at 2 rue Pierre Guienne from the widow of the former mayor of the village to whom they had been introduced by Manet.[8] Their first long-standing guest there seems to have been Alfred Sisley, who may have lived with them from December 1871 until the following spring. Certainly he and Monet painted several sites in Argenteuil side by side, and their joint absence from Paris and Right Bank café society at this time was noted by Rivière.[9]

Rivière also pointed out that, uncharacteristically, Renoir rarely left Paris for the country during the first years of the Third Republic.[10] Unlike Monet and Sisley, he devoted himself to the Salon, to which his submissions were rejected both in 1872 and 1873. In May 1872 Renoir was one of twenty-six signatories of a petition to the minister Jules Simon requesting a Salon des Refusés – Pissarro and Cézanne's names also appear, Monet and Sisley's do not – and the minister's refusal notwithstanding, Renoir settled down to work on the largest canvas he would ever paint, his *envoi* to the Salon of 1873.[11] As Renoir himself recalled, *Riding in the Bois de Boulogne* (cat. no. 13) would occupy him throughout the autumn and winter of 1872–73. He seems to have been included neither in the dinner that Monet, Sisley, and Pissarro planned in honour of Paul Durand-Ruel in November 1872 nor in the group that invited Zola to dinner at the Café Anglais in December of that year.[12] Although Monet and Renoir both painted more or less identical scenes of the busy Pont Neuf from a café near the Louvre, they did not work on these pictures in tandem, as they had at La Grenouillère three years before. Renoir's canvas, dated 1872, captures a sunny summer's afternoon; Monet's, now assigned to the winter of 1871, is of a wet and windy shower.[13]

Renoir's determination to make his reputation at the Salon, despite officialdom's distinct lack of encouragement, may have prevented him from becoming too close to Monet in this period. As early as April 1873, Monet had been militating for an alternative system of exhibition and sale, and discussions conducted at Argenteuil were sufficiently developed for Zola to pass the word to his colleague Paul Alexis, who on 5 May 1873 reported enthusiastically in the radical *L'Avenir National* that "this powerful idea, the idea of association, is growing."[14] Plans for the future Société Anonyme Coopérative des Artistes Peintres were being hatched a year before the first Impressionist exhibition opened, with Renoir taking no part, it seems, in the earliest deliberations. On 7 May 1873 Monet informed Alexis that he and "a group of painters assembled in my home" were about to constitute a new society and sent him the names of the founding members, which Alexis

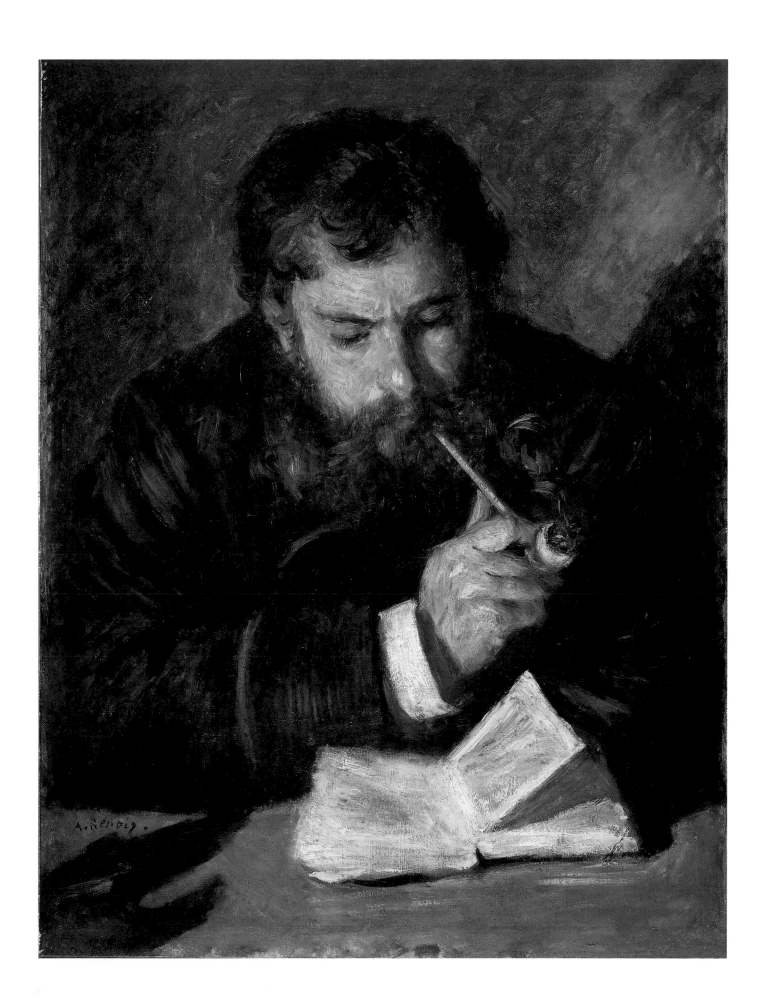

duly published ten days later.[15] Pissarro, Jongkind, and Sisley are among them; Renoir's name does not appear.[16]

Only after the humiliating experience of exhibiting his rejected picture at the Salon des Refusés between May and June 1873 did Renoir abandon his allegiances to the State – albeit temporarily – in favour of the cooperative venture being organized by Monet and his fellow Naturalists in Argenteuil. His first documented sojourn with Monet and his family dates to the summer of 1873, when both artists painted certain motifs together – the duck pond, the railroad bridge viewed from the port – and when Renoir depicted Monet painting the dahlias in front of his house (cat. no. 14).[17] Renoir's name appears in Monet's correspondence for the first time since their move to Argenteuil only in September 1873 (admittedly, the period from 1872 to 1874 is quite unevenly documented), when Monet informed Pissarro that he could spend the night if he wished, since Renoir was away.[18] By December 1873 Renoir was fully committed to the project for a deregulated, independent artist's cooperative. He seems to have modified some of Pissarro's more radical demands for the charter of association, and while Monet was still combing Paris, unsuccessfully, for founding members in December 1873, Renoir was sent on a similarly fruitless mission to recruit Guillemet.[19] Such was the transformation of his allegiances that Renoir served as one of the three principal officers of the newly constituted Société Anonyme, and it was in his studio in the rue Saint-Georges that the ailing cooperative would be dissolved in December 1874.[20]

Renoir's portraits of Monet need to be integrated within this chronology of gradual affiliation; only then are the resonances of their particular iconography meaningful. Although he is portrayed neither painting nor drawing, Monet is shown in working clothes. His jacket with its velvet collar buttoned to the neck – no white shirt or foulard visible – is similar to the one he had worn in Fantin-Latour's *Studio in the Batignolles* (fig. 62), in which he had appeared as something of an interloper.[21] It is this costume, along with his "petit chapeau" – neither bowler, nor cap – that Monet is also wearing in Renoir's portrait of him painting out of doors.[22] This is the apparel of an independent artist: neither the urban dandy, nor the jobbing painter attired in a smock for outdoor work. The smoking pipe adds a distinctly bohemian reference, which in the early years of the Third Republic might suggest a more determined radicalism. In both Manet's *Bon Bock* (Philadelphia Museum of Art) and Pissarro's etching of Paul Cézanne (fig. 139), images that are strictly contemporary with Renoir's portraits of Monet, the artist's sturdy integrity is communicated through the inclusion of the long-stemmed pipe – an

attribute also beloved of the Maître d'Ornans – again in contrast to the more rarefied city dwellers who smoke cigarettes.[23] By placing a paperback novel in front of him (no binding is visible in the Washington portrait), Renoir alludes perhaps to Monet's advanced literary tastes, and in the Marmottan portrait the sitter's interest in *japonisme* is discreetly implied by the back of the gilded chair carved to resemble bamboo that had appeared in Monet's earlier scenes of a family at breakfast.[24]

In *Claude Monet Reading* the artist is shown deep in concentration reading a newspaper. While it is less easily identified than in *The Inn of Mère Antony*, the letters "NT" reveal that he is reading *L'Événement*, a newspaper that had shut down in November 1866 but started publishing again in April 1872.[25] Under the direction of Émile Magnier, *L'Événement* was relaunched as a fashionable but staunchly Republican daily, establishing itself as a sort of "democratic Figaro."[26] In January 1874, it would be among several journals to publish the Société Anonyme's founding charter. On 24 January Monet informed Pissarro from Le Havre that he was pleased to know that the administrative council was doing its job in his absence, since he had seen the articles of incorporation in *L'Événement*.[27]

Renoir's earliest perception of Monet – which, since it is recorded by his son, needs to be treated with some caution – was that of an elegant dandy, who refused to perch on a stool in Gleyre's studio, resisted the advances of female students ("I only sleep with duchesses or maids; the best would be the maid to a duchess"), and wore lace cuffs on his impeccably ironed white shirts.[28] Even a decade later, photographs of Monet taken in Amsterdam (fig. 140), which confirm once again Renoir's remarkable fidelity to details of physiognomy, show him in a finely tailored suit, with velvet collar, wide lapels, and a rakish waistcoat. Renoir's portraits construct a quite different image of his host and fellow artist. While lovingly documenting Monet's handsome features – the bushy beard, flecked with colour, the long eyelashes, painstakingly described – Renoir pares both paintings to their essentials. Through the spartan setting that Renoir has chosen for Monet, which gives no clue as to whether we are in Paris or Argenteuil,[29] and in the attributes that have been carefully selected – pipe, "petit chapeau," outdoor jacket – Renoir insists upon the "négligé de l'artiste" to arrive at "the energetic, scrupulous, and fine Claude Monet."[30] In so doing, he has crafted nothing less than an icon of the independent artist, while at the same time expressing wholehearted solidarity with the prime mover of the New Painting.

61.2 × 50.3 cm
Sterling and Francine Clark Art Institute,
Williamstown, Mass.

JUST AS RENOIR painted two portraits of Monet in identical costume, alternately reading a book and a newspaper, so did he proceed in his portraits of Monet's wife, Camille. In *Camille Monet Reading* she is portrayed turning the pages of a paperback book, most probably a novel; in *Madame Monet on a Sofa* (fig. 35) she reclines with a copy of *Le Figaro*. The earlier of the two portraits, *Camille Monet Reading*, was exhibited late in Renoir's lifetime as having been painted in 1872, a dating that has remained virtually unquestioned.[1] Given the chronology established for the portraits of Monet in the National Gallery of Art, Washington (cat. no. 15), and the Musée Marmottan in Paris (fig. 137), this painting as well should be dated to the summer or autumn of 1873, when Renoir once again became a familiar of the Monets. Although *Camille Monet Reading* could have been among the "numerous studies" that he recalled doing in Monet's company at Argenteuil in the summer of 1873, its interior setting, suggestive of autumn, might place it slightly later in the year.[2]

In this painting, Camille Léonie Monet, née Doncieux (1847–1879) is shown seated upright on a large sofa whose floral-patterned covering is of distinctly *japonisant* design. On the pillow to her right can be seen a strutting bird, possibly a crane, Japanese symbol of longevity.[3] Suspended on the blue wall above Camille's head are three *uchiwa*, the ubiquitous round Japanese fans. Chinese in origin, made from bamboo and printed paper, they had recently begun to appear in genre paintings and portraits by fashionable artists such as Whistler, Tissot, and Stevens, and would also infiltrate the Parisian paintings of Manet, Degas, Monet, and Renoir.[4] One such Japanese fan is placed discreetly on the mantelpiece in the background of Monet's *Madame Monet on the Sofa* (1870–71, Musée d'Orsay, Paris), a rare interior portrait of Camille that Renoir may have known when painting his own. Five years later, *uchiwa* fans will erupt in Monet's *Camille Monet in Japanese Costume* (1876, fig. 155).[5]

Although Renoir was often quoted as disavowing *japonisme*, his *Camille Monet Reading* is conclusive proof that, in the early 1870s at least, he too was hardly immune to its charms.[6] Nor was this the first time that he incorporated decorative elements inspired by Japan in his portraits. The motif of a strutting bird appears in the backgrounds of the portraits of his brother Pierre-Henri (cat. no. 7) and sister-in-law Blanche (fig. 115), and Rapha Maître is shown holding a splendid Japanese fan (cat. no. 11). In *Camille Monet Reading* the slanting *uchiwa* fans serve a double purpose. They allude to Monet's passion for things Japanese – as early as 1868 he had been described as "a faithful emulator of Hokusai" – and grouped together in this way they symbolize hospitality,

Renoir's elegant thank you to his hosts for the spare bedroom at Argenteuil.[7]

Indeed, the surface of Renoir's sparkling canvas is as animated as the interwoven Japanese matting at Camille's feet. It is a veritable kaleidoscope of dabs and dashes of paint applied with unfailing assurance to create an image of complete spatial coherence. Supported by pillows at her back and under her feet, a rather bulky Camille is represented doll-like, absorbed in her reading. Comparable in handling to Renoir's *Claude Monet Painting in His Garden at Argenteuil* (cat. no. 14), Renoir's prodigious technique allows him to attend to a myriad of details. Camille's chin and claw-like hands are outlined in blue; touches of white impasto describe the knot at her collar, the cuffs of her sleeve, the pages of her book, and the bow on her shoe. No detail of interior furnishing escapes Renoir's brush: the piping around the sofa cushions, the matting on the floor, the embroidery and buttons of Camille's dress.

On one level, of course, Renoir is thoroughly mainstream in his depiction of Camille Monet reading, which was painted more or less at the same time as Fantin-Latour's *Reader* (Musée d'Orsay, Paris), a portrait of his wife Victoria Dubourg exhibited at the Salon of 1873.[8] Renoir's inclusion of Japanese elements also places him in the tradition popularized by such mediocrities as Firmin-Girard (a former classmate at Gleyre's studio), whose *Japanese Interior* (Museu de Arte de Ponce, Puerto Rico) was the hit of the Salon of 1873.[9] Indeed, *Camille Monet Reading* anticipates an entire subgenre of aesthetic interiors with fashionable Parisiennes reclining or reading, as in Croegaert's manic *Reader* (fig. 141), painted a decade and a half later.[10] These comparisons – and many more like them – are instructive in reminding us that while Renoir's choice of subject might not be at all original, his pictorial language and means of expression decidedly are. He is at once riotous in his use of colour and understated in his *japonisant* allusions.

As has been often noted, Camille Monet wears the same dress in the second portrait of her (fig. 35), in which she reclines on a sofa of the purest white.[11] This blue day-dress, with its richly worked central panels whose design is repeated on the sleeves, would have been intended for indoor wear: it buttons along the centre and has close-fitting sleeves. Despite the vogue for Japanese costume – and Renoir would later paint the portrait of Madame Hériot, the formidable proprietor of the Grands Magasins du Louvre, in a kimono (fig. 143) – it is clear that Camille's dress, though not strictly Parisian in design, was inspired by a different Orientalism. Less flamboyant than the Algerian costume worn by Nina de Callias in Manet's portrait of her (fig. 61), in which she too is shown against a background of *uchiwa* fans, Camille's *costume d'intérieur* is a variation on the Turkish caftan. And like Manet, Renoir effects a seamless blending of exotic elements in his depiction of an elegant Parisienne, albeit one who is painted in the suburbs.[12]

Despite her iconic status in the imagery and mythology of

Impressionism, little is known about Camille Monet (fig. 142).[13] Born in Lyons on 15 January 1847 to Charles-Claude Doncieux (1806–1873), a businessman ("négociant"), and his considerably younger wife Léonie-Françoise Manéchalle (1829–after 1879), she moved with her family to Paris at the age of eight and would first pose for Monet ten years later in the summer of 1865.[14] Her parents seem to have been relatively modest members of the bourgeoisie; owning no property, they lived in a rented apartment in the Batignolles. Camille's portion of the family estate upon her father's death in September 1873 was a mere 12,000 francs, slightly less than half Monet's income that year.[15] From 1865 until her death from uterine cancer fourteen years later, she was Monet's primary model and devoted companion, even though Monet's father initially objected to the liaison and in April 1867 had encouraged his son to abandon her when informed of Camille's pregnancy. Camille gave birth out of wedlock to her first son, Jean-Armand-Claude (1867–1914), in August 1867. She and Monet were married in June 1870 in a ceremony attended by her parents and consented to by Monet's father *in absentia*. And she accompanied her husband to London and Amsterdam between September 1870 and November 1871, before returning to establish residences in Argenteuil (1872–1878) and later in Vétheuil.[16] In March 1878 Camille gave birth to a second son, Michel-Jacques (1878–1966), but by that time she was greatly enfeebled by the cancer that had first been diagnosed in the winter of 1876.[17] After six months of agonizing illness, she died on 5 September 1879.[18]

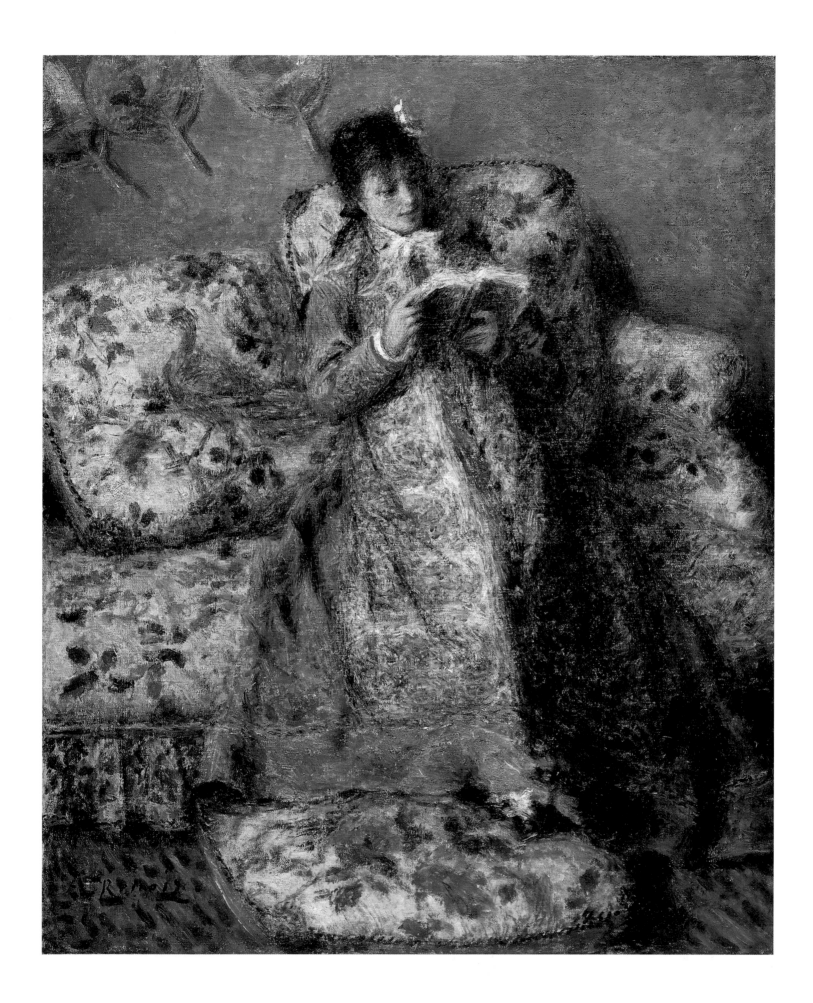

17　*Camille Monet and Her Son Jean in the*
　Garden at Argenteuil　1874

50 × 68 cm
National Gallery of Art, Washington
Ailsa Mellon Bruce Collection

The genesis of Renoir's *Camille Monet and Her Son Jean in the Garden at Argenteuil* is legendary in the annals of Impressionism.[1] Visiting Monet at Argenteuil on 23 July 1874, Manet – who was spending the summer at his family property at Petit-Gennevilliers on the opposite bank of the Seine – painted a *plein-air* study of Camille and seven-year-old Jean in the garden of the Maison Aubry (fig. 144).[2] Renoir arrived while work on this painting was in progress, and, delighted to find a pair of models awaiting him, immediately borrowed canvas, palette, and paint-brushes from his host so that he could join Manet in the garden.[3] Renoir chose a closer viewpoint, cropping Camille's skirt and excluding Monet with his watering can and the screen of flowerbeds and trees in the background. Apparently irritated by Renoir's presence, Manet cast an eye at his work and informed Monet: "He's a nice boy, but since he's your friend, you should encourage him to give up painting straight away: what he does is simply awful."[4]

Attired in elegant and spotless summer clothes, Camille and Jean are shown reclining on the lawn of their rented house at 2 rue Pierre Guienne, from which they would be moving in the autumn.[5] Jean is wearing a sailor boy's suit and a straw hat trimmed with red; his mother is wearing a long white summer dress and a bonnet draped in white tulle, trimmed with black ribbons and decorated with a sprig of red flowers. These outfits were not brand new, since Camille and Jean had been shown wearing them in Monet's *Lunch* (*Decorative Panel*) (Musée d'Orsay, Paris), begun in 1873 and completed for the second Impressionist exhibition of 1876.[6]

Comparing Manet and Renoir's paintings, one admires Renoir's audacity and dynamism all the more. In some ways, his *Camille Monet and Her Son Jean in the Garden at Argenteuil* is more a sketch than a finished composition, and next to it, Manet's *Monet Family in the Garden* – in which Camille and Jean recline in stately repose – appears weighty, almost formal, despite the innovative handling and heightened tonal range. Manet has used the figure of Monet the gardener to anchor his composition. His garden recedes logically through clearly defined zones of light and shade, and the painting's surface is enlivened throughout by syncopated accents of red paint.[7]

This earliest of Manet's *plein-air* paintings is normally cited as an example of the older artist renewing his style after exposure to the freer brushwork and lighter palette of his Impressionist colleagues.[8] While there is no doubt that the time he spent with Monet and Renoir in Argenteuil in the summer of 1874 encouraged him to broaden his repertoire and experiment in a higher key, the unexpected collaboration seems to have been of greater consequence for the youngest of the three artists, Renoir, whose *Camille Monet and Her Son Jean in the Garden at Argenteuil* is more Manet-like than any of his previous Impressionist paintings. Something of a chameleon in the 1870s, Renoir has temporarily abandoned the flickering brushwork and encrusted surfaces of his earlier Argenteuil landscapes to paint with opaque, largely unblended strokes of colour, wet on wet.

Yet if Manet provides the language for *Camille Monet and Her Son Jean in the Garden at Argenteuil*, the syntax is all Renoir's. Compared to the harmony and repose of Manet's *Monet Family in the Garden*, Renoir's vision is frenetic. He conjures a world in motion, with Camille and Jean ungainly and uncomfortable, and the flower-beds and shade-providing tree dismissed in the most cursory of terms. Renoir paints his sitters close up and from a certain height. He looks down on them from a distinctly *japonisant* point of view, and if Jean meets his gaze, Camille's attention is decidedly elsewhere.

And while both artists have approached their subject with a certain wit – Manet introduces a family of chickens to mirror Monet's own brood – Renoir is even more raucous and irreverent. At right, a strutting rooster, painted in summary strokes of orange, yellow, red, and brown, has inadvertently entered the scene, suggesting that the barnyard is not as far away as Monet and Camille might like. Less critical than Daumier of fashionable Parisian attitudes towards the country (fig. 145), Renoir nonetheless misses no opportunity to poke fun at his hosts' somewhat laboured gentility.

Renoir later claimed that he had painted *Camille Monet and Her Son Jean in the Garden at Argenteuil* in his studio at 35 rue Saint-Georges – thereby raising the possibility that the painting was finished in Paris.[9] Certainly, his transcription of a summer's afternoon in the suburbs is more artfully constructed than might initially appear. On the basis of a similar but perhaps not identical hat worn by Suzanne Leenhoff in *On the Beach* (1873, Musée d'Orsay, Paris) and *Boating* (1874, Metropolitan Museum of Art, New York), it has been suggested – unconvincingly, in the present writer's view – that Manet had provided Camille with one of his wife's summer bonnets in which to pose.[10] Camille had a sufficiently large wardrobe of her own, but the suggestion that there is a staged quality to these paintings is surely apt. If, as has generally been assumed, Monet painted a portrait of Manet seated by his easel in the garden while working on the portrait of Camille and Jean (fig. 146), Monet's role as gardener in *The Monet Family in the Garden* is fictional, since he could hardly have been in two places at the same time.[11]

It is further clear that Renoir selected each element in this work with some care. Having wilfully rusticated his sitters by the inclusion of the rooster – his unadorned portrayal runs counter to Monet's far stricter and more serious depiction of Camille and Jean in the garden painted the previous year[12] – he has, as well, incorporated a favourite prop in the form of Camille's tricolour fan, which Manet rendered as a crescent of pure red.[13] Intending, perhaps, to register his host's passion for Oriental objects, Renoir shows Camille with the same fan that she will proudly hold aloft in Monet's portrayal of her in Japanese costume two years later (fig. 155).[14]

Although Tabarant held Vollard responsible for spreading the story of Manet's suggestion that Renoir take up an alternative career (which, as Rewald pertinently observed, may well have been said tongue-in-cheek), it is quite clear that the source of this tale was the ageing Monet himself.[15] He seems to have recounted the anecdote to anyone who would listen – first to Vollard, who probably heard it when he visited Monet in Giverny,[16] then to Maurice Denis, then to Helleu's daughter Paulette (the future

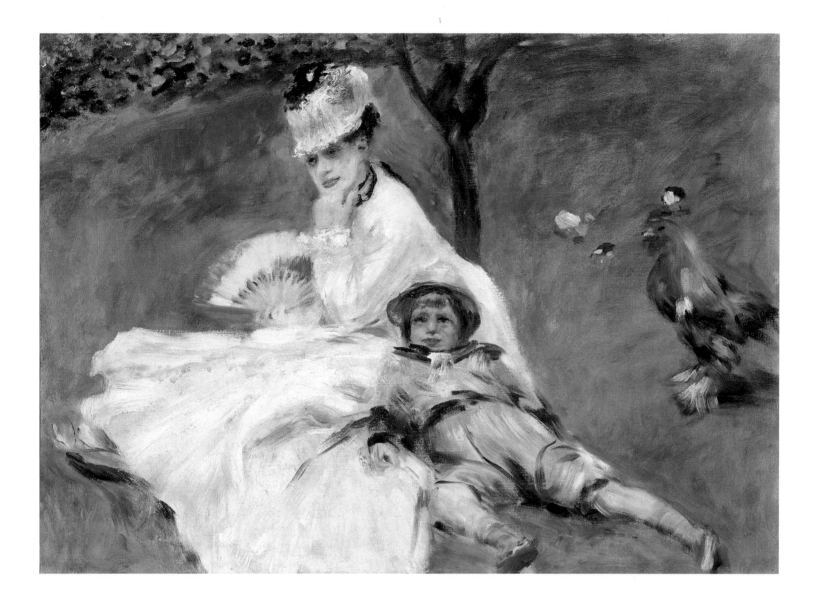

Madame Howard-Johnston), and finally to Marc Elder, who published it in 1924, while Monet was still living.[17] Renoir seems to have been amused rather than insulted by the story, especially since it was clear that Monet held his painting in particular esteem.

Both Manet and Renoir had presented their garden scenes to their host upon finishing them. Four years later, in 1878, perhaps as a way of assisting Monet, whose earnings had dropped to 4,000 francs that year, Manet offered to exchange the more valuable *Women in the Garden* (1866, Musée d'Orsay, Paris) by Monet,

which he owned, for his far smaller *Monet Family in the Garden*.[18] Renoir's *Camille Monet and Her Son Jean in the Garden at Argenteuil* remained in Monet's collection throughout his life: Paulette Helleu remembered seeing it in his bedroom at Giverny in November 1924.[19] After Jean Monet's terrible last years – he had contracted syphilis during his military service and gradually lost his mind, dying at the age of forty-four in February 1914 – Renoir's painting must have acquired even greater poignancy for its first owner.[20]

18 *Charles Le Coeur* 1874

42 × 29 cm
Musée d'Orsay, Paris
Gift of Eduardo Mollard, 1961

HOLDING A HAND-ROLLED CIGARETTE, his straw boater at a rakish angle, waistcoat a little tight and bearded jowls rather heavy, the forty-four-year-old architect Charles Justin Le Coeur (3 May 1830–19 April 1906) appears very much the self-possessed and prosperous paterfamilias in Renoir's miniature full-length portrait. Shown out of doors, he may well be standing in front of one of the restaurants at Fontenay-aux-Roses, a tiny village some nine kilometres south of Paris where the Le Coeurs had acquired a *maison de campagne* in 1873.[1] The famous rose bushes that gave the village its name would appear prominently in at least two landscapes that Renoir painted there the following year.[2] "Ô GALAND JARD," quite legibly inscribed on the sign at upper right, is shorthand for "Au Galant Jardinier," and Renoir indulges in clever wordplay by transforming the title of a village inn into an invocation to this rather cosmopolitan gardener in a freshly ironed summer suit.

Daring in technique if formally rather conservative, Renoir's diminutive full-length is his only finished portrait of the Protestant architect whose friendship and support – along with those of several members of his family – were crucial to him between 1865 and 1874.[3] Charles Justin Le Coeur was born on 3 May 1830 to Joseph Le Coeur (1801–1857), a successful building contractor, and Catherine Apolline Félicie Jaullain (1805–1874). Between 1850 and 1856 he trained as an architect with Labrouste at the École des Beaux-Arts, as did his younger brother Jules.[4] Upon graduating, on 26 February 1856 he married Marie Charpentier (1834–1922), daughter of Louis Charles Théodore Charpentier (1797–1867), the architect of the Salle Favart (1840) and the Galeries de la Madeleine (1846) and Louis-Napoléon's *architecte des fêtes publiques* between 1848 and 1852.[5] Le Coeur and his wife moved into the family residence at 23 rue Humboldt, and he established his architect's practice at 128 rue de Grenelle. Throughout his forty-year career Le Coeur would work almost exclusively for local and municipal governments. In the 1860s he was the architect attached to the arrondissement of Compiègne, where he designed the Mairie de Pierrefonds, and he went on to build some of Paris's most prestigious secondary schools – the Petit Lycée Condorcet, the Lycée Fénélon (1883), the Lycée Montaigne (1885) – and to supervise the renovation of the Lycée Louis Le Grand (1885–93). Although most of his work was based in Paris, he was awarded commissions as far afield as Bayonne and Montpellier. His last major project would be the construction of a thermal complex at Vichy.[6]

While public sector commissions took precedence over the design of private residences, in 1867–68 Le Coeur was hired by Prince Georges Bibesco (next to Darras, his closest friend at this time) to build a town house for him at 22 boulevard de Latour-Maubourg. As is well known, Le Coeur chose Renoir to decorate the interiors of Bibesco's *hôtel particulier* – Renoir's only ceiling paintings were commissioned as a result – and he was responsible for introducing the artist to Bibesco and Darras, who both befriended him.[7]

In the late 1860s the patronage of the Le Coeur family was crucial to Renoir: their portrait commissions alone sustained him at a time when private collectors of his work were generally lacking. Charles's younger brother Jules painted alongside Renoir in Marlotte and Montigny and modelled for *The Inn of Mère Antony* in 1866 (cat. no. 4). Catherine Apolline, Madame Le Coeur *mère* – the redoubtable matriarch who ran her husband's company until her death – sat to Renoir in 1866 for a strongly characterized, if unfinished, three-quarter length (fig. 147).[8] Charles's mother-in-law, Madame Charpentier, did the same unwittingly three years later, when Renoir painted a spirited and informal portrait of her sewing.[9] In 1870, Charles and his wife were the subjects of a pair of unfinished companion portraits by Renoir, again diminutive in scale; and their three eldest children, Marie Félicie (1858–1937), Théodore Joseph (1860–1904), and Louise Marthe (1865–1961), each had their portraits painted by Renoir.[10] Joseph's services were available in the winter of 1872–73 when he modelled for the well-dressed boy in *Riding in the Bois de Boulogne* (cat. no. 13).[11]

The Le Coeur family's attachment to Renoir and their willingness to provide support also extended to members outside the family circle in Paris and Marlotte. Charles Clément Le Coeur (1805–1897), an architect of some distinction who had been one of the witnesses at the birth of his nephew and namesake Charles Justin, is now remembered as the far-sighted curator of the Musée de Pau who, in February 1878, acquired Degas's *Portraits in an Office* (fig. 84) for his museum for 2,000 francs.[12] As founder of the Société des Amis des Arts de Pau and first curator of the town's museum (instituted in March 1864), he must also have been responsible for inviting Renoir to participate between January and March 1866 in their annual winter exhibition, inaugurated in 1863 "to make the stay in Pau more agreeable for foreigners." Renoir exhibited three landscapes (which cannot be identified with certainty), but none of them was acquired for the fledgling museum.[13]

Such was the level and consistency of support offered by the Le Coeurs – as Douglas Cooper observed, Renoir's letter of March 1871 to "Monsieur Charles" was the most intimate that he is known to have written[14] – that it is surprising to find no mention of the family in Renoir's recollections to Vollard. His silence would seem to substantiate the story that Renoir was banished from the household after he had made advances towards the Le Coeurs' eldest daughter, the sixteen-year-old Marie Félicie: a letter was intercepted and all communication between the two families ceased.[15] The landscapes and portrait painted at Fontenay-aux-Roses in the summer of 1874 are thus the final records of a friendship that had lasted just under a decade. As Cooper has noted, a study of the paintings owned and commissioned by the Le Coeurs provides an unparalleled view of Renoir's emergence as a fully formed Impressionist.[16]

Certainly, the jaunty portrait of Charles Le Coeur is a consummate example of the New Painting. Constructed of dabs and strokes of paint – the roses at right little more than a series of cross-hatches, the folds of Le Coeur's cream waistcoat modelled in icy blue – Renoir's portrait nonetheless remains faithful to the imposing features of his sitter (fig. 148) while communicating something of the affection and irony that must have characterized their friendship. It is to be regretted, then, that this most spirited of full-lengths would shortly assume the aura of a valediction.

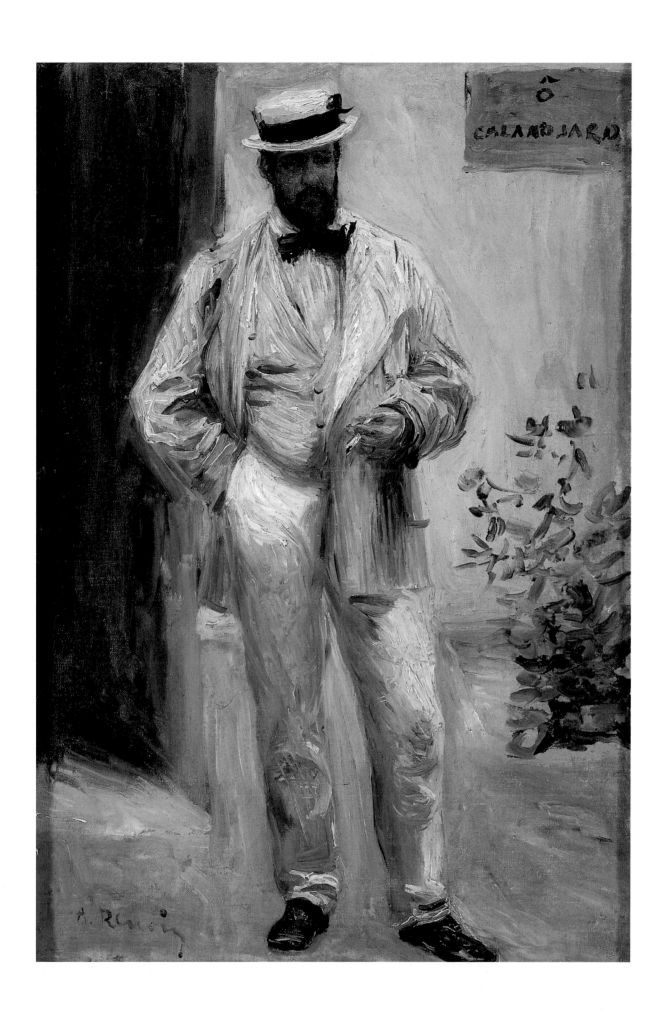

19 *Madame Henriot "en travesti"* (*The Page*)
1875–76

161.3 × 104.8 cm
Columbus Museum of Art, Ohio
Museum Purchase, Howald Fund

20 *Madame Henriot* c. 1876

66 × 50 cm
The National Gallery of Art, Washington
Gift of the Adele R. Levy Fund, Inc.

RENOIR'S FAVOURITE MODEL of the 1870s was Henriette Henriot. She appears in at least eleven of his paintings between 1874 and 1876 and was the subject of three full-lengths whose status hovers midway between grand-manner portraiture and the heroic painting of modern life.[1] Henriot posed for the fashionably attired Parisienne (fig. 149) exhibited at the first Impressionist exhibition and acquired by Henri Rouart in 1874 for 1,200 francs.[2] She is the nymph clutching her robes who emerges from the reeds in *La Source* (1875, Barnes Foundation, Merion, Pa.) a painting that Renoir withdrew from auction in March 1875 when it failed to fetch more than 110 francs.[3] And she is shown in theatrical costume in a portrait worthy of Van Dyck that Renoir remembered as being marked down for sale at 80 francs (cat. no. 19).[4]

A dark-eyed and not particularly beautiful actress (fig. 150) who achieved modest fame as a vaudeville star, Henriot is remembered in theatrical history for the tragic death of her daughter Jane (1878–1900), a promising twenty-one-year-old beginner at the Comédie-Française who suffocated from the fumes of the fire that ravaged the theatre in March 1900.[5] Madame Henriot seems to have withdrawn from the stage thereafter, sinking quietly into obscurity, although she sat to Renoir once again in old age (fig. 152). The hitherto sparse and inaccurate information available on her has succeeded admirably in preventing this actress's less than respectable origins from coming to light – a deception of which Madame Henriot would have thoroughly approved.[6]

Henriot, who never married, was born on 14 November 1857 to Aline Grossin, a milliner living alone in a single room at 13 rue de Buffault in the 9th arrondissement. She was baptized Marie Henriette Alphonsine Grossin two days later, and the name of her father was not recorded.[7] Aline Grossin's situation seems gradually to have improved, for by 1876 she and her daughter were installed in a three-bedroom apartment at 15 rue de Maubeuge, about a ten-minute walk from Renoir's studio in the rue Saint-Georges.[8] In 1872 Marie Henriette Grossin enrolled at the Conservatoire to study under François Régnier, who seems to have taken little notice of her.[9] The following year she left for the provinces, but was back in Paris by 1874, and in the autumn of 1875 began appearing in minor roles at the Théâtre de l'Ambigu-Comique, where she played Gertraud in Féval's *Fils du Diable* and Marie Lechesne in *Le Fils de Chopart*, while also modelling for Renoir to earn money and gain exposure. It was at this point that Marie Henriette assumed the name Henriot.[10]

On 28 April 1878, Henriot gave birth to an illegitimate daughter Jeanne Angèle, who would become known as Jane Henriot.[11] She was living at the time with Antoine Rey (1810–1881), a former leading man at the Comédie-Française famous for his performances of Molière in the 1840s, who now taught diction at the little Théâtre de la Tour d'Auvergne. It seems unlikely that the sixty-eight-year-old Rey, "surly and grumpy, but a decent man nonetheless," was the father of Henriot's daughter, although his presence at her birth is attested to by documents, and it was only after his death that Henriot officially recognized her daughter at the mairie of the 9th arrondissement.[12]

Styling herself an "artiste dramatique," Henriot seemed destined to remain a bit player. In the 1880s she was offered only minor roles – the second apparition in a verse translation of Macbeth at the Odéon in October 1884, Eva in a reprise of Sardou's *Dora* at the Gymnase in April 1888[13] – and it was not without resentment that she later recalled this period of her career: "For a while I went back and forth between the Odéon and the Gymnase, getting nowhere with the classical repertory and given only understudies' roles or complete duds to perform."[14] All this changed after Henriot was introduced to the extraordinary actor-director André Antoine (1858–1943), who had created the avant-garde Théâtre-Libre in the rue Blanche in March 1887 to perform new plays by Naturalists and Parnassians alike.[15] In November 1889 Henriot appeared as the female lead in *L'École des veufs*, one of Antoine's less exalted commissions, a vulgar comedy of manners by Georges Ancey, at whose première subscribers received an obscene programme that offended even Edmond de Goncourt.[16] During the 1890s she was one of Antoine's leading ladies, routinely offered "tous les rôles de cocottes," and she returned with a five-year engagement to the Vaudeville and the Gymnase to star in light comedies such as *Au bonheur des dames* and *Divorçons*.[17] After the death of her daughter, Madame Henriot retired from the stage. She died on 17 March 1944 in Saint-Germain-en-Laye, aged eighty-seven.[18]

Renoir's raven-haired model of the mid-1870s was thus an eighteen-year-old actress who had yet to make her mark, and whom the artist posed in a series of "respectable" roles. Unlike Anna or Margot, Henriette does not seem to have modelled for any of Renoir's paintings of nudes *en plein air*. Indeed, standing before a red velvet curtain which offers a glimpse of a pair of Doric columns and the stage behind – here the baroque device also serves a purpose – it is as an actress receiving applause that she is portrayed in *Madame Henriot "en travesti"* (cat. no. 19). Her tight-waisted doublet, with its fur collar and cuffs and prominent silver buckle, is reminiscent of a troubadour's costume; her long hair, left unstyled, and her swagger pose further indicate that she is playing a boy's role.

Alexandra Murphy was the first to suggest that Renoir's *Madame Henriot "en travesti"* might have something to do with Meyerbeer and Scribe's opera *Les Huguenots*, which was revived in April 1875 for the reopening of the Opéra at the Palais Garnier.[19] It can easily be established that Henriot never performed in this grandiose production: she would have been ill equipped to do so, having had no training as a singer, and while *Les Huguenots* packed the new opera house she was in fact playing supporting roles in a series of modern costume dramas at the Ambigu-Comique.[20] However, among the leading female roles

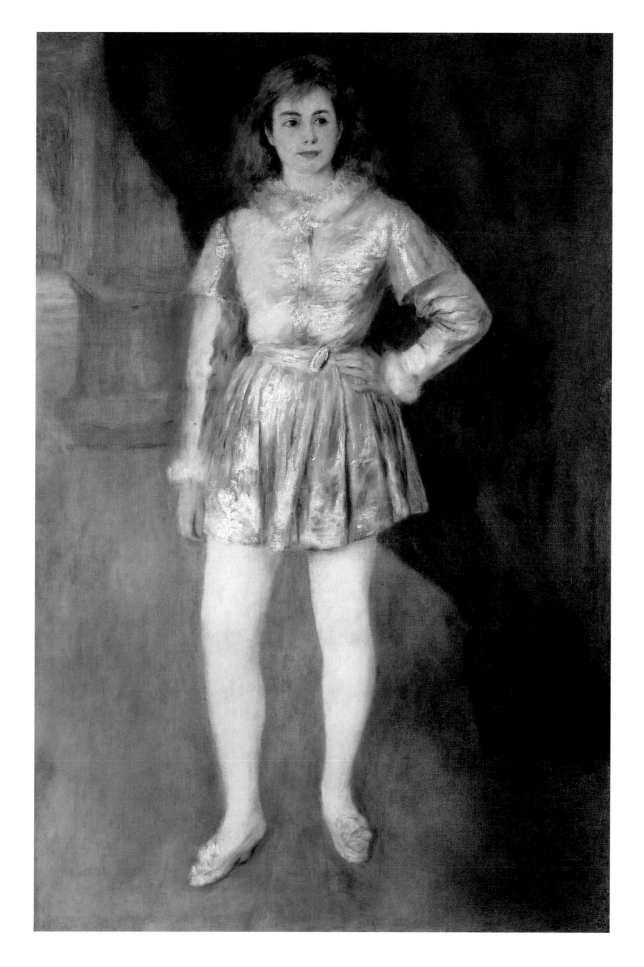

cat. no. 19

in Meyerbeer's *Les Huguenots* was that of the "beautiful page" Urbain, who serves Queen Marguerite and delivers her declaration of love to the Protestant nobleman Raoul de Nangis. In the tradition of Mozart's Cherubino, the part of Urbain was always sung by a soprano – in 1875 the role was performed by Mesdemoiselles Daram and Arnaud – and various set designs show Urbain in a troubadour's costume not unlike that worn by Mademoiselle Henriot.[21] In his discussions with Vollard some forty years later Renoir would refer to this painting as that of a page, and it seems quite possible that Meyerbeer and Scribe's opera, which was given thirty-two performances in 1875 and the same number in 1876 – the period to which this portrait is assigned – provided Renoir with the inspiration for both his model's costume and pose.[22]

Renoir's *Madame Henriot "en travesti"* is thus a fantasy portrait on several levels, for painter and model seem to have colluded in a work that embodies their respective ambitions at this point. Marie Henriette Grossin might aspire to high drama – twenty years later, she jokingly offered herself as a candidate for the classical repertory – but her deficient training prevented her from being considered for such roles.[23] She later transferred something of these hopes to her daughter, who finished first in her class at the Conservatoire and was assured a promising career at the Comédie-Française. "She will make her debut in an important role, or she will keep quiet," Madame Henriot told a reporter in 1896.[24] Indeed, so desirous of official recognition was the mother, that she was persuaded to drop charges of negligence against the administrators of the Comédie-Française after they promised to place Carolus-Duran's portrait of Jane Henriot on permanent display in the theatre's foyer.[25]

It is, of course, hazardous to extrapolate from Henriot's later career in interpreting Renoir's portrayal of her at eighteen or nineteen years of age. But the scale of the work and the specificity of the costume are evidence enough that both painter and sitter were angling to make their mark in the theatre: Henriot as performer, Renoir as chronicler. In this sense, *Madame Henriot "en travesti"* might be seen as a dress rehearsal for the genuine article – Renoir's standing full-length of Jeanne Samary (cat. no. 30), *sociétaire* of the Comédie-Française, which would be exhibited at the Salon of 1879.

Nothing is known of the relationship between Renoir and Henriette Henriot in the mid-1870s, although Marie Henriette was certainly of an age to appeal to Renoir and had the physical characteristics he most admired. As with *Lise Tréhot in a White Shawl* (fig. 27), his valedictory portrait of a previous mistress, Renoir's most affectionate portrayal of Henriette Henriot was also his last: the Washington *Madame Henriot* (cat. no. 20), painted around 1876, is documented by Daulte as the only portrait of herself by Renoir that she owned.[26] Diaphanous in handling, prestidigitatorial in its treatment of silks and gauzes, this portrait – in which the nineteen-year-old Marie Henriette Grossin dissolves in a blue-green mandorla – is as radiant as anything Renoir produced in the 1870s. While it is very thinly painted overall, Henriot's dark-brown eyes and red lips are voluptuously described, as is her *décolletage* (with a sprig of flowers serving as corsage), while her fingers are nervously entwined. Renoir's touch becomes more hardy in the whites of her well-fitting bodice, where patches of impasto serve to render the effects of ambient light. The unforced loveliness of Renoir's presentation accounts in part for the work's enduring appeal (in the 1970s *Madame Henriot* was used to advertise skin cream) as well as the lack of serious consideration it has received.[27] The sureness and economy of Renoir's technique operate on the highest level here: painting white on white is "awfully difficult," he informed Vollard, but "it produces the most beautiful effects."[28] At the same time, Renoir's endless capacity for romance performs an alchemy of sorts, for it is clear from several contemporary photographs of Henriette Henriot – wide-eyed, full-jawed, her hair parted severely in the middle (fig. 151) – that the actress was far from actually possessing the elegance or charm attributed to her by Renoir. In fact, the only obvious similarities between these photographs and Renoir's painting are the sitter's tiny waist and penetrating gaze. Unlike the photographs, Renoir's *Madame Henriot* – with its soft, pliant forms and full breasts, the upper arms exposed through transparent sleeves – is an almost tactile experience, yet one comfortably free of an erotic charge. On display, yet modest in spite of her *décolletage*, and confident beyond her nineteen years, Mademoiselle Henriot is a gentler intimation of Zola's *Nana*, but none the less fictional for that.

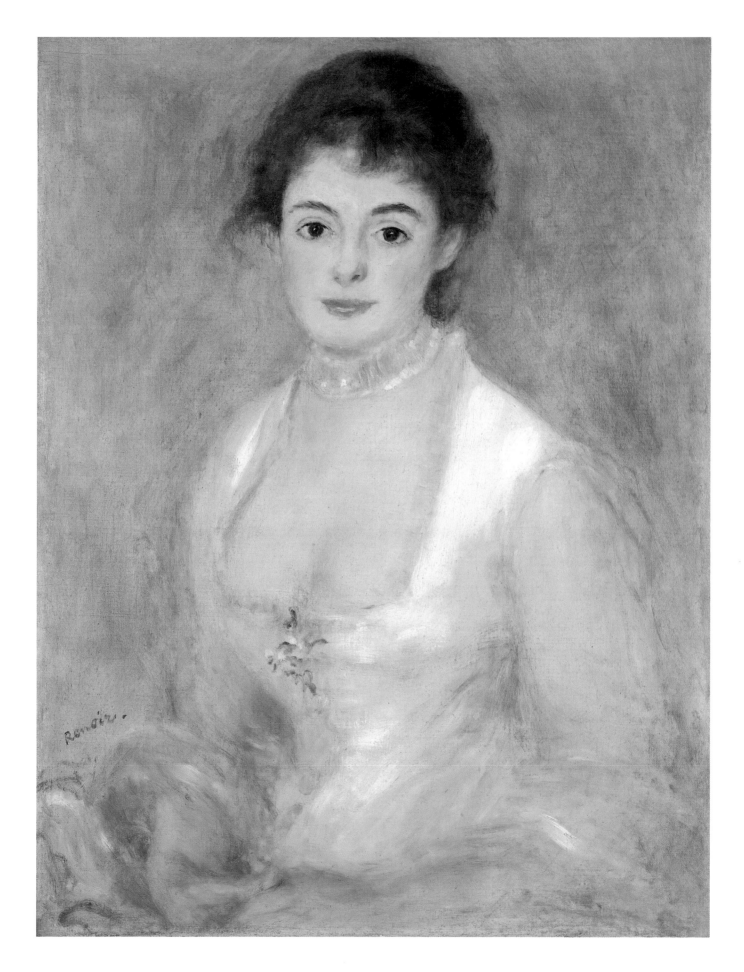

cat. no. 20

21 *Claude Monet Painting* 1875

85 × 60.5 cm
Musée d'Orsay, Paris
Bequest of Monsieur and Madame Raymond
Koechlin, 1931

AMONG THE MOST PONDERED and deliberate of Renoir's Impressionist portraits – two preparatory sketches are known – *Claude Monet Painting* was universally well received at the group's second exhibition of April 1876, where it was praised for its vigour, likeness, and solidity of modelling.[1] The portrait was one of two paintings by Renoir, still to be paid for, that were lent to the exhibition by Jean Dollfus (1823–1911), grandson of the founder of the textile manufacturing firm Dollfus-Meig and a collector of Old Masters who had very recently become interested in the New Painting.[2] Despite his patron's wealth and the good press his pictures received, Renoir was paid a mere 300 francs for *Claude Monet Painting* and *Head of a Woman* (Fondation Rau pour le Tiers-Monde, Zurich), only a little more than the price his paintings had fetched at the disastrous auction of March 1875.[3] At the Dollfus sale in March 1912, *Claude Monet Painting* would be acquired by Dollfus's nephew Raymond Koechlin for 20,200 francs.[4]

In *Claude Monet Painting* Renoir is unusually attentive to details of interior décor. He shows Monet with his back to the small sunroom (conservatory would be too grand a term) of his house at 5 boulevard Saint-Denis in Argenteuil – the newly built Pavillon Flament into which he and his family had moved in October 1874.[5] With its Japanese matting and oleander trees in Oriental vases, this room provided the setting for Monet's *Camille Monet Embroidering* (fig. 153), painted early in 1875.[6] It was from here, too, that Monet painted *A Corner of the Apartment* (Musée d'Orsay, Paris), looking across the hall to the dining room, with Camille seated at a table in the distance.[7] In Renoir's *Claude Monet Painting*, the blue-and-red-patterned curtain is pulled back in like fashion, and the leaves of the oleander tree form a nimbus around the sitter's head. The long windows with their connecting rail and high wainscotting beneath are rendered exactly as they appear in *Camille Monet Embroidering*, as is the rubber plant at lower left (though it is more difficult to make out because the leaves begin on the floor just behind the paintbrush in Monet's right hand and are almost indistinguishable from the curtain above). In fact, Monet is situated quite precisely: he is shown standing next to one of the potted plants that were placed on either side of the entrance to the sun-room.

Scrupulous in his inclusion of these home furnishings, Renoir was no less fastidious in his presentation of the sitter, whom he studied both with and without a hat.[8] As in his unfinished *Self-portrait at Thirty-five* (cat. no. 25), Renoir had some difficulty in resolving the position of the paintbrushes. The pentimento that is visible to the naked eye reveals that the brushes held in Monet's left hand were initially placed higher, at the level of his waist, and parallel to the lower edge of the canvas.

Dressed in his customary "petit chapeau," with his white shirt peeking through the jacket that is buttoned to the neck, his

"palette carrée" meticulously prepared, and his long-tipped brushes wet with paint, Monet is portrayed as the Impressionist poised before an absent canvas – an image that would later gain currency though illustrations such as Paul Renouard's unpleasant pastiche (fig. 154).[9] Yet if Renoir's *Claude Monet Painting* assumed iconic status early on, the pertinence and specificity of its references have been little discussed.

It may be noted that Monet's palette is arrayed with a generous sampling of reds and yellows, and that the brush he holds in his right hand is dipped in red paint. Given that the no-longer-flowering oleander tree in the background has been brought indoors for the winter months, it seems reasonable to assign Renoir's portrait to the period during which Monet was working on his most ambitious figure painting for almost a decade, *Camille Monet in Japanese Costume* (fig. 155), signed and dated 1876.[10] This enormous painting of Camille in a blond wig, sporting a tri-colour fan and dressed in a highly decorated kimono of the most vibrant scarlet, had been in progress since October 1875, when Monet had informed Philippe Burty that he had embarked upon "one of those marvellous actor's robes that are superb to paint."[11] With an artist as economical as Renoir, details such as the tonality of Monet's palette and the colour of the pigment on his brushes are rarely gratuitous – consider, for example, his treatment of these elements in the portrait of Bazille (cat. no. 5). That Monet is shown in the act of painting justifies that we at least ask what it is he might be painting. And was it simply fortuitous that Renoir's *Claude Monet Painting* would be reunited with the painting-beyond-the-canvas in April 1876, when both works were shown in the Grand Salon of Durand-Ruel's gallery in the rue Lepeletier?[12]

Comparison with photographs of Monet from around this time confirm, if confirmation be needed, the fidelity and acuity of Renoir's treatment of physiognomy. Monet's determined and handsome features, along with his beard, styled "en éventail,"[13] were recorded on several occasions during the 1870s, in photographs that show him in relatively formal attire (fig. 156).[14] Yet in Renoir's portrait, Monet is well on the way to becoming the "Indépendent" who keeps his distance from the city and affects a studied rusticity. In *L'Artiste* in February 1880 he was described as having "black curly hair that falls in curls across his forehead, a full beard, and a sharp eye"; in June of that year Émile Taboureux characterized Monet as "a strapping fellow, sturdily built, his beard correctly trimmed, his nose no different from other noses, but with eyes as clear as crystal."[15] Five years earlier Monet's position had been far less assured. His annual income had dropped precipitously to less than 10,000 francs; his begging letters to Manet of June and July 1875 are as strident as those of the late 1860s to Bazille; and in October Camille was obliged to use her inheritance of 2,000 francs to pay her husband's debts.[16] Renoir allows none of this material insecurity to compromise Monet's stature, whom he shows with long hair, full beard, and in unadorned costume, uncannily anticipating the artist's arrival at the end of the decade. *Claude Monet Painting* is the pictorial equivalent of a self-fulfilling prophecy.

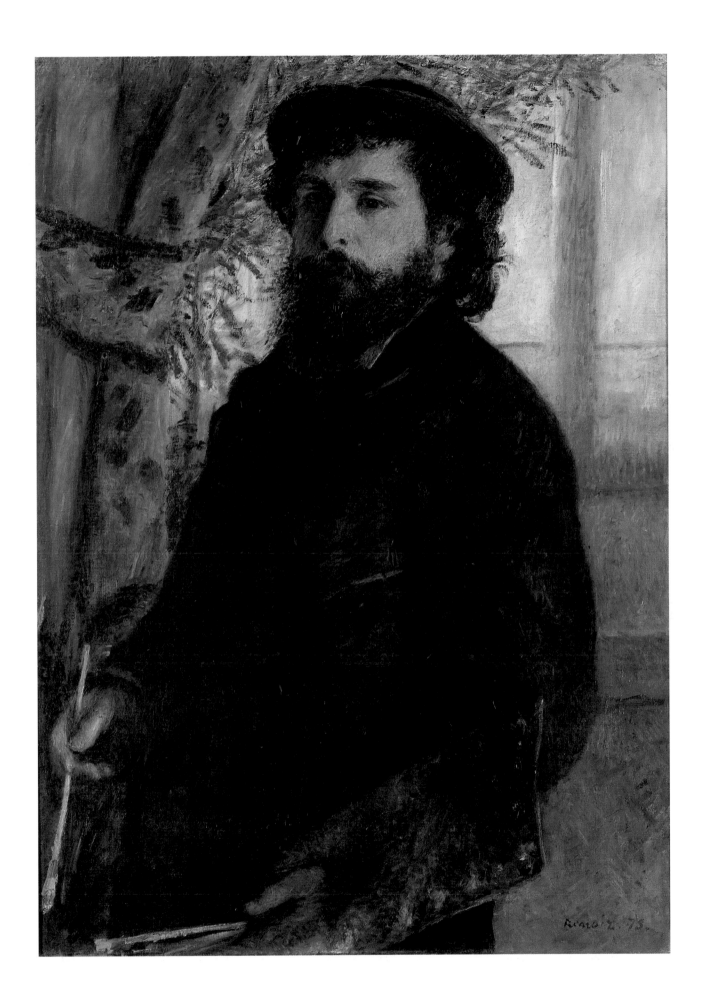

65 × 54 cm
Private collection

HOWEVER CLOSE THEY MAY appear to be in the 1870s, portraiture and genre occupy largely separate spheres in Renoir's oeuvre. His portraits of young women are distinguished from the subject pictures of dark-eyed Parisiennes (whose models are more or less interchangeable) by their particularity and decorousness. Requiring a more exacting verisimilitude, however informal, the portraits nearly always reveal something of the status of the sitter and the milieu to which she belongs, and invariably maintain a certain degree of propriety with regard to pose, dress, and accoutrements.

It is to the portrait category that the present work most assuredly belongs, even though it has proved impossible to uncover any information on the sitter.[1] With her imposing chestnut hair piled high in a bun and falling just below her shoulder, Renoir's sitter poses somewhat tentatively in a simple day-dress enlivened by an array of jewels – earrings, a gold neckband, a ruby-studded brooch, and two rings on her left hand. She is seated on a slipper chair covered in a patterned fabric that matches the wall hanging at left. And, in keeping with Renoir's understated inclusion of fashionable Japanese motifs, she holds an *uchiwa* fan in both hands.

The portrait is thinly but fluidly painted over a light ground, with areas of impasto to indicate the sitter's lace cuffs, her oversized bow, and her sparkling earrings and diamond ring. Whereas the background is little more than sketched in, her face, dress, and hands are more solidly modelled, with touches of green and blue enlivening her hair and dabs of pink on her white bow. Both in style and format, this painting relates to the silvery handling in the portraits of Alphonse Fournaise, the innkeeper from Chatou (fig. 157), and of his daughter Alphonsine (fig. 206), both signed and dated 1875, as well as to the unfinished *Self-portrait* (cat. no. 25) of the following year, whose violet-blue tonality it shares.[2] And although Renoir generally painted his portraits full on, reserving the profile for his paid models, the unusual placement of this anonymous sitter is not unique among his Impressionist portraits: that of his boon companion Georges Rivière (fig. 158) is also in strict profile.[3] As is often the case with Renoir, these stylistic affinities also reflect a commonality of milieu. It would not be surprising if the unknown young woman came from the same petit bourgeois circles as the Fournaises, or as Renoir himself.

This portrait of an anonymous sitter was completely unknown until 1952, when it was exhibited in Nice as the "Portrait de Madame X." It was noted unhelpfully at the time that the work had "hitherto remained in the family of the sitter," and research has failed to throw new light on its commission and subsequent history.[4] Philippe Brame recalls that in the winter of 1948–49 his father showed him this "beautiful portrait," recently purchased from "an old lady living in a large nineteenth-century apartment, but with no valuable works of art." According to Brame, his father had come across "the wonderful Renoir" in one of the back rooms of the apartment, there hidden because, as his hostess informed him, "Renoir painted my portrait when I was young and beautiful and now, being old, I do not like to look at it."[5] While there is no reason to doubt this reminiscence, the sitter of Renoir's portrait would have had to be well into her nineties when Brame visited her in 1948–49.[6]

Accounts of Renoir's life occasionally mention specific portrait commissions for which no known works can be identified. More than forty years after the event, Renoir told Vollard of "une brave dame de Versailles" who in 1871 paid him 300 francs to paint the portrait of her and her daughter, and who refrained from interfering or suggesting improvements.[7] The portrait of this discriminating woman has not yet reappeared. When the situation is reversed, as in the present example, and no information on the early provenance of a portrait is available, it is possible only to speculate as to the type of sitter represented. Although, as I have noted in the introductory essay, Renoir was not in sympathy with Duranty's claim that modern portraits represent the "financial position, class, and profession" of the sitter, his portraits nonetheless distil something of the sitter's origins and milieu.[8] While we know nothing of her profession – or that of her husband – it is likely that the attractive young wife portrayed here is from a relatively modest household.

François Daulte's *catalogue raisonné* lists the first owner of the "Portrait de Madame X" as Gaston Lévi, and this name has been linked with the fervent collector of Bonnard and Dunoyer de Segonzac (among others), whose paintings and pastels were sold at auction in November 1932.[9] Research into archival records in Paris has uncovered a Gaston Lévy, born on 26 February 1884 to Godchaux and Joséphine Lévy, haberdashers from the Marais. Madame Lévy, née Joséphine Samuel, was born in 1851 or 1852, and thus would have been twenty-three or twenty-four when Renoir's portrait was painted.[10] The link is too fragile to propose as anything more than a hypothesis. Daulte is the only source to cite Gaston Lévi as the portrait's first owner, and Brame's records, which might have provided clarification on this point, are silent as to the name of the family from whom the company acquired the work. Were the identification to prove correct, however, it would present the intriguing possibility that the sympathetically rendered "Madame X" is another of Renoir's Jewish sitters.

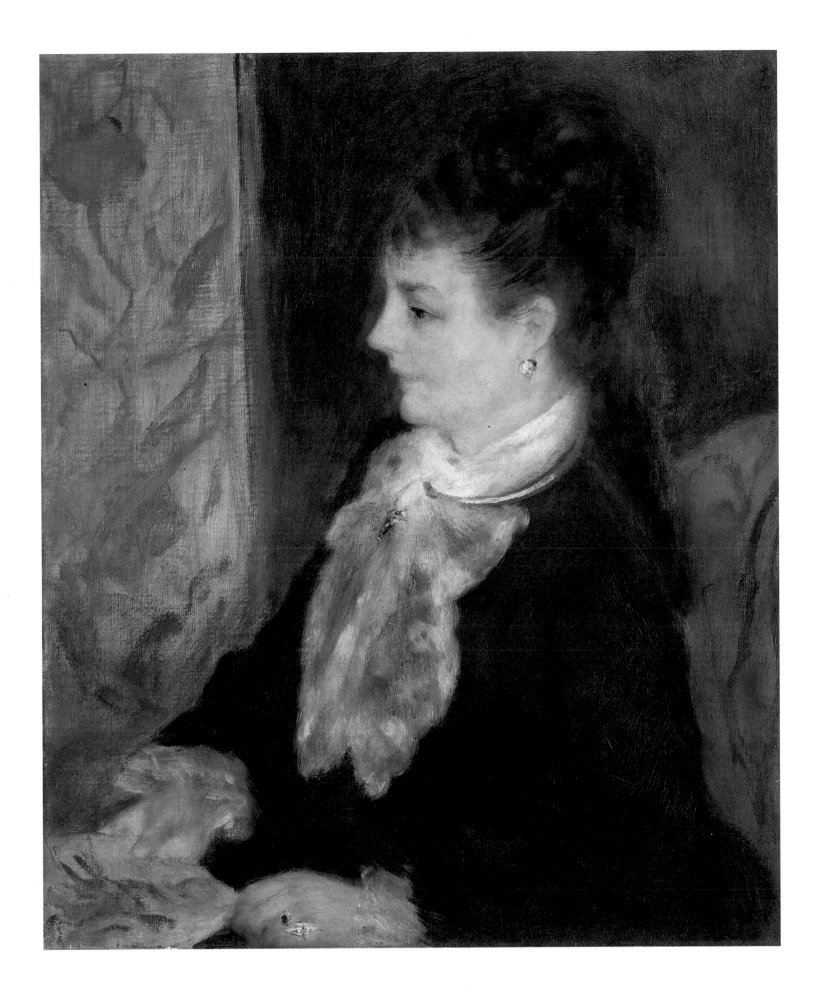

81.3 × 59.1 cm
Philadelphia Museum of Art
The Henry P. McIlhenny Collection,
in memory of Frances P. McIlhenny

CLASPING HER HANDS A LITTLE nervously, and lowering her eyes to avert our gaze, Renoir's young sitter is shown in a modest interior – its patterned wallpaper mostly covered by blue-green drapery – into which "the natural light of day" has penetrated, "influencing all things."[1] She is neatly dressed in a spotless black pinafore which protects her blouse and skirt beneath, but this everyday uniform is enlivened by the blue ribbons in her hair and around her neck, as well as by her simple jewellery – earrings with tiny stones as cerulean as her eyes, a gold pendant, slightly askew, and a ring on her left hand. The young girl's calm and stable pose serves to anchor the bravura performance of Renoir's brush, which applies rich strokes of paint, often wet on wet, with extraordinary assurance. Note the deft touches of blue that create the creases of her blouse, the blacks of the pinafore, on which six buttons are to be seen, and the extreme softness with which the face and hands are modelled, painted almost like porcelain, with touches of blue at the temples and greens and purples in her hair.

One of Renoir's most enchanting portraits of children, *Mademoiselle Legrand* is also one of his most mysterious, since very little that has been written about the sitter and the early history of the canvas can be substantiated. The portrait was long thought to represent the daughter of the art dealer Alphonse Legrand – a would-be impresario of the Impressionists and former employee of Durand-Ruel, who in 1876 helped organize their second exhibition and the following year embarked upon a joint venture with Caillebotte and Renoir to produce MacLean cement for the decoration of Parisian interiors.[2] It was assumed, reasonably enough, that Legrand lent this portrait to the Impressionist exhibition of April 1876, and that it also appeared in the first retrospective of Renoir's work in April 1883.[3] In fact, Philadelphia's *Mademoiselle Legrand* is securely documented for the first time only around 1910, when the portrait was photographed hanging somewhat incongruously amid a cluster of Renoir's late nudes in the salon of the dealers Josse and Gaston Bernheim.[4] Vuillard, who attended a party there in December 1910, was moved to note the wall of "marvellous Renoirs" in his journal, and the following year, in a critical appreciation that has yet to be equalled, Meier-Graefe published the work as in the collection of J. and G. Bernheim.[5] There, unsold, it would remain, until in 1934 a remarkably precocious (and extremely wealthy) collector from Philadelphia, Henry P. McIlhenny (1910–1986), succeeded in convincing Paul Rosenberg to lower his asking price of $60,000 – "too high and out of the question" – to a more reasonable $35,000.[6]

The sitter in the McIlhenny portrait – Delphine to her husband, Ninette to her mother[7] – was not an art dealer's daughter at all. She was christened Marie-Adelphine Legrand and born on 6 May 1867 to Désiré-Barthélémy Legrand (1839–1907), a shop assistant ("employé de commerce"), and Marie-Joséphine, née Coquillard (1844–1913), a maker of straw hats ("ouvrière en chapeaux de paille").[8] Her paternal grandfather, Denis Legrand, had

been a cobbler, but at the time of her birth was recorded as working as a "shop-boy" (he was sixty-five years old!); her paternal grandmother, Marie-Françoise Garceau (1804–1874), formerly a linen maid, was then employed as a concierge.[9]

Through lineage and occupation, the Legrands were members of the petite bourgeoisie. Marie-Adelphine's mother, Marie-Joséphine, had lost her own mother at the age of fourteen (no father is recorded in the documents), and at the time of her marriage nine years later, on 26 July 1866, she was employed as "demoiselle de compagnie" to Jacques-Marie Michallon, a seventy-two-year-old property owner and *chevalier* of the Légion d'Honneur.[10] One is put in mind of Christine Hallegrain, the frail and devoted companion of Claude Lantier in Zola's *L'Oeuvre*, "lectrice" to the wealthy widow Madame Vanzade.[11] Following their marriage, the Legrands occupied a modest one-bedroom apartment on the third floor of 10 rue Thévenot – absorbed into the rue Réaumur at the end of the nineteenth century – and it is here that Marie-Adelphine was born.[12] Nothing more is known of the family until Marie-Adelphine's second marriage in 1899, when her parents, now in retirement, were noted as living in the more comfortable district of Auteuil.[13]

How the Legrands came to know Renoir, and the degree of familiarity that enabled him to create such a sympathetic – and honest – portrayal of their eldest daughter (fig. 159), are questions that cannot be answered satisfactorily. Before her marriage, Marie-Adelphine's mother had lived at 7 rue Godot-de-Mauroy; in January 1866 Bazille rented an "atelier avec petite chambre" on the opposite side of the same street, and it is possible that Renoir's acquaintance with the family dates from this time.[14] That the Legrands numbered at least one prominent artist among their circle is documented by the unexpected appearance of the sculptor Jean-Baptiste Carpeaux – the preferred portraitist of the Imperial household, whose *Danse* (1865–69, Musée d'Orsay, Paris) had just been formally commissioned – listed as "friend of the bride and groom" among the witnesses at their wedding in July 1866.[15]

In February 1893, at the age of twenty-five, Marie-Adelphine Legrand married the poet Jules-Gustave-Édouard Besnus (1867–1897) (fig. 160), son of a notary from Conflans-Sainte-Honorine, and a minor Parnassian who founded the short-lived journal *L'Idée Libre* (1892–95), which published the work of Morice, Régnier, and Richepin, among others.[16] At the civil ceremony, the bride was represented by the landscape painter Eugène d'Argence (1853–1914) and by Renoir himself.[17] "A tall, narrow-shouldered boy, whose eyes were almost too blue and whose blond hair was too fiery," Besnus died four years later at the age of thirty-five, after a lingering illness.[18] The couple had two children, a son, Marcel Henri, born in September 1893, who lived only nine months, and a daughter, Geneviève Denise (1895–1932), shown with her mother at about age five in a photograph that confirms the continuing beauty and gentleness of the former Mademoiselle Legrand (fig. 161).[19] After two years of widowhood, on 9 September 1899, Marie-Adelphine, now living in the rue Donizetti in the 16th arrondissement and working as a piano teacher, married her brother-in-law Henri-Adrien Besnus (1862–1942), a notary's clerk.[20] This second marriage produced two sons, André (1900–1973) and Marcel (1905–1993). In 1916 the family left Paris for Le Havre, where Marie-Adelphine would continue to live until her death at the age of seventy-nine on 10

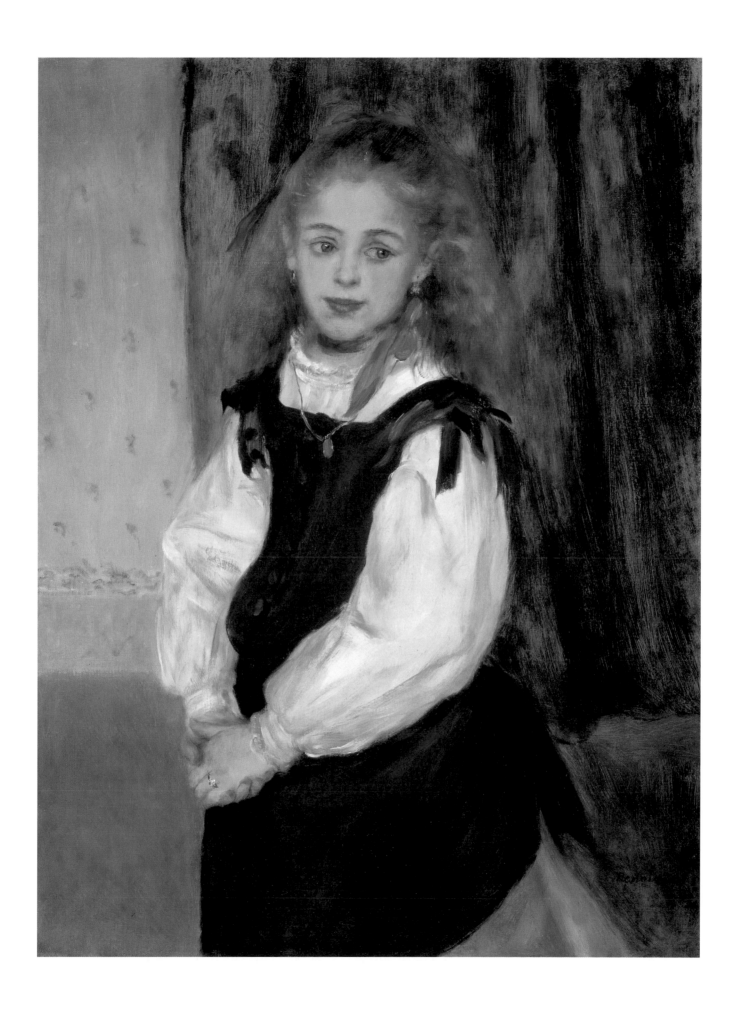

June 1946.[21] In a photograph of her in old age (fig. 162) she still shows the freshness and good humour that had so attracted Renoir seventy years earlier.

But what of the dealer Alphonse Legrand, whose association with Renoir for the period 1875 to 1878 is securely documented and whose *Portrait de jeune fille* by Renoir was certainly exhibited both in 1876 and 1883.[22] Mentioned approvingly in several reviews of the second Impressionist exhibition, the critics' comments on Renoir's *Portrait de jeune fille* are in general too lapidary to be of much help.[23] Zola provided a little more information when he described this portrait as representing "a sympathetic and strange figure, with a long, fair face, vaguely smiling, a sort of Spanish infanta."[24] Such comments might well apply to *Girl with a Jumping Rope* (fig. 163) – unquestionably a portrait of Alphonse Legrand's daughter, who, confusingly, was also called Delphine and known as Ninette[25] – which Albert Barnes acquired in April 1912 as *The Little Girl in the Blue Dress*.[26] Dated 1876, it is of the same size as and similar in format to Renoir's *Jeanne Durand-Ruel* (fig. 39), the portrait of the daughter of Legrand's former employer and competitor, to which it relates both formally and strategically.[27] Although it is very difficult to squeeze any more information out of the reviews of the second Impressionist exhibition – at which the *Girl with a Jumping Rope* would have been one of Renoir's most recently painted submissions – it is worth noting that Zola's allusion to Velázquez's *Infanta*, generic though it was, implies a frontal presentation and a wide dress, elements that are not to be found in Philadelphia's *Mademoiselle Legrand*.

The identity of Renoir's demure sitter, mistaken or not, did not prevent Meier-Graefe from responding with exceptional sensitivity to Renoir's *Mademoiselle Legrand*, which he classed with *Jeanne Durand-Ruel* as among the masterpieces of the genre. In a rare departure from his stately and occasionally impenetrable prose, he was moved to describe these young girls as the type of "kid you want to kiss from head to toe."[28] In contrast to Whistler's *Cicely Alexander* (Tate Gallery, London), which required over seventy gruelling sessions between 1872 and 1874, Renoir's portraits were seen by Meier-Graefe as having achieved both a realism and a distinction that Whistler's banker's daughter lacked.[29] Even if Renoir did not attempt to render details with any "corresponding objectivity," he delivered "an urgent reality before our eyes." And the distinction of his portraits was aesthetic, not moral: "It is a distinction that does not elevate, but rather responds to the tailor's instinct in us."[30] Because of this, "in the realm of art, Renoir's child is the little princess, whereas the English girl is at best a recently ennobled milady."[31]

Indeed, as photographs from various stages of Marie-Adelphine's life confirm, Renoir not only crafted a remarkably faithful and prescient portrait of his eight-year-old sitter, he also captured the quintessential "jeune fille," a type that was of quite recent invention in French culture.[32] Several ranks above Hugo's Cosette, but presented with all the refinement of the aristocratic Sophie (heroine of the comtesse de Ségur's best-selling children's book), Renoir's *Mademoiselle Legrand* responds in almost every detail to the standard definition of the "Young Girl": "Compared to little boys . . . little girls are generally more delicate, their constitution is weaker, their skin is paler and whiter, their complexion more moist . . . Little girls are more gentle, more tender, more affectionate, livelier, wittier, more docile, and more precocious."[33] It is Renoir's surpassing achievement here that, unlike so many contemporary interpretations of the "jeune fille" that remain rooted in the sentiments of their time, *Mademoiselle Legrand* continues to evoke associations that resonate effortlessly for a contemporary audience – different associations, perhaps, but no less compelling than they had been for observers a hundred and twenty years ago.

24 *Self-portrait* c. 1875

39.1 × 31.7
Sterling and Francine Clark Art Institute,
Williamstown, Mass.

25 *Self-portrait at Thirty-five* 1876

73.2 × 57.1 cm
Fogg Art Museum, Harvard University Art
Museums, Cambridge, Mass.
Bequest from the Collection of Maurice
Wertheim, Class of 1906

DOUBT AND INTROSPECTION ARE hardly the characteristics most readily associated with Renoir, but his two self-portraits of the mid-1870s reveal a temperament that is unexpectedly sober and contemplative. In the rugged, almost violently painted *Self-portrait* from Williamstown, Renoir looks past the viewer with an intensity reminiscent of Rembrandt (fig. 164). The more ambitious *Self-portrait at Thirty-five*, in which he assumes the traditional guise of the painter at his easel, brushes in hand, was abandoned early on, yet the mood created is more Romantic. Looking considerably younger than his thirty-five years, a boyish Renoir interrupts his painting and turns to address the spectator with a gaze that is shy and almost sorrowful.

Renoir spoke about the genesis and early history of the Williamstown *Self-portrait* in conversation with Vollard, in a passage that has generally been overlooked.

> Do you remember the little portrait I did of myself, that paltry sketch that everyone praises nowadays. At the time, I had thrown it into the rubbish bin, but since Chocquet asked me to let him take it, I had to agree, even though I was sorry that it was no better than it was. A few days later he came back with one thousand francs. Monsieur de Bellio had seen the painting at his house, fallen in love with it, and paid him this enormous sum of money. That's how art lovers were in those days![1]

Vivid though it is, Renoir's memory was not altogether reliable – why sign a canvas that you intend to throw away? However, the progression of ownership from Chocquet to de Bellio, two of the earliest collectors of Impressionism, even if it did not take place quite in the way Vollard described, can be substantiated by reference to other sources.

The Williamstown *Self-portrait* was among the seventeen paintings that Renoir sent to the second Impressionist exhibition at Durand-Ruel's gallery in April 1876. It was one of the six works lent by Victor Chocquet, and, for reasons that are difficult to fathom, it was listed in the catalogue under no. 214 simply as "Tête d'Homme."[2] Renoir's *Self-portrait* seems to have been hung alongside a portrait of Chocquet (1876, either fig. 42 or fig. 45), with which it was paired in several discussions.[3] Chocquet, who spent most of his time at the second Impressionist exhibition expounding the virtues of the New Painting to anyone who would listen, may well have sold Renoir's *Self-portrait* to the Rumanian expatriate and homoeopath Georges de Bellio (1828–1894) shortly after the exhibition closed.[4] Around this

time, de Bellio acquired three of the paintings that had been exhibited by Berthe Morisot; on 4 May 1876 he bought Renoir's *Still Life with Melon* from Durand-Ruel; and the following month saw the first of his many purchases from Claude Monet, far and away his favourite painter.[5] Not only was de Bellio now launched as a collector of Impressionism, but in the decade that followed he ministered to most of the artists and their families, although how competent he was as a doctor is a delicate question.[6]

If Vollard's account of the early provenance of the Williamstown *Self-portrait* needs to be amended, it also errs with regard to price. As de Bellio's biographer first pointed out, to have paid 1,000 francs for a small canvas by Renoir in 1876 would have required a generosity (or foresight) shared by no other collector at this time.[7] In July 1876 Monet offered de Bellio two sketches for 150 francs the pair; in June 1877 he may have been obliged to sell ten paintings for 100 francs each, the going price for Impressionist landscapes at that time.[8] Renoir himself remembered de Bellio as a discriminating collector who was nonetheless accustomed to getting his pictures cheap. If anyone had urgent need of 200 francs, he recalled, "he would run over to the Café Riche at lunchtime, where he was sure to find Monsieur de Bellio, who would buy whatever painting was offered to him without even looking at it."[9] Thus it seems likely that de Bellio paid considerably less for Renoir's *Self-portrait* than Vollard claimed – 100 francs rather than 1,000 francs, perhaps – although of the eight paintings by Renoir in his collection, it occupied a relatively exalted place, hanging above the sideboard in his crowded apartment in the rue des Martyrs.[10]

Recognized by most critics at the second Impressionist exhibition as a self-portrait, this small painting, along with Renoir's portraits of Chocquet, Bazille (cat. no. 5), and Monet (cat. no. 21), doubtless inspired Burty's apt characterization of Renoir's figures as "of unquestioned originality, both as regards physiognomy and colouring."[11] Among those who remarked on the *Self-portrait*, opinion was divided. At one extreme, the critic of *Le Constitutionnel* could claim of this painting and the portrait of Chocquet that "never had the burlesque and the absurd been taken to such extremes," a view shared by Marius Chaumelin, writing in *La Gazette*, who dismissed both portraits as "caricatures executed by Goya in a moment of high spirits."[12] Leroy, heavy-handed in his contempt, was "charmed" by Chocquet's green and sky-blue hair, while Renoir's *Self-portrait*, "spotted like a jaguar," induced almost ecstatic reverie.[13] Porcheron, in *Le Soleil*, drew attention to Renoir's unorthodox handling of paint, while Georges Rivière, in his first published art criticism, praised Renoir's portrait of Chocquet (which he termed the portrait of an old man!) and his *Self-portrait* as "very remarkable," an enthusiastic if hardly illuminating assessment.[14]

Chaumelin's reference to Goya seems wholly unexpected, but would be repeated in a far more positive vein seven years later by Armand Silvestre, in his review of Durand-Ruel's Renoir retrospective of April 1883, to which the *Self-portrait* had been lent.[15] "His portrait has reminded me of the best Goyas, infused as it is with the same personality."[16] Both writers were probably thinking of the frontispiece *Self-portrait* from *Los Caprichos*, almost a signature for Goya in France at this time, and a print that was widely reproduced. It illustrated both the biography of Goya in Blanc's *Histoire des peintres* and the first of Paul Lefort's three articles on the artist published in the *Gazette des Beaux-Arts* in

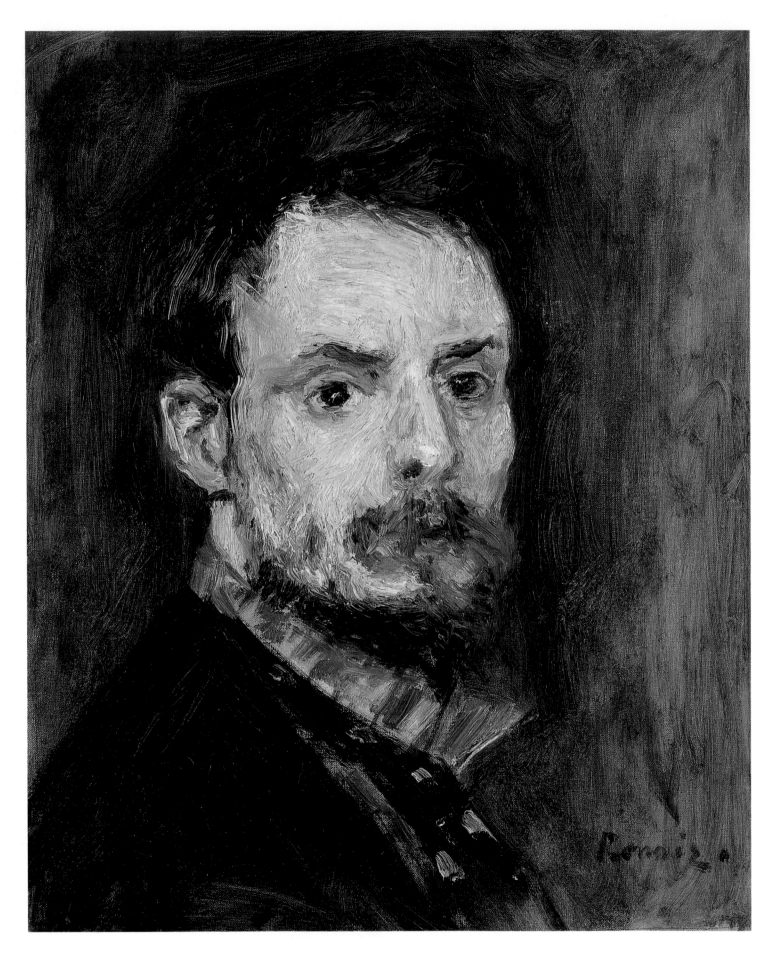

cat. no. 24

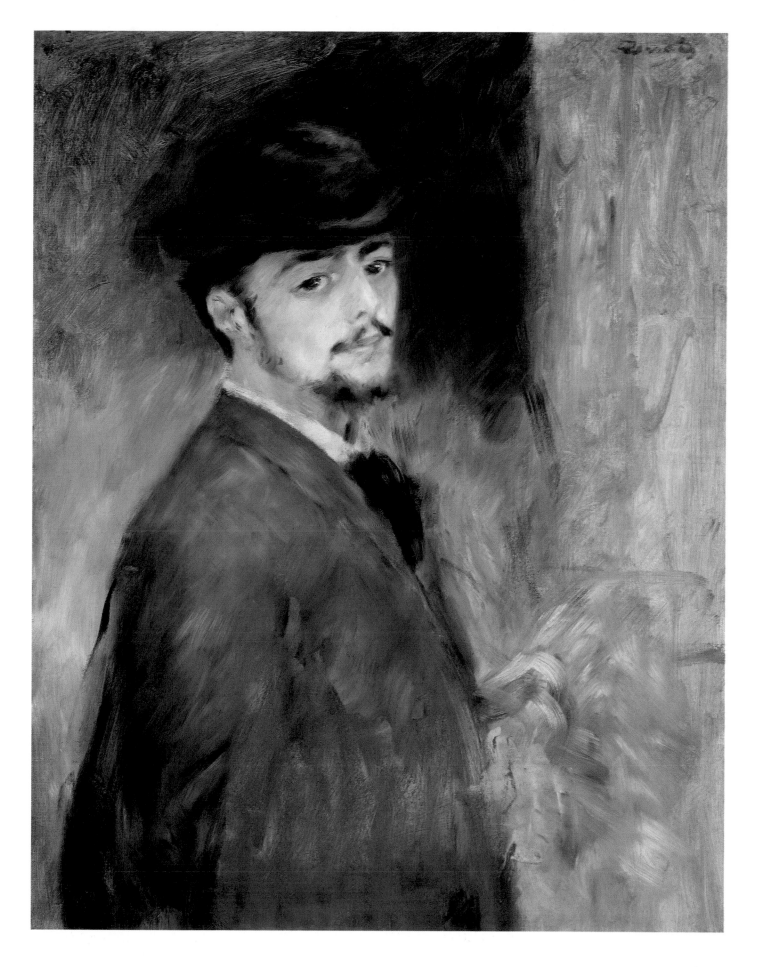

cat. no. 25

December 1875 (fig. 165).[17] Whether Renoir himself had been impressed by Goya's moody but elegant manner of self-presentation is hard to say, but Lefort's analysis of the artist as "essentially modern . . . one whose portraits, compositions, and way of treating light, indeed his entire artistic practice, is both of yesteryear and tomorrow," would surely have appealed to the young Frenchman.[18]

For as in Goya's *Self-portrait*, the bravura of Renoir's brushwork and his uncompromising expression were placed in the service of a defiantly elegant presentation. Comparing the Williamstown canvas with a photograph of Renoir taken in 1875 (fig. 166), we see the same thinning hair, parted at the crown; a similarly scrubby beard and moustache, hastily trimmed; and the same starched collar and well-tailored suit – in the painting, the former is inflected with dashes of sky blue. In his *Self-portrait* Renoir is shown wearing a dark-blue lavalier with white dots, the "cravate lavallière" especially favoured by artists that would remain his preferred type of necktie well into old age.[19]

Scrupulous in its treatment of apparel, the *Self-portrait* is equally candid in its portrayal of character. Rivière, the only biographer to have known Renoir in the 1870s, was initially struck by his "serious face, his furrowed brow, his short, rough beard, all of which made him look older than he was."[20] Edmond Renoir wrote in June 1879 of "the pensive, thoughtful, sombre, preoccupied look" in his elder brother's eye.[21] And Vollard's first impression upon meeting Renoir in 1894 was of a "spare man, sharp-eyed and nervous, who seemed incapable of ever standing still."[22] The *Self-portrait* captures this quality of distracted energy with admirable economy.

Much more mysterious are the origins and history of the unfinished *Self-portrait at Thirty-five*, published by Vollard in 1918 as simply "Portrait d'homme."[23] With only the head and shoulders brought to any acceptable degree of finish, the painting is little more than a sketch, but it provides a fascinating insight into Renoir's working methods.[24] On a pre-primed canvas covered with a light ground, Renoir blocks in the contours of his figure with generous swags of grey, green, madder, and cobalt. The modelling of the face and hat are particularly audacious: the beard and moustache are a mixture of lime-green and alizarin, highlighted with blue, and his "petit chapeau," similar to the kind worn by Monet (cat. nos. 14, 21), is sumptuously rendered in rich blues and blacks. Such is the colourist's licence that Renoir paints his brown eyes – recorded as such in his military record of August 1870 – in the same hue as his hat and jacket.

The composition may have foundered on Renoir's difficulty in resolving the placement of his right arm. As is customary in self-portraits, and as would have been the case here, a right-handed artist will appear on the canvas as holding his paintbrushes in his left hand. Renoir had initially painted his right arm bent at the elbow, intending perhaps to place the palette in his right hand: blue lines indicating knuckles may be seen at the logical extension of his right sleeve. The practical confusion that this may have entailed – one imagines Renoir continually having to swap palette and brushes as he tried to fix the image on the canvas – seems to have led him to abandon the palette and seek an alternative solution. His right arm would now hang by his side, and accordingly he blocked out the right sleeve as a vertical: note the virtuoso madder brushstrokes that describe the outer edge of his jacket and the folds just below the shoulder. The unexpected consequence of these changes, however, was an unfortunate rotundity in Renoir's lower body, which became pear-shaped as a result of the adjustments to his right arm. At this point the artist's interest in the self-portrait seems to have come to an end.

It is indeed curious that during Renoir's lifetime Vollard could reproduce this self-portrait as an anonymous figure, and that Renoir himself, who annotated many of the plates in Vollard's book, passed over the identity of the painting in silence.[25] Yet it would be excessively punctilious to dispute its identification. Renoir has idealized his somewhat gaunt features, certainly – his face is softer and his form more ample – but in essentials his distinctive physiognomy is recognizable. He also wears the same "petit chapeau" in which he had appeared in Fantin-Latour's *Studio in the Batignolles* (fig. 62).

Less problematic is the dating of the unfinished *Self-portrait at Thirty-five*, which in its dappling of blues and greens and its violet tonality relates to Renoir's experiments in *plein-air* figure painting in Montmartre, where he had rented a house with a garden in May 1876.[26] Such is its affinity with *The Swing* (Musée d'Orsay, Paris) and *Ball at the Moulin de la Galette* (fig. 15) that it is worth asking whether Renoir may not have intended to show himself painting out of doors. Even in its unfinished state, the *Self-portrait at Thirty-five* conveys something of the sensation of daylight refracted through foliage, the hallmark of his paintings from the summer of 1876. No less than the recalcitrant right arm, this would have placed another burden on the artist, since self-portraiture – with its requirement of a mirror – accommodated painting *en plein air* less easily than did the other genres.

Compromised in its realization, perhaps, Renoir's *Self-portrait at Thirty-five* was anything but fanciful in its expression of reticence. Rivière wrote that the artist was "reserved and timid, recoiling from anything that would draw attention to himself."[27] But shyness could be overcome by immersion in work, from which Renoir was known to experience an epiphany of sorts. And this is the real subject of the *Self-portrait at Thirty-five*: "If you want to see his face light up, if you want to hear him humming cheerfully to himself . . . then do not look for him at the dinner table, or in the places where people go to enjoy themselves, but try instead to catch him in the middle of working."[28]

66.4 × 54.2 cm
The Art Institute of Chicago
Mr. and Mrs. Lewis Larned Coburn Collection

IN MAY 1926, when asked to identify a portrait by Renoir purporting to be of Alfred Sisley, Monet, now aged eighty-five, could reply without hesitation: "I know of only one portrait of Sisley by Renoir. It's the one he did at my house in Argenteuil, where he's sitting astride my chair."[1] Monet was referring to Renoir's portrayal of his fellow Impressionist Alfred Sisley (1839–1899), painted almost fifty years earlier, in which his starched cuffs are held in place by cufflinks, and a polka-dotted lavalier falls rakishly beneath his beard. Sisley indeed straddles a bamboo-style chair of the very type that had appeared in earlier paintings by Monet, but were it not for the latter's recollection, there would be no reason to associate this portrait with his second house at Argenteuil, the setting of Renoir's portrait of Monet of the previous year (cat. no. 21).[2]

For Renoir's approach to setting is characteristically minimalist. A window at upper right provides the source of light; heavy blue-green drapery hangs behind Sisley in barely distinguishable folds; the wallcovering below the window is of the deepest red. Similar in construction to the unfinished *Self-portrait at Thirty-five* (cat. no. 25), in which daylight would have entered through the quadrant at upper right, *Alfred Sisley* is set in an interior pared of domestic reference. Sisley's casual pose is appropriated from the conventions of studio photography and is also indebted to the paintings of Frans Hals (fig. 169), the first artist systematically to use this straddling device in his male portraits.[3]

With its flickering striations of blues, blacks, greens, and yellows, applied with a dry brush – "almost as if they were hatchings in pastel"[4] – Renoir's vibrant portrait manages to evoke the imposing frame of his sitter while at the same time constructing a shallow space that almost seems contiguous with our own: note how Sisley's left elbow projects over the back of the chair, itself placed at the very edge of the picture plane. In attempting to define volume and form through the most subtle of gradations, Renoir's colourism is particularly audacious. Although the blues and blacks of Sisley's jacket seem at times to merge with the related hues of the background, this does not diminish Renoir's heroic effort to revisit a traditional interior subject in the language of *plein-airisme*.

One of seven portraits included in his submission of twenty-one paintings to the third Impressionist exhibition of April 1877, and the only portrait identified fully in the catalogue, *Alfred Sisley* attracted little attention in the press, overshadowed as it was by those of celebrities such as the actress Jeanne Samary (cat. no. 29) and the deputé Eugène Spuller (fig. 167).[5] While it was generally admitted that Renoir had "undeniably the eye and the hand of a portraitist," only three reviews discussed *Alfred Sisley* in any detail.[6] Most positive by far was Georges Rivière, the self-appointed oracle of Impressionism, for whom it possessed "an extraordinary likeness and great value as a work of art."[7]

Rivière may also have been responsible for the inaccurate dating of *Alfred Sisley* to 1874, an error which has consistently dogged this otherwise well-documented work. Illustrated with this date in his monograph on Renoir, published in 1921, the portrait has been assigned to 1874 by practically all historians, with the exception of Meier-Graefe, who published the work as having been painted in 1879, and more recently by Anne Distel, who proposed a tentative dating of "around 1875."[8] At this stage in his career, however, it would have been quite unlike Renoir to withhold a painting from public display for three years – it was only in the following decade that he would subscribe to the dictum that his latest work had to be "bottled" for a year before being exposed to the public[9] – and it seems reasonable to assume that *Alfred Sisley* was painted after the close of the second Impressionist exhibition in April 1876. In its stippling brushwork and "violet" tonality, it can be compared stylistically to such portraits as *Georgette Charpentier* (1876, fig. 6) and *The Artist's Studio, rue Saint-Georges* (1876, fig. 18); in handling it is also close to the undated *Young Woman with a Veil* (Musée d'Orsay, Paris), generally assigned to 1875–77.[10] Finally, it is not without interest that when *Alfred Sisley* was shown publicly for a second time in Durand-Ruel's portraiture exhibition of June 1912 (it then belonged to the dentist Georges Viau, who had treated Sisley at the end of his life) it was published as having been painted in 1876.[11]

This shift in chronology does not much alter the status of the painting as an affectionate homage from one founding Impressionist to another, whose friendship had begun in Gleyre's studio some fourteen years before (see cat. no. 1). *Alfred Sisley* admirably conveys the delicacy of the sitter's nature – "the soul and brush of a poet" – that impressed all who came into contact with him.[12] As Rivière noted in 1926: "This pleasant-looking man [fig. 168], so charming and elegant, was also timid, and it pained him to offer his painting as merchandise."[13] Renoir's portrait equally insists upon Sisley's innate decorum and propriety: "Even at the time of his worst afflictions, he dressed appropriately and kept his collars impeccably starched."[14]

Yet *Alfred Sisley* is also a good example of what Burty termed Renoir's "romantic Impressionism."[15] For all his elegance and sensitivity, Sisley had disaffected his bourgeois father through his liaison with Marie-Adélaide-Eugénie Lescouezec (1834–1898), an artist's model and part-time florist who bore him two children out of wedlock, Pierre (1867–1929) and Jeanne-Adèle (1869–1919), both of whose portraits Renoir painted in 1875 (fig. 170).[16] With the depletion of his father's fortune after the Franco-Prussian War and Sisley's difficulties in securing a market for his work, the artist and his family were obliged to remain outside Paris – from Voisins-Louveciennes, they moved to Marly-le-Roi (1875–1877), then to Sèvres (1877–1880), and finally to Veneux-

Nadon near Moret, where for the next twenty years they lived "in genteel rather than grinding poverty," with Sisley increasingly embittered that his landscapes failed to receive even the most grudging recognition.[17] Sisley would eventually marry Eugénie in the Cardiff Register Office in August 1897, but by this time her illness was well advanced: she died of cancer of the tongue in October 1898.[18] Sisley himself died of throat cancer in January 1899, unable to afford more than the most rudimentary medical treatment.[19]

In 1876, the depressing story of Sisley's late career and his break with Renoir (who told Julie Manet how Sisley had once crossed the road rather than speak to him) were both well in the future.[20]

Indeed, for the first owner of this portrait, the pastry-cook and collector Eugène Murer (fig. 47) – a source of both credit and nourishment to the Impressionists between 1877 and 1880, and with whom Sisley maintained a precariously cordial relationship into the 1890s – the sitter was the very example of gentlemanly correctness: "Brighter than a chaffinch, he was a good eater with poor digestion, who kept the company amused at dessert by his witty sallies and ripples of laughter."[21] Not unexpectedly, Renoir preferred the elegiac to the hearty. "Sisley's gift was gentleness," Jean Renoir recalled his father saying; and Renoir's achievement was to capture that quality in paint.[22]

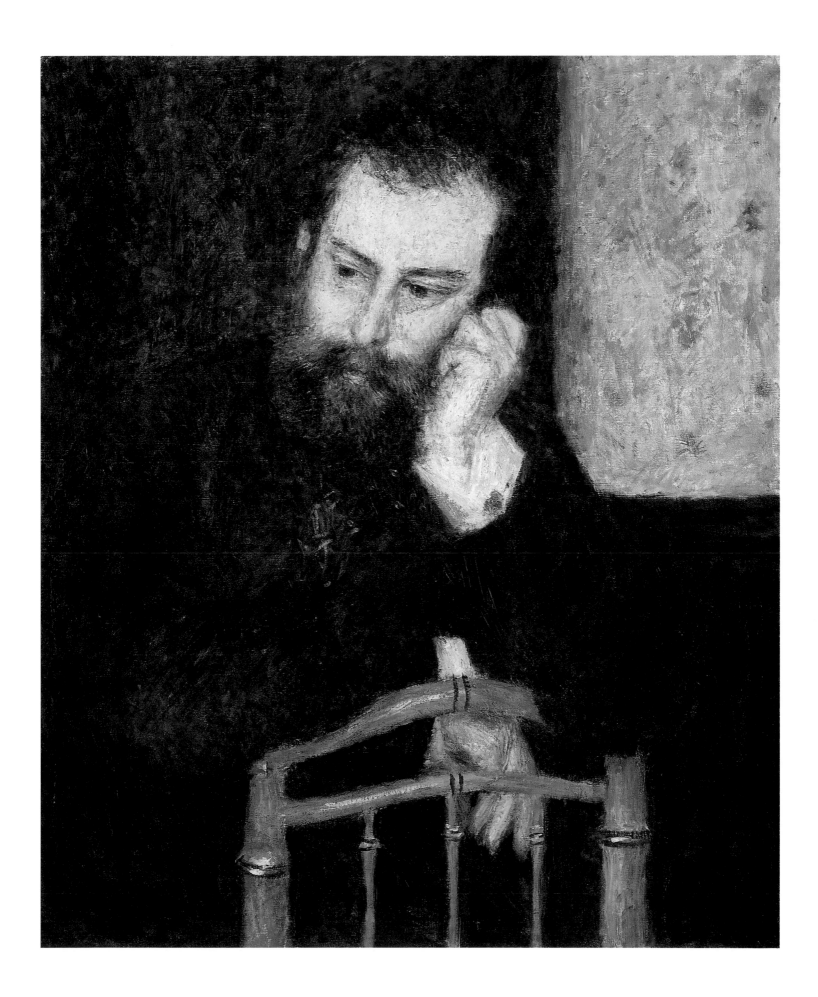

46 × 38 cm
Stiftung "Langmatt" Sidney und Jenny Brown,
Baden, Switzerland

VIEWED FROM ON HIGH, in a typically *japonisant* point of view, Renoir's eight-year-old sitter – a sweet faced-boy with large ears – sits upright in a red armchair, dressed in his Sunday best. His black velvet jacket, with satin trim on the collar and lapels, is held in place by a single button, and his white shirt, starched cuffs exposed, is tied with a blue silk foulard. Delicate, but not intimidated, the boy appears both stoical and expectant, perfectly still against a mobile background of highly patterned wallpaper divided from the floorboards by a blue-green baseboard.

Paul Meunier was one of four family portraits, including his own, that Hyacinthe Eugène Meunier, known as Eugène Murer (1841–1906) – father of the little boy – commissioned from Renoir in 1877 at the bargain price of 100 francs each.[1] Like *Eugène Murer* (fig. 47), the portrait of his son was painted on a size 8 canvas, and it is executed with the same mixture of bravura and affection.[2] Apart from slight changes in the placement of Paul's ears and left hand, Renoir brings off the unexpected angle of his pose without difficulty. His colourism is at its most audacious in the dabs of reds, browns, and greens that model the boy's wavy auburn hair, and in the blues and greens that are inflected on the whites of his collar and cuffs to render them ice-cold in hue. As Théodore Duret would note the following year, Renoir's supreme gift as a portraitist was not only his ability to capture the features of his sitters, but through them "to grasp both their character and their private selves."[3] In this instance, Renoir neither flatters nor condescends to his young sitter, whose slightly puny ("chétif") appearance is rendered with admirable sympathy.

Christened Eugène Hyacinthe after his father, Paul Meunier (as he later became known) was born on 2 December 1869 to Hyacinthe Eugène Meunier (as Murer was then called) and Marie-Antoinette Constance Masson (1845–1872), his wife of two years.[4] He was the first of their four children, and the only one to reach adulthood. A son, christened Achille Eugène, had died in infancy in August 1867; twin girls had been born the following year, one dead at birth, the other, Eugénie, dying after three weeks on 2 July 1868.[5] Paul's mother, Marie-Antoinette – a former seamstress, whose brother was a butcher – died on 11 October 1872, just before his third birthday.[6] By then, the family had left the rue François Miron in the Marais for 95 boulevard Voltaire, where Murer opened a patisserie and restaurant above the Prince Eugène public baths.[7] It was only in July 1872 that the pastry-cook had been formally recognized by his own parents, and after his wife's death he was joined in his business by his half-sister, Marie Meunier (fig. 50), who shared responsibility for Paul's upbringing.[8]

In 1881 Murer sold his shop in Paris and moved his family to Auvers-sur-Oise, where he would live for the rest of his life. He also acquired the Hôtel du Dauphin et d'Espagne in nearby Rouen, which he and his sister operated until 1897.[9] Paul was sent to school at the Collège Municipal de Pontoise (to which Monet had considered sending his son Jean in September 1882), before returning to Paris to commence apprenticeship as a wood-carver

("sculpteur sur bois") with a firm that produced furniture for the faubourg Saint-Antoine.[10] Pissarro, who at the time was being badgered by his wife to find a similar position for their younger son, Georges, took a dim view of the training "young Murer" received. As he wrote to Lucien on 3 June 1887: "They told your mother that in the place where young Murer was taught, they made the apprentices run errands for two years. Now that's a fine way to learn!"[11]

By March 1888 the situation seems to have worsened, and Paul Meunier may have abandoned his job as a wood-carver. Murer evidently threatened to cut off his son and this prompted Pissarro, decent patriarch that he was, to intervene in the most impassioned of terms. Tremulous, but determined, he wrote to Murer on 29 March 1888, imploring him to take back his son:

> This time, there will be nothing about art in my letter; this time, it's more serious, it's about humanity, but will I be sufficiently eloquent to move you? . . . I know that he is in a terrible position, and in such misery . . . Whatever his faults, there is still time to prevent the evil from spreading, since he is so young. Come what may you will be able to prevent him from falling any lower . . . What will happen to this child, without a family, without a sense of purpose, whose only occupation is routine work, which is of no use, believe me! Think it over Murer, you will see that your son is not to blame: he has been the victim of fatal circumstances.[12]

The letter seems to have had some effect, for after completing his military service Paul took a job working in his father's hotel in Rouen. In a letter to Murer that can be dated to August 1893, Renoir asked to be remembered "to that strapping son of yours," whom he promised to visit in Rouen in September: "I shall look forward to seeing him as a cook; after the helmet, the chef's hat."[13]

How long Paul remained at the Hôtel du Dauphin et de l'Espagne is not known, but he is next found in Beaulieu-sur-mer, just north of Nice on the Côte d'Azur, where on 2 October 1899 he married the impressively named Laetitia Appolonie Françoise Nemea Joséphine Mazet (1880–1910), a young woman eleven years his junior.[14] A son, christened Léopold Eugène, was born to the couple exactly a year later.[15] Named sole legatee of his father's estate in January 1901 – another sign that the rupture had been mended – Paul was working as a garage owner in Beaulieu-sur-mer at the time of Murer's death in April 1906.[16] Disappointed perhaps in his meagre inheritance of property and effects valued at 7,800 francs – Murer had sold his Impressionist paintings a decade earlier to the dentist Georges Viau[17] – Paul lost little time in liquidating the remnants of his father's collection.[18] He deposited Renoir's *Eugène Murer* with Durand-Ruel, although the dealer, whom he had obliged to make the journey to Beaulieu-sur-mer, clearly felt that the effort had not been worthwhile.[19] The last mention of Paul Meunier that has so far come to light is the record of his second marriage in Paris on 30 January 1923 to a Marie Apolline Amélie Palmyre Marguerite Portier (born August 1893); this time, he took a bride twenty-three years his junior.[20] Information on Paul's subsequent life in Paris – including the year and place of his death – remains to be discovered.

Seated in front of one of the walls in Murer's establishment that Renoir himself may have painted with "garlands of flowers and

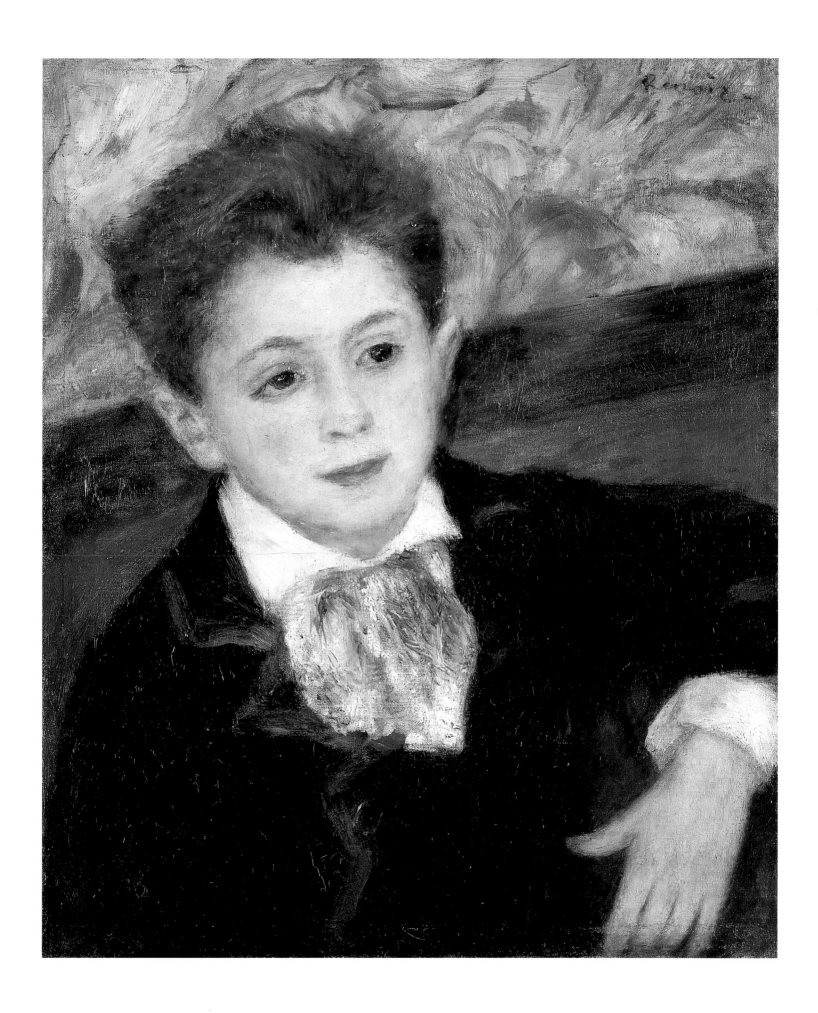

foliage" – a typically understated self-quotation – Paul Meunier, looking for all the world like a Parisian Lord Fauntleroy, gives no hint of his origins as a baker's son and a butcher's nephew.[21] And although the portrait ably communicates a sense of contentment and assurance, family feeling did not run deep in this household. Murer had very little affection for his own mother, whom he described as "a cantankerous, despotic woman, of whom I saw little; in coming to die at my house, she provided me with the only happiness I experienced during forty years of motherhood."[22] Relations with his only son may not have been a great deal more cordial. Renoir's objectivity as a portraitist was obviously selective (and perhaps self-serving), and it is this quality that earned him Burty's approval as a "romantic Impressionist."[23] Even the most partial recreation of the life of Paul Meunier shows how astute was this epithet.

28 *Jeanne Samary* 1877

46 × 40 cm
Comédie-Française Collection, Paris

29 *Bust-length Portrait of Jeanne Samary*
(*La Rêverie*) 1877

56 × 46 cm
Pushkin State Museum of Fine Arts, Moscow

30 *Jeanne Samary* 1878

173 × 102 cm
State Hermitage Museum, Saint Petersburg

AS FAMOUS IN HER DAY AS Sarah Bernhardt, Léontine Pauline Jeanne Samary (4 March 1857–18 September 1890) was already a successful actress at the Comédie-Française when she first sat to Renoir early in 1877.[1] Over the next three years, he would record her features no fewer than twelve times in portraits in oil and pastel and on MacLean cement, as well as in the occasional genre painting (fig. 180).[2] Yet despite Renoir's fondness for "la petite Samary, who delights women, but men even more" and the satisfaction he derived from painting her portrait (Rivière claimed that no full-length ever gave Renoir greater pleasure), their association was at an end by 1880.[3] Samary's allegiances were henceforward with the more fashionable Realists who specialized in portraying the leading ladies of the Comédie-Française – Bastien-Lepage, Carolus-Duran, and Louise Abbéma, each of whom painted at least one portrait of her (figs. 174, 178).[4]

Born into a dynasty of divas – her maternal grandmother was Suzanne Brohan (1807–1887), the greatest *comédienne* of Louis-Philippe's reign – Jeanne was the third child of Louis-Jacques Samary (1815–1893), a cellist at the Opéra, and Elisabeth Brohan (1828–1891), a sister of two of the most formidable *sociétaires* of the Comédie-Française, Augustine and Madeleine Brohan.[5] Louis-Jacques Samary, the son of a strolling fiddler, was said to wash his hands at least thirty-five times a day and keep his finger-nails impeccably manicured. Each of his four children was destined by him for the stage.[6] The eldest, Marie Louise Antoinette Samary (1848–1941) (fig. 176), made a successful career at the Odéon and later the Théâtre de la Renaissance;[7] the second, Georges Émile Achille (1851–1921), was a violinist at the Opéra-Comique before becoming an antique dealer;[8] and the youngest, Henri Samary (1865–1902) (fig. 177), like Jeanne a prize-winning student at the Comédie-Française, abandoned the stage early on to join his brother selling antiques. After arranging a successful European tour for his wife, the "brilliant divette" Juliette Méaly, he seemed likely to become an impresario, but this second career was cut short by his death from peritonitis at the age of thirty-seven.[9]

"Enfant gâtée" of the Théâtre-Français, Jeanne entered the Conservatoire in November 1871 at the age of fourteen, won first prize for comedy in July 1875, and made her debut the following month as Dorinne in Molière's *Tartuffe*.[10] She excelled in playing servant girls and soubrettes (fig. 172), and these roles were now routinely offered to her. In 1884, a critic who had been present at her debut recalled: "How pretty she was! Small and already a little heavy, but with such a smile on her face, such a delicious mouth, and such freshness and gaiety seeping from every pore of her plump little body!"[11] By 1877 it was noted that "Mademoiselle Samary has taken possession of all the roles of soubrette in the company's repertory," and in recognition of her success she was made a full member (*sociétaire*) of the Comédie-Française in January 1879, two months before her twenty-second birthday.[12]

The following year, in November 1880, at the height of her fame, she married Marie-Joseph Paul Lagarde (1851–1903), "a perfectly dashing young man with Parisian good looks,"[13] the son of a wealthy stockbroker who had opposed the match and initiated legal proceedings to prevent the wedding from taking place. Defeated in court, Lagarde's parents did not attend the ceremony at the Église de la Trinité, which was something of a media event, attended by painters, actors, and journalists and reported widely in the press (fig. 179).[14] Three daughters were born to the couple. The first, Andrée, died in March 1883 at the age of six months. Blanche (1885–1913) and Madeleine (1886–1968), who both trained as actresses, went on to marry theatre directors, thus maintaining the Brohan legacy.[15] On 5 September 1890, two months before her tenth wedding anniversary and after opening the season as Suzanne in Pailleron's *Le Monde où l'on s'ennuie*, Madame Samary (as she was known after her marriage) returned to join her husband and daughters on holiday at Trouville, where she was diagnosed as having typhoid fever. She was rushed back to Paris and died in her apartment in the rue de Rivoli on 18 September, aged thirty-three. The following day, two thousand mourners, including the staff of all the theatres in Paris, accompanied her coffin to the Église Saint-Roch.[16]

Although in 1877 she was living with her parents in the rue Frochot, only a stone's throw from the rue Saint-Georges, it seems most likely that Samary was introduced to Renoir by the Charpentiers.[17] Both Rivière and Duret recalled that she regularly attended Marguerite Charpentier's salon – where, like her fellow actor Coquelin the younger, she might be called upon to recite the latest work of one of the other guests – and it would be in character for her hostess to encourage this young celebrity to sit to her protégé of the moment.[18] For while the twenty-year-old Samary cannot be said to have shown any great interest in Impressionism, she was eager to have her image in the public domain. In March 1877 Alphonse Hirsch exhibited a portrait of her "en travesti" at the Cercle Artistique et Littéraire in which she was dressed in the role she had performed in Pailleron's *Le Chevalier Trumeau*.[19] In May, two portraits of Mademoiselle Samary, "pensionnaire de la Comédie-Française," appeared at the Salon: a painting by Bonnat's pupil Georges de Dramard, and a marble bust by Robert David d'Angers that portrayed her as Pulchérie, the innkeeper's wife, from Pailleron's *Petite Pluie*, a comedy in which she had appeared in December 1875.[20]

In contrast to all this, Renoir, who disliked the acting at the Comédie-Française and rarely attended performances there, avoided any reference to the theatre in his portraits of Mademoiselle Samary.[21] The earliest of the three (cat. no. 28), dated 1877, was in all likelihood painted for the landscapist Joseph-Félix Bouchor (1853–1937), who, with his younger brother, the poet Maurice Bouchor (1855–1929) – of whom Renoir painted a full-length portrait – was part of the bohemian

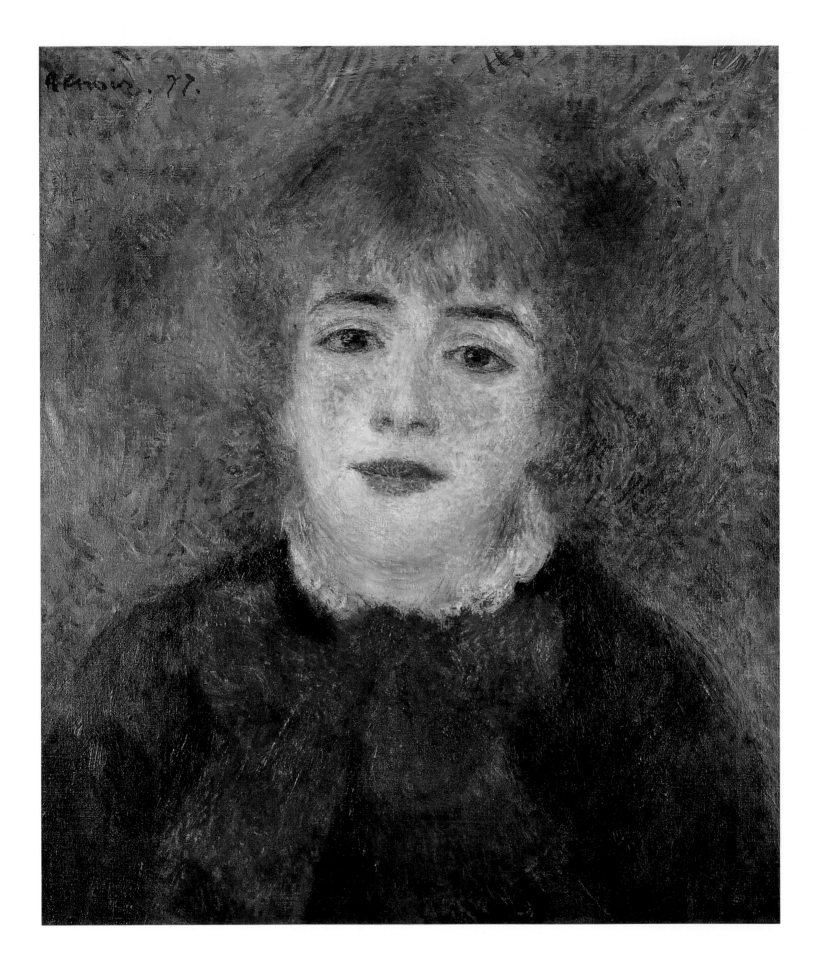

cat. no. 28

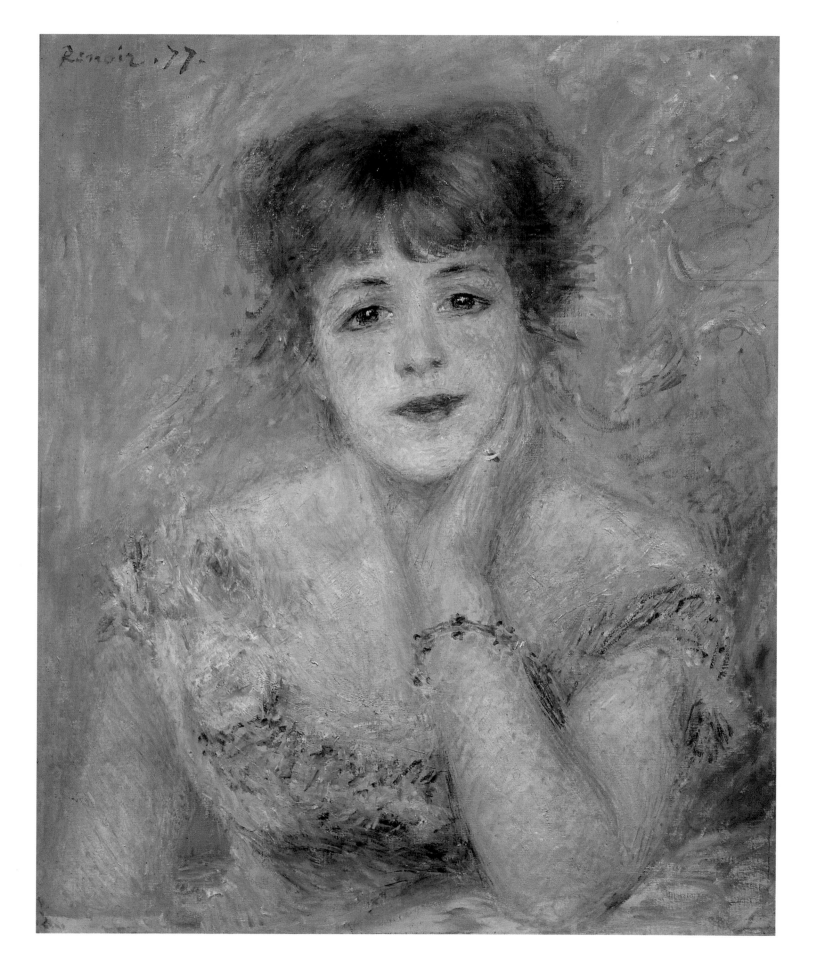

cat. no. 29

confraternity that gravitated around Richepin and Renoir in the late 1870s.[22] A generation younger than the Naturalists who were fêted at the rue de Grenelle – and considerably less polished – this group of poets and painters appreciated "la verve réaliste et gauloise" of Bouchor's *Chansons joyeuses* (1874) and Richepin's *Chanson des gueux* (1876), and Samary's preference for plebeian roles, her love of regional accents, and her "demonic laugh" surely commended her to them.[23]

The extravagant brushwork notwithstanding, Renoir's *Jeanne Samary* is in many ways his most reticent portrayal of the actress. Samary emerges, but only just, from a background of multi-coloured cross-hatchings, her wide blue eyes imploring and her lips closed without the hint of a smile. She is shown simply dressed, her white collar buttoned to the neck, and somewhat overwhelmed by the huge bow whose colour is dimly reflected in the reds of her cheeks. This half-length portrait, no doubt executed very quickly, seems to have been painted over an earlier composition, whose traces are still visible on the surface of the canvas.

Considerably more resolute and audacious, indeed among the most ravishing of all his Impressionist portraits, is the portrait of Jeanne Samary known as *La Rêverie* (cat. no. 29) exhibited by Renoir at the third group exhibition of April 1877, where it hung as a pendant to his portrait of the Republican député Jacques-Eugène Spuller (fig. 168).[24] "A burst of sunshine,"[25] painted with a parrot-coloured palette, *La Rêverie* conveys the glamour that we now associate automatically with celebrities of the stage (and screen) – with all its romance and mendaciousness – in a way that no other theatrical portrait of his time succeeds in doing.[26] Her chin propped squarely in the palm of her hand, her elbow resting on a table that is just visible at lower right, the actress is shown bejewelled and in a low-cut evening dress with a corsage of roses, "her complexion that of tea-roses, her lips blood red."[27]

The press responded positively to Renoir's celebrity portrait – the appearance in person of "la jolie pensionnaire du Théâtre-Français" at the exhibition may have helped – with only the occasional dissenting voice.[28] Ballu, the most openly hostile, complained that "the face of this charming model, so well known, is lost in the brutally coloured pinkish background . . . Such a strange portrait! Nothing, it seems to me, could be further from the truth."[29] But for most critics, Renoir had succeeded in achieving both a physical and psychological likeness. Zola considered this "blond, laughing head" quite simply the "success of the exhibition," while the portrait impressed Flor O'Squarr as "rosy, fresh, pert, gracious and gentle, just like the model herself."[30] The latter was exceptional, however, in also claiming that the portrait was "astonishing in its solidity."[31] Despite their enthusiasm, the critics could not be expected to respond altogether positively to Renoir's experimental technique – Samary's face and shoulders are modelled through cross-hatchings of the most vivid blues, pinks, and greens – and they either skirted the issue by referring to the work as a "sketch" (even though it was prominently signed and dated), or labelling it "un morceau décoratif" (hence the comparisons to a Beauvais tapestry).[32] Renoir's colouristic modelling was troubling, for read literally Samary was seen to be "cloaked in a pale blue gauze, with shoulders of green marble."[33] "Where," asked Véron, "has the artist ever seen such arms, rough arms covered in scales?"[34]

The most astute commentary on *La Rêverie* came from Renoir's friend and supporter Philippe Burty, who compared it to a fantasy portrait by Fragonard. He added: "Not only does this portrait capture perfectly the pretty features of the lively soubrette, it also evokes something of the atmosphere that is unique to the stage."[35] In fact, while the third Impressionist exhibition was taking place in a rented apartment across the street from Durand-Ruel's gallery, Jeanne Samary was appearing at the Comédie-Française as the figure of Night in Molière's *Amphitryon*, a play that had not been performed since the siege of Paris. Comparison with a photograph of her in mythological costume taken in April 1877 (fig. 173) serves to underline Renoir's determination to avoid theatrical reportage in any shape or form.[36]

Renoir's most ambitious portrait of Samary, in which she is shown full-length in a ball gown (cat. no. 30), was exhibited at the Salon of 1879, but unlike *Madame Charpentier and Her Children* it was poorly hung, skied in Room 5 of the Palais de l'Industrie, and as a result received hardly any attention in the press. Instead, Louise Abbéma's portrait of the actress (fig. 178), which hung in the same room as Bastien-Lepage's *Sarah Bernhardt* (fig. 181), drew all the attention.[37] Samary had been made a *sociétaire* of the Comédie-Française in January 1879 – she is listed as such in the Salon *livret* – and at first sight Renoir's portrait would seem a fitting testimonial to this promotion. This would be to credit the artist with the power of prophecy, however, since *Mademoiselle Samary* was painted in the autumn of 1878 – the year appears quite prominently at lower left – and finished by 15 October, at the same time as *Madame Charpentier and Her Children*.[38]

The full-length portrait was never owned by the actress, and after its poor showing at the Salon Renoir seems to have experienced some difficulty in selling the work. It remained in his studio until December 1881, when Durand-Ruel agreed to take it on deposit (but not to buy it), and was shown, *hors catalogue*, in Durand-Ruel's Renoir retrospective of April 1883, "an exhibition with hardly any visitors."[39] That this was a last-minute addition is confirmed by Renoir's note to Duret, written on the back of a letter thanking him for his sensitive preface to Durand-Ruel's catalogue: "Go to Durand-Ruel's and see the portrait of the little Samary girl. It will not be understood, but I think it is pretty, the flesh tones work well against the background. In my opinion, it's worth seeing, at least."[40] *Mademoiselle Samary* was also one of the thirty-eight Renoirs that Durand-Ruel shipped to New York in April 1886 as part of *The Impressionists of Paris*. Durand-Ruel finally bought the portrait on 29 December 1886, more than eight years after it had been painted, for 1,800 francs; he sold it the same day to the prince de Polignac for a profit of only 200 francs.[41]

The genesis of *Mademoiselle Samary* is equally curious. Although Renoir told Vollard that he had painted all the portraits of Jeanne Samary in the garden of the rue Cortot, Rivière, followed by Jean Renoir, stated categorically that the full-length was painted in Renoir's studio in the rue Saint-Georges (in contrast to *Madame Charpentier and Her Children*, done at the sitter's home in the rue de Grenelle).[42] In one sense, these conflicting accounts are beside the point, for Renoir creates a setting that is midway between the *japonisant* salon of the Charpentiers and the elegant foyer of the Comédie-Française, but which has nothing to do with either Montmartre or the simple interior of his studio in the rue Saint-Georges.

Her strawberry blond hair slightly dishevelled and her ruby lips parted in the beginning of a smile, the twenty-one-year-old actress

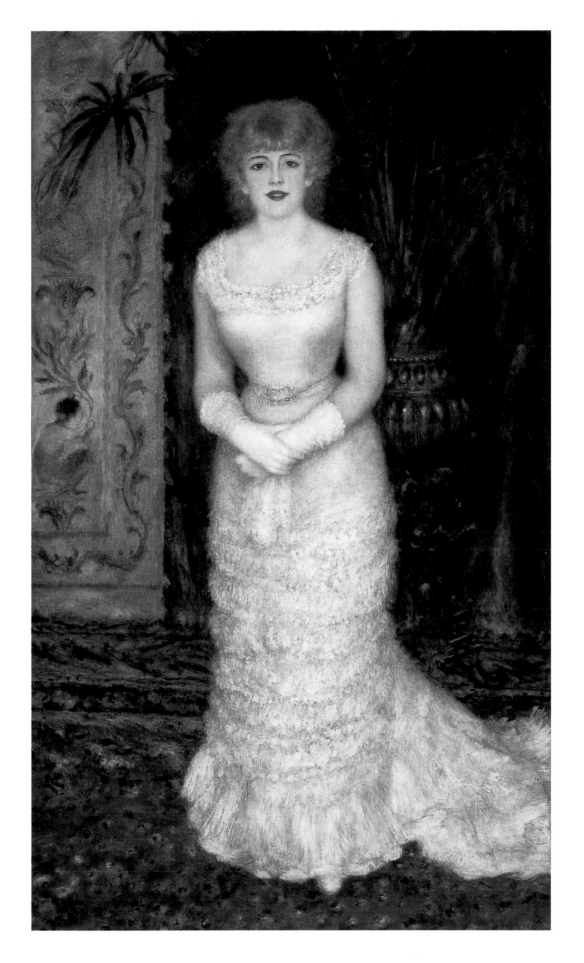

cat. no. 30

poses, almost diffidently, in a low-cut evening dress of pink satin trimmed with white lace and buckled at the waist. Wearing long white gloves with scalloped cuffs, she holds a white handkerchief in place of a fan, and seems almost reluctant to assert herself. The opulent crimson carpet with its foliated border continues flush to the panel at left, possibly part of a door that opens outward. The panel itself is decorated with a Japanese motif, repeated in reverse, of a squatting griffin (or merman) in navy hat and yellow jacket who holds an exotic flower in his hands. Next to the panel is a red curtain that serves as the portrait's backdrop *d'apparat*; just in front of this, to the right of the actress, is a copper urn mounted on an ironwork stand from which emerge the papyrus leaves that fill the upper section of the canvas.

Renoir later claimed that he had never intended *Mademoiselle Samary* to be varnished but that it was given a coat on the eve of the *vernissage* of the Salon of 1879 by a kindly porter who believed that the portrait had been left unvarnished for reasons of economy. Alerted to the fact that his picture was now "dripping," Renoir rushed to the Salon and repainted the canvas.[43] Whether Renoir's anecdote can be fully trusted – after all, he himself had supervised the varnishing of *Madame Charpentier and Her Children* – it suggests that the "freshness" Renoir achieved in the half-length portrait of the previous year and that he hoped to maintain in this more public version was compromised early on. Despite the chequered first appearance of *Mademoiselle Samary*, Renoir's handling was equal to his ambition – the creation of a full-length figure, solidly, even voluptuously, modelled, who stands in a dignified interior and is illuminated by a caressing light – and he deploys the full range of his technique to this end. From the richly impasted folds and ruffles of Samary's ball gown and train, to the delicately worked features of her face, Renoir's touch unerringly adapts itself to the priorities of the composition. Such was the contrast in handling between the upper body and the finely painted features of her face that Camille Mauclair, in the first extended analysis of the portrait, could be forgiven for assuming that Renoir had painted Samary's body with a palette knife (an instrument the artist had long abandoned), since "her eyes, eyebrows, mouth and nostrils are each registered by his brush with the precision of Japanese drawings."[44]

Upon first seeing *Mademoiselle Samary*, Marguerite Charpentier is said to have exclaimed, "it's very good, but how her collarbones

stick out!"[45] She was referring to the fact that Renoir had transformed the "short, plump, rosy, and gay" young actress – compared by one critic to a "fat little quail" – into an elegant, almost slender young woman, sensuous certainly, but demure in appearance.[46] And this stood in distinct contrast to Samary's much publicized theatrical personality. In July 1878, her contract with the Comédie-Française stipulated that she play "soubrettes and sweethearts," flirtatious servants and plain-speaking country lasses.[47] On 13 May 1879, two days after the Salon opened, she appeared as Toinon (Antoinette), the orphaned goddaughter of a wealthy marquise, in Pailleron's comedy *L'Étincelle*: destined to marry the village notary, the inexperienced country girl becomes briefly infatuated with a dashing captain who is clearly too good for her.[48] This was her most successful role to date, and she performed it to great acclaim in London the following month when the Comédie-Française left Paris for a six-week engagement at the Gaiety Theatre.[49] Of Samary as Toinon, one critic wrote: "What a country lass she was, half farmer's wife, half little miss."[50]

Indeed, coarseness and vulgarity were central to Samary's appeal. She was renowned above all for her infectious laugh, which gave her the opportunity to display a set of flawless white teeth (fig. 175), to the point where photographs of her laughing were to be seen "in shop-windows all over Paris" (her image was particularly popular with dentists).[51] Huysmans might weary of "that eternal, unbearable laugh," but for most critics it was "the laughter of Molière and the sparkle of contemporary art."[52] Nor were Samary's "impish mouth and the prettiest teeth in the world" the only popular attributes that Renoir chose to disregard.[53] With her protruding jaw, "bold as brass," her eyes wide open (she was extremely short-sighted), and her constantly dishevelled hair, her smiling visage proliferated in countless engravings and photographs (fig. 171).[54] In each of his portraits of her, Renoir diminishes Samary's vulgarity and disguises her coarseness: she is close-lipped in the half-lengths, and her hair is only "slightly tousled by a gust of springtime air" in his Salon painting.[55] Instead, with the romance that is characteristic of his best portraits, he transforms a laughing hoyden into an alluring "star," with "all the grace and devotion which the artists of the eighteenth century invested in the images they have left us of their favourite actresses."[56]

31 *First Portrait of Madame Georges Charpentier*
1876–77

46.5 × 38 cm
Musée d'Orsay, Paris
Gift of the Société des Amis du Musée
du Luxembourg, with the participation of
Madame Tournon, née Georgette
Charpentier, 1919

32 *Madame Georges Charpentier and
Her Children* 1878

153.7 × 190.2 cm
The Metropolitan Museum of Art, New York
Catharine Lorillard Wolfe Collection,
Wolfe Fund, 1907

BETWEEN 1876 AND 1882 Renoir painted seven portraits and two full-length figures for the Charpentiers, as well as providing mirror frames in MacLean cement and advising them on the varnishing and framing of his pictures.[1] "Painter in ordinary" to Marguerite Charpentier (1 March 1848–30 November 1904), he attended her celebrated salon in the rue de Grenelle and was "pushed" by her and her husband – the word is Pissarro's – to exhibit again at the official Salon in 1878.[2] The following year Marguerite Charpentier used her considerable influence to ensure that Renoir's portrait of her and her children would enjoy a place of honour ("les honneurs de la cimaise") at the Salon of 1879. "If one day I succeed," Renoir informed her husband, "it will be entirely thanks to her, because I would most certainly have been incapable of doing so on my own."[3]

In fact, it was the "éditeur du naturalisme," the laconic but charming Georges Charpentier (fig. 182) – "publisher of angels and the most angelic of publishers" – who, after acquiring three paintings by Renoir at auction in May 1875, assembled a modest collection of Impressionist works. He met Monet in July 1876 and lent money to him and Renoir that year.[4] In April 1877, Charpentier and his friend Ernest Hoschédé were the only "outsiders" at the inaugural Impressionist dinner at the Café Riche, presided over by Zola.[5] With the founding of the arts magazine *La Vie Moderne* as an offshoot of his publishing house in April 1879, Charpentier was also able to promote the Impressionists through a series of one-man shows (Renoir, Monet, Sisley) and through sympathetic articles and reviews.[6] His son-in-law would later write that "painting had always appealed to him over publishing," but Charpentier's taste, eclectic and fashionable, ran also to the conventional.[7] His favourite artist, who in February 1898 would sponsor his election as *officier* of the Légion d'Honneur, was Jacques Henner.[8] "Vieil ami de la maison" and much admired in Republican circles – in July 1879 the Ministre de l'Instruction Publique could quite seriously compare him to Leonardo – Henner painted sympathetic portraits of Charpentier and of his elder daughter Georgette.[9] Renoir might well recall Cézanne's discomfort at the mondain gatherings at the rue de Grenelle, but the Impressionists were always in the minority there.[10] After 1880, Bastien-Lepage, Carolus-Duran, Jacques-Émile Blanche, and Paul Robert each successively replaced Renoir as the family portraitist.[11] By then, however, the jaunty correspondence between Renoir and the Charpentiers had long come to an end. In one of his last letters to Madame Charpentier, dated 28 November 1894, Renoir acknowledged: "My painting no longer pleases you; and therein lies all the difficulty."[12]

Nonetheless, between 1876 and 1879 the support and influence of the Charpentiers – and especially Marguerite – were crucial in establishing Renoir as a successful portraitist. The portrait commissions he received from Daudet, Clapisson, Spuller, Banville, Plunkett, and Samary all originated in the salon in the rue de Grenelle, and it was there that Renoir also competed (unsuccessfully) for the spoils of Republican largesse – the curatorship of a provincial museum, the decoration of a municipal building.[13] Between 1877 and 1879, Gambetta and Jules Ferry were but the most prominent of the many "notabilités républicains" at the Charpentiers' Friday dinners, and it was clear that their hostess considered official honours and stipends – a librarianship for Flaubert, the Légion d'Honneur for Zola – the legitimate extension of her patronage.[14]

Occasionally overbearing but at the same time "remarkably intelligent,"[15] Madame Charpentier (fig. 184) "had the advantage of being pretty, of seeming very clever and very kind, and of being cleverer than she seemed and every bit as good . . . Whereas her husband was lazy and appeared not to give a damn, she was energetic, ambitious, and determined."[16] Born Marguerite Louise Lemonnier on 1 March 1848, she was the eldest daughter of Alexandre Gabriel Lemonnier (1808–1884) – Crown jeweller to Napoleon III and *joaillier-bijoutier* of Queen Isabella of Spain[17] – and his second wife Sophie Reygondo Duchatenet (1822–1880), who descended from a well-established dynasty of publishers and printmakers.[18] The Lemonniers' only son, Albert-Alfred, died at the age of two in 1856; their youngest child, Isabelle (1857–1926), named for her godmother, the Queen of Spain, later became one of Manet's favourite sitters and correspondents.[19]

With their apartment and jeweller's shop at 25 place Vendôme, the Lemonniers witnessed at first hand some of the most extreme events of the Commune, but it was the dissolution of the Imperial household that brought an end to their prominence and prosperity. "A bourgeois family, unconditionally opposed to their daughter marrying without the assurance of a solid fortune,"[20] the Lemonniers had not looked favourably upon an alliance with Georges Auguste Charpentier (24 December 1846–15 November 1905), son of the brilliant but erratic Gervais Hélène Charpentier (1805–1871) – the publisher of de Musset and Balzac who had introduced the cheap, octodecimo edition into France – and his estranged wife Justine Aspasie Générelly (1819–1887).[21] Nevertheless, on 24 August 1871 Georges married Marguerite at her family's château at Gometz-Le-Châtel, with Théophile Gautier as best man.[22] The civil contract drawn up in Paris the week before shows that the Lemonnier fortune had yet not entirely disappeared: Marguerite received a trousseau valued at 12,000 francs and an annuity of 2,500 francs.[23]

With Émile Bergerat and Maurice Dreyfous, former companions-in-bohemia, Charpentier now set about running the family business, to which he attached Zola, Flaubert, Daudet, and Edmond de Goncourt in quick succession. From 1872 Marguerite Charpentier held a series of receptions at her husband's offices at 28 quai du Louvre (the young couple were living in Neuilly at

this time), an activity that gained in scale and ambition after 1876, when the Charpentiers, now the parents of three young children, moved both home and publishing house to 11–13 rue de Grenelle.[24]

Towards the end of 1876, after painting a portrait of their four-year-old daughter Georgette (fig. 6) as well as two standing figures to decorate the entry to their apartment, Renoir received the commission to paint a half-length portrait of the hostess herself (cat. no. 31).[25] Seated erect, with light entering from behind the curtain at upper right, Marguerite Charpentier seems to have turned her head, quite sharply, to attend to one of her guests: her left earring still swings behind her collar. Against a background enlivened by only the occasional touch of carmine, Madame Charpentier's face and upper body are rendered with characteristic virtuosity. Oily blacks flecked with ultramarine describe her dress; white and yellow impasto indicate the folds and ruffles of her corsage, in which is placed the smallest of tea roses; lines of blue and green paint create the ribbing in the collar of her chemisette. If, as is evident from the critics' response when the painting was first exhibited in April 1877, Madame Charpentier was admired for the solidity of its modelling and the warmth of its colour harmonies, this should not obscure the fact that Renoir's handling is no less daring and experimental than in his more flamboyant portraits, such as the bust-length of Mademoiselle Samary (cat. no. 29).[26] Indeed, Renoir tailored his style to suit the character and status of his sitter. As Rivière observed of Madame Daudet (fig. 186), a portrait also shown in April 1877, "his colouring here is less lively and less light, perhaps, since the change of model has determined the transformation of his technique."[27]

Madame Charpentier was one of five paintings lent by Georges Charpentier to the third Impressionist exhibition of April 1877; with Renoir's portraits of Spuller, Samary, and Madame Daudet, it attested to the Charpentiers' wholehearted endorsement of the New Painting at this time.[28] Not only did Renoir achieve an impressive likeness in this portrait – and the Charpentiers must have agreed, since the painting was given the "honours of the cheminée" in their refurbished drawing room (fig. 185) – he also captured something of the affectionate bantering and irony that characterized his relationship with the sitter.[29] Kinder than Edmond de Goncourt – who had described her as "a little woman with a pretty face, dressed like the most appalling flirt, but so tiny, so short, so dwarfish, and so pregnant, that in her fairytale dress she might have been about to perform the Reine des Culs Bas ['Queen of the Low-slung Arses']" – Renoir insists rather upon the vivacity and intelligence that struck all who came into contact with Marguerite Charpentier in the 1870s.[30] In part he does this by having her turn her head three-quarters to the left, thereby adding torsion and movement to a static and fairly conventional pose. Renoir's brilliant solution was something of an afterthought, however, since he had initially painted Madame Charpentier looking to her right (fig. 187), resulting in a composition that was unanchored and somewhat vacuous.[31]

"Her expression mysterious and dreamy, a smile of ardent life on the flower-like flesh of the lips, the throbbing pulses animating the face where the blood seems actually to circulate beneath the silken tissue of the skin" – Léonce Bénédite's recreation of Madame Charpentier as a latter-day Mona Lisa draws attention to the humanity and absence of flattery that are the hallmarks of Renoir's best portraits.[32] For such an economical painter, false sentiment was equally abhorrent. On 15 April 1876, several months before Madame Charpentier was painted, the couple had lost their second child, Marcel Gustave, named for his godfather, Flaubert. The boy was barely two years old when he died, and one can only imagine how deeply the family would have been affected by his death.[33] Propriety demanded that parents wear mourning dress for at least a year – full-mourning for eight months, half-mourning for four – and this is how Renoir shows Marguerite Charpentier, although it is with the greatest discretion that he incorporates her mourning attire, with its black lace at the bodice, into his composition.

While it was often considered preparatory to Renoir's Madame Charpentier and Her Children (cat. no. 32), it is clear that Madame Charpentier was conceived as an independent work – the most accomplished of the three half-lengths he painted of her between 1876 and 1879.[34] But in one sense, as Duret noted, it was a "trial run," whose success encouraged the Charpentiers to commission a far grander and more ambitious group portrait some eighteen months later.[35] With the reaffirmation of the Republican majority in the Assemblée Nationale after the elections of October 1877 – when Marguerite Charpentier was to be found counting the votes at the offices of La République Française – the Charpentiers' influence and ambition expanded accordingly.[36] Eager for their protégés to succeed through official channels, they encouraged Renoir to exhibit Le Café (also known as The Cup of Chocolate, private collection) at the Salon of 1878 (where it was completely overlooked by the critics), and on their return to Paris from summer holidays at Gérardmer around the middle of September 1878, Marguerite and her two children, Georgette and Paul, sat to Renoir for a portrait that was certainly intended for the Salon of 1879.[37] Although the scale of Madame Charpentier and Her Children and its wealth of accessories led one historian to claim that Renoir worked "slowly and patiently . . . and required a great many sittings,"[38] the portrait seems to have been painted in just under a month. On 15 October 1878 Renoir informed Duret that his large portrait was "completely finished, but do not ask me what I think of it, because I have no idea whatsoever; in a year's time I shall be able to judge perhaps, but not before."[39] Renoir supervised the varnishing (and later the unvarnishing) of the work and may have also chosen the frame.[40] On 2 December, with Madame Charpentier's permission, he brought "two friends of Bonnat," Deudon and Ephrussi, to see the painting, and he later accompanied Berthe Morisot to the rue de Grenelle for a private viewing.[41] Well before Madame Charpentier and Her Children was exhibited at the Salon in May 1879, Renoir's success was widely known. Cézanne alluded to it in a letter to Chocquet written from L'Estaque on 7 February 1879, and the following month L'Artiste referred to Madame Charpentier and Her Children as "a charming work by Renoir, the artist turned socialite."[42]

In his letter to Duret announcing the completion of Madame Charpentier and Her Children (and the full-length Mademoiselle Samary), Renoir also thanked him for sending 100 francs, "which gave me the greatest pleasure."[43] Renoir was still intermittently impoverished in these years, and if the Charpentier's commission brought him fame, it did not immediately resolve his finances. Like many of the earliest collectors of Impressionism, the Charpentiers expected to pay bargain prices for their paintings – in March 1878 Charpentier acquired Manet's Kearsage and the

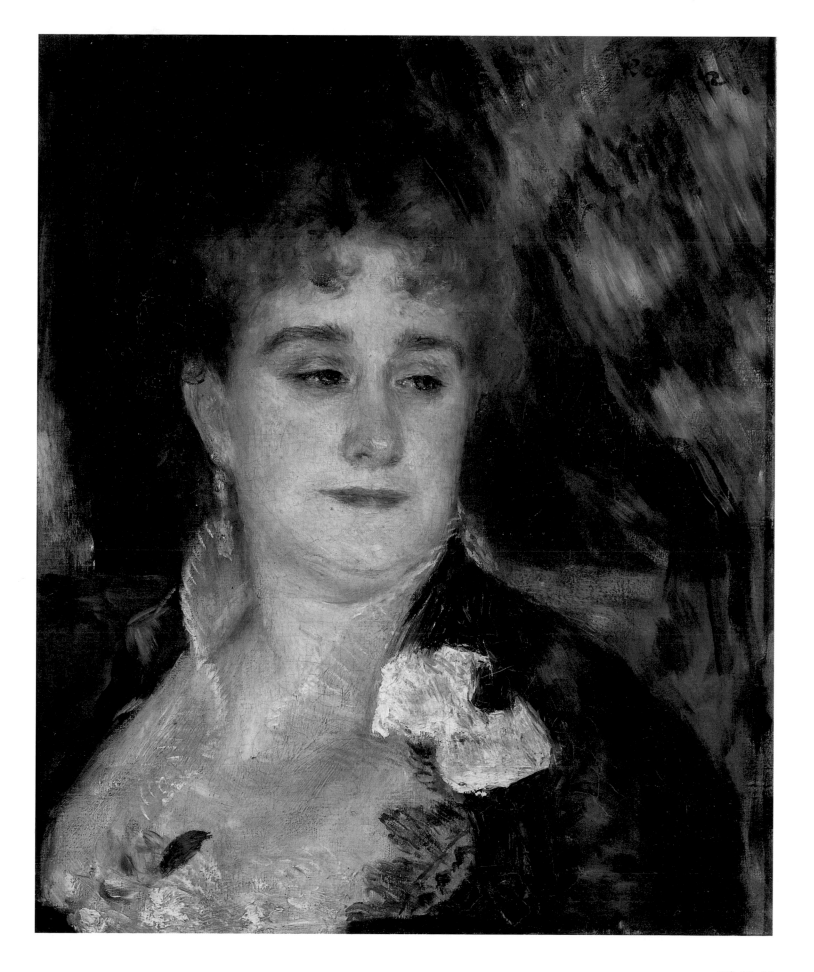

Alabama (1864, Philadelphia Museum of Art) at auction for 700 francs, in June 1880 his wife secured a discount of twenty-five percent from Monet for the large *Floating Ice* (Shelburne Museum, Shelburne, Vt.)[44] – and Renoir was no exception here. Duret claimed that he was paid 1,500 francs for *Madame Charpentier and Her Children*; Renoir mentioned an even lower figure to Vollard, "around 1,000 francs."[45] Less than thirty years later, the painting was acquired at auction by the Metropolitan Museum for 84,000 francs.[46]

As is well known, *Madame Charpentier and Her Children* was hung in a place of honour at the Salon of 1879. With the exception of Bertall (for whom it displayed "a total ignorance of the principles of drawing as well as of all established artistic procedures"[47]) and Zola (who failed to mention the work in his Salon review), the painting was warmly, indeed enthusiastically, received in the press. From a floor plan published in *La Presse* on the opening day of the Salon (fig. 183), we know that *Madame Charpentier and Her Children* hung in Room 11, east of the sculpture garden, where it had to compete with only one "grande machine," Roll's *Feast of Silenus* (Museum voor Schone Kunst, Ghent).[48] Renoir recalled in an interview in 1904 that Madame Charpentier "had wanted the work to be hung well and knew members of the jury upon whom she could prevail."[49] While it comes as little surprise that Henner was on the jury that year, it was apparently Cabanel who gave the order to lower the painting so that it could be placed in the centre of the wall where it might be seen to best advantage.[50]

Complimentary though they were, most reviews drew attention primarily to the sitters – "the family of a publisher known throughout the world and loved by all men of letters" – and to the phenomenon of a "converted *intransigeant*" returning to the fold, since Renoir had refused to participate in the fourth Impressionist exhibition earlier in the year.[51] The richness of Renoir's palette, the liveliness of his touch, the freshness and luminosity of the canvas ("rayonnement" is a term that appears several times), and the harmoniousness of the composition were all mentioned approvingly. "A spider's web by God, but woven from rays of sunshine by a worker who has risen early in the morning," is perhaps the most dithyrambic of such comments.[52] Both Burty and Chesneau analysed Renoir's manner of modelling through colour and light, without the assistance of line,[53] but the most incisive observation was made by Castagnary, who marvelled at "the complete absence of convention, both in the arrangement of the sitters and in the technique."[54] So compelling and "natural" is *Madame Charpentier and Her Children*, and so quickly was it produced – not a single preparatory sketch or drawing is known – that it is easy to assume that the work emerged, full-born and Athena-like, from Renoir's multicoloured palette. Not only does Renoir disguise his sources seamlessly, he also integrates a wealth of pertinent information and reference, but with such subtlety that they are easily overlooked.

Renoir had probably never seen Degas's *Bellelli Family* (fig. 81), the only comparable contemporary interior portrait of such scale and ambition, though far darker in mood and association.[55] But his boundless admiration for Delacroix's *Women of Algiers in Their Apartment* (1834, Musée du Louvre, Paris) is well documented, and the rhythms and coloration of that composition, as well as Delacroix's manner of painting both figures and accessories with equal attention, resonate, if distantly, in *Madame Charpentier and*

Her Children.[56] Proust compared the painting of Madame Charpentier's "pompous train of velvet and lace" to "the most beautiful Titians," and indeed Renoir's study of the Old Masters served him well in the elaboration of this composition.[57] There are echoes of Rubens's *Hélène Fourment and Her Children* (Musée du Louvre, Paris), which he had copied as a student. For the group of well-dressed Charpentier children and their long-suffering dog, Renoir may have looked to Van Dyck's *Children of Charles I*, a copy of which hung in the Grande Galerie of the Louvre during his lifetime.[58] The expression and costuming of Madame Charpentier herself, with her "round face shaded by curls,"[59] bear a striking affinity to Ingres's *Madame Rivière* (fig. 188), whose pose Renoir uses in reverse.[60] Renoir came to know *Madame Rivière*, which was transferred to the Louvre in November 1874, particularly well, since it hung next to Delacroix's *Jewish Wedding* (1837–41, Musée du Louvre, Paris), a copy of which he was commissioned to paint for Jean Dollfus in 1875. As he later informed Meier-Graefe, while working on Dollfus's copy, he "could not resist occasionally casting his eyes upon Delacroix's neighbour."[61]

Renoir uses this amalgam of sources as an armature for depicting (and ennobling) the quotidian, which he seems to render at first glance with complete transparency – Castagnary's "absence of convention." On a sofa covered in a floral tapestry, the thirty-year-old Marguerite Charpentier rests a protective arm above the head of her three-year-old son Paul Émile Charles (1875–1895) – Zola's godson – who, in accordance with the fashion of the time (fig. 189), wears the same blue and white dress as his elder sister Georgette Berthe (1872–1945).[62] Although no longer in mourning, Madame Charpentier wears a black day-dress with a train of white lace, of a design traditionally ascribed to Worth, who had been her mother's couturier.[63] Her corsage is decorated by a brooch in the form of a daisy or "marguerite,"[64] and in her left hand she clasps a small golden etui.[65] Her daughter Georgette sits atop Porthos, the indulgent Newfoundland that accompanied the family on its lengthy holidays (fig. 191) – a present to Georges Charpentier from the niece of a grateful author.[66]

The room itself appears to be spacious, but somewhat underfurnished for the time. In the background to the right, in front of the curtain through which one enters and beyond which can be glimpsed the well-polished floorboards of an adjoining salon, is placed a bamboo tea table and a single bamboo-and-wicker chair. The table is set with a bowl of grapes and a service of dessert wineglasses that rest on a red lacquer tray.[67] On the red walls behind Madame Charpentier and her children hang what would appear to be three sections of a dismembered Japanese screen, possibly of the Rimpa school, although only the central panel is shown in its entirety and the panels have vertical lines running through them and wavy edges. Reading from the left, we see a pair of peacocks looking down from a branch onto water below; the middle section, less easy to make out, shows branches and foliage; and on the right a splendid crane, with white plumage, swoops to the ground. Next to the screen, attached to a panel of red lacquer at right angles to the wall, is a hanging scroll (*kakemono*) that shows a single figure in bright green robes.[68]

Edmond Renoir noted in June 1879 that his brother had painted this portrait "at Madame Charpentier's house, with none of the furniture moved from its usual place";[69] indeed, as Renoir joked to Georges de Bellio, the very prospect of standing on his

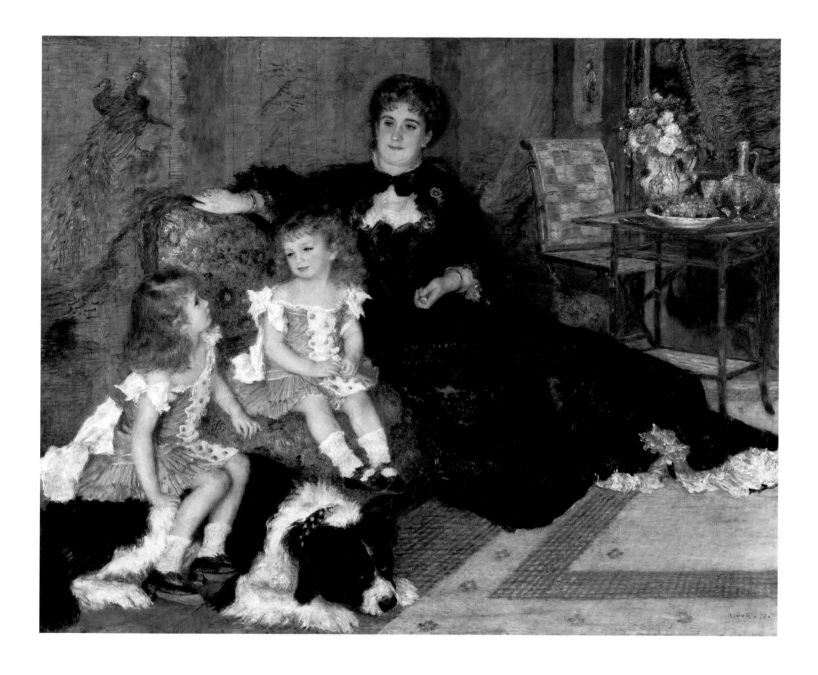

feet all day at the rue de Grenelle "frightened" him.[70] In his discussions with Vollard, many years later, Renoir recalled that "the Charpentiers' reception rooms were entirely decorated with *japonaiseries*," adding ungraciously that it was "from having seen so many of them there that I came to detest Japanese art."[71] Yet in 1878 Renoir records the Japanese elements in the Charpentiers' interior both meticulously and sympathetically, while never allowing them to overwhelm the composition; in fact, a quite rigorous process of selection and editing seems to have taken place. For the Charpentiers were avid *japoniste* dilettantes who, even before moving to the rue de Grenelle, had given Ernest d'Hervilly's Japanese comedy *La Belle Sianara* its première in their salon on the quai du Louvre.[72] In furnishing their new apartment, Marguerite Charpentier had called upon the critic Philippe Burty,

an esteemed collector and historian of Japanese art, for assistance. In November 1875, having just been informed by Burty ("my son in matters Japanese") that she was embarking on a Japanese bedroom, Edmond de Goncourt invited her to inspect the two rooms in his apartment that were done in this taste.[73] In November 1876 Marguerite Charpentier was still adding to the interior decoration: "She's launched on *japonisme* and is now buying elephants!"[74] Her husband was a lender to the great exhibition of Japanese objects held at the Trocadéro between May and November 1878; during the Exposition Universelle he arranged for a demonstration of Japanese watercolour technique to be held in his salon; and on 5 November 1878, three weeks after *Madame Charpentier and Her Children* was completed, the Charpentiers organized an authentic Japanese dinner, with food prepared by a

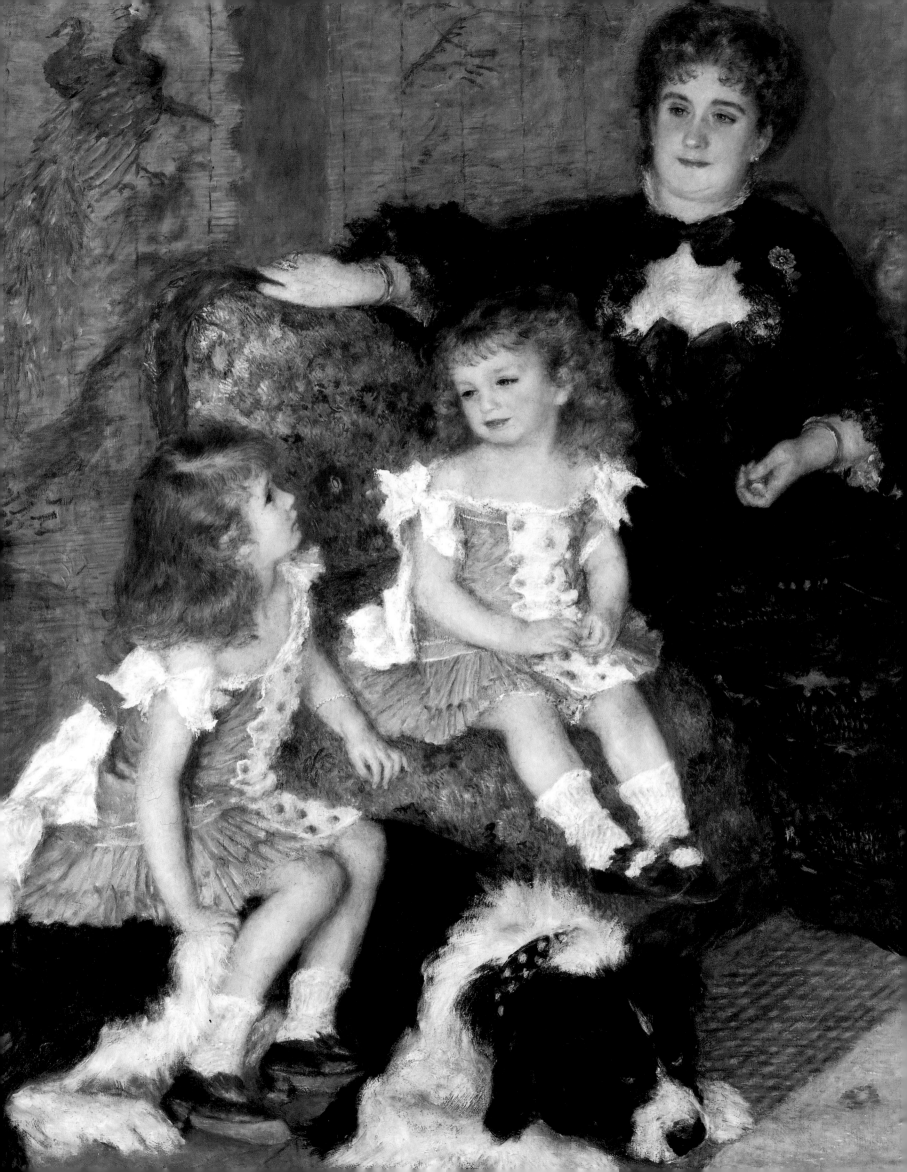

Japanese cook.[75] Goncourt considered the meal very strange, but not unpleasant; the cook was a young Japanese painter Hosui Yamamoto (1850–1906), who later decorated Judith Gauthier's Breton cottage with wall paintings in the *goût japonais*.[76]

Given the Charpentier's passion for things Japanese, and the claim that Renoir had recreated the interior "with the furniture in its usual place," it is worth asking where exactly Madame Charpentier and her children are sitting. For Rivière as well as critics like Théodore de Banville, both frequent guests at the rue de Grenelle, Renoir had painted "the little Japanese salon that served as a smoking room."[77] But Burty, who was in a position to know and who liked to flaunt his familiarity with celebrities, noted that the portrait was set within "the amusing walls of a boudoir decorated in the Japanese style."[78] Situating *Madame Charpentier and Her Children* in the hostess's bedroom on the second floor at 11–13 rue de Grenelle, above the "relatively narrow" reception rooms through which passed a constant stream of guests, helps illuminate the calm and intimacy that Renoir has achieved in a work that is public in scale.[79] In this group portrait, the chic of the sitter's dress and the "fashionable" furnishings are secondary to the romance of mother and children "at home." An essentially bourgeois, Parisian romance, admittedly, but so well crafted by Renoir's "poetical and constructive genius" that Meier-Graefe could consider *Madame Charpentier and Her Children* the precursor to Bonnard's grand and harmonious interiors.[80]

If Flaubert's elliptical comment on *Madame Charpentier and Her Children* – "I've finally seen the famous portrait and have nothing more to say" – and Zola's silence in both the press and his private correspondance are any indication, the Naturalists did not respond warmly to Renoir's depiction of their patroness and her children.[81] Proust and Fry excepted, the portrait has inspired half-hearted admiration at best, even from those sympathetic to Renoir's art.[82] Since this grand domestic idyll was the last commission of significance that Renoir received from the Charpentiers – in 1882 he was at work on a full-length pastel portrait of their youngest daughter, Jane Blanche Edmée (born 11 January 1880), that appears not to have been completed[83] – it seems fitting to end with a brief summary of the lives of its three protagonists.

Georgette (born 30 July 1872), shown seated on Porthos, was married at sixteen in November 1888 to the novelist and essayist Abel Hermant (1862–1950).[84] Blanche's portrait of her in the year of her marriage (Musée du Petit Palais, Paris) captures something of the headstrong yet childish temperament that so exasperated her parents. On first meeting her husband she informed him that she hoped to have three children, "and that her greatest wish was to eat an entire bag of sweets on her wedding night and spend the next evening at the Théâtre-Libre."[85] A son was born to the couple on 22 December 1889, but died just over three weeks later, and the Hermants divorced in November 1892.[86] Georgette married for a second time the following year, again to a man of letters, the editor Pierre Marcel Chambolle, with whom she had

a son, Robert Gabriel, born in October 1894.[87] Shortly afterwards, she divorced Chambolle, and married Raymond Elois Tournon (1869–1947), a businessman from Bordeaux, on 27 May 1905. This marriage, which took Georgette to Costa Rica, was her last; she died in Paris on 18 December 1945, at the age of seventy-three.[88]

Zola's godson Paul (born 10 July 1875), seated between his sister and mother, was groomed to succeed his father as head of the Bibliothèque Charpentier (fig. 190). Having failed his *baccalauréat* in 1893, he was encouraged by Zola to sit the exams once again – "there are many intelligent publishers who are not *bacheliers*" – but his career was in any event interrupted by military service.[89] In May 1895, quartered with his regiment at Saint-Quentin, he was hospitalized for peritonitus. His parents rushed to his side, bringing him home to Paris in early June. He seems to have rallied – on 24 June his godfather was informed that Paul was "out of danger; he gets up at two in the afternoon and is eating meat" – but this was only a temporary reprieve, and the young man died in his bed on 19 July 1895.[90] Octave Mirbeau, who attended the funeral, could barely contain his fury: "Little Paul Charpentier, dead from the rigours inflicted by his regiment and the obstinacy of the company surgeon who refused to believe that he was ill. That this sort of thing can still happen is beyond me! What will the Charpentiers say about 'the Fatherland' now, I wonder!"[91]

Paul's death prompted Georges to retire from business.[92] On New Year's Eve 1895, papers were drawn up in which his interest in the company was acquired by his partner Eugène Fasquelle (1863–1952) – who in the 1890s owned Renoir's *Parisian Women in Algerian Dress* (1872, National Museum of Western Art, Tokyo) – and in June 1896 the Charpentiers left the rue de Grenelle for a luxurious apartment at 3 avenue du Bois de Boulogne (now the avenue Foch).[93] Marguerite Charpentier, growing stouter by the day (fig. 192), was now principally absorbed by philanthropic work. In the 1880s she had become increasingly neurasthenic, was prone to fainting, and "carried her neurosis with her day and night."[94] In February 1887 the eminent pathologist Dr. Charcot claimed that she would probably go mad within two years.[95] Salvation seems to have come in the form of "La Pouponnière," a crèche for the infants of working women that Marguerite founded in 1891 at Reuil, and which moved in June 1893 to Porchefontaine, outside Versailles. By 1897 La Pouponnière boasted three pavilions with the capacity to care for one hundred and fifteen infants and was also equipped with respirators for babies born prematurely.[96] Although Marguerite Charpentier would now enlist fashionable artists such as Carolus-Duran and Gervex in the clay pigeon shoots that she organized to benefit La Pouponnière,[97] there is a pleasing irony in the fact that a day nursery for the children of working mothers had originated in the 1870s with Renoir, who had been concerned at the lack of assistance for the young (and single) mothers of Montmartre and had tried without success to interest Madame Charpentier in supporting "Le Pouponnat."[98]

33 *Gypsy Girl* 1879

73.5 × 54.5 cm
Private collection, Canada

The first time I saw Renoir paint was at Berneval-sur-mer,
near the Normandy château where Monsieur Paul Berard
offered him hospitality each season. He had fisherman's
children pose for him in the open air – those fair-haired,
suntanned children with rosy skin who look like little
Norwegians.[1]

IN A DENSE UNDERGROWTH that offers no protection from the
fierce afternoon sun, Renoir's young model is shown standing
only a little self-consciously, reticent but lively, and unlikely to
remain still for very much longer. It is doubtful that she was much
constrained, however, since the so-called *Gypsy Girl* was painted
very quickly and with extraordinary assurance, Renoir applying
translucent veils of colour over a thick white ground – the canvas
is barely covered at lower right – to achieve a luminosity compa-
rable to his experimental *plein-air* paintings of the mid-1870s.[2] His
handling is as energized and spontaneous as in *Landscape at
Wargemont* (1879, Toledo Museum of Art) surely painted during
the same campaign; in both, Renoir's virtuosity is at the service
of an exacting plasticity, which requires that each stroke of colour
define volume and model form.

Particularly susceptible to red-haired children,[3] Renoir res-
ponds to the fisherman's daughter with unmediated delight – the
strand of hair that falls over her left eye will return as a leitmotif
in his paintings of Gabrielle – and, as has been noted, he
approaches her more as sitter than as model: her features are
characterized and his composition is free of typological and anec-
dotal reference.[4] Yet Renoir allows himself liberties of facture and
presentation that would be inappropriate in a commissioned por-
trait. The licence of his brushwork – almost viscous in the bushes
behind the girl's head, uncommonly abbreviated in the lower half
of the canvas – mirrors an unsettling negligence in the appearance
of the girl herself. Wide-eyed and dishevelled, lips moist and red,
her blouse in tatters and her shoulders bare – where other artists
might deploy these elements to suggest an affecting poverty,
Renoir avoids the sentimental in a confrontation that is altogether
more unsettling.[5]

The red-haired gypsy girl was the subject of two subsequent
works, both pared of any such ambiguity. *Gypsy Girl* was
recorded in a pastel on prepared canvas that shows the girl full-
length with sturdy clogs and a more docile expression (fig. 194).[6]
And she appears in identical costume – the same gaping shoulder
– at the centre of *Mussel Fishers at Berneval* (fig. 195), painted in
September 1879 for submission to the Salon the following May: a
stately, somewhat additive ensemble, lacking the freshness and
spontaneity of Renoir's initial composition.[7]

Although Blanche claimed that Renoir's Salon painting was
done at the beach at Berneval-sur-mer, "whose shore was owned
by the Berards,"[8] Renoir took pains to inscribe *Gypsy Girl* with
the name of Berard's château and estate at Wargemont two kilo-

metres inland, where he was a guest, probably for the first time,
in August and September 1879.[9] In fact, the only site-specific
studies that Renoir made for *Mussel Fishers at Berneval* are the
group of drawings that illustrated Jeanne Baudot's reminiscences
of her teacher (fig. 193), which have the appearance of doodles.[10]
Thus, while it clearly relates to the larger composition, *Gypsy Girl*
was conceived as an independent work and is quite different in
mood and technique.

The inscription on *Gypsy Girl* commemorates the beginning of
Renoir's life-long friendship with the Protestant banker Paul
Berard (1833–1905). It may also have had significance for the first
owner of the painting, the Jewish collector and art historian
Charles Ephrussi (1849–1905), who became a fervent admirer of
Impressionist painting around 1880, and who was among the
"high barons of finance" entertained by Berard at Wargemont.[11]
This *mondain* enthusiast of the New Painting was particularly
receptive to the charm of Renoir's *gamines*, of which he owned
three examples (*Gypsy Girl* included) by December 1881. Writing
that month from Berlin, Ephrussi's former amanuensis, the
Symbolist poet Jules Laforgue, asked to be remembered to
"Renoir's dishevelled little savage."[12]

In March 1882 Renoir himself referred to Ephrussi's picture as
"the little girl from Berneval,"[13] and it seems to have acquired the
title "Gypsy Girl" only at the time of Durand-Ruel's retrospec-
tive of April 1883, where it was the first work listed in the cata-
logue.[14] For Renoir's *Gypsy Girl* shares none of the attributes of
a type that had long fascinated French painters, both conventional
and progressive. Gypsies were commonly shown with black hair
and sallow complexion, their skin "tawny as Havana cigars," with
dark eyes that "look into the depths of your soul."[15] Renoir had
previously painted at least two examples of this genre: *Summer
(Study)* (1868, Nationalgalerie, Berlin) in which Lise Tréhot poses
as a slovenly gypsy girl, and the lost *Petite Bohémienne* (c. 1875), a
vertical painting of unusual format that was acquired by Monet's
brother Léon at the Impressionist auction of March 1875.[16]

Images of gypsy girls continued to proliferate during the 1870s,
when the genre lost little of its popularity at the Salon –
Bouguereau's *Young Gypsies* accompanied his *Birth of Venus*
(Musée d'Orsay, Paris) at the Salon of 1879 – and illustrations of
the music-making gypsy routinely appeared in fashionable maga-
zines.[17] But if Renoir's approach to his subject differs from con-
ventional portrayals of the gypsy girl (fig. 196), it also parts
company with the equally well-established traditions for repre-
senting peasant girls in regional costume.[18] In fact, in its seamless
integration of model and setting, *Gypsy Girl* anticipates the more
self-consciously aesthetic genre of children in nature that would
flourish the following decade.[19]

Despite the freedom of its brushwork and the brio of its palette
– dominated, as Blanche noted, by "a reddish violet" that critics
disparaged as "red currant jam" – Renoir briefly considered
exhibiting *Gypsy Girl* at the Salon of 1882.[20] From Algiers in
March 1882, he mentioned it as a candidate to Paul Berard, whom
he had entrusted with his submission that year: "If Charles
Ephrussi could be prevailed upon to buy frames for his pictures
that cost more than 3 livres 10 sous, we could have shown the
little girl from Berneval."[21]

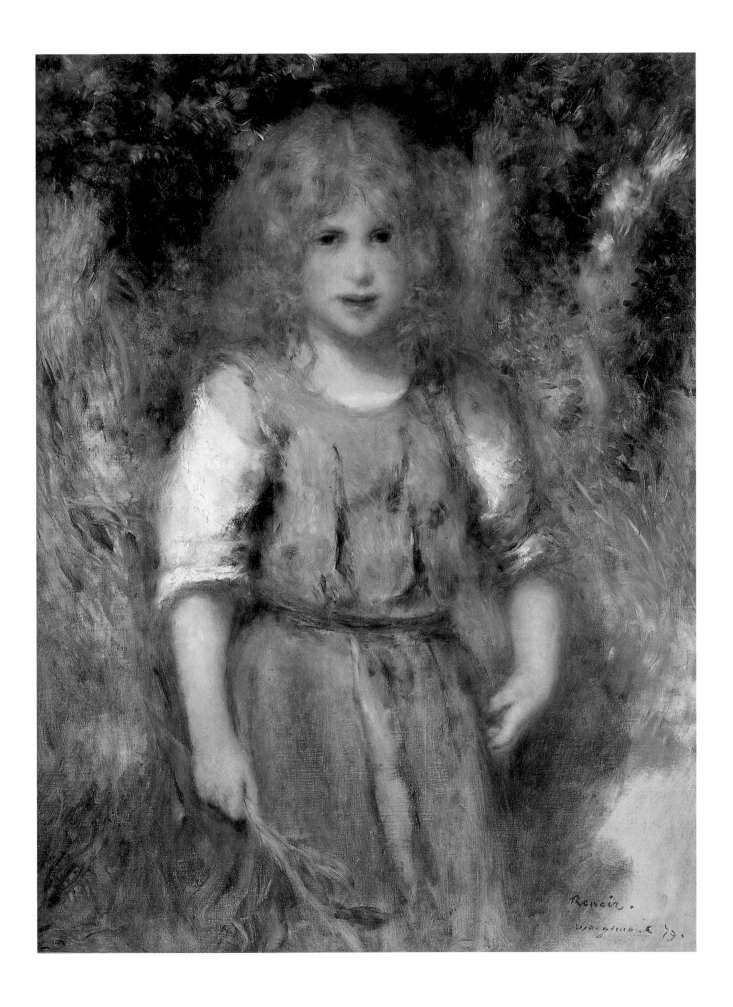

34 *Margot Berard* 1879

41 × 32.4 cm
The Metropolitan Museum of Art, New York
Bequest of Stephen C. Clark, 1960

ONE OF RENOIR'S MOST VIVID portrayals of children, *Margot Berard* was painted at Wargemont in the summer of 1879, around the time of the equally exuberant but more high-coloured *Gypsy Girl* (cat. no. 33). Her hair unruly and her eyes opened wide – all the Berard children had large eyes – the five-year-old has been stopped in her tracks long enough for the artist to take her likeness, although we sense that she will rush off again at the first opportunity. The solidity of Renoir's modelling is not immediately evident in a work of such apparent spontaneity, yet the deliberation with which he describes Margot's facial features and her russet hair is nothing less than a tour de force. Only in the maroon background does he make concessions to the fashion popularized by Henner and Bonnat – for Burty, such "dignified" tonal backdrops had all the banality of a *carte de visite* – yet neither this nor the relatively restrained colour range of the portrait detracts from the startling immediacy of Renoir's presentation.[1] And, as is borne out by comparison with a photograph of Margot in her Sunday best (fig. 197), the mischievous charms of this little girl have been captured with the fidelity of a camera's lens.[2]

In contrast to the smart clothes in which Berard's daughters would appear in *Children's Afternoon at Wargemont* (cat. no. 49), Margot is shown in the white pinafore worn by little girls for school lessons and domestic chores, and it is in a similar costume that Renoir would later portray her younger sister Lucie (fig. 244).[3] This supports the anecdote recounted by Margot to her nephew Maurice Berard that Renoir had come across her crying on the stairs as she was about to run into the garden after a miserable lesson with her German governess. "To cheer her up, he wanted to paint her with a joyful face."[4] Whatever the truth to this story, Renoir admirably conveys the sensation that for the time being the storm has happily subsided.

Born at Wargemont on 26 July 1874 and christened Marguerite Thérèse, Margot was the Berards' third child, and their second daughter.[5] At twenty-three she married her cousin Alfred Louis Berard (1866–1940), whom Renoir had earlier portrayed as a young country gentleman with his dog (fig. 198) and whose family owned the adjoining property at Graincourt.[6] Like his uncle (and future father-in-law) Paul Berard, Alfred served for a while in the diplomatic corps: he entered the Direction des

Affaires Politiques in 1891, and received postings to Berlin and Saint Petersburg as *secrétaire d'ambassade* in 1894–95. In October 1895, at his own request, he returned to a desk job in the Quai d'Orsay, where he remained for the next ten years before retiring from the profession altogether.[7]

Margot bore Alfred two children – a son, Jacques, in 1897, a daughter, Yvonne, the following year – and despite her delicate appearance in Renoir's portrait, was hale and energetic well into old age and lived to be ninety-two.[8] Another of her nephews, Christian Thurneyssen, recalled that at the end of the Second World War she would bicycle over twenty kilometres to Dieppe every day to tend the wounded soldiers hospitalized there (she was then seventy-one years old).[9]

Margot Berard also informed her nephew Maurice that Renoir had painted her portrait very quickly – "en quelques instants."[10] That Renoir worked fast was no small advantage in such commissions. Jacques-Émile Blanche affably related the difficulties he had encountered in painting the portrait of the young Elaine de Greffulhe (later the duchesse de Grammont), who arrived at his studio near Dieppe accompanied by her English nanny and a host of toys and dolls to keep her amused. After three days of posing, during which she refused to sit still for more than a few minutes at a time, Blanche lost patience, ordered the nanny outside, locked the girl in his studio, and slapped her until she sat properly for him.[11] Renoir's facility notwithstanding, it is difficult to imagine him ever behaving in this way.

But speed alone cannot account for the undeniable sympathy of Renoir's best portraits of children, among which *Margot Berard* ranks high. It is clear that he felt a real affection for Berard's young brood, and this is confirmed by a previously unpublished letter to Berard, written from Wargemont around the time that Renoir painted Margot's portrait:

> I believe that your little Margot may have caught the mumps. Just to be sure, I told her to lie down in her bedroom and had someone take care of her. She has accepted the situation very well and has lost none of her appetite. Perhaps it is nothing more than a simple swelling after all. I'll write to you again tomorrow, but for the moment there is nothing to worry about. She is very cheerful, plays with her dolls, and I've only made her stay in her room as a precaution.[12]

In the absence of his hosts, Renoir quite naturally assumed a parental responsibility for Margot. His letter is tender and solicitous, and confirms what is immediately communicated by the portrait: his genuine fondness for his five-year-old sitter.

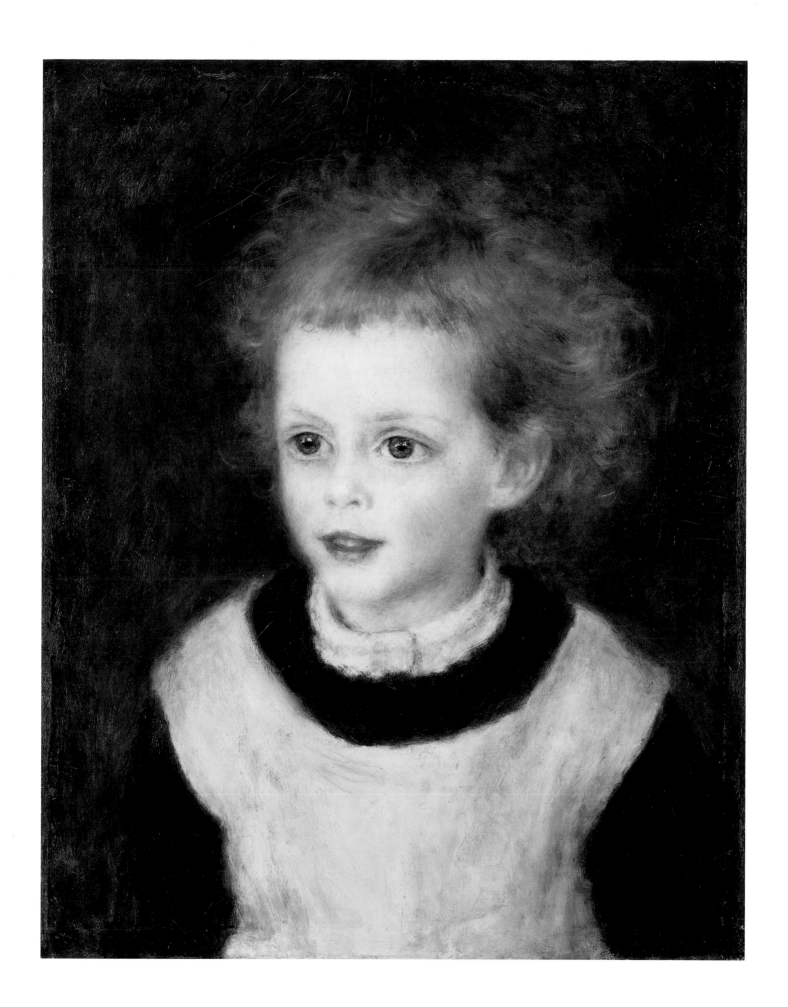

35 *Acrobats at the Cirque Fernando (Francisca and Angelina Wartenberg)* 1879

131.5 × 99.5 cm
The Art Institute of Chicago
Mr. and Mrs. Potter Palmer Collection

SEEN FROM ABOVE, but up close – as if observed through opera glasses[1] – Renoir's little circus girls are shown receiving applause at the end of a performance. The older girl at left takes her bow in a pose that is almost balletic. Her sister, wearing identical costume and looking wistfully across the circus floor to the other side of the ring, holds in her arms some of the oranges offered by an appreciative audience (of the oranges remaining on the ground, one is still wrapped in tissue).[2] In the background, above the girls' heads, are glimpsed some of the wealthier members of the audience, mostly men in formal attire, one of whom rests his opera glasses on the balustrade lined in red velvet. To the left of the gate through which the performers make their entrance can be seen the striped trousers of an army captain.

Shown in a blond, even light, the two little girls command the composition absolutely. They are presented with the same sympathy as Renoir's *Clown (James Bollinger Mazutreek)* (fig. 38) of a decade earlier,[3] and their calm, statuesque appearance – they are standing perfectly still – evokes a realm far removed from this boisterous Montmartre circus.

Renoir may have had high hopes for *The Acrobats* (as it was originally entitled): it was the single painting in his inaugural exhibition of pastels at the gallery of *La Vie Moderne* in June 1879.[4] But the work failed to find a buyer – it was never owned by the family of the circus girls – and was deposited with Durand-Ruel (but not purchased by him) in April 1881.[5] Now given the title *Les Saltimbanques*, the painting was exhibited *hors catalogue* at the seventh Impressionist exhibition of March 1882 – which Renoir boycotted – where it received a solitary and unfavourable mention in the press.[6] "Monsieur Renoir is also showing two poor little *Saltimbanques*, born with legs that were too short, and whom he has compensated by painting their hands too long and full of large oranges."[7] In May 1882, Durand-Ruel acquired *Les Saltimbanques* for 2,000 francs, a quite respectable price for a figure painting of this size. He did not include the painting in his Renoir retrospective the following year, but showed it in New York (1886) and Paris (1892) before selling it to Mrs. Potter Palmer on 11 May 1892 for the relatively modest sum of 8,000 francs.[8]

The chequered early history of the Chicago painting is all the more difficult to explain in light of Edmond Renoir's enthusiastic and sensitive account of the painting in *La Vie Moderne* of June 1879: "In Renoir's *Acrobats*, there is no sense of arrangement whatsoever. He has captured the two children's movements with unbelievable subtlety and immediacy. This is exactly how they walked, bowed, and smiled in the circus ring."[9] That Renoir's vision of these performers is remarkably direct and unmediated is further confirmed by his handling of paint, which is applied in thin, translucent washes and with a lightness of touch quite different from his Salon paintings of the same period. His colouring is eccentric – the skin tones of the little girls are modelled in Naples yellow and their arms and legs are outlined in violet – and

his use of impasto is idiosyncratic: the paint literally reproduces the ornamentation of their gaudy costumes.

Such freshness and spontaneity were arrived at only after careful deliberation. Renoir first established the poses and setting for his circus picture in a preparatory black-chalk drawing (fig. 199), probably made *in situ*, since the canvas itself was painted in his studio in the rue Saint-Georges.[10] Although he would remain reasonably faithful to this compositional study, which served to establish the poses of the little girls, there are significant changes. In the drawing at lower right can be seen the pointed hat and dark collar of a clown, who is suppressed in the painting. The use of a wider angle gives greater prominence to the audience (several rows of seats are indicated in the drawing) and, with the cropped head of the clown, changes the mood of the composition. In the drawing, the girl with her arms crossed is the single fixed element in an agitated setting. When Renoir came to apply paint to canvas, he gave equal weight to both figures, who now share the pictorial space, and this bipartite focus pared the composition of any lingering anecdote. Furthermore, while the drawing served as a blueprint, it did not constrain Renoir in his application of paint: the figures of both girls, but particularly the one holding the oranges, are full of evident alterations. The latter's hands and left elbow have been shifted several times, as has her hair, and Renoir shows the same hesitation in the placement of the older girl's hands – all this despite his uncustomary preparations in black chalk.

Rivière claimed that the evening performances at the recently established Cirque Fernando were among Renoir's favourite distractions in the late 1870s, but it is remarkable how little the circus actually intrudes in the picture itself.[11] The Cirque Fernando was initially little more than a tent pitched on waste ground at the corner of the boulevard Rochechouart and the rue des Martyrs. Such was its popularity that in January 1874 *Le Figaro* announced that a permanent circus was to be built on this site, and the new circular brick and iron building opened in June 1875, with the capacity to seat over 2,000 people.[12] One of four permanent circuses in Paris, the Cirque Fernando was primarily a "cirque de quartier" for Montmartre, with its artistic, bohemian, and working-class population. It immediately attracted members of the Batignolles community: Stevens, Bonnat, Manet, and Clairin were among its earliest habitués, and Gervex recalled meeting Manet there. By the late 1870s, the Cirque Fernando could almost be considered a nocturnal annex of the Café de la Nouvelle-Athènes.[13]

If the Cirque Fernando later inspired masterpieces by Toulouse-Lautrec and Seurat, it first entered the repertory of subjects from modern life in an undistinguished painting by Maurice Blum, exhibited at the Salon of 1874 (fig. 200).[14] In January 1879 Degas made several drawings of the mulatto gymnast Miss La La in preparation for his *Mademoiselle La La at the Cirque Fernando* (fig. 201), probably painted around the same time as Renoir's *Acrobats* (their costumes and little boots are more or less the same).[15] Yet whereas Degas was fascinated by the gymnast in action, took pains to indicate the interior of the recently refurbished circus, and faithfully reproduced the gaslight of an evening performance, Renoir provided only a minimum of local detail.[16] Such was his distaste for the interior lighting of the circus – "an uncertain light that turns faces into grimaces" – that he painted his circus girls "*en plein air*."[17]

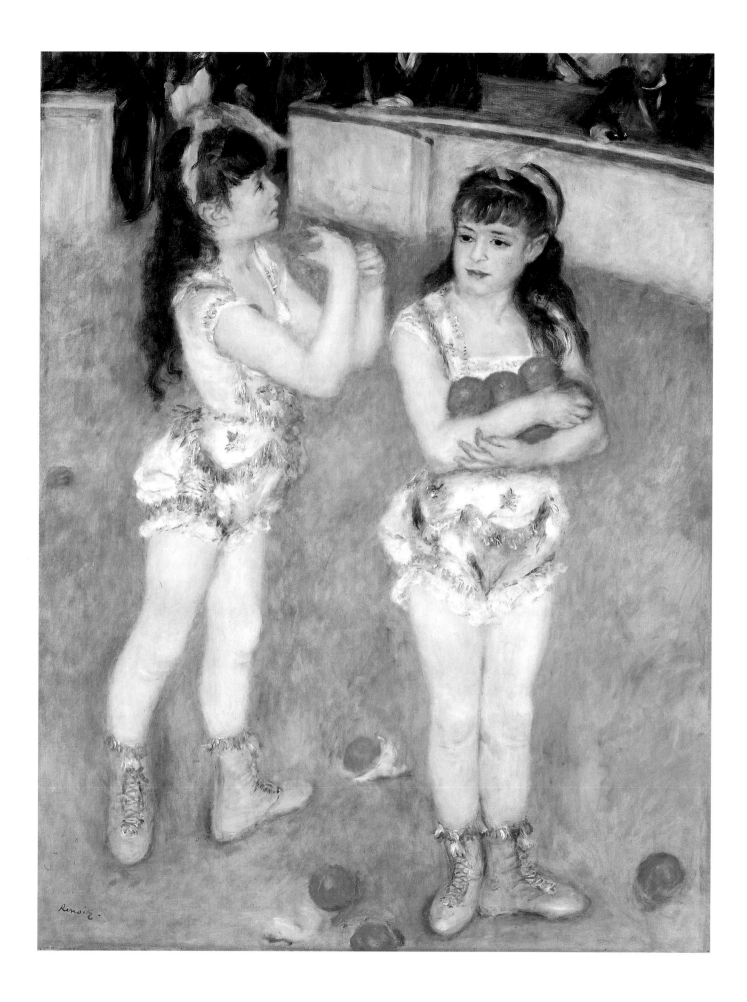

Renoir's choice of models was also obscure. Francisca and Angelina Wartenberg, aged seventeen and fourteen respectively, were part of an itinerant German acrobatic troupe who performed in Paris in 1879.[18] Their parents were Carl Richard Ludwig Wartenberg, "Gymnastischer Künstler," and Joséphine Hermine, née Decamps;[19] the family was not related in any way to the founder of the Cirque Fernando, the Belgian impresario Ferdinand Constantin Beert (1835–1902), who passed the management of the circus to his son Louis Fernando in 1882.[20] Mentioned in none of the early histories of the Cirque Fernando, the Wartenberg sisters were in no sense celebrities of the Paris theatre. Born around 1861 in Berlin, Frances Charlotte Wartenberg (Francisca) would be married by 1893 to George Sebastian Miehling from New York, a "professional instructor" at the Olympic Club of San Francisco.[21] A daughter Marguerite was born to the couple in January 1902, and it is she who later provided the identification of Renoir's "circus kids." Angelina Joséphine Hermine Wartenberg, the sister holding the oranges, was born in Berlin on 21 August 1863; she was still alive in the early 1940s.[22]

The troupe Wartenberg did not remain long in Paris. In 1880 the family was performing in Saint Petersburg, and their visit was recorded there in a curiously staged photograph of them in incongruous white wigs (fig. 202). By 1889 they had moved to San Francisco – another sister, Marguerite, appeared with them at the Grand Opera House that year – and by 1893 Francisca was performing under the stage name of "Mademoiselle Mazella" (fig. 203).[23] Comparing *Acrobats at the Cirque Fernando* with these images confirms that Renoir had little interest in the acrobats as performers. Although he faithfully reproduces their long hair and pert expressions – after her marriage, Francisca would become considerably more stout – he portrays them with a sensitivity and grace that are apparent in none of the surviving photographs (fig. 204).

Consciously or not, Renoir was responding to the challenge laid down by Edmond de Goncourt in the preface to his circus novel *Les Frères Zemganno*, published in March 1879. The Realists, Goncourt claimed, had been too much concerned with the lower strata of society – "the base, the repugnant, and the fetid."[24] By endowing his circus brothers with more sensitive natures, Goncourt was granting them "the dreamy, contemplative, one might even say literary" capabilities of the "superior and educated classes."[25] It was the gypsy blood of Gianni and Nello, the heroes of his novel, that enabled them to engage in "rêverie poétique." Renoir had no need of such casuistry to justify his circus picture. Without the slightest condescension, as Edmond Renoir noted, *Acrobats at the Cirque Fernando* communicates "reality with all its poetry and with all its flavour."[26] A painting of modern life, it is instinct with the dignity and grace of the sisterhood of Nike.

36 *Girl with a Fan* 1880

65 × 50 cm
State Hermitage Museum, Saint Petersburg

IN 1881 DURAND-RUEL BEGAN TO BUY Renoir's paintings in sufficient quantity to ensure the artist a steady income.[1] Among the first group of nine works, which he acquired on 6 January 1881, was *Girl with a Fan*, for which he paid 500 francs and which he would keep for more than a quarter of a century.[2] Having exhibited the painting in Berlin and London, as well as in Paris on several occasions,[3] Durand-Ruel reluctantly parted with it on 1 October 1908, when it was sold to the Moscow collector Ivan Morosov (1871–1921) for 30,000 francs.[4]

Revising the early history of *Girl with a Fan* not only establishes its date conclusively as 1880, it also corrects a misunderstanding in the scholarly literature that has hitherto gone unnoticed. For if, as Daulte asserts, Durand-Ruel acquired *Girl with a Fan* in the summer of 1891, how could this painting have appeared as part of the stock that he sent to the seventh Impressionist exhibition nine years earlier?[5] What actually took place on 25 August 1891, however, was an internal transaction whereby the ownership of all the Renoirs in Durand-Ruel's possession, including *Girl with a Fan*, was transferred to the family company.[6]

Girl with a Fan was one of twenty-five paintings by Renoir that Durand-Ruel lent to the seventh Impressionist exhibition in March 1882, at which time it was prominently caricatured in the press (fig. 205).[7] As noted in my essay above, Renoir was categorically opposed to this exhibition and refused to participate in it. In a hysterical letter from his sickbed in L'Estaque, he explained the reasons for his abstention and urged Durand-Ruel not to support the venture. He granted, however, that he could not deny the dealer the right to lend paintings already in his possession. "Of course, you can lend works that you own without my authorization. They are your property and I would not presume to prevent you from disposing of them as you see fit, as long as it's in your own name."[8] This is precisely what Durand-Ruel did with *Girl with a Fan*, which had been part of his stock for over a year.

In the coming decade, whenever Renoir needed to reassure his dealer, he would compare his latest work with *Girl with a Fan*, a painting that was "soft and highly coloured, but bright."[9] Seated in a commodious red armchair set at a slight angle to the picture plane, Renoir's lively model is portrayed full-square against a white background inflected with scumbles of Naples yellow. Her hair in a fringe ("à la chien") and parted down the centre in the latest fashion, she reacts to something beyond the canvas: her mouth is open and her eyes glance to the right. Renoir's technique, which maintains a sketch-like spontaneity while insisting upon the structure of his model and her accoutrements, is responsible for transforming an essentially conventional pose into an experimental and bravura performance. His touch is varied and audacious: thin and wash-like in the background and in the sleeves of the violet-blue dress, thick and impasted in the lace ruffles of his model's collar and cuffs, insistent and finished in the details of her face (it is almost possible to count her eyelashes). The surface of Renoir's canvas is as unified as shot silk, and it is the solidity of his modelling, achieved at no compromise to his heterodox colourism and abbreviated handling, that recommended this painting both to Durand-Ruel and to the critics of the seventh Impressionist exhibition.[10] If jokes could still be made about Renoir's palette – it was noted that the girl had "burnt madder" eyes, and that the "violet tones" of her hair were the result of a "recent dyeing"[11] – there was general approval for the painting's "vigour,"[12] "femininity,"[13] and even its "delicacy."[14] Philippe Burty, in one of his most enthusiastic reviews to date, judged *Girl with a Fan* worthy of Delacroix: "No one captures the mysterious play of shadows on a young brunette's face, neck, and shoulders as candidly as Renoir does."[15]

The more perceptive critics of the seventh Impressionist exhibition noted an affinity between *Girl with a Fan* and two other paintings done at Chatou, *Luncheon of the Boating Party* (fig. 16) and *Two Sisters* (cat. no. 40).[16] In fact, the model for *Girl with a Fan* was in all likelihood Louise Alphonsine Fournaise (1846–1937), daughter of the proprietor of the Hôtel Fournaise (site of *Luncheon of the Boating Party*), whose portrait Renoir had painted five years earlier (fig. 206) and who may have posed for as many as four single-figure paintings done around this time.[17]

The eldest child of Alphonse Fournaise (1823–1905) and Louise Braut (1823–1896), Alphonsine had married Louis-Joseph Papillon (1839–1871), a hosier from Chatou, in September 1864, but continued to assist in the running of her father's restaurant and boat-rental business.[18] After the death of her husband during the siege of Paris in January 1871, she devoted all her energies to the family establishment.[19] A haunt not only of the Impressionists but also of the Naturalist writer Maupassant – who refers to the restaurant in his short story "Yvette"[20] – the Hôtel Fournaise underwent refurbishment in 1877, and its reconstructed balcony would be memorialized by Renoir in *Luncheon of the Boating Party*.[21]

Renoir stayed with the Fournaises during his painting campaigns at Chatou in August–September 1880 and would have had ample opportunity to paint Alphonsine at this time.[22] It is actually difficult to be certain that she was the model for *Girl with a Fan* – comparison with his earlier portrait of her is inconclusive – but at one level the issue is irrelevant. For while it is undeniable that Renoir painted from a model, in subject pictures such as *Girl with a Fan* he was not bound by the same principles that governed the production of portraits, however informal.[23] That he was attentive to the distinctive physiognomy and spirited personality of his model is unquestionable – she reappears in *Young Girl with a Smile* (private collection)[24] – but that he also fictionalized from the living presence is no less an essential component of his genre painting. This disjunction is immediately apparent when *Girl with*

a Fan is compared with a portrait of Alphonsine from the same period (fig. 207) or even with a photograph of her from the following decade (fig. 208).

If Alphonsine Fournaise was indeed the model for *Girl with a Fan*, then an interesting metamorphosis has taken place. For, as Huysmans was quick to point out, Renoir's figure is a Parisienne, "with a fine gleam in her big dark eyes" – the type of painting that exudes the very scent of a "fille de Paris."[25] Although the neutral background gives no clue as to location or milieu, it should be noted that Renoir's model is not dressed in boating costume, that she is seated in a bourgeois "fauteuil crapaud," and that her fan is also the attribute of the fashionable young flirt. The urban, as opposed to suburban, resonance of this painting is also suggested by Renoir's handling, which is closer to the abbreviated style of *Place Clichy* (1880, Fitzwilliam Museum, Cambridge), whose subject is the pert grisette, than to the more monumental and richly worked *Luncheon of the Boating Party*.[26]

The allure and vivacity of Renoir's figure, above all her parted scarlet lips that are blatantly erotic, would not have been out of character for the thirty-four-year-old widow from Chatou. In the 1880s, Alphonsine took up with Maurice Réalier-Dumas (1860–1928), a pupil of Gérôme's who was fourteen years her junior and who would remain her companion until his death.[27] Around the turn of the century, Renoir revisited the Hôtel Fournaise with his family and his pupil Jeanne Baudot. Rather sourly, the latter commented: "He wanted us to meet the 'femme fatale,' who by now had lost all her charms."[28]

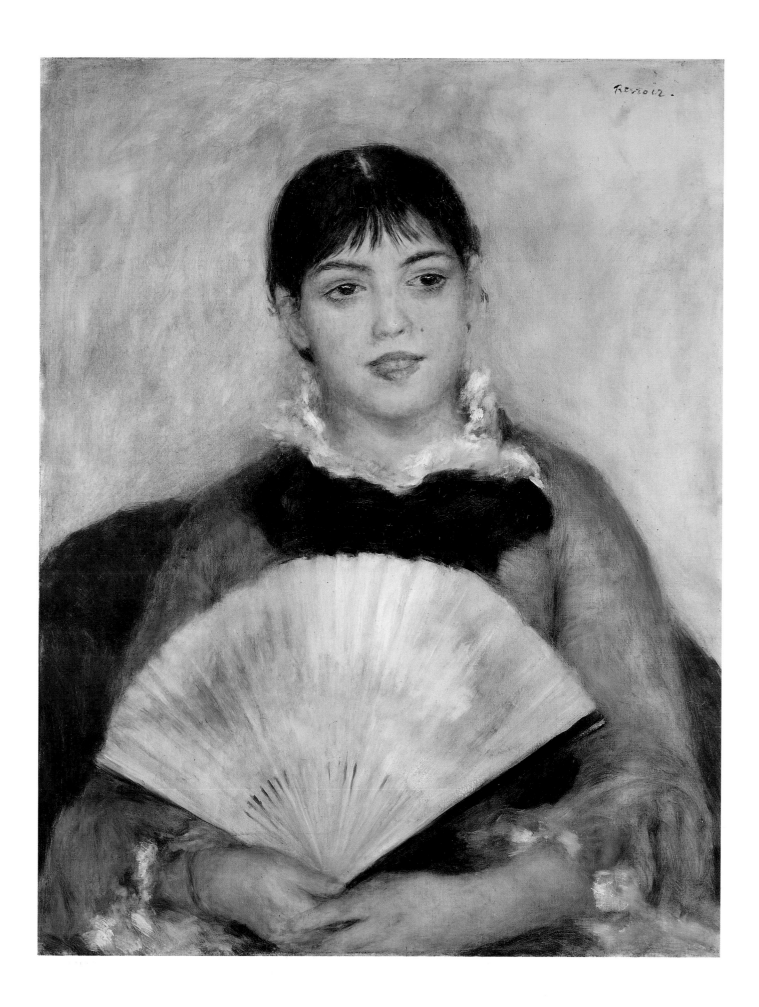

79.8 × 63.7 cm
The J. Paul Getty Museum, Malibu, Calif.

Tᴴᴇ ɢᴇɴᴇꜱɪꜱ ᴏꜰ *Albert Cahen d'Anvers* is exceptionally well documented – the fashionable composer was thirty-five years, eight months, and one day old when Renoir completed the portrait – and most of the pertinent information is presented directly on the canvas.[1] At the lower-right corner Renoir inscribed the place and date of execution, "Wargemont, 9 Sbre 81," indicating that the portrait was painted at Berard's country house outside Dieppe on 9 September 1881. The floral wallpaper in the background and the Louis XV *fauteuil* in which Cahen d'Anvers is seated are part of the "petit salon" on the first floor of the château; the furnishings had remained unchanged when the room was photographed in the 1930s (fig. 209), and are still more or less intact today.[2] And although he sat to Renoir in the country, Cahen d'Anvers did not choose to modify his elegant, almost dandified, appearance. He is dressed in a rather tight-fitting suit with the jacket fully buttoned, a separate collar, heavily starched cuffs, and a patterned silk cravat held in place by a bejewelled tie-pin. His pose is quite relaxed – his legs are crossed, his left elbow rests easily on the arm of the chair – and he holds a ready-made (as opposed to hand-rolled) cigarette in a golden cigarette holder.[3] A discreet wedding band is visible on the fourth finger of his left hand.

It was noted by a contemporary that Cahen d'Anvers's brothers were "scrawny fellows, small men, always in motion" – characteristics that Albert would appear to have shared.[4] The same chronicler also claimed that they were impeccably dressed – their tailors were "beyond reproach"[5] – and Renoir has seized upon a sartorial fastidiousness that is equally apparent in Nadar's photograph of Cahen d'Anvers in middle age (fig. 210), as well as in Bonnat's posthumous portrait (1903, Bibliothèque Nationale, Paris), painted from a slightly later photograph.[6]

The solidity of Renoir's modelling and the imposing presence of the sitter belie the fact that *Albert Cahen d'Anvers* was painted quickly and with little alteration – the only visible change is the slight shifting of the left sleeve and cuff. From a letter to Deudon written by Berard and co-signed by Renoir and Ignace Ephrussi – the latter was another house guest at this time – we learn that on 7 September the portrait was "coming along well"; two days later, on 9 September, it was finished and dated.[7] Painted in such affable circumstances, the portrait exudes a bonhomie that may have been a little painful for its sitter to look back on, since Cahen d'Anvers's visit to Wargemont would have been cut short by the death of his father just a few days after the painting was completed. The banker and philanthropist Meyer Joseph, comte Cahen d'Anvers, died at his country seat, the château de Nainville, on 11 September 1881, aged 77.[8] The funeral, at which the chief rabbis of France and Paris both officiated, took place four days later, and was attended by all the inhabitants of Nainville, who had made the journey to Paris in order to accompany Meyer Joseph's coffin to its grave.[9]

Albert Henri (8 January 1846–23 February 1903) was the youngest of five children born in Antwerp to the Jewish banker Meyer Joseph Cahen d'Anvers (1804–1881) and his wife Clara Bischoffsheim (1810–1876), and the only son not to enter his father's profession.[10] He was the younger brother of Louis Raphaël Cahen d'Anvers (1836–1922), whose three daughters had sat to Renoir in 1880–81 (fig. 10 and cat. no. 38), and, like him, had doubtless been encouraged in this commission by Charles Ephrussi.[11] Cahen d'Anvers had trained as a pianist with Madame Szarvady in the 1860s, going on to study with César Franck, whose most devoted, if not most gifted, pupil he became. His earliest orchestral compositions were performed in 1874–75, but they met with such little enthusiasm that he turned to writing for the stage: he made his début at the Opéra-Comique in October 1880 with *Le Bois*, a lyric song cycle.[12] It was noted at the time that while he was an artist "by vocation," Cahen d'Anvers also enjoyed the advantages of a "pretty fortune" which allowed him to continue in what has been described as a "mediocre and protracted career" for the next twenty years.[13] His most successful opera, *Le Vénitien*, was first performed in Rouen in April 1890 – the ailing Franck claimed that it had been "one of the best moments of my musical life" – but the composer's friend Maupassant was more realistic in recognizing the need to drum up support among the critics.[14] "I want to seduce the Rouennais press to be favourable to this opera," he confided to the town's municipal librarian.[15] Cahen d'Anvers's music is completely forgotten today, but musicologists consider his best work to be *Marines*, an early group of *mélodies* to the poems of Paul Bourget and Maurice Bouchor written around 1878.[16] Both poets were part of the bohemian circle that congregated at the rue Saint-Georges in the late 1870s, when Renoir painted a full-length portrait of Bouchor.[17]

Cahen d'Anvers frequented an altogether more fashionable set, however. In April 1876, he married the strikingly beautiful Polish émigrée Rosalie Louise Warshawska (1854–1918), known as Loulia, who, as Edmond de Goncourt noted sourly, had only to open her mouth to be called "la petite perfection."[18] Loulia was the sister of Marie Warshawska, Madame Édouard Kann, the future mistress of Bourget and Maupassant, who, after 1881, lived with her in the petit hôtel de Villars at 118 rue de Grenelle – the Cahen d'Anvers's family house since 1854 – where Loulia entertained on a lavish scale.[19] Blanche, in his memoirs, noted that "the influence of these Jewesses on society during the Third Republic is unimaginable today." Goncourt, who attended one of their soirées in December 1885, spoke of the "immense apartments with their succession of salons and their silk-clad walls."[20] Cahen d'Anvers's marriage was childless, and it is not clear that it was a happy one. He died at the age of fifty-seven at Cap d'Ail near Monte Carlo, where he was living separately from his wife; his funeral service took place in Paris on 3 March 1903, and, like his father's, was officiated at by the chief rabbi of France.[21]

One of Blanche's dabblers in Impressionism, Cahen d'Anvers was eclectic in his collecting of modern art, and showed no particular interest in the New Painting. He had been an early enthusiast of Henri Regnault, owned superb pastels by Millet, and in 1889 acquired his single landscape by Monet, as well as Gustave Moreau's *Young Man and Death* (1865, Fogg Art Museum, Cambridge, Mass.), which Durand-Ruel remembered selling him.[22] His preferred portraitist was not Renoir, but Bonnat, who in the early 1880s painted workaday ovals of him and his wife and in 1891 produced an overbearing society portrait of Loulia (fig. 211), with whom he had fallen in love.[23]

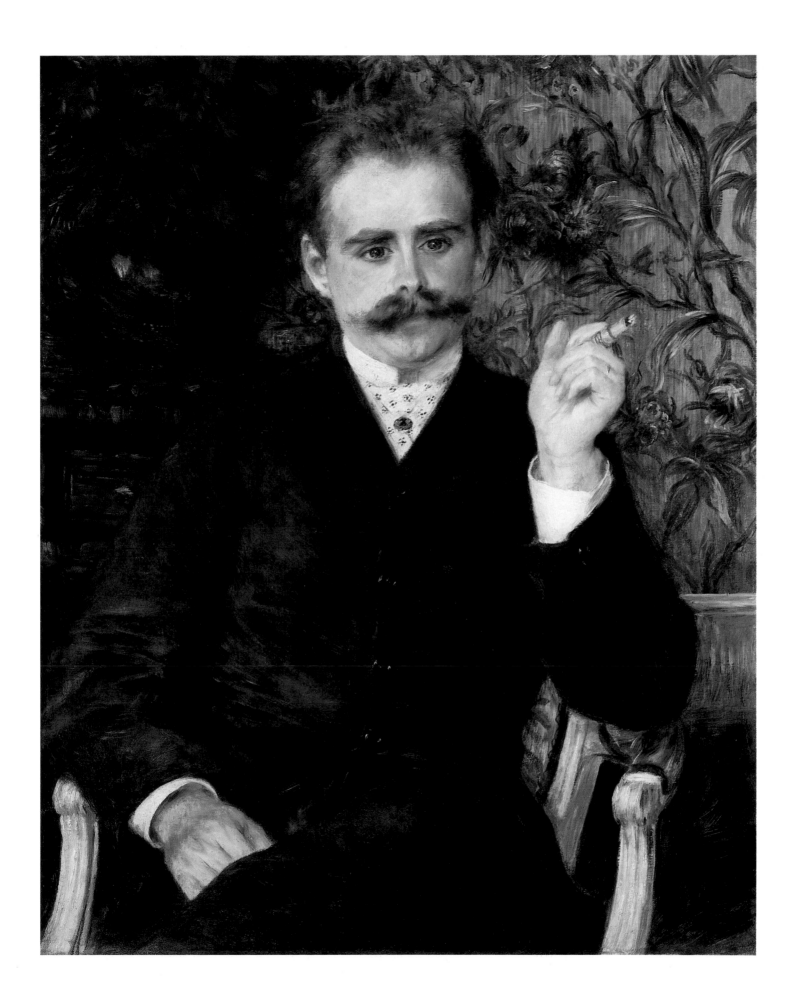

Just as Renoir's *Cahen d'Anvers* was something of an anomaly for its sitter, so was it an eccentric society portrait, despite its fidelity to appearances. Renoir's colour harmonies are exquisitely stylized: the purple costume dappled with green and white, the sitter's jaw modelled in blue, his left ear painted red, and his shock of auburn hair highlighted in olive-green and yellow. Forms acquire a rhythmical, animated existence, independent of the objects they describe. Hence, as John House has pointed out, Cahen d'Anvers's moustache rhymes with the floral patterning of the wallpaper behind him;[24] his jacket is a surface of dancing brushstrokes; and, most flagrantly of all, the purple tendrils of the wallpaper, however true to the decoration of the "petit salon," have more vegetal energy than the modest vase of dahlias behind the sitter. Indeed, *Cahen d'Anvers* is a proto-Symbolist portrait. And even if Renoir's dandified smoker does not communicate the "creeping neurasthenia of urban existence," we might be forgiven for thinking that his cigarette is of the perfumed variety favoured by Huysmans's des Esseintes, or that he is sitting in an interior designed by a forerunner of Émile Gallé.[25]

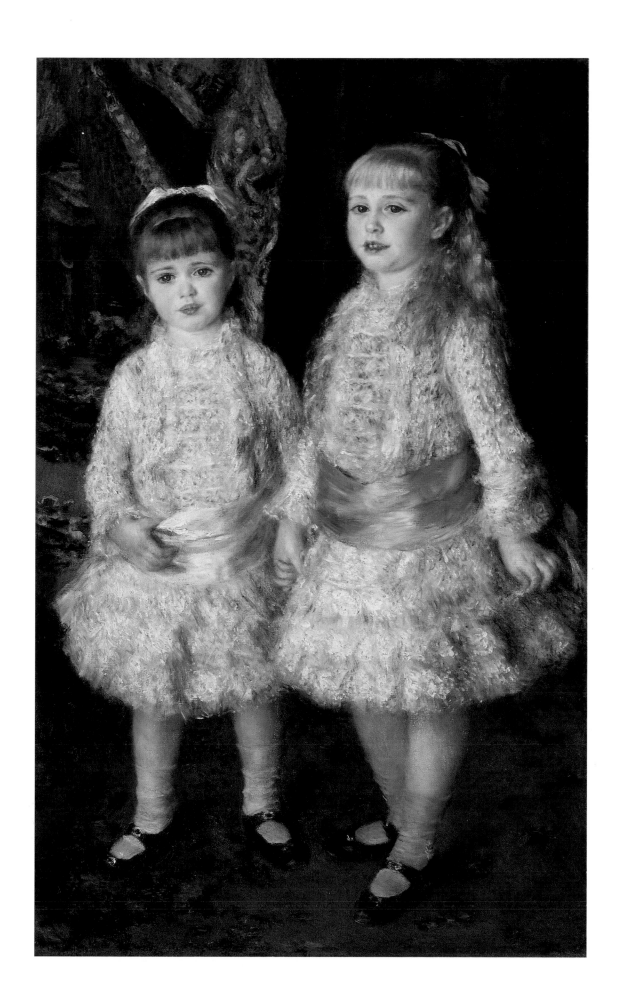

39 *Studies of the Children of Paul Berard* 1881

62.6 × 82 cm
Sterling and Francine Clark Art Institute,
Williamstown, Mass.

IN THE SUMMER OF 1881 – his third at Wargemont – Renoir painted an unusual "group portrait" of the four Berard children in various informal poses. Although it partially adopts the notational system that he later used for preparatory studies, *Studies of the Children of Paul Berard*, in spite of its title, is a fully realized composition, brought to a degree of finish that distinguishes it from the informal painted sketches that appear intermittently in Renoir's oeuvre.[1] Duret compared this engaging family album to "a lively salad."[2] That Renoir could produce such natural and relaxed vignettes was due in part to the intimacy that had developed between him and his sitters over the previous two years, during which period each child – with the exception of Lucie, born in July 1880 – had sat to Renoir for their portrait at least once.[3]

At lower left, in the grey school uniform with its wide white collar (the same uniform he had worn in three earlier portraits – see fig. 53), thirteen-year-old André Victor Berard (16 March 1868–5 January 1939) sits reading a book; such is his concentration that we can almost see his lips move as his eyes scan the page.[4] In the middle of the composition, holding a volume bound in Morocco leather, is the Berard's second child and eldest daughter, Marthe Marie (8 May 1870–19 January 1946), aged eleven.[5] She appears again in profile at lower right, this time wearing a pink smock, with her long hair unbraided. The simplicity of her hair and dress in both vignettes raises the possibility that Renoir has painted her in pyjamas (or their equivalent), washed and brushed and ready for bed. This is certainly the case of Lucie (see also cat. no. 47), aged one, who begins the upper row of heads, fast asleep in her cradle, and who is also represented awake, looking to her right. In between the studies of Lucie asleep and awake is the head of seven-year-old Margot, sitting with her nose in a book. Her hair now considerably longer than in Renoir's earlier portrait (cat. no. 34), she is seen again at far right, listening attentively with her hands folded in her lap.

A series of highly characterized portrait miniatures, each occupying its individual space, *Studies of the Children of Paul Berard* imposes itself as a fully unified composition through Renoir's undulating rhythms and balanced colour harmonies. As has also been noted, Renoir may have achieved a flawless likeness, but his colouring is far from naturalistic: touches of blues, reds, and lemon yellow model the children's faces, while blues, purples, olive green, and red go into the painting of their gleaming hair.[6]

Only once before had Renoir used this multiple format in a commissioned portrait, that of Marie-Sophie Chocquet (fig. 33), painted for his first champion, Victor Chocquet, in 1876. As I have already suggested, the absence of the little girl, who had been dead for nearly eleven years, compromised that portrait from the beginning, for Renoir was obliged to use photographs of Marie-Sophie at various ages.[7] By contrast, *Studies of the Children of Paul Berard* has an impressive vitality – the living model was essential for Renoir – yet this "secular chorus of disembodied angels"[8] is no less indebted to a precedent in eighteenth-century art for its successful realization.

In *Studies of the Children of Paul Berard* Renoir adapts the *mise en page* habitually used by Watteau in his drawings of different heads, one of the finest examples of which (fig. 216) was part of a large survey, *Les Dessins des maîtres anciens*, exhibited at the École des Beaux-Arts in May 1879.[9] Since Charles Ephrussi had been responsible for the organization of this exhibition, there is every reason to believe that Renoir would have taken the trouble to see it.[10] He seems to have been especially struck by the man in the three-cornered hat at the lower left of Watteau's drawing, who reasserts himself in the presentation of André Berard – like Watteau's figure, set somewhat apart from his companions. More generally, the reference to Watteau would have pleased Paul Berard, an *amateur* whom Monet affectionately remembered arranging his collection of eighteenth-century porcelain and *bibelots*, "to which he was attached with all his heart."[11]

Finally, consciously or not, Renoir may have been spurred in this painting by the wish to compete with Mary Cassatt, who, earlier in the year, had been given the commission to paint a pastel portrait of baby Lucie during Renoir's absence in Algiers. Berard had sought Renoir's permission before committing himself – Cassatt seems to have been a friend of Madame Berard – and in March 1881 Renoir generously replied: "Let Mademoiselle Cassatt do the pastel; it will not upset me at all to have a neighbour."[12] The neighbour in question would turn out to be the rather stiff *Baby in a Striped Armchair* (private collection), which shows Lucie at her most formal.[13] By contrast, Renoir's ambitious group study, "profoundly tender" though it is, also served to confirm his position as the unsurpassed chronicler of the Berard family.[14]

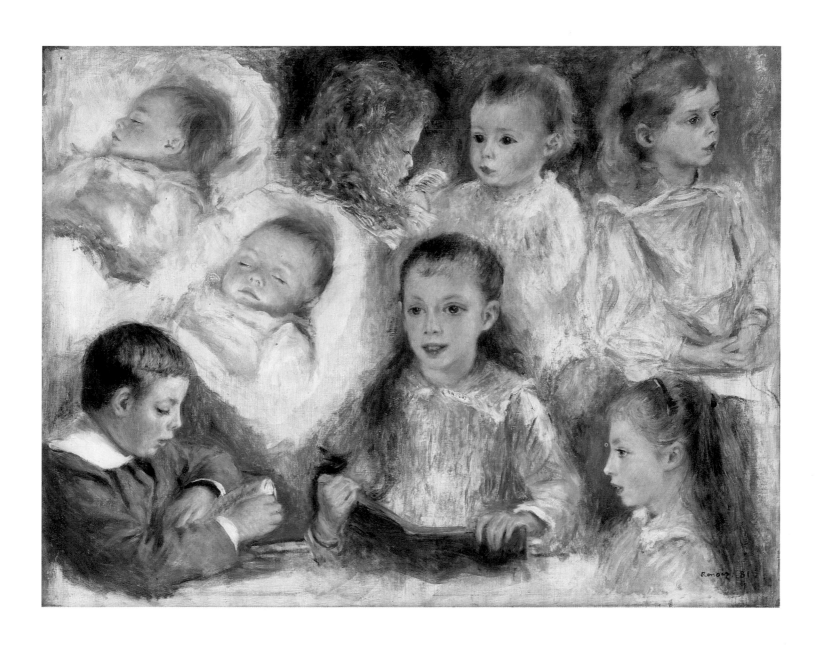

100.5 × 81 cm
The Art Institute of Chicago
Mr. and Mrs. Lewis Larned Coburn
Memorial Collection

*T*wo Sisters, also known as *On the Terrace*, is Renoir's valedic-
tion to the theme of Parisian recreation in the country – a
central motif in the iconography of modern life. As such, it closes
the ambitious cycle of paintings set in Chatou ("the prettiest of all
the suburbs of Paris") done over a period of nine months, of
which *Luncheon of the Boating Party* (fig. 16) is the crowning
achievement.[1] Renoir had first stayed at the Hôtel Fournaise on
the Île de Chatou in 1875, yet it was only in the summer of 1880
that this village on the Seine replaced Montmartre as his preferred
site for the picturing of Parisian conviviality.[2] Fifteen kilometres
to the west of Paris, accessible from the Gare Saint-Lazare, and
within walking distance of Louveciennes (where Renoir's mother
was living), Chatou had by the 1870s established itself as the
centre of rowing, just as Argenteuil had become home to the
regatta.[3] Spread over a series of narrow islands through which the
Seine branched off in two channels, this little village of around
3,000 inhabitants catered to a slightly more elegant crowd than
the nearby La Grenouillère, a popular spot for day-trippers from
Paris to go bathing and dancing.[4]

Although it was the terrace of Fournaise's new restaurant that
provided Renoir with the setting for his great multifigured paint-
ing of modern life, it was the riparian landscape that had initially
drawn him to Chatou. As Rivière noted, "he was particularly
fond of the limpid sky, the river on its undulating course, the trees
with their light foliage, and the low-lying hills in the background
that gently merged with the hazy horizon."[5] Relegated to the
background in *Luncheon of the Boating Party* – a painting begun in
August 1880 and finished by February 1881 – this landscape
reasserts itself in *Two Sisters*, which was painted after Renoir's
return from Algeria in early April 1881. Lunching with Whistler
at Chatou on Easter Monday (18 April 1881), Renoir informed
Théodore Duret that he was postponing his visit to London
because of this picture: "I am engaged in a struggle with trees in
bloom and women and children and can see no further than that
at the moment . . . The weather is fine and I have my models;
that's my only excuse."[6] Renoir probably completed *Two Sisters*
by the early summer.[7] A *terminus ante quem* for the painting is pro-
vided by Durand-Ruel's stock book: on 8 July 1881 he acquired
this work, originally entitled *Jeune femme au bord de la Seine*, from
Renoir for 1,500 francs. It would remain in his family's collection
until 1925, when Joseph Durand-Ruel sold it to Mrs. Lewis
Coburn of Chicago for $100,000.[8]

In *Two Sisters*, it is Fournaise's establishment that makes the
more discreet appearance, since the terrace on which the two girls
are posed is not the same as the expansive setting of *Luncheon of
the Boating Party*: the design of the ironwork is different, and the
space is altogether more constricted.[9] Viewed from above,
Renoir's models are presented on an adjoining terrace, at right
angles to the restaurant, that faced south across the Seine to Reuil
(fig. 217), with no trace of the Pont de Chatou in sight. Unaware
of the spectator's gaze, the girls look in different directions, their

attention caught by the sound or sight of things we cannot see.
The little girl, a diminutive Flora, wears a white pinafore to pro-
tect her blue dress; the young woman, her broad-brimmed hat
trimmed with a red flower, is shown in the dark-blue flannel dress
favoured by female boaters, similar to those worn by the women
in *The Rowers' Lunch* (1875–76, Art Institute of Chicago).[10]
Although her hat and corsage strike a more elegant note, her cos-
tume reminds us that we are in the heart of rowing country, as is
immediately apparent from the many boats in the background. In
the centre of the river can be seen a gig in which two people are
rowing; slightly more inland, just left of the red hat, is a scull with
a single figure in a straw boater; right of centre, moored in
between the trees, are two sailboats, their white sails unfurled.

Renoir's spatial construction in *Two Sisters*, seemingly straight-
forward and transparent, is breathtaking, since he manages to
convey at the same time a sense of enclosure – the two figures,
cut off at the knees, wedged within the shallow space of the dia-
gonal terrace – and a sense of distance – the airy vista of red roofs
and blue hills, filtered through the screen of trees, with creeping
plants and flowering bushes pushing forward from the middle
ground. Renoir achieves perfect coherence and legibility despite
these conflicting viewpoints (the girls seen from above, the river
almost from below) and through a technique as energized and
various as at any point in the previous decade. From the silken
finish of the faces and hands of the two figures, to the rich impasto
of the little girl's headdress and the balls of wool in the fore-
ground, to the dabs of white pigment that describe the flowers at
left, Renoir's virtuosity is highly disciplined, since each element
is configured within a rigorous compositional unity.

The luminosity of *Two Sisters* is no less remarkable: it is as if the
light of North Africa had infiltrated the Île de France by stealth.
Renoir has suppressed shadows and reflections almost completely
(the older girl's right cuff is the single exception here), while suc-
cessfully conveying the illusion of both depth and recession. He
does not adopt traditional Impressionist modelling (his brushwork
is neither consistently broken nor flickering), but rather restricts
his palette to the primary colours, enhanced by an abundant use
of white, his priming of choice in the 1880s.[11] The intensity of the
afternoon sunlight is established not so much by Renoir's
handling, which is insufficiently systematic, as by the structure of
his design. The verticals and diagonals of the terrace, the boats,
and the trees provide a dynamic grid against which the burgeon-
ing undergrowth and diaphanous foliage resonate in a gradual
diminuendo. And against the syncopation of leaves, flowers, and
water are anchored the more weighty forms, almost cylindrical, of
the two girls, the basket, and the barrel that has been transformed
into an oversized flower pot.

Despite Renoir's audacious composition and experimental
handling, *Two Sisters* was an immediate favourite with Durand-
Ruel – like *Sleeping Girl with a Cat* (fig. 23) and *At the Concert*
(1880, Sterling and Francine Clark Art Institute, Williamstown,
Mass.), this was the type of figure painting he preferred – as well
as with the critics, both conservative and progressive.[12] Repro-
duced almost immediately in Hoschedé's *L'Art de la Mode*, it was
exhibited regularly during Renoir's lifetime – first as "Les Deux
Soeurs," then as "Sur la terrasse" – and as early as 1892 was recog-
nized by his most admiring critic as "one of the capital works in
his oeuvre."[13] Ironically, the painting's immense popularity,
however deserved, has discouraged appreciation of Renoir's

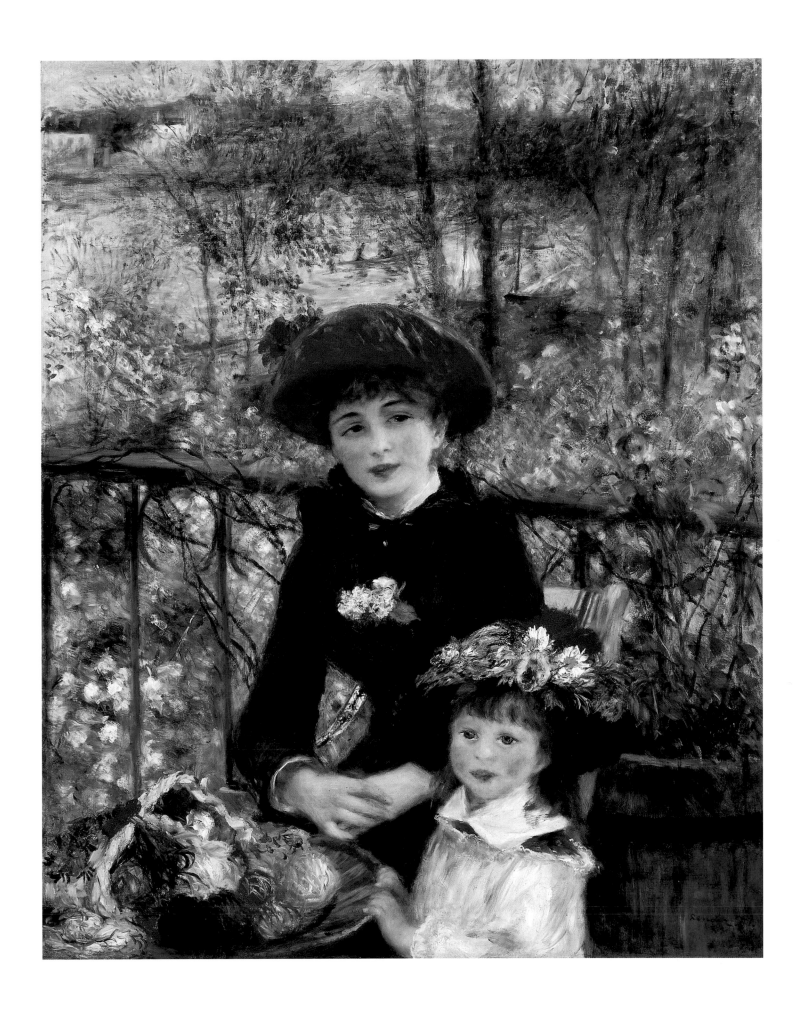

idiosyncratic manner, as well as masking the degree of risk-taking in such an ambitious composition. For while few would question the validity of Alexandre's insight, made in 1892 – "Not a single woman or child that Renoir has painted during the last twenty years has lost anything of their ineffable youth: no matter what the date of their hat or their dress, they are so unashamedly modern that it is impossible to imagine them as grandmothers"[14] – the creation of an enduring type of modern beauty, apparently immune to the vicissitudes of time and fashion, is rarely considered an achievement worthy of note.[15] Nor is the subject of *Two Sisters* as straightforward as is often assumed.

Although it was praised as early as 1882 for its "two good portraits,"[16] *Two Sisters* was a subject picture firmly inscribed within the canon of modern life, an example of Renoir "attempting to distil the contemporary from the sites in which it is to be found."[17] But comparison with *Young Girl Seated* of the previous year (fig. 221) – in which the model is seated on an identical deck chair in the corner of a terrace – shows how characterized are the figures in *Two Sisters* and how distinctive their physiognomies. In fact, following François Daulte's brilliant identification of the older girl as Jeanne Darlaud, future star of the Théâtre Gymnase, it is possible to confirm the degree of Renoir's fidelity to the features of his model, who is treated with the same affectionate but honest scrutiny as if she had commissioned her portrait from him.[18]

The eldest daughter of a bookbinder and a brocade weaver, and granddaughter of a cabinet-maker from Limoges, Eugénie Marie Darlaud, as she was christened, was born in Paris on 25 January 1863, and would have been eighteen years old when she posed for Renoir.[19] In August 1882, Jeanne Darlaud (as she was now called) entered the Conservatoire, but a year later asked to terminate her apprenticeship so that she could accept Koning's offer to perform at the Gymnase theatre: the monthly salary of 400 francs would enable her, she claimed, to look after an ailing mother (who was all of thirty-seven years old at the time!).[20] Released from the Comédie-Française in August 1883, she appeared in numerous light comedies at the Gymnase during the next twelve years, and photographs of her in various roles show a soubrette of quite remarkable beauty, whose dusky features and accentuated eyebrows are already present in Renoir's painting (figs. 218, 219).[21] They are also discernible, though rendered dull and conventional, in André Brouillet's society portrait, reproduced on the cover of *La Vie Moderne* in March 1888 (fig. 220) and exhibited at the World Columbian Exposition in Chicago in 1893.[22] Although Mademoiselle Darlaud finally made her debut at the Comédie-Française in June 1899, where she played Valentine in a revival of Dumas's *Le Demi-Monde*, her theatrical career ended at this point, and she retired from the stage at the age of thirty-seven.[23]

In October 1920, after visiting the Durand-Ruel collection, René Gimpel recorded an anecdote relating to the "portrait of an exceedingly pretty girl," in all likelihood the *Two Sisters*. Renoir, he was told, had picked up an impoverished actress at Argenteuil who had agreed to model for him in return for food; she later became one of "the stars of the demi-monde."[24] In fact, Renoir probably had access to the Darlaud daughters through their mutual family connection with Limoges: his father Léonard would certainly have known Jeanne's grandfather, Léonard Darlaud (1809–1883).[25] And although Jeanne's theatrical career was undistinguished – Durand-Ruel could not remember her

name – she did exceptionally well for herself. Gossip columnists reported that she had followed her younger sister in taking "a powerful *seigneur* for a protector, without abandoning her elegant lover."[26] The "elegant lover" may well have been the composer Louis Varney (1844–1908); her protector was the chocolate manufacturer Gaston Menier (1855–1934), who seems to have paid for the sumptuous *hôtel particulier* on the avenue de Friedland that Jeanne acquired in July 1895 for 405,000 francs and refurbished after her retirement from the stage in 1899.[27] Dying unmarried on 26 September 1914, Jeanne Darlaud left an enormous estate, with extremely generous charitable bequests: 100,000 francs each to the Orphelinat des Arts, the Association des Artistes Dramatiques, the Oeuvre Française et Populaire des 30 Ans de Théâtre, and the Dispensaire Marie Hélène, a charity for sick children.[28] In accordance with his mistress's wishes, Gaston Menier, now senator for the Seine-et-Marne, bought back the hotel at 43 avenue de Friedland for half a million francs and gave the money to her sister.[29]

In Renoir's subject picture, Jeanne Darlaud is acting her first role: that of the demure Parisienne at play in Chatou. Such is the sweetness and docility of her appearance that twentieth-century commentators have not hesitated in characterizing her as the mother of the little girl.[30] In fact, the first title of the picture, "Femme au bord de la Seine," made no reference to the little girl at all – her identity remains unknown – and the crude response to the title used at the seventh Impressionist exhibition eventually led Durand-Ruel to replace "Les deux soeurs" with the generic "Sur la terrasse."[31] For while reviewers could hardly be expected to know that the two girls were not related, Draner's innuendo (fig. 205), almost untranslatable into English – "'The two sisters,' says the catalogue; 'go take a running jump!' says the public" – fixed upon something less than decorous in Renoir's composition.[32] Indeed, sisterly protectiveness was far from apparent to Georges Lecomte, whose description of the painting is the most extended of contemporary reviews: "The insinuating and crafty grace of her sly face is accentuated by the malicious obliquity and alarming smile in her eyes. She has the look of a modern Mona Lisa who knows all about love and seduction and is shamelessly flirting with you."[33] In accordance with this hot-house reading of Renoir's *Two Sisters*, the drypoint engraving accompanying Lecomte's text (fig. 223) exaggerated the feline quality of Darlaud's mouth and eyes.

One last motif in *Two Sisters* remains to be satisfactorily explained: the large basket of brightly coloured balls of wool in the foreground of the composition. On closer inspection, it is clear that Renoir has painted a yellow straw basket, lying on its side, from which the balls of wool spill into a shallow, circular pannier – made of bamboo, perhaps – supported on legs beyond the canvas's edge. When the painting was caricatured in *Le Charivari* in March 1882, the basket was transformed into an abundant flowerbed (fig. 205), a more logical accessory given the floral array that decorates the girls' costumes. Since then, if any attention has been paid to the balls of wool at all, their presence has been related to the little girl, who is seen to have dashed into the picture "to select a piece of yarn for a game or project."[34] In contrast, however, to Renoir's many genre paintings of young girls sewing and crocheting, the pretty Parisienne in *Two Sisters* seems unlikely to start knitting, an activity at odds with the nautical, outdoor setting.

By including the brightly coloured balls of wool, Renoir may have been settling scores of his own in defying critics who commented adversely on his technique. As early as 1879, in a generally hostile review of *Madame Georges Charpentier and Her Children* (cat. no. 32), Bertall had complained that Renoir's "weak sketch seems to have been constructed of different coloured balls of wool."[35] Blanche recalled that it was in such terms that Renoir's handling was routinely described in the 1880s: "It's a piece of knitting ["du tricotage"], they would say, like multicoloured wool or silk."[36] When critics generally favourable to Renoir had reservations about his style, it was to such "tricotage" that they referred. Burty, who disliked the Venetian landscapes that Renoir exhibited in April 1883, complained that "in their blurred and isolated iridescence, they remind one of balls of wool strewn across the ground, or *heaped together in a large basket*" (italics mine).[37]

The allusion to balls of wool was not always negative – Degas famously described Renoir as an artist "who can paint anything he wants to; have you ever seen a kitten playing with coloured wools?" – but it was often so.[38] In response, Renoir incorporates this critical trope in order to deflate it – with discretion and humour in *Flowers and Cats* (private collection), which dates from the same period, and more stridently and with greater confidence in *Two Sisters*, where the motif becomes a self-referential metaphor for Renoir's own vibrant palette and astonishing virtuosity. But with characteristic self-effacement, the balls of wool divert no attention from the artist's "delight in harmonies of nature and society" – the true subject of *Two Sisters*.[39]

41 *Joseph Durand-Ruel* 1882

81 × 65 cm
Private collection
Loan obtained with the assistance of
Durand-Ruel et Cie, Paris

42 *Charles and Georges Durand-Ruel* 1882

65 × 81 cm
Private collection
Loan obtained with the assistance of
Durand-Ruel et Cie, Paris

43 *Mademoiselle Marie-Thérèse Durand-Ruel
Sewing* 1882

64.8 × 53.8 cm
Sterling and Francine Clark Art Institute,
Williamstown, Mass.

44 *The Daughters of Paul Durand-Ruel
(Marie-Thérèse and Jeanne)* 1882

81.3 × 65.4 cm
The Chrysler Museum of Art, Norfolk, Va.
Gift of Walter P. Chrysler, Jr. in memory of
Thelma Chrysler Foy

IN THE SUMMER OF 1882 Renoir was commissioned to paint the portraits of the five teenage children of his dealer Paul Durand-Ruel (1831–1922), "portraits in the sun" which, individually and as a group, rank among his greatest works in any genre.[1] Superb examples of Renoir's "polychromy," the portraits were done in Dieppe, where Durand-Ruel had rented a house for the month of August.[2] Three of the four paintings are set out of doors, although Jacques-Émile Blanche remembered them all as having been done "in a garden on the *côte de Rouen* beneath the flickering leaves of the chestnut trees, the sun dappling the children's cheeks in a way that contravened the beautiful 'flat modelling' of the studio."[3] From this description, Renoir might seem to be reverting to an earlier Impressionist manner, one that in the 1870s had captured form through the dissolving lens of ambient light; in fact, he was experimenting with a different technique, almost anti-Impressionist. The resurgence of a traditional hierarchy of planes, with the figure dominating in each instance; the heightened, anti-Naturalist key of his palette; the exceptional concentration with which his sitters are portrayed: Renoir's efforts to fuse an Impressionist's vision with the structure and solidity he perceived in the art of the past marked an important stage in the transformation of his style, one of which Paul Durand-Ruel did not altogether approve.[4]

The commission to paint this series of four portraits had originated as something of a peace offering: it represented a return to normalcy after the straining of relations between Renoir and Durand-Ruel that had occurred as a result of the seventh

Impressionist exhibition. In February 1882, Renoir had violently opposed showing with "the Pissarro-Gauguin combination," but had accepted that he could not prevent Durand-Ruel from lending pictures in his possession.[5] Despite an apparent reconciliation, Renoir, who was recuperating from pneumonia in Algiers, confided to Berard in March that he was still concerned that Durand might "drop him."[6] By June 1882 such fears were laid to rest once and for all: "Durand wants me to do all the family, and has asked me to set aside the entire month of August."[7]

For Durand-Ruel equally, the commission was unprecedented – Renoir having painted but one family portrait in the entire decade of their acquaintance – and it symbolized his renewed commitment to the New Painting. As well, perhaps, it illuminated something of his solid bourgeois values: pride in family, a sense of propriety, prosperity without ostentation. For, despite his support of *intransigeant* artists and *refusés*, Durand-Ruel was a respectable paterfamilias, a devout Catholic with strong monarchist sympathies, whose fortunes had risen steadily during thirty years of dealing in modern pictures (see cat. no. 64).[8] In May 1882, he had commissioned a series of still-life panels from Monet to decorate the doors of the sitting room of his apartment in the rue de Rome, into which he had moved earlier in the year, and it is no coincidence that the invitation to Renoir followed directly thereafter.[9] For despite the collapse of the Union Générale bank in February 1882, and the bankruptcy of Durand-Ruel's silent partner Jules Féder, who had been subsidizing his operations since 1880, the dealer's investment in Impressionist landscapes and figure paintings seems not to have been immediately affected. On the contrary, in the summer of 1882, Durand-Ruel worked hard to consolidate his relationships with Monet and Renoir.[10] He had initially intended to spend his summer with Monet and the Hoschedés in Pourville – Monet was house hunting for him in July – but instead rented a property in Dieppe, eight kilometres to the east of this fishing village and within striking distance of Wargemont, where Renoir had the run of Berard's estate.[11]

Renoir's four portraits of Durand-Ruel's children on holiday in Dieppe, the fruits of this summer campaign, are surprisingly formal. Whereas the artist famously arrived in Dieppe on market day dressed in a panama and wearing espadrilles – the state of his wardrobe was a source of considerable distress to Blanche's mother – his young sitters are attired in immaculate summer costumes with not a hair out of place.[12] The pleats and folds of the girls' white dresses are freshly ironed; the boys' waistcoats are buttoned to the neck, their watch chains and tie-pins unfailingly noted by Renoir's scrupulous brush. As a group, the paintings offer a summation of Renoir's surpassing quality as a portraitist: his ability to render a faithful likeness and evoke character sympathetically without compromising his aesthetic integrity, or, as he would have put it, "his researches."[13] In a commissioned work, the latter was obviously vulnerable, and Renoir's confidence had been undermined recently by the rejection of his first portrait of Madame Clapisson, *Dans les roses* (fig. 94), a work he had completed immediately before embarking upon the series for Durand-Ruel.[14] Difficult though it is to imagine, Durand-Ruel's reaction to Renoir's portraits of his children seems to have been similar to that of the Clapissons. In the autumn of 1882 Renoir confided to Berard, "I don't think Durand is very pleased with his portraits," joking that he was going to abandon "portraits in the sunshine,"

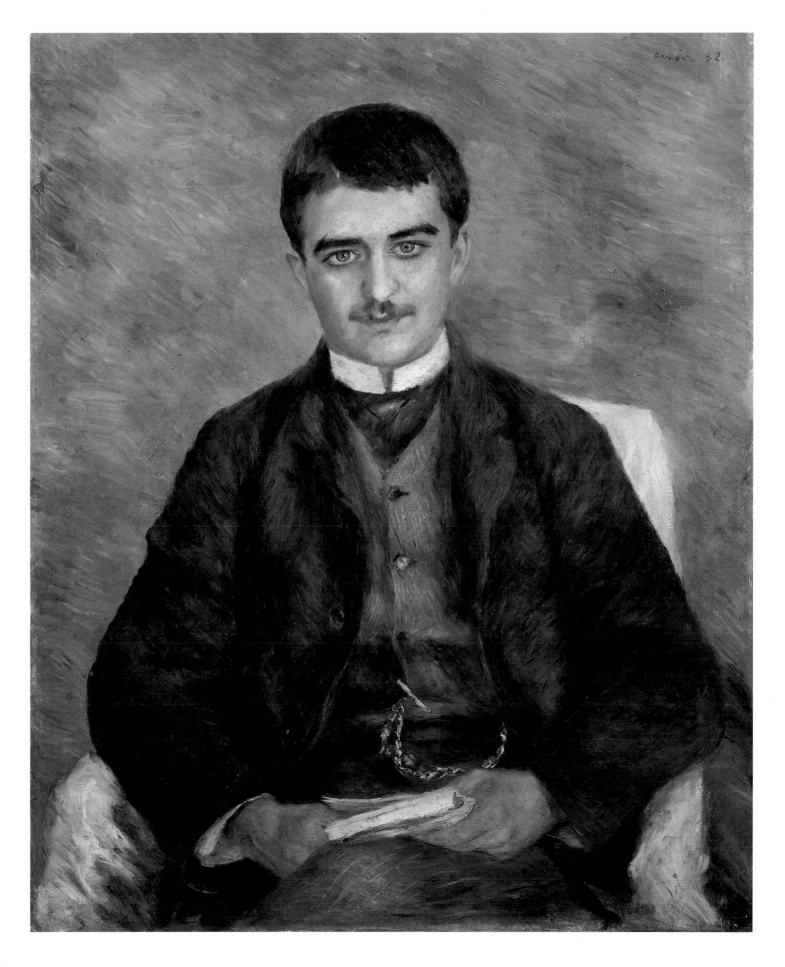

cat. no. 41

return to the true path of painting, enter Bonnat's studio, and make his fortune in "portraits with dark backgrounds."[15] Although this mutual dissatisfaction would soon pass, Durand-Ruel's initial disappointment confirms the acuity of Renoir's insight, first made in March 1882, that his latest manner of painting was unsaleable: new work needed to be bottled away for at least a year.[16]

It is not possible to establish a chronology for the four Durand-Ruel portraits, although it might be argued that *The Daughters of Paul Durand-Ruel*, with the girls set at some distance from the picture plane in an almost blinding afternoon light, maintains the structure of figure paintings done at Chatou the previous year and so would be the earliest in the series. For the purposes of the present discussion, I shall consider the portraits in the order of the birth of the sitters, starting with the eldest child Joseph, and conclude with some remarks about the group as a whole.

Five children were born to Paul Marie Joseph Durand (his official name until August 1897) and Jeanne Marie Lafon (fig. 225), known as Eva (14 November 1841–27 November 1871), the daughter of a watchmaker from Périgueux and the niece of Émile Lafon (1817–1886), a painter of religious subjects.[17] Durand had met Eva Lafon at the house of a well-known maker of ecclesiastical ornaments, and they were married on 4 January 1862 in the Église de Saint-Sulpice, one of whose chapels had been decorated by her uncle.[18] Eva died of an embolism on 27 November 1871, two weeks after her thirtieth birthday (she was pregnant with their sixth child), and her five children would be raised by Durand's *gouvernante*, Prudence Lebeau, who died in August 1917.[19]

Joseph Marie Pierre (fig. 226), the eldest son (25 November 1862–30 December 1928), was nearly twenty when Renoir painted his portrait.[20] Shown indoors, seated on an armchair covered with a white sheet, he appears both jaunty and sympathetic in a pose of studied casualness: his legs are crossed, and his right thumb keeps the place in his book as he looks up to face the viewer. Having received his *licence ès lettres* from the Université de Clermont in November 1881, Joseph would go on to study law, gaining a *bachelier en droit* in August 1885.[21] In between, he completed a year's military service in the 12th *chasseurs*, in which he enrolled in November 1882, three months after Renoir had painted his portrait. Joseph's army record states that he stood one metre seventy (a centimetre taller than Renoir), that his eyes were grey, his eyebrows chestnut, his forehead low, and his chin round – details that Renoir reproduces faithfully, while also capturing a certain boyishness that would soften Joseph's formal, if elegant, appearance in the decades to come (fig. 224).[22] Götz Adriani has recently noted that Joseph would have to be content with the role of "crown prince" in the family business until his father's retirement in 1913, when he assumed the directorship of both the Paris and New York branches of Durand-Ruel and Company.[23] Yet as early as September 1888 Pissarro informed his son that Joseph was "very much the dealer, it would appear, and exercises considerable influence over his father."[24] Renoir, in his business dealings with him, seems to have especially appreciated Joseph's punctiliousness.[25]

On 22 September 1896, at the age of thirty-four, Joseph married Mary Jenny Lefébure (1868–1962), a talented pianist whose father had left the family's lace-making business to run the Salle Pleyel, one of Paris's most prestigious recital halls.[26] Degas and Puvis de Chavannes appeared as witnesses for the groom; Pissarro

was invited to the wedding.[27] The couple honeymooned in New York, which must have been something of a busman's holiday, since Durand-Ruel had established a gallery there in 1888 and Joseph was frequently called upon to cross the Atlantic for business (his father informed Renoir in August 1892 that Joseph suffered "enormously" from the summer heat in New York).[28] The couple had four children, the youngest of whom, Charles Marie Paul Durand-Ruel (1905–1985), succeeded his father as the last active head of Durand-Ruel and Company. Renoir painted a pastel portrait of Joseph's daughter Marie-Louise, aged one, in 1898, and would paint the portrait of Jenny Durand-Ruel in the family's house in Saint-Cloud in the summer of 1911 (fig. 228).[29]

Joseph's two younger brothers, Charles Marie Paul (9 January 1865–18 September 1892) and Georges Marie Jean Hugues (2 August 1866–6 May 1931), are shown seated side by side on the garden bench that appears more prominently in *The Daughters of Paul Durand-Ruel*.[30] The boys' handsome features, square faces, and chiselled chins are also known from contemporary photographs (figs. 227, 229), which again confirm the vivid likeness of Renoir's double portrait. Aged seventeen and a half, Charles is shown in a light-grey suit, flecked with pink, purple, blue, and yellow, his white collar held in place by an opal tie-pin. His light-brown hair is modelled by dabs of green, grey, mauve, and orange, and his moustache is more advanced than his brother's. A newspaper, whose title is not indicated, rests on his lap. Georges, who had just turned sixteen when he sat to Renoir, is presented as something of a dandy, with his boutonnière and starched cuffs standing to attention, although his cigarette has gone out. Poised and relaxed, the brothers look in different directions, but their interlocking forms, with Charles watching over the younger Georges, convey affection and dependence without false sentiment.

Charles seems not to have attended university, but to have entered the family business straight away. In March 1886, at the age of twenty-one, he made his first visit to New York, accompanying his father for the family's inaugural exhibition, *The Impressionists of Paris*, and returning a second time in October with Joseph.[31] "Monsieur Charles," as Renoir addressed him, seems to have been responsible for the American operations of the company, managing Durand-Ruel's first gallery at 297 Fifth Avenue in 1888, selling paintings by Mary Cassatt in Montreal in July 1892, and participating in the organization of the French section for the World Columbian Exposition that would take place in Chicago in 1893.[32] However, he did not live to see his efforts on this last project come to fruition, for after returning to Paris from Holland in September 1892 he fell ill with an intestinal disorder and died of peritonitis on 18 September, at the age of twenty-seven.[33] Cassatt informed Mrs. Potter Palmer that the family "are all broken-hearted over the death of poor Charles"; Pissarro claimed that he had been the "soul" of the family business.[34]

The youngest son, Georges Marie Jean Hugues – named for his godfather, the painter and first family portraitist, Hugues Merle (1823–1881) – was educated at the Jesuit college in the rue de Maderie and received his *baccalauréat* in both arts and sciences from the Faculté de Paris.[35] After a year of military service at Tours (November 1886–November 1887), he entered the family business in 1888 at the age of twenty-one. He was responsible for selling Renoir's *By the Seashore* (1883, Metropolitan Museum of Art, New York) to Louisine Havemeyer, and assisted his father

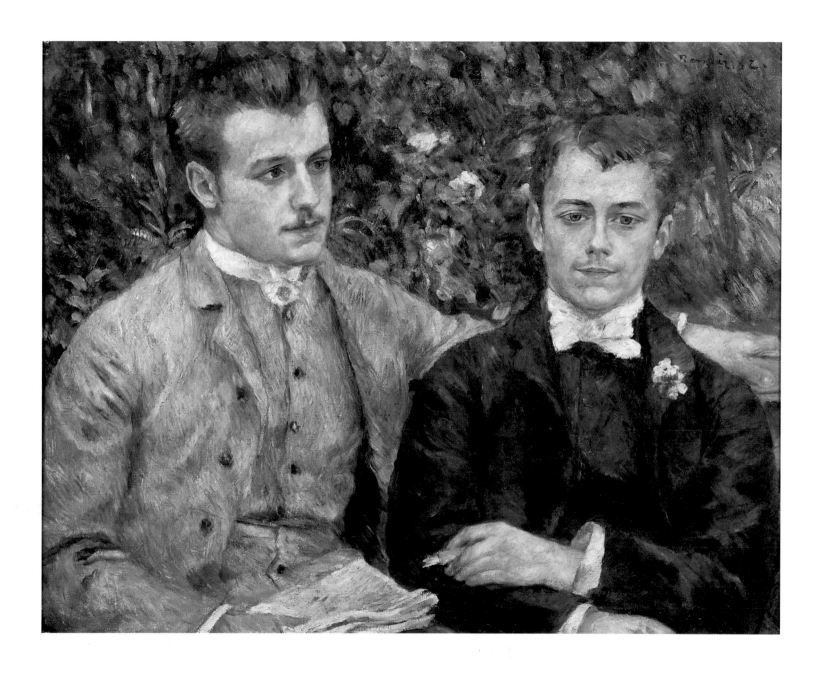

cat. no. 42

and eldest brother in both Paris and New York.[36] He was particularly close to Renoir and his family: as Jean's godfather, he gave the boy his first phonograph and regaled him with stories of America, both of which would have an influence on the future film director that could hardly have been suspected at the time.[37] Jean Renoir also claimed that at the time of his christening (July 1895) his mother had tried to arrange a match between his godfather and Jeanne Baudot (1877–1957), Renoir's well-bred young pupil, but that her efforts were thwarted when Georges introduced his American companion to the family.[38] Whether or not this story is true, it would be another thirteen years before the couple married: the wedding of Georges Durand-Ruel and Margaret Tierney from New York (born 1 January 1868) took place on 24 July 1918 at Brantôme, north of Périgueux, where Georges resided in the château de Balans, family property that had descended from his mother.[39] Mary Cassatt, who was living outside Grasse at the time, remarked spitefully that he had married "an American, old and not good looking, no notices were sent."[40] Since both bride and groom were in their fifties, the marriage was childless.

The smallest portrait of the group, a size 15 – the others are all size 25 – shows Durand-Ruel's eldest daughter Marie-Thérèse (31 August 1868–19 March 1937), not quite fourteen years old, intent upon her embroidery. Her jet-black eyes are fixed on the white cloth whose border she is decorating, and her lips are parted in concentration.[41] She wears the same straw hat with its garnet brim that appears in full sunlight in *The Daughters of Paul Durand-Ruel*; her long hair falls in tresses around her shoulder, and were this not a summer portrait, one might be forgiven for reading the strokes of black, brown, and red as the fur collar of her blue dress. Renoir shows Marie-Thérèse occupied in "woman's work" (the most ubiquitous feminine activity of the nineteenth century), but he incorporates this commonplace motif without undue anecdote: Marie-Thérèse's sewing suggests neither dalliance nor excessive virtuousness. Indeed, so involved in her needlework is the sitter that she seems unlikely to suffer the hysteria that Freud attributed to the "dispositional hypnoid state" induced by the constant daydreaming to which young women embroidering were especially prone.[42]

As comparison with a photograph of Marie-Thérèse taken eight years later suggests (fig. 232), Renoir was exact in recording the rather heavy, dark-set features of his sitter, even to the point of showing the hairline on her left cheek. Marie-Thérèse inherited her thick black hair and dark eyes not only from her mother, but from her Italian grandmother, for whom she was named.[43] In 1888, she would sit to Renoir again, for a more "elegant" but less inspired portrait, which even the artist considered "dreary."[44] Marie-Thérèse was the first of Durand-Ruel's children to wed, marrying Félix André Aude (1867–after 1937), *attaché de l'ambassade*, on 23 May 1893, with whom she would have two daughters.[45] Puvis de Chavannes and Degas appeared as witnesses for the bride, in the first of the three family weddings for which they would be called upon to perform this service.[46]

Marie-Thérèse appears again, in the same hat but in a different dress, in *The Daughters of Paul Durand-Ruel*, the most "Impressionist" portrait of the series. She is seated on the left side of the bench, holding a bunch of flowers in her lap, one of which she has inserted in her red belt. The red bow in her collar serves to maintain the canvas's flickering rhythms, which swell to a symphonic iridescence as the sunlight filters through the overhanging leaves to mark the girls' dresses with an array of pinks, blues, mauves, and greens. Next to her sits Durand-Ruel's youngest child, twelve-year-old Jeanne Marie Aimée (27 May 1870–27 April 1914), smiling shyly and not quite sure what to do with her hands.[47] Her long hair braided, and her sun-hat placed to one side, she turns to face the spectator in a look that might have been confrontational had not the two girls been posed at some remove from the picture plane. Renoir records a considerable amount of information in this double portrait: Jeanne's blue choker and gold pendant, the coloured silks attached to her straw bonnet, her tightly laced boots. Indeed, he is at pains even to distinguish between the design of the girl's summer frocks: the collar of Marie-Thérèse's dress is quite small, and the folds of her skirt fall vertically from the knee. Jeanne, by contrast, has a large collar that extends almost to her shoulder, while the skirt of her dress consists of a series of horizontal pleats. In a lesser painter, details such as these would have been an impediment to the luminosity that Renoir so admirably achieves: to borrow his own words, they would have "extinguished the sun."[48]

Jeanne, who at the age of six had been the subject of Renoir's first portrait commission from Durand-Ruel (fig. 39), announced her engagement to Albert Édouard Louis Dureau (1859–after 1919), the son of a prominent family of functionaries in Lille, in July 1893.[49] The couple were married two months later in September, with Puvis de Chavannes and Degas once more acting as witnesses for the bride's family, and with Pissarro, who had sent Jeanne a painted fan as a wedding gift, more than a little put out at not being invited to the wedding ceremony.[50] No children were born to the couple, and in January 1912 Vollard had to break the news of Jeanne's cancer to Renoir: "There is someone close to you who is very ill."[51] Jeanne was operated upon immediately, and although her family were confident of a full recovery, she was hospitalized again in April 1913 and endured another year of illness before dying on 27 April 1914 at the age of forty-three. In his letter of condolence to Paul Durand-Ruel, Renoir noted that Aline would be particularly "distressed by the death of poor Jeanne, who had suffered so much."[52]

This group of portraits has generally been placed at the beginnings of Renoir's Ingresque manner, the so-called "sour" or "dry" style whose masterpieces are *Children's Afternoon at Wargemont* (cat. no. 49) and *The Great Bathers* (1884–87, Philadelphia Museum of Art).[53] However, the most cursory inspection of any of the Durand-Ruel portraits suggests that Renoir was still far from adopting the linear handling and thinning of medium that characterizes this transitional period: his brushwork is energized and painterly, he applies his pigments variously, and areas of impasto, particularly in the whites, are abundant. Nonetheless, the distinct contours of his sitters (even in *The Daughters of Paul Durand-Ruel*, Marie-Thérèse is outlined in blue) and the clear delineation of their features and costumes are evidence of a dramatic reappraisal. In his dual concern for structure and commemoration, Renoir approaches these portraits rather like bas-reliefs or frescoes; accordingly, he is less interested in details of climate or topography.[54]

Crucial to an understanding of Renoir's ambitions here is his trip to Italy of the previous winter (November 1881–January 1882), when he had extended his visual repertory in ways that would serve him for the decade to come.[55] From his correspon-

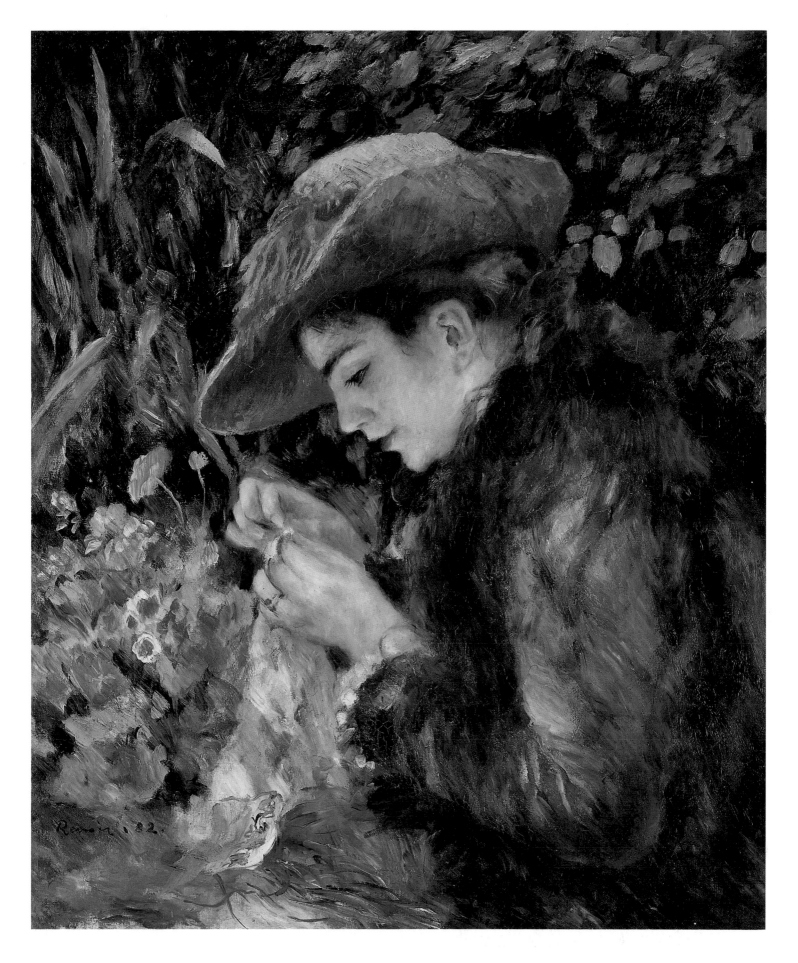

cat. no. 43

dence, it emerges that Renoir was particularly impressed by Raphael's frescoes, "admirable in their simplicity and grandeur," but less so by his oil paintings; by the frescoes in the Naples Museum, where he ordered Deudon to "spend the rest of his life"; and by public sculpture, seen in the open air.[56] It would take some time for the lessons learnt in Rome and Naples to manifest themselves in paintings done in Paris and Normandy, and Renoir himself cautioned against an easy correlation; he joked to Deudon that the critics would soon be saying that he had been "influenced."[57] But during the month-long campaign at Dieppe the following summer, certain formal solutions — above all, Renoir's iconic presentation of his sitters — imposed themselves as a consequence of his Italian experience.

In November 1881, Renoir had informed Berard: "Sculptors are the lucky ones; their statues stand in the sun and when their forms are pure, they become one with the light, existing in nature like a tree."[58] This would have aptly described the clarity and solidity of *Charles and Georges Durand-Ruel*, whose separate but interlocking forms recall an antique group such as *Pan and Daphnis*. Without assigning specific visual sources to works painted six months after the fact, there is surely more than a passing affinity between the portraits of Durand-Ruel's sons and Pompeian wall painting, for example the *Portrait of a Baker and His Wife* (fig. 230), which Renoir would have seen in the Museo Nazionale in Naples. Rivière noted that during Renoir's Italian sojourn, "the lessons of the painters" were reinforced by "the mutilated sculptures scattered in the various museums [and] by the ruins of ancient monuments."[59] Among the many antique prototypes to which *Marie Thérèse Durand-Ruel Sewing* might relate, a fragment such as *Young Girl Sewing* (fig. 231) offers the most striking visual analogy.[60] The hieratic quality of Renoir's portrait was also indebted to early Renaissance painting, particularly that of fifteenth-century Florentine masters such as Pisanello, outstanding examples of which were available to him in Paris.[61]

Barbara White has aptly observed that in the notebook he took with him to Italy Renoir made not a single copy of the art he saw.[62] Indeed, were it not for the ecstatic formulations in his correspondence, one would hesitate before positing the influence of Pompeian wall painting or antique fragments on the Durand-Ruel portraits.[63] A source nearer to home, Manet's *In the Conservatory* (fig. 233), has rightly been identified as a painting of modern life to which both *Charles and Georges Durand-Ruel* and *The Daughters of Paul Durand-Ruel* are indebted.[64] And the evidence of photography further reminds us that not the least of Renoir's concerns was to achieve a convincing and recognizable likeness in the portraits of his dealer's children. In the summer of 1882, these disparate sources cohere to produce a series of curiously formal masterpieces, portraits as imposing and, in their way, as affectionate as any in Renoir's oeuvre. With little hint of the "interior trouble" that would lead him to reformulate his manner in the mid-1880s,[65] and with Ingres yet to gain ascendancy, Renoir succeeds in reaching "the larger harmonies, without becoming immersed in the details that extinguish the sun instead of kindling it."[66]

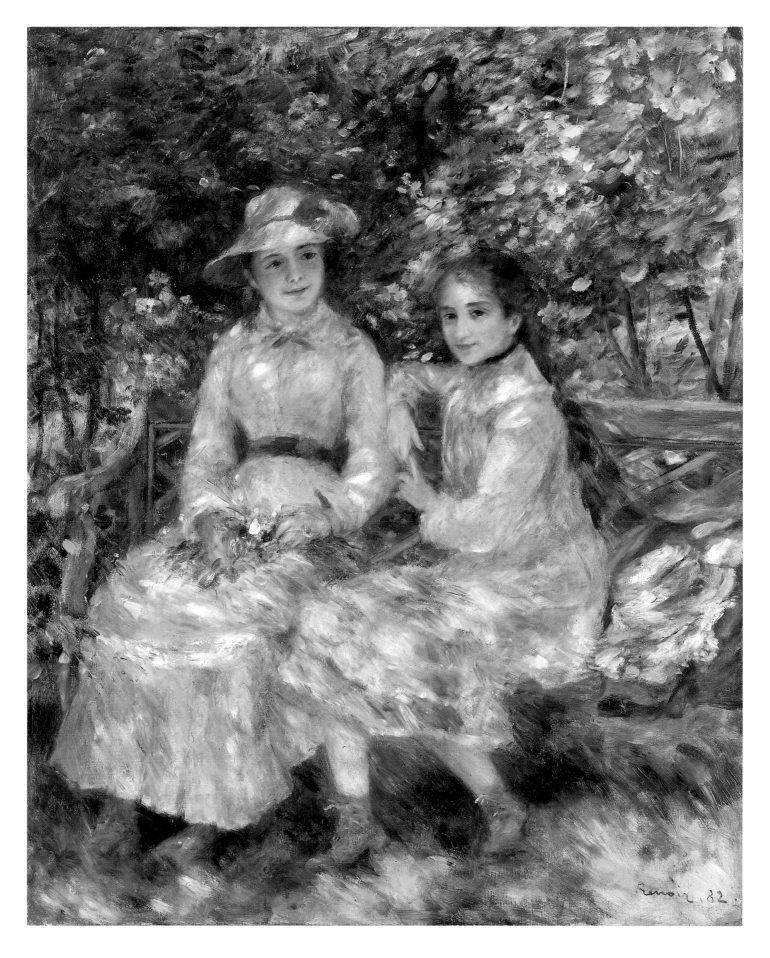

cat. no. 44

182 × 98 cm
Museum of Fine Arts, Boston
Picture Fund

To the same gallery there has been added, since we wrote last week, Monsieur Renoir's brilliant and vivacious vision of dancers at Bougival. It is of course unlike a great deal of excellent art, but it tells perfectly and with real subtlety of understanding the story of its Bohemian scene. A true knowledge of this picture persuades one thoroughly of its painter's powers of keen observation and of frank and unfettered record. The scene depicted is brought to one's very door. No artistic convention intervenes between the scene and the representation of it, provided that the artistic conventions are not in one's own eyes when one arrives to look at it.[1]

THIS UNEXPECTEDLY PERCEPTIVE first response to Renoir's *Dance at Bougival*, appearing in London's foremost art journal in May 1883, must have reassured Durand-Ruel in his decision to shop the painting to an Anglo-Saxon audience. Having been exhibited at Dowdeswell and Dowdeswell's gallery at 133 New Bond Street between April and July 1883, the canvas was next seen publicly in New York at the American Art Galleries in the spring of 1886.[2] *Dance at Bougival* was not shown in Paris until May 1892, almost a decade after it had been painted.[3] Deposited with Durand-Ruel on 16 April 1883, but not acquired by him until late in 1886, the picture remained without a buyer until January 1894, when it was sold to the businessman and collector Félix-François Depeaux (1853–1920) from Rouen on the understanding that he would eventually bequeath it to the municipal museum of his home town.[4] When financial difficulties forced Depeaux to liquidate his collection in May 1906, *Dance at Bougival* was sold for a record sum of 47,000 francs – much to Durand-Ruel's regret and well beyond the price that French museums were prepared to pay for a Renoir at this time.[5]

Among Renoir's most perfectly realized figure paintings, *Dance at Bougival* is also his most romantic: the tender yet passionate pose of the dancing couple conveys an ardour and eroticism that are almost palpable. Eyes masked by his boatman's straw hat, the male dancer expresses his intentions through a body language that is as legible today as it would have been a century ago. His companion's willing compliance, more modestly communicated, completes the harmony, both visual and sensual, that is at the heart of this painting. As light as air, the young woman waltzes "deliciously abandoned" in her partner's arms, his breath upon her cheek.

Along with *Dance in the City* and *Dance in the Country* (figs. 235 and 237) – demonstrably conceived as pendants – *Dance at Bougival* is a work that arises out of the most productive four months in Renoir's career.[6] Yet the period between January and April 1883, when Renoir was completely absorbed in the painting of these three monumental canvases, is also among the least well documented in his oeuvre. Despite the abundant literature on the paintings, and their unquestioned standing among his most popular and beloved works, their origins remain mysterious, and much that is regularly claimed of them can be shown to have no basis in fact.

Their scale and ambition notwithstanding, none of these three works was commissioned by Durand-Ruel, or painted for a specific patron,[7] or intended for the Salon.[8] An independent work in every sense, *Dance at Bougival* may not even have been painted in Renoir's modest studio in the rue Saint-Georges, since Suzanne Valadon, who modelled for the young woman, insisted that she had posed "for a motif from Bougival" in Renoir's studio in the rue d'Orchampt in Montmartre.[9] Furthermore, although Renoir's most sensitive historian, John House, has situated the genesis of this series to the summer or autumn of 1882, there is no reason to believe that the works were executed over such a long period of time.[10] Given that they are prominently signed and dated "Renoir 83," and that all three were ready for exhibition by April of that year, it seems reasonable to assume that they were painted during the winter and early spring of 1883.

With its slightly larger format and more fully realized background figures, *Dance at Bougival* may have been the first of the three dance panels, which, "simpler and more clearly structured than *Luncheon of the Boating Party* [fig. 16], were among the last of [Renoir's] major pictures of urban and suburban recreation."[11] In an unequalled analysis of these works, House has rightly stressed Renoir's new-found concentration on the foreground figures – painted in sharp focus, with no attempt to integrate them into the pictorial space.[12] For Meier-Graefe, *Dance at Bougival* and its related panels were the first instance of a "sculptural firmness" asserting itself over an earlier Impressionist mode – a stylistic conflict that would be resolved only in the nudes of 1885–87.[13] Yet to call the dance paintings "transitional" is to diminish them. The contingent, the casual, and the ephemeral are painted with the assurance of a Manet; through Renoir's wholehearted engagement in his subject, they are also rendered heroic.

If these works may be said to close Renoir's picturing of Parisian leisure, their astonishing virtuosity and sureness of touch are to be explained by a decade of immersion in the genre. Speedily executed in the studio, with a minimum of revisions, *Dance at Bougival* achieves the luminosity of Renoir's earlier experiments *en plein air* while maintaining the solidity of modelling that had characterized his most recent portraits and figure paintings (see cat. nos. 41–44, 46). Renoir's technique is both sufficiently deft to evoke the easy sociability of the supporting cast in the background – who lean forward on their chairs, smoke cigarettes, or flirt standing in top hats and white collars – while fixing our attention on the central couple, whose ardour is virtually inscribed in paint. The dancer's pink summer dress, crafted of thick strokes of primary hues blended on the canvas, is trimmed, wet on wet, with red on the bodice and bustle, and blue on the hem. Her partner's costume is an array of carefully modulated blues; his trousers, lighter than the violet-blue jacket, have been painted with a generous sampling of yellow. Renoir – the son of a tailor, after all – even indicates the lining of the oarsman's sleeves, painted white against the roseate tones of his finely modelled hands. The inclusion of such details (to which might be added the detritus on the dance floor and the oversize plums on the dancer's scarlet bonnet) never degenerates into anecdote, nor does it distract us from the central figures, whose movement is ingeniously conveyed through the blurring of focus of the background elements. Renoir's touch may be various – "finished" in

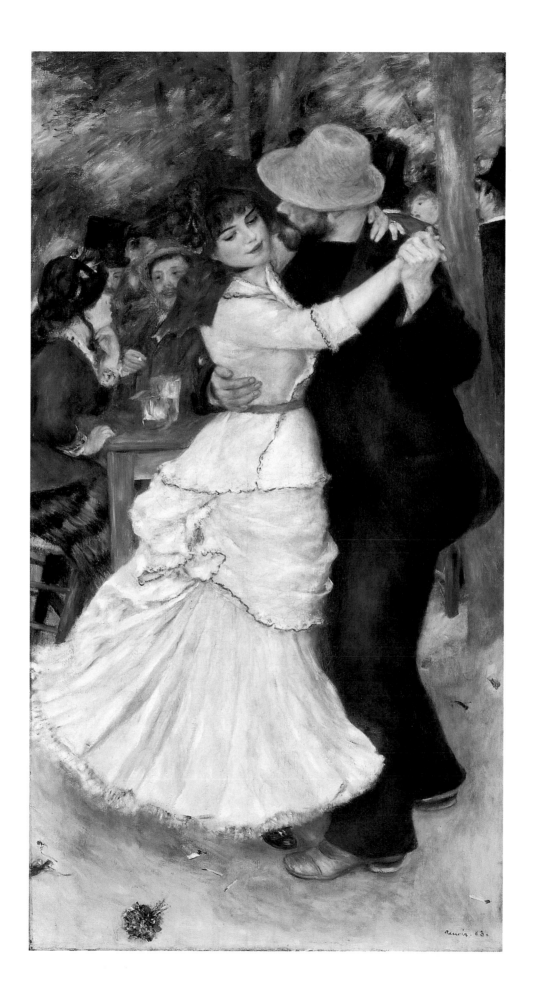

the dancing couple, sketchy in the screen of figures in the background, even more abbreviated (but not systematically so) in the foliage overhead[14] – but it serves a value system that is no longer Impressionist. In terms of spatial organization, if not subject matter, *Dance at Bougival* could be considered Renoir's earliest classical figure painting.

Yet unlike *The Great Bathers* (1884–87, Philadelphia Museum of Art), to which this epithet more obviously applies – and for which Valadon also modelled – *Dance at Bougival* was executed with a minimum of preparation: the absence of drawings or painted sketches is all the more remarkable since so few pentimenti are visible to the naked eye.[15] The most accomplished of the sheets that can be associated with this composition, Renoir's pen and ink drawing inscribed in his hand, "elle valsait délicieusement abandonnée entre les bras d'un blond aux allures de canotier" (fig. 236), was done several months after the painting; it was made for the engraving that illustrated Paul Lhote's short story "Mademoiselle Zélia", published in *La Vie Moderne* on 3 November 1883 and from which Renoir's quotation was taken.[16] The drawing modifies certain details in the painting. A bottle of wine appears on the table in the background, and a wineglass replaces the oarsman's beer; the cigarettes, matches, and violets have disappeared from the dance floor; there is no chair to the right of the dancers. But it is an otherwise faithful *ricordo*.

Around 1890, Renoir revisited *Dance at Bougival* (at this time it was part of Durand-Ruel's stock) in two soft-ground etchings, for which two preparatory drawings exist.[17] The more resolved second etching is also more sinister. Not only has Renoir altered the model's dress, replacing her bustle with a series of bows, but her partner assumes an altogether more aggressive pose, from which the woman, now almost fearful, seems to recoil.[18] The only study that may be considered in any sense preparatory to *Dance at Bougival* is a slight red-chalk drawing of the dancers (location unknown).[19] Schematic, jaunty, almost comical in its personifications, this drawing established the contours of the dancers' costumes and set their pose, but little more.

If *Dance at Bougival* appeared, complete and resolved, Athena-like from Renoir's head, this may also have been partly due to his models, whom he portrays with the sympathy and degree of characterization he normally reserved for the sitters of his portraits. The dashing oarsman who modelled for all three dance canvases was the thirty-two-year-old Paul Auguste Lhote – after Rivière, Renoir's best friend at this time.[20] An intrepid traveller, incorrigible ladies' man, and writer of occasional short stories,[21] Lhote had served with the Zouaves in North Africa and worked as a merchant seaman before taking a desk job in 1876 with Agence Havas, the forerunner of Agence France Presse.[22] Having travelled with Renoir to Algeria, Italy, and, most recently, the Channel Islands, their intimacy was well established: in April 1890 Lhote was one of four witnesses at the artist's marriage to Aline Charigot.[23]

Lhote had modelled for Renoir since 1876. He is one of the foreground figures in *Ball at the Moulin de la Galette* (fig. 15), and (if Rivière is to be believed) it is he and not Ephrussi who appears top-hatted in the background of *Luncheon of the Boating Party*.[24] While Lhote remains a shadowy figure at best, and no photographs of him are known, it can be assumed that Renoir took some licence in transforming his dark beard and moustache into those of a blonder variety. And the oarsman in *Dance at Bougival*

might well gaze intently into the eyes of his partner, since apart from being a natural flirt, Lhote was also extremely short-sighted (several anecdotes attest to his having been "blind as a bat").[25]

With the female dancer we are on safer ground in arguing that Renoir portrayed his models in *Dance at Bougival* with scrupulous fidelity to appearances. It is clear from her rather brutal *Self-portrait* (1883, Centre National d'Art et de Culture Georges Pompidou, Paris) and a fine photograph from the end of the decade (fig. 239) that in Suzanne Valadon (1865–1938) Renoir encountered a model of quite exceptional beauty, whose endless eyebrows, flawless skin, and demure smile had already recommended her to a host of painters.[26] Born Marie-Clémentine Valadon to an unmarried washerwoman from the Limousin, she followed her mother to Paris in 1871, and after rudimentary schooling apprenticed in a series of menial jobs before joining the Cirque Molier as a trapeze artist at the age of fifteen.[27] A back injury brought her circus career to an end after only six months, and she became an artist's model, though like Renoir's future wife, Valadon listed her profession as "seamstress."[28] As a model, her greatest achievement was to have posed for all the figures, young boys included, in Puvis de Chavannes's *Sacred Grove, Beloved of the Arts and Muses*, a staircase decoration for the Palais des Arts in Lyons, commissioned in the summer of 1883.[29] Unlike the other models who proliferated in Montmartre, Valadon had artistic talent of her own – her drawings were admired by no less a connoisseur than Degas[30] – and it was as a painter (and as the mother of the painter Maurice Utrillo, conceived while Valadon was modelling for Renoir's dance pictures) that she would eventually achieve fame and notoriety, as well as a substantial income.[31] A lively if unreliable memoirist, Valadon left several versions of her encounter with Renoir, for whom she modelled intermittently between 1883 and 1887,[32] noting his passion for hats – "he took me to all the milliners" – as well as the care with which he selected her wardrobe for *Dance at Bougival* and *Dance in the City*.[33]

Despite Renoir's familiarity with his models and his casting of them in appropriate roles – the ravishing grisette, the debonair Lothario – *Dance at Bougival* cannot be considered a portrait in any conventional sense (although it incorporates elements from his practice as a portraitist), nor is it an unmediated transcription of Parisian leisure. At first sight, the subject seems straightforward enough. A young woman, with a ring on her wedding finger and her scarlet bonnet properly tied under the chin, waltzes in the arms of a sturdy, passionate oarsman, while behind them, beneath the shade of yellowing plane trees, young people sit or stand in groups, drinking and smoking. Of those who can be identified, we see another rower in a straw panama and several dandified men with moustaches (but no beards) in more formal attire. The young women wear bonnets, or red flowers in their hair, and flirt with their companions.

Where is the scene located? The titles that Renoir (and later Durand-Ruel) gave to this painting should be of some help here, but they are not always consistent. When Renoir first deposited the canvas in April 1883 it was called simply "la danse à la campagne."[34] In London and New York, the painting was exhibited as "La Danse à Bougival"; in Paris, as "La Danse"; it was sold in 1906 as "Le Bal."[35] To confuse matters slightly, when in November 1883 Renoir illustrated Lhote's short story for *La Vie Moderne*, a passage of which had been inspired by this painting, he did not hesitate to reproduce the central couple from *Dance at Bougival*,

even though Lhote's tale is set in Montmartre, with Mademoiselle Zélia and her blond oarsman waltzing on the terrace of the Moulin de la Galette.[36]

Clearly, Renoir presents us with Parisians participating in a form of entertainment that was not confined to the city itself. Bougival, "a prettily situated village . . . much frequented by rowing parties," was located eighteen kilometres west of Paris, on the opposite bank of the Seine from Chatou, and within walking distance of La Grenouillère, considered less "select."[37] This village of some 2,000 inhabitants boasted two café-restaurants, the Café de Madrid and Café de Pignon, either of which might have inspired Renoir . By the early 1880s Bougival was celebrated for its community of artists; Turgenev and Berthe Morisot had both purchased villas there.[38]

Perhaps the site is of less importance than the scene: Edmond Renoir, who provided a series of articles on the environs of Paris for *La Vie Moderne* in September 1883, considered Bougival and Montmartre virtually interchangeable.[39] Renoir shows his attractive, healthy, young characters enjoying a Sunday afternoon *bal*, or open-air dance, a popular form of recreation among working-class Parisians for more than half a century. Less particularized in its setting than *Ball at the Moulin de la Galette*, painted seven years earlier, *Dance at Bougival* evokes the same robust, slightly bawdy bonhomie, presenting a similar mix of classes (again, without a corresponding mix of ages). As Robert Herbert has pointed out, it is a scene that reveals more about Renoir's urban utopia than about the realities of public dancing in Paris and the suburbs.[40] Yet if Renoir's vision is wilfully roseate, it is not without focus: modernity is in the details. The array of matches and cigarettes strewn across the ground reflect the democratization of this bourgeois habit.[41] Valadon's pink dress and bustle, as well as the fruit decorating her "chapeau Niniche," are examples of the latest summer fashions – not high fashion, but fashion nonetheless.[42] Valadon's hair is cut "à la chien," its fringe left low on her forehead in a style introduced in 1883.[43] And comparison with the dancing couple at the far left in *Ball at the Moulin de la Galette*, who fairly grab at each other's waists, confirms that Valadon and Lhote waltz in a manner that would not have shocked polite society.[44]

Valadon, in her Sunday best, might be one of Jules Vallès's "Republican girls who can dress elegantly for a louis and smell sweetly from a bouquet that costs a sou," but despite its contemporary resonance, *Dance at Bougival* is clearly an idealized painting of modern life.[45] The open-air public dances, celebrated in both *Dance at Bougival* and *Dance in the Country*, had reached their heyday during Louis-Philippe's reign and had been in steady decline since the early years of the Second Empire.[46] While they remained popular in Paris and the suburbs, their organization had changed – the cotillion ("quadrille") was replaced by dances such as the waltz and the polka – and they came to cater almost exclusively to a petit bourgeois and proletarian public.[47] Rarely as decorous as Renoir would have us believe – Winslow Homer's engraving of a dance at the Bal Mabille, one of the more venerable public dance halls, which closed its doors in 1882, is more authentic reportage (fig. 234) – the *bals* underwent a second transformation during the 1880s, as popular culture in Montmartre was marketed – and commodified – for a bourgeois public. Increasingly professionalized, with paid dancers clearing the floor to perform the lascivious *chahut*, the *bals* also became notorious sites for prostitution and pimping ("raccrochage").[48] These were the aspects that attracted a younger generation of progressive painters, notably Toulouse-Lautrec, whose mistress Valadon soon became, and whose great paintings of the Montmartre entertainments chronicled the drab and tawdry qualities of the nocturnal *bal*.[49]

A comparison between Renoir's depiction of Valadon in *Dance at Bougival* and Lautrec's use of her for his haggard *Drinker* (fig. 240) eloquently summarizes the distance travelled.[50] Edmond Renoir could still write that "the *bals* have remained what they have always been, the only form of respectable entertainment," but he was indulging in the same sort of nostalgia that infused his brother's art.[51] Even at Bougival, these dances had hardly been "respectable" (fig. 238). And as early as 1867 Madame Morisot cautioned her daughter against a village renowned, in her words, "as a rustic meeting place frequented by the most frivolous society, where a man might arrive alone, but is sure to return in the company of at least one other person."[52]

By the mid-1880s, the mixing of classes and regional types that had sustained Renoir's most ambitious figure paintings (the oarsman and bourgeois still sit at the same table in *Dance at Bougival*) could find little validation in the brittle realities of an increasingly commercialized popular culture. It is not surprising that the dance panels mark Renoir's withdrawal from urban and suburban subjects; the terrain had become too rude. His themes will reappear towards the end of the decade in the work of Lautrec and Seurat, there to be depicted with more searing honesty perhaps, but with less joy.

81.8 × 65.2 cm
The Art Institute of Chicago
Mr. and Mrs. Martin A. Ryerson Collection

Painted early in 1883, *Madame Clapisson* was Renoir's "second try" at the portrait of Marie Henriette Valentine Billet (20 October 1849–30 August 1930),[1] the young wife of Louis Aimé Léon Clapisson (26 November 1836–12 March 1894) – retired lieutenant, stockbroker, and recent convert to the New Painting.[2] Thirteen years younger than her husband, Valentine Billet had been born in Paris out of wedlock to the nineteen-year-old Virginie Roch from Strasbourg. Only in April 1865, a month before her wedding to Clapisson – she was not yet sixteen – did her father Henri Billet, a retired stockbroker living in the municipality of Sannois, recognize his daughter.[3] Her mother did not attend the wedding, which took place at Sannois on 20 May 1865, in the presence of Clapisson's parents – his father, Louis Antoine (1808–1866), the prolific composer of light operas, had been elected to the Institut the year before – but her written consent was delivered by Billet's current wife, Alexandrine Gouverneur.[4] From such unorthodox beginnings, a comfortable, indeed prosperous, household was established, with Clapisson and his wife acquiring an imposing mansion at 48 rue Charles-Laffitte in Neuilly in 1881. The couple were without issue, having lost a child of whom nothing is known apart from a brief mention in Clapisson's military record of 1877.[5] And although, as Anne Distel has noted, Clapisson is traditionally listed as a stockbroker – the profession of his father-in-law – in most of the documents that have been discovered his profession is given as "rentier."[6] The source of his substantial income remains somewhat mysterious.

Renoir claimed to have met the Clapissons through Madame Charpentier (see cat. nos. 31, 32), and it is quite possible that the senior Clapisson had known Marguerite Lemonnier's parents.[7] By the age of thirty, Valentine had established herself as a hostess of some distinction – her white sauce was discussed in the society pages of *La Vie Moderne* in June 1879[8] – yet it was only after her husband's interest in modern art took a sharp turn towards the Impressionists that Renoir was called upon to paint her portrait. Durand-Ruel, rather than Marguerite Charpentier, may have been the conduit here.

The commission had originated in the summer of 1882, when Renoir was invited to paint the portrait of Madame Clapisson in the garden of the couple's mansion at Neuilly. There he laboured during the last week of June, but although the sitter was compliant, and the roses easily done, Renoir experienced difficulty in bringing this "wretched portrait that will not work"[9] to completion: "My days are spent taking the canvas back indoors . . . After making this exquisite woman put on a spring dress, the sessions always end in the same way."[10] To compound his frustration, the *plein-air* portrait of Madame Clapisson taking tea in the rose garden (fig. 94) was deemed unacceptable and returned to the artist, who agreed to provide a more appropriate replacement.[11]

Clapisson's reaction to the first portrait, judged "too audacious," is difficult to comprehend.[12] He clearly appreciated Renoir's most recent manner, having just acquired three of his North African scenes from Durand-Ruel,[13] and in May 1882 he had purchased Manet's high-keyed *Bench* (fig. 241), which may well have inspired Renoir in his first portrait of Madame Clapisson.[14] Unsettled, Renoir did not abandon portraiture in the open air – he would go on to repeat the format of *Dans les roses* in his double portrait of Durand-Ruel's daughters (cat. no. 44) – but he tailored his style to suit the wishes of his patron. In his second portrait of Madame Clapisson, she is shown dressed for a ball, seated indoors in a conventionally elegant pose: she could easily be one of the women in Béraud's *Coquelin the Younger Reciting a Monologue* (fig. 242).

Madame Clapisson was Renoir's sole submission to the Salon of 1883, where it was overlooked by the critics and the authorities alike. It is hard to believe that Renoir still hoped for official recognition, but he seems to have been discouraged by the lack of response. This, at least, was the assumption of the English painter John Lewis Brown, who in a letter of September 1883 confided to Durand-Ruel that Renoir's portrait had made more of an impact than he realized: "The gentlemen of the jury, in admitting his work, could not help exclaiming that his painting was a 'blond' Delacroix. What medal could equal such praise from one's enemies?"[15] Renoir was well remunerated for this commission – he received 3,000 francs, twice as much as Charpentier had paid for the portrait of his wife and children[16] – yet although he remained on good terms with Clapisson, this was the last painting by him to enter the stockbroker's collection.[17]

Renoir would later tell Vollard how much he had enjoyed painting the two portraits of the "charming Madame Clapisson," but he was less sanguine at the time.[18] He complained to Berard: "I cannot tell whether it will turn out to look much like her, since I am no longer capable of judging for myself."[19] Indeed, while *Madame Clapisson* offers "a remarkable synthesis of the conventions of Neoclassical portraiture with a colourist palette," this synthesis was not effortlessly achieved.[20] Renoir initially gave his sitter a much fuller coiffure (her chignon occupied a greater space to the right), which was then reduced and reworked, with the white and blue aigrette added almost as an afterthought. He seems to have been unsure of the placement of her right arm, which he shifted and then returned to its original position, and he substantially reworked her fan. At twice the size, the fan's uppermost edge originally lay parallel with her upper arm, and it continued to the lower-left corner of the canvas. Such is Renoir's technique of painting wet on wet here that his earlier brushstrokes are still visible: traces of the white feathers can be seen beneath Madame Clapisson's cobalt-blue dress.

Although the decorous pose and presentation of Renoir's sitter invite comparison with conventionally fashionable portraiture such as Gervex's *Avant le bal* (fig. 243), *Madame Clapisson* was hardly the compromise that Duret claimed.[21] With its double priming of lead white, and the generous admixture of white in almost all the pigments used, it is very far from adopting the "nice black background" of a Bonnat.[22] And the weave of colours that create an aureole around the sitter, no less than the Naples yellow that models her arms and neck, can hardly be considered "sober."[23] In fact, in its unyielding luminosity, *Madame Clapisson* maintains the intensity of Renoir's portraits of the previous summer, though its setting is now pared of those naturalistic elements to which the artist might still feel a lingering responsibility. It is the beginning of a process of liberation that culminates in the radiant *Aline Charigot* (cat. no. 50).

47 *Child in a White Dress (Lucie Berard)* 1883

61.7 × 50.4 cm
The Art Institute of Chicago
Mr. and Mrs. Martin A. Ryerson Collection

B Y THE AGE OF THREE, when Renoir painted her standing very still in a white blouse and smock, Lucie Louise Berard (10 July 1880–26 March 1977) had already sat (or slept) to Renoir and Mary Cassatt.[1] Renoir commemorated the birth of the youngest of the Berards' four children in a joyous letter (fig. 52); he had included Lucie three times in *Studies of the Children of Paul Berard* (cat. no. 39), and would record her intense features twice more: in the mesmerizing *Lucie Berard in a White Pinafore* (fig. 244) and as part of the trio in *Children's Afternoon at Wargemont* (cat. no. 49), his valedictory portrait of the Berard family.

In March 1905 Lucie was betrothed to Jules Edmond David Pieyre Lacombe de Mandiargues (30 March 1879–9 August 1916), a civil engineer: the bans were read on 12 and 19 March, and a marriage contract drawn up on 23 March.[2] The ceremony itself did not take place until 11 April 1905 and could not have been a happy one, since the bride's father had died unexpectedly eleven days earlier, on 31 March 1905, and Lucie would have been in the second week of mourning.[3]

The couple had two sons, André (1909–1993) and Alain (born 1915). André Pieyre de Mandiargues became a prominent novelist and poet, whose early work was much influenced by the Surrealists. David Pieyre de Mandiargues died at the front in August 1916 – he was decorated with several military honours and commended for his exceptional bravery – and his wife never remarried.[4] With the longevity characteristic of the Berard girls, Lucie Pieyre de Mandiargues died on 26 March 1977, three months before her ninety-seventh birthday.[5]

Child in a White Dress is deceptive in its simplicity. In its transition from ultramarine to duck-egg blue, the freely brushed background conveys both the depth and passage of light suggestive of an actual setting: yet Renoir gives absolutely no clues in this regard. His touch is various, from the active scumbling of the *fantaisiste* background, to the more blended, "finished" application of paint on Lucie's face, hair, and hands, rendered in relatively "soft" focus.[6] Small pools of impasto evoke the embroidery on the yoke of Lucie's smock and the ivory buttons that continue to the picture's lower edge. Her golden hair is painted with highlights of olive green and rose madder, and the creases of her billowing sleeves are suggested by strokes of violet-blue.[7]

Renoir's structure and handling repeat, in a more muted register, his procedure in *Madame Clapisson* (cat. no. 46), a portrait painted immediately before *Child in a White Dress*. Informing Berard of the difficulties he was experiencing in completing the Clapisson commission – "le portrait deuxième édition" – Renoir assured him that "this will allow me to get my hand back so that I can start on Lucie as soon as you arrive."[8] Although the precise dating of Renoir's letter is problematic, it is likely that *Child in a White Dress* was painted after Durand-Ruel's exhibition of April 1883 – to which Berard lent seven works, and would surely have included this portrait, had it been finished – and before Renoir's month-long holiday in Guernsey in September 1883.

If to late-twentieth-century eyes *Child in a White Dress* comes perilously close to the saccharine or sentimental, these were not the qualities immediately apparent to Renoir's contemporaries, who were increasingly discomfited by the unconventional format and colouring of his portraits of children. The incomprehension and hostility that greeted Renoir's commissioned portraits of 1882–83 is discussed elsewhere in this catalogue, and it is within such a context that *Child in a White Dress* should be understood.[9] On 12 December 1883, Berard confided to their mutual friend Charles Deudon that Renoir was "utterly discouraged," overwhelmed by his new studio, and without a single commission in sight:

> I've gone to the expense of having a beautiful frame made for the portrait of Lucie, which I've hung in the best spot in my study, and Marguerite and I swoon with pleasure in front of it; but unfortunately for Renoir, we cannot get others to derive the pleasure that we do from his work, and this portrait, so different from the type that Henner paints, simply frightens people away.[10]

Berard surely had in mind such "sensitive" portraits as Henner's ubiquitous *Alsatian Girl* (fig. 245). While such works – and others like it by Carolus-Duran, Baudry, and Bastien-Lepage – rejected the porcelain finish and attention to detail that characterized high academic painting, they nonetheless maintained a "poetic" presentation and Rembrandtesque chiaroscuro that satisfied haut bourgeois Republican taste. Renoir's portrait of the banker's daughter-turned-Infanta questions these proprieties, thereby assuming a disturbing quality that can be appreciated today only by the most determined leap of the historical imagination.

57 × 43 cm
The Nelson-Atkins Museum of Art, Kansas City, Mo.
Purchase: Nelson Trust

"WHO HAS EXPRESSED MORE perfectly than Renoir has the beautiful animalism of childhood?"[1] Roger Fry's observation is well exemplified by the portrait of four-year-old Paul Haviland, who poses in the blue and white sailor suit worn by the sons of the well-to-do, his soft hands resting against an almost invisible table-top of Louis XVI design.[2] With a slightly glazed expression on his face – and with the large ears and almond eyes seen also in a photograph taken the previous year (fig. 248) – Paul returns our regard with the docility of an affectionate puppy.[3]

Despite the sobriety of Renoir's presentation – for once, he actually employs a "nice dark background" – his handling is rich and occasionally impasted, almost Impressionist in parts.[4] The white piping on Paul's collar and cuff is applied wet on wet, the cobalt blue of his costume inflected with crimson; his blond hair is a mosaic of mauves, blues, and yellows. And while, in keeping with the "solidity of modelling" that characterizes Renoir's style in the early 1880s, the contours of this composition are more defined, *Paul Haviland* has neither the uniform surface nor the sharpness of focus of *Children's Afternoon at Wargemont* (cat. no. 49), painted later in the year.[5]

Christened simply Paul Haviland – he would adopt the middle name Burty in adulthood – Paul was born in Paris at 9 avenue Hoche on 17 June 1880 to Charles Edward Haviland (7 January 1839–15 March 1921), the Protestant porcelain manufacturer (fig. 246), and his much younger second wife Madeleine Burty (13 November 1860–13 December 1900) (fig. 247), daughter of Renoir's friend the critic and fervent *japoniste* Philippe Burty (1830–1890).[6] Paul's father, Charles, had been born in New York to the American engineer David Haviland (1814–1879), who had moved to Limoges in 1842 to establish a company that designed porcelain for export to the United States. It was Charles who was responsible for the transformation of the family firm into a manufacturing industry. Not until 1865 did Haviland et Cie produce its own porcelain, and in 1872 Charles founded a separate workshop in Auteuil, west of Paris, where, under Bracquemond's direction, the company experimented with innovative glazes and decoration inspired by Japanese and Islamic models.[7]

Edmond de Goncourt might describe Haviland's wares as "little more than chamber-pots for America," but Degas was one of the artists who provided designs for his Impressionist vases in the later 1870s.[8] By the middle of the decade, Haviland was collecting Japanese prints under the guidance of Philippe Burty – he owned no fewer than 6,000 examples at the time of his death – and during the 1880s he also acquired a handful of superb Impressionist pictures, including Manet's *Café-concert* (1878, Walters Art Gallery, Baltimore), Degas's *Jockeys before the Start* (c. 1879, Barber Institute of Fine Arts, Birmingham), and Renoir's *Onions* (1881, Sterling and Francine Clark Art Institute, Williamstown, Mass.).[9] Haviland's taste was not exclusive, however; the most admired modern painting in his collection was Puvis de Chavannes's *Woman at Her Toilette* (1883, Musée d'Orsay, Paris), bought directly from the artist for 3,500 francs.[10]

Charles Haviland's first marriage, to Marie-Valérie Guillet (1843–1873), a wife he seems to have adored, produced a daughter, Jeanne (1865–1916), and a son, Georges (1870–1947).[11] A widower with two young children, this "sensual American" was then swept off his feet by the beautiful seventeen-year-old daughter of Philippe and Euphrosine Burty, to whom he had been introduced at a dinner given by the Bracquemonds.[12] The couple married on 27 July 1877, with Bracquemond, Goncourt, and Gambetta as witnesses, and Madeleine bore him three sons in regular succession: Paul (1880–1950), Jean (1883–1961), and Franck (1886–1971).[13] Despotic and unyielding, Charles Haviland soon tired of his extravagant and increasingly neurasthenic wife, and from 1887 began to live openly with his twenty-one-year-old mistress, Eugénie Hulot. Ever more unstable, her mental health deteriorating as a result of the breakdown of her marriage, Madeleine committed suicide at her mother's home in December 1900 by shooting herself in the head with a pistol.[14]

Although Renoir may have come into contact with Charles Haviland during the 1870s – the artist's first career, after all, had been as a decorator of porcelain plates and vases[15] – the commission to paint the portrait of Haviland's first son from his second marriage was no doubt due to Philippe Burty, although there is no evidence to support the claim that Burty had included paintings by Renoir in Madeleine's dowry.[16] As a lender to Petit's Japanese exhibition of March 1883, Haviland would also have known Charles Ephrussi, who vigorously promoted Renoir's skills as a portraitist in the early 1880s.[17] Although he acquired, in 1884, at least two other paintings by Renoir,[18] and the two men remained on good terms (in the summer of 1893 Renoir encouraged Berthe Morisot to accept Haviland's invitation to his country house outside Limoges, recalling "the wonderful chestnut groves on the hillside" there[19]), the wealthy industrialist did not employ Renoir's services as a portraitist again. Here he behaved differently from Renoir's other haut bourgeois patrons, who, if they chose not to sit to the artist themselves, at least had him paint the portraits of each of their children.[20]

Whereas Haviland's son from his first marriage maintained the family's commitment to manufacture and commerce, those from his second marriage inherited the artistic inclinations of their maternal grandfather Burty.[21] Educated at the Lycée Condorcet, Paul received a bachelor's degree in philosophy from the Université de Paris in 1898 and went on to do postgraduate work at Harvard between 1899 and 1901. Upon graduating he moved to New York as a representative of his father's firm, but soon gravitated to Alfred Stieglitz and his little galleries of the Photo-Secession at 291 Fifth Avenue, from whom, in January 1908, he acquired a series of watercolours by Rodin. The meeting with Stieglitz – who welcomed the support of this attractive, urbane, and wealthy amateur (fig. 249) – rekindled his interest in photography, which he had practised as a boy, and much encouraged by him Haviland began to produce photographs seriously.[22] Having worked with Clarence White in 1909, in November of the following year he exhibited seven prints in the open section of Stieglitz's ambitious *International Exhibition of Pictorial Photography*, organized at the Albright Gallery, in Buffalo, New York.[23] In February 1908, Haviland guaranteed the lease of Stieglitz's new gallery across the hall from "291." Between 1910 and 1915 he served as associate editor and regular contributor to *Camera Work*, today considered "probably the most influential and certainly the

most handsome periodical ever published to promote photography as art."[24] Before long he was devoting more time to criticism and photography than to business – in 1913 he was the co-author with the Mexican caricaturist Marius de Zayas of *A Study of the Evolution of Plastic Expression*, and his portraits and views of New York rank among the finest examples of the Pictorialist movement. Paul was recalled to Paris by his father in July 1915, soon after the outbreak of the First World War.[25] With Zayas and Agnes Meyer, he had just launched the avant-garde journal *291*, whose fourth issue published Picabia's portrait of him.[26]

In 1914 Haviland listed his credentials as "Haviland & Co., lover of art, photographer, writer, associate Editor of Camera Work," and even here it was clear that the family business took priority.[27] Once back in France, Haviland was sent to work in Limoges, but relations with his father were increasingly strained and eventually he was obliged to sell his shares in the company. Having withheld his consent on two previous occasions, in December 1917 Charles permitted his son to marry the painter and decorator Suzanne Renée Lalique (1892–1989), natural daughter of René Jules Lalique, the celebrated jeweller and glass-maker, and Augustine Ledru, the daughter of a sculptor.[28] Paul soon took over the running of his father-in-law's factory at Combs-la-Ville, outside Paris, and in 1920 Haviland and his family left Paris to supervise the operations of Lalique's new glass house in Wingen-sur-Möder in Alsace.[29] Although he inherited a substantial bequest from his father's estate in 1922, Haviland seems to have experienced financial difficulties later in the decade, and he apparently even considered making a career as a commercial photographer.[30] Now the father of two children, Jack René (born 1918) and Nicole (born 1923), he abandoned business for viticulture, and in 1934 acquired the Prieuré de la Mothe, a seventeenth-century priory at Yzeures-sur-Creuse, northeast of Poitiers, where he lived out the rest of his days as a gentleman farmer. He died in Paris at the Lalique family home at 40 cours Albert 1er on 21 December 1950.[31]

49 *Children's Afternoon at Wargemont*
 (*Marguerite, Lucie, and Marthe Berard*) 1884

127 × 173 cm
Nationalgalerie, Berlin

T HE MOST MONUMENTAL AND AMBITIOUS of the fourteen
 family portraits commissioned by Paul Berard – and for
which Renoir received "only a very modest sum"[1] – *Children's
Afternoon at Wargemont* was painted during the summer of 1884 in
the family's eighteenth-century manor house, ten kilometres
north of Dieppe, that had been Renoir's country retreat for half a
decade (fig. 250).[2] The château de Wargemont had passed to
Berard through his maternal grandmother, Ursule Brigitte
Merlin, the comtesse d'Haubersart (1782–1855), who had inher-
ited the property in 1844 and who, after the death of her first son
in 1868, had entailed the house and grounds to her eldest daugh-
ter, Lodoyse Marie d'Haubersart (1802–1884), Berard's mother.[3]
Berard's two youngest daughters had been born at Wargemont,
and all three had sat to Renoir before.[4] Hence the quiet self-assur-
ance of girls whom Blanche had dismissed as "unruly savages who
refused to learn to write or spell," here portrayed in one of the
château's spare but elegantly furnished ground-floor salons look-
ing onto a lush, sunny garden.[5] At left, sitting on the Louis XVI
canapé that remains at Wargemont to this day (fig. 251), the
middle daughter, Marguerite (Margot), just ten years old, reads a
sumptuously bound children's book. Shown standing, in a blue
sailor suit, the youngest daughter, Lucie, who had celebrated her
fourth birthday on 10 July, rests her porcelain doll on her elder
sister's lap. Fourteen-year-old Marthe, her long hair braided with
a red ribbon, concentrates on her sewing.

Of similar dimensions to *The Great Bathers* (Philadelphia
Museum of Art), upon which Renoir may have embarked at the
same time, *Children's Afternoon at Wargemont* was painted with a
minimum of preparation and with remarkable concentration.[6]
The angle of Margot's book has been adjusted, as has the arm and
back of the canapé on which she sits, but such changes are very
slight. Even if, as Meier-Graefe first noted, Renoir had the
benefit of knowing his young sitters very well, his iconic presen-
tation of them was achieved with little of the self-questioning that
attended the production of *The Great Bathers*, which took three
years to complete.[7]

So vivid and arresting is this group portrait that the extrava-
gance and eccentricity of Renoir's composition are not immedi-
ately apparent. Rarely had the artist's polychromy been pushed to
such limits, and it is the extraordinary pitch of *Children's Afternoon
at Wargemont* to which Blanche was objecting when he described
the painting as "lit up like a street lamp."[8] Indeed, to our eyes,
Renoir's canvas invites comparison with Ensor and Balthus rather
than with the society portraitists of the Belle Époque.[9] It is worlds
apart from Sargent's *Daughters of Edward D. Boit* (fig. 252), another

masterpiece of the genre, which Renoir would have seen at the
Salon of 1883, and with which it shares not only its scale and sub-
ject matter, but also its considerable ambition.[10]

The elements of Renoir's heterodoxy in *Children's Afternoon at
Wargemont* were brought to light in an unequalled analysis by the
German art historian (and author of the first monograph on
Renoir) Julius Meier-Graefe (1867–1935), who had ample leisure
to study the painting after its donation to the Nationalgalerie in
Berlin in December 1906.[11] Meier-Graefe perceived immediately
the stylistic kinship between this group portrait and Renoir's
"Bathers" of the 1880s: it too eschews Impressionist technique
("l'impressionnisme dissolvant"), and manifests a tendency
towards idealization, with the faces of the girls now treated syn-
thetically, almost as types.[12] Most striking, however, was the sur-
real lighting in *Children's Afternoon at Wargemont* – "a light that
gives no heat and does without shadows" – and the fantastic
quality of the setting, despite Renoir's faithfulness to appear-
ances.[13] This was a sitting room with no walls, "a residence of the
sun."[14] Spatial recession, plasticity of form, solidity of modelling
– the stock-in-trade of the figure painter – might all be in evi-
dence here, but they are achieved through extreme stylization,
with the artist finally liberated from the tyranny of the object.[15]

The simplified contours and hieratic quality of Renoir's com-
position have since been regularly commented upon, as has his
reductive and at times literal-minded touch, which is neither con-
sistently Ingresque nor Cézannesque.[16] Indeed, in places the paint
is almost trowelled on, with the Caucasian carpet on the table, the
chintz draperies, the pot of nasturtiums, and the dresses of the girls
each variously impasted.[17] Perhaps the most radical aspect of
Renoir's manner here, as Anne Distel has recently pointed out, is
its democracy of values. The traditional hierarchy between sub-
ject and setting, maintained even in Impressionist figure painting,
is now collapsed: Marthe's profile is rendered with the same touch
and emphasis as the porcelain jardinière or the floral-patterned
curtains, and the furnishings and costumes are painted with "the
same density of colours" as the figures.[18] Such parity of tone and
touch, visually disturbing though it must have been to Renoir's
contemporaries,[19] may be related to the artist's "Irregularist" prin-
ciples, which were being worked out at this very time. At one
level *Children's Afternoon at Wargemont* reflects his belief that the
fine and decorative arts should be reintegrated in contemporary
practice, as they had been during the Ancien Régime.[20]

In its painstaking literalness, *Children's Afternoon at Wargemont* is
a mosaic of pattern and hue, with no detail too insignificant for
Renoir's sharp eye: the herringbone floorboards, the ribbon orna-
ment carved into the canapé's seat rail, the green ribbon ties on
Margot's book, the casters on the legs of the table. Yet for all this,
the group portrait is less direct a transcription of life in
Wargemont than might be thought. From Renoir's letter to
Berard regarding the bust portrait of Lucie, "nouvelle manière" –
a more modest portrait commissioned around the same time
(fig. 244) – it is clear that Renoir hesitated before undertaking

new work for his devoted patron and friend. "I will not begin work on a portrait until I am sure of myself and until I have finished my research . . . If I do anything more for you, I want it to be the last word in art."[21] Surely, one can argue, Renoir would have been no less scrupulous with regard to *Children's Afternoon at Wargemont*, even if his preparations, his "recherches," cannot be documented with the same degree of precision here. Indeed, an undated letter to Berard, written in the summer of 1884, suggests that the group portrait may not have been executed exclusively at Wargemont, but was probably finished in Paris, in Renoir's new studio at 37 rue Laval: "I cannot tell you whether the painting is any good, since it is not yet quite dry . . . I also do not know whether I should bring the large canvas with me, so as to frighten the children."[22]

If this is in fact a reference to *Children's Afternoon at Wargemont*, it establishes that Renoir was at work on the portrait without the sitters in front of him, as would be the case when he was commissioned to paint the daughters of Catulle Mendès (fig. 8) four years later.[23] And it further helps explain the slight inaccuracy in Renoir's recreation of the ground-floor salon overlooking the garden at Wargemont. Noting that "there had never before been such a room in the history of painting," Meier-Graefe unwittingly touched upon this issue when he concluded, "and one is tempted to ask if the room really existed."[24] Of the five ground-floor reception rooms at Wargemont, which have remained essentially unchanged since Renoir's day, only two have the distinctive herringbone floorboards that appear so prominently in the painting. The first of these, the library for which Renoir painted floral decorative panels, is not the room represented here, since the walls of the library are lined with bookshelves.[25] The salon adjoining the library is indeed the site of Renoir's portrait – even the handle of the casement window has been meticulously recorded – but Renoir erred with regard to the boiseries, which he has shown as adjacent panels of different dimensions, an oversight that would not have been tolerated in eighteenth-century domestic architecture and is not in evidence in the room itself.

While this misprision has gone unnoticed, it has long been acknowledged that *Children's Afternoon at Wargemont* is indebted to examples from ancient art and Renaissance painting for its colourism, drier handling, and frieze-like composition. As early as 1905, Roger-Milès evoked the influence of Primaticcio and his school; more recently, a case has been made for Ghirlandaio, whose frescoes Renoir would have seen during his visit to Italy in 1881–82, or Botticelli, two of whose frescoes were acquired for the Louvre from Charles Ephrussi in February 1882.[26] While a specific prototype for *Children's Afternoon at Wargemont* – comparable to Girardon's fountain for *The Great Bathers* – cannot be cited, a potent source here is classical relief sculpture. The composition's divided grouping – with Marthe at right in uncompromising profile – and the shallow, separate space inhabited by each of the figures, are formal qualities characteristic of the Hellenistic reliefs (fig. 253) that Renoir had so admired in Naples.[27]

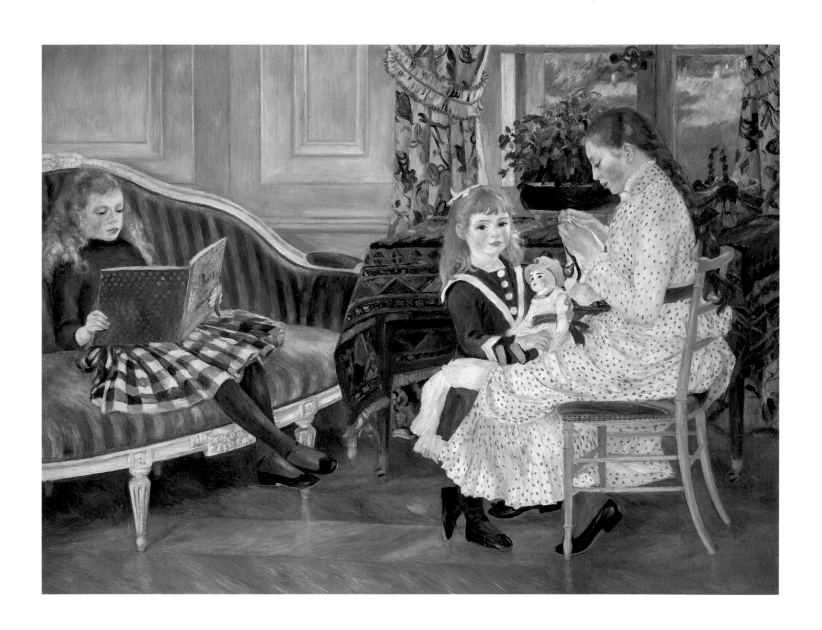

65.4 × 54 cm
Philadelphia Museum of Art
W.P. Wilstach Collection

ALINE VICTORINE CHARIGOT WAS BORN on 23 May 1859 in Essoyes – a town of under 1,500 inhabitants in the Champagne region – to Claude Charigot (1836–before 1915), a baker, and his wife of six months, Thérèse Émilie Maire (1841–1917), a seamstress.[1] Of peasant stock, both parents came from families of wine-growers, and Aline was to be the only child of their short-lived and unhappy union. Claude abandoned his wife and daughter early on and emigrated to the United States, apparently becoming a farmer in the Red River Valley in North Dakota.[2] Thérèse and Aline moved to Paris, where they eked out a penurious existence, Aline learning her mother's trade and entering the workshop of a dressmaker from Dijon in the butte Montmartre.[3] According to Jean Renoir, his maternal grandfather went on to marry a Canadian girl; Thérèse Charigot was granted a divorce on 21 March 1887.[4]

Very little is known of Aline's early days in Montmartre, although Jean Renoir insisted upon the respectability of his grandmother Charigot (called Mélanie by her family), "entrenched in her propriety and domestic virtue."[5] It was from Montmartre's floating population of seamstresses and dressmakers that artists habitually took their models (and their mistresses), and Renoir seems to have met Aline in this way. After the death of Alma-Henriette Leboeuf, the model "Margot," Aline began to pose regularly for Renoir, most notably as the fashionable flirt playing with her lapdog in *Luncheon of the Boating Party* (fig. 16).[6] By 1881 she was Renoir's mistress, accompanying him at the end of the year to Naples and Capri (a trip she later referred to as their honeymoon[7]), where she posed with a gold band on her wedding finger for the resplendent *Blond Bather* (fig. 254).[8] She was also the model for Lauth's cheery partner in *Dance in the Country* (fig. 237).[9]

Despite having posed for innumerable subject pictures, Aline sat to Renoir for only three portraits – two of which show her as an old woman (see cat. no. 62 and fig. 256).[10] This earliest of the three, signed by Renoir while the paint was still wet, is among the most luminous and direct of all his portraits, and is generally assigned to the summer or autumn of 1885, in the months following the birth of their first son, Pierre, on 21 March 1885.[11] A patchwork of richly impasted whites, blues, and yellows, from which Aline's ruddy cheeks and hefty arms sing out with the clarity of a bell, *Aline Charigot* is painted in a manner that recalls Cézanne's hatching brushwork of the mid-1880s, but without fully adopting its detached regularity. Renoir's impasto is more wayward, applied in dabs and touches to model Aline's shapeless jacket as it falls across her waist, and blended wet on wet in the jaunty flowers on her straw bonnet. As is customary, his handling is at its most delicate in the treatment of his sitter's face and neck, the latter modelled with the consistency of porcelain. With Aline portrayed slightly off centre – her hair dishevelled, her tiny gold earrings just visible (but no ring on her fourth finger!) – the painting pays discreet homage to the principles of "Irregularity" that

had preoccupied Renoir the previous year. As he had written: "Even in the most beautiful face the two eyes will always appear slightly dissimilar, and no nose is ever situated exactly above the middle of the mouth."[12]

A portrait in full bloom, *Aline Charigot* lovingly captures the pert, unaffected companion whom the artist would marry five years later, on 14 April 1890.[13] Although the abstracted background gives no clue of the setting or location, Aline is here presented as a healthy country girl, in casual apparel, cheeks red from the fresh air. She is the type of "natural woman" that the peasant mother of Maupassant's Bel-Ami would have preferred over the sophisticated Madeleine Forestier – "the daughter-in-law of her dreams, a plump, fresh farmer's wife, as red as an apple, and as round as a brood mare."[14] The contrast with Renoir's earlier portrayal of Aline as the flirtatious grisette in *Luncheon of the Boating Party* could not be more marked, but it should not be assumed that the present portrait is necessarily the more "authentic." For all its seeming truthfulness, *Aline Charigot* deliberately constructs its mode of representation.[15] When Renoir painted her portrait, Aline was part of the proletariat of Montmartre who frequented the Moulin de la Galette and were demonized in the popular imagination as "ambitious seamstresses, discouraged florists, laundresses whose irons are broken . . . who will leave their hard-won jobs at a moment's notice for an amorous encounter that will cheer up their lives."[16] Jean Renoir might fondly remember his mother as a talented dressmaker, protected by the unbearable "Mélanie," but he was indulging in pure fiction when he described the impeccable Charigot household and Aline's piano lessons.[17] In fact, until 1893, the cadastral records list "dame Charugo" [sic] as occupying a single "chambre à feu" on the first floor at 15 rue Bréda, in the heart of Paris's red-light district.[18]

That Renoir chose to portray Aline as the "natural" woman may be related to a more general trend in his figure painting in the mid-1880s, where he seems to be retreating from the particularities of Parisian existence, although Aline's straw bonnet, "un chapeau Timbale," retained a topical resonance, since such hats had become popular among the girls of Montmartre in the mid-1870s.[19] In the case of the future Madame Renoir, however, life seems to have imitated art. Upon meeting her for the first time in 1895, Vollard was immediately put in mind of the "plump and welcoming *bourgeoises*" in Perronneau's pastels.[20] Julie Manet admired Aline for her unaffected manners and good humour; she was "unashamedly plump and peasant-like."[21] It is these very qualities that Renoir had chosen to stress in 1885, and the image of Aline as a rustic Madonna would be further consolidated in the "Maternité" series begun that autumn (fig. 255).[22]

But it is also worth recalling the affection that is so deeply inscribed within this portrait. For, as Aline recounted to Julie Manet in September 1895 (and as is apparent on practically every page of Jean Renoir's reminiscence of his parents), theirs was a true love match: "The first time she saw Monsieur Renoir, he was accompanied by Monsieur Monet and Sisley. All three wore their hair long and just watching them walk by was an event in the rue Saint-Georges, where she was living at the time."[23] Thus it is hardly surprising that Renoir should have used this portrait as the model for the posthumous sculpture of Aline (fig. 257), made under his supervision by Richard Guino in the year following her death, at the age of fifty-six, on 27 June 1915.[24]

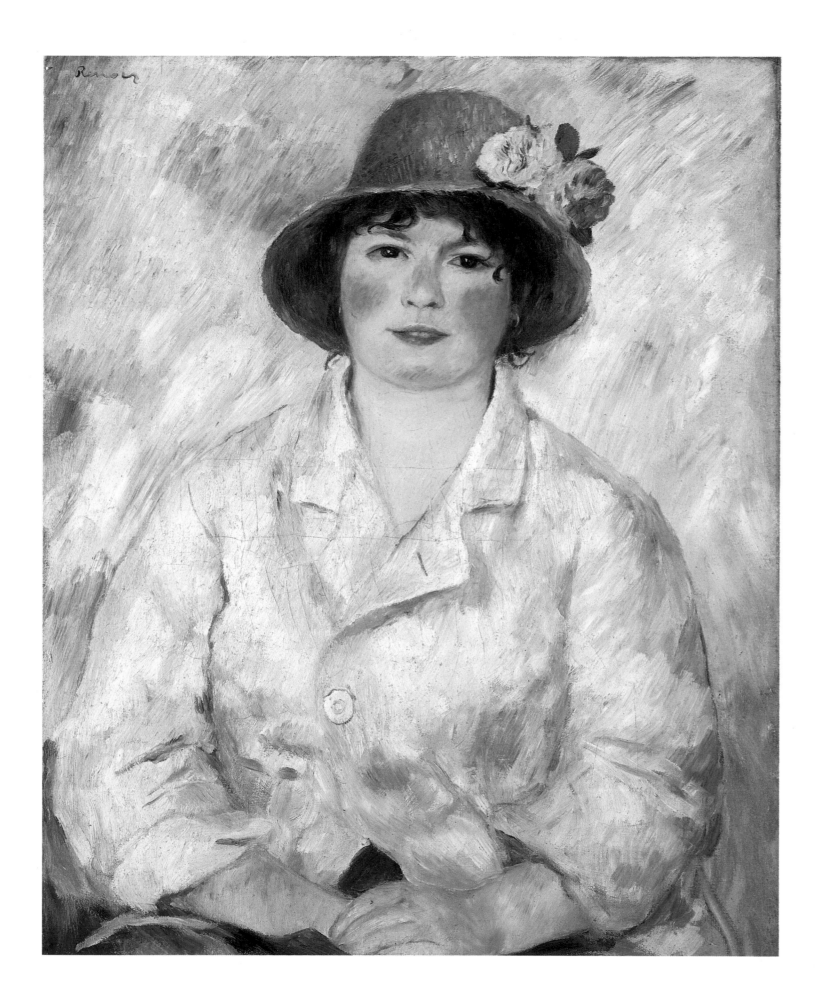

105 × 75 cm
State Hermitage Museum, Saint Petersburg

THE COMMISSION TO PAINT the portraits of the four children of Dr. Étienne Goujon (1839–1907), the recently elected senator for the Ain, would be Renoir's last hurrah as a "portraitiste mondain."[1] Disconcertingly self-possessed under such intense scrutiny, the Goujon children, though lacking the gentleness evident in his portraits of more familiar sitters, bring to a close the series of "society portraits" that had provided Renoir with regular employment and a steady income since 1878. If, in January 1886, Pissarro was unable to borrow money from Renoir because he had none to spare, this was but another indication that the commissions from bankers, doctors, industrialists, and politicians had finally come to an end.[2]

The four Goujon portraits do not constitute a uniform group, nor is it clear that they were all executed at the same time; in all likelihood they were commissioned in pairs. Those of Goujon's two elder sons, Pierre Jean Léon (1874–1900) (fig. 259) and Pierre Étienne Henri (1875–1914) (fig. 260), in which the boys are dressed in the sailor suits worn by so many of Renoir's young upper-middle-class sitters, share a similar format – a size 6 – and are painted in the same linear, hard-edged style.[3] The considerably larger portraits of the younger children, also portrayed in identical costumes, while not true pendants, are both set out of doors in a well-tended garden.[4] The most monumental of the group portrays Goujon's only daughter, Marie Isabelle Henriette (1876–1939), aged eight, with her hoop and stick (fig. 258); Étienne Léon Denis (21 October 1880–19 November 1945) holds a toy whip, although the spinning top is nowhere to be seen.[5] Like the sailor suits, the hoop and whip were enduring motifs in the iconography of privilege in mondain portraiture of the Third Republic (fig. 261): they are the attributes of wealthy children at play.[6]

Published as recently as 1987 as "Girl with a Whip,"[7] *Child with a Whip* captures something pugnacious, even bullish, in this four-year-old boy who, despite his curls and fancy dress, seems only slightly more compliant than his sister. Painted on a priming of lead white, which can be seen through the craquelure in the boy's hair, the portrait startles by its luminosity and high colour. Although it falls in the middle of Renoir's so-called Ingresque period – when, as he famously recounted to Vollard, he "had reached the end of Impressionism . . . and felt he knew neither how to paint nor how to draw" – *Child with a Whip* revisits the procedures of the previous decade without entirely abandoning them.[8] Renoir poses the little boy in broad daylight, recording the effects of the sun as it filters through the overhanging foliage; the ambient light irradiates Goujon's white dress with a panoply of blues, greens, yellows, and reds. Yet Renoir's bravura, variegated touch reinforces a traditional hierarchy of planes in which the figure is isolated from its "natural" setting.[9] Although the flowers in the circular flower-bed at left are applied wet on wet and the dappling of light in the middle ground is rendered through the blending of brushstrokes – both reminiscent of an earlier manner – the contours of the figure itself are crisply delineated, and the boy's face, hair, and hands are painted with the concentration of

enamel. The range of Renoir's touch is truly astonishing: pulpy and oily in the background foliage, additive and deliberate in the folds and ruffles of Étienne's costume, soft and delicate on his hands and socks. Despite his disavowal of Impressionist technique, it is clear from the tension between the solidly modelled figure and the afternoon light that seeks to envelop it that Renoir's apostasy was far from complete.

Little is known about Renoir's relationship with Goujon senior and the origins of this generous commission. Two years older than the artist, Senator Étienne Goujon was born on 28 April 1839 to the corn-chandler of Pont-de-Veyle, a small town on the outskirts of Macon, in the Ain.[10] Studying medicine in Paris, he qualified as a doctor in 1866 with a thesis entitled "Recherches sur quelques points d'anatomie et de physiologie" – an article on "bisexual hermaphroditism" would follow – and his bravery during the outbreak of cholera in the Nièvre was recognized in 1869.[11] Goujon returned to Paris to run the *maison de santé* at 88 rue Picpus (a mental asylum founded in 1862), and on 21 October 1873 he married the seventeen-year-old Marie Desirée Gilberte Rouen (1855–1904) from Cayenne in French Guiana, whose dowry of 100,000 francs enabled him to take possession of the asylum and expand its operations.[12] A good friend of Gambetta and Jules Ferry, Goujon had political ambitions – in 1879 he was elected mayor of the 12th arrondissement, and he competed unsuccessfully in the legislative elections of April 1883 – but his hopes for public office were almost ruined by a malpractice scandal involving the sequestration of a Mademoiselle Fidelia de Monasterio, whom he had admitted to his mental asylum on the flimsiest of evidence. Although he was publicly rebuked for negligence, Goujon was able to ride out the storm and in January 1885 was elected senator for the Ain, the département of his birth. A solid Republican, and secretary of the Senate between 1887 and 1890, he was reelected in 1894 and 1903, and died in office on 7 December 1907.[13]

Goujon may have been introduced to Renoir in January 1885 by Antonin Proust, who was briefly the minister of fine arts in Gambetta's cabinet, or by Paul Berard, who is mentioned as a mutual acquaintance in a letter of October 1886.[14] The most likely intermediary, however, is the dentist, sculptor, and dealer-collector Paul Paulin (1852–1937), a lifelong friend of Goujon's who commissioned a series of fans for his fiancée from the Impressionists in 1885.[15] In January 1886, Paulin is found acting on Pissarro's behalf in trying to interest Goujon in a decorated fan for his wife, for which the impecunious artist was extremely grateful.[16] Paulin was the first owner of Renoir's *Mother and Children* (1875–76, Frick Collection, New York), which he sold to Durand-Ruel in April 1892, and he would later sculpt Renoir's portrait in exchange for his *Lady with Black Gloves* (whereabouts unknown), a portrait of Paulin's wife, née Jeanne Trinquesse.[17]

At what point (or points) in 1885 Renoir executed his portraits of the Goujon children is another vexed issue. While the high-keyed tonality of *Child with a Whip* might suggest a date during the summer, Renoir had spent much of June and July painting in La Roche-Guyon in Cézanne's company, and his canvases from this period betray the influence of the latter's constructive brushwork, less pronounced in the portraits of Étienne and Marie Goujon.[18] In fact, the handling of *Child with a Whip*, as well as Renoir's experiments with his medium – one consequence of which is the crackle pattern in the boy's hair – are closer to *Bather*,

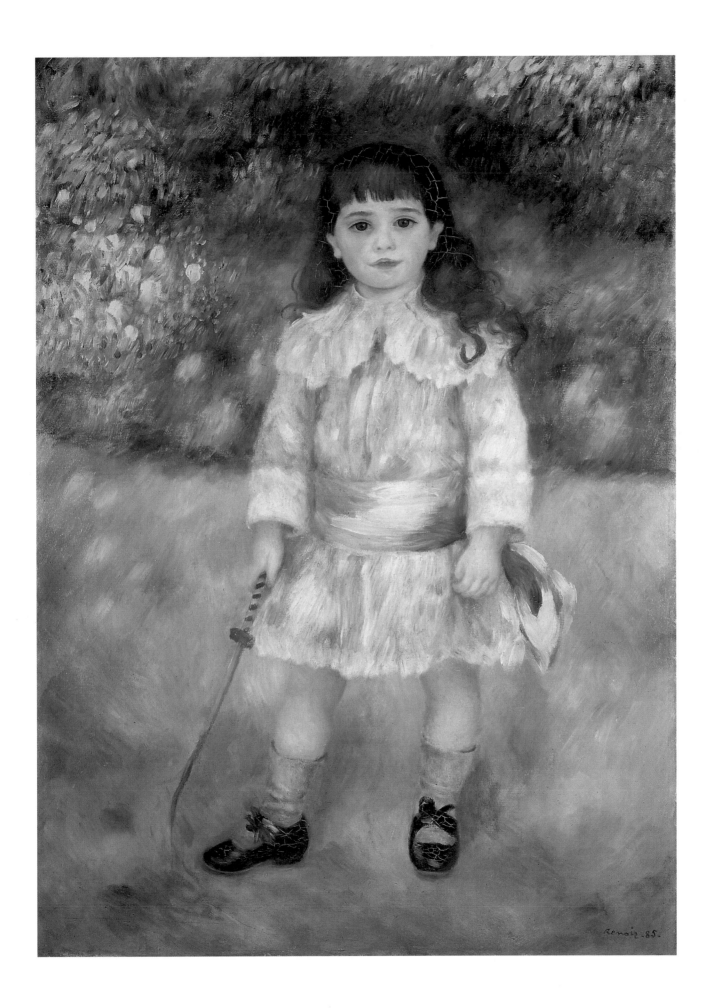

known as *La Coiffure* (Sterling and Francine Clark Art Institute, Williamstown, Mass.), which, as John House has pointed out, was completed and placed on deposit with Durand-Ruel in April 1885.[19]

Although Senator Goujon seems to have shown more than a passing interest in modern painting, and the commission to Renoir would alone be sufficient to establish him as a significant patron, neither he nor his children were particularly attached to these family portraits.[20] *Pierre Goujon* was sold to Brame in 1903,

and *Child with a Whip* entered the Morosov collection, through Vollard's good offices, in 1913.[21] Of Étienne Léon Denis Goujon's adult life next to nothing is known. He never married, had no career, and at the time of his father's death in 1907 was still living in the family home at 15 place Daumesnil, next to the mental asylum in the rue Picpus.[22] He died on 19 November 1945 in his château de la Ferté, at La Ferté Saint-Aubin, south of Orléans, aged sixty-five.[23]

80 × 63.5 cm
The Robert B. Mayer Family Collection,
Chicago

OF THE SECOND GENERATION OF collectors who discovered Impressionism in the 1890s, none was more wholehearted in his enthusiasms than Paul Sébastien Gallimard (1850–1929), an extremely wealthy bibliophile, theatre owner, and playboy, whose eldest son Gaston founded the publishing house in 1911 that still bears the family name.[1] The Gallimard fortune had been made by Paul's maternal grandfather, a coppersmith named Chabrier, who invented the protective nipple for nursemaids and later introduced street lighting into Louis-Philippe's Paris.[2] Paul's parents, Sébastien Gustave Gallimard (1821–1893) and Henriette Chabrier (1830–1918), established the imposing family residence at 79 rue Saint-Lazare, where the collections of both father and son would be housed on separate floors.[3] Paul was educated at the Lycée Condorcet and the École des Beaux-Arts – in official documents he listed his profession as architect – and studied painting in the studio of Stanislas Lepine.[4] On 7 April 1880, he married Lucie Duché (1858–1942), the daughter of Pierre Jean Baptiste Duché, a businessman (deceased), and his widow, Marie Guyot.[5] Lucie bore him three sons in regular succession: Gaston (born 8 January 1881), Raymond (born 29 September 1883), and Jacques (born 29 August 1886).[6]

Having collected books since the age of thirteen – and with his father's Barbizon landscapes as a model – Gallimard was at first surprisingly conservative in his taste for modern art. His protégé, Eugene Carrière (1849–1906) – whose paintings Pissarro dismissed as "spineless and sentimental"[7] – exhibited a rather flashy portrait of Madame Lucie Gallimard (fig. 263) at the Exposition Universelle of 1889, and it was only in June of that year, a month after the Salon had opened, that Gallimard seems to have been introduced to the New Painting at a dinner in honour of Monet and Rodin.[8] In December 1889, he purchased his first canvas by Renoir, *Blond Bather, II* (1882, private collection), and while he remained committed to Carrière, his conversion was otherwise complete.[9] Gallimard was among the earliest purchasers of Monet's "Grainstacks," and in February 1891 he acquired his first painting by Pissarro.[10] In time, his collection would number over two hundred works, and although not always fortunate in his choice of Old Masters – signal works by El Greco, Poussin, and Goya all turned out to be copies – his taste in modern French art was more assured.[11] Among the masterpieces in his collection were Corot's *Hagar in the Wilderness* (1835, Metropolitan Museum of Art, New York), Daumier's *Third-class Carriage* (1862, National Gallery of Canada, Ottawa), and Manet's *Le Linge* (1876, Barnes Foundation, Merion, Pa.). By 1903, he owned no fewer than sixteen paintings by Renoir; after that of the dentist Georges Viau, his was the largest accumulation in private hands.[12]

Although never a publisher himself, Gallimard's immersion in contemporary art was inspired by his bibliomania. A dinner with Goncourt and Raffaelli in December 1888 had served to finalize plans for a lavish edition of *Germanie Lacerteux*, with illustrations by Raffaelli and an introduction by Gustave Geffroy, to be printed in three copies only.[13] To Goncourt such largesse naturally brought to mind the Farmer-General's luxury edition of La Fontaine's *Fables*, and Gallimard consciously played the role of a Maecenas in his dealings with Renoir, who considered him "a real eighteenth-century Frenchman."[14] Following Durand-Ruel's retrospective of May 1892 – to which he lent three paintings – Gallimard took Renoir for a month's holiday to Madrid;[15] the two men also travelled together to London and Holland in the autumn of 1895.[16] Gallimard invited Renoir to his country house at Bénerville, outside Deauville – the artist spent brief periods there in June 1893 and August 1894[17] – and in 1895 commissioned a series of decorative panels on the "wildly improbable" subject of Sophocles' *Oedipus Rex*, which were never installed.[18]

Although Pissarro, frustrated in his attempts to secure a firm commitment from Gallimard for his son Lucien's book illustrations, railed against the man's "miserliness," claiming furthermore that "he made Renoir accept prices that were even lower than those that Durand-Ruel paid for his paintings," Renoir himself seems to have been unaffected by Gallimard's indecisiveness and his occasional penny-pinching.[19] Their complicity flourished. Renoir solicited manuscripts and autographs from Mallarmé and Léon Dierx for Gallimard's *Exposition Internationale du Livre Moderne*, held at Bing's gallery, L'Art Nouveau, in June 1896.[20] In turn, Gallimard was responsible for introducing Renoir in 1893 to Jeanne Baudot, a distant cousin, and in 1904 to his brother-in-law, Maurice Gangnat, who had just moved back to Paris from Naples. The former became Renoir's most devoted student, and godmother of his second son; the latter was the most important collector of his last years.[21] And Gallimard also provided Renoir with an admirable model in the person of his mistress, the actress Amélie Laurent, Mademoiselle Dieterlé (1870–1941), a former chorus-girl in his Théâtre des Variétés. As late as September 1911, Renoir could be found visiting the Gallimard-Dieterlé household at Croissy, where Mademoiselle Dieterlé and Gabrielle spent the sunny afternoon posing for him in the garden.[22]

Surprisingly, it was Lucie Duché who encouraged her husband to approach Mademoiselle Dieterlé, since she had been struck "by the stunning blondness of her skin, which reminded her of a painting by her teacher, Renoir," and had wanted the actress to pose for her.[23] Renoir's painting lessons to Madame Gallimard, with whom, despite his allegiance to her husband, he seems also to have remained on good terms, are an unexplored chapter in his career. Their friendship also endured. In March 1899, he wrote that he was not leaving Cagnes as expected since Madame Gallimard was to pass through on her way back to Paris at the end of the month.[24]

What little is known about Lucie Duché in the early years of her marriage suggests a temperament and character quite unlike that of the comfortable, open-faced young matriarch who takes full possession of Renoir's canvas in the most unintimidating manner. Goncourt, who dined with her in June 1889, spoke fondly of "a brunette with gentle dark eyes, eyes that occasionally interrogate you like the eyes of a Sphinx."[25] He changed his opinion upon further acquaintance, however, noting in April 1890, "the woman is so hysterical, that sensible people who drive with her are obliged to ask the coachman to let them out."[26] During the summer and winter of 1891, Lucie had been very ill, and Pissarro informed his son in December that she had just undergone "a painful and very serious operation, which may yet turn out to be fatal."[27] By the following summer, when the thirty-

four-year-old Madame Gallimard sat to Renoir at the Villa Lucie at Bénerville, she would appear to have recovered completely (fig. 262). Renoir's portrait, unlike Carrière's vampish representation, radiates calm and well-being to the point of being almost excessively *gemütlich*. A smaller portrait of Lucie in profile (fig. 264) – which has been described as preparatory to *Madame Gallimard*, but in which, it should be noted, she wears a green scarf around her neck – captures more of the Sphinx-like quality that had initially impressed Goncourt.[28]

Renoir's affectionate portrayal of his hostess in a simple yellow and white summer dress may not have been his first portrait for the family – a "portrait d'enfant" was among the three works that Gallimard had lent to Durand-Ruel's retrospective in May 1892.[29] However, it may well have been the last, for despite several references to further commissions, none seems to have been forthcoming. A rather cryptic letter to Gallimard, written on stationery from the Grand Hôtel Terminus near the Gare Saint-Lazare and which can be assigned to the summer of 1893, would suggest that Renoir was expecting to paint at least one more portrait of Lucie.

> I shall come when Madame Gallimard has returned. I shall rent a room on the road to Deauville and do a portrait of Madame Gallimard as a pendant to the one by Madame Manet, and that is all. If Madame Gallimard refuses to sit for a head – only three sessions – then I shall do a landscape, and that is all. I simply cannot stay in the villa all alone. It is agreed then. Do not worry about me for the present. We shall see each other again in the autumn, when we shall start on the big Spanish portraits.[30]

At the end of August 1894, Renoir wrote to Durand-Ruel from the Villa Lucie at Bénerville, where he had gone "to paint a por-trait," the subject of which is unknown.[31] The "big Spanish portraits" referred to at the end of Renoir's letter to Gallimard, seem never to have materialized – another example, perhaps, of his patron's equivocation. Nor is it possible to identify the second portrait of Madame Gallimard, which was to serve as a pendant to "the one by Madame Manet" – Berthe Morisot's three-quarter-length *Young Girl in a Red Dress* (fig. 265) – if indeed it was ever executed.[32]

Despite the affable relations between the two families, it must be admitted that Renoir's portraiture was not highly esteemed in the Gallimard household. Indeed, although the portrait is both signed and dated, it would appear that Lucie Gallimard never took possession of it, or else that she returned it to Renoir before his death. For *Madame Paul Gallimard* was noted as among the best of the first consignment of paintings from Renoir's atelier to come onto the market in April 1921. Gimpel, who had met both Lucie and Paul Gallimard, noted spitefully that "she was the very sort of petit bourgeois lady who insists on giving the maid a hand. Such familiarity pushed her husband into the actress's arms. Renoir, a good friend of the lawful wife, also did a portrait of the mistress."[33] Their eldest son, Gaston Gallimard, reviewing Durand-Ruel's 1912 exhibition *Portraits par Renoir* for the *Nouvelle Revue Française*, showed remarkable insensitivity to the subject as a whole. In Gaston's opinion, Renoir was not a preeminent portraitist; he was best left to his "own temperament"; sitters placed unacceptable constraints on his talent, "and defects are the result"; form and verisimilitude are unimportant to him, since his figures are painted in the manner of still lifes, and are all "plastered onto the canvas."[34] From Proust's friend and future editor, one might have expected greater insight than this.

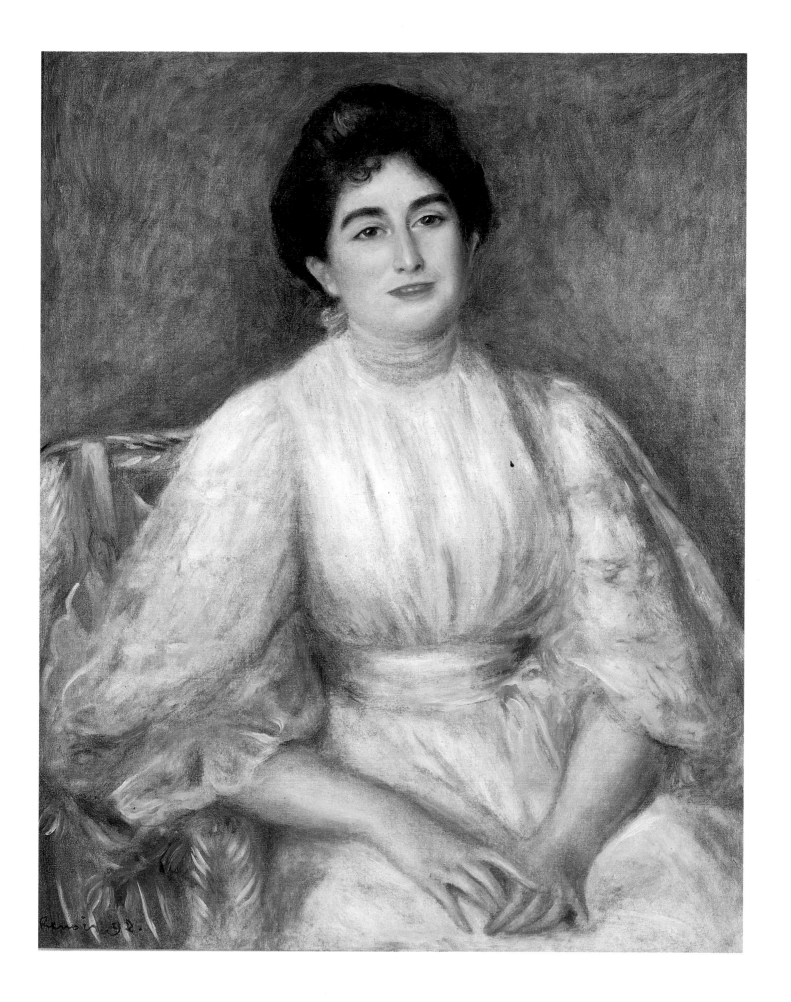

81 × 65 cm
Private collection, Paris

IN A ROOM OF INDETERMINATE FURNISHINGS sits the fifty-three-year-old Berthe Marie Pauline Morisot (1841–1895), widow of Manet's brother Eugène who had died in April 1892 at the age of fifty-eight, two years before this portrait was painted.[1] Perched somewhat precariously on the arm of the chair is her fifteen-and-a-half-year-old daughter Eugénie Julie Manet (1878–1966), wearing a long-sleeved dress and one of the extravagant hats that she affected.[2] Her chestnut hair, which the poet Henri de Régnier compared unkindly to a "wig worn by a seventeenth-century pedant," falls loosely around her shoulders.[3] Morisot, whose own hair had only recently turned white, stares fixedly in front of her; despite their proximity, mother and daughter occupy separate spheres. "I am ending my life in the widowhood that you experienced as a young woman," wrote Morisot to an old friend, six months after her husband died. "I do not say in loneliness, since I have Julie, but it is a kind of solitude nonetheless."[4] This is the very mood that Renoir's dignified and muted portrait admirably conveys.

We are unusually well informed about the genesis of *Berthe Morisot and Her Daughter Julie Manet*. In early April 1894, Renoir had begun a portrait of Julie Manet (private collection) in the family's third-floor apartment in the rue Weber.[5] Finding himself distracted there, he invited Morisot to join her daughter, but to allow him to paint their double portrait in his own studio: "If you do not mind, instead of painting Julie alone, I should like to paint her with you. But what bothers me is that, were I to do it at your house, there would always be something to prevent me from coming. If you could agree to give me two hours, that is, two mornings or two afternoons a week, I think I can finish the portrait in six sessions at the most."[6] Although she did not record these sessions in her diary – which is silent for the period between 19 March and 8 August 1894 – more than half a century later Julie Manet (now Madame Ernest Rouart) recalled posing for Renoir with her mother in his studio in the rue Tourlaque. Once the sittings were over, all three ascended the butte Montmartre to the Château des Brouillards, where Madame Renoir had lunch waiting for them.[7]

Renoir first worked out this double portrait in an elaborate and vibrantly coloured pastel (fig. 266), which Vollard later tried to sell on his behalf to the Amis du Musée du Luxembourg for 100 francs.[8] In the pastel – which is more animated, but less stately, than the finished work – Renoir established the placement of his figures, but paid scant attention to their facial expressions, which are indicated summarily. He adhered to this preparatory sketch in the finished portrait, but by extending his composition vertically to incorporate the black band of Morisot's dress, he gave greater emphasis to Julie, who now towers over her mother. The flowering of Julie goes some way towards relieving the sobriety of Renoir's portrait, which is painted in thin washes of colour, with a restricted palette and a generalized touch.

Renoir had always preferred to paint portraits in his own studio, and certainly there was much to distract him at Morisot's home in the rue Weber, a virtual museum of Impressionism.[9]

Yet, as has been pertinently noted, in *Berthe Morisot and Her Daughter Julie Manet* he adopts an overlapping format that is rare in his oeuvre but quite frequent in Morisot's portraiture.[10] Her unfinished *Self-portrait with Daughter* (fig. 267), painted several years earlier, may have inspired Renoir in the uncustomary juxtaposition of his sitters, but closer still is Morisot's *Children of Gabriel Thomas* (Musée d'Orsay, Paris), begun on 19 October 1893, and finished only on 28 October 1894.[11]

Renoir's portrait of Morisot and her daughter may also have been executed more expeditiously than promised. His undated letter inviting Morisot to sit for him is generally placed early in April 1894, when Renoir was preoccupied with settling the Caillebotte bequest.[12] From his correspondence with Henri Roujon (1853–1914), the Directeur des Beaux-Arts, it emerges that Renoir was at Saint-Chamas in the Midi, "for health reasons," from 14 April until 27 April.[13] Given the speed with which he worked, it is quite possible that *Berthe Morisot and Her Daughter Julie Manet* was completed in under a fortnight.[14]

Renoir described his friendship with Berthe Morisot as "one of the most solid of his life," yet their intimacy developed only in the last decade of Morisot's life.[15] Six months older than Renoir, Morisot had spent the first seven years of her childhood in Limoges, where her father, Tiburce Morisot, was Préfet de la Haute Vienne.[16] Renoir's father, a journeyman tailor, left Limoges for Paris in 1845, but even had he stayed, it is unlikely that the families would have come into contact, such was the difference in their respective backgrounds and milieus.[17] Morisot went on to enjoy a privileged and enlightened upper-middle-class upbringing in Passy, where her parents made sure that she received a proper artistic training. After studying with Joseph Guichard and working alongside "papa Corot" himself, she became Manet's model and protégée. An intimate of Mallarmé's, Morisot held a salon on Thursday evenings at 40 rue de Villejust, attended by painters and writers, and she participated in seven of the eight Impressionist exhibitions.[18] As Renoir famously remarked to Mallarmé, "With all this, any other woman would have found a way to make herself unbearable."[19]

Renoir's earliest correspondence with Morisot dates from the spring of 1877, when, with Caillebotte, he had formally invited her to the third Impressionist exhibition.[20] Not until January 1886 did their friendship develop, when Morisot began to visit Renoir in his studio and to note his advice in her *carnets*.[21] He first attended one of her Thursday dinners in December 1886, and the following year was commissioned to paint the portrait of her daughter, Julie (private collection), which Degas likened to a flowerpot.[22] Although Renoir did not introduce his wife, Aline, to the Eugène Manets until the summer of 1891 – one year after their marriage and six years after Pierre's birth – the families grew steadily closer, sharing dinners regularly and holidays occasionally, and Renoir's influence on Morisot's painting became increasingly marked.[23]

The impulse to paint Morisot's portrait – originating as it did with the artist rather than with the sitter – may have been prompted by the appearance of Manet's portraits of her as a young woman, two of which came onto the market in March 1894 when Duret put his Impressionist pictures up at auction.[24] Morisot and Julie cut short their visit to Brussels in order to view the sale, which they did on Saturday 17 March; that evening, Renoir, Mallarmé, and Degas were invited to dinner, and Duret's

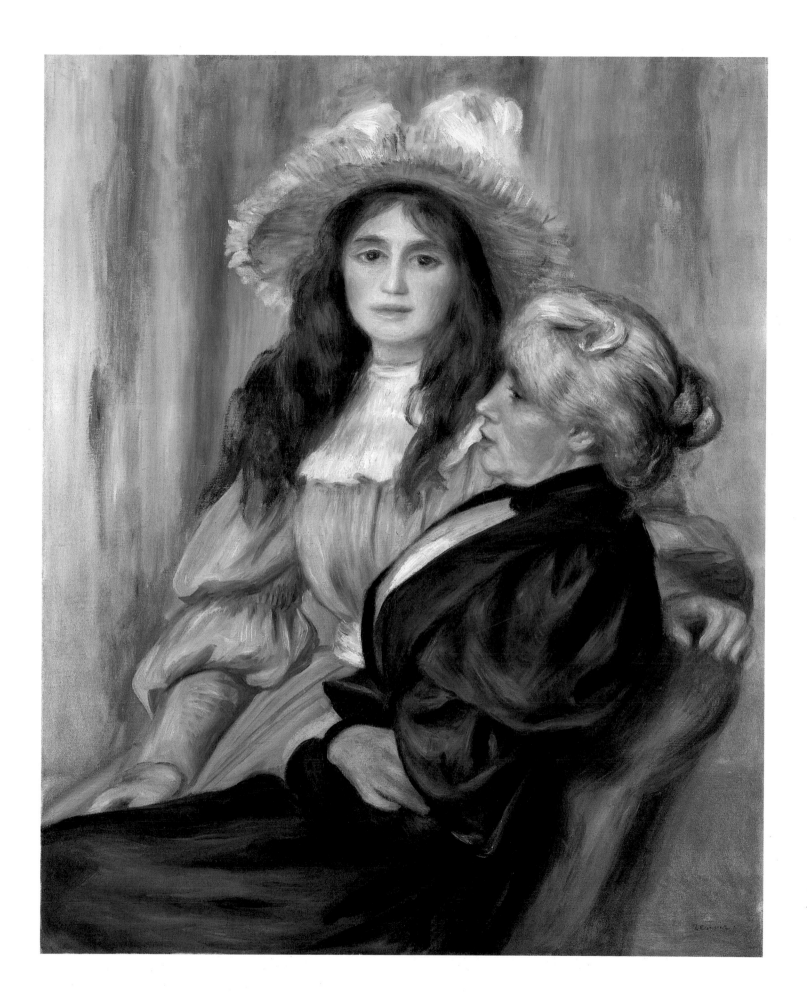

perfidy must have been the chief topic of conversation.[25] As a result of a misunderstanding with her agent, Morisot was unsuccessful in her efforts to buy back *Le Repos* (1870, Museum of Art, Rhode Island School of Design, Providence) – the painting went to the baritone Faure for 11,000 francs – but she did retrieve *Berthe Morisot with a Bunch of Violets* (1872, private collection, Paris) for the sum of 4,500 francs.[26] When the same group reconvened for dinner at Renoir's on 5 April, discussions on this subject most likely continued.[27]

If the reappearance of Manet's portraits of Berthe Morisot encouraged reflection on the related issues of commemoration and mortality, Renoir's decision to include Morisot in his portrait of Julie assumes a more weighty significance. It should also be noted that, in revisiting Manet's favourite model, Renoir adhered to a scrupulous verisimilitude. A comparison with photographs of both mother and daughter taken in 1894 (figs. 268, 269) confirm, once again, his unerring fidelity to appearances. But Renoir was also the kindest of chroniclers. Mallarmé's young friend Henri de Régnier (1864–1936), another frequent visitor to Morisot's salon, noted of Julie that she was a "silent, wild girl, with naively coloured cheeks,"[28] and of Morisot that she was "a slim, nervous, white-haired woman, delicate and slightly tense, aloof, with something of the curt and military about her, having a deep, dark, almost haggard look in her eyes, and the mien of a tragic mother."[29] Renoir hints at both Julie's wildness and Morisot's aloofness, but his vision, unsentimental though it is, is suffused by kindness and has none of Régnier's distasteful superiority.

Berthe Morisot died on 2 March 1895 from a pulmonary infection that developed from a cold she had caught from her daughter. Julie moved back to the family home in the rue Villejust to live with her orphaned cousins; Mallarmé had been appointed her guardian, and both Degas and Renoir were part of the family council set up after Eugène Manet's death to administer her affairs.[30] In the summer following her mother's death, Julie was practically adopted by Renoir and his wife.[31] Her accounts of the artist and his household in the diary that she kept until her engagement to the painter Ernest Rouart (1874–1942), whom she would marry on 29 May 1900 – a match engineered by Degas – are among the most vivid and authentic that have come down to us.[32]

It comes as something of a disappointment, then, to learn that Renoir's double portrait, poignantly described by Rivière as "a sober canvas of rare emotion," did not find favour with either mother or daughter.[33] Renoir himself may not have been altogether satisfied with it, since, according to Jeanne Baudot, "he had felt constrained in painting this portrait, which prevented him from surpassing himself as he would have wished."[34] In old age, Julie Manet recalled that her mother had felt uncomfortable in the low chair in which Renoir had placed her, and that he had painted her neck too short.[35] To Rosamond Bernier she confided that Renoir had made her mother "too harsh," when in reality she was "very delicate." "We both appear slightly affected, and I think we would have been more at ease at home."[36] While Julie Manet's statements cannot be questioned, Jeanne Baudot's reminiscence is open to doubt. Renoir admired the portrait sufficiently to use it as the model for his engraving of Morisot, intended as the frontispiece of the catalogue that accompanied her posthumous retrospective of March 1896.[37] Complications ensued, since Julie had informed Renoir that only a photograph of Manet's *Le Repos* was to be reproduced in Mallarmé's essay. Realizing that she may have hurt his feelings, Julie asked her guardian to intervene: "Aunt Edma and Paule [Morisot's sister and niece] cannot believe that I wrote to Monsieur Renoir to say that we will not be using his drypoint in the catalogue. They think he will be most offended, since he is rather sensitive."[38] Mallarmé wrote immediately to his "cher lepreux" to repair the damage, but the print did not appear in the 1896 catalogue, and remained unpublished until 1924, when it served as one of the illustrations in Duret's monograph on Renoir.[39]

65 × 54 cm
Musée National de l'Orangerie, Paris
Jean Walter and Paul Guillaume Collection

BEFORE HE WAS TWO YEARS OLD, Renoir's second son, Jean, who was born in Paris on 15 September 1894, had sat to his father for an entire series of paintings, pastels, and drawings in which he is portrayed under the protective eye of Gabrielle Renard, the sixteen-year-old nursemaid from Essoyes who had joined the family a month before his birth and would remain with them for the next nineteen years. With a focus and attention hitherto unprecedented in his work, Renoir studied Jean and Gabrielle in the most mundane of poses: the baby is shown sitting on his nurse's lap, playing with toy animals, or reaching out to grab an apple from a little girl. At least five separate compositions can be identified – each with its preparatory drawings and pastels – before Renoir's interest in his new-born son culminates in the magisterial *Artist's Family* (fig. 58), where Jean and Gabrielle dominate the canvas.[1]

Renoir's immersion in this new subject can be documented quite precisely to the autumn and winter of 1895–96. After Sunday lunch on 17 November 1895, Renoir unveiled a portrait of Jean and Gabrielle to Julie Manet, which she found charming.[2] On 1 February 1896, he wrote enthusiastically to a fellow painter, Congé: "One must become personally involved in what one does; only with the right frame of mind is it possible to get others to follow you . . . At the moment I am painting Jean pouting. It's no easy thing, but it's such a lovely subject, and I assure you I am working for myself and myself alone."[3] Such was the care with which Renoir scrutinized his son, that it is almost possible to propose a chronology for the series based on the length of Jean's hair, which was not cut until he was five years old. And a review of the series as a whole also reveals the extraordinary deliberation with which Renoir approached a body of work that appears, at first sight, among his most natural and spontaneous.[4]

In the Orangerie picture Gabrielle is shown playing with a toy bull, while Jean grabs a figure of a shepherdess that is not easily recognizable because it is unfinished.[5] Like the toys, the table at which Gabrielle and Jean sit is only sketched in, but the remainder of the composition is fully realized, with the figures built up in thin, fluid washes of paint and only the occasional impasto.[6] Jean's intense gaze and Gabrielle's own concentration – so involved in the game is she that she has yet to brush the lock of hair from her eyes – are effects that Renoir took considerable pains to achieve. Having already painted Jean in a bonnet, sitting on Gabrielle's knee (in a canvas of identical format),[7] he proceeded to make numerous head studies of the baby, hatless and alone,[8] before going on to a large charcoal drawing of Jean and Gabrielle (fig. 270) which, while it shows the couple in a different pose, is the first to record the stray lock of hair over Gabrielle's left eye.[9] Next, Renoir made a large and more elaborate black-chalk drawing (fig. 271), not much smaller than the painting itself, which laid out the essential details of his final composition, but in which Gabrielle and Jean's expressions are less lively and alert. In the painting, Renoir followed this preparatory drawing quite faithfully, although he changed the position of Gabrielle's left

hand so that it appears tucked under Jean's arm, thereby reducing the bulk of her body and reinforcing the tautness of the composition.

Not long after finishing *Gabrielle and Jean*, Renoir revisited the subject in a canvas of identical dimensions but horizontal in format (fig. 272). Although very similar to the Orangerie painting, in this version Jean's hair is now longer, falling well below his ear, and there are more farmyard animals – all of which are finished – including the oversized rooster with which Gabrielle now plays. Renoir's facture in the second *Gabrielle and Jean* is tighter and less animated, yet, given its dependence on the Orangerie composition, it comes as something of a surprise to discover two fine preparatory drawings for the work: a large drawing in red and black chalk,[10] and a superb vertical sheet that records meticulously the slight differences in Gabrielle's coiffure and the farm animal she holds.[11] Finally, the subject was revisited a third time in the larger and more ambitious *Gabrielle, Jean, and a Girl* (private collection), probably painted early in 1896, for which there exists a fine preparatory pastel as well as a quickly painted sketch.[12] An etching of Gabrielle and Jean, curiously entitled *Mother and Child*, was published in the album of the Peintres-Graveurs in 1896, and is related to yet another small painting and a small pastel.[13] Such a carefully calibrated process – from life study to preparatory drawing to painted composition and back again – evokes the working method of Jean-Antoine Watteau, whom Renoir venerated.

Gabrielle's devotion to her young charge, for whom she indeed became a surrogate mother, is at the heart of this series of paintings and pastels, and since she is the most important model of Renoir's later years – she posed, naked and clothed, for around two hundred paintings[14] – a review of her biography is long overdue. From her unpublished birth certificate it emerges that Fernande-Gabrielle Renard was the illegitimate daughter of the widowed Marie Céleste Prélat (born 14 July 1842), a grocer, and Charles Paul Renard (1841–1916), an unmarried wine-grower. She was born in Essoyes on 1 August 1878, and it was her father who made the requisite declaration at the mairie; he and Marie Céleste would marry four years later, and a son was born to the couple on 10 April 1887.[15] On 20 May 1895, Marie Céleste's son from her first marriage took as his wife Marie Victorine Maire, Aline's Charigot's twenty-five-year-old cousin, thus establishing a distant relationship between the Renoirs and the Renards.[16] Three months later, Fernande-Gabrielle, just sixteen, moved from Essoyes to Paris.

Gabrielle quickly became indispensable to Renoir and his children. A high-spirited, independent, but fiercely loyal member of the household, she acted not only as Renoir's model and studio assistant, but also, especially in later years, as his nurse and watchdog.[17] By 1912, however, her relationship with the mistress of the house had soured – as she informed Vollard in June, "he is very nice, but his wife gets on your nerves" – and although she followed the Renoirs to Essoyes and Cagnes, open warfare with Aline gradually developed.[18] Mary Cassatt, who admired her devotion – "the only one with heart is his former model and now nurse"[19] – informed Louisine Havemeyer on 28 December 1913 that Gabrielle had finally been dismissed: "Poor Renoir is suffering . . . the wife sent off the former model who has been with them 18 years and was Renoir's devoted nurse, she the wife was jealous and says that she takes the nursing on herself, that she don't, and he is without a nurse, he who is as helpless as a baby."[20]

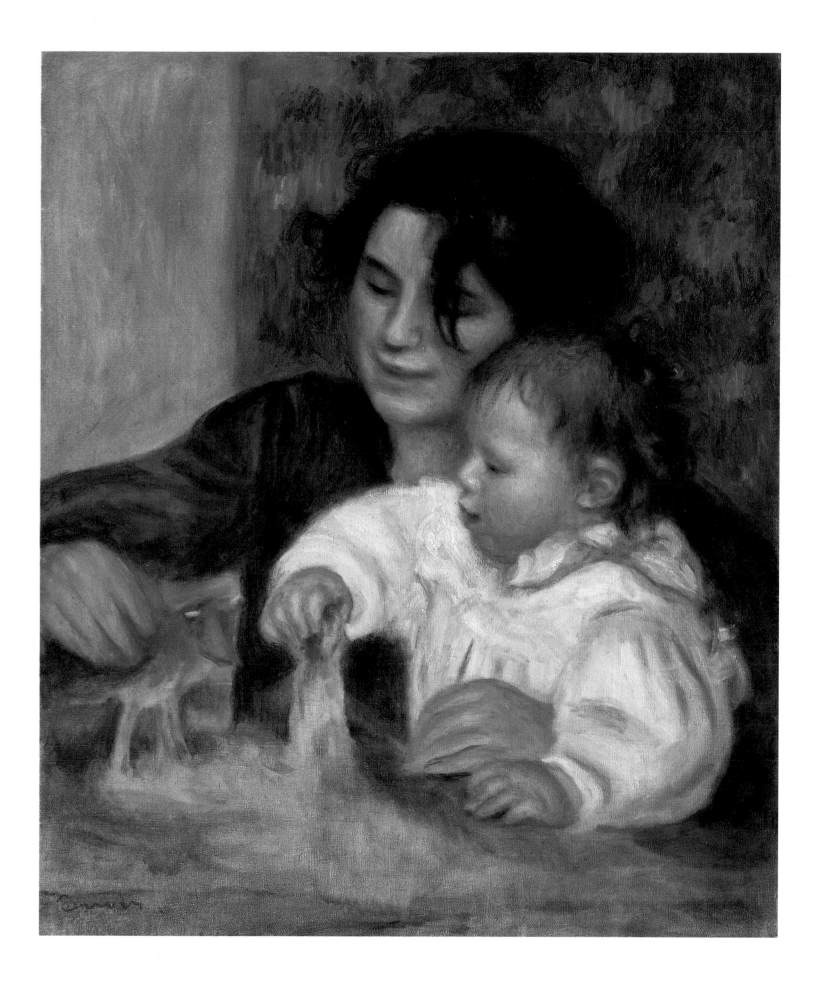

Gabrielle did not move very far, and after Aline's death in September 1915 she returned to service in Renoir's household. She remained in Cagnes after his death, and on 18 May 1921 married a well-born painter from Boston, Conrad Heusler Slade (1871–1950), who had arrived in the south of France in 1910.[21] An utterly mediocre artist, Slade painted in the manner of Renoir, and in old age was generally considered to look like him. In the summer of 1941, Gabrielle, Conrad, and their infirm son Jeannot left war-torn Europe and settled in Beverly Hills, upon Jean Renoir's invitation (fig. 273).[22] In 1953, Gabrielle began working with Renoir on the biography of his father, a task that kept her happily occupied during the last six years of her life.[23] She died in Beverly Hills in February 1959 and was buried next to her husband in the family plot in Mount Auburn Cemetery, Cambridge, Massachusetts.[24]

Jean Renoir recalled that his father shied away from demonstrating his emotions in front of his family, but that he overcame this "instinctive aversion" in his painting.[25] Certainly, comparing Renoir's portrayal of Gabrielle with photographs of her from around the same time (fig. 274), it is clear that he has softened her rather coarse features and alluded with a fine restraint to the young girl's inchoate maternal instincts. But the object of her affection, and of the artist's, is the fully absorbed infant, whose concentration is unlikely to last much longer. As Jean Renoir eloquently noted more than half a century after this portrait was painted: "With sharp but tender touches of his brush, he would joyfully caress the dimples in his children's cheeks or the little creases in their wrists, and shout his love to the universe."[26]

55 *Christine Lerolle Embroidering* 1897

82.6 × 65.8 cm
Columbus Museum of Art, Ohio
Gift of Howard D. and Babette L. Sirak,
the Donors to the Campaign for Enduring
Excellence, and the Derby Fund

IN 1897 RENOIR PRODUCED A SERIES of "lovingly painted" portraits of Yvonne and Christine Lerolle,[1] daughters of the wealthy and successful Salon painter Henry Lerolle (1848–1929) and his wife Madeleine Escudier (1856–1937), to whom he had been introduced by Berthe Morisot three years earlier.[2] Although largely forgotten today, Lerolle exhibited regularly at the Salon between 1868 and 1889 and participated in the Salon des Artistes Français from 1890 until the end of the century. His commissions included large-scale decorations for the Sorbonne, the Hôtel de Ville, and various churches; his Salon paintings entered numerous provincial museums, as well as collections in Boston and New York; and the French government acquired the portrait of his mother for the Luxembourg in 1895.[3] A pupil, like Degas, of Louis Lamothe, Lerolle worked independently of both the École des Beaux-Arts and the academic system in a modified "modern" style, midway between Bastien-Lepage and Jacques-Émile Blanche. He had been a good friend of Degas's since 1883 and was an avid collector of his work, as Renoir makes clear in *Yvonne and Christine Lerolle at the Piano* (fig. 275).[4]

Curiously, neither that picture nor *Christine Lerolle Embroidering* was ever owned by Lerolle, nor were they commissioned by him. Julie Manet first saw *Yvonne and Christine Lerolle at the Piano* in Renoir's studio in October 1897, just after it was completed;[5] in January 1899 it was one of the "lovely things" hanging in the salon of his apartment in the rue de la Rochefoucauld.[6] *Christine Lerolle Embroidering* also remained in Renoir's possession until his death. At the outbreak of the First World War, it was deposited for safekeeping with Durand-Ruel, along with many other cherished paintings, and in fact narrowly avoided destruction when the house opposite the gallery was shelled on 13 March 1918.[7]

Like the series devoted to Jean and Gabrielle, the Lerolle portraits are among Renoir's idyllic and somewhat idealized paintings of family subjects in recognizably bourgeois settings – part genre, part portraiture – and as such form a counterpart to the nudes and bathers that increasingly came to occupy him during the 1890s. His commitment to this sort of painting should caution us against seeing the decade primarily as a retreat from the realities of urban existence to the consolations of a meridional Arcady.[8] Not only did Renoir choose a subject of "modern life" in 1892 for *Young Girls at the Piano* (Musée d'Orsay, Paris), his first (and last) State commission,[9] but in the summer of 1899 he contemplated doing a large composition of six well-bred young ladies – the Lerolles, the Gobillards, Julie Manet, and Jeanne Baudot – while he was summering at Saint-Cloud.[10]

In *Christine Lerolle Embroidering*, the figure of Renoir's eighteen-year-old model dominates the composition. Eyes lowered in concentration, she is so absorbed in her handiwork that we are not immediately aware of the comfort and opulence of her surroundings. Two oriental carpets separated by polished hardwood floors; well-framed paintings and drawings hanging against a backdrop of

William Morris wallpaper;[11] a Japanese vase on its pedestal: with the greatest discretion Renoir delineates the well-appointed apartment at 20 avenue Duquesne that Maurice Denis remembered as "a harmonious ensemble of family furniture and modern furniture, and of very well-chosen works of art."[12] Despite the "documentary" qualities of the composition – Christine embroidering, two men looking at the collection – Renoir makes no attempt to represent the Lerolles' interior in all its splendour. Rather, his canvas is suffused by the glowing reds of Christine's dress, which resonate throughout – not only are her cheeks flushed, but her dark-brown hair is inflected with touches of red, and her fingers are modelled in this hue. A scarlet tonality is maintained in the patterning of the carpet, in the faces of the bearded connoisseurs, even in the red boutonnière on the lapel of the figure furthest to the right.

Although largely incidental in Renoir's composition, the background figures are not mere staffage: they allude to Lerolle's distinction as a collector of modern art. The man looking hard at the horizontal canvas – in all likelihood Renoir's own *Bather Drying Herself* (1890, private collection)[13] – is the Belgian sculptor Louis-Henri Devillez, an intimate of the household, whose promotion of Eugène Carrière would have important consequences for the development of Lerolle's style in the 1890s.[14] Devillez's companion has generally been identified as the collector Henri Rouart, yet not only does he seem younger than the sixty-four-year-old industrialist, his attitude is faintly proprietorial.[15] It seems more likely, indeed, that it is Lerolle himself who is portrayed in the background, showing his recently acquired Renoir to an admiring friend. Renoir even indicates the Légion d'Honneur on his lapel, which Lerolle had been awarded in 1889, a detail also included in his quickly brushed portrait of him (fig. 276).[16]

In October 1897 Renoir recalled the circumstances under which his portrait of Christine had progressed. Apparently, Madame Lerolle's father had been unable to restrain his amusement at the manner in which his granddaughter was being portrayed:

> Laughing, he said: "So this is the modern style of painting!" Madame Lerolle did her best to interrupt him – "Father, let me introduce you to Monsieur Renoir, the artist who painted the portrait" – but he carried on regardless. Once he realized his blunder, he apologized immediately. "Please, don't let that stop you," replied Monsieur Renoir."[17]

Renoir could feel at such ease in this haut bourgeois household because the tastes of his hosts accorded so well with his own. Her father's *faux pas* notwithstanding, Madame Lerolle and her husband were among the first to recognize younger artists as diverse as Denis, Bonnard, and Gauguin, and their salon was also a gathering place for new musical talent.[18] It is this mutual sympathy – reminiscent of his relationship with the Eugène Manets and the Mallarmés – that allows Renoir to portray the well-bred Christine Lerolle so affectionately.

Born in the family apartment on the avenue Duquesne, Christine (13 November 1879–26 July 1941) was the second of the Lerolles' four children.[19] The eldest, Yvonne (1877–after 1938), had been born two years earlier, and two sons would follow, Jacques (1880–1944) and Guillaume (1884–1954), neither of whom Renoir chose to paint.[20] The artist was particularly fond of Christine – his rather proper portrait of her (fig. 277), also painted

in 1897, is inscribed "au petit diable"[21] – and this becomes all the more evident when his paintings are juxtaposed with Degas's photographs of the sisters, taken the following year (fig. 278).[22] Christine's dark hair and imposing presence are common to both the paintings and the photographs, but, as Jean Boggs has aptly noted, "before a camera lens, less indulgent than Renoir, she seems primmer than in the painting."[23] On 12 February 1901, Christine married Henri Louis Rouart (1875–1964), the youngest of the collector's four sons, whose brother Eugène, an early enthusiast of Picasso, had married Yvonne Lerolle on Christmas Eve 1898.[24] Between 1902 and 1915, Christine bore Louis seven children; Degas's magisterial late portrait of her and her husband (fig. 279) was probably executed during one of the rare periods when she was not pregnant.[25] Christine's marriage to Rouart, a publisher committed to the revival of Catholicism in France, seems not to have been a very happy one. Gide, who despaired at the "alarming insignificance" of the talk at the Lerolles' teas[26] – which he nonetheless attended regularly between 1907 and 1912 – recorded a conversation of Christine Rouart's overheard in January 1910:

> "You must be quite glad," someone said to his wife, "to see him so religious."

"Why, I am as sorry as I can be!" she exclaimed. "So long as he wasn't religious, I was able to count upon religion to improve his character. Now I have given up counting on anything."[27]

The "essential tragedy" of their union, as Jean Boggs has termed it, was long in the future when Christine Lerolle posed for Renoir, and it is only with hindsight that the protective ambience so delicately communicated in *Christine Lerolle Embroidering* assumes a certain poignancy.[28] For Renoir, this mood of comfort and assurance was achieved through immersion in his subject as well as in the art of the past. A preparatory red-chalk drawing shows Christine full-face but expressionless, with her headband and collar and bow in place.[29] However, the inspiration for the final pose, and for the more animated portrayal of his model, came from another source and is somewhat unexpected. Jeanne Baudot, who accompanied Renoir to the Louvre in the mid-1890s, recalled the range of her teacher's enthusiasms for the collection of Old Masters: "Renoir was sensitive to the sincerity with which the Dutch and Flemish painters expressed the charms of everyday life. He particularly liked Terborch and de Hooch, but his favourite was *The Lacemaker* by Vermeer."[30]

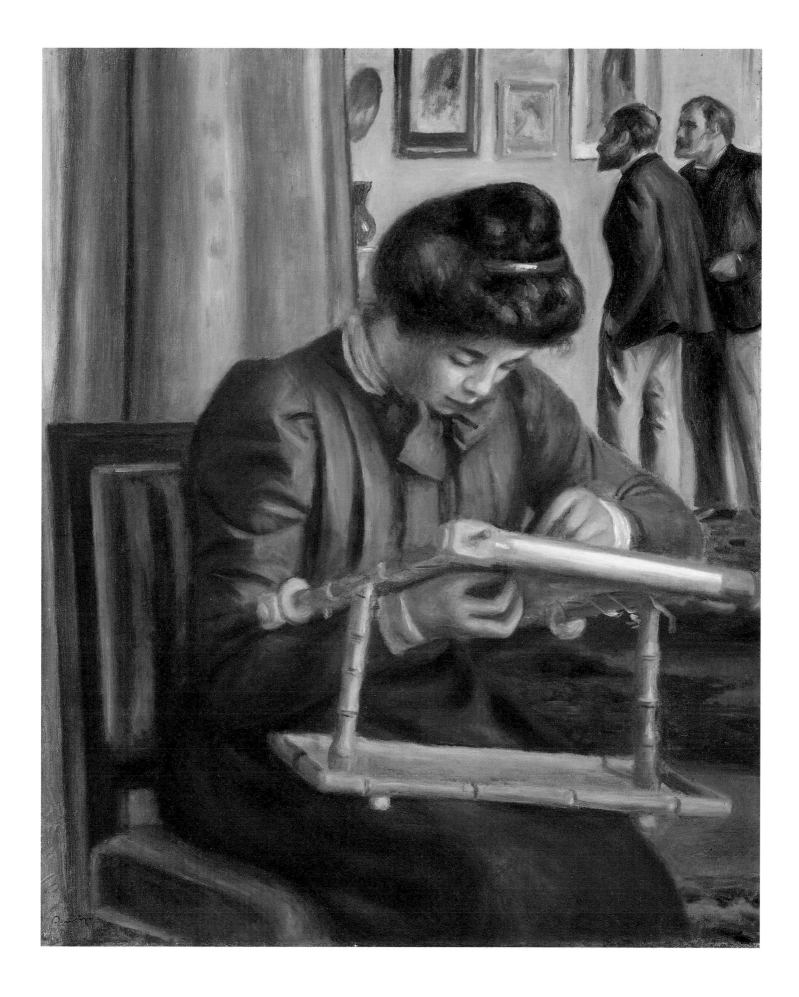

41.1 × 33 cm
Sterling and Francine Clark Art Institute,
Williamstown, Mass.

ALTHOUGH PREVIOUSLY DATED TO 1897, the second of the Clark's self-portraits was painted, and revised, in August 1899 under the appreciative eye of Julie Manet, who was spending a fortnight with Renoir and his family in the summer house they had rented at 39 rue Gounod in the fashionable suburb of Saint-Cloud.[1] Julie's diary for 9 August 1899 noted: "Monsieur Renoir is finishing a self-portrait that is very nice, in which he initially appeared rather harsh and wrinkled; we insisted that he remove some of the wrinkles and now it's more like him. 'I think it more or less catches those calf's eyes,' he says."[2]

Although Renoir's caressing brushstrokes soften the ravages of premature old age and increasing illness, comparison with a photograph of him taken shortly after the self-portrait was painted (fig. 280) confirms that he has constructed the geography of his face with detachment and honesty. Renoir's willingness to please his young friends notwithstanding, he attenuates neither the sunken crevice of his left eye nor the deadened appearance of the right (the consequence of an earlier paralysis). However, since he is recording his features from a mirror, in the *Self-portrait* the eyes are reversed.

With his slight form dominating the canvas but not imposing itself on the viewer, Renoir presents himself in painter's attire: soft jacket, cotton shirt and cravat, and the grey trilby ("chapeau mou") that he always wore indoors to cover his bald pate – this, his single vanity.[3] The patterned wallpaper in the background, with its touches of reds and dancing forms, introduces a note of irreverence into a composition that is both sober and reflective. Although Renoir adjusted the position of his hat and collar and tie – their initial contours are still visible – his *Self-portrait* is otherwise painted deftly and directly, with a minimum of revisions. Two days before completing this work, he confided to Julie Manet that the painter should have no tricks up his sleeve: "Once there is a secret to it, an art loses its stature; in both Rubens and Velázquez's painting, there's nothing hidden, nothing underneath, it's all done in one go."[4] And something of the "lightness" with which Velázquez painted the ruffs of his sitters – of which Renoir was so admiring – seems to have inspired him in the jaunty handling of his own collar and tie.[5]

It is impossible to discuss the Clark *Self-portrait* without considering Renoir's physical frailties, above all his encroaching and debilitating rheumatism, "a prelude to the arthritis which was to cripple him in later years."[6] Since breaking his right arm for a second time after falling off a bicycle two years earlier, Renoir was in increasing discomfort, often unable to paint. In fact, while he was finishing this self-portrait he finally acceded, albeit reluctantly, to Dr. Baudot's request that he undergo thermal treatment at Aix-les-Bains; he would make the first of his many visits there, in the company of Gabrielle, on 13 August 1899.[7] Yet it would be a mistake to interpret the *Self-portrait* in excessively morbid terms. Renoir's dishevelled, slightly haggard features were by no means a recent phenomenon. Blanche, who had known the artist since the 1880s, remembered him from the beginning as having a face that was "already ravaged, gaunt, and lined," with a "ragged beard and two twinkling, watery eyes that shone from brows that could not hide his sweetness and good nature."[8] The poet Henri de Régnier, introduced to Renoir at a dinner given by Berthe Morisot in December 1893 – six years before the *Self-portrait* was painted – noted in his journal immediately afterwards: "Renoir has a face that is agitated and yet paralysed on one side, with one eye already half closed. His beard is scraggly, but there is also something unyielding about him, despite his delicate and fine simplicity."[9]

House felt that Renoir had modified the effects of his facial paralysis and "idealized" his self-portrait, but the photographs of the period do not show a very much more ravaged physiognomy (fig. 281).[10] Where Renoir certainly departed from documented "reality," however, was in presenting himself in such serious, silent, and stable terms. Normally he was in constant motion – smoking, talking, even singing while he worked. Thadée Natanson described his manner in 1896:

> He goes away, comes back, sits down, stands up, now that he is standing sits down again, stands up again, looks for the cigarette he has misplaced – on the stool? or over there? perhaps on the easel? no, not on the table – then decides to roll another one, which he is bound to lose as well, before he will even have time to light it . . .[11]

Self-portraiture demands scrutiny and encourages contemplation; perhaps that is why Renoir practised it so rarely.[12] His son noted that his father "was extremely reticent about revealing his private feelings to anyone – even to himself perhaps."[13] In this unwonted exercise of introspection, Renoir certainly reveals something of his physical frailty; he may also be giving pictorial form to his concerns about ageing and infirmity, although this is more speculative. Above all, he is characteristically plain-spoken in recording his appearance. "My father had something of the old Arab about him," recalled Jean Renoir.[14] When he painted in the fields of Essoyes, little girls "thought he could kiss a goat between the horns," so thin was his face.[15] Seen in these terms, Renoir's *Self-portrait* neither romanticizes nor idealizes the fifty-eight-year-old artist.

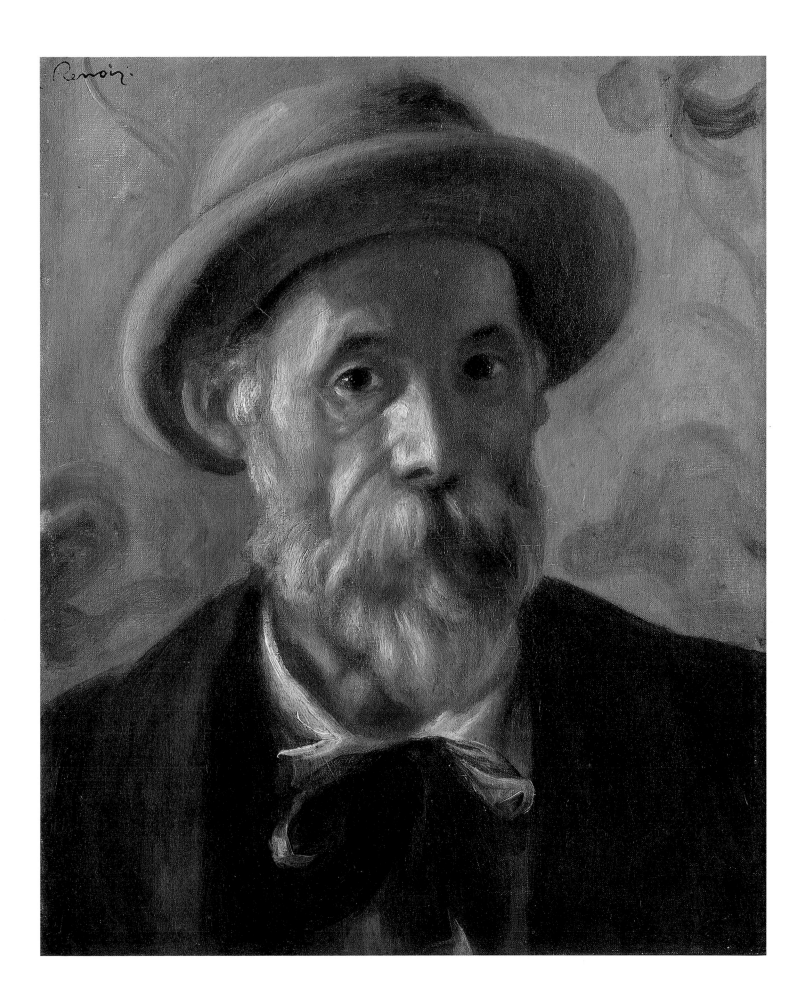

57 *Jean Renoir Drawing* 1901

45 × 54 cm
Virginia Museum of Fine Arts, Richmond
Collection of Mr. and Mrs. Paul Mellon

58 *The White Pierrot (Jean Renoir)* 1901–02

81 × 62 cm
The Detroit Institute of Arts
Bequest of Robert H. Tannahill

IN OCTOBER 1901 RENOIR and his family rented a first-floor apartment at 43 rue Caulaincourt in the heights of Montmartre, and a studio on the same street, some fifteen houses away.[1] It was "while we were living in the rue Caulaincourt," recalled Jean Renoir sixty years later, "that my father had me pose for him most often."[2] His memory was not entirely accurate here, since the arrival of Renoir's third son, Claude – who was born in Essoyes the previous August and would soon become his father's favourite model – had hastened the decision to send Jean to school. In the autumn of 1901 he entered the Jesuit Collège de Sainte-Croix at Neuilly, where his elder brother Pierre was already enrolled.[3] Before attending classes, the seven-year-old had to have his hair cut. His long tresses, the "pure gold" that Renoir loved to paint, had been a source of embarrassment to Jean for some time now.[4] Boys in the street would taunt him with "Mademoiselle, where's your skirt?" and school represented salvation. As he himself noted: "I impatiently awaited the day when I was to enter the Collège de Sainte-Croix, where the regulations required a hairstyle more suited to my middle-class ideals."[5] *Jean Renoir Drawing* and *The White Pierrot* are testaments to this liberation.

Having his sons pose while in the act of drawing guaranteed that his models would be both stationary and absorbed. Renoir had already painted a portrait of three-year-old Pierre in this way (fig. 282) and would do so again with Claude in 1905 (fig. 283). Jean remembered quite vividly the circumstances in which he had modelled for his father: "I was myself exactly seven when the painting was done. I had caught a cold and could not go to school and my father took the opportunity to use me as a model. To keep me quiet, he suggested that a pencil and a piece of paper should be given to me and he convinced me to draw figures of animals while he was himself drawing me."[6]

Crouched over his work, Jean is shown seated at a rough-hewn table, with all his powers of concentration directed towards the unintelligible forms emerging on the folded sheets of paper in front of him. His recently cut russet hair, with ends sticking out on both sides of his head, provides the warmest accents in an otherwise spare and austere composition. Painted almost entirely in earth tones, it is easy to overlook the patches of indigo blue that

represent the boy's shirt under his greyish-brown jacket, or the delicate touches of pink that line the edges of the paper. Renoir has also indicated Jean's feline eyelashes and wide mouth with unexpected delicacy.

Beginning with Courbet's *The Painter's Studio: A Real Allegory* (1855, Musée d'Orsay, Paris), the motif of the infant drawing had come to assume the weighty significance of a symbol of naivety. Courbet's child-artist viewed the world and depicted it with an innocence that the trained painter could recover, if at all, only through intense struggle.[7] Images of children painting and drawing proliferated thereafter (fig. 284), although, in reality, such a pastime was pursued outside of school only by "les enfants des élites sociales."[8] In his straightforward depiction of Jean drawing, Renoir avoids both the symbolic and the mondain. The quietude that emanates from this carefully constructed canvas puts one in mind not only of Chardin, but of a still life by Giorgio Morandi.

Although it has been dated to as late as 1906[9] – when Jean would have been twelve years old – *The White Pierrot* is executed in the same delicate washes of paint, thinly applied over a white ground, as in *Jean Renoir Drawing*.[10] That these two portraits were painted around the same time is further supported by Albert André's affectionate homage to his master in his new studio (fig. 285), generally dated to 1901.[11] Here Jean is shown as a rather sullen Pierrot, who waits while Renoir paints the wailing baby on his nursemaid's knee. He is even angrier in André's drawing of him, seated (fig. 286), which must have been made while he was posing for his father, since his right arm is slung over the top of the chair in identical fashion.[12]

Yet in Renoir's portrait Jean is transformed into a resplendent Pierrot, shrouded in an aureole of blue that intensifies as it approaches the figure before dissolving beneath the more thickly impasted whites of his costume. Painted as fluidly as quicksilver, its spatial transitions treated tonally – the walls are predominantly violet-blue, the floor pale orange – *The White Pierrot* appears to have been conceived *alla prima*, with the reworking of Jean's right knee and foot taking place on the canvas itself. The dancing rhythms of Pierrot's tunic, with its oversize sleeves, respond to the fugitive hatching stokes of the blue mandorla in the background – the kind of virtuoso brushwork that was increasingly rare in Renoir's late oeuvre – and such is the lightness of his touch that the weave of the canvas is visible in many places. Only in the painting of Jean's hair does Renoir's handling become somewhat leaden: three angry strokes to indicate his son's newly cropped fringe.

Why, it might be asked, did Renoir choose to paint Jean as a figure from the *commedia dell'arte* – "a fearful, coarse, stupid valet, who was generally pushed around and unsuccessful in everything he undertook?"[13] Since his consecration in the popular theatre of the July Monarchy by the mime Baptiste Debureau (1796–1846) and his veneration by the Romantics – for Gautier, Pierrot was "pallid and slender . . . always hungry, always beaten" – the sad clown had become a poignant symbol of the misunderstood artist,

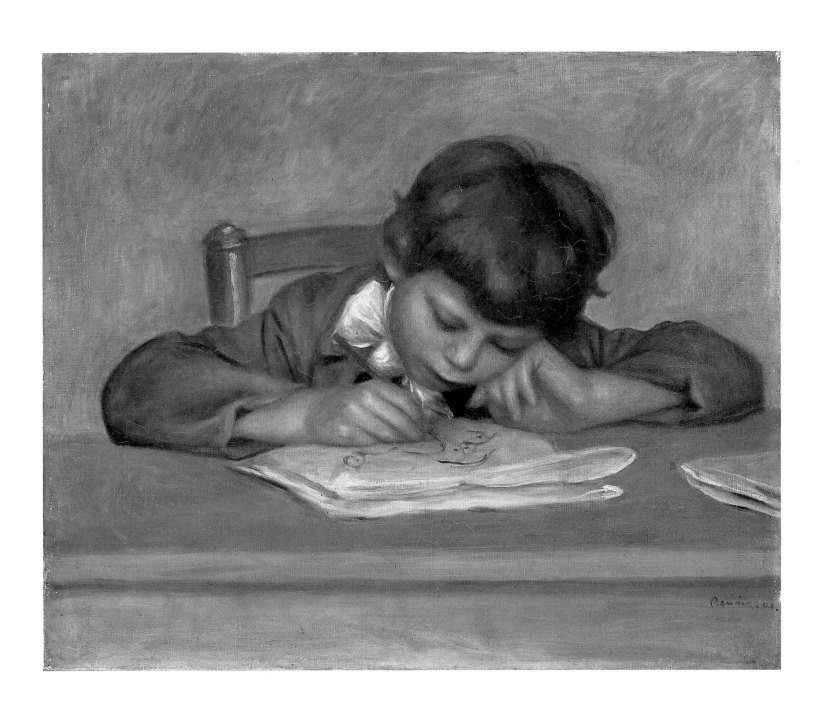

cat. no. 57

sensitive and rebuffed.[14] By the end of the nineteenth century, it was even possible to speak of a revival of his cult. Not only did Pierrot regularly appear in pantomime, but an entire sub-genre of Symbolist literature came to be devoted to him.[15] Daumier's weatherbeaten street performer and Nadar's savvy huckster was now transformed into a "Pierrot pessimiste et macabre," with a languid and decadent sensuality eminently suited to *fin de siècle* sensibilities.[16]

Renoir's Pierrot is happily immune to the contemporary fascination with the perverse and the sickly. He is neither sad nor melancholy; and he is not particularly ingratiating. Since Jean Renoir insisted that his father preferred his sons to assume natural poses and that he painted them in activities of their own choosing, the reasons for portraying Jean in a Pierrot's costume must be sought within the family's intimate history.[17] In 1958, Jean Renoir listed his "favourite childhood memory" as "going to the theatre on Sundays and to Vaudeville."[18] Before he progressed to the pantomimes of Montmartre and the café-concerts – to which he was taken by Gabrielle and his uncle Pierre-Henri and Aunt Blanche – Sunday theatre meant the Punch and Judy shows (the "Guignol") performed in the Tuileries, which were to have a lasting influence on the future film-maker.[19] The boy's adoration of these puppet-shows was recognized by his doting godfather, Georges Durand-Ruel, who made him a present of a "life-size" Polichinelle, "clad in shiny satin."[20] Jean's favourite "Punch," as he remembered it, was "the Neapolitan one, dressed in white clothes too big for him."[21] This was the guise in which Renoir chose to portray him in the last portrait he would paint of Jean as a child.

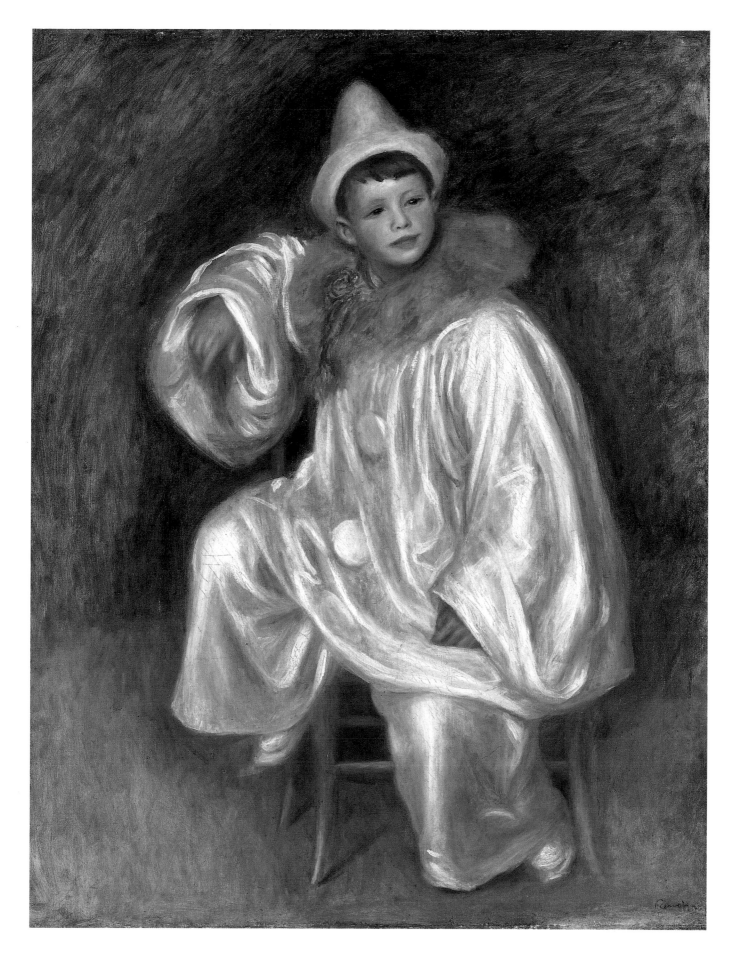

cat. no. 58

78.7 × 63.5 cm
National Gallery of Canada, Ottawa

As Jean Renoir recalled, he was replaced as his father's favourite model soon after the arrival of his younger brother Claude – born on 4 August 1901 in Essoyes,[1] and called "Clo Clo" by his parents[2] – who would prove "one of the most prolific inspirations my father ever had."[3] Of the many early portraits of Claude, *Claude and Renée* is the most ambitious and monumental, and has been aptly described as among "the most spare figure compositions in Renoir's whole career."[4]

Resplendent in the white dress and baby's bonnet that Renoir so liked to paint – similar to Jean's costume in *The Artist's Family* (fig. 58), but less elaborate – Claude is shown held aloft by a sympathetic if perhaps long-suffering maid, from whom he strains to be free. Understated in its coloration, the painting has an even, blond tonality, from which emerges a rococo palette of pinks, yellows, and blues. Claude's golden locks and the highlights in Renée's coiffure are picked up in the touches of Naples yellow on her collar and the baby's smock. The insistent blues of Claude's eyes are echoed in the ruffles of his bonnet and in the stripe running down Renée's skirt, just visible beneath her apron. Finally, the abundant pinks of both sitters' rosy cheeks and hands continue in the patterning of Renée's blouse, in the soft soles of Claude's shoes, and in the touches of rose madder in Renée's hair. The whites of Claude's dress and Renée's skirt are applied more insistently, with a texture and crispness achieved through the use of broader brushes. Although Claude's form is given prominence in this way, the composition is ultimately unified by the random touches of pinks and yellows that animate the background, where colour is used decoratively, rather than for description. Renoir's itinerary for 1903 – a year in which he spent hardly any time at all in Paris – would situate this portrait in Essoyes, where it was probably painted in the summer of 1903, but the canvas itself offers no clues in this regard.[5]

As with *Gabrielle and Jean* (cat. no. 54), Renoir arrived at the appropriate and natural poses of his sitters only after intense study and preparation. *Claude and Renée* was worked out in two large drawings that have something of the spectral quality of the "Maternités" by Carrière, an artist Renoir disliked. In the first, inscribed to the critic Claude Roger-Marx (fig. 287), Renoir experimented with a slightly different composition, in which Claude is not held aloft but is supported on a surface we cannot see. He seems about to cry, and Renée, strands of hair falling on both cheeks, does her best to cajole him into good humour.[6] A second drawing, on two joined sheets of paper, of practically identical dimensions to the canvas, establishes the contours and relationship between the baby and his nurse (fig. 288).[7] Here, the physiognomies are more generalized, and the poses more ample. Renée leans back as if hoisting the baby against her right hip; Claude's billowing dress gives him a pear-shaped appearance. Did Renoir use the drawing to trace his composition?[8] While there is no evidence of his having prepared *Claude and Renée* in this way, it is clear that the large sheet – dedicated to Claude's godfather, the painter Albert André (1869–1954) – provided the artist with a blueprint of sorts, since Renoir initially painted Renée in a

similarly wide-angled position, which was adjusted early on to create the more statuesque grouping. It should also be noted that Renoir continued to study the bonneted figure of his son after resolving the composition, painting him in exactly the same pose but with a less angelic demeanour and without his attendant (fig. 289).[9] That the artist was also scrupulous in his documenting of Claude's dress, face, and hair is borne out by comparison with a photograph of the baby held by his mother, taken at Le Cannet the previous year (fig. 290).

Claude's nurse was first identified as Renée Jolivet by Jean Renoir, who considered her the most memorable of his father's housemaids/models after Gabrielle, Georgette Pigeot, and La Boulangère. "A superb creature," Renée became an actress "who travelled a good deal and lived in Egypt for many years."[10] As is often the case, the facts are a little less colourful than in Jean Renoir's recounting of them. Born in Châtillon-sur-Seine on 20 December 1885, Renée was the second of the three daughters of Auguste Jolivet (1859–1893), a day labourer, and Marie Rosalie Dumay (1857–1947), a midwife.[11] By October 1892 the family had moved to Essoyes, where Renée's younger sister was born. Her father died the following year at the age of thirty-four, and her mother remarried a wine-grower.[12] Marie Rosalie remained in Essoyes as the town's midwife, and it was probably she who delivered Claude in August 1901 at the family's home in the rue Beaufort. When the time came for the Renoirs to need help with the new baby, the midwife's daughter came well recommended.

Renée's employment in the Renoir household was brief and not altogether happy. Since Renoir was spending more of his time in the south of France, Renée would have been responsible for Claude under Aline's demanding eye, without the diversion of "the boss," the older children, or the seasoned family retainer, Gabrielle. By February 1904, she handed in her notice on the grounds of her forthcoming wedding, which would not take place until August. Responding to the news, Renoir wrote to Aline from Paris: "I'm very pleased about Renée's marriage. I had been willing to take her back on principle, but without really wanting to do so."[13] On 22 August 1904 Renée married Alphonse Cayat, an obscure actor from Montluçon who performed under the name of "Cayat de Castella."[14] She divorced him in 1920, remarried the sixty-one-year-old Gracien Frédéric Arquier on 17 March 1934, and died a widow in Montluçon two months before her eighty-eighth birthday on 25 October 1973.[15] Of her career as an actress and her life in Egypt there is no record; her death certificate listed her profession simply as "retraitée de commerce."[16]

House considered Renoir's technique in *Claude and Renée* to have been influenced by Rubens, who was much on the artist's mind in the last decades of his life.[17] The painting also looks to both classical and medieval statuary for its iconic and immobile presentation.[18] Well might Roger-Marx enthuse over the pleasure that Renoir took in painting his infant son – "never before had he experienced such joy in following the games of this young human animal, who awakens, instinct with light and milk" – but in this instance, although Renoir aspires to the beatific, he narrowly avoids an impression of stupor in his portrayal of Claude and Renée.[19] In the end, it is Degas who provided the most concise and pertinent assessment of the painting's amalgam of the sacred and the domestic. His comment on Mary Cassatt's "Maternités" applies equally well to Renoir's (of which this is decidedly one): "Tiens, l'Enfant Jésus avec sa nurse!"[20]

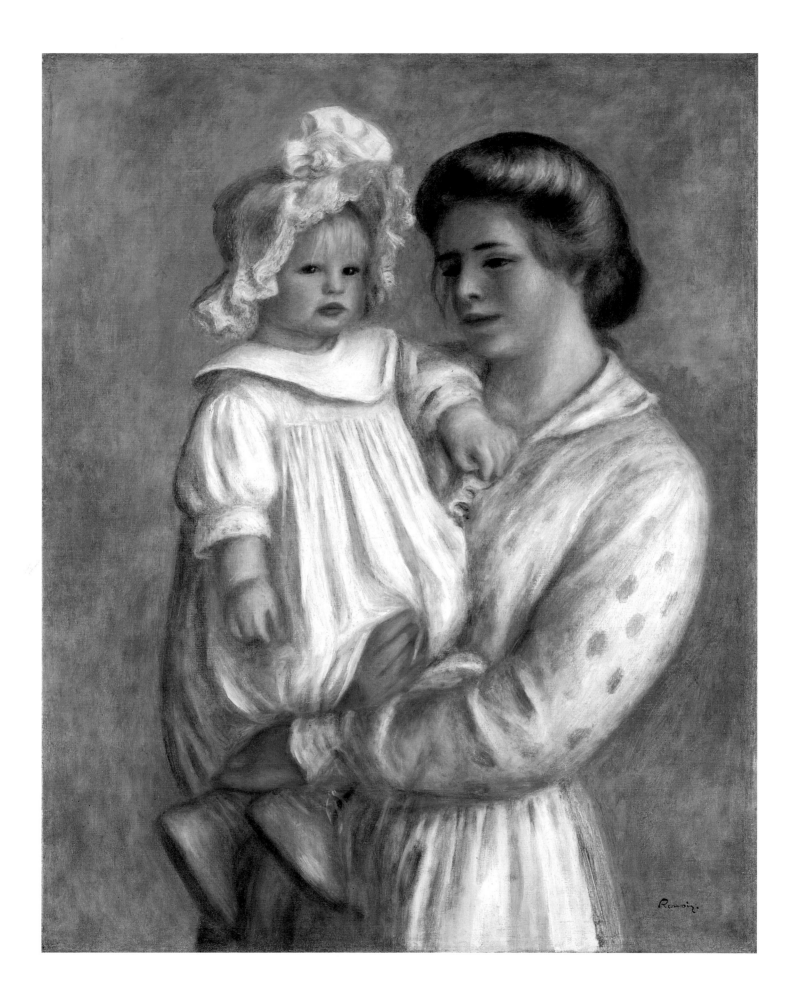

81.6 × 65.2 cm
Courtauld Institute Galleries, London
Samuel Courtauld Collection

IN MAY 1908 RENOIR invited the forty-one-year-old art dealer Ambroise Vollard (3 July 1866–22 July 1939) to visit him in Cagnes, where he was in the middle of building a house.[1] Never one to miss an opportunity to spend time with the master, Vollard made his way to the villa that Renoir and his family were renting while work progressed on Les Collettes.[2] During his stay, Vollard would encourage Renoir to try his hand at soft-wax sculpture.[3] In return, Renoir painted the third and most affectionate of his five portraits of Vollard, one that the sitter would later describe, quite inexplicably, as "a very advanced painted study."[4]

Prominently signed and dated at upper left, *Ambroise Vollard* is, in fact, a fully resolved and finished work, and, after *Ambroise Vollard as a Toreador* (cat. no. 69), the most substantial of Renoir's portraits of him. Against a resonant, if generalized, red and ochre background, Vollard is shown seated with his elbows on the table, caressing the original plaster of Maillol's *Crouching Woman* (fig. 294) in his large, fine hands. In comparison with the thin, gaunt sitter of Cézanne's portrait, painted nine years earlier (Musée du Petit Palais, Paris), or Renoir's more recent bandit (fig. 291), Vollard now appears the prosperous bourgeois, whose collar is a little tight, and whose short-cropped hair has started to turn grey.[5] In spite of his crisp cuffs and jaunty silk handkerchief, Vollard's dark suit, whose folds and creases are lovingly described, still manages to convey something of his legendary shabbiness.[6] In fact, the lining of his jacket pocket has worked its way inside out – or is it a white handkerchief that peeks through the well-worn mohair?

So mesmerized is he by Maillol's statuette that Vollard is oblivious to any untidiness in his appearance. His concentration and the massiveness of his presence are relieved only by the gaily patterned tablecloth, with its bounding animals, and by the blue and white Oriental figurine and pot that have just been unwrapped. The recumbent female figure, still partially in its tissue, may well be a Chinese porcelain water-dropper, originally used for preparing the calligrapher's ink.[7]

As in his finest nudes of the period, Renoir's handling in *Ambroise Vollard* communicates a plenitude and joyousness that are almost visceral. Given his heavy-set sitter and the stasis inherent in the genre of portraiture, Renoir's brushwork is uncommonly vibrant. The pulsating rhythms of the faience and the dancing tablecloth are taken up in the washes of whites and greys that animate Vollard's suit and in the mobile hatchings of the walls in the background. Renoir's touch is fluid and deft, but always rigorous in the modelling of form and volume. Dabs of white catch the light on Vollard's forehead; strokes of black and grey, applied with a fine brush, mark his beard and side-whiskers; blended whites, pinks, and yellows craft his long fingers and the sinuous limbs of Maillol's statuette. Vollard's rotundity might be almost tactile, but his pose and expression are those of a voluptuary.

Picasso's friend André Salmon remembered Vollard as one who ate lunch alone in the cellar of his gallery with "a white napkin tied around his neck and a Renoir propped against the table for company."[8] Indeed, in keeping with a long-established tradition in Western portraiture, it is as a voracious art lover that Renoir has chosen to portray his dealer, updating Titian's portrait of Jacopo Strada (fig. 295), antiquary and supplier of works of art to the Hapsburgs.[9] While remaining faithful to Vollard's features – as can be seen by comparing the portrait to any number of photographs (figs. 292, 293) – Renoir also ennobles his sitter through a skein of references and allusions. As in his best portraits, his apparently "natural" portrayal is at some remove from documented reality. In the context of their thirteen-year-long relationship, this portrait assumes the status of an unexpected *hommage*; it is in stark contrast to the condescending, bantering, and frequently cruel relationship that Renoir had established with his most ardent admirer.[10]

The eldest of the ten children of Alexandre-Ambroise Vollard and his wife Marie Louise Lapierre, Henri Louis Ambroise was born in Saint-Denis, capital of the French island of Réunion, off the east coast of Madagascar in the Indian Ocean.[11] His father, a notary, intended his first-born to enter one of the liberal professions, and Vollard was sent to study law in Montpellier, moving to Paris to pursue a doctorate. Living in a garret in Montmartre, by the early 1890s Vollard had abandoned law for a career as an art dealer. Having been refused a position with Georges Petit, he apprenticed at an obscure gallery, the Union Artistique, managed by Alphonse Dumas, a fashionable amateur who had trained with the highly commercial genre painter Debat-Ponsan.[12] Vollard's first sign of independence was to buy the prints and drawings of decadent Realists such as Rops, Forain, and Willette.[13] As early as March 1894 he was recognized by Pissarro as "a little dealer who is both intelligent and enthusiastic";[14] in June of that year he purchased his first painting by Van Gogh, as well as four Cézannes, at Tanguy's posthumous sale.[15]

Having established himself in a shop at 37 rue Laffitte in October 1893 – he would move next door in April 1895, before relocating in May 1896 to 6 rue Laffitte on the other side of the street[16] – he insinuated himself into the good graces of several of the Impressionists, who were now entering late middle age. According to Jean Renoir, shortly before she died Berthe Morisot had encouraged Vollard to introduce himself to Renoir.[17] Vollard remembered their first meeting rather differently: he had been advised to show Renoir the portrait of an unknown sitter by Manet, Renoir identified the figure as a Monsieur Brun, and Vollard then sold the painting to Degas.[18] Both of these anecdotes can be situated to 1895, the year Renoir encouraged Vollard to mount the first exhibition to be devoted to Cézanne, which would take place in his "boutique" in November 1895.[19] Vollard exhibited Cézanne's works again in 1898, 1899, and 1905; before 1900 he had organized one-man shows of Van Gogh, Gauguin (whose exclusive dealer he would become in March 1900), Redon, and the Nabis. He exhibited works by Picasso in June 1901 and Matisse in June 1904; he acquired the contents of Derain's studio in February 1905 and of Vlaminck's studio in April of the following year.[20]

While Renoir came to admire Vollard's intensity and ardour, in his personal relationship with the young man he allowed himself a licence that would have been unthinkable in his more formal dealings with the Durand-Ruels. "The glutton Vollard" played banker, nursemaid, and shop-boy to the ageing painter.[21]

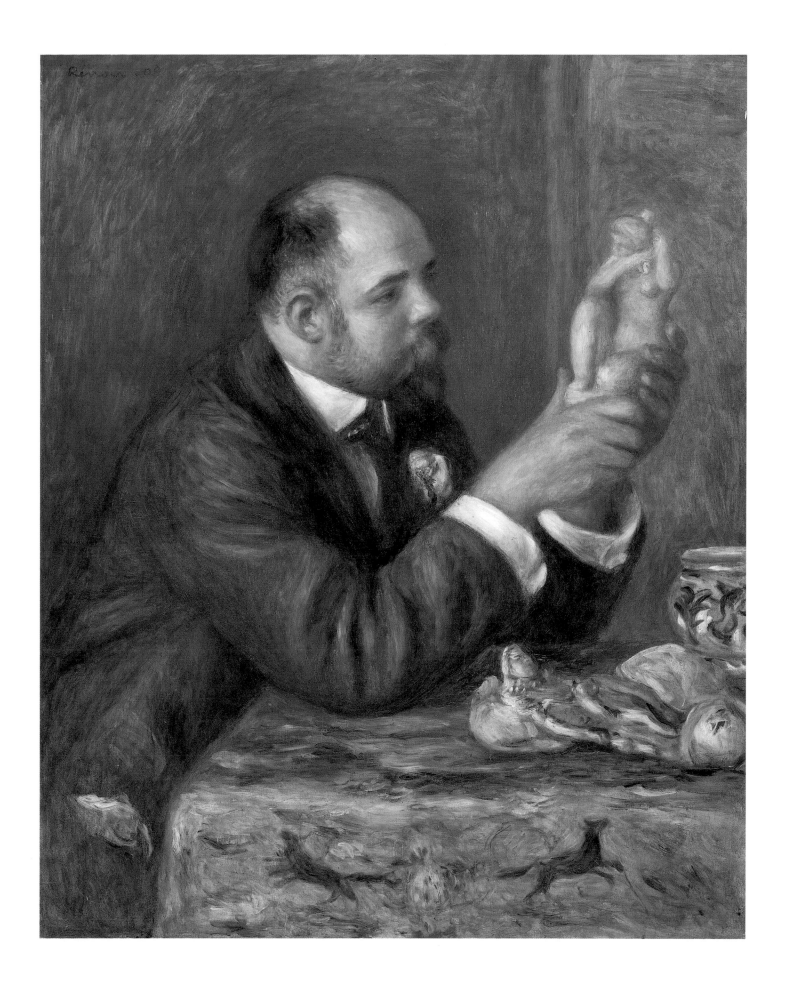

Jokes were made about having to keep an eye on the family silver when Vollard came to dinner.[22] Renoir inscribed a self-portrait drawing of 1915 to "Vollard, mon raseur sympathique."[23] In moments of anger, such familiarity could turn nasty. Dauberville recalled that Renoir "made fun of Vollard, using him as his whipping boy and his jester."[24] Infuriated with Vollard for requesting yet another portrait, Renoir is supposed to have shouted: "Go and find me a palm tree; I'll paint you hanging onto it and scratching your backside."[25] Indeed, according to Georges Besson, one reason why Renoir so objected to the publication of Vollard's biography of him was that "he feared the vengeance of a dealer whom he had humiliated thousands of times."[26]

At his first visit to Renoir's home at the Château des Brouillards, Gabrielle had mistaken Vollard for a carpet salesman.[27] Not only was he very tall and very shabby, he was also dark-skinned, Gertrude Stein later describing him as "a huge dark man glooming."[28] Whenever Vollard came to the door, Jean Renoir recalled with some embarrassment, he would cry out, "Mummy, it's the monkey! or Mummy, it's the Negro!"[29] Picasso, whose relationship with the dealer was never easy, once held up a slice of tongue in the middle of lunch and announced that it was a portrait of Vollard.[30] When Renoir's *Ambroise Vollard* was exhibited at Durand-Ruel's in June 1912, it was described by one critic as showing "the clever Créole of the rue Laffitte."[31]

Set against this precarious intimacy and latent racism – Vollard was a "young Othello," "Masinissa, King of Numidia" (even Pissarro referred to him as "ce brave Créole")[32] – Renoir's portrait appears stately and decorous, and accords its sitter considerable respect. The artist might well be responding to Cézanne's assessment of Vollard as "a man with great flair, of good bearing, and knowing how to behave."[33] Quite forgotten are the lubricious dinners in the cellar of the rue Laffitte, which Renoir had attended the previous year, in which Vollard regaled his company with the story of a husband who had murdered his wife by kicking her in the stomach.[34]

Renoir's generous portrayal of Vollard is grounded as well in personal and private terms; the accoutrements he includes are not random, they are the referents of a long-established intimacy. Most prominently, Maillol's *Crouching Woman* testifies to a shared passion that had originated with Vollard. Aristide Maillol (1861–1944), to whom Vollard had been introduced by Édouard Vuillard in 1900 – the date of the *Crouching Woman* – was one of the dealer's many discoveries.[35] Not only had Vollard encouraged Maillol to cast his wooden statues in bronze, but in June 1902 he had given him his first exhibition, which Renoir attended in the company of Jeanne Baudot.[36] It was Vollard, furthermore, who had commissioned Maillol to sculpt Renoir's portrait, done in Essoyes in September 1906 and cast in bronze the following year.[37] Renoir came to admire Maillol as a sculptor more than Rodin (but less than Degas),[38] and it was noted in 1912 that the statuette in his portrait of Vollard "was one of the few objects that adorn his house in Provence."[39] Vollard also kept statuettes by Maillol on the mantelpiece in his cellar in the rue Laffitte, much to Rodin's irritation.[40]

If Maillol was a shared interest, the pieces of blue porcelain, so daintily coloured, refer to an obsession that was Vollard's alone. The dealer noted in his autobiography that he had been fascinated by "fragments of blue porcelain" since childhood, and that as soon as he was in a position to do so, he had commissioned ceramics from artists in his circle.[41] Even the patterned tablecloth may have a secondary (and jocose) significance. One of the many unanswerable questions with which it was Vollard's maddening habit to regale Renoir was, "Tell me, Monsieur Renoir, why do they not have bullfights in Switzerland, seeing that they have so many cows."[42]

Although, like a coquettish woman, Vollard loved to have his portrait painted, he did not always choose to keep the results. Picasso's great Cubist portrait of him, finished in the autumn of 1910, was sold to the Russian collector Ivan Morosov in 1913 for 300 francs.[43] Renoir's portrait of 1908 fared rather better. Designated as a gift to the Musée du Petit Palais in the will he drew up on 7 December 1911 – along with Cézanne's portrait of him – Vollard changed his mind in June 1927 and sold the portrait to the English textile manufacturer Samuel Courtauld (1876–1947) for the princely sum of 800,000 francs.[44] Vollard had apparently been informed that Courtauld's distinguished collection of French paintings was to go to the National Gallery, which must have appealed to his vanity and made parting with Renoir's portrait a little easier.[45] His letter to Courtauld also throws fascinating (and unexpected) light on Renoir's technique. From it we learn that the portrait of Vollard had never been varnished, and that the dealer hoped that it might remain so. "If it is going to be put under glass, might it be possible not to varnish it?"[46] On this last point, Vollard was not to receive satisfaction.

120 × 77 cm
Musée National de l'Orangerie, Paris
Jean Walter and Paul Guillaume Collection

There were some difficult moments during the final sessions for my portrait as a red clown. I must have been nine or ten at the time.[1] The costume came complete with white stockings, which I absolutely refused to wear. In order to finish the canvas, my father insisted on the stockings; there was no avoiding it; they irritated me. My mother found a pair of silk stockings; these tickled me. Then followed threats and negotiations. In turn, I was offered a spanking, an electric train set, being sent away to boarding school, and a box of oil paints. Eventually I agreed to wear the stockings, but only for a few minutes; my father, barely able to contain his anger, finally completed the canvas, despite the contortions I was making in order to scratch my legs.[2]

CLAUDE RENOIR'S REMINISCENCE OF posing for the most monumental of the scores of portraits that his father painted of him strikes an undeniably authentic note, despite the fact that it was published nearly forty years after the event. It affords a momentary glimpse of Renoir as anything but the indulgent and kindly artist, happy for his models to move about and act naturally. It offers a plausible explanation for why there are so few grandiose and statuesque portraits of Renoir's children – Claude later confided to Michel Robida that, as a model, he was rarely expected to stand still for more than three minutes at a time[3] – and it gives due emphasis to the ambition of Renoir's undertaking, both in *The Clown* and in *Jean Renoir as a Hunter* (cat. no. 63), painted the following year. As Claude's account makes clear, Renoir worked on the full-length portrait over several sessions, leaving the lower half until his model could finally be persuaded to put on the white stockings. Initially, Renoir had to be satisfied with an incompletely attired clown: in his intense and fully resolved bust of Claude (fig. 296), the artist's impatience to do the figure whole is almost palpable.[4]

Writing admiringly of Monet's new group of *Water Lilies*, Renoir confided to Durand-Ruel in February 1909: "He is possessed of an energy that I am far from having."[5] Yet, as Albert André pointed out, it was precisely at this time that Renoir returned to painting monumental figures in vertical formats.[6] Despite his crippling arthritis,[7] he made plans to travel to Italy in the spring of 1909 (the project was abandoned).[8] With Veronese on his mind, he undertook a pair of life-size dancing figures as part of a decorative scheme for Maurice Gangnat.[9] And he found mechanical solutions to the physical impediments that prevented him from painting in large formats. Renoir's chair was placed on a trestle so that he could be lifted to the appropriate height (the

artist had long stopped working on his feet), and pulleys were attached to his easel to allow him to raise and lower his canvas without having to turn the lever by hand, since he no longer had the use of his fingers.[10] As Claude Renoir would later note, by this point his father was practically immobile: either Renoir or the canvas had to be moved every twenty centimetres or so, since he was unable to stretch his painting arm any wider.[11]

Even without his sitter's obstreperousness, the execution of the portrait of his younger son in clown's costume would have been a truly Sisyphean task. Yet the work communicates plenitude rather than effort, as well as Renoir's pleasure in the favourite colour of his later years. As always, the representation is anchored by the artist's "unyielding probity with regard to the model"[12] – eight-year-old Claude's doe-like physiognomy, his almond eyes, wide jaw, and cropped hair are rendered with documentary scrupulousness (fig. 297).[13] Claude had recently started school, and, like his brother before him, he had to have his hair cut for the occasion; indeed, Renoir's nostalgia for his son's flaxen locks may account for the tenderness with which Claude's golden aureole is painted.[14]

As has often been noted, Renoir also looked to sources in the history of art for the vaguely classical presentation of his youngest son. The Baroque state portrait, and Velázquez in particular, may well have been in Renoir's thoughts while he was at work on *The Clown* – in emulation rather than in parody, it should be added[15] – but a more potent source, and one that the artist knew well, was Watteau's *Gilles* (fig. 298), which had hung in the Louvre as part of the Lacaze bequest since 1869.[16] Comparison with the haunting but enigmatic *Gilles* is instructive for several reasons. While Watteau may not have intended his street performer to appear sombre or melancholy, his painting was interpreted as such by successive generations.[17] Watteau's sad clown, symbol of the misunderstood artist, was furthermore the spiritual godfather to Picasso's "Saltimbanques" and "Harlequins," painted just prior to Renoir's *Clown*.[18] Yet sentiment of this sort is thoroughly expunged from Renoir's portrait, as is the "Anglo-Saxon melancholy" attributed to the circus performers themselves.[19] While the reasons for dressing Claude as a clown may have been prompted by the family's nickname for him – originally Clo Clo, only later Coco[20] – it was the opulent red costume that intrigued Renoir above all. When, following the outbreak of the First World War, the painting was deposited for safekeeping with Durand-Ruel, it was entitled simply "garçonnet à la robe rouge."[21]

Claude's black skull-cap that sets off the reds of his billowing silk suit confirms the primacy of the formal elements in Renoir's composition, for as in his earlier "Spanish" genre paintings, accuracy of costuming has been sacrificed to the expressive potentialities of colour.[22] Renoir's irritated young model, fidgeting and eager to be on his way, may have compromised (at one level) the successful realization of his father's monumental composition – Claude's lifeless left arm and hand are far from convincing – but anatomical exactitude is secondary to more painterly concerns. It

hardly matters that the Ionic column is placed precariously close to a squared cognate of indeterminate style and architectural function (is it another column, or perhaps the end of a screen or wall?), or that the setting is neither as mysterious as its Baroque antecedents nor as neutral as the red-curtained backdrop to which Renoir habitually had recourse in the portraits done at Les Collettes. For in *The Clown* pictorial space also serves an expressive function: the reds of Claude's suit and neckband, with their gaping folds and quasi-Surrealist rhythms, reverberate distantly in the pinks of the squared column, the veins in the marble, and the roseate hatchings of the foreground.

It is faintly ironic that Claude Renoir (4 August 1901–7 October 1969), whom the photographer Henri Cartier-Bresson remembered as "very sweet but less flamboyant than his brothers, who had something majestic about them," should have been portrayed so grandly.[23] "Calm, serene, and mature" Renoir's portrait may be,[24] but it delights primarily in the warm resonances of the "Venetian" reds against the creams, pinks, and beiges of the secondary elements. Presented with admirable naivety, closer to the Douanier Rousseau's portraits of children than to Picasso's displaced bohemians and performers, *The Clown* brings to an end a long and respectable figurative tradition, while looking resolutely to the future in its insistence upon the means and materials of the painter's art. As such, it is Renoir's first twentieth-century masterpiece.

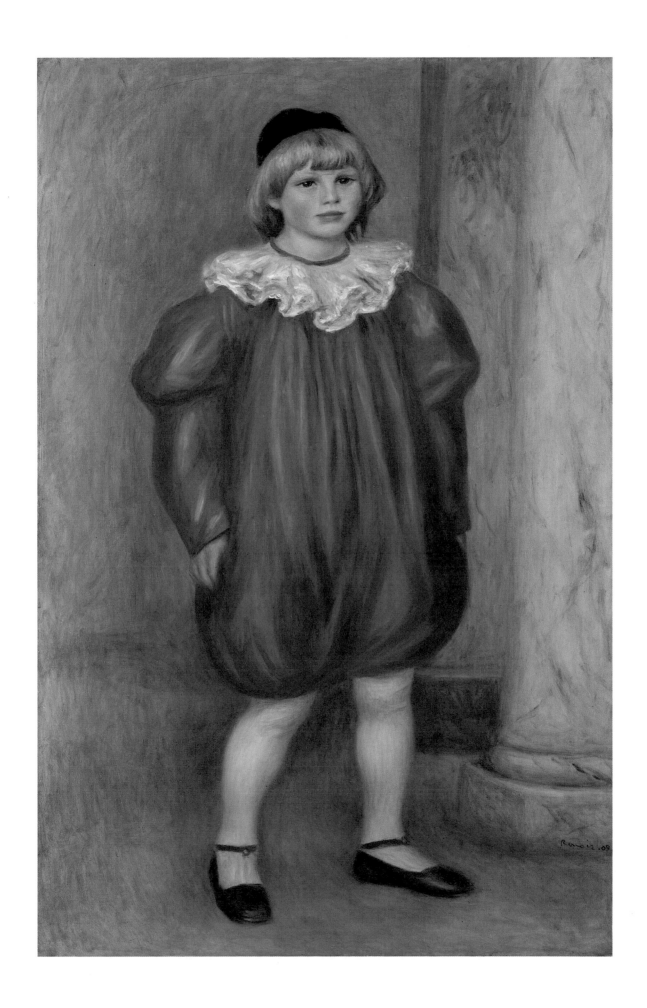

62 *Madame Renoir and Bob* c. 1910

81 × 65 cm
Wadsworth Atheneum, Hartford, Conn.
The Ella Gallup Sumner and Mary Catlin
Sumner Collection

AUDACIOUSLY PAINTED, Renoir's portrait of his wife and the family pup Bob is also the most candid and affectionate of tributes. Looking considerably older than her fifty years, Aline Renoir poses in one of the loose-fitting and unflattering day-dresses that she affected (fig. 299), her grey hair coming loose from its bun. Presented full-square and without the slightest idealization, she is also shown with a minimum of jewellery: a round brooch on the bodice of her dress and a double wedding band on the fourth finger of her left hand. Aline returns her husband's gaze (and ours) directly, even quizzically, yet her maternal instincts, as well as her massive presence, are communicated by the tiny dog, sound asleep in her protective lap.

Madame Renoir and Bob dates to early in 1910 and is contemporary with Renoir's mondain and somewhat crowded portraits of the Bernheim de Villers (fig. 302) and Madame Josse Bernheim-Jeune and her son Henry (1910, Musée d'Orsay, Paris) – both painted at Les Collettes – whose rainbow palette and wealth of elegant accoutrements it most decidedly does not share.[1] Clearly, Renoir could speak in different tongues at the same time. His commissioned portraits, fluidly painted though they are, are respectful of fashion and interior decoration, and evoke the elaborate conversation pieces of Vuillard and Bonnard. His private portraits are spare, almost minimalist by comparison. They are also far more penetrating, as for example the sardonic *Self-portrait* (fig. 300) signed and dated 1910, whose tonalities and handling are very similar to those of *Madame Renoir and Bob*.[2]

Despite the simplicity, not to say conventionality, of Madame Renoir's pose – associated in the history of Western art with melancholy or pensiveness[3] – Renoir's touch is as dynamic as in any of his figure paintings of 1910 (something of an *annus mirabilis* for him). While the composition is treated as large masses of colour in strident harmonic juxtaposition – the red background, Aline's yellow presence, the green tablecloth at right, the golden picture frame at left – Renoir's handling is liquid and abbreviated, and at times as thin as watercolour. White and yellow striations of paint are applied liberally all over, to suggest the fall of light on the sitter's arms and face, to enliven the greys of her hair, and to create the folds and creases of her dress. Nodules of impasto describe the crispness of her lace collar and cuffs with admirable tactility, while Renoir's cursive brushwork succeeds in conveying not only the billowing contours of Aline's robes, but also the weight of her figure underneath.[4] *Madame Renoir and Bob* was the sort of picture that the dealer Joseph Durand-Ruel had in mind when he claimed that Renoir, far more than Rodin, was the artist "who had most influenced modern sculpture." And this "because of his brush, his forms, his masses, his amplitude, and the sculptural qualities of his painted figures."[5]

Comparison with contemporary photographs of Aline confirm that Renoir exaggerated neither her size nor the casualness of her attire[6] – although for once she has refrained from wearing polka dots (fig. 299).[7] He also respected his wife's indifference towards jewellery: in a formal photograph of the couple, from the same period (fig. 301), a double gold wedding ring is Aline's only adornment. Above all, Renoir communicates something of his wife's weariness and increasingly poor health. Before she had reached her fiftieth birthday, Aline was suffering from chronic bronchitis and emphysema. Renoir confided to Rivière: "Things will certainly take a turn for the worse, but to get help for her is beyond my capacities."[8] She aged even more quickly after the outbreak of the First World War – her two eldest sons were both wounded in action – and she was eventually diagnosed as diabetic, although she refused to alter her diet.[9] In June 1915, returning from a particularly arduous journey to Gérardmer to visit her wounded son Jean in hospital – and to prevent the surgeons from amputating his leg[10] – she collapsed of exhaustion and died at the age of fifty-six.[11]

"My mother brought a great deal to my father: peace of mind, children whom he could paint, and a good reason not to go out in the evening."[12] Jean Renoir's affectionate and at times excessively roseate memoirs present us with a partial view of his parents' married life. From him we learn also that his mother loved dogs, but was not always very good with them;[13] was strong-minded and devoted, but not entirely subservient; and that her peasant blood and practical business sense led her to take over the running of the family homes in Essoyes and Cagnes.[14] Aline liked billiards and fishing (and was good at both),[15] enjoyed motoring (she taught Baptistin, the family chauffeur, how to drive),[16] and told funny stories at dinner.[17]

Kind, if unsparing, Renoir's portrait hints at a more complicated conjugality; there were tensions in the household that were just beginning to manifest themselves. For one thing, Aline was growing increasingly jealous of Gabrielle. It may not have helped matters that Renoir painted some of the most voluptuous of his many figures of Gabrielle at this time,[18] but the model no longer hid the contempt in which she now held her employer's wife (and distant cousin). To Vollard she confided that Madame Renoir was only happy when things went exactly as she wanted;[19] that while "the boss" was nice, his wife was "a nuisance," who would "come and annoy you all the time";[20] that she had filched some of the master's etchings against his wishes.[21] In December 1913 the situation would reach a crisis of sorts, and Gabrielle had to be dismissed. Mary Cassatt, who despised Aline,[22] relayed the denouement of this domestic drama in breathless tones: "The wife sent off the former model who has been with them 18 years and was Renoir's devoted nurse, she the wife was jealous and says she takes the nursing on herself, that she don't, and he is without a nurse, he who is as helpless as a baby."[23]

Unlike his son, who insisted on his parents' untroubled domesticity, Renoir does not shrink from exploring Aline's toughness and steely resolve. His portrait suggests that in addition to being a devoted companion and a protective mother she might well be a formidable opponent. "Not only does he capture the features of his sitters, he goes beyond these features to grasp their very character and their private selves."[24] Duret's celebrated adage, coined some thirty years earlier, is almost chilling in its acuity.

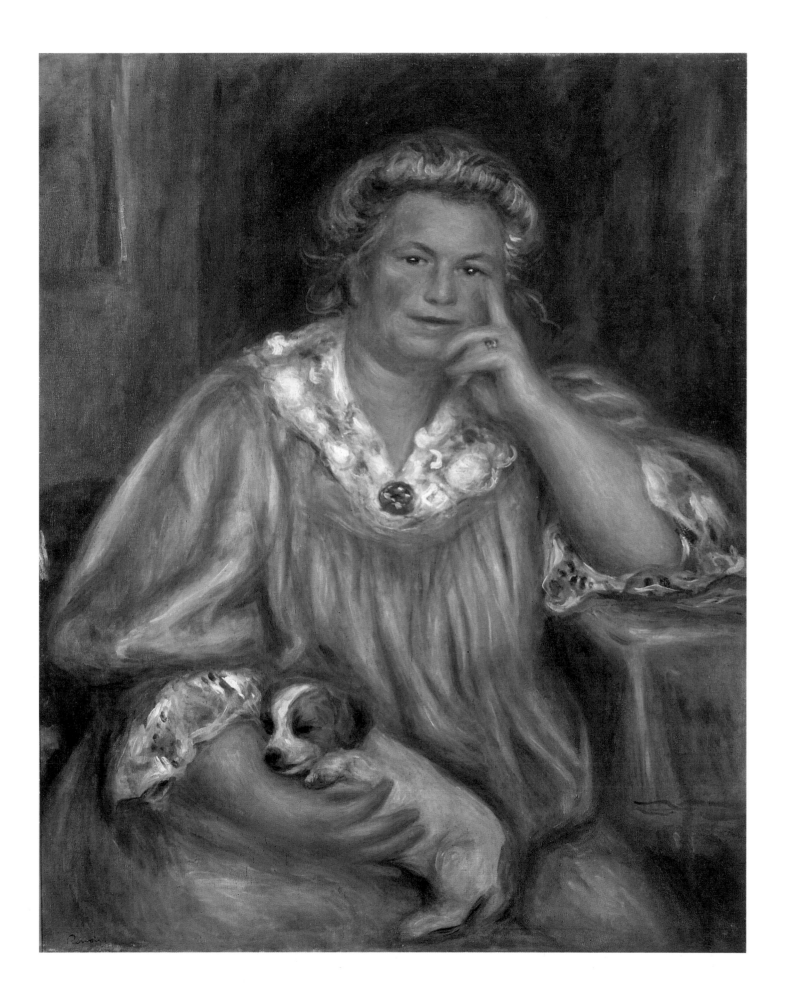

173 × 89 cm
Los Angeles County Museum of Art
Gift of Jean Renoir and Dido Renoir

"BECAUSE IT WAS BEING SAID that Renoir, now paralysed and no longer able to stand in front of his easel, was painting only reclining figures on horizontal canvases, he had his chair placed on a trestle so that he could execute vertical compositions such as the dancing figures in the Gangnat collection, the portrait of his son Jean as a hunter, and several other large canvases."[1] In his heroic account of the crippled Renoir deciding to return to large formats – and particularly to large vertical formats – Albert André gave pride of place to the towering portrait of Jean as a hunter.[2] The sitter himself offered a more practical explanation. One of the material advantages of his father's success in old age was to "be able to paint what he wanted in whatever size suited his fancy. He would buy large rolls of canvas, generally a yard in width, and cut out a piece with his tailor's scissors . . . He also had rolls much wider for his 'big jobs.'"[3] Jean also noted, somewhat flippantly, that Renoir had been inspired to paint this full-length after discovering an ornate frame in an antique shop in Nice, which he believed to be of seventeenth-century Italian origin and which was regilded at his request. Renoir felt that this massive frame was essential if the picture was to be presented properly, "especially in a drawing room in the Midi, where there is so much else to tempt the eye."[4]

Jean Renoir as a Hunter is a rarity in Renoir's late oeuvre: a portrait *en plein air* (except that, as we shall see, it was painted entirely in the large studio at Les Collettes). The artist's rejuvenated palette delights in the juxtaposition of potentially discordant hues – a scarlet cravat against a purple jacket, for example – as well as in a variety of whites, blues, oranges, and purples unified, almost miraculously, through a liberal application of ochre. The diaphanous background is painted in thin washes of colour, so lightly applied that the weave of the canvas is visible in places. Despite the solidity of the figure, Renoir's handling of Jean's costume and accoutrements is joyous and mobile: the various folds and tucks of the striped jacket are meticulously described, as are the two buttons that catch the light, and dabs of white impasto are generously arrayed throughout. Pentimenti attest to the several changes that occurred in the position of Jean's head and right shoulder, his right hand, and the angle of his gun (the barrel of which has been moved more than once). By contrast, Jean's face and hands are modelled with the deliberateness of sculpture.

Set against a resplendent Mediterranean landscape, fifteen-year-old Jean is dressed in the French equivalent of a Norfolk jacket, in knickerbockers that are rumpled at the knees, and in oversized hunting boots.[5] The family setter, Bob, seen as a puppy in Renoir's slightly earlier portrait of Aline (cat. no. 62), has now grown a little and sits expectantly at Jean's feet, a dog collar around his neck. Jean himself, at the time a student at the Lycée Masséna in Nice, is both boyish – with wide eyes and chubby cheeks – and large of frame: Maurice Denis, visiting Cagnes in February 1913, remarked upon his being "tall and well built."[6]

Evidently 1910 was a good year for portraits, as it was for painting in general: Renoir allowed that his art "was a happy one since it is capable of maintaining our illusions, and even bringing us joy."[7] By the end of March, Renoir had painted the fine portrait of his wife (cat. no. 62), as well as two family portraits of the Bernheim-Jeunes and their daughter Geneviève (both Musée d'Orsay, Paris), all of which Maurice Denis admired.[8] His grandiose portrait of Jean was probably executed between March and August, before the entire family left Cagnes for Wessling am See, on a lake outside Munich, where they were the guests of the Thurneyssens (see cat. nos. 66–67).

In a discussion that unaccountably failed to make its way into his memoirs of his father, Jean Renoir provided the most detailed description of the genesis of this full-length portrait:

> At Les Collettes, when I was fifteen years old, I wore a jacket that reminded my father of a hunter, so he had me pose with a gun and with Bob for a hunting dog. The gun was borrowed from one of our farmers. I shot it only once, killed a bird, and was horrified. The posing sessions, which were held in the big studio, went on for several months, but fortunately they were very short. I had just been given my first motor bike and I was impatient to go full-speed through the beautiful roads of southern France.[9]

Renoir's choice of attributes and accoutrements, while fanciful, was not altogether arbitrary. Even though Jean recoiled from having shot a bird, his boyhood ambition was to enter military service, and in February 1913 he signed up for three years in the 1st *régiment des dragons* (he would become *sous-lieutenant* of the 6th *batallion de chasseurs alpins* in March 1915).[10] Renoir has somewhat idealized his son's features, giving him a vacant, almost ageless expression that is unexpectedly closer in feeling to photographs of the film director in old age (fig. 304) than to the energetic young cavalry officer on the eve of the First World War (fig. 305).

Although both the pose and the costume of *Jean Renoir as a Hunter* had been used by Renoir before – Jean's attitude repeats that of the much earlier *Sailor Boy (Robert Nunès)* (1883, Barnes Foundation, Merion, Pa.), and Renoir had painted the well-born Alfred Berard, aged nineteen, as a hunter in 1881 (fig. 198) – the artist was not primarily indulging in self-quotation.[11] Rather, he was inspired by Velázquez's royal hunting portraits, notably *Prince Baltasar Carlos as a Hunter* (fig. 303), seen in Madrid some eighteen years earlier.[12] Thanks to Vollard, we know how moved Renoir had been by the paintings of Velázquez that he and Gallimard had seen in the Prado (for Renoir, the Prado *was* Velázquez) and that he responded above all to the dignity and humanity of the Spanish master's figures and portraits.[13] "What I admire most in this painter," he informed Vollard, "is his unerring aristocracy, which is to be found in the slightest detail, in a simple ribbon, for example."[14]

Renoir also claimed that Velázquez derived joy from the practice of his art,[15] a typically Ruskinian notion that preoccupied him at a time when he was writing the foreword to Victor Mottez's translation of Cennino Cennini's *Libro delle arte* (finally published as *Le Livre de l'art ou Traité de la peinture* in 1911).[16] Here Renoir was able to develop one of his favourite themes, the vitality of the decorative arts in a pre-industrial age, and the joy that craftsmen took in what they made.[17] Oblique though the connection might be, Renoir's insistence on having *Jean Renoir as a Hunter* appropriately framed (a growing concern of his later years) and his enthusiasm for Velázquez as a "natural painter" are both related to

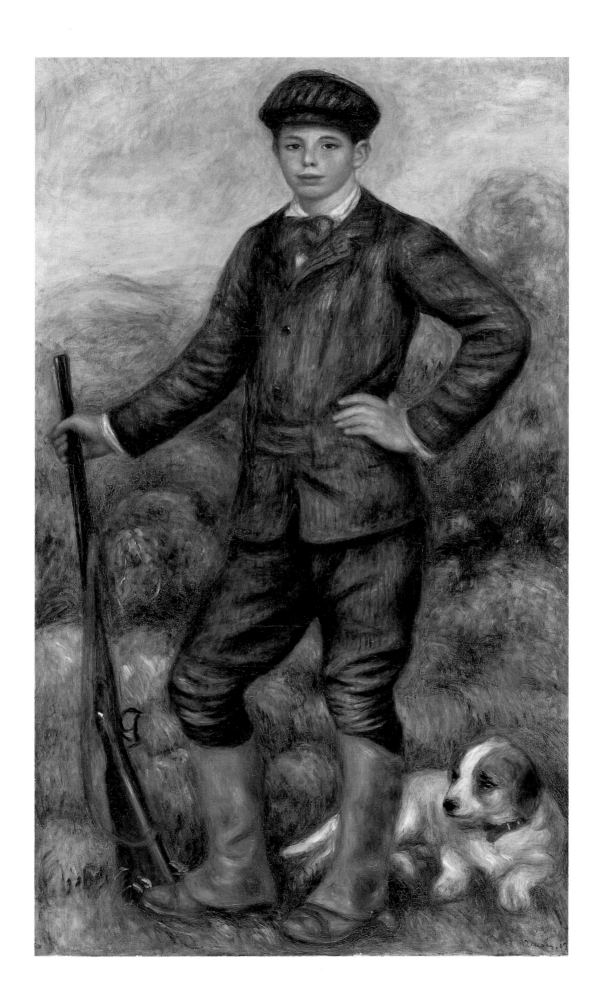

his deep-seated if idiosyncratic interest in the Arts and Crafts movement, given focus by the forthcoming publication of the *Libro delle arte*.

If Velázquez had been secondary to Watteau as the inspiration for Renoir's *Clown* (cat. no. 61), in *Jean Renoir as a Hunter* the influence of these two artists is reversed. And yet, while the primacy of Velázquez cannot be questioned – even Bob derives from his Spanish predecessor – Renoir always saw himself as part of an essentially "French" tradition, "this school that I love so much, so pleasant, so light, such good company."[18] In one of his rare descriptions of the landscape at Les Collettes, a Mediterranean "earthly paradise" that pervades the late work,[19] Renoir might well be describing the setting for *Jean Renoir as a Hunter*: "Look at the light that falls on the olive trees, bright as diamonds. Now pink, now blue. And the sky coming through. It's enough to drive one mad! And the mountains that float past with the clouds. It's a background straight out of Watteau."[20]

65 × 54 cm
Durand-Ruel, Paris

A man of medium height, with a round, clean-shaven face, short white hair, a toothbrush moustache, and bushy eyebrows that reveal a pair of extremely lively eyes (by turn serious and penetrating, always sparkling with mischief). A rather husky voice, but clear, each word carefully chosen. Mild-mannered and courteous, hands behind his back, head bent forward a little and turned slightly to one side, the better to hear his interlocutor. Often ironic; few grand words and no fancy phrases. Instead, every indication of an unshakable obstinacy: an iron will, though not a violent one, that achieves its ends with a smile.[1]

WITH ALEXANDRE'S TESTIMONIAL IN MIND, and as is confirmed by two contemporary photographs of the sitter (figs. 306, 307), Renoir's exceedingly affectionate portrait of Paul Durand-Ruel (31 October 1831–3 June 1922) is scrupulous not only with regard to the man's physical appearance but also with regard to his character (or at least to the character he presented in public). As a boy, Jean Renoir had been struck by "the clean smell about his person,"[2] and Durand-Ruel's grooming, his propriety, and his reserve are all here evoked with an admirable economy of means.

Seated on a red canapé of indeterminate design, a gleam in his eyes, the seventy-nine-year-old dealer – who had yet to retire from business[3] – is represented as approachable if a little weary.[4] His soft "Renoir-pink skin" and his "gentleman's outfit" testify to a comfortable bourgeois existence,[5] although the shrunken throat and snow-white hair are signs of age. Everything about the portrait is restrained – from the sitter's somewhat shapeless frockcoat (or is it an overcoat?) to the rosebud pattern on the wallpaper in the background – and Renoir's tonal range of warm reds, mauve-greys, and golden ochres is appropriately understated. In general, the paint is applied thinly but with extreme delicacy: in lively cross-hatchings on the coat, which Durand-Ruel is perhaps unbuttoning; more thickly on his cuffs and bat-wing collar; and with a calligrapher's touch on his pupils, the tufts of his moustache, and the wisps of hair on his closely cropped head. Renoir's portrait uncannily evokes an earlier description of the dealer that had compared him, in outward appearance at least, to "a provincial notary or a lawyer from the suburbs: punctual, methodical, and formal."[6]

Dated 1910, the portrait was painted in Paris, probably in Renoir's studio at 73 rue Caulaincourt, and most likely in June–July, when Renoir, as was his custom, left Les Collettes to divide the summer months between Paris and Essoyes.[7] From the artist's correspondence, we know that Durand-Ruel did not visit Renoir in Cagnes until January 1911[8] – although an invitation had been issued almost two years earlier[9] – and while the backgrounds of the late works are rarely site-specific, it is worth noting that *Paul Durand-Ruel* lacks the sensuous reds of the portraits and figures executed at Les Collettes (cat. no. 62). Furthermore, since Renoir indicated to Durand-Ruel that he planned to be back in Paris around the middle of June, he would have been able

to visit the dealer's commemorative exhibition of paintings by Monet, Pissarro, Sisley, and himself that ran from 1 to 25 June.[10] Little discussed in the press, this exhibition, while taken from stock, paid tribute to a brotherhood that had long since vanished (two of its members having been dead for some time). The nostalgic character of the enterprise may have played some part in influencing Durand-Ruel to commission a portrait from one of the two surviving Impressionists. The very opposite of Vollard in this regard, Durand-Ruel (whom Monet and Renoir always referred to privately as "le père Durand") was extremely reticent about having his portrait painted, despite his well-deserved reputation as the "self-appointed Saint Vincent de Paul of the Impressionists."[11] Thus the cluster of images and interviews that appeared in 1910 and 1911 mark something of a departure from his customary self-effacement.

"We needed a reactionary to defend our painting, which Salongoers said was revolutionary. Here was one person, at least, who was unlikely to be shot as a Communard!"[12] Renoir was well aware of certain incongruities in Durand-Ruel's role as the lone promoter of a despised and misunderstood school. A devout Catholic and ardent monarchist, in October 1873 he publicly announced his support of the comte de Chambord, legitimist pretender to the throne.[13] Yet in the coming years Durand-Ruel did not hesitate to support Intransigent artists and to continue to buy the work of Courbet, a disgraced Communard.[14]

The only son of a stationer's clerk who had married the proprietor's daughter and expanded her family's art supplies store into an elegant gallery of modern painting in the rue de La Paix, Paul Marie Joseph Durand was, by his own admission, an extremely reluctant picture dealer.[15] "As for me, I detested business," he confided to Fénéon in April 1920, "and dreamt only of becoming an army officer or missionary."[16] After passing the entrance examinations for the École Militaire de Saint-Cyr in October 1851, he was accepted the following month into the 20th *régiment d'infanterie légère*, on the condition that he sign up for seven years.[17] This seems to have prompted a change of heart, and Durand now returned to his father's thriving picture gallery, which dealt primarily in Romantic genre painting and landscapes. Although he soon emerged as a passionate supporter of the "École de 1830," Durand *fils* was eclectic in his tastes and drawn to a wide range of new talent, which in the 1860s was more likely to include Bouguereau (whom he represented exclusively until 1868) and the now forgotten Hugues Merle than Manet and Courbet.[18] Indeed, as Linda Whiteley has pointed out, Durand made it a habit to visit the studios of returning Prix de Rome winners in order to be among the first to buy their works. The young moderns whom he patronized in this way included Cabanel, Hébert, Baudry, and Bonnat.[19]

After the outbreak of the Franco-Prussian War, Durand left Paris with his wife and five children for London, where he began to show the work of French artists (living and recently dead) in the inappropriately named German Gallery on New Bond Street.[20] In London, he was introduced to Monet by Daubigny, who in turn introduced him to Pissarro and Sisley (he acquired and exhibited works by all three newcomers).[21] Returning a widower to Paris early in 1872 – his wife had died in November 1871, pregnant with their sixth child[22] – he was introduced by Monet to Renoir, and in March 1872 acquired the latter's *Pont des Arts* (1867, Norton Simon Art Foundation, Pasadena, Calif.) for 200

francs, thus inaugurating a relationship that would cease only with Renoir's death forty-seven years later.[23] If Durand-Ruel's commitment to the Batignolles school was reaffirmed during the 1870s, it should also be remembered that this was a precarious decade for him, forced as he was to scale back his operations (Courbet, to whom he owed a small fortune, assumed that he had declared bankruptcy in January 1876).[24] Only after an infusion of capital in the winter of 1879 from Jules Féder, head of the Union Général (a Catholic bank), was Durand-Ruel able to negotiate the exclusive rights to the Impressionists' work (the sort of arrangement that he preferred), and from 1881 Renoir, for one, began to receive a regular income from him.[25] Despite the accumulation of an impressive stock of Impressionist paintings and lavish commissions to both Monet and Renoir in the early 1880s, by 1885 Durand-Ruel was almost bankrupt once again. His company's finances were restored by the unexpected success of his first New York showing in April–May 1886, and the American market would remain crucial in sustaining operations until collectors at home began to accept the École des Batignolles as the natural successor to the now venerated École de Barbizon (over which Durand-Ruel had also exercised a monopoly).[26]

Durand-Ruel's position was still far from assured, and in a letter to *L'Événement* published in November 1885 he stated his allegiances in a manner that was truly heroic. Coming more than a decade after the first Impressionist exhibition, his letter also serves to remind us that the consecration of the New Painting was still far from assured:

> I have been and still am the friend of Bouguereau, of Cabanel, of Bonnat, of Baudry . . . I was one of the first to recognize their merits and contribute to their fame . . . Was that a reason to hold great artists such as Millet, Corot, Delacroix, Rousseau, or Courbet in contempt and leave them in oblivion? Since that time, I have searched among the young artists for those called upon to become masters in their turn . . . Lhermitte, Fantin-Latour, Boudin, Roll, Duez. I could say that almost all of our great artists know what I have done for them and honour me with their friendship. I come now to my great crime, the one that towers above all the others. For a long time I have bought and greatly admired works by very original and skilful painters, many of whom are men of genius, and I seek to make them known to collectors. I consider that works by Degas, by Puvis de Chavannes, by Monet, by Renoir, by Pissarro, and by Sisley are worthy of being included in the most beautiful collections.[27]

Such fervent support earned Durand-Ruel the undying loyalty of the Impressionists. A year before he died, Monet (by now an extremely wealthy man) confided to René Gimpel: "I have a debt of gratitude to Durand-Ruel, because he alone made it possible for me to eat when I was hungry."[28] Yet, unlike his competitors Vollard and Bernheim-Jeune (who had the greatest respect for him), Durand-Ruel was unable to move beyond the core group

of Impressionists. He was less than wholehearted in his admiration of Cézanne, whose reputation he considered overblown, and he complained to Renoir in April 1908 of "those jokers who claim that there are only three great masters, Cézanne, Gauguin, and Van Gogh, and who have unfortunately succeeded in mystifying the public accordingly."[29] Although his gallery was the first to show works by Gauguin (November 1893), Redon (March 1894), and Toulouse-Lautrec (May 1902), Durand-Ruel's interest in the younger generation was cautious and faint-hearted.[30] He encouraged the tepid Impressionism of André, d'Espagnat, and Maufra.[31]

By the first decade of the twentieth century, Durand-Ruel's commitment to Impressionism was thoroughly vindicated at auctions, in international exhibitions, and through purchases made by museums and private collectors, particularly in Germany, Russia, and the United States. For the ageing artists themselves, the dealer and his sons continued to perform any number of services, chiefly financial: paying rent, renewing insurance policies, taking care of charitable donations.[32] Louisine Havemeyer noted with some amazement that Degas "looked upon Durand-Ruel as upon a bank account."[33] The head of the company could still remind artists of their obligation to him – Renoir was rebuked in November 1903 for having signed sketches and unfinished works that might cause his prices at auction to fall[34] – but, even though he remained energetic until well into his eighties,[35] Durand-Ruel now distanced himself from the daily business of dealing, and his "warm rule" was replaced by the more gentle manner of his eldest son.[36] In March 1913, Mary Cassatt, with typical venom, reported that Durand-Ruel *père* was giving away "140,000 francs a year to uphold right-thinking newspapers! All of which is useless, and he has four children, such it is to be a bigoted Catholic."[37] Rather than gossiping behind his back, Renoir occasionally stood up to the dealer. After hearing Durand-Ruel complain about never having made any money from selling pictures, Renoir is reported to have replied, "And how did you make your money? I don't know of any other business you have."[38]

This anecdote, related by Mary Cassatt a year after the painter died, has the ring of truth. In general, however, relations between Renoir and Durand-Ruel, ten years his senior, were mutually respectful and solicitous, rather formal, and yet grounded in affection – characteristics that resonate in his late portrait of the man. Jean Renoir noted that his father was unfailingly reserved in the display of his emotions and feelings towards those for whom he felt the most.[39] Seen in this light, Renoir's letter of November 1885 written in support of Durand-Ruel, who had been implicated in a scandal concerning the authenticity of a forged Daubigny, is both impassioned and heartfelt: "They will never be able to destroy your real quality. A love of art and the support of artists before they are dead. In years to come this will be your real glory."[40] Nowhere is such a tribute expressed with greater emotion and conviction than in Renoir's magisterial late portrait of Paul Durand-Ruel.

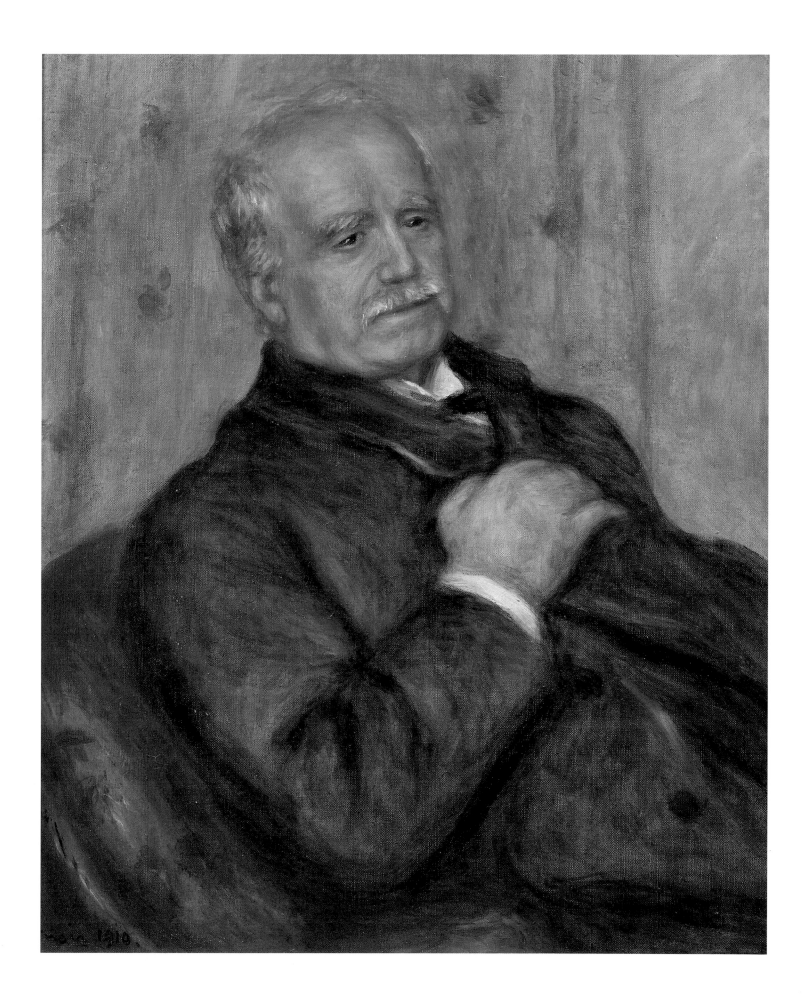

65 *Wilhelm Mühlfeld* 1910

55 × 45 cm
Southampton City Art Gallery, England

Wilhelm Mühlfeld WAS THE FIRST portrait that Renoir completed during his month-long holiday in Wessling am See, a popular bathing resort twenty-five kilometres outside Munich, where he and his family were staying as guests of the Thurneyssens (see cat. nos. 66, 67). As Gabrielle informed Maurice Gangnat, in a letter that can be dated to the middle of August 1910, "the boss" was hard at work on the portrait of Madame Thurneyssen and her daughter, having already "painted some views of the lake as well as a beautiful portrait of Monsieur Mulfield [sic]. He doesn't have much of an appetite, but perhaps that's because of the beer."[1]

The portrait of which Gabrielle approved is indeed a virtuoso performance, painted in thin washes of colour applied over a rapidly sketched silhouette. A more loaded brush describes the sitter's face, neck, and foulard, while the collar of his open shirt is deftly painted in white impasto. With considerable brio, Renoir has crafted an unidealized, but disarmingly frank, portrayal of this robust and somewhat dishevelled sitter, whose wavy hair is greying at the temples and whose rustic attire – a white shirt trimmed with red, a cravat that has come undone – seems slightly at odds with the more formal monocle, whose silk chord is missing. One wonders if he is also wearing *Lederhosen*.

As is immediately apparent from comparison with a photograph of Mühlfeld taken earlier in the decade (fig. 308), Renoir has invented nothing: in fact, he has made the sitter a little younger and less bullish. The slightly suspicious look on Mühlfeld's face – as if the wind had temporarily been taken out of his sails – is beautifully observed, as is the impression of a large and somewhat untidy man who is on holiday and does not have to worry about his appearance. Renoir's instinctive honesty (and sympathy) in recording both his sitter's physical attributes and his "temperament" – even though he had just met Mühlfeld and could not converse with him in his native tongue[2] – confirms that in old age his surpassing talents as a portraitist were in no way diminished.

Wilhelm Johann Mühlfeld (7 January 1851–29 November 1912) was fifty-nine when he sat to Renoir.[3] The second son of a musical family – his father Leonhard (1819–1876) was music director at the spa town of Salzungen – he and his three brothers had been trained as violinists but went on to teach themselves various wind instruments.[4] Wilhelm became an oboist of some repute, was accepted into the military band of the 80th regiment of Wiesbaden in October 1869, and saw action in France the following year. Stationed with his regiment near Versailles during the siege of Paris, his unit was called upon to give weekly concerts to Emperor Wilhelm. At the end of the war he returned to Wiesbaden, where between 1873 and 1892 he served as oboist in the spa orchestra ("Kurkapelle"). He resigned his post in 1892 on an annual pension of 600 marks, worked as a piano teacher and choirmaster (he was apparently much in demand in girls' schools), and dabbled in composing.[5] Although he received offers to join the Dresdener Hofkapelle and to perform in America, he chose to remain in Wiesbaden (it was here that he would have met Fritz Thurneyssen and his father[6]), and his contribution to the cultural life of this fashionable watering hole was duly recognized in 1908, when he was made Königliger Musikdirektor, a purely honorific title that carried no professional obligations. He never married. Although the sitter of Renoir's portrait seems in perfectly good health, Mühlfeld soon after succumbed to cancer of the liver and the stomach and, following a long illness, died in November 1912, just over a month before his sixty-second birthday.[7]

For many years thereafter, the sitter would be routinely misidentified as Wilhelm's younger brother Richard Mühlfeld (1856–1907), who had died three years before Renoir's portrait was painted.[8] The principal clarinettist at the court of Saxe-Meiningen, whose beautiful tone had been compared by Liszt to the sensation of biting into a ripe peach, Richard was a musician with an international reputation.[9] In a photograph of the four Mühlfeld brothers, taken in the 1870s, he appears just right of centre, straddling a chair, while a much slimmer Wilhelm, sporting a monocle, stands to his right (fig. 309). It was Richard's brilliant playing at Meiningen in March 1891 that persuaded Brahms to start composing again: the clarinet trio, opus 114, and clarinet quintet, opus 115, were dedicated to and performed by Mühlfeld in Berlin the following December.[10] In November 1895 Brahms arranged for himself and Richard, whom he embarrassingly referred to as "Fraulein von Mühlfeld, meine Primadonna," to perform his new piano and clarinet sonatas for Clara Schumann at her home in Frankfurt. Wilhelm Mühlfeld was among the small group of guests, although this is the only occasion on which he is known to have mingled in such exalted circles.[11]

In the summer of 1910, by contrast, Wilhelm Mühlfeld's musical gifts were readily placed at the disposal of his hosts' Parisian visitors. He taught the sixteen-year-old Jean Renoir to play the trumpet, an instrument he considered "the best introduction to the great composers."[12] And he spent much of his time encouraging the twenty-four-year-old Renée Rivière (future wife of Paul Cézanne *fils*), who had accompanied the Renoirs on this visit, to take her singing more seriously. Mühlfeld simply could not understand why "anyone with such a voice should show so little desire to devote herself to the cult of Mozart and Bach."[13] Renoir, who had encouraged Renée in exactly the opposite direction – in April 1909 he had told her father to make sure that she brought some of her "trashy" music with her[14] – amply repaid Mühlfeld for his forbearance and good humour in this spirited and *gemütlich* half-length portrait that deserves to be better known.

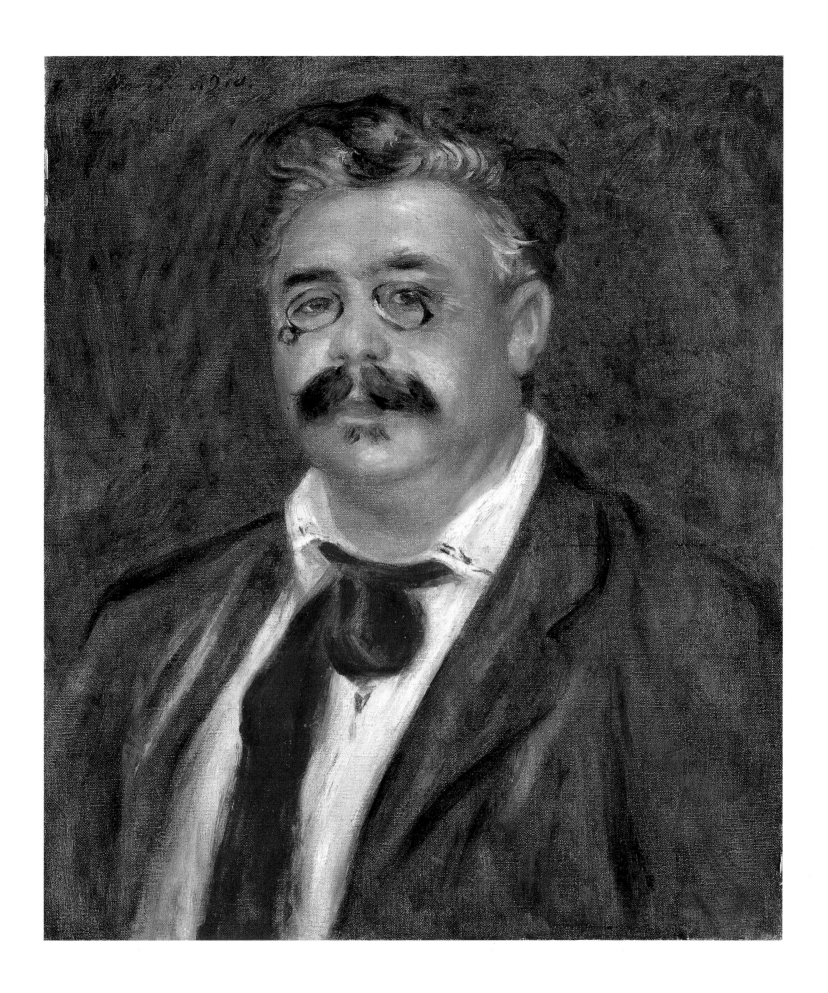

66 *Madame Thurneyssen and Her Daughter* 1910

100 × 80 cm
Albright-Knox Art Gallery, Buffalo, N.Y.
General Purchase Funds, 1940

67 *Young Shepherd in Repose*
(*Alexander Thurneyssen*) 1911

75 × 93 cm
Museum of Art, Rhode Island School of
Design, Providence
Museum Works of Art Fund

IN AUGUST 1910 RENOIR AND HIS FAMILY were invited for the summer to the resort town of Wessling am See by Dr. Fritz Thurneyssen (1872–1947), a wealthy Munich intellectual and a recent convert to modern art.[1] Accompanied by Gabrielle and Renée Rivière, the Renoirs and their three children were lodged in the schoolteacher's house overlooking the lake, and although Jean would remember this Bavarian holiday as idyllic, the summer was one of the wettest on record.[2] Renoir, bored by the flatness of the landscape, eventually cut short the stay to one month, but not before visiting the Alte Pinakothek, whose peerless collection of paintings by Rubens he greatly admired.[3] The latter's *Hélène Fourment with Her Eldest Son, Frans* (fig. 316) presides over *Madame Thurneyssen and Her Daughter* (cat. no. 66), the most significant work that Renoir would paint in Munich that summer. As Renoir told the American Walter Pach, who interviewed him in Cagnes the following year: "See the pictures by Rubens in Munich; there is the most glorious fullness and the most beautiful colour, and the layer of paint is very thin."[4]

Renoir had met Thurneyssen and his family in Cagnes in 1908, when he had painted a three-quarter-length portrait of his wife (fig. 310) as well as a rather more lively oval of his ten-year-old son Alexander (fig. 312).[5] After Renoir's visit to Wessling am See in 1910, the Thurneyssens returned to the south of France the following year so that Alexander could sit for one of the more unlikely commissioned portraits in the history of French art (cat. no. 67).[6] And in March 1912 they saw Renoir for the third consecutive year when they visited him in Nice, where he was recovering from a leg operation.[7] Thurneyssen was now lobbying for the donation of a recent work to the Neue Pinakothek. Reluctant at first, Renoir suddenly changed his mind, and by the end of the year his portrait of Monsieur Bernard had been offered to the museum by Durand-Ruel.[8] With the outbreak of the First World War, communication between the two families ceased.

No less an authority than Meier-Graefe considered the Thurneyssen collection second only to that of Maurice Gangnat's

for its late Renoirs. Indeed, he claimed that it was the only place in Germany where one "could properly judge the master's recent development."[9] Vollard referred in passing to Thurneyssen as an enthusiastic art lover who had abandoned Meissonier and Bouguereau for Cézanne, and whose behaviour became noticeably more sophisticated as a result.[10] And Renoir remembered a beautifully framed drawing of a nude by Degas that he had seen in Thurneyssen's apartment in Munich, "the only thing one saw in the whole room, like a piece of the Parthenon."[11]

Despite all this, Thurneyssen and his family remain little known; and what has been written about them is largely incorrect because of an unfortunate homonymic coincidence. Since Thérèse Berard (figs. 55, 56), the niece of Renoir's great patron Paul Berard, had married a Colonel Albert Thurneyssen (1858–1936), it has generally been assumed that this couple and the Munich Thurneyssens were one and the same.[12] Drawing upon police records, and unpublished municipal and family archives, it is now possible to present a summary biography of the Munich Thurneyssens which establishes that the two families – one German, the other French – had nothing whatsoever to do with each other.

Born in Biebrich am Rhein and christened Friedrich Albert Thurneyssen, Fritz (25 July 1872–23 February 1947) was the second son of Alexander Thurneyssen (1825–1916), a partner in a successful chemical factory, and his wife Albertina (1844–1876), who died when the boy was four years old. In 1882 Alexander retired from business and moved with his two sons to Wiesbaden, where Fritz attended grammar school (it was at this time that the family would have met Wilhelm Mühlfeld; see cat. no. 65) before being accepted into the University of Munich in 1891.[13] After a year's military service in the First Bavarian Field Artillery Regiment, Fritz returned to Munich to pursue a doctorate in political science under Lujo Brentano, the country's leading authority on trade unionism. In 1895, his thesis on the history of the Munich cabinet-makers was accepted, and it would be published two years later in *Münchener Volkswirtschaftliche Studien*.[14] Subsequently, Thurneyssen seems to have had no career as such. In June 1899 he married Barbara (Betty) Dörr (14 January 1872–27 July 1922) from Munich, who was already the mother of his six-month-old son Friedrich Albert Alexander, born in Paris on New Year's eve 1898. A daughter, Josefine Albertina, was born to the couple on 11 August 1907.[15] This remarkably good-looking family seems thereafter to have led an exemplary upper-middle-class existence in Munich (fig. 311).

In January 1910, Maurice Denis recorded an off-colour joke recently told by Vollard at the Tour d'Argent, during a dinner that the latter had given for Count Harry Kessler and to which he had invited Maillol, Van Rysselberghe, and Denis. It concerned a German collector who wanted Renoir to paint "an intimate portrait of his wife." Renoir, asking his sitter to button up her blouse, elicited the husband's disappointed response, "So, we're not going to see anything of her breast?" (this in a mock-German

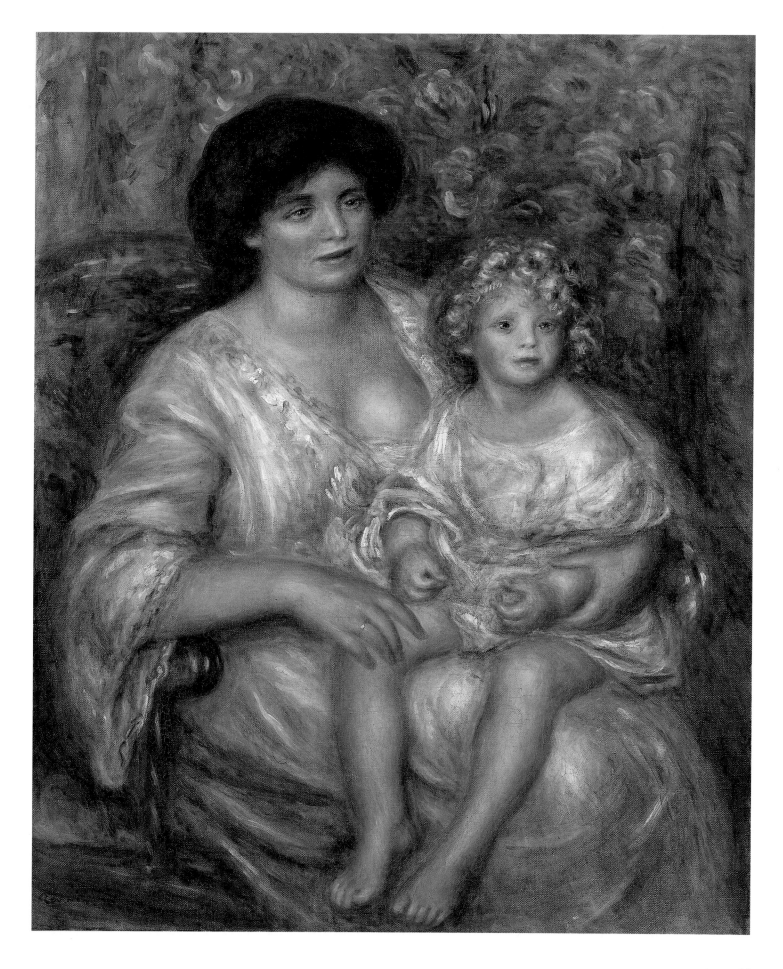

cat. no. 66

accent).[16] Vollard would later repeat and embellish this story. In one version, the sitter is a Greek woman, of whom Renoir would later paint a grander portrait.[17] In another, the German and his wife visit Renoir in his studio while he is painting a female nude. In order to give his patron an idea of the type of portrait he will paint of his wife, Renoir drapes the model in a variety of styles; when the patron insists that the portrait is to be more intimate, Renoir covers the model's bosom with a scarf. "No, no!" protests the German. "I mean really intimate . . . at least one breast should be showing."[18]

Whichever version is the truer, the story does draw our attention to one of the most disturbing features of the portrait that Renoir painted of Betty Thurneyssen and her daughter in August 1910. For whereas in the 1908 three-quarter-length portrait her costume has nothing unusual about it, in the double portrait her left breast is revealed in a manner that would be appropriate only in a "Maternité" – and Josefine, aged three, is too old to be nursed. It would appear that Fritz Thurneyssen's wishes were finally satisfied.

The patron's unorthodox request inspired one of Renoir's most sensuous portraits, in which his vision of motherhood is almost ecstatic. As Meier-Graefe noted: "One could think of it as a new type of Madonna and Child, with the mother having no intimation of the child's godliness."[19] Renoir has temporarily abandoned his roseate, meridional palette for darker hues. Painted over grey priming, the two figures emerge as from a penumbra, the pinks of their flesh tones and the whites of their dresses applied with exceptional energy and rhythm. Both mother and daughter share a roundness, an almost pneumatic corporeality, that will receive its fullest expression in late nudes such as the magnificent *Bathers* (1918–19, Musée d'Orsay, Paris). And while the melding of thin washes of paint, with only the occasional impasto on the abundant folds of Betty Thurneyssen's peignoir, is indebted to Rubens, Renoir's unusually sombre palette (due to a liberal application of black) and his "ebullient, ribbon-like" brushstrokes, evoke the late work of Titian.[20] Indeed, Renoir might well have been describing his own procedures in *Madame Thurneyssen and Her Daughter* when he observed in an interview with Walter Pach that "Titian is a man who always stays great for me . . . No one ever painted flesh as he did . . . [it] seems to have light coming out from it, like a lantern. It seems to rise above painting."[21]

We are exceptionally well informed as to the gestation of Renoir's double portrait thanks to the testimony, both written and drawn, of the German Impressionist Heinrich Brüne (1869–1945), a member of the Luitpold Gruppe, in whose large and recently built studio in Oberpfaffenhofen, one kilometre from Wessling, the work was executed.[22] For Brüne, the meeting with Renoir was the most memorable of his life, and he left a vivid if slightly breathless account of the painter and his entourage arriving from Wessling in a charabanc, with Renoir, "Lazarus-like," being carried into his studio in a wheelchair and preparing to work amidst a gaggle of chattering and singing onlookers.[23]

Brüne made several drawings of Renoir, two of which are dated 17 August 1910 (fig. 313). The most telling shows him at work on the portrait of Madame Thurneyssen and her daughter and confirms what propriety would have dictated: that Renoir could not possibly have painted his hostess with her breast exposed. In Brüne's drawing, Betty Thurneyssen is shown wearing a dress the cut of whose bodice is unremarkable (fig. 314).[24]

Although published posthumously, Brüne's written account would seem to resolve the vexed problem of Madame Thurneyssen's left breast (while also providing a fascinating glimpse into Renoir's working methods). In Brüne's memoir, Renoir is at work on a female figure – neither the word "portrait" nor the name Thurneyssen is mentioned – and paints from a model whom he instructs with the most "cursory of signals." The model is dressed in a "genuine Paris dressing gown of white tulle and pink bows, which already hinted at the work of art that would emerge."[25] Having laid out the composition in charcoal, and "tirelessly casting his eye back and forth between model and canvas so that her entire form could be fitted within the confines of the given space,"[26] Renoir proceeds to create, "with soft, caressing brushstrokes," the "curves of her body, the oval of her face, the fullness of her breast."[27] The colours on his palette are compared to a "mess of potage." Only later are blue and ochre added to the black, white, and vermilion, in order to produce the green and golden tones of the background.[28]

Given the dress that his model is asked to wear, and the range of colours he uses, Renoir is surely at work here on the portrait of Madame Thurneyssen. Brüne's account also states that the painting was produced over several sessions – he has Renoir working on this portrait every day for three weeks[29] – and it seems reasonable to assume that Betty and Josefine made an appearance as and when required. That the process was fairly lengthy is confirmed by Gabrielle's letter to Maurice Gangnat, written in the second half of August, in which she enthuses over the portrait of their host's wife: "The boss is feeling better. He's made good progress on his portrait. I wish you could see how pretty it is. Madame Thurneyssen in a pink and white dress that is very open with her little daughter on her lap. The girl has blond hair and is not at all pretty, but the boss has been able to make something good of her."[30]

Fritz Thurneyssen was sufficiently pleased with Renoir's portrait of his wife and daughter to commission a second and similarly ambitious portrait of his son Alexander.[31] Because of Renoir's decision to return to Paris earlier than expected, work was postponed until the following year, when Alexander, whom Jean Renoir remembered as being "as beautiful as a Greek shepherd," sat to Renoir in the guise of the mythological hero Paris.[32] For all the whimsy of Renoir's presentation, in one regard he was simply painting what he saw: family photographs confirm that Alexander was not only an extremely pretty boy, but that he also wore his thick auburn hair in the most extravagant coiffure (fig. 318).

256

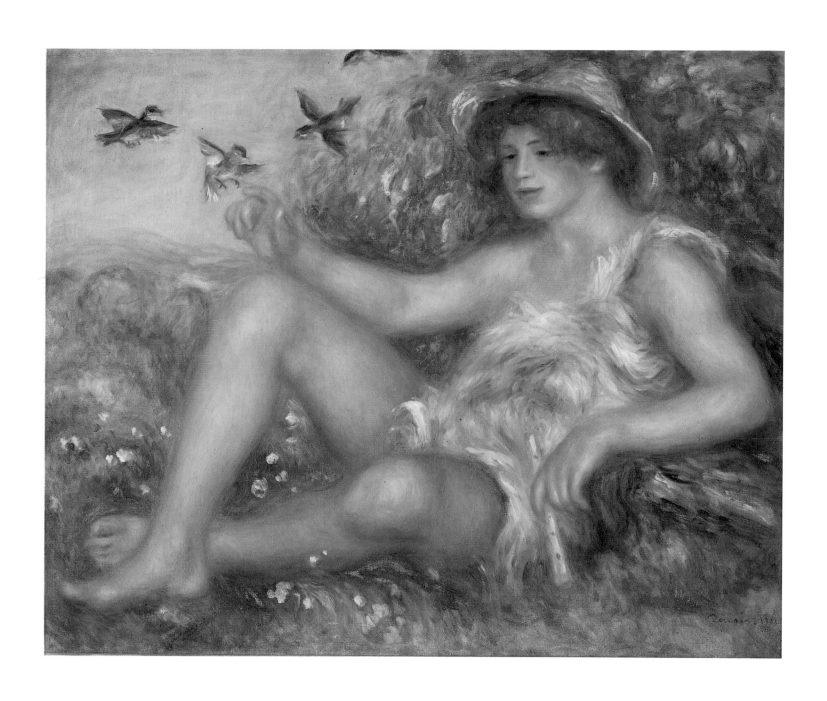

cat. no. 67

Painted at Les Collettes, *Young Shepherd in Repose (Alexander Thurneyssen)* portrays Renoir's adolescent sitter, not yet thirteen years old, reclining out of doors in Gabrielle's straw hat, and posed after the celebrated Dionysus figure on the east pediment of the Parthenon (fig. 317).[33] The monumentality and stillness of Renoir's composition is also indebted to Maillol's sculpture. Holding a flute in his left hand, gesturing to the birds in benediction with his right, young Thurneyssen is part Phrygian rustic – "A Daphnis waiting to meet his Chloe"[34] – and part Saint Francis of Assisi.[35] As in the portrait of Madame Thurneyssen and her daughter, this mixing of metaphors is at the heart of Renoir's enterprise.[36] Once again, he may have used a studio model (probably female) for the boy's body, but it is unlikely that he would have undertaken the portrait entirely from memory, as Pach suggested, since the presence of the sitter, while certainly mediated in this instance, was always crucial to him.[37] That the Thurneyssens visited Renoir on at least one occasion in 1911 is confirmed by Gabrielle's letter to Vollard, written from Croissy in September of that year, informing him that the Thurneyssens had just left, "and were only sorry not to have seen you. They say that the portrait of Alexander gets prettier and prettier."[38]

Renoir's personification of Alexander was both prescient and erudite. He could hardly have guessed that the twelve-and-a-half-year-old boy would grow up to become a famous musician (fig. 315). In 1925, Alexander left Munich for Athens, where he performed as a pianist and taught piano at the Athens Conservatory and the Hellenic Conservatory. He married Galatée Gregoriardis (1902–1966) from Macedonia, who bore him two children, Alexander and Betty. After his death at the age of eighty-six on 26 May 1985, a group of grateful students founded the Alexander Thurneyssen Conservatory in his honour.[39] Renoir would, however, have known that after being exposed on Mount Ida, the infant Paris, son of King Priam of Troy, was rescued by shepherds who raised him and gave him the name Alexander – the protected one.[40] Hence the artist's charming conceit, which also alludes, with admirable discretion, to the city of Alexander Thurneyssen's birth. A delicate homage, and one that would surely have been appreciated by Fritz Thurneyssen and his friends among the Munich intelligentsia.

92.1 × 73.7 cm
The Metropolitan Museum of Art, New York
Bequest of Stephen C. Clark, 1960

N O PAINTING BETTER evokes the cosmopolitanism of avant-garde European culture on the eve of the First World War than Renoir's *Tilla Durieux*, done in the artist's studio in Paris during the first two weeks of July 1914.[1] It shows Germany's leading stage actress in the evening gown that Paul Poiret had designed for her to wear as Eliza Doolittle in the fourth act of George Bernard Shaw's *Pygmalion*.[2] In November 1913, six months before its London première, the play had opened in Berlin's Lessingtheater, where it ran for over a hundred performances – its success due, in large part, to Durieux's forcefully characterized Eliza.[3] As Shaw had commented to his German translator: "Pygmalion is essentially a star play: unless you have an actress of extraordinary qualifications and popularity, failure is certain."[4]

Durieux's portrait was commissioned by her husband, the dealer and impresario Paul Cassirer (1871–1926), who had long been an admirer of Renoir's work.[5] Known as "the German Durand-Ruel," Cassirer first exhibited paintings by Renoir in his gallery on Berlin's Viktoriastrasse in October 1901; at the time war was declared, he had at least twenty-six paintings by the artist on consignment from Durand-Ruel.[6] By 1914, German museums were aggressively seeking Renoir's work; those in Berlin, Hamburg, Frankfurt, Dresden, Munich, and Bremen already owned canvases that would have been the envy of any French provincial museum.[7] And such was the understanding between Cassirer and his French colleagues that he felt no hesitation in leaving Renoir's portrait of his wife to dry in the artist's studio, knowing that it would be held for him by Durand-Ruel.[8] The Cassirers left Paris for their summer house in Noordwijk in Holland on 20 July 1914. On 4 August, the day after Germany formally declared war on France, Meier-Graefe visited Renoir for the last time and found him making additions to the portrait's jewel-like surface.[9]

Radiant and monumental, Renoir's portrait of the thirty-four-year-old actress shows her staring past the viewer, as impassive as an ancient Egyptian burial figure (she herself remembered sitting "still as stone" for the artist).[10] Her "large red hands,"[11] and swarthy complexion – in 1910 her dark-eyed "Slavic features" were compared to those of an "Indian woman, or a Creole"[12] – are painted directly and with particular delicacy. Yet there is something larger than life about Renoir's representation, which John House has rightly associated with High Renaissance prototypes such as Titian's *Isabella of Portugal* (Prado, Madrid).[13] Such is the commanding presence of the sitter that *Tilla Durieux* might also be compared to one of Titian's Doges. Although rather more

inviting, she is as imposing as *Andrea Gritti* (National Gallery of Art, Washington).

Titian's influence – especially the late work – is also felt in Renoir's remarkably assured but economical handling of paint: the overlapping ribbons of colour that describe layer upon layer of chiffon and gauze; the luminous flesh tones, modelled with a caressing brush; the weight and solidity of the figure itself, articulated in the most abbreviated of pictorial languages. From Tilla Durieux's vivid account, first published forty years after the event, we know that Renoir laboured on this portrait four hours a day for two weeks – two hours in the morning, two hours in the afternoon;[14] that he painted in a wheelchair (fig. 319), with his palette and paintbrushes being placed in his hand by a young female assistant;[15] and that he first chose a much smaller canvas, only deciding to paint his sitter life-size (as she and her husband so ardently desired) once work on her portrait was underway.[16]

Durieux's careful description of Poiret's evening gown (which she brought with her from Berlin, packed in a cardboard box), and a photograph of her wearing it, both bring us a little closer to Renoir's alchemy as a portraitist. As the curtain rises on act 4 of *Pygmalion*, Eliza has returned at midnight from the ambassador's party, "in all the finery in which she has just won Higgins's bet for him."[17] Durieux recalled the costume as consisting of a

> narrow skirt of white chiffon – the chiffon was visible only in the front, for behind and on the sides it was covered in a splendid dark-green brocade, with stiff, deep-purple French lilies woven in. Above it was a gold-embroidered veil-like material that exposed only a bit of the neck, and the same material, on wide sleeves, covered my arms. The result was something closer to an Oriental costume than an evening gown.[18]

In the photograph of Durieux as Eliza (fig. 320), we see a fashionable flapper: sheathed in white, and pencil-thin.[19]

As always, Renoir was attentive to detail in his rendering of costume. The golden wrap with its wide sleeves, the green brocade visible just below the sitter's belt and continuing to the lower edge of the canvas by her right hand, even the trimming on her transparent apron – each element is transcribed in paint with the conscientiousness of a couturier's assistant. Yet the effect could not be further from Poiret's "style Sultane."[20] Durieux's dress now emphasizes the qualities of expansiveness and amplitude that are at the very heart of Renoir's representation, a transformation mirrored in his treatment of the sitter herself. Making only one adjustment to her appearance – he asked her to pin a pink rose in her hair[21] – Renoir nonetheless recreated Tilla Durieux as a mulatto goddess, softening her earthiness and flamboyance (fig. 321) and endowing her with a serenity that could hardly be considered part of her persona, public or private.[22]

After Sarah Bernhardt – whom Durieux had seen in Vienna, when she was fifteen years old[23] – no actress posed for painters and photographers more readily than Tilla Durieux.[24] Before her visit to the boulevard Rochechouart in July 1914, she had been por-

trayed as a Spanish dancer by Corinth (fig. 323), as an anguished ingenue by Kokoschka (fig. 322), and as a decadent witch-goddess by von Stuck (Nationalgalerie, Berlin).[25] Most recently, the sculptor Ernst Barlach had been summoned to Cassirer's summer house in Noordwijk to model a rather vapid bust of her (fig. 324).[26]

The daughter of an overbearing mother with theatrical ambitions for her daughter and of a professor of chemistry who died of cancer at the age of forty-six, Ottilie Godeffroy was born in Vienna on 18 August 1880. She would adopt the name Durieux – her paternal grandmother's – upon enrolling in Karl Arnau's training school for actors in 1898.[27] In 1903, following an apprenticeship in Breslau, she was invited to join Max Reinhardt's Deutsche Theater in Berlin, where she was to remain until 1911.[28] Partly to assert her independence from her mother, in 1904 she married the painter Eugen Spiro (1874–1957), who went on to become the president of the Berlin Secession between 1915 and 1933.[29] On a visit to Paris early in their marriage she met the art historian and future biographer of Renoir, Julis Meier-Graefe, through whom she was introduced to Paul Cassirer, then a divorcé with two children. Cassirer and Durieux began a passionate love affair and were married in 1910.[30]

From early in her career, Durieux was reputed to be one of the most exciting young actresses working in the new Expressionist style.[31] After having performed in place of Gertrud Eysott (for whom she understudied) on the opening night of Wilde's *Salome* in May 1903, she was regularly offered the leading roles in new plays by Hofmannsthal, Gorky, Wilde, and Wedekind, being cast alternately as the smouldering or the ferocious heroine.[32] Although she had performed Shaw in Berlin before, the decision to offer her the part of Eliza Doolittle in *Pygmalion* was a stroke of genius, for this was precisely the role she had come to play in her relationship with Cassirer. Despite her perfectly respectable bourgeois origins, Cassirer had insisted that Durieux shed her Viennese accent, learn proper voice techniques, and improve herself generally (he gave her Goethe's poetry to read).[33] Durieux took piano and singing lessons, learned to ride, and upgraded her wardrobe. Cassirer turned out to be a good deal less stable than Henry Higgins, however, and after the First World War their marriage rapidly deteriorated. In January 1926 Cassirer and Durieux finally divorced. Once the papers were signed, Cassirer excused himself from the lawyer's office, went into a nearby room, and shot himself with a pistol, dying in hospital (with Durieux at his side) twenty-four hours later.[34] His family tried to prevent Durieux from attending the funeral.[35]

By now attached to the beer magnate and industrialist Ludwig Katzenellenbogen, whom she would marry in February 1930, Durieux continued to be involved with the Weimar Republic's most experimental theatre company. She had encouraged Katzenellenbogen to subsidize Erwin Piscator's Political Theatre as early as September 1926, and she continued to find money for his productions in the decade to come.[36] In 1933, after the false indictment (and arrest) of her husband, and the impounding of his assets, she left Germany for Yugoslavia (it was around this time that she began to sell off her pictures).[37] Katzenellenbogen died in a concentration camp in 1943,[38] and Durieux herself remained an exile until 1952, when she returned to Berlin to start a second career as an actress and teacher.[39] She died in her ninety-first year on 21 February 1971.

It seems fitting that Renoir's last great commission should have allowed him to return to the "celebrity portrait" – a genre that had sustained him as a young Impressionist. Although he now worked far more slowly, little else in the way he approached his sitter had changed. Once she was able to relax in his presence, Durieux recorded Renoir's astonishment in discovering her familiarity with Rabelais; she noted his preference for Bach and Mozart over Wagner, to whom he could no longer listen; and was moved above all by his unexpected modesty.[40] "I didn't want to paint any more portraits," he confided to her, "but I'm glad that I agreed to do yours. I've made some progress, don't you think?"[41]

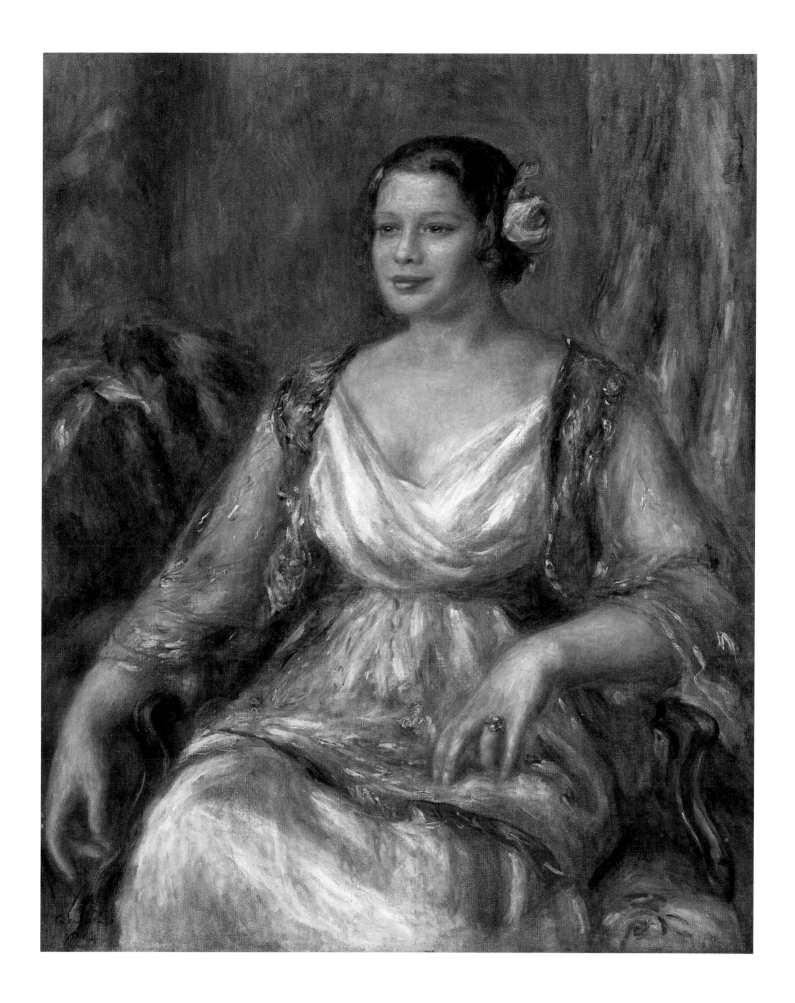

102.2 × 83.2 cm
Nippon Television Network Corporation,
Tokyo

RENOIR'S LAST PORTRAIT, and one of the greatest works in his oeuvre, *Ambroise Vollard as a Toreador* is painted with an exuberance and technical assurance that belie the septuagenarian's infirmities and progressive enfeeblement. It shows the fifty-year-old Vollard – the "richest dealer of modern paintings"[1] – seated on a rattan *chaise longue*, his toreador's red cape slung over his left shoulder and his black-velvet *monterilla* balanced like a ship on his bald head. Glowering at the artist, his legs crossed and his hands folded on his lap, there is little chance of Vollard assuming his habitual pose, that of sleeping. Behind him we see the stretcher of a large canvas that has been turned to face the wall, next to which is an oversized architectural element, possibly a frame. The cool pinks and greys of this geometric background serve as an armature for the colourfully costumed and massively proportioned sitter, whose figure is painted with considerable brio and a minimum of revisions. Initially, Vollard's cape descended in a straight line that would have prevented Renoir from including the golden embroidery on its reverse; and the position of both his legs, particularly the right, has been adjusted.

The intricacies of Vollard's apparel are meticulously described: the fringes and tassels dripping from his bolero and culottes; his scarlet *bola*, slightly askew; and his fetching red hose, painted in fine, parallel strokes. The whites of his shirt front and cuffs, heavily impasted, gleam through the dancing pinks, lime-greens, and reds of his well-fitting toreador's costume. Something of Vollard's formidable size – he stood one metre ninety[2] – is communicated by the curious way his body recedes from the picture plane. His legs and feet loom closest to us, while his torso and delicately painted face are set further back and rendered slightly smaller. It is as if Vollard were retreating from the very scrutiny he customarily demanded of his artists.

In spite of several anecdotes describing Renoir at work on this extraordinary portrait – from the sitter himself, and from the artist's two younger sons – the origins of *Ambroise Vollard as a Toreador* are far from clear. In Vollard's telling, it is Renoir who asks him to bring back a toreador's costume from his trip to Spain. Unable to find one to fit him, Vollard is obliged to have the costume made to measure, and on his return to Paris is confronted with an inquiring (and incredulous) customs official. Explaining that these are his working clothes, Vollard is requested to put them on. He complies; a crowd gathers; Vollard-the-toreador hops into a taxi, heads immediately to Renoir's studio, and the artist, delighted, paints his portrait.[3] While none of this sounds plausible in the slightest, Vollard's account of Renoir's ensuing conversation strikes a more authentic note. Vollard had suggested that he shave off his beard before Renoir start work on the portrait. "Even shaved," Renoir replies, "do you think anyone would take you for a real toreador? All I ask you to do is not to fall asleep while you are sitting for me."[4] And when Vollard picks up a rose that he finds lying on a table, in imitation perhaps of *Carmen*'s Don José, Renoir tells him to put it down; he wants nothing to interfere with the painting of his hands.[5]

Jean Renoir tells a slightly different story, claiming that it was his father's idea to paint Vollard as an "exotic potentate," but that neither the artist nor Gabrielle could think of the appropriate guise. "In rummaging through a chest of drawers, where he kept all kinds of odds and ends, my father came across a toreador's costume that he had bought in Spain on his trip there with Gallimard."[6] Although Renoir admitted that Vollard did not look much like a toreador, he was convinced that "the colour will suit him."[7]

A third story, told by Claude Renoir to his son Paul, was recently published in the catalogue that accompanied a group of little-known family photographs, one of which shows Vollard sitting for this portrait (fig. 325) – a fascinating document that confirms the veracity of Renoir's representation (compare the *chaise longue*, the details of the costume, and Vollard's sceptical expression).[8] While visiting the family in Les Collettes, Vollard had gone for a walk with Claude and some of the village children. "Seized with panic" in front of a troop of cows, Vollard had hidden in a tree until the animals had passed by, and after Claude recounted this story to his father, Renoir promised Vollard that he would paint his portrait if he brought back a toreador's costume from his forthcoming trip to Spain.[9]

As is so often the case, there is an element of truth in each of these conflicting and improbable accounts, which also contain much that is apocryphal.[10] In a footnote to the final chapter of his biography of Renoir, Vollard stated that Renoir's last portrait of him, dressed as a toreador, had been done in Essoyes.[11] This renders suspect both the notion of his taking a taxi to Renoir's studio,[12] as well as Claude's version, which places the incident in Cagnes and is dated two years too early.[13] Jean Renoir, while he does not claim to have been present when Vollard sat to his father, could only have known of the episode second-hand, since he was serving as a pilot in the French Flying Corps at the time.[14]

In fact, it is the earliest account of this portrait (one rarely cited) that is probably the most reliable. On 15 August 1918, the dealer René Gimpel, who had met Renoir in Les Collettes the previous March, recorded in his diary a conversation with his fellow dealer Georges Bernheim, in which Vollard's praises were sung:

> Now there's one who knows how to get Renoir's attention. One day he brings him a pile of fish fresh from the market. He throws them down on the table and says, "Paint that for me!" Intrigued, Renoir sets to work and Vollard leaves with a canvas. Another time, Vollard appears out of nowhere, disguised as a toreador, and Renoir, enchanted by the colours, paints his portrait.[15]

As Duret noted, Vollard had indeed been to Barcelona in the summer of 1917,[16] both to attend an exhibition of modern French paintings at the Palau de Belles Artes – in which Renoir was represented by five works[17] – and to lecture at the Barcelona Athenaeum for a series sponsored by the Service de Propagande that also took him to Madrid.[18] Upon his return, with the splendid toreador's costume in hand, he doubtless made his way to Essoyes, where Renoir was staying between July and September 1917, and for once the artist needed little persuasion to agree to paint his portrait.

Spanish subjects of the type that had intrigued Manet in the 1860s had made a brief appearance in Renoir's repertory towards the end of the 1890s. Inspired by "la belle Otéro" – a dancer at

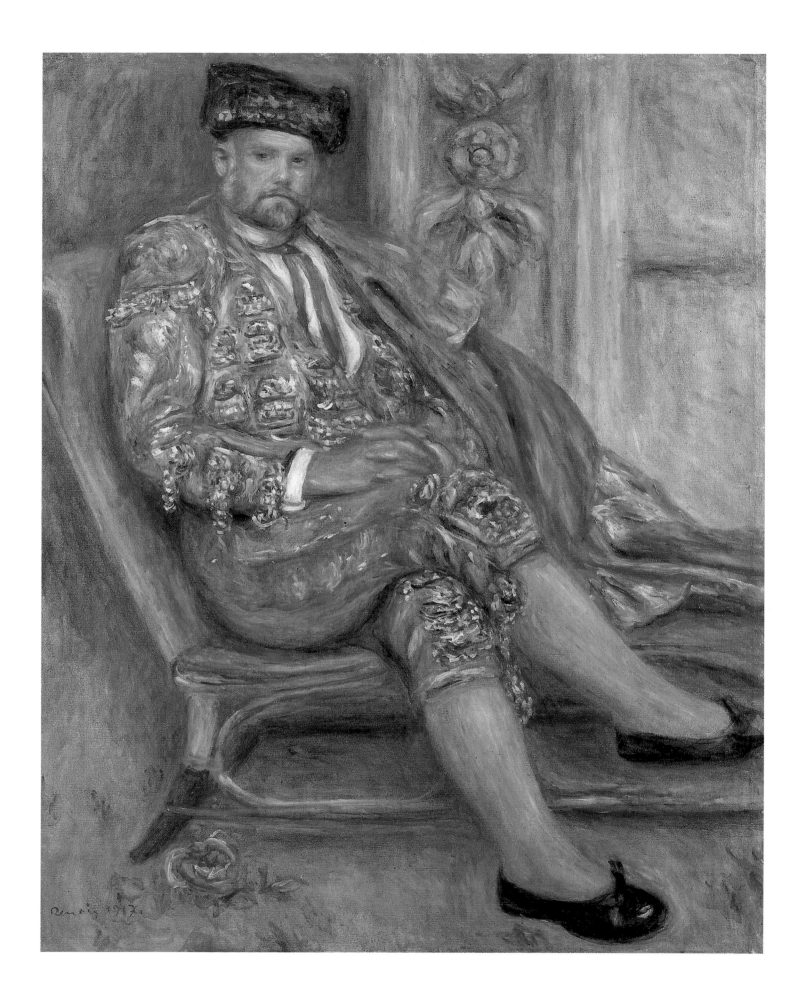

the Folies Bérgères – Renoir in 1897 had painted a group of genre pictures of dancers and guitarists in Spanish dress.[19] As Jeanne Baudot recalled, he had bought such costumes and accessories for his model Germaine.[20] At least one other male portrait in toreador's costume by Renoir is recorded. Among the paintings in his atelier published by Vollard in 1918 was a half-length portrait of a stocky, bearded man – possibly the painter Louis Valtat – in a similar toreador's costume; the work was neither titled nor dated by Vollard, and has since disappeared.[21]

Despite these examples, Spanish subjects cannot be said to have interested Renoir a great deal. Although Picasso later claimed that in painting Vollard as a toreador Renoir had "stolen his stuff," it was neither the corrida, nor contemporary representations of it, that Renoir had in mind.[22] Instead, following an eighteenth-century tradition in which well-bred sitters were portrayed in fancy dress, and with an eye to Goya's matadors, he painted Vollard "en costume espagnol."[23] His portrait looks rather to Fragonard's "portraits de fantaisie" than to Picasso's sculptures of toreadors (an example of which had already entered Vollard's collection by this time).[24] And compared to Picasso's exquisitely Ingresque drawing of Vollard, done two years earlier (fig. 326), Renoir's representation is all the more riotous and experimental. "Renoir is amazing," Monet wrote to Georges Durand-Ruel in December 1916. "He is supposed to be ill, but suddenly he is working again, hale and hearty. He is quite simply admirable."[25] No painting better demonstrates the enduring verve and aplomb of Renoir's best work than *Ambroise Vollard as a Toreador*.[26] Of it, Renoir might have said, as he had of a slightly earlier portrait of Vollard, "You see, one doesn't need a hand in order to paint! The hand, that's just a lot of crap!"[27]

NOTES AND
COMPARATIVE ILLUSTRATIONS

1 *Forty-three Portraits of Painters in Gleyre's Atelier* c. 1856–68
Collective work with contributions by Renoir and Émile Laporte c. 1862–63
117 × 145 cm
Musée du Petit Palais, Paris, PPP 0899

PROVENANCE Acquired from the fresco painter Paul Albert Baudouin (1844–1931); entered the museum in 1931.

EXHIBITIONS Not exhibited in Renoir's lifetime.

REFERENCES Laffon 1981–82, II, no. 993; Hauptman 1985a, 90; Hauptman 1985b, 65–66; Shone 1992, 22–23.

NOTES

1 First on the left, fourth row down, is Hirsch's portrait of Cabat; Hirsch is recorded in Gleyre's studio in 1856. At the very bottom, to the right of the nude figure, is a portrait of the comte de Gironde, who entered Gleyre's studio only in 1868.

2 Vollard 1918a, 18, 20.

3 Suggested recently in Shone 1992, 203. The inscription behind this portrait gives only the name of the sitter, not the artist (Hauptman 1985a, 100).

4 Hauptman 1985a, 101.

5 Ibid., 104, 106–107. Hauptman observes that Bazille wore his beard in this style ("with the distinctive clean-shaven area just below the lip") at least until 1865.

6 Ibid., 89–90. That both canvases have been painted over in places, with certain heads cut out and sent to family members as testimonials, seems most plausible, but I see no reason to believe, as Hauptman does, that the two group portraits were originally joined as one canvas.

7 Ibid., 91–92. On Baudouin see also Saur 1992–96, VII, 527–528. Baudouin's murals for the Petit Palais are reproduced in Laffon 1981–82, II, no. 1004.

8 Hauptman 1985a, 92.

9 Just as in a well-known contemporary photograph (fig. 102), Renoir's appearance in *Gleyre's Atelier* gives the lie to Jean Renoir's comment that, as a student, his father "portait pour travailler sa longue blouse blanche d'ouvrier peintre" while the others "arboraient le veston de fin velours noir" (Renoir 1981, 114).

10 For a listing of some six hundred students, which, as Hauptman has shown, is not definitive, see Staiger-Gayler in *Gleyre* 1974, 140–146. Weinberg (1991, 50–66) discusses Gleyre's American students, the most famous of whom was Whistler.

11 Boime 1971, 58–65; Monneret 1978–81, I, 244–246.

12 Vollard 1918a, 20; Boime 1971, 61, 197.

13 Dumaurier 1894, 76; Prinsep 1904, 338; Hauptman 1985a, 82–83.

14 Boime 1971, 23.

15 "Il est aimé de ceux qui l'approchent." Gleyre was suffering from ophthalmia at this time – "il paraît que le pauvre homme est menacé de perdre la vue" (Bazille *Correspondance*, 75, Bazille to his father, 20 January 1864).

16 Hauptman 1985b, 64–66.

17 "J'ai encore énormément à faire pour dessiner convenablement, et je n'ai encore pas touché à la couleur, du reste je compte n'en arriver là que quand je dessinerai très bien" (Bazille *Correspondance*, 47, Bazille to his father, 25 February 1863). Compare the reminiscence of Albert Anker (1831–1910), one of Gleyre's most gifted Swiss pupils: "Il aimait à ce qu'on dessinât longtemps et à ce qu'on se mit à peindre que tard, persuadé que c'est le dessin qui est la base de tout art" (Clément 1878, 174).

18 "Il traversa l'atelier de Gleyre" (Burty 1883). Alexandre (1892, 12) also engaged in special pleading: "Nous avons, pour l'exactitude matérielle, donné Renoir comme élève de M. Gleyre. Il faudrait pour l'exactitude intellectuelle et artistique dire qu'il fut en réalité élève des maîtres admirables de l'École Française . . . Watteau, Fragonard, Boucher." As is often pointed out, Renoir consistently presented himself as "élève de Gleyre" in his Salon submissions.

19 House and Distel 1985, 294; Rey 1926, 34–36.

20 House and Distel 1985, 295, quoting from Renoir's military records in the Service Historique de l'Armée de Terre, Vincennes, dossier 2233; Rey 1926, 36.

21 Boime 1971, 60, followed by Hauptman 1985a, 86–87.

22 Rewald 1945, 179; Boime 1971, 62. This misunderstanding arises from a partial reading of Bazille's correspondence. From letters to his father written on 16 October and 29 November 1863, it emerges that Bazille was lobbying for his own studio ("un atelier m'est indispensable, je t'assure"); needing parental approval for the additional expense, he pleads, "il faut cependant que je puisse dessiner en dehors de l'atelier Gleyre, si je veux faire des progrès sérieux, M. Gleyre me l'a conseillé lui-même" (Bazille *Correspondance*, 62, 64).

23 Pesquidoux 1874, 158–162.

24 "Il n'admettait pas que la reproduction des scènes de la vie familière fût un emploi digne de la peinture" (Montégut 1884, 145–146). "Une vraie école de poésie et de style . . . nul s'est mieux souvenu des Grecs" (Houssaye 1877, 431). On Gleyre's conservatism see also Daulte 1952, 29–32.

25 Rivière 1921, 8–10; Vollard 1918a, 21; Julie Manet (1979, 66, 19 September 1895) records a conversation with Renoir in which the latter claimed that it was Diaz himself "qui vendait ses tableaux comme des Rousseau. Il [Renoir] en faisait une huitaine par jour."

26 House and Distel 1985, 294 (for Renoir's permission of 8 November 1861 to copy at the Bibliothèque Impériale, requested by Gleyre); *Bazille* 1992, 154; Hauptman 1985a, 100; Stuckey 1995, 188–189.

27 "Ce qui m'attirait chez Gleyre, c'était que j'allais y retrouver mon ami intime, Laporte. Nous nous étions liés tout enfants . . . Je serais peut-être resté tout de même chez mon fabricant de stores, sans l'insistance avec laquelle Laporte m'engageait à venir le rejoindre" (Vollard 1918a, 20).

28 Tuleu 1915, 29–34; Glaeser 1878; Monneret 1978–81, I, 318.

29 Tuleu (1915, 34) notes that he was apprenticed to a "M. Faconnet, graveur sur cuivre, un ami de la famille." I am most grateful to Véronique

Notin for providing me with a copy of the relevant passages of Tuleu's family book.

30 House and Distel 1985, 295; Tuleu 1915, 33; Daulte 1971, nos. 9, 10; Notin 1991, 12.

31 "Puis il offrit à la famille qui le recevait alors presque quotidiennement, un tableau représentant une guirlande de fleurs" (Tuleu 1915, 34); Vollard 1918a, 24.

32 "Je croyais, me disait-il, que je ne parviendrais jamais à dessiner une tête, tant cela me paraissait difficile" (Rivière 1921, 9).

Fig. 99 Various artists, *The Delaroche Atelier*, 1835–45. Musée du Petit Palais, Paris

Fig. 100 Pierre-Auguste Renoir, *Émile-Henri Laporte*, 1864. Private collection

266

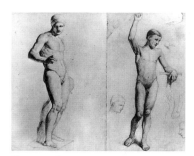

Fig. 101 Pierre-Auguste Renoir,
Studies from a Plaster Cast and Live Model,
c. 1862. Private collection, France

Fig. 102 Pierre-Auguste Renoir, c. 1860. Bibliothèque
Nationale, Paris

2 *William Sisley* 1864
81 × 65 cm
Signed and dated diagonally centre left:
A. RENOIR 1864
Musée d'Orsay, Paris, RF 1952-3
Daulte no. 11; House/Distel no. 2

PROVENANCE By inheritance to William
Sisley's daughter Aline-Frances Leudet, née
Sisley (1834–1904); sold by her son Maurice
Leudet to Bernheim-Jeune in 1910; briefly
owned by the financier Ernest May (1845–
1926), Paris, who sold it back to Bernheim-
Jeune in 1911; Bernheim-Jeune, Paris;
Lazare Weiller, Paris; Monsieur Vincent,
Paris; acquired by the Musée du Louvre
from the sale at Galerie Charpentier, Paris,
27 March 1952, no. 21.

EXHIBITIONS Salon 1865, no. 1802; *Renoir*
1912, no. 6.

REFERENCES Rosenblum 1989, 220, 223;
Shone 1992, 12, 14, 18, 28; *Sisley* 1992, 260;
House 1994, no. 1.

NOTES
1 "Lisa elle-même conseillait à mon père d'être
prudent et de faire du portrait. 'C'est exacte-
ment ce que je faisais. Le seul ennui est que mes
modèles étaient des amis et que les portraits
étaient à l'oeil'" (Renoir 1981, 123).
2 Daulte 1971, nos. 11, 37. Until recently the
portrait of Alfred Sisley in the Bührle
Collection, Zurich, was dated to 1868, palpably
too late for what is in some ways an awkward
effigy. Shone (1992, 28, 34) was the first to
point out the similarities between Renoir's por-
traits of Sisley *père* and *fils* (both share the same
format, a size 25, and the same pose) and to
redate the Bührle painting to 1864; he is fol-
lowed by Adriani 1996, 70–72.
3 House and Distel (1985, 182) give credit for the
commission to Alfred Sisley. Shone (1992, 28)
argues that the portrait of William Sisley was
"doubtless commissioned by the businessman
to help his son's friend." House (1994, 52) now
finds "no evidence that this was a commis-
sioned portrait."
4 House and Distel 1985, 183.
5 Shone 1992, 14; Archives de Paris, vbis 10.13.3,
"Registre d'inscription des signatures des nota-
bles commerçants ayant leur domicile dans le Xᵉ
arrondissement," 1 January 1860–17 March 1875.
6 Sisley 1949, 251; Shone 1992, 14, where
William Sisley is mistakenly noted as the son of
Thomas and "the third of his French wives."
William's mother was Anne-Félicité, née
Dagneau, Thomas's second wife; see Romane-
Musculus 1974, 459.
7 Shone 1992, 14.
8 Ibid.
9 Archives de Paris, D3/2U3/22, "Acte de
société," registered 29 April 1841; Bibliothèque
Historique de la Ville de Paris, 4⁰/z1 and z3, for
Sisley's business addresses; Archives de Paris,
D1P4/704 and 705, for the family's various resi-
dences in the 9th arrondissement.
10 Shone (1992, 202) points out that the notion of
Sisley importing artificial flowers originated
with Leclercq (1899, 228) and that Duret (1922,
75) was responsible for the statement that his
clientele spread as far as South America.
11 Shone 1992, 18.
12 "Son père tombé malade et incapable de sur-
monter la crise survenue dans ses affaires, subit des
pertes qui amenèrent sa ruine" (Duret 1922, 76).
13 Shone 1992, 43, 46, 204, where correct bio-
graphical information, including the date of
Sisley's death, is published for the first time.
14 "Son père . . . peu satisfait de voir son fils
préférer la peinture aux sérieuses occupations
du commerce, l'avait abandonné aux intem-
péries de la bohème" (Leclercq 1899, 228).
15 Shone (1992, 43) quotes a letter from a cousin
who wrote "as to Alfred, on account of his
irregular liaison, one did not mix with him."
Duret (1922, 76) implied that Sisley received
income from his family until 1870, but Shone's
discovery (1992, 40–43) of a letter to Joseph
Woodwell, datable to May 1867, in which

Sisley, penniless, asks for 150 francs, would tend
to contradict this.
16 Shone 1992, 26. Woodwell and Sisley's corre-
spondence is on deposit with the Archives of
American Art, Washington.
17 This family photograph was published for the
first time in Sisley 1949, 250.
18 Compare, for example, Baudry's portrait of
comte Albert de Balleroy (1859) in *Baudry* 1986,
96–97. For a different point of view see
Champa 1973, 35.
19 For Gleyre's precept that "le noir d'ivoire est la
base des tons" see Clément 1878, 176. See also
Renoir's comment, "c'était seulement chez
Gleyre que j'apprenais la peinture" (Vollard
1918a, 21).

Fig. 103 Pierre-Auguste Renoir,
Alfred Sisley, 1864. Foundation E.G.
Bührle Collection, Zurich

Fig. 104 William Sisley, c. 1864. Location unknown

3 *Mademoiselle Romaine Lacaux* 1864
81 × 65 cm
Signed and dated centre right: A. RENOIR
/ 1864
The Cleveland Museum of Art, Gift of the
Hanna Fund, 42.1065
Daulte no. 12; House/Distel no. 1

PROVENANCE Lacaux family, Paris;
Edmond Decap, Paris; by descent to
Madame Maurice Barret-Decap, Biarritz;
Hôtel Drouot, Paris, Barret-Decap sale,
12 December 1929, no. 12, bought for
330,000 francs by Roger Bernheim, Paris;
Jacques Seligmann and Co., New York,
by 1941; gift of the Hanna fund to the
Cleveland Museum, 1942.

EXHIBITIONS Not exhibited in Renoir's
lifetime.

REFERENCES *Second Empire* 1978, 348–
349; McCauley 1985, 200–201; Tinterow
and Loyrette 1994, no. 169.

NOTES

1 Using information obtained from Renoir,
Burty (1883) mentions "une Esmeralda bitu-
mineuse qu'il achevait de gratter avec son
couteau de palette, au moment même où un
acheteur venait de lui en offrir 1500 ff." For a
survey of Renoir's early portrait commissions
see Champa 1973, 34–43.

2 Distel 1993, 17. *Romaine Lacaux* was first pub-
lished on the cover of the *Bulletin de l'Art*,
September–October 1928, as "Portrait de Mlle
Germaine Lacaux" [sic]. For eloquent analyses
of the picture see Rishel in *Second Empire* 1978,
348–349, House and Distel 1985, 182, and
Tinterow and Loyrette 1994, 452.

3 Romaine Lacaux's date of birth was first pub-
lished in House and Distel 1985, 182.

4 Archives de Paris, V2E/6682, "Acte de nais-
sance," 10 May 1855, Romaine Louise Lacaux,
living at 27 rue de la Roquette.

5 Ibid., V2E/1659, "Acte de naissance," 4 April
1816, Paul Adolphe Lacaux; V2E/2193, "Acte
de naissance," 18 September 1823, Denise
Léonie Guénault; V2E/8951, "Extrait du registre
des mariages," 28 April 1842, for the listing of
Lacaux's profession.

6 Ibid., DIP4/976, "Cadastre de 1852," 27–29 rue
de la Roquette.

7 *Annuaire-Almanach du Commerce/Didot-Bottin*
(1862), 340, 1023, 1597.

8 Archives de Paris, V2E/4548, "Acte de nais-
sance," 26 July 1843, Nicolas François Lacaux,
with the family listed at 25 rue de la Roquette;
for Romaine Louise see note 4 above.

9 According to *Renoir* 1941 (113) the portrait was
executed in Barbizon. Francis (1943, 97) added
that it was commissioned while the Lacaux
were on holiday. Both of these unsubstantiated
assertions have found their way into the recent
literature; see House and Distel 1985, 182, and
Tinterow and Loyrette 1994, 452.

10 Archives de Paris, DIP4/978, "Cadastre de 1862,"
rue de la Roquette. The *Annuaire-Almanach du
Commerce/Didot-Bottin* for 1876 lists 31 rue la
Roquette as "maison Briffault, construction de
fourneaux et de calorifères."

11 Archives de Paris, DIP4/1143, "Cadastre de
1862," 60 rue des Tournelles.

12 Archives de l'Enregistrement, Paris, 4 August
1909, "Succession," Denise Léonie Guénaut,
veuve Lacaux, which cites Lestrade's profession
at the time of his wedding and notes that the
marriage contract was drawn up on 26 April
1883 by Maître Philippot.

13 Archives de Paris, DIP4/490, "Cadastre de
1876," rue Geoffroy-Marie, where in 1886
Lestrade is noted as "tenant un magasin de
plusieurs espèces de marchandises."

14 Archives de l'Enregistrement, Paris, 11 August
1921, "Succession," Francis Lestrade.

15 Ibid., "Succession," Madame Lestrade, which
also gives the date of her marriage and the birth-
date of her daughter Pauline.

16 Rishel in *Second Empire* 1978, 349; House and
Distel 1985, 182.

17 "Acte de naissance," as in note 8 above, where
his godfather is Jean-Jacques Florent Gautier,
"fabricant de faïences." At 21 rue de la Roquette
was to be found Simon-Cocheux, "taïences,
porcelains et verreries," and at 41 rue de la
Roquette, Masson Frères, "fabrique de faïence";
the Massons were related to the Lacaux
(*Annuaire-Almanach du Commerce/Didot-Bottin*
[1862], 1597).

18 See McCauley 1985, 200, for a brilliant com-
parison with a photograph by Disdéri, but a
rather less inspired description of Renoir's por-
trait as having "a stable and unoriginal pose, and
lifeless eyes and mouth." Champa (1973, 36)
notes that "Renoir seems to fear a coherent and
legible description of space."

19 Tinterow and Loyrette 1994, 452.

20 Reff 1964, 555–556.

21 Reed and Shapiro 1984, 34–35.

22 Gleyre signed his canvases in precisely the same
manner, as can be seen, for example, in *The
Bath* (1868, Chrysler Museum of Art, Norfolk,
Va.).

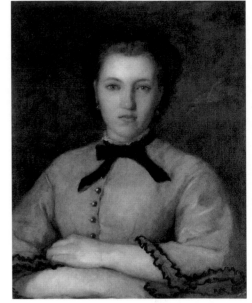

Fig. 105 Pierre-Auguste Renoir, *Marie-Zélie Laporte*,
1864. Musée Municipal de l'Évêché, Limoges

Fig. 106 Edgar Degas, *Mademoiselle
Nathalie Wolkonska*, 1860–61, etching
and drypoint. Museum of Fine Arts,
Boston, Katherine E. Bullard Fund in
memory of Francis Bullard, and proceeds
from the sale of duplicate prints

4 *The Inn of Mère Antony* 1866
195 × 131 cm
Signed and dated lower right: RE 1866
Nationalmuseum, Stockholm, NM 2544
Daulte no. 20; House/Distel no. 4

PROVENANCE According to Renoir,
Mère Antony, Marlotte, may have been the
first owner (Vollard 1918a, 23); purchased
in 1905 for 45,000 francs by the bronze-
caster Adrien A. Hébrard (1865–1937),
Paris, until 1911; purchased for 55,000

florins in 1912 by the Swedish collector and art critic Klas Fåhraeus (1863–1944), of Saltsjöbaden, near Stockholm; placed in Fåhraeus's villa at Lidingö, near Stockholm, 1913 (see Roosval 1913); gift of the Friends of the Nationalmuseum, Stockholm, 1926.

EXHIBITIONS Basel 1906, no. 514; *Venice Biennale* 1910, no. 12; Amsterdam 1912, no. 436; Stockholm 1917, no. 91.

REFERENCES *Sisley* 1992, 261; Tinterow and Loyrette 1994, no. 170.

NOTES

1 "Je me rappellerai toujours l'excellente mère Antony et son auberge de Marlotte, la vraie auberge de village. Je pris comme sujet de mon tableau la salle commune qui servait aussi de salle à manger. La vieille femme coiffée d'une marmotte est la mère Antony en personne; la superbe fille qui sert à boire, c'est la servante Nana; le caniche blanc, c'est Toto, qui avait une patte en bois. Je fis poser autour de la table quelques-uns de mes amis, dont Sisley et Le Coeur. Les parois de la salle, comme je l'ai indiqué dans mon tableau, étaient couvertes de peintures faites à même le mur. C'était l'oeuvre sans prétention, mais souvent très réussie, des habitués de l'endroit. La silhouette de Murger, que j'ai reproduite en haut à gauche dans ma toile, était de moi" (Vollard 1918a, 23).

2 "Ce que j'étais content de me voir accroché! Il me semblait déjà que c'était la gloire" (ibid.). Renoir's memory may have been clouded on this point, since the authors of a biography of Murger recalled seeing "a posthumous portrait of Murger painted on the wall of a village inn by Renoir in the 1860s," which had been preserved "until fairly recently" (Moss and Marvel 1946, 199).

3 Tinterow and Loyrette 1994, 453.

4 Meier-Graefe (1912, 4) claimed that Renoir posed for the standing figure rolling a cigarette. Daulte (1971, no. 20) has Le Coeur as the seated, clean-shaven figure and Monet as the standing man. According to Jean Renoir (1981, 140) "on reconnaît Sisley debout et Pissarro de dos. Le personnage rasé est Frank Lamy [sic]." His account of the site is authentic – both he and Paul Cézanne *fils* owned homes in Marlotte – but further confuses the identification of his father's models. Rewald (1973, 134–135) was the first to identify Sisley and Le Coeur correctly.

5 Cooper 1959, 164, 322.

6 Shone 1992, 34.

7 House and Distel 1985, 184.

8 Scheen 1981, 60–61.

9 Cooper 1959, 322; Le Coeur 1996, 23.

10 Vollard 1919, 37; Meier-Graefe 1912, 4; Meier-Graefe 1929, 12, where the work is dated to 1865–66. Following these, Rewald (1973, 134) states that Renoir painted *The Inn of Mère Antony* "in the first weeks of 1866."

11 Cooper 1959, 164–167.

12 Distel (House and Distel 1985, 179–180), in a brilliant piece of detective work, has shown that Renoir's major submission to the Salon of 1866 was in all likelihood a large composition of two female figures in a landscape – one seated and fully clothed, the other naked – inspired by Courbet's *Women Bathing* (1853, Musée Fabre, Montpellier), and that this is probably the painting in a gold frame that towers over the artists in Bazille's *Studio in the rue La Condamine* (1870, fig. 63). The seated woman in Renoir's rejected Salon painting corresponds in every detail to his *Portrait of a Woman* (1866, whereabouts unknown), which Distel reasonably assumed to have been a fragment, salvaged from the larger work that Renoir later destroyed. Renoir's second *envoi* to the Salon of 1866, a landscape done at Marlotte in about two weeks, which he himself called "une pochade," was intended as a backup for his more ambitious figural composition; as Marie Le Coeur explained to her brother on 6 April 1866, "il ne l'a envoyé à l'exposition que parce qu'il en avait un autre qui avait plus de valeur, sans cela il en aurait trouvé qu'il ne fallait pas l'exposer" (*Cahiers d'aujourd'hui*, 1921).

13 Cooper 1959, 164; Tinterow and Loyrette 1994, 453.

14 Cooper 1959, 163, 167. With regard to Renoir's *Inn of Mère Antony*, Cooper's dating is more reliable than the chronology established by Tinterow and Loyrette (1994, 314), who incorrectly date the work to February 1866.

15 Champa 1973, 41; House and Distel 1985, 185; Tinterow and Loyrette 1994, 452–453.

16 Meier-Graefe 1929, 85.

17 Girard 1988, 8, 25; Miura 1994, 27. Gleyre again provides the link here, since Firmin-Girard had been a pupil of his in the mid-1850s, and Oulevay, with Laporte, had been among those who had encouraged Renoir to enter Gleyre's studio in 1861 (Renoir 1981, 112).

18 See, for example, the lively memoirs of Jean-Baptiste Georges Gassies (1819–1883), a landscapist who painted in Barbizon in the 1850s; he notes that lunch was not served at the Auberge Ganne, but that artists were provided with "un gros déjeuner" of hard-boiled eggs, cheese wrapped in paper, and a bottle of wine that they carried in a canvas sack known as "un pochon" (Gassies 1907, 31).

19 "Le dîner était la grande récréation de la journée. Ce qui sonnait, c'était le coucher du soleil . . . On jetait ses chapeaux . . . on attachait avec des ficelles les chiens aux pieds des chaises . . . Une grosse joie de jeunesse, une joie de réfectoire de grands enfants, partait de tous ces appétits d'hommes avivés par l'air creusant de toute une journée en forêt" (Goncourt 1867, 239–240).

20 Rewald 1973, 134; Reff 1975, 42; Tinterow and Loyrette 1994, 452–453.

21 "*L'Événement*, avant l'apparition du *Figaro* quotidien, était le journal littéraire en faveur sur le Boulevard, lu de préférence par les artistes, les gens de lettres et de théâtre" (Duret 1922, 6). On Cézanne and *L'Événement* see Rewald 1985, 78–89, and Athanassoglou-Kallmyer 1990, 482–492.

22 Rewald 1985, 80–81. Zola's seven articles on the Salon of 1866 appeared between 27 April and 20 May 1866.

23 Zola 1991, 125, "Mon Salon" (1866). His "Adieux d'un critique d'art" appeared on 20 May 1866. It should be noted that Zola's articles continued to appear in *L'Événement* until November 1866, when the journal ceased publication.

24 "Ma tante paraît enchantée. De tous les côtés elle reçoit des félicitations: elle n'a reçu que de trois personnes l'Événement que vous avez envoyé aussi" (Wildenstein 1974–91, I, 423, Monet to Gautier, 22 May 1866).

25 Renoir's inclusion of *L'Événement* further supports Cooper's dating of *The Inn of Mère Antony* to the early summer of 1866. Newspapers appear again in the early 1870s in *Claude Monet Reading* (fig. 137) – Monet is reading *L'Événement*, which resumed publication that year – and in *Madame Monet on a Sofa* (fig. 35), in which Camille reclines with a copy of *Le Figaro*.

26 "Son séjour dans le village avait attiré là toute une colonie parisienne" (Daudet 1879, 11). On Murger and the invention of an artistic bohemia see, most recently, Seigel 1986, 31–58.

27 "Une tête grasse et triste, les yeux rougis, la barbe rare, indices du médiocre sang parisien . . . toujours un fusil sur l'épaule, feignant de chasser" (Daudet 1879, 11). On Murger at Marlotte see also Moss and Marvel 1946 and Billy 1960, 88–99. Such was the posthumous fame of this bohemian par excellence that Jules de Goncourt crowed to Flaubert in December 1861, "on parle de mettre une inscription latine sur le tombeau de Murger; si ladite idée se réalise, je me demande comment son ombre, en revenant de la brasserie des Martyrs, pourra retrouver son lit" (Goncourt 1930, 199).

28 For photographs of Murger see *Nadar* 1995, 29, 80. Reff (1975, 42) was the first to identify the quotation. I am grateful to Ulf Abel, curator at the Nationalmuseum, Stockholm, for having transcribed Renoir's wall painting for me.

29 On the Impressionists in the forest of Fontainebleau see Tinterow and Loyrette 1994, 301, 307. Billy (1947, 77–83, 91) quotes from the register of the Auberge Ganne, among whose more unlikely guests were Gérôme, Stevens, and Bonnat.

30 "Pittoresque et riante auberge que cette auberge de Barbizon, vrai vide-bouteille de l'Art" (Goncourt 1867, 235).

31 "La salle à manger, toute décorée de peintures faites les jours de pluie quand on ne pouvait aller travailler en forêt et étudier d'après nature" (Gassies 1907, 30). In this connection, it should be noted that the stage directions for Meilhac and Halévy's *La Cigale*, whose sets Renoir and Monet helped paint in October 1877, call for a country inn at Barbizon with walls "couverts d'esquisses et d'ébauches" (Meilhac and Halévy 1884, 1).

32 "Phalanstère ignoble du harem licencié de Murger . . . je regarde ce qui salit les chaux des murs, des peintures et des dessinaillures infectes de rapins . . . Au milieu de cela, une charge abominable et bête de Murger en blouse, un fusil sous le bras" (Goncourt 1956, I, 1309–1310).

33 "La rusticité de l'auberge lui devenait dure, presque attristante. Il souffrait du bon fauteuil qui lui manquait, de toutes les petites insuffisances de l'installation, de cette misère d'eau et de linge faite à sa toilette, des serviettes de huit jours" (Goncourt 1867, 238, 250).

34 "Les hôtelleries campagnardes de l'art ont changé d'aspect . . . Elles ne sont plus hantées seulement par le peintre; elles sont visitées et habitées par le bourgeois, le demi-homme du monde, les affamés de villégiature à bon

marché, les curieux désireux d'approcher cette bête curieuse: l'artiste, de le voir prendre sa nourriture, de surprendre sur place ses moeurs, ses habitudes, son débraillé intime et familier" (ibid., 246).

35 "Dans le *Cabaret de la Mère Anthony* . . . on sentait au front de ces artistes, dans cette conversation ardente, rôder l'ombre du peuple et monter autour de la pièce l'invisible appel de la grève, de la catastrophe ou du salut" (Gasquet 1921, 43).

36 The comparison was first made by Maxon in *Renoir* 1973, no. 4.

Fig. 107 Jules Le Coeur, c. 1865, photograph by Paul Berthier. Private collection, Paris

Fig. 108 Marie-François Firmin-Girard, *Hot Day at Marlotte*, 1865. Private collection

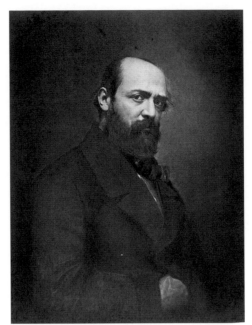

Fig. 109 Henri Murger, c. 1855, photograph by Nadar. The J. Paul Getty Museum, Malibu, Calif.

5 *Frédéric Bazille Painting "The Heron"*
1867
105 × 73.5 cm
Signed and dated lower right: A. Renoir 67.
Musée d'Orsay, Paris, Bequest of Marc Bazille, brother of the sitter, RF 2448
Daulte no. 28; House/Distel no. 6

PROVENANCE Édouard Manet, Paris, until 1876; at the time of the second Impressionist exhibition, Bazille's close friend Edmond Maître (1840–1898) is asked by the father of the sitter, Gaston Bazille (1819–1894), to arrange an exchange with Manet for Claude Monet's *Femmes au jardin* (see Poulain 1932, 103–104); Claude-Marc Bazille (1845–1923), brother of the sitter; bequeathed by him to the Musée du Luxembourg, 1924.

EXHIBITIONS Impressionist Exhibition 1876, no. 224; Salon d'Automne 1910, no number.

REFERENCES Moffett 1986, 146, 164; Rosenblum 1989, 220–221; Daulte 1992, 53; Tinterow and Loyrette 1994, no. 172.

NOTES

1 For the most conclusive chronology to date see Tinterow in Tinterow and Loyrette 1994, 332–333, 462. Loyrette (ibid., 454) assigns Renoir's portrait of Bazille to late winter or spring 1867, a dating that is not compatible with the evidence of Bazille's letters. On the basis of style, Cooper (1959, 168) dated the portrait correctly to "about November 1867."

2 "J'ai loué un immense atelier aux Batignolles" (Bazille *Correspondance*, 146, Bazille to his father, undated, late November 1867). Interestingly, like Renoir's portrait of Bazille, Bazille's *Studio in the rue La Condamine* – the name to which the rue de la Paix was changed in late 1868 – was also undertaken as something of a valediction. While working on this painting, Bazille signed a lease for another apartment in the rue des Beaux-Arts, into which he would move in April 1870.

3 "J'ai fait depuis deux jours deux grandes natures mortes. Je n'en suis pas trop content: cependant il y en a une avec un grand héron gris et des geais, qui n'est pas mal" (Tinterow and Loyrette 1994, 333, quoting Bazille's undated letter to his parents, first published in Poulain 1932, 110); Tinterow places this letter to November–December 1867 on the basis of a comment made in a subsequent letter, also undated, in which Bazille notes that *Flowers* (Musée de Peinture et de Sculpture, Grenoble), the second of these still lifes, should be dry enough to dispatch to Montpellier by 15 January 1868. Regrettably, the earlier letter is missing from Bazille *Correspondance*, and has consequently been overlooked in the literature.

4 Tinterow and Loyrette 1994, 462.

5 "Monet m'est tombé du ciel avec une collection de toiles magnifiques qui vont avoir le plus grand succès à l'Exposition" (Bazille *Correspondance*, 135, Bazille to his mother, undated, late February 1867). Monet had been working in the streets of Honfleur, wrapped in three overcoats, where he produced "quelques effets de neige assez heureux" (Wildenstein 1974–91, I, 444, Dubourg to Boudin, 2 February 1867). See also Stuckey 1995, 192.

6 "Grand et mince . . . avec cheveux bouclés, sa barbe légère, son nez droit, un peu fort, ses yeux noirs d'une douceur hautaine" (Daulte 1992, 97, quoting Zola's description of the patrician Hautecoeur, hero of *Le Rêve*, published in 1888, and based in part on Bazille).

7 House and Distel 1985, 186–187; Monet's *Road in Honfleur near the Snow* (collection of Mr. and Mrs. Alex Lewyt, New York) is reproduced in colour in Rewald 1973, 179.

8 Tinterow and Loyrette 1994, 332.

9 "La plénitude plastique de ses figures" (Meier-Graefe 1912, 29).

10 First noted in House and Distel 1985, 186. Champa (1973, 46) writes eloquently that "on one level at least Renoir's picture documents the increasing sense of group awareness of the four painters . . . as suggested almost clairvoyantly by the snowscape on the wall, all three were to turn their attention to Monet over the next few months."

11 Vollard (1919, 52) gives Renoir's account of Manet's admiration for this work: "Devant chacun de mes tableaux, il répétait, 'Non, ce n'est plus le portrait de Bazille,' cela laissait supposer que j'avais fait, au moins une fois, quelque chose de pas trop mal." See Poulain 1932, 103, for Manet's letter of 1876 to Gaston Bazille, proposing the exchange of Renoir's portrait of Bazille for Monet's *Femmes au jardin* (1866–67, Musée d'Orsay, Paris), in which he notes: "J'avais trouvé juste au moment où un groupe d'artistes faisait une protestation, qu'un hommage fut rendu par l'exposition de son portrait

au modeste et sympathique héros qu'ils avaient compté dans leurs rangs."

12 Daulte 1992, 54–55; Tucker in Moffett 1986, 93–96.

13 "Avec ces gens-là, et Monet qui est plus fort qu'eux tous, nous sommes sûrs de réussir" (Bazille *Correspondance*, 137, Bazille to his mother, undated, April 1867).

14 "Je vais définitivement changer d'atelier. Quoiqu'en dise maman je n'ai pas assez de place rue Visconti" (ibid., 146, Bazille to his father, undated, end of November 1867).

15 On Degas's portrait of Tissot see Loyrette in *Degas* 1988, 130–132.

16 "Je ne serais pas fâché de pouvoir offrir une mèche de mes cheveux à ma future, et s'ils continuent à tomber dans trois ans cela me sera impossible" (Bazille *Correspondance*, 152, Bazille to his mother, undated, January 1868). "Mes chemises laissent un peu plus à désirer, elle commencent à s'effiler aux manchettes, il m'en faudra quelques autres dans trois ou quatre mois" (ibid., 105, Bazille to his mother, undated, January 1865).

17 In Bazille's *Studio in the rue Visconti* (1867, Virginia Museum of Fine Arts, Richmond) the oval palette rests on the foot of the easel at lower left; it appears twice in his *Studio in the rue La Condamine* (fig. 63), suspended on the wall at right and held by Bazille at centre left.

18 "La palette carrée . . . est généralement employé quand on travaille à des tableaux de chevalet" (Larousse 1866–90, XII, 61; different types of palettes are illustrated in Larousse 1898–1904, VI, 626). McQuillan (1986, 38) was the first to draw attention to the rectangular palette in Renoir's portrait of Bazille.

19 "Je suis à Chailly depuis samedi dernier et uniquement pour rendre service à Monet" (Bazille *Correspondance*, 115, Bazille to his father, 31 August 1865). For Monet's hectoring letters of July and August 1867 see Wildenstein 1974–91, I, 423–424.

20 "Tu peux être tranquille quant à moi, vu que je n'ai ni femme ni enfant, et que je ne suis pas prêt d'avoir ni l'un ni l'autre" (Poulain 1932, 154, Renoir to Bazille, undated, August 1868).

21 See Daulte 1992, 163, whose dating of Bazille's portrait of Renoir is to be preferred to the confused entry in *Bazille* 1992, 139. For Bazille's letter to his mother, undated, April 1867, in which he expresses his intention to send "un portrait que je fais de Monet" (of which there is no trace) to their independent exhibition, see Bazille *Correspondance*, 137. For Bazille's portrait of Sisley see Shone 1992, 28.

22 "Cherchez . . . aussi des toiles où il y a des choses abandonnées tel que votre portrait en pied et une autre toile de 60 où j'avais fait de mauvaises fleurs" (Wildenstein 1974–91, I, 426). For a discussion of why Monet gave up figure painting at the end of the 1860s see also Wagner 1994, 613–629.

23 "Notre jeune ami Frédéric Bazille dont nous savions apprécier la charmante nature et l'égale amitié" (Poulain 1932, 103, Manet to Gaston Bazille, 1876).

Fig. 110 Frédéric Bazille, *Still Life with Heron*, 1867. Musée Fabre, Montpellier

Fig. 111 Alfred Sisley, *Still Life with Heron*, 1867. Musée Fabre, Montpellier

Fig. 112 Frédéric Bazille, photograph by Étienne Carjat. Private collection

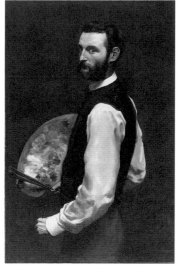

Fig. 113 Frédéric Bazille, *Self-portrait with a Palette*, c. 1865. The Art Institute of Chicago, Restricted gift of Mr. and Mrs. Frank H. Woods in memory of Mrs. Edward Harris Brewer

6 The Artist's Father, Léonard Renoir

1869
61 × 45.7 cm
Signed and dated centre right: Renoir. 69.
The Saint Louis Art Museum, 37:1933
Daulte no. 44; House/Distel no. 11

PROVENANCE Renoir family; sold by Renoir's eldest son, Pierre, to Ambroise Vollard (1866–1939), Paris, 10 December 1917, for 12,000 francs (receipt in the Bibliothèque du Musée du Louvre, Paris, Archives Vollard, MS 421 [297]); part of the Vollard collection acquired by Étienne Bignou, Paris, and Knoedler and Co., New York, in 1933; purchased by the City Art Museum, Saint Louis, 1933.

EXHIBITIONS Not exhibited in Renoir's lifetime.

REFERENCES Detroit 1976, no. 278; Cowart 1982, 28; Gerstein 1989, no. 70.

NOTES
1 Duret (1922, 90) referred to him as "un petit tailleur . . . qui ne trouva pas à Paris la fortune entrevue." On his wine see Bazille *Correspondance*, 183: "Renoir prie de savoir si quelqu'une de nos connaissances n'aurait pas 200 à 250 litres de vin ordinaire à vendre à son père" (Bazille to his father, undated, January 1870).
2 Hugon 1935, 453–454.
3 "Ma mère, m'a-t-elle souvent raconté comment mon grand-père, de naissance noble et dont la famille avait péri sous le Terreur, fut recueilli, tout enfant, et adopté par un sabotier qui s'appelait Renoir" (Vollard 1919, 17). See also Renoir 1981, 14–15.

4 Hugon 1935, 454. For a good survey of Limoges in the first half of the nineteenth century see Merriman 1985, 3–43.

5 Hugon 1935, 434. The horrid so-called *Portrait of Renoir's Mother* (c. 1860–61, private collection), most recently published in Adriani 1996, 60–61, surely cannot be of the fifty-three-year-old Marguerite Merlet. Might it be of Renoir's grandmother, Anne Regnier, who had died in April 1857?

6 Hugon 1935, 455. Hugon also notes that the Renoirs were not listed in the 1846 census for Limoges. Renoir informed Vollard that he was just four years old when his family left Limoges, which places their departure in 1845 (Vollard 1919, 17).

7 "Il y a une boutique et 33 locations pour petits rentiers industriels et ouvriers" (Archives de Paris, DIP4/42, "Cadastre de 1852," 23 rue d'Argenteuil). Jean Renoir (1981, 57) dated the move accurately to 1854, but confused the issue by claiming that the family went to live in the rue des Gravilliers.

8 "Après le travail Léonard Renoir rangeait soigneusement tout ce qui recouvrait 'le banc.' Mon père apportait un matelas et des couvertures reléguées au-dessus d'une armoire et faisait son lit" (Renoir 1981, 32). On the rental of the additional room in 1858 see "Cadastre de 1852," as in note 7 above.

9 For an excellent study of this topic see Johnson 1975.

10 Renoir 1981, 80–88.

11 "Renoir avait encore présent à l'esprit la vision de son père, les jambes croisées comme un Hindou, entouré de rouleaux d'étoffes, d'échantillons, ciseaux, pelotes de fil" (ibid., 31). Coquiot (1925, 16) described Léonard Renoir as "une sorte d'artisan oriental, accroupi, les jambes repliées sur un plancher surélevé et en pente." This had been the stock image of the tailor since the middle of the nineteenth century; see Vanier 1960, 57–73.

12 Duranty's celebrated axiom (Moffett 1986, 44).

13 House and Distel (1985, 296) quote from the electoral rolls for Louveciennes of January 1870 in which Léonard Renoir stated that he had been a resident for eighteen months. "C'est un des plus délicieux villages des environs de Paris. Air excellent, sources abondantes, points de vues magnifiques sur la vallée de la Seine et le vallon de Bougival, ravissantes promenades, rien n'y manque. Aussi y a-t-on construit une multitude de villas" (Larousse 1866–90, X, 766). On Voisins-Louveciennes as part of the cradle of Impressionism see Brettell 1984, 79–81, 94–98.

14 "Homme grave et silencieux" (Renoir 1981, 32). "Mon grand-père avait acquis, même dans sa vie privée, l'habitude de ne jamais se départir d'une certaine solennité" (ibid., 41).

15 "L'air d'un magistrat, avec une certaine noblesse." (Coquiot 1925, 18)

16 A point first made in House and Distel 1985, 190.

17 In a letter to Bazille of 25 September 1869 Monet notes that Renoir has just spent "two months" with them (Wildenstein 1974–91, I, 427). On his earliest paintings of La Grenouillère see Tinterow and Loyrette 1994, 454–455.

18 Poulain 1932, 156; House and Distel 1985, 296.

Fig. 114 Paul Gavarni, *Voilà pourtant comme je serai dimanche*. From *Le Figaro*, 6 June 1839, Bibliothèque Nationale, Paris

7 The Artist's Brother, Pierre-Henri Renoir 1870

81 × 64 cm
Signed and dated lower left: A. Renoir. 70.
Private collection
Daulte no. 61

PROVENANCE One of a pair of pendant portraits commissioned from the artist in 1870 by his brother the engraver Pierre-Henri (1832–1903); Ambroise Vollard (1866–1939), Paris; passed into the collection of his mistress Madeleine de Galéa, née Morau (1874–1956); by inheritance to her grandson the architect Pierre Christian de Galéa (b. 1917); sold, Sotheby Parke Bernet, London, *Impressionist and Modern Paintings and Sculpture* (I), 26 June 1984, no. 15.

EXHIBITIONS Not exhibited in Renoir's lifetime.

REFERENCES *Renoir* 1979, no. 6; Bailey 1995.

NOTES

1 The exception, of course, is Renoir's youngest brother, Victor-Edmond (1849–1944), who, with Georges Rivière, was his preferred male model of the 1870s.

2 See Bailey 1995, 684–687, for the renaming of the Fogg's *Comtesse Edmond de Pourtalès* to *Blanche Marie Blanc, Madame Pierre-Henri Renoir*.

3 "Sous l'influence de Delacroix, il commence à modeler plus mollement et à élargir la palette sombre de Courbet" (Meier-Graefe 1912, 32).

4 Mairie de Limoges, "Acte de naissance," 13 February 1832, Pierre Henry Renoir, witnessed by Jean-Baptiste Dauriac, "imprimeur," and Louis Gandoin, "tailleur." The Renoirs had lost two babies in 1829 and 1830 (Hugon 1935, 454).

5 Bailey 1995, 686.

6 "Et, pourtant, c'était un merveilleux graveur" (Renoir 1981, 80). "Mon frère aîné, qui était graveur sur médailles, me procurait quelquefois des armoiries à reproduire" (Vollard 1918a, 18).

7 *Collection complète de chiffres et monogrammes par H. Renoir, élève de S. Daniel, graveur* (Paris, dated from the printer's copy of this book, inscribed "21 9bre [Novembre] 1863," in the Cabinet des Estampes, Bibliothèque Nationale, Paris), translated as *Monograms and Ciphers, Complete Collection, Alphabetically Arranged* (Edinburgh, 1867). He also published *Chiffres à deux lettres anglaises, par H. Renoir* (Paris, 1874).

8 Bailey 1995, 686.

9 "L'autre tableau dont je désire parler est celui qu'Henri Renoir a intitulé *Lise*" (Zola 1991, 211, "Mon Salon" [1868]).

10 Archives de Paris, "Acte de mariage," 18 July 1861, Renoir and Blanc, published in Bailey 1995, 687.

11 Bailey 1995, 686, n. 26.

12 *Croquis de chiffres, études sur les monogrammes des époques les plus utiles par H. Renoir* (Poissy [Seine et Oise], 1896); *Séries d'alphabets par Renoir*, 1er série (Paris, 1898).

13 Archives des Yvelines, "Recensement de population," Poissy, 1906, lists Pierre Renoir and Blanche Blanc as living at 4 rue du Cep, with Cesarine Brayeul, "née en 1868 à Roscoff, domestique."

14 Mairie de Poissy (Yvelines), "Acte de décès," 11 October 1909, Pierre-Henri Renoir, "decédé le 9 Octobre 1909"; Bailey 1995, 687.

15 "C'est à ces sages décisions que je dois de connaître le répertoire délicieusement ordurier des chanteurs du début du siècle, et à peu près tous les mélodrames de la grande époque que l'on jouait encore au Théâtre-Montmartre" (Renoir 1981, 454).

16 "Les parquets et les meubles Renaissance de chez Dufayel étaient cirés comme des miroirs" (ibid., 452). See Bailey 1995, 686.

17 Renoir 1981, 59, 87.

18 Bailey 1995, 686.

19 "Henri emmena mon père à une exposition de laques et de porcelaines ramenées par une mission mi-diplomatique mi-commerciale" (Renoir 1981, 80). In all probability this was the Far Eastern exhibition mounted at the Union Centrale in the autumn of 1869.

20 "Mon frère ne comprenait pas mon enthousiasme. Il était déjà pris par la mode" (ibid.).

21 Renoir 1981, 452.

Fig. 115 Pierre-Auguste Renoir, *Madame Pierre-Henri Renoir*, 1870. Fogg Art Museum, Harvard University Art Museums, Cambridge, Mass., Bequest of Grenville L. Winthrop

Fig. 116 Title page from *Collection complète de chiffres et monogrammes* by Henri Renoir, 1863. Bibliothèque Nationale, Paris

8 *Madame Stora in Algerian Dress* (*The Algerian Woman*) 1870

84.5 × 59.6 cm

Signed and dated lower right: A. Renoir. 70.

Fine Arts Museums of San Francisco, Gift of Mr. and Mrs. Prentis Cobb Hale in honour of Thomas Carr Howe, Jr., 1966.47

Daulte no. 47; House/Distel no. 17

PROVENANCE Stora family; purchased around 1894 by the painter Paul-César Helleu (1859–1927), Paris, for 300 francs; Claude Monet, Giverny, by 1906; inherited by Michel Monet, Giverny, 1926; Galerie Bernheim-Jeune, Paris, by 1938; Reid and Lefevre and William Hallsborough Ltd., London, by 1952; Prentis Cobb Hale, San Francisco; gift to the California Palace of the Legion of Honor (now part of the Fine Arts Museums of San Francisco), 1966 .

EXHIBITIONS *Orientalistes français* 1906, no. 52.

REFERENCES *Rembrandt to Renoir* 1992, no. 64; Schnell 1993, 222–223.

NOTES

1 Cooper (1959, 168) dated the portrait of Madame Stora to the spring of 1870.

2 Noted by all commentators, Delacroix's influence was analysed magisterially by Meier-Graefe (1912, 19–34). For one of Renoir's several pronouncements on Delacroix see Vollard 1919, 229: "*Les Femmes d'Alger*, il n'y a pas de plus beau tableau au monde . . . ce tableau sent la pastille du sérail: quand je suis devant ça, je m'imagine être à Alger."

3 House and Distel 1985, 195. Stevenson (1991, 62) goes so far as to consider this work a reflection of Renoir's "colonial prerogative." For the

most recent and thorough account of North African imagery in Renoir's work see Schnell 1993, 216–231.

4 Archives de Paris, v4E/1047, "Acte de mariage," 11 June 1868, Nathan Stora and Rebecca Clémentine Valensin; ibid., DIP4/ 1114, "Cadastre de 1862," 1–3 rue Taitbout. This archival material completes and corrects the previously published biographical information.

5 Hillairet 1964, I, 663; Hughes 1981, 23, 38–40; Haskell 1982, 40–41.

6 "Acte de mariage," as in note 4 above, for Stora's witnesses, Zacharie Solal, Elie Aman, and Léon Bouchara, "négociants" living at nos. 6 and 24 boulevard des Italiens.

7 Ibid., v4E/1052, "Acte de naissance," 25 April 1869, Zara Stora; 5Mi3/191, "Acte de naissance," 11 July 1873, Zara Estelle; 5Mi3/196, "Acte de naissance," 16 January 1876, Semha Lucie; 5Mi3/2202, "Acte de naissance," 14 August 1879, Moïse Maurice.

8 Gimpel 1963, 277, entry for 7 September 1924.

9 "Ce tableau a été fait dans un atelier à Paris; mon modèle était la femme d'un marchand de tapis" (Vollard 1919, 50).

10 See Christie's, London, 16 June 1994, no. 398.

11 Johnson 1981–89, III, 195–196. On Dehodencq's *Mariage juive à Maroc* (1870, Musée Saint-Denis, Reims) see Thornton 1983, 107. Vollard (1919, 50) recalled that Benjamin-Constant's portrait of her was the pride of Madame Stora's collection.

12 The family portraitist Constant-Joseph Brochart (1816–1898) also alludes to Stora's profession in the Oriental rug that unfurls, incongruously, by the pet gazelle.

13 "Les Stora qui trouvaient ce tableau horrible" (Gimpel 1963, 70).

14 "Il y a au moins trente ans, le peintre avait rencontré dans une ville d'eaux la belle Mme Stora . . . et il lui avait demandé de la peindre" (ibid.).

15 Renoir 1981, 223,

16 *Encyclopaedia Judaica* (Jerusalem, 1972), XV, 415 (Stora), XVI, 58 (Valensi).

17 "La franchise brutale de leur pinceau" (Houssaye's letter in Bertrand 1870, 319).

18 "Il voyait cent portes ouvertes devant lui et ne savait pas par laquelle passait son chemin . . . On peut trouver étroites les limites qu'il s'est imposées à lui-même quand on les compare à l'ampleur de Delacroix, on peut accorder qu'il ne déroba, à vrai dire, qu'un coussin au palais du maître: mais dans cette limitation que son instinct lumineux s'imposait volontairement, il s'est montré un maître d'une sagesse exemplaire" (Meier-Graefe 1912, 25).

Fig. 118 Au Pacha, 24 boulevard des Italiens, Paris, c. 1870. Private collection, New York

Fig. 119 Charles-Henri-Joseph Cordier, *La Juive d'Alger*, c. 1863, bronze, enamel, and onyx. Private collection

Fig. 117 Pierre-Auguste Renoir, *Woman of Algiers* (*Odalisque*), 1870. National Gallery of Art, Washington, Chester Dale Collection

Fig. 120 Constant-Joseph Brochart, *Clementine Stora and Her Daughter Lucie*, c. 1877. Private collection

19 Renoir, in discussing the portrait of Madame Stora, alluded dismissively to "la manie des amateurs de toujours demander ma manière ancienne" (Vollard 1919, 50).

20 Gimpel 1963, 70. The latter's journal entry of 6 September 1918 is corroborated by Vollard (1919, 50), who, in search of Renoir's portrait, was informed by Madame Stora that she had just sold it for 300 francs.

9 *Madame Marie Octavie Bernier* (formerly called *Madame Darras*) 1871

78.9 × 62.2 cm

Signed and dated lower right: A. Renoir 71.

The Metropolitan Museum of Art, New York, Gift of Margaret Seligman Lewisohn, in memory of her husband, Samuel A. Lewisohn, and of her sister-in-law, Adele Lewisohn Lehman, 1951, 51.200

Daulte no. 69

PROVENANCE Purchased by Durand-Ruel from a Monsieur Bernier, 31 rue des Dames, Paris, 26 July 1919, for 10,000 francs, as "un portrait de femme"; according to Durand-Ruel's records, the painting was held jointly with Bernheim-Jeune; Bernheim-Jeune's records indicate that they bought the painting from Durand-Ruel on 29 July 1919 and resold it through their branch in Lausanne to Josef Stransky (1872–1936), conductor of the New York Philharmonic who in May 1921 lent the work to the Metropolitan Museum of Art, New York, as "Lady in Black"; Adolph Lewisohn, New York, 1925–38; Samuel A. Lewisohn, New York, 1938–51; Adele Lewisohn Lehman, New York, 1951.

EXHIBITIONS Not exhibited in Renoir's lifetime.

REFERENCES Sterling and Salinger 1967, 145–146.

10 *Captain Édouard Bernier* (formerly called *Captain Paul Darras*) 1871

81 × 65 cm

Signed and dated lower left: Renoir 71. Gemäldegalerie Neue Meister, Staatliche Kunstsammlungen Dresden

Daulte no. 70

PROVENANCE Purchased by Durand-Ruel from a Monsieur Bernier, 31 rue des Dames, Paris, 26 July 1919, for 5,000 francs, as "un portrait de capitaine d'infanterie"; according to Durand-Ruel's records, the painting was held jointly with Bernheim-Jeune, until Durand-Ruel sold its share to

Bernheim-Jeune on 12 March 1920; however, Bernheim-Jeune's records indicate that the painting was purchased by them from Durand-Ruel (along with cat. no. 9) on 29 July 1919, and bought back by Durand-Ruel only on 28 February 1920; owned by Josef Stransky (1872–1936), conductor of the New York Philharmonic; purchased from Stransky by Dr. Karl Lilienfeld, Dresden, 15 May 1926; acquired from Lilienfeld by the Staatliche Gemäldegalerie, Dresden, 1926, as "Offiziersbildnis".

EXHIBITIONS Not exhibited in Renoir's lifetime.

REFERENCES Adriani 1996, no. 14.

NOTES

1 House and Distel 1985, 296–297, quoting from Renoir's military records in the Service Historique de l'Armée de Terre, Vincennes, dossier 2233. The Archives Durand-Ruel, Paris, contains an envelope postmarked "28 October 1870" addressed to "M. Renoir, 10ᵉ Chasseurs, 4ᵉ peloton, faire suivre à Libourne."

2 "Enfin je me suis payé la dysenterie et j'ai failli claquer sans mon oncle qui est venu me chercher à Libourne et m'a emmené à Bordeaux" (Cooper 1959, 327, Renoir to Charles Le Coeur, from Vic-en-Bigorre, 1 March 1871); Rivière (1921, 13) noted that after Bordeaux, Renoir was "affecté à une compagnie de remonte, et la guerre prit fin alors qu'il était encore à Tarbes."

3 White 1984, 40, followed by Adriani 1996, 97. Cooper (1959, 163) dated the portraits to after April 1871 (i.e., later than that of Rapha Maître).

4 Cooper 1959, 327–328. Bibesco and Darras had both entered Saint-Cyr in 1855. Both served under General du Barail, and they were taken prisoner together in Coblenz in October 1870. For an absorbing account of their honourable confinement in Germany see Bibesco 1899, 67–68, 121–123.

5 Dresden 1926, 39, no. 145; Meier-Graefe 1929, 43, "Bildnis eines Offiziers, vielleicht Darras."

6 Geffroy 1920, 162; New York 1921, 23, no. 101. It should be noted that in May 1921, contrary to the provenance in Daulte, the portrait was listed as from the collection of Josef Stransky.

7 For a thorough listing of references to the Metropolitan Museum's *Madame Darras* see Sterling and Salinger 1967, 145–146.

8 Posse 1927, 248, reproducing the work as *Offiziersbildnis*, and noting "es stellt wahrscheinlich nach dem militärischen Vorgesetzten Renoirs, den Capitaine Darras dar"; George and Bourgeois 1932, 306; Dresden 1930, 67, no. 2608, as "Bildnis eines Offiziers (Capitaine Darras)."

9 The material that follows results from the brilliant detective work of my assistant John Collins, who realized that there might be a discrepancy between the uniform worn by Renoir's sitter and Darras's rank as *capitaine de*

l'infanterie, and who enlisted the generous support of Florence Le Corre, documentaliste-iconographe at the Musée de l'Armée, Paris. Anne Distel is also to be thanked for her advice.

10 "Monsieur Renoir nous raconte qu'après la guerre étant soldat il a passé deux mois dans un château, où il était servi comme un prince, et donnant des leçons de peinture à la jeune fille, se promenant toute la journée à cheval" (Manet 1979, 132, entry for 20 September 1897).

11 Jean Renoir (1981, 149–150) describes the captain as "un brave homme, cavalier professionnel, adorant les chevaux et navré à l'idée qu'il devrait s'en séparer bientôt pour les envoyer à cette boucherie inutile." Renoir *père* is reported as saying: "Le capitaine me recevait comme l'enfant de la maison. Je regardais peindre la petite et en même temps je faisais son portrait."

12 Cooper 1959, 327.

13 Larousse (1898–1904, III, 793) notes that the dolman with nine brandenburgs was introduced for chasseurs and hussards in 1871; Renoir's sitter is wearing up-to-date military costume.

14 Daulte 1971, nos. 69, 70. I am grateful to Anne Distel for consulting the Archives Durand-Ruel for me.

15 Service Historique de l'Armée de Terre, Vincennes, 27417, 3ᵉ série, "État de Services," Édouard Bernier. Zeldin (1973, II, 878–879), noting the slowness of the promotion of non-commissioned officers, estimated that it might take fifteen years to rise from sub-lieutenant to captain, and that such an officer would be unlikely to go much further. This is precisely the case with Bernier, who went from sub-lieutenant in 1856 to full captain in 1870, and retired two years later.

16 Service Historique de l'Armée de Terre, Vincennes, 27417, 3ᵉ série, "Situation Militaire," 11 September 1871, Édouard Bernier, capitaine d'habillement au 10ᵉ de chasseurs.

17 Ibid., "État Général des Services et Campagnes," 11 April 1872, Édouard Bernier; Archives Nationales, Paris, Archives de la Légion d'Honneur, 203/2, for Bernier's letter of 23 July 1876 giving details of his whereabouts after his retirement from the army in 1872. Bernier's widow seems to have spent the rest of her life in Saint-Saens, where she died in November 1920.

18 Service Historique de l'Armée de Terre, Vincennes, 27417, 3ᵉ série, for copies of Bernier's birth and wedding certificates and Marie-Octavie's birth certificate.

19 Lamathière 1875–1911, IX, 305–306; *DBF*, X, 212.

20 First noted by Cooper (1959, 327, n. 35).

21 Service Historique de l'Armée de Terre, GD 218, 3ᵉ série, "État de Services," 17 July 1883, Paul-Édouard-Alfred Darras; Archives Nationales, Paris, Archives de la Légion d'Honneur, 633/28, for Darras's promotions within the order of the Légion d'Honneur.

22 I am indebted to Marc Le Coeur for sending me photographs of Captain Darras still in the family's possession. Additionally, although such evidence is always hard to assess, it might be noted that if Darras and Bernier share the cropped haircut and manicured moustache obligatory for military men, Darras keeps his chin neatly trimmed, whereas Bernier sports a long goatee, which gives him something of the appearance of a Chinese mandarin.

23 Disdéri 1864, 82.
24 Fox 1909, 23.
25 Disdéri 1864, 72–73.

Fig. 121 Paul-Édouard-Alfred Darras, 1883–85. Private collection, Paris

Fig. 122 Paul-Édouard-Alfred Darras, c. 1880, photograph by Paul Berthier. Private collection, Paris

11 *Rapha Maître* 1871
130 × 83 cm
Signed and dated lower right: A. Renoir. avril. 71.
Private collection
Daulte no. 66; House/Distel no. 19

PROVENANCE Edmond Maître (1840–1898), Paris; after Maître's death, sold to Durand-Ruel by "Madame Maître," 79 rue de Seine, 11 October 1898, for 1,000 francs; sold by Durand-Ruel, 5 April 1909, to the collector Poznanski, Paris, for 15,000 francs; by 1916, in the collection of the margarine manufacturer Auguste Pellerin (1852–1929), Paris; by inheritance to Pellerin's daughter Madame René Lecomte; Louis de Chaisemartin, Neuilly-sur-Seine; private collection.

EXHIBITIONS Berlin 1900, no. 244, as "Frauenportrait"; Basel 1906, no. 517.

REFERENCES Adriani 1996, no. 13.

12 *Rapha Maître* c. 1871
37.4 × 32.3 cm
Signed upper left: Renoir
Smith College Museum of Art, Northampton, Mass., 1924:16
Daulte no. 68

PROVENANCE Edmond Maître (1840–1898), Paris; sold to Durand-Ruel by "Madame Maître," 79 rue de Seine, 14 March 1899, for 250 francs; purchased from Durand-Ruel by the Berlin art dealer Paul Cassirer (1871–1926), 23 November 1911, for 2,800 francs; with the antiquarian Dikran K. Kélékian (1868–1951), New York, until it was sold in the Kélékian sale, American Art Association, New York, 30 and 31 January 1922, no. 103, for $1,600 to Bourgeois Galleries, New York; purchased by Smith College, 1924.

EXHIBITIONS Not exhibited in Renoir's lifetime.

REFERENCES Daulte and Marandel 1978, no. 72.

NOTES
1 House and Distel 1985, 296–297, quoting from Renoir's military records in the Service Historique de l'Armée de Terre, Vincennes, dossier 2233.
2 "En revenant de Bordeaux [sic], je tombai à Paris en pleine Commune" (Vollard 1919, 52).
3 "Au pinceau en pleine pâte" (André 1923, 35), Renoir's term for his early manner.
4 Cooper 1959, 327. Cooper's brief analysis is more acute than the extended, if not altogether accurate, reading in Boime 1995, 51.
5 House and Distel 1985, 198.
6 "Des effets à la Alfred Stevens, comme par exemple dans le portrait de *Madame Maître* de 1871, qui ressemble à l'enveloppe d'un Renoir sans le contenu d'un Renoir" (Meier-Graefe 1912, 34).
7 For example, Émile Pierre Metzmacher's *Songbird* (1877, Christie's, New York, 25 October 1989, no. 108).

8 Faison 1973, 571–578.
9 Such was the richness of the paint surface that Blanche mistakenly assumed that Renoir had returned to using the palette knife. "C'est encore la de la pâte épaisse, il emploie le couteau" (Blanche 1933).
10 For the often repeated anecdote of Renoir's meeting with Raoul Rigault, *procureur* at the Préfecture de Police, see Vollard 1919, 53–55.
11 "L'enrôlement forcé décrété par la Commune mit Renoir dans une position difficile" (Rivière 1921, 13). Although the Conseil de la Commune abolished conscription, the decrees of April 5 and 7 established compulsory military service in time of civil war for men between 18 and 40; see Goncourt 1956, II, 761.
12 "Sur le quai Voltaire, odeur de poudre apportée par le vent et remontant la Seine sur le cours de l'eau" (Goncourt 1956, II, 774, entry for 19 April 1871). Renoir was living at this time "dans une chambre au coin de la rue du Dragon" on the Left Bank (Vollard 1919, 52).
13 "Je suis frappé du peu de monde qu'on rencontre. Paris a l'air d'une ville, où il y a la peste" (Goncourt 1956, II, 761, entry for 8 April 1871).
14 Ibid., II, 760, 766.
15 "La guerre civile est commencée!" (ibid., II, 755).
16 "Quelques misérables petits pots de verdure au Marché aux Fleurs, que des ouvriers emportent en mordant dans leur pain" (ibid., II, 777, entry for 22 April 1871).
17 "J'ai donc cheminé sans encombre jusque chez moi, me heurtant à chaque pas à de hideux cadavres . . . dans ces rues en ruines, habitées par des morts" (Daulte 1952, 86).
18 Archives municipales de Bordeaux, 1E 190/465, "Acte de naissance," 23 April 1840, Louis Maître, son of Hugues Adrien Maître (1812–after 1898), "avocat," and Elisabeth Morillot, known as Betsy (died 1 April 1847).
19 Daulte 1952, 44–65, remains the standard biography of Maître until Bazille's death in 1870. See also Blanche 1927, 605–606.
20 "Un dilettante qui, s'il avait eu une grande fortune aurait été le plus intelligent des Mécènes" (Rivière 1921, 65). Daulte (1952, 85–86) cites a heartrending letter of February 1871 from Maître to his father informing him of Bazille's death: "C'est une moitié de moi-même qui s'en va . . . Personne au monde ne remplira jamais la place vide qu'il laisse dans ma vie." On his friendship with Fantin-Latour see Druick and Hoog 1983, 16.
21 Druick and Hoog 1983, 208–210. In June 1871 Fantin described Maître as "a discriminating mind, an amateur musician employed at the Hôtel de Ville."
22 "Cet éternel amoureux du beau sexe" (Blanche 1927, 605). Bazille's portrait of Maître (National Gallery of Art, Washington) is most recently catalogued in *Bazille* 1992, 115; for Renoir's see White 1984, 39.
23 Archives de Paris, "Acte de décès," 30 May 1898, Louis-Edmond Maître, where it is stated that he is "célibataire." "Camille, patronne de céans, la maîtresse de l'étudiant bordelais au Quartier Latin, 'Mme Edmond Maître' pour la concierge" (Blanche 1949, 12). Daulte (1978, 16) claims that she was Belgian, but provides no further information on this point.
24 "À la mémoire d'Edmond Maître à qui . . . je suis redevable de tant de lumières reçues dès

mon enfance" (Blanche 1931, frontispiece). Maître had not only taken Blanche to Manet's studio, but had also introduced him, through his small collection, "aux multiples perspectives de l'art moderne" (Blanche 1922, 98).

25 "Une vieille compagne à lui collée . . . depuis la pension du 'Quartier' où il était descendu comme étudiant" (Blanche 1927, 605).

26 "Une horrible mégère" (Blanche 1949, 124). "Maritorne acariâtre, querelleuse . . . [avec] sa voix de harengère" (Blanche 1922, 108, 189)

27 Blanche 1949, 123–125.

28 "Je trouvais là . . . deux chefs-d'oeuvre: le portrait de la maîtresse du logis, en robe beige, et cette merveille, un petit garçon nu couleur de nacre" (Blanche 1927, 605).

29 See Daulte 1971, 50, for the portrait of Rapha Maître (1870) in the Hausmann collection. Daulte (1984, 166) has also published *Femme au corsage de Chantilly* (1869, private collection, Geneva) as a portrait of Rapha, which seems most improbable.

30 House and Distel 1985, 296.

31 "Pensez! il y a quarante-trois ans que nous étions ensemble, comme vous nous avez vus! . . . Il y a longtemps qu'il n'était plus ragoûtant. Je l'ai nettoyé, jour et nuit, comme un gâteux" (Blanche 1922, 267).

32 Archives de Paris, DQ7/11712, October 1898, "Succession," Edmond Maître. No *inventaire après décès* was drawn up, and the estate was valued at 10,365 francs. Edmond's younger brother Léon (1847–1929) had commissioned Renoir's pastel portrait of his daughter Elisabeth in 1879; see Sotheby's, New York, 18 May 1983, no. 9.

33 Archives Durand-Ruel, Paris, 4768, "Portrait de Mme Maître," bought from "Madame Maître, 79 rue de Seine," for 1,000 francs, 11 October 1898; 5099, "Portrait de femme (Mme Maître)," purchased from her for 250 francs, 14 March 1899.

34 "Ce sont du reste deux choses sans valeur, surtout *La Femme à l'oiseau.* Je ne vous engage pas à vous emballer sur ces croûtes" (Godfroy 1995, II, 9, Renoir's response to Joseph Durand-Ruel's request that he authenticate *Bather with a Griffin* [1870, Museu de Arte de São Paulo] and *Woman with a Parrot*).

35 "Quadrillé d'un treillage de jardin . . . et bordé dans toute sa longueur d'une caisse rectangulaire dans laquelle fleurissaient des chrysanthèmes" (quoted in Monneret 1986, 470).

36 *Matisse* 1993, 396–399; Schneider 1992, 406–407. Matisse privileges the rococo aspects of Renoir's composition in the first version of *Auguste Pellerin*, which the sitter considered "trop osée pour être accrochée au mur de son bureau." In the accepted work, the flouncing skirt and trellis-patterned wallpaper are treated as disembodied, almost abstract, forms.

37 "Cette oeuvre diverse et raffinée, qui fera tourner la tête des connaisseurs de l'avenir" (Blanche 1949, 441, Blanche to his father, 15 August 1882, quoting from Maître's letter to him).

Fig. 123 *Quelques nouveaux costumes de MM. Arigon et Bordet.* From *La Vie Parisienne,* 30 September 1871

Fig. 124 Pierre-Auguste Renoir, *Still Life with Bouquet,* 1871. The Museum of Fine Arts, Houston, The Robert Lee Blaffer Memorial Collection, Gift of Sarah Campbell Blaffer

Fig. 125 Alfred Stevens, *Woman in Pink, or The Exotic Curio,* c. 1865. Musées Royaux des Beaux-Arts de Belgique, Brussels

Fig. 126 Pierre-Auguste Renoir, *Boy with a Cat,* 1868–69. Musée d'Orsay, Paris

Fig. 127 Henri Matisse, *Auguste Pellerin* (I), 1916. Private collection

Fig. 128 Henri Matisse, *Auguste Pellerin* (II), 1917. Centre National d'Art et de Culture Georges Pompidou, Paris

13 *Riding in the Bois de Boulogne* 1873
261 × 226 cm
Signed and dated lower left: A. Renoir.
1873.
Hamburger Kunsthalle, Hamburg, 1567
Daulte no. 94

PROVENANCE Purchased by the industrialist and amateur painter Stanislas-Henri Rouart (1833–1912), Paris, from the artist over a period of seven months, April–October 1874, for 2,000 francs; at the turn of the century, it was displayed prominently at Rouart's studio, 34 rue de Lisbonne, Paris; Galerie Manzi-Joyant, Paris, Rouart sale, 9–11 December 1912, no. 269, bought for 95,000 francs by the Berlin art dealer Paul Cassirer (1871–1926), who sold it to the Kunsthalle, Hamburg, 1913.

EXHIBITIONS Salon des Refusés 1873.

REFERENCES Alexandre 1892, 14–15; Vollard 1919, 57–58; Duret 1922, 92–93; Manet 1979, 151; Isaacson 1982, 103–104; Herbert 1988, 149–150; Distel 1989b, 180, 182, 191; Godfroy 1995, II, 121, 123.

NOTES

1 "Quant à l'histoire de ce tableau elle n'est pas longue. J'avais mon ami Darras officier d'ordonnance du Général du Barail qui a bien voulu mettre à ma disposition un des Salons de l'École Militaire et le manège pour pouvoir étudier le galop du cheval. À cette époque je ne faisais pas grand cas de mes productions qui étaient du reste peu appréciées et j'ai perdu toutes les études préalables qui m'ont servi à faire ce tableau, études faites au bois de Boulogne. C'est madame Darras qui a posé pour l'Amazone" (Hamburger Kunsthalle, Hamburg, Archives [Ausländer], Renoir to Lichtwark, from Les Collettes, 28 January 1913). Lichtwark had addressed his letter of 18 January 1913 in care of Georges Durand-Ruel, who had passed it to Renoir on 22 January 1913, reminding him: "D'après que vous avez dit à mon père, l'amazone en question était la femme du capitaine Darras, officier d'ordonnance du général de Barail [sic]" (Godfroy 1995, II, 123).
2 Vollard 1919, 57–58, where the painting is dated a year too early: "Elle fut terminée seulement dans les premiers mois de 1872. Je l'envoyai au Salon cette même année; on la refusa." On *La Source* see Daulte 1971, 124.
3 In the *livret* for the Salon of 1873, at which Darras exhibited *Vue prise de l'École Militaire* and *Escalier d'honneur de l'École Militaire*, his address is given as "l'École Militaire." Larousse (1866–90, VII, 120) noted that "le maréchal commandant de garde . . . ainsi que plusieurs officiers d'état majeur, sont aussi logés à l'école militaire."
4 Archives municipales de Dijon, "Acte de mariage," 21 February 1859, Darras and Oudiette. Darras, whose mother had died in July 1847 and his father in April 1852, had received a bursary to enter the École Militaire de Saint-Cyr in January 1855. In his application he was described as "orphelin de père et de mère ruinés par des revers de fortune" (Service Historique de l'Armée de Terre, Vincennes, GD218, 3ᵉ série).
5 Cooper (1959, 327) was the first to propose the identification. Vollard (1919, 58) has Darras posing with his wife, which is clearly wrong.
6 Cooper (1959, 327–328) assumed that Renoir gave this painting to Charles Le Coeur, though it could also have been presented by Madame Darras; see Daulte 1971, 93.
7 Service Historique de l'Armée de Terre, Vincennes, GD218, 3ᵉ série, "Extrait des minutes des actes de décès," 23 June 1903, Paul-Édouard-Alfred Darras.
8 *Chronique des Arts* 1873, noting also that applicants were requested to pay a fee of 20 francs to cover "les frais d'aménagement, d'assurance, de suspension, de publicité, etc."
9 Christie's, London, *Illuminated Manuscripts, Continental and English Literature*, 16 December 1991, no. 321, receipts in Renoir's hand dated 2 April, 4 June, and 1 October 1874, for the sums of 1,000, 800, and 200 francs respectively, "à compte sur mon tableau intitulé (Amazone)." On Rouart's collecting see Distel 1989b, 176–193. Reutersvard (1952) noted that Rouart exhibited landscapes at the Salon des Refusés, along with Jules Le Coeur (*La Femme rouge*, *Rue à la glacière*).
10 "Une quasi-impossibilité de transport s'oppose également à ce qu'on trouve ici l'oeuvre qui, à partir de 1873, nous permet de le suivre désormais sans interruption" (*Renoir* 1892, 14).
11 "Il pourra conquérir de jour en jour plus d'éclat et de grâce, ou plutôt un éclat et une grâce différents, mais on ne saurait déjà rencontrer rien de plus puissant ni de plus harmonieux" (ibid., 14–15).
12 "Les bêtes sont suffisamment construites et, chose rare même dans le Salon officiel, elles sont dans leur action" (Reutersvard 1952, quoting Burty in *La République Française*, 1873). "Et comme on lit dans la physionomie la béatitude de se sentir emportée, de fendre le vent!" (Castagnary 1892, II, 70).
13 "Enfin l'amazone, avec la fine carnation qui fleurit tendrement sous son léger voile bleu . . . demeurera, pour l'avenir, une des plus exactes et aussi des plus séduisantes créations de l'art moderne" (*Renoir* 1892, 15).
14 "Les chevaux sont d'un mouvement étonnant, l'amazone pleine de grâce, le fond est ravissant. Je n'avais jamais vu quelque chose de M. Renoir dans ce genre-là" (Manet 1979, 151).
15 "Renoir fait un pas en arrière vers la *Diane Chasseresse*" (Meier-Graefe 1912, 34).
16 Rewald 1973, 302.
17 White 1984, 45.
18 Herbert 1988, 149–151.
19 Mozley 1972, 14–18; Scharf 1962, 186–195.
20 Quoted by Moffett in *Manet* 1983, 339.
21 Isaacson 1982, 104.
22 See the superb discussion in Herbert 1988, 141–151.
23 Baedeker 1876, 137.
24 Herbert 1988, 145–146.
25 Anthony North Peat, *Gossip from Paris during the Second Empire* (London, 1865), quoted in Herbert 1988, 149, entry for 1865.
26 "Le vrai monde a d'ailleurs une autre façon de jouir du Bois. C'est le matin qu'on s'y rend à cheval ou en voiture, et cela tous les jours, sans manquer, pour y cueillir les roses du visage. On cite des dames de haut rang qu'aucun événement n'empêche de partir pour le Bois à huit heures" (Debans 1889, 300).
27 "M. Renoir n'a-t-il pas exprimé avec force le fard qui monte aux joues d'un jeune garçon . . . le vent qui fouette le visage d'une jeune femme qui fait, au bois de Boulogne, la promenade du matin?" (Burty, quoted in Reutersvard 1952).
28 "Darras, écuyer consommé, rêvait d'un de ces grands beaux chevaux anglais qui faisaient la gloire des écuries impériales, et que sa fortune modeste ne lui permettait pas d'acquérir" (Du Barail 1898, 9).
29 "Chaussée finement, ganté juste, avec des cravates prodigieuses et des chapeaux ineffables" (Zola, *La Curée*, 132). The thirteen-year-old Maxime is introduced to the Bois de Boulogne by his stepmother Renée: "Là, elle lui faisait un cours de haute élégance" (ibid., 133).
30 Rouart and Wildenstein 1975, I, 146, no. 160. Manet's *L'Amazone*, neither a commissioned portrait, nor an exhibited work, was painted around 1870. "M. Renoir, affolé par la peinture de Carolus Duran, brosse des amazones improbables, des chevaux impossibles" (Claretie 1876, 162). Alexandre noted that while Renoir's equestrian painting had been refused from the Salon of 1873, "une autre amazone faisait l'admiration des critiques et la pâmoison du public" (*Renoir* 1892, 15).
31 "Un portrait de Mlle Croizette sur un cheval qui en rigoureuse perspective ne pouvait reculer d'un pas sans tomber en pleine mer" (Alexandre 1892, 15). McCauley (1994, 73–74) notes the presence of equestrian portrait studios in the west end of Paris, in proximity to the Bois.
32 See Brown 1995, 250, on the history of *La Curée*, first serialized in twenty-eight instalments in *La Cloche*, withdrawn by Zola in September 1871, and published in novel form by Charpentier in October 1872.
33 Baudelaire 1964, 13. "Le costume, la coiffure et même le geste, le regard, et le sourire (chaque époque a son port, son regard, et son sourire) forment un tout d'une complète vitalité" (Baudelaire 1961, 1163). "Le Peintre de la vie moderne," first published in November 1863, was reprinted in *L'Art Romantique* in 1869.
34 Baudelaire 1964, 31. "Quel est l'homme qui, dans la rue, au théâtre, au bois, n'a pas joui, de la manière la plus désintéressée, d'une toilette savamment composée, et n'en a pas emporté une image inséparable de la beauté de celle à qui elle appartenait, faisant ainsi des deux, de la femme et de sa robe, une totalité indivisible" (Baudelaire 1961, 1181).

Fig. 129 Madame Henriette Darras, c. 1880, photograph by Paul Berthier. Private collection, Paris

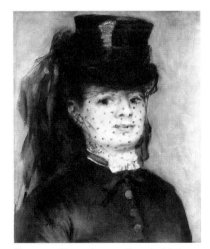

Fig. 130 Pierre-Auguste Renoir, *Madame Darras as an Amazon*, 1873. Musée d'Orsay, Paris

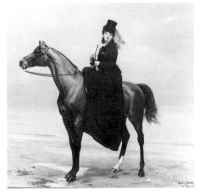

Fig. 131 Charles-Émile Auguste Carolus-Duran, *Sophie Croizette on Horseback*, Salon of 1873. Musée des Beaux-Arts, Tourcoing

Fig. 132 Edmond Morin, *Un temps de galop au Bois de Boulogne*. From *L'Esprit Follet*, 29 May 1869

14 *Claude Monet Painting in His Garden at Argenteuil* 1873
46 × 60 cm
Signed lower left: A. Renoir.
Wadsworth Atheneum, Hartford, Conn.,
Bequest of Anne Parrish Titzell, 1957.614
Daulte no. 131; House/Distel no. 23

PROVENANCE Hôtel Drouot, Paris, *Vente de tableaux*, 17 April 1896, no. 87, bought for 800 francs by Durand-Ruel, who sold it to Edmond Decap the same day; Edmond Decap, Paris; the dramatist Georges Feydeau (1862–1921), Paris; Hôtel Drouot, Paris, [Feydeau sale], 14 June 1902, no. 17, *Le Peintre*, bought by Durand-Ruel for 4,700 francs; Charles Albert Corliss (1868–1936), New York; Mr. Josiah Titzell, Georgetown, Conn.; bequeathed by Anne Parrish Titzell to the Wadsworth Atheneum, 1957.

EXHIBITIONS London 1905, no. 258; Durand-Ruel Paris 1910, no. 36; *Renoir* 1912, no. 29.

REFERENCES *Art for the Nation* 1991, 166; *Goya to Matisse* 1991, no. 39; *Wadsworth Atheneum* 1992, 76–77; House 1994, no. 7; Tucker 1995, 87.

NOTES
1 "Mon atelier, mais je n'ai jamais eu d'atelier moi, et je ne comprends pas qu'on s'enferme dans une chambre. Pour dessiner, oui; pour peindre, non!" (Taboureux 1880, the painter's first recorded interview, given at Vétheuil).

2 "On multiplie les dahlias soit par semis, soit par bouturage, soit surtout par division des tubercules au moment où on les plante (fin mai ou commencement de juin); la floraison a son apogée en août et se continue jusqu'aux gelées" (Larousse 1898–1904, III, 492).
3 "Je fis, cette même année [1873], nombre d'études à Argenteuil, où je me trouvais en compagnie de Claude Monet, notamment un *Monet peignant des dahlias*" (Vollard 1919, 58).
4 House and Distel 1985, 201; see also the entry in House 1994, 64–65.
5 Moreau-Nélaton 1926, I, 22; Wildenstein 1974–91, I, 58.
6 For an unsurpassed account see Tucker 1982, 10–19.
7 Walter 1966, 337. *Pace* House 1994, 64, these are not "recently built villas like his own," a comment applicable rather to Monet's second residence at Argenteuil, the Pavillon Flament, built between 1873 and 1874.
8 The relationship between these two pictures, less straightforward than immediately apparent, has been discussed in Rewald 1973, 284–285, Tucker 1982, 143, Moffett in *Art for the Nation* 1991, 166, and Tucker 1995, 86–87.
9 Tucker 1982, 143–144.
10 Moffett in *Art for the Nation* 1991, 166.
11 Walter 1966, 335, 342, n. 13.
12 *Monet et ses amis* 1977, 89, no. 126.
13 "Ridges of dry paint below the paint surface, wholly unrelated to the present composition, show that Renoir was reusing a canvas" (House 1994, 64). I am most grateful to Patricia Garland and Stephen Kornhauser, Conservators of Painting at the Wadsworth Atheneum, for having X-rayed this painting and shared their findings with me.
14 See Wildenstein 1974–91, I, 206, no. 205, where the identification of the model as Camille is curiously questioned. Tucker (1982, 128–131) is in no doubt that Monet has painted his wife here. Camille Monet's distinctive oval face and rather gaunt features are also seen in *The Red Kerchief: Portrait of Camille Monet* (c. 1872, Cleveland Museum of Art).
15 House 1994, 64. In his account of Renoir painting *Camille Monet and Her Son Jean in the Garden at Argenteuil* (cat. no. 17) the following year, Monet told Marc Elder that Renoir had asked him "for a palette, a brush, and canvas," so the custom of using his host's materials was an established one (Elder 1924, 70).

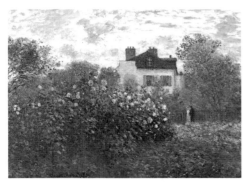

Fig. 133 Claude Monet, *The Artist's Garden in Argenteuil* (*A Corner of the Garden with Dahlias*), 1873. National Gallery of Art, Washington, Partial gift of Janice H. Levin in honor of the 50th anniversary of the National Gallery of Art

Fig. 136 X-radiograph of *Claude Monet Painting in His Garden at Argenteuil* (cat. no. 14). Wadsworth Atheneum, Hartford, Conn.

Fig. 134 Pierre-Auguste Renoir, *Claude Monet Standing*, 1873, pastel. Musée Marmottan, Paris, Bequest of Michel Monet

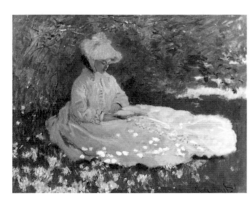

Fig. 135 Claude Monet, *The Reader* (*Springtime*), 1872. The Walters Art Gallery, Baltimore

15 *Claude Monet* (*The Reader*)

1873–74
61 × 50 cm
Signed lower left: A. Renoir.
National Gallery of Art, Washington,
Collection of Mr. and Mrs. Paul Mellon,
1985.64.35
Daulte no. 87

PROVENANCE Jean Dollfus (1823–1911), Paris; Galeries Georges Petit, Paris, Dollfus sale, 2 March 1912, no. 57, bought for 12,000 francs by Paul Rosenberg (1881–1959); Paul Rosenberg and Co., Paris; the popular writer and dramatist Pierre Decourcelle (1856–1926), Paris, by 1917; Hôtel Drouot, Paris, Decourcelle sale, 16 June 1926, no. 63, bought for 225,000 francs by Durand-Ruel; sold by Durand-Ruel, New York, to Arthur Sachs, 31 December 1928 for $20,000; Arthur Sachs, Paris; sold by Arthur Sachs to Paul Mellon, through Bernheim-Jeune, 1960; Paul Mellon, Upperville, Va; donated to the National Gallery of Art, 1985.

EXHIBITIONS *Renoir* 1883, possibly no. 44; *Renoir* 1892, no. 62; Rosenberg Paris 1917, no. 66.

REFERENCES McQuillan 1986, 18.

NOTES
1 Daulte 1971, nos. 73, 74, 78, 85, 86, 87, 104, 131, 132 (although his dating of several of these

works is open to revision). Rivière (1921, 16) called Monet "le plus favorisé des Intransigeants . . . l'âme du petit cénacle."

2 *Monet et ses amis* 1977, 3–5, 98–99.

3 On Dollfus see André Michel's introduction to *Catalogue de tableaux modernes . . . dépendant des collections de M. Jean Dollfus*, Galerie Georges Petit, Paris, 2 March 1912, 8–11, and Distel 1989b, 151–155.

4 Distel (1989b, 152) reproduces Renoir's receipt of 23 June 1876 acknowledging Dollfus's payment of 300 francs for *Head of a Woman* (1875, Fondation Rau pour le Tiers Monde, Zurich) and the portrait of Monet (1875, cat. no. 21); the latter had been exhibited in the second Impressionist exhibition and it is unlikely that Dollfus would have paid more for the smaller *Reader*.

5 *Catalogue de tableaux modernes . . . dépendant des collections de M. Jean Dollfus*, 2 March 1912, no. 57, "Le Liseur, portrait de Sisley" (1876); Duret 1922, 76.

6 Stuckey (1995, 197–199) is the first to date the portraits to "probably 1873," though I cannot agree with his suggestion that Renoir was being "ironic by portraying Monet in a dark manner altogether at odds with his colourful style."

7 For information on *The Reader* I am grateful to Anne Hoeningswald, Conservator of Paintings at the National Gallery of Art, who is presently conducting a thorough survey of the French paintings for the Gallery's systematic catalogue.

8 Wildenstein 1974–91, I, 57–58, remains the most succinct account.

9 Shone (1992, 22, 226) notes that Monet was "Sisley's chief companion in painting expeditions at this time." On Sisley's production at Argenteuil in early 1872 see *Sisley* 1992, 104–107, 263. "Monet et Sisley ne venaient, pour ainsi dire, jamais à la Nouvelle Athènes" (Rivière 1921, 32).

10 "A cette époque, Renoir ne s'absentait guère de Paris" (Rivière 1921, 14).

11 Boime (1969, 421–422) points out that the petition, drafted by Authier, initially met with some sympathy from Jules Simon, but that Simon was overruled in this instance by Charles Blanc. See also Tucker in Moffett 1986, 103–104.

12 On the dinner for Durand-Ruel, who had yet to purchase paintings by Renoir in any quantity, see *Sisley* 1992, 263, Sisley to Pissarro, 29 November 1872. Becker in *Manet* 1983, 524, cites a joint letter of 4 December 1872 from Pissarro, Sisley, Monet, and Manet asking Zola "de leur faire le plaisir d'accepter à dîner le mercredi 11 courant."

13 On Renoir's *Pont Neuf* (National Gallery of Art, Washington) see House and Distel 1985, 200–201. Monet's *Pont Neuf* (Dallas Museum of Art), which is dated to 1872 by Wildenstein (1974–91, I, 202, no. 193) and 1873 by Rewald (1973, 281), has now been assigned to the winter of 1871 by Tucker (1995, 50–51).

14 Wildenstein 1974–91, I, 66; Tucker in Moffett 1986, 104; Stuckey 1995, 197.

15 "Un groupe de peintres réunis chez moi a lu avec plaisir l'article publié par vous dans *L'Avenir National*. Nous sommes tous heureux de vous voir défendre des idées qui sont les nôtres, et nous espérons, ainsi que vous le dites, que *L'Avenir National* voudra bien nous prêter son appui quand la Société que nous sommes en train de former sera entièrement fondée"

(Wildenstein 1974–91, I, 428, Monet to Alexis, 7 May 1873).

16 Wildenstein (ibid., I, 66) lists the "groupe de Naturalistes" published by Alexis, which also included Béliard, Gautier, Guillaumin, Authier, Numa Coste, and Visconti.

17 For Renoir's *Duck Pond* (Dallas Museum of Art) and Monet's *Duck Pond* (private collection, Paris) see Rewald 1973, 286. For Monet's *Railroad Bridge* (Niarchos collection, London) see Tucker 1982, 65. For Renoir's identical *Bridge at Argenteuil* see Galerie Charpentier 1962. All these paintings were done in 1873. Wildenstein (1974–91, I, 66) notes that "l'été de 1873 est l'époque de leur travail en commun." See also House and Distel 1985, 297.

18 "Renoir n'est pas là, vous pouvez coucher" (Wildenstein 1974–91, I, 429, Monet to Pissarro, 12 September 1873). See also Stuckey 1995, 197.

19 On Renoir's reaction to Pissarro's proposed charter of association, "hérissés de défenses et de pénalités," see Rewald 1986a, 200–201, 385. "Renoir est allé chez Guillemet, nous ne savons pas encore s'il signera" (Wildenstein 1974–91, I, 429, Monet to Pissarro, 11 December 1873).

20 Wildenstein (1974–91, I, 66) notes that with Béliard and Ottin, Renoir was elected to the "comité de surveillance." Rewald (1986a, 391, 394–395) published the accounts of the Société Anonyme for May 1874, in which Renoir is listed with Latouche and Béliard as a member of the "commission de contrôle," as well as the minutes of the "assemblée générale . . . tenu chez M. Renoir, 35 rue Saint-Georges," where the Société was dissolved on 17 December 1874 at 4:45 PM.

21 Druick and Hoog 1983, 208–213.

22 "Renoir l'a représenté lisant, fumant sa pipe, et aussi la palette et les brosses aux mains. Il est fort et barbu, les cheveux longs et bouclés, et coiffé d'un invariable petit chapeau" (Geffroy 1922, I, 109).

23 See Georgel's excellent discussion of the artist's pipe as "un emblème réaliste" in Georgel and Lecoq 1983, 199–201. Baudelaire's *La Pipe* offers a striking poetic analogy to Renoir's portraits of Monet: "J'enlace et je berce son âme / Dans le réseau mobile et bleu / Qui monte de ma bouche en feu" (Baudelaire 1961, 64–65, from *Les Fleurs du mal*).

24 For example, the chairs in *Dinner* (1868–69, Bührle Collection, Zurich) and the empty chair, prominently positioned in the lower-right corner in *Luncheon* (1868–69, Städelsches Kunstinstitut, Frankfurt).

25 Monneret 1978–81, I, 200.

26 Lermina 1884, 951, entry for Magnier, "grand journal à la fois mondain et républicain avancé, une sorte de *Figaro* démocratique"; Vapereau 1893, 1211.

27 "J'ai su également par le journal *L'Événement* que le conseil d'administration faisait sa besogne: l'annonce de la formation de la société en est la preuve" (Wildenstein 1974–91, I, 429, Monet to Pissarro, 27 January 1874).

28 "Excusez-moi, mais je ne couche qu'avec des duchesses . . . ou bien des bonnes . . . L'idéal serait une bonne de duchesse" (Renoir 1981, 122).

29 Since returning to France in November 1871, Monet had shared a fourth-floor studio with Amand Gautier at 8 rue de l'Isly "à la porte de la gare Saint-Lazare," where he seems to have worked between the hours of 10 and 4 when he was in Paris. See for example his letter of 11 December 1873 to Pissarro: "Si le hasard vous amène à Paris après-demain samedi, je serai à l'atelier toute la journée" (Wildenstein 1974–91, I, 429).

30 Heilbrun and Néagu 1986, 8. "Ce Liseur, qui est l'énergique, attentif et fin Claude Monet" (Geffroy 1894, 121).

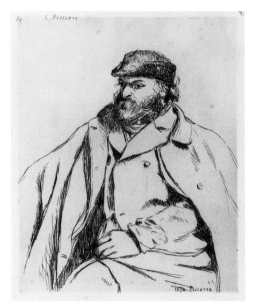

Fig. 139 Camille Pissarro, *Paul Cézanne*, 1874, etching. National Gallery of Canada, Ottawa

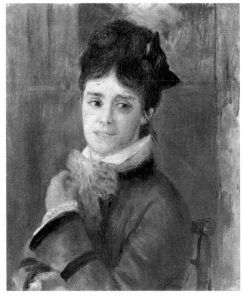

Fig. 137 Pierre-Auguste Renoir, *Claude Monet Reading*, c. 1873. Musée Marmottan, Paris, Bequest of Michel Monet

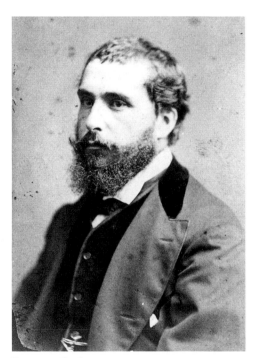

Fig. 140 Claude Monet, 1871, photograph by A. Greiner, Amsterdam. Private collection

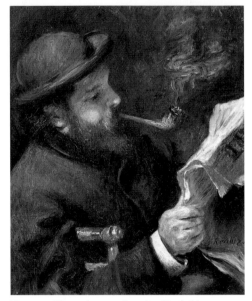

Fig. 138 Pierre-Auguste Renoir, *Camille Monet*, c. 1873. Musée Marmottan, Paris, Bequest of Michel Monet

16　*Camille Monet Reading*　c. 1873
61.2 × 50.3 cm
Signed lower left: A. Renoir
Sterling and Francine Clark Art Institute,
Williamstown, Mass., 612
Daulte no. 73

PROVENANCE　According to Daulte,
purchased by Durand-Ruel from Renoir,
25 July 1891, for 1,500 francs; sold by
Durand-Ruel to Robert Sterling Clark,
2 February 1933.

EXHIBITIONS　Salon d'Automne 1904,
no. 20; London 1905, no. 250; *Renoir* 1912,
no. 13.

REFERENCES　*Barnes* 1993, 96, 300 n. 5;
Distel 1993, 39; Adriani 1996, no. 17.

NOTES

1　*Renoir* 1912, no. 13, "Portrait de Mme Monet,
1872." However, that catalogue is not always
reliable: Renoir's portrait of William Sisley,
painted in 1864, is there dated to 1867. Only
recently has the dating of Renoir's portraits of
Camille been questioned. Moffett (*Barnes* 1993,
300, n. 5) dates *Camille Monet Reading* to c. 1872.
Distel (1993, 39) dates both portraits to c. 1872.
Rewald (1973, 344) was the first to assign the
later date of 1874 to the Gulbenkian picture,
which is surely correct.

2　Vollard 1919, 58.

3　On the proliferation of ornithological motifs in
Japanese fabrics and ceramics at this time see
Gruber 1994, 197. Adriani (1996, 104) identifies
the bird on the cushion as a heron. Reff (1976,
83–84), discussing the inclusion of cranes in the
background of Manet's *Nina de Callias* (fig. 61)
and *Nana* (1877, Hamburger Kunsthalle, Ham-
burg), noted the scurrilous meaning of the
term: in French slang "une grue" was a woman
of easy virtue – a resonance that surely cannot
be applied to Renoir's *Camille Monet Reading*.

4　Pickvance 1980, 157–165, is the best introduc-
tion to *japonisme* in Renoir's paintings of the
1870s. On the history of *uchiwa* fans see Weber
1922, I, 172–173, and Gruber 1994, 239, 283.

5　On Monet's *Madame Monet on the Sofa* see
House 1978, 642.

6　In his chapter on the Charpentiers, Vollard
(1919, 97) has Renoir claim: "C'est peut-être
d'avoir vu tant de japoniaiseries que m'est venue
cette horreur pour l'art japonais." Rivière
(1921, 58) is even more emphatic: "Renoir
échappa à cette emprise de l'art japonais. Jamais
à aucun moment il n'en fut influencé." Such
commentary postdates Renoir's "*japonisant*"
period by forty years, and runs counter to the
evidence of certain canvases from the early
1870s. Also of interest here is Renoir's unpub-
lished letter to Philippe Burty (possibly written
in April 1874, when he was left to hang the first
Impressionist exhibition on his own) in which
he notes that he is looking forward to visiting
the critic "et de bavarder un peu de japonisme"
(Archives du Louvre, Paris, MS 310 [3], Fonds
Henraux, no. 742).

7　Astruc's phrase, from his article "Le Japon chez
nous," in *L'Étendard*, 26 May 1868, quoted in
Stuckey 1995, 193. Weber (1922, I, 172) noted

that at the completion of a house, "on attache
au faîte trois éventails disposés en roue."

8　See Druick and Hoog 1983, 241–242, in which
the salmon-coloured cover of the books reveals
that the sitter is reading an issue of the *Revue des
Deux Mondes*; Camille's reading matter is not
indicated with any such precision.

9　Pickvance 1980, 157–159.

10　On the Aesthetic movement's adoption of *japo-
nisme* see Gere 1989, 306–310, and *Japonisme*
1988, no. 83.

11　Whether this is also the dress that she wears in
Monet's *Madame Monet Embroidering* (1875,
Barnes Foundation, Merion, Pa.) remains open
to doubt, *pace* Moffett in *Barnes* 1993, 96.

12　Cachin in *Manet* 1983, 347–348.

13　The most complete biography is in Wildenstein
1974–91, I, 31–37, 45–46, 64, 97–99. See also
the judicious account in Tucker 1995, 23–26,
34–36, which insists perhaps too forcefully on
the loveless aspect of the Monets' marriage.

14　Wildenstein 1974–91, I, 31, n. 215. Although
Wildenstein does not recognize Camille as one
of the models in Monet's monumental *Déjeuner
sur l'herbe* (Pushkin State Museum of Fine Arts,
Moscow), begun in the summer of 1865, her
presence in this canvas – and hence the begin-
ning of her liaison with Monet – is claimed by
all other scholars; see, for example, Isaacson
1972, 24, and Tucker 1995, 23–24.

15　Wildenstein 1974–91, I, 46, 63. In 1873 Monet
earned 24,800 francs.

16　Ibid., I, 37, 46, 52, 57, 92–93; Archives de Paris,
5MI3/670, "Acte de mariage," 28 June 1870,
Oscar Claude Monet and Camille Léonie
Doncieux, which records Adolphe Monet's
formal agreement to the marriage, "reçu par
maître Daussy et son collègue, notaires au
Havre, le huit avril dernier."

17　See Monet's heartrending letter to de Bellio,
dated to the winter of 1876–77, in which
Camille's illness ("il s'agit d'ulcérations de la
matrice") is diagnosed for the first time: "Je suis
très effrayé, car on ne me cache pas la gravité du
mal, et nous serions bien heureux, ma femme et
moi, si vous vouliez nous conseiller, car on
parle d'une opération à faire qui épouvante
beaucoup ma femme" (Wildenstein 1974–91, I,
431).

18　Mairie de Vétheuil, "Acte de décès," 5 Septem-
ber 1879, witnessed by Denis Paillet, mason,
and Louis Havard, clockmaker.

Fig. 141　Georges Croegaert, *La Liseuse*, 1888.
Roy Miles Gallery, London / Bridgeman Art
Library, London

Fig. 142　Camille Doncieux (Madame Claude Monet),
1871, photograph by A. Greiner, Amsterdam. Private
collection

Fig. 143 Pierre-Auguste Renoir, *Madame Hériot*, 1882. Hamburger Kunsthalle

17 *Camille Monet and Her Son Jean in the Garden at Argenteuil* 1874

50 × 68 cm
National Gallery of Art, Washington, Ailsa Mellon Bruce Collection, 1970.17.60
Daulte no. 104; House/Distel no. 30

PROVENANCE Claude Monet, Giverny; Michel Monet, Giverny; exhibited in New York, 1952, as part of the collection of fashion designer Captain Edward Molyneux (1891–1974), Paris; purchased from Molyneux by Ailsa Mellon Bruce (d. 1969), New York, 1955; bequeathed by Ailsa Mellon Bruce to the National Gallery of Art, 1970.

EXHIBITIONS *Renoir* 1913, no. 6.

REFERENCES National Gallery of Art 1978, 44; Adriani 1996, no. 24.

NOTES

1 Most recently, it has even inspired an occasional piece in the *New Yorker* – Ian Frazier's "In the Plain Air," 1 October 1990, 34–35.

2 On 23 July 1874, Zola wrote to Guillemet: "Je ne vois personne . . . Manet, qui fait une étude à Argenteuil, chez Monet, est introuvable. Et comme je ne mets pas souvent les pieds au café Guerbois, mes renseignements s'arrêtent là" (Zola *Correspondance*, I, 362). On Manet's *Monet Family in the Garden* see Moffett's exemplary entry in *Manet* 1983, 360–363.

3 "J'arrivais précisément chez Claude Monet au moment où Manet se disposait à traiter ce même sujet. Je ne voulus pas laisser échapper une si belle occasion d'avoir des modèles tout prêts; et c'est ainsi que je peignis ma toile" (Vollard 1919, 67). Monet told a similar story to Marc Elder, noting moreover: "[Renoir] me

demande ma palette, une brosse, une toile, et le voilà peignant aux côtés de Manet" (Elder 1924, 70).

4 "Et Manet: 'il est gentil ce garçon-là. Mais puisque c'est votre ami, dites-lui donc de ne plus faire de la peinture. C'est affreux ce qu'il fait.'" (Denis 1957–59, III, 45, entry for 9 November 1924). For other versions of this anecdote see notes 16 and 17 below.

5 On 18 June 1874, just over a month before Renoir and Manet were to paint these garden scenes, Monet signed a six-and-a-half-year lease for a recently completed neighbouring villa, owned by the carpenter Alexandre-Adonis Flament; occupancy was to begin on 1 October 1874. See Walter 1966, 337.

6 Wildenstein 1974–91, I, 236, no. 285; Stuckey 1995, 199.

7 Moffett in *Manet* 1983, 363.

8 Rewald 1973, 341–342.

9 "Pour en revenir à la rue Saint-Georges, parmi les tableaux que j'exécutai dans cet atelier je me rappelle . . . enfin la *Famille Monet en plein air*, dans le jardin de Monet, à Argenteuil" (Vollard 1919, 67). Although it is difficult to imagine what portion of the work might have been completed away from the motif, the implications of Renoir's comments have not, to my knowledge, been previously registered.

10 Moffett in *Manet* 1983, 363.

11 Wildenstein 1974–91, I, 260, no. 342. The whereabouts of Monet's painting have been unknown since the 1930s.

12 On Monet's more "sober" family paintings of this period see Tucker 1982, 137–140, and Bailey in Bailey and Rishel 1989, 48–51.

13 Adriani (1996, 124) was the first to recognize the "Japanese" fan in Renoir's painting.

14 See Wildenstein 1974–91, I, 280, no. 387.

15 Tabarant 1947, 252–257. Rewald (1973, 342) pointed out that Manet had encouraged Fantin-Latour to place Renoir closer to him in *Studio in the Batignolles* (fig. 62), where he is indeed "enframed" by the empty gilded frame hanging on the wall.

16 Vollard 1937, 179. Vollard first met Monet on 9 May 1897 at the opening of his Cézanne exhibition. His visit to Giverny is not dated, but must have taken place before Renoir's death, since he first published this anecdote in his life of Renoir; see Vollard 1919, 67.

17 Denis 1957–59, III, 45, entry for 9 November 1924; Howard-Johnston 1969, 29–30 (visit of early November 1924); Elder 1924, 70.

18 Moffett in *Manet* 1983, 363. It should be noted that Monet's *Women in the Garden* had only recently entered Manet's collection: he had traded Renoir's portrait of Bazille (cat. no. 5) for it with Gaston Bazille in 1876.

19 Howard-Johnston 1969, 32, 76.

20 On Jean Monet see Tucker 1995, 201, 235–236.

Fig. 144 Édouard Manet, *The Monet Family in the Garden at Argenteuil*, 1874. The Metropolitan Museum of Art, New York, Bequest of Joan Whitney Payson, 1975

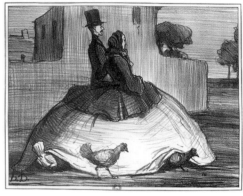

Fig. 145 Honoré Daumier, *Une erreur excusable*, 1857, lithograph. Bibliothèque Nationale, Paris

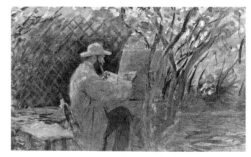

Fig. 146 Claude Monet, *Manet Painting in Monet's Garden at Argenteuil*, 1874. Stolen from a New York collection in 1935

18 *Charles Le Coeur* 1874
42 × 29 cm
Signed lower left: A. Renoir
Inscribed upper right: Ò GALAND JARD.
Musée d'Orsay, Paris, Gift of Eduardo
Mollard, RF 1961-22
Daulte no. 99

PROVENANCE Charles Le Coeur, Paris;
purchased by the art dealer Hector Gustave
Brame (1866–1936), Paris, 14 May 1924
(also called "L'Homme en blanc"), as part
of the Le Coeur collection; Dr. Eduardo
Mollard (1863–1947), Biarritz, by 1933;
given to the Musée du Louvre by Madame
Enriqueta Alsop-Mollard (1890–1971) as
"donation Eduardo Mollard," 1961.

EXHIBITIONS Not exhibited in Renoir's
lifetime.

REFERENCES Gimpel 1963, 277–278;
Distel 1989b, 10, 16; Rosenblum 1989, 291;
Le Coeur 1996, no. 11.

NOTES
1 Cooper 1959, 328. "Ce village est agréablement
 situé sur le penchant d'un coteau, dans un terri-
 toire où se font remarquer de nombreux
 champs d'arbustes, et surtout de rosiers, qui
 donnent à Fontenay un aspect des plus riants"
 (Larousse 1866–90, VIII, 578). The village was
 home to 2,386 residents in 1870.
2 *The Garden at Fontenay* (1874, Oskar Reinhart
 Collection, Winterthur; see Distel 1989b,
 10–16) and *The Rose Garden* (1874, private col-
 lection, Switzerland; see Kosinski and Pissarro
 1995, 114, where the work is dated to 1873, the
 similarities with the Reinhart picture having
 been overlooked).
3 Cooper 1959, 322–328, remains the standard
 account. See also Le Coeur 1996.
4 Archives de Paris, V2E/2917, "Acte de nais-
 sance," 5 May 1830, Charles Justin Le Coeur,
 where his father is described as "menuisier" and
 the family is listed as living at 11 rue de l'Ouest;
 Le Coeur's certificate of admission to the
 "deuxième classe d'architecture" as Labrouste's
 pupil on 9 December 1852 is in the Institut
 Français d'Architecture, Paris, Fonds Le Coeur.
5 Archives de l'Enregistrement, Paris, 9 March
 1928, "Succession," Le Coeur, which notes that
 the marriage contract was passed before Maîtres
 Turquet and Guyot on 14 February 1856. On
 Charpentier see Le Coeur 1996.
6 Archives Nationales, Paris, Archives de la
 Légion d'Honneur, 1533/37, "Résumé des
 services de Monsieur Le Coeur (Charles-
 Justin), Architecte du Gouvernement." See also
 the obituary in *L'Architecture*, 19 May 1906,
 which notes that "la construction d'établisse-
 ments scolaires des plus importants absorba la
 majeure partie de sa carrière." A useful listing of
 Le Coeur's commissions is to be found in
 Cooper 1959, 326. See also Chemetov and
 Marrey 1984, 71–72, 191.
7 The commission is first mentioned in
 L'Architecture, 19 May 1906. Dumas (1924, 361,
 366) reproduces two of Renoir's projects for
 the ceilings, which, as noted in Cooper 1959,

326, were destroyed around 1911. Le Coeur also
designed the town house of Bibesco's brother,
Prince Brancovan, on the avenue Hoche.
8 Cooper 1959, 326; Daulte 1971, no. 26; Le Coeur
 1996, 25, 33.
9 Cooper 1959, 327; Daulte 1971, no. 43; Le Coeur
 1996, 25.
10 Cooper 1959, 326–327; Daulte 1971, nos. 63,
 64, 67, 52, 41, 67, 90. The Le Coeurs' youngest
 children, François Charles (1872–1934), who
 would become a prominent architect, and
 Marie Josèphe Madeleine (1877–1969), were
 not painted by Renoir, by now an outcast in the
 family.
11 As Henri Loyrette has recently pointed out
 (Tinterow and Loyrette 1994, 455), notwith-
 standing the admitted similarity between
 Renoir's dark-eyed model and the eight-year-
 old Joseph, it strains credulity to imagine the
 respectable "Monsieur Charles," whom Renoir
 always addressed with a certain formality,
 allowing his son to pose as the naked ephebe in
 Boy with a Cat (1868–69, Musée d'Orsay, Paris).
12 Brown 1994, 90–94; Georgel 1994, 251–253;
 Archives de Paris, V2E/2917, "Acte de nais-
 sance," 5 May 1830, Charles Justin Le Coeur,
 "en présence de M. Charles Clément Le Coeur,
 architecte . . . oncle paternel."
13 Brown 1994, 92, quoting from Le Coeur's *De la
 fondation d'une Société des Amis des arts à Pau*
 (1863), which continues: "Quelle plus attrayante
 distraction peut leur être offerte qu'une exposi-
 tion publique de tableaux et d'objets d'art,
 appelés de tous les points de la France?" On the
 three paintings that Renoir exhibited at Pau
 between January and March 1866 see House
 and Distel 1985, 295.
14 Cooper 1959, 327.
15 Ibid., 328.
16 Cooper 1959, 163–171, 322–328. Cooper's pair
 of articles on the episode remain unsurpassed
 for their clarity and judicious interpretation of
 sources.

Fig. 147 Pierre-Auguste Renoir,
Madame Joseph Le Coeur, 1866. Musée
d'Orsay, Paris

Fig. 148 Charles Le Coeur, c. 1875. Private
collection, Paris

19 *Madame Henriot "en travesti"*
(*The Page*) 1875–77
161.3 × 104.8 cm
Signed lower right: Renoir
Columbus Museum of Art, Ohio,
Museum Purchase: Howald Fund, 44.3
Daulte no. 123

PROVENANCE According to Vollard
(1919, 101) the painting once belonged to
Durand-Ruel's former employee Paul-
Victor Poupin, listed in the *Bottin* (1876) as
a dealer in "tableaux modernes" at 8 rue
Lafayette, who apparently displayed it for
sale at 80 francs; possibly the *Page* recorded
in the inventory of the Rumanian collector
and homeopathic physician Dr. Georges
de Bellio (1828–1894), Paris, in 1894;
Alexandre Berthier, Prince de Wagram
(1883–1918), Paris; Knoedler and Co.,
New York, 1929; acquired from Knoedler
in January 1930 by Stephen C. Clark
(1882–1960), New York; purchased from
Albert R. Lee and Co., New York, by the
Columbus Gallery of Fine Arts (now the
Columbus Museum of Art), 1944.

EXHIBITIONS Not exhibited in Renoir's
lifetime.

REFERENCES Meier-Graefe 1912, 54, as
"portrait d'une Dame en Page"; Vollard
1919, 101, as "Le Page"; Nicolescu 1964,
268; *Renoir* 1988, no. 8; Distel 1989b, 120;
Adriani 1996, no. 29.

20 *Madame Henriot* c. 1876
66 × 50 cm
Signed lower left: Renoir.
National Gallery of Art, Washington, Gift
of the Adele R. Levy Fund, Inc., 1961.3.1
Daulte no. 190

PROVENANCE Madame Henriot, Paris;
Dr. Vaucaire, Paris; Madame Berne-
Bellecour, Paris; Prince de Wagram, Paris;
Princesse de la Tour d'Auvergne, Paris;
Étienne Bignou, Paris; the art dealer Paul
Rosenberg (1881–1959), Paris, by 1935; Dr.
and Mrs. David M. Levy, New York by
1941; Mrs. Adele R. Levy.

EXHIBITIONS Not exhibited in Renoir's
lifetime.

REFERENCES *Renoir* 1941, no. 19.

NOTES

1 Daulte 1971, nos. 102, 109, 123, 124, 127, 168, 183, 184, 186, 189, 190.
2 House and Distel 1985, 20, 204. For Renoir's receipt to Rouart for 1,200 francs, "prix d'un tableau intitulé Parisienne que je lui ai vendu," see Christie's, London, *Illuminated Manuscripts, Continental and English Literature*, 16 December 1991, no. 321.
3 Daulte 1971, 124.
4 According to Meier-Graefe (1912, 54) the painting was sold by a shopkeeper in the rue de Rennes for 80 francs. Vollard (1919, 101) reports Renoir's claim that he had seen the painting with Poupin, a former employee of Durand-Ruel, who had marked the price of 80 francs on the surface in chalk.
5 Lyonnet 1911–12, II, 193. For a moving eye-witness account see Antoine 1928, 156–161. Jean Renoir (1981, 168–169) has his father rushing in to help save Mademoiselle Henriot's dog, which both falsifies and trivializes the event; Jane Henriot was the only victim of the fire, having arrived early to prepare for her role in a matinée performance of Racine's *Bejazet*.
6 Lyonnet (1911–12, II, 193) identified her incorrectly as Henriette Amelot, who performed at the Odéon between 1863 and 1868; this has formed the basis for all subsequent accounts of her theatrical career.
7 Archives de Paris, V2E/7365, "Acte de naissance," 14 November 1857, Marie Henriette Alphonsine Grossin; ibid., "Extrait du registre des actes de baptême," 16 November 1857, giving the godfather as Alphonse Ludovie, the godmother as Marie Louise Mayer.
8 Archives de Paris, D1P4/710, "Cadastre de 1876," 15 rue Maubeuge.
9 "J'avais quinze ans quand je fus admise au Conservatoire. J'entrai dans la classe de Régnier" (Bibliothèque Nationale, Paris, Collection Rondelet, Rt 8135, L. Puech, "Nos actrices" [c. 1896]). Henriot's memory is accurate here, since Régnier had retired from the Comédie-Française in 1872 and began teaching at the Conservatoire that year (Hartnoll 1967, 792).
10 *Annales du Théâtre et de la Musique* (1875), 409, "Fils du Diable" (14 September 1875), 414, "Le Fils de Chopart" (5 December 1875). Henriot also appeared as Madeleine in *La Vénus de Gordes*

(4 November 1875). All three plays were spectacular flops, precipitating the retirement of the director Rocques (ibid., 414–416).
11 Archives de Paris, 5Mi3/R200, "Acte de naissance," 1 May 1878, Jeanne Angèle Grossin.
12 "Suit la déclaration d'Antoine Rey, artiste dramatique . . . ayant assisté à l'accouchement" (ibid.). For a brief biography of Rey see Lyonnet 1911–12, II, 596 ("bourru, grincheux par apparence, car l'homme était bon"). In 1878 Henriot is listed as living at 21 rue de la Tour d'Auvergne, which was the address of Rey's theatre. Rey died in May 1881, and Jeanne Angèle was recognized by her mother on 21 December 1881.
13 Camille Le Senne, *Le Théâtre à Paris* 1883–84, 304; 1887–88, 532.
14 "J'ai longtemps, m'a-t-elle dit, roulé de l'Odéon au Gymnase, pataugeant dans le classique, affligée d'un tas de doublures et de pannes" (Bibliothèque Nationale, Paris, Collection Rondelet, Rt 8135, "Les Étoiles d'hier-soir" [n.d., before 1900]).
15 "Le Théâtre-Libre m'a seul faite ce que je suis" (ibid). For the director's recollections of rehearsing with Mademoiselle Henriot see Antoine 1921, 157. On Antoine see Waxman 1926, 70–75, 109–111, and Henderson 1971, 60–61.
16 "Avec la pièce de L'École des veufs, on distribuait aux abonnés qui le prenaient, un programme où était représentée une femme nue, dont le sexe était légèrement creusé dans le gaufrage polisson" (Goncourt 1956, III, 1079, entry for 27 November 1889).
17 "Les Étoiles d'hier-soir," as in note 14 above.
18 Mairie de Saint-Germain-en-Laye, "Acte de décès," 17 May 1944, Marie Henriette Alphonsine Grossin, dite Henriot.
19 Murphy in *Renoir* 1988, 235.
20 Since *Les Huguenots* was performed throughout 1875 and 1876, it is worth noting that after appearing at the Ambigu-Comique in the *Fils du Diable* and *Le Fils de Chopart*, Henriot was Louise in *Miss Multon*, 8 February 1876, and Milida in *Dans mes meubles*, 18 March 1876 (*Annales du Théâtre et de la Musique* [1876], 644–645).
21 *Annales du Théâtre et de la Musique* (1875), 25; 1876, 62; and 1878, 8 (where it is noted that since it was first staged in February 1836, *Les Huguenots* had been performed 647 times). On the costumes designed for the revival of 1875 see Wild 1987, 145.
22 "J'ai vu chez Poupin . . . une de mes toiles, *le Page*, une figure de femme debout, grandeur nature" (Vollard 1919, 101). Meier-Graefe (1912, 54) called the painting "le Portrait d'une Dame en Page." Vollard (1918b, I, 93, no. 371), catalogued the work as "Le Page," but dated it incorrectly to 1880.
23 "Eh bien, je pensais entrer par la petite porte à la Comédie-Française, à demander à Claretie de me prendre comme figurante. C'était peut-être pas si bête, hein?" ("Les Étoiles d'hier-soir," as in note 14 above).
24 "Je vous réponds qu'elle n'imitera pas sa mère. Elle débutera dans un rôle important ou elle restera tranquille" ("Nos actrices," as in note 9 above).
25 "Ce n'est pas l'argent qui peut la tenter: ce qui la désarme, c'est surtout la promesse de la Comédie-Française de faire exécuter un portrait de sa fille qui resterait placé dans le foyer

des artistes" (Antoine 1928, 173–174, where it is noted that Claretie had even offered her a pension for life of 3,000 francs). On the various portraits of Jane Henriot commissioned by the Comédie-Française see Dacier 1905, 172.
26 Daulte 1971, 190. While it is true that Madame Henriot owned none of the other paintings for which she modelled, the discovery of her correct name makes it possible to identify her as the owner of a *Vase of Flowers* by Renoir, which she sold to Durand-Ruel for 400 francs in December 1881 (Archives Durand-Ruel, Paris, "Journal," 17 December 1881, no. 2100.)
27 "Renoir needed thousands of brushstrokes to create a beautiful face. You'll need only a few" (National Gallery of Art, Washington, curatorial files, advertisement for Elizabeth Arden's "Color Veil").
28 "C'est joliment difficile, disait-il, mais rien n'est plus excitant à peindre, ni d'un plus joli effet" (Vollard 1937, 13).

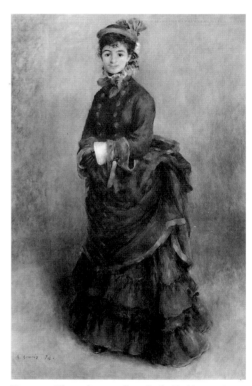

Fig. 149 Pierre-Auguste Renoir, *La Parisienne*, 1874. National Museum and Gallery, Cardiff

Fig. 150 Henriette Henriot, photograph by Georges Numa. Bibliothèque de l'Arsenal, Paris, Collection Rondelet

Fig. 152 Pierre-Auguste Renoir, *Henriette Henriot*, 1916. Location unknown

Fig. 151 Henriette Henriot, photograph by Étienne Carjat. Bibliothèque de l'Arsenal, Paris, Collection Rondelet

21 *Claude Monet Painting* 1875

85 × 60.5 cm

Signed and dated lower right: Renoir. 75.
Musée d'Orsay, Paris, Bequest of Monsieur and Madame Raymond Koechlin, 1931, RF 3666
Daulte no. 132

PROVENANCE On 14 June 1876, Jean Dollfus paid 300 francs for this portrait and *Head of a Woman* (Daulte no. 167); Galeries Georges Petit, Paris, Dollfus sale, 2 March 1912, no. 56, sold to his nephew, the journalist, collector, and art historian Raymond Koechlin (1860–1931) for 20,200 francs; bequeathed by Monsieur and Madame Koechlin to the Musée du Louvre, 1931.

EXHIBITIONS Impressionist Exhibition 1876, no. 220; *Renoir* 1912, no. 12.

REFERENCES Moffett 1986, no. 36; Distel 1989a, 152–153; Rosenblum 1989, 298–299.

NOTES

1 "M. Renoir expose plusieurs portraits très différents d'exécution . . . celui de M. Claude Monet, plus vigoureux, plus osé" (Pothey 1876). "M. Renoir a fait de M. Monet un portrait ressemblant et d'un bon effet, bien que d'une exécution singulière" (*Petit Moniteur Universel* 1876). "M. Renoir a déployé moins d'humour en peignant le portrait de M. Monet, son confrère: ce n'est pas moins-là une de ses meilleures, une de ses plus solides productions" (Chaumelin 1876). "Son portrait de Claude Monet est un morceau ferme et poussé à point"

(Blémont 1876). "Dans son *Peintre*, certaines parties sont d'un maître" (Rivière, reprinted in Dax 1876). "Le portrait de M. Monet qu'il expose est très étudié et très solide" (Zola 1991, 315, "Lettre de Paris" [29 April 1876]).

2 Impressionist Exhibition 1876, no. 217, "Tête de Femme, Appartenant à M. Dollfus," and no. 220, "Portrait de M. M . . ., Appartenant à M. Dollfus," reprinted in Moffett 1986, 164. Dollfus had retired from the family business in 1860 and been forced to leave Mulhouse for Paris after the Franco-Prussian War; although Corot was the modern artist whose work he collected with the greatest discernment, Dollfus was noted as having "le goût très éclectique et très libre" (Michel 1912, 7). On the other paintings by Renoir in his collection, including the copy of Delacroix's *Jewish Wedding in Morocco* (Worcester Art Museum), commissioned in 1876, see Distel 1989b, 151–159.

3 Dollfus's authorization of payment dated 14 June 1876 and Renoir's receipt of 23 June are published in Distel 1989b, 152. The second Impressionist exhibition had opened on 30 March and closed towards the end of April. At the auction of 24 March 1875, twenty paintings by Renoir had fetched 2,391 francs, an average of 120 francs each (Bodelsen 1968, 334–336).

4 Distel 1989b, 152; Fénéon 1921, 165.

5 Walter 1966, 337–339.

6 First noted in Wildenstein 1974–91, I, 270, no. 366. See also Moffett in Barnes 1993, 96–97.

7 *Monet* 1980, 151–153. Both of Monet's pictures would have been painted in the winter of 1874–75, for they appeared at the Impressionists' auction of 24 March 1875 (Wildenstein 1974–91, I, 270).

8 Daulte 1971, nos. 129, 130. The study in which Monet is shown with a hat appeared most recently at Christie's, London, 27 June 1989, no. 316.

9 Renouard's *Un impressionniste* was published as an illustration to "Le Monde des arts" in *La Vie Moderne*, 9 May 1885.

10 *Monet* 1980, 153–154.

11 "Il est en train de peindre une des fameuses robes d'acteur. C'est superbe à faire" (Wildenstein 1974–91, I, 430, Monet to Burty, from Argenteuil, 10 October 1875).

12 On the hanging in this exhibition see Clayson in Moffett 1986, 146–147.

13 For a table illustrating sixteen different types of beard see Larousse 1898–1904, I, 726.

14 For Grenier's photograph of 1871 see Stuckey 1995, 196. For a photograph of Monet taken in 1875 see Elder 1924, no. 41. Rewald (1973, 363) dates Schaarwachter's photograph of Monet to 1877.

15 "Quarante ans, les cheveux noirs et bouclés sur le front, la barbe bien fournie, l'oeil vif" (*Artiste* 1880). "Un robuste gaillard, assez bien planté, convenablement taillé de barbe, un nez qui ressemble à tous les nez dont on ne dit rien, et des yeux clairs comme de l'eau de roche" (Taboureux 1880).

16 Stuckey 1995, 200; Wildenstein 1974–91, I, 429–430 (especially no. 83, Monet to Manet, undated, summer of 1875: "Ma boîte à couleurs sera longtemps fermée à présent si je ne puis me tirer d'affaire").

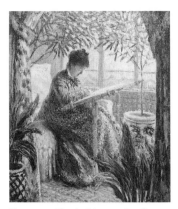

Fig. 153 Claude Monet, *Camille Monet Embroidering*, 1875. The Barnes Foundation, Merion, Pa.

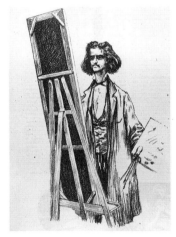

Fig. 154 Paul Renouard, *Un impressionniste*. From *La Vie Moderne*, 9 May 1885

Fig. 155 Claude Monet, *La Japonaise* (*Camille Monet in Japanese Costume*), 1876. Museum of Fine Arts, Boston, 1951 Purchase Fund

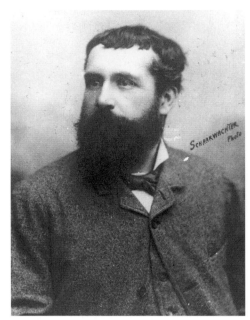

Fig. 156 Claude Monet, c. 1875, photograph by Schaarwachter. Roger-Viollet, Paris

22 *Portrait of an Anonymous Sitter*
1875
65 × 54 cm
Signed lower right: Renoir.
Private collection
Daulte no. 160

PROVENANCE Daulte records the first owner until 1948 as a Gaston Lévi; however, according to Philippe Brame, in 1948–49, his father, Paul Brame (1898–1971), having discovered the portrait in the apartment of the sitter herself, acquired it in partnership with César de Haucke; sold by them to the Matthiesen Gallery, London, 1954; by 1958 with Mr. and Mrs. Samuel Bronfman, Montreal; private collection.

EXHIBITIONS Not exhibited in Renoir's lifetime.

REFERENCES National Gallery of Canada 1962, no. 34.

NOTES
1 Portraits for which the name of the sitter has never been advanced are rare in Renoir's oeuvre; *Young Girl in a Feathered Hat* (1876, Niarchos collection, London) is the only other comparable example of such lost, as opposed to mistaken, identity.
2 Daulte 1971, nos. 158, 159.
3 Idid., no. 259.
4 "Portrait de madame X . . . cette toile, conservée pendant longtemps dans la famille du modèle, n'a jamais figuré dans aucune exposition" (*Renoir* 1952, no. 5). While it was customary for portraits exhibited during Renoir's lifetime to appear without the name of the sitter (or with only the first initial of the name), this sort of fastidiousness is unusual in such a recent publication.
5 Letter from Philippe Brame to the author, 20 October 1995.
6 The inventory numbers "BR.1320," and "B.25" appear on the stretcher, confirming that Brame consigned the painting to his partner César de Hauke, but the company's records go no further in elucidating the identity of the sitter.
7 "J'eus la bonne fortune de rencontrer une brave dame de Versailles qui me commanda pour trois cents francs le portrait d'elle-même et de sa fille. J'ajouterai qu'elle ne me fit aucune observation, ni sur ma peinture, ni sur mon dessin" (Vollard 1919, 52).
8 Moffett 1986, 44.
9 Daulte 1971, no. 160. See Hôtel Drouot, Paris, *Catalogue de tableaux, pastels, aquarelles . . . formant la collection de Monsieur G.L.*, 17 November 1932; from the transcript of this sale it appears that Lévy was living at 43 boulevard de Clichy at this date. For the Bonnards in his collection see Dauberville 1965–74, I, nos. 225, 336; II, nos. 557, 652, 738, 820, 938, III, nos. 1283, 1421, 1498,; IV, nos. 01859, 02146.
10 Archives de Paris, 5MI3/1078, "Acte de naissance," 28 February 1884, Gaston Lévy; his father, Godchaux Lévy, aged thirty-five, and his mother Joséphine Samuel, aged thirty-two, are both listed as "marchands de mercerie" living in the rue du Foin. Gaston Lévy died on 1 January 1952 (Mairie du 16ᵉ arrondissement, Paris, "Acte de décès").

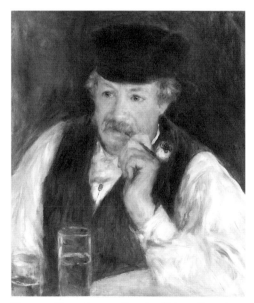

Fig. 157 Pierre-Auguste Renoir, *Alphonse Fournaise*, 1875. Sterling and Francine Clark Art Institute, Williamstown, Mass.

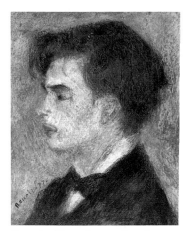

Fig. 158 Pierre-Auguste Renoir,
Georges Rivière, 1877. National Gallery
of Art, Washington, Ailsa Mellon Bruce
Collection

23 *Mademoiselle Legrand* 1875
81.3 × 59.1 cm
Signed and dated lower right: Renoir. 75
Philadelphia Museum of Art, The Henry P.
McIlhenny Collection in memory of
Frances P. McIlhenny, 1986-26-28
Daulte no. 141

PROVENANCE Bernheim-Jeune, Paris by
1911; purchased by Henry P. McIlhenny
(1910–1986) from Paul Rosenberg (1881–
1959), Paris, by May 1935, for $35,000;
bequeathed to the Philadelphia Museum of
Art by Henry P. McIlhenny, 1986.

EXHIBITIONS *Renoir* 1912, no. 9; *Renoir*
1913, no. 10.

REFERENCES Dauberville 1967, 572;
Rishel 1987, 46–47.

NOTES
1 The phrase is from Mallarmé's "The
 Impressionists and Édouard Manet" (1876),
 reprinted in Moffett 1986, 30.
2 Daulte 1971, 415. For a summary of Legrand's
 activities see Distel 1989b, 34–35. On Legrand,
 "très dévoué au groupe des peintres impression-
 nistes," see also Rivière 1921, 35–36, 154.
3 Impressionist Exhibition 1876, no. 223, in
 Moffett 1986, 164; Daulte 1971, no. 141.
4 The photograph of the salon of the Bernheim's
 hôtel particulier on the avenue Henri-Martin is
 reproduced in Dauberville 1967, 572.
5 Groom 1993, 193; Meier-Graefe 1911, 53.
6 Rishel 1987, 45. McIlhenny would have first
 seen *Mademoiselle Legrand* at the Orangerie's ret-
 rospective of June 1933, where it was exhibited
 as "La fillette attentive" and lent by Messieurs
 Bernheim-Jeune (*Renoir* 1933, pl. 13). That
 autumn he was shown a photograph of the
 work by Paul Rosenberg, who was trying to
 interest Paul Sachs in acquiring it for the Fogg
 Art Museum for $60,000. McIlhenny returned
 to Paris the following autumn, and by May

1935 *Mademoiselle Legrand* was hanging in his
house in Germantown (Rishel 1987, 35, 43–44).
A letter to his insurance agent of 6 May 1935 in
the Archives of the Philadelphia Museum of Art
indicates that McIlhenny had acquired the por-
trait from Paul Rosenberg for $35,000.
7 Archives Besnus, Paris, joint letter from the
 couple on holiday in Cosqueville to Madame
 Legrand *mère*, 16 August 1894, in which Besnus
 refers to his wife as Delphine and Marie-
 Adelphine signs herself "Ninette."
8 Archives de Paris, 5Mi3/534, "Acte de nais-
 sance," 6 May 1867, Marie Adelphine Legrand.
9 Archives Besnus, Paris, "Acte de mariage," 19
 December 1837, Legrand and Garceau, where
 Denis François Paschal Legrand is listed as "cor-
 donnier" and his wife as "lingère."
10 Archives de Paris, V4E/162, no. 1520, "Acte de
 mariage," 26 July 1866, Legrand and Coquil-
 lard, where Coquillard is listed as "fille majeure
 de Elisabeth Louise Coquillard, décédée à Paris
 le 27 janvier 1858"; Michallon was one of the
 witnesses at the wedding.
11 Zola 1983, 43.
12 Archives de Paris, D1P4/1129, "Cadastre de
 1862," rue Thévenot.
13 Mairie du 9ᵉ arrondissement, Paris, "Acte de
 mariage," 9 September 1899, Besnus and Le-
 grand. The Legrands lived at 118 rue Lafontaine
 in the 16th arrondissement.
14 Address given in "Acte de mariage" in note 10
 above. On Bazille's apartment at 22 rue Godot-
 de-Mauroy ("c'est ce que j'ai vu de meilleur
 marché") see Bazille *Correspondance*, 117.
15 "Acte de mariage," as in note 10 above. On Car-
 peaux's reputation at the time see Wagner 1986,
 199–200, 224–229; in August 1866 he would be
 made *chevalier* of the Légion d'Honneur.
16 Mairie du 16ᵉ arrondissement, Paris, "Acte de
 mariage," 9 February 1893, Besnus and Legrand.
 "Échos," in *Mercure de France* (October 1897,
 317), noted that Besnus died on 1 September
 "d'une maladie qui, depuis quelque temps déjà,
 ne laissait plus, ni aux siens ni à ses amis, aucun
 espoir de le sauver." For a summary of his brief
 career as a poet and "homme de lettres" see
 Pottecher in Besnus 1899, 7–19.
17 "Acte de mariage," as in note 16 above. On the
 obscure landscapist Eugène Louis d'Argence see
 Saur 1922, IV, 44.
18 "Ce grand garçon aux épaules étroites, aux yeux
 d'un bleu trop clair, aux cheveux d'un blond
 trop ardent" (Pottecher in Besnus 1899, 9).
19 Archives Besnus, Paris, "Acte de décès," 18
 June 1894, Marcel Henri Besnus; "Acte de nais-
 sance," 25 January 1895, Geneviève Denise
 Besnus. Both documents list the family as living
 at 118 rue Lafontaine, 16th arrondissement.
20 "Acte de mariage," as in note 13 above.
21 Mairie du Havre, "Acte de décès," 10 June
 1946, Legrand, veuve Besnus. Marie Adel-
 phine, died at 4 rue Eugène Delacroix, where
 she was living with her eldest son, André, a
 bank clerk ("caissier comptable").
22 Impressionist Exhibition 1876, no. 223, "Portrait
 de jeune Fille, Appartient à M. Legrand,"
 in Moffett 1986, 164; *Renoir* 1883, no. 7,
 "Portrait de Mlle U. [sic], Appartenant à M. A.
 Legrand."
23 "Un très caractéristique portrait de jeune fille"
 (Blémont 1876). "Un très joli portrait de jeune
 fille, très franc de ton, d'un modelé suffisant et

d'une aimable fraîcheur" (Enault 1876).
24 "Une figure sympathique et étrange, la face
 longue, blonde et vaguement souriante, pareille
 à quelque infante espagnole" (Zola 1991, 315,
 "Lettre de Paris" [29 April 1876]).
25 Gachet 1956, 163, 181.
26 Barnes Foundation Archives, Merion, Pa.,
 receipt from Durand-Ruel and sons to Dr. A.C.
 Barnes, 13 April 1912. Renoir's *Girl in the Blue
 Dress* was purchased for $11,500.
27 On *Jeanne Durand-Ruel* see Distel in *Barnes*
 1993, 48–49.
28 "Gosse de part en part, à croquer de baisers"
 (Meier-Graefe 1912, 50).
29 On Whistler's *Cicely Alexander* see Dorment's
 excellent entry in Dorment and Macdonald
 1994, 146–147.
30 "Aucun détail ne fait jamais songer au corre-
 spondant réel, mais c'est pourtant une réalité
 impérieuse que nous avons-là devant nous . . .
 Cette espèce de distinction ne nous élève pas,
 elle ne satisfait qu'un instinct de tailleur"
 (Meier-Graefe 1912, 50).
31 "Dans le royaume de l'art, l'enfant de Renoir
 est la petite princesse, tandis que l'anglaise est
 tout au plus une jeune lordship récemment
 anoblie" (ibid.).
32 For the most recent discussion of this phenom-
 enon see Savy 1989.
33 "Ainsi les petites filles sont généralement plus
 délicates, d'une constitution plus molle, d'un
 teint plus pâle ou plus blanc, d'une complexion
 plus humide . . . La petite fille est plus douce,
 plus tendre, plus affectueuse, plus vive, plus
 spirituelle, plus docile, et plus précoce" (from
 the entry on "Fille" in Larousse 1866–90,
 quoted in Savy 1989, 35).

Fig. 159 Mademoiselle Marie-Adelphine Legrand,
c. 1880. Private collection, Paris

287

Fig. 160 Maurice Baud, *Jules-Gustave-Édouard Besnus*, 1899, engraving

Fig. 162 Marie-Adelphine Besnus, née Legrand, c. 1920. Private collection

Fig. 161 Marie-Adelphine Besnus, née Legrand, with her daughter, Geneviève Denise Besnus, 1897–99. Private collection

Fig. 163 Pierre-Auguste Renoir, *Girl with a Jumping Rope* (*Delphine Legrand*), 1876. The Barnes Foundation, Merion, Pa.

24 *Self-portrait* c. 1875
39.1 × 31.7
Signed lower right: Renoir.
Sterling and Francine Clark Art Institute, Williamstown, Mass., 584
Daulte no. 157

PROVENANCE First owned by the customs administrator and collector of Impressionist painting Victor Chocquet (1821–1891), Paris, 1876, who sold it about this time to Dr. Georges de Bellio (1828–1894), Paris; by inheritance to de Bellio's son-in-law Eugène Donop de Monchy, Paris; Paul Rosenberg (1881–1959), Paris, by 1917; by 1929 with the French dramatist and collector Henry Bernstein (1876–1953), Paris; according to Daulte, on 14 February 1939, Bernstein sold the painting for 12,600 francs to Durand-Ruel, who sold it the same day to Robert Sterling Clark (1877–1956) for $15,000.

EXHIBITIONS Impressionist Exhibition 1876, no. 214; *Renoir* 1883, no. 53; Rosenberg Paris 1917, no. 60.

REFERENCES Vollard 1919, 78; Distel 1989b, 119; Kern 1996, 55–56, 58.

25 *Self-portrait at Thirty-five* 1876
73.2 × 57.1 cm
Signed upper right: Renoir [added later at the request of Ambroise Vollard]
Fogg Art Museum, Harvard University Art Museums, Cambridge, Mass. (1951.61), Bequest from the Collection of Maurice Wertheim, Class of 1906
Daulte no. 191

PROVENANCE Ambroise Vollard (1866–1939), Paris; Paul Guillaume (1891–1934), Paris, 1929; Brandon Davis, London; Josef Stransky (1872–1936), formerly conductor of the New York Philharmonic, by 1931; William H. Taylor, Philadelphia, by 1937; Knoedler, New York, to the investor Maurice Wertheim (1886–1950), December 1946; bequeathed by Wertheim to the Fogg Art Museum, 1951.

EXHIBITIONS Not exhibited in Renoir's lifetime.

REFERENCES O'Brian 1988, no. 7.

NOTES
1 "Vous souvenez-vous de ce petit portrait que j'avais fait d'après moi? Tout le monde vante aujourd'hui cette esquisse sans importance. Je l'avais jetée, à l'époque, dans la boîte aux ordures; M. Chocquet me demanda de la lui laisser prendre. J'étais seulement un peu confus que ce ne fût pas meilleur. Quelques jours après, il m'apporta mille francs. M. de Bellio,

qui l'avait vue chez lui, s'était emballé sur ce bout de toile, et le lui avait racheté pour cette somme énorme. Voilà comment étaient les amateurs de ce temps-là!" (Vollard 1919, 78).

2 Impressionist Exhibition 1876, no. 214, "Tête d'Homme, Appartient à M. Choquet [sic]," reprinted in Moffett 1986, 164. Despite the ingenious suggestion made by the authors of *The New Painting* that it was exhibited "hors catalogue," it is clear that the numbers assigned to the pictures on the walls of Durand-Ruel's gallery differed slightly from those of the catalogue; thus Renoir's portrait of Chocquet, number 211 in the catalogue, is referred to as no. 197 by the critics, and is paired with the "Tête d'Homme" (no. 214 in the catalogue, number 200 in the reviews), which they consistently identify as a self-portrait. Chocquet would receive another offer for this painting from the dealer Legrand, who asked him if he wanted to sell the "portrait d'homme peint par Renoir et exposé sous le no. 214 du catalogue" (Hôtel Drouot, Paris, *Lettres et manuscrits autographes*, 23 June 1969, no. 197, undated).

3 See the reviews by Enault, Chaumelin, Leroy, and Rivière cited at notes 12, 13, and 14 below.

4 On Chocquet's proselytizing see Duret quoted in Rewald 1973, 367–368. This lays to rest the implausible suggestion by White (1984, 91) followed by McQuillan (1986, 118) that Renoir painted the Williamstown *Self-portrait* in 1879 to thank de Bellio for treating his model and mistress Alma-Henriette Leboeuf, known as Margot, who died of smallpox in February 1879.

5 Nicolescu 1964, 213; Distel 1989b, 119–120. Of the thirty paintings by Monet in de Bellio's collection, twenty-nine entered the Musée Marmottan in 1957 as part of the bequest of his daughter and son-in-law Valentine and Eugène Dunop de Monchy.

6 Distel 1989b, 109–121.

7 Nicolescu 1964, 213.

8 Wildenstein 1974–91, I, 431–432. At his most desperate, Monet was prepared to let de Bellio have his paintings at 20 francs each. "Avec cinq cent francs, je sauve la situation. Il me reste environ, tant chez moi que chez M.S. . . . vingt-cinq toiles. Je vous les donne à ce prix. En faisant cela, vous me sauverez" (ibid., I, 432, Monet to de Bellio, undated, June 1877).

9 "Heureusement qu'il se trouvait d'autres amateurs, tel M. de Bellio, qui acceptaient d'avoir chez eux de la peinture 'bon marché' . . . Toutes les fois que l'un de nous avait un besoin urgent de deux cents francs, il courait au Café Riche, à l'heure du déjeuner; on était certain d'y trouver M. de Bellio, lequel achetait, sans même le regarder, le tableau qu'on lui portait" (Vollard 1919, 71).

10 For a photograph of the interior of de Bellio's apartment circa 1890 see Nicolescu 1964, 267. As Renoir and Lucien Pissarro both noted, by the 1880s de Bellio's collection of Impressionists was so large that he had to store most of it in a rented shop, "dans laquelle il avait fait mettre des rayons où ses tableaux étaient entassés" (Gachet 1957, 84, Pissarro to Paul Gachet, 26 January 1928).

11 Burty 1876, 364. Burty noted also that Renoir was "one of the most vigorous artists of the whole group."

12 "Jamais le burlesque et l'absurde ne sont allés plus loin que dans ces deux portraits d'homme catalogués sous les numéros 197 et 200" (Enault 1876). "Ses portraits numéros 197 et 200 ne sont que trop vivants: on les dirait exécutés par Goya en un jour de verve caricaturale" (Chaumelin 1876).

13 "Son monsieur aux cheveux verts et bleu de ciel m'a charmé; son particulier, tacheté comme un jaguar, m'a plongé dans une rêverie voisine de l'extase" (Leroy 1876).

14 "Un portrait de l'auteur tout en hachures" (Porcheron 1876). "Un portrait de vieillard et le sien qui sont très-remarquables" (Rivière, first published in *L'Esprit Moderne*, excerpted in Dax 1876, 348).

15 *Renoir* 1883, no. 53, "Portrait, Appartenant à M. de Bellio."

16 "Son portrait m'a fait pensé aux meilleurs Goya, tout en étant empreint de la même personnalité" (Silvestre 1883, 243).

17 See Sotain's nasty engraving in Blanc 1860–77, IV, "Goya," 1, and Lalauze's more accomplished print in Lefort 1875, 507; Lefort's remaining articles appeared in April and December 1876.

18 "Goya, par ses tendances, est essentiellement un moderne: son style dans le portrait, ses habitudes de composition, son mode d'interprétation de la lumière, toutes ses pratiques enfin sont d'hier et de demain" (Lefort 1875, 506).

19 Jean Renoir (1981, 36–37) recalled that his father continued to wear "sa cravate lavallière, bleu roi à petits pois blancs . . . soigneusement nouée autour du col de sa chemise."

20 "Mais avec son visage sérieux, sillonné de rides, sa barbe courte et rude, il paraissait un peu plus que son âge" (Rivière 1921, 3).

21 "L'air pensif, songeur, sombre, l'oeil perdu" (Renoir [Edmond] 1879b, reprinted in Venturi 1939, II, 337).

22 "Un homme maigre, aux regards extraordinairement pénétrants, très nerveux, donnant l'impression de ne point pouvoir tenir en place" (Vollard 1919, 10).

23 Vollard 1918b, I, 70, no. 279; no date is assigned, which is also unusual for a work from this period.

24 See the thoughtful discussion and technical analysis in O'Brian 1988, 54–56, 151.

25 The painting was reproduced in Vollard 1920, 32, but without a date or title. It was first recognized as a self-portrait only after entering the collection of Joseph Stransky, the retired conductor of the New York Philharmonic, where it was dated to 1872 (Flint 1931, 87–88).

26 Rivière (1921, 129) dates the move to the rue Cortot to the very month. On the developments in Renoir's style at this time see Distel in House and Distel 1985, 210–211.

27 "Comme il le resta toute sa vie, [Renoir était] réservé, timide, ayant l'horreur instinctive de tout ce qui pouvait le mettre en évidence" (Rivière 1921, 5).

28 "Mais si vous voulez voir son visage s'illuminer, si vous voulez l'entendre – ô miracle! – chantonner quelque gai refrain, ne le cherchez pas à table, ni dans les endroits où l'on s'amuse, mais tâchez de le surprendre en train de travailler" (Edmond Renoir, as in note 21 above).

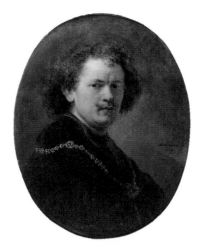

Fig. 164 Rembrandt, *Self-portrait Bareheaded*, 1633. Musée du Louvre, Paris

Fig. 165 After Francisco Goya y Lucientes, *Self-portrait*, from *Los Caprichos*, reproduced in *Gazette des Beaux-Arts*, December 1875

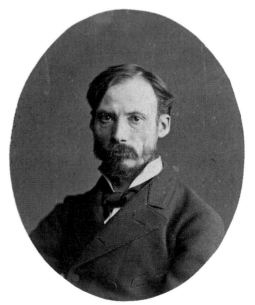

Fig. 166 Pierre-Auguste Renoir, c. 1875. Musée d'Orsay, Paris

26 *Alfred Sisley* 1876
66.4 × 54.2 cm
Signed lower right: Renoir.
The Art Institute of Chicago, Mr. and Mrs.
Lewis Larned Coburn Memorial
Collection, 1933.453
Daulte no. 117

PROVENANCE First owned by the pastry-cook and collector of Impressionist painting Eugène Murer (1841–1906), Paris, by April 1883; sold to Durand-Ruel in 1896, at the time of the dispersal of his collection; purchased from Durand-Ruel by the Russian collector Ivan Shchukin (1870–1908), Paris; Hôtel Drouot, Paris, [Shchukin sale], 24 March 1900, no. 17, where it was acquired by the Parisian dentist and collector Dr. Georges Viau (1855–1939) for 6,100 francs; Howard Young, New York; Mrs. Lewis (Annie) Coburn (d. 1932), Chicago, by 1929.

EXHIBITIONS Impressionist Exhibition 1877, no. 190; Murer Collection 1896; Dresden 1904, no. 2246; *Renoir* 1912, no. 34.

REFERENCES Gachet 1957, 92; Wildenstein 1974–91, IV, 421; Moffett 1986, no. 63; Shone 1992, 122–123, 208 n. 17.

NOTES

1 "Je ne connais qu'un portrait de Sisley par Renoir. C'est celui qu'il a fait chez moi à Argenteuil, représenté à cheval sur ma chaise" (Wildenstein 1974–91, IV, 421, Monet to Joseph Durand-Ruel, 4 May 1926).

2 Of identical form is the empty bamboo chair at right in Monet's *Luncheon* (1868–69, Städelsches Kunstinstitut, Frankfurt). Slightly different in design is the chair shown in Renoir's *Claude Monet Reading* (c. 1873, fig. 137); see Shone 1992, 208, n. 17. Renoir himself owned the same type of bamboo chair, which can be seen at far left in the photograph of Matisse with Renoir and his sons at Les Collettes in early 1918 (reproduced in *Matisse* 1992, 291).

3 McCauley 1985, 154, 195–203; Haskell 1976, 89–90, for the rediscovery of Hals in the 1860s inaugurated by Thoré's criticism and Manet's paintings. By the 1870s, however, Hals had been absorbed into the academic canon, Rivière ranking him with Velázquez as one of the painters slavishly followed by students of the École des Beaux-Arts, "les enfants volontaires du quai Malaquais" (Rivière 1877a, 3).

4 "Son procédé de coups de brosses déposés comme des hachures de pastel" (Sébillot 1877).

5 Two examples among many: "Le portrait de M. Spuller et celui de Mlle Samary . . . produisent aussi leur impression" (Grimm 1877). "Ah! quelles magnifiques chairs vertes M. Renoir nous montre . . . Avec cela deux portraits: *Mlle Jeanne Samary* et *M. Spuller*" (Leroy 1877).

6 "Cet intransigeant . . . a sans contredit l'oeil et la patte du portraitiste" (Lora 1877b). Of the thirty-nine reviews of the third exhibition that I have consulted, the three in which *Alfred Sisley* is mentioned specifically are: Anonymous 1877, where the portrait is merely cited with that of *Madame Charpentier* (cat. no. 31); Bergerat 1877 ("celui qui sait le plus est M. Renoir, qui sur vingt toiles expose deux tableaux intéressants: celui de Mlle Samary, de la Comédie-Française et celui de M. Sisley"); and Rivière 1877a.

7 "La série de portraits est close par celui d'un des commensaux du logis, M. Sysley [sic]; ce portrait est d'une ressemblance extraordinaire et d'une grande valeur comme oeuvre" (Rivière 1877a, 4).

8 Rivière 1921, reproduced opposite page 51; Meier-Graefe 1929, 136; Distel 1993, 168. Rewald (1973, 364) dated the portrait c. 1874. Shone (1992, 122) notes that it is "traditionally ascribed to 1874" and suggests that it was painted prior to Sisley's visit to Hampton Court in the company of the baritone Jean-Baptiste Faure in June 1874.

9 "Je vois d'après l'article de Wolf, qui est bien l'idée bourgeoise générale, qu'il ne faut montrer ma peinture qu'après une mise en bouteille d'au moins un an" (Venturi 1939, I, 123–124, Renoir to Durand-Ruel, March 1882).

10 Daulte 1971, nos. 151, 178, 188. On the Koechlin *Young Woman with a Veil* see, most recently, Adriani 1996, 154–155.

11 *Renoir* 1912, 5, no. 34. Renoir had considered asking Murer to lend *Alfred Sisley* to Durand-Ruel's exhibition of 1–25 April 1883, but changed his mind for reasons that are unclear: "J'ai l'intention de vous demander le portrait de Sisley pour mon exposition du 1er avril et peut-être le vôtre" (Gachet 1957, 92, undated letter).

12 "Une âme et un pinceau de poète," Murer's epithet, in his biographical sketch of Sisley (Gachet 1956, 193).

13 "Ce grand garçon de bonne mine, très sympathique, d'allure élégante, était un timide et il lui répugnait d'offrir sa peinture comme une marchandise" (Rivière 1926, 926).

14 "C'est à travers les pires misères, une certaine correction de tenue et des faux-cols irréprochablement blancs" (Leclercq 1899, 228).

15 "Pour le caractériser mieux, il faudrait dire un 'impressionniste romantique'" (Burty 1877).

16 Cahn in *Sisley* 1992, 261; Shone 1992, 39–43. Renoir's *Pierre Sisley* most recently appeared at Sotheby's, London, 27 June 1990, no. 109.

17 Shone 1992, 110.

18 Ibid., 188, 195–201.

19 Duret (1922, 85) noted that Sisley died "d'un cancer des fumeurs." There is a pathetic letter from Sisley to Dr. Viau, dated 31 December 1898, in which he asks him to recommend a doctor who "would not cost more than 100 to 200 francs" (quoted by Cahn in *Sisley* 1992, 280).

20 "Quand il rencontrait M. Renoir avec lequel il avait vécu, il traversait la rue pour ne pas lui parler" (Manet 1979, 227). Arsène Alexandre situated the onset of Sisley's morbidity to 1870, a decade too early, but his insight still stands: "L'oeuvre continue à être pleine de fraîcheur et d'éclat, tandis que le caractère bifurque: il devient ombrageux et farouche" (preface to the sale of Sisley's studio held at Galeries Georges Petit, 1 May 1899, reprinted in Shone 1992, 220).

21 "Plus gai qu'un pinson. Beau mangeur avec un mauvais estomac, il nous charmait tous au dessert par ses saillies spirituelles et son rire en fusée" (quoted in Gachet 1956, 193). On Murer and Sisley see Shone 1992, 110–112.

22 "Le cadeau de Sisley était la douceur" (Renoir 1981, 131).

Fig. 167 Pierre-Auguste Renoir, *Jacques-Eugène Spuller*, c. 1877. Private collection, New York

Fig. 168 Alfred Sisley, c. 1892–94, photograph by Clement Maurice, Paris. Roger-Viollet, Paris

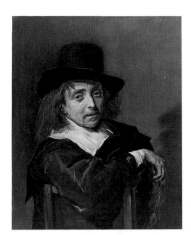

Fig. 169 Frans Hals, *Portrait of a Seated Man*, c. 1645. National Gallery of Canada, Ottawa

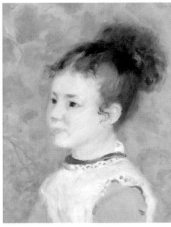

Fig. 170 Pierre-Auguste Renoir, *Jeanne Sisley*, 1875. The Art Institute of Chicago, Gift of Mrs. Henry Woods

27 *Paul Meunier* 1877

46 × 38 cm
Signed upper right: Renoir.
Stiftung "Langmatt" Sidney und Jenny Brown, Baden, Switzerland, 181/GZ
Daulte no. 247

PROVENANCE Commissioned from Renoir by Eugène Murer for 100 francs; sold in 1896 with Murer's collection to the dentist Georges Viau; Galeries Durand-Ruel, Paris, Viau sale, 4 March 1907, no. 63, as "Jeune Garçon," sold for 8,100 francs to Bernheim-Jeune, Paris; briefly with Viau's brother-in-law Hocquart, Maison-Lafitte; apparently this portrait was the second French Impressionist painting to enter the collection of the Swiss electrical engineer Sidney Brown (1865–1941), Baden, purchased from Hocquart, 25 February 1909, for 18,000 francs, through their mutual acquaintance the Winterthur painter Carl Montag (1880–1956).

EXHIBITIONS Murer Collection 1896; Salon d'Automne 1904, no. 9, as "Portrait de jeune garçon"; Stuttgart 1913, no. 323; Winterthur 1916, no. 131.

REFERENCES Bailey and Rishel 1989, 35; Deuchler 1990, 178–179 (no. 49), 238, 240.

NOTES

1 Daulte 1971, nos. 246, 247, 248, 249; Distel 1989b, 208. Gachet (1956, 172, 175) is the only author to date the painting to 1879 ("elle clôt la série des portraits de famille commandés par Murer à ses amis impressionnistes"). As Murer informed Pissarro on 23 June 1878, "ayant payé celui de Renoir cent francs," he was not about to pay more for his portrait (Pissarro and Venturi 1939, 147). Pissarro's reply shows that Renoir had been beaten down from 150 francs: "Je tiens donc à vous faire savoir qu'avant de vous faire un prix j'avais consulté l'ami Renoir et nous nous étions arrêtés d'un commun accord à ce prix [150 francs] . . . Si Renoir a baissé son prix c'est que vous lui avez fait une réduction" (Pissarro *Correspondance*, I, 115, Pissarro to Murer, undated, early July 1878).

2 Bailey and Rishel 1989, 33–35.

3 "Sur les traits, il fixe le caractère et la manière d'être intime du modèle" (Duret 1878, 28).

4 Archives de Paris, 5Mi3/578, "Acte de naissance," 7 December 1869, Eugène Hyacinthe. The family was then living at 64 rue François Miron in the 4th arrondissement.

5 Ibid., 5Mi3/578, "Acte de naissance," 7 August 1867, Achille Eugène Hyacinthe, date of death not recorded; ibid., 5Mi3/582, "Acte de naissance," 16 June 1868, Eugénie Hyacinthe, died 2 July 1868 (her twin sister, "un enfant sans vie du sexe féminin," had not been named).

6 Ibid., 5Mi3/257, "Acte de décès," 11 October 1872, Marie Antoinette Constance Masson.

7 Gachet 1956, 156, confirmed by Archives de Paris, D1P4/1128, "Cadastre de 1862," boulevard du Prince Eugène (which became boulevard Voltaire), in which Murer "pâtissier" is registered from 1870 to 1881.

8 Archives de Paris, 5Mi3/254, "Acte de reconnaissance," 17 July 1872, Antoine Meunier and Marie-Thérèse Pineau, "négociants," parents of Eugène Hyacinthe; Gachet 1956, 153; Distel 1989b, 207.

9 Gachet 1956, 161–165; Bailey and Rishel 1989, 33.

10 "Quant au Collège, je pense que vous pourrez y mettre Jean. C'est bien tenu. Murer y envoie son fils, il pourra mieux que moi donner des renseignements" (Pissarro *Correspondance*, I, 165, Pissarro to Monet, 18 September 1882). On Paul's apprenticeship, see ibid., II, 177: "Les tendances ne seraient pas, je crois aussi dangereuses à Londres, chez Morris, qu'ici dans la maison 'Murer' qui fait pour le faubourg Antoine" (Pissarro to Lucien, 31 May 1887).

11 "Il paraît du reste que dans la maison où était le jeune Murer, on a prévenu ta mère que l'apprenti était pendant deux ans chargé des courses à faire . . . Comme c'est agréable" (ibid., II, 180, Pissarro to Lucien, 3 June 1887).

12 "Mon cher Murer, Cette fois, rien d'esthétique dans ma lettre, c'est plus grave, il s'agit d'humanité, serai-je assez éloquent pour vous attendrir? . . . Il s'agit de votre fils! . . . je le sais dans une position atroce, dans quelle misère! . . . Quelles que soient ses fautes, il est temps d'arrêter le mal, il est si jeune: dans tous les cas, vous pouvez l'empêcher de tomber plus bas . . . Qu'adviendrait-il de cet enfant, sans famille, sans idéal, n'ayant pour toute distraction qu'un travail de routine, rien de bon, croyez-moi! Pensez à ça, Murer, vous verrez que votre fils est excusable, il est le jouet de circonstances fatales" (ibid., II, 221–222, Pissarro to Murer, 29 March 1888).

13 "Faites donc bien mes amitiés . . . à votre grand gaillard de fils. J'irai le voir en cuisinier: après le casque, le bonnet" (Gachet 1957, 107–109, Renoir to Murer, from Pont-Aven, undated, August 1893). Gachet noted that Paul had done his military service with the second dragoons.

14 Mairie de Beaulieu-sur-mer, "Registre des actes de mariage," 2 October 1899, Meunier and Mazet. Laetitia was born in Nice on 18 March 1880 (she died in Beaulieu-sur-mer on 22 January 1910); in their marriage certificate Paul is listed simply as tradesman ("commerçant").

15 Ibid., "Registre des actes de naissances," 2 October 1900, Léopold Eugène Meunier.

16 Archives de l'Enregistrement, Paris, 22 October 1906, "Succession," Monsieur Meunier dit Murer, referring to Murer's "testament olographe" of 5 January 1901 in which "M. Eugène Paul Meunier son fils" is named "son légataire universel." Distel (House and Distel 1985, 28, n. 40) cites a letter from Meunier to Durand-Ruel in which he gives his profession as garage owner.

17 Distel in House and Distel 1985, 23; Bailey and Rishel 1989, 37.

18 Before honouring Murer's bequest of 4,000 francs and twelve pastels to the Commune d'Auvers, Paul's portion consisted of property in Auvers, Murer's own paintings and pastels (valued at 3,400 francs), 2,600 francs from the sale of his father's furniture, and 6,000 francs in cash ("Succession," as in note 16 above).

19 Distel in House and Distel 1985, 28, n. 40.

20 Mairie du 17ᵉ arrondissement, Paris, DS/230, "Acte de mariage," 30 January 1923, Meunier and Portier.

21 Gachet 1956, 156, noting of Murer's shop on the boulevard Voltaire that it had "brillants lambris que Murer va bientôt demander à Renoir d'encadrer de guirlandes de fleurs et de feuillage peint." The connection with Renoir's decoration was first made by Deuchler (1990, 178).

22 "J'avais une mère acariâtre et despote, que je voyais rarement du reste. Elle est venue mourir chez moi. C'est le seul bonheur qu'elle m'ait donné pendant quarante ans de maternité" (Reiley Burt 1975, 54, entry in Murer's unpublished journal from the end of his life).

23 Burty 1877.

291

28 *Jeanne Samary* 1877
46 × 40 cm
Signed and dated upper left: Renoir. 77.
Comédie-Française Collection, Paris
Daulte no. 228

PROVENANCE Possibly painted for the
landscape painter Joseph-Félix Bouchor
(1853–1937), who frequented Renoir's
studio in the rue Saint-Georges, and who
donated the painting to the Comédie-
Française before 1897.

EXHIBITIONS *Peintres actuels* 1909, no. 42.

REFERENCES Monval 1897, 155; Gauthier
1976, 31.

29 *Bust-length Portrait of Jeanne Samary*
(*La Rêverie*) 1877
56 × 46 cm
Signed and dated upper left: Renoir. 77.
Pushkin State Museum of Fine Arts,
Moscow, 3405
Daulte no. 229
Not exhibited

PROVENANCE Collection of Samary's
husband, the stockbrocker Paul Lagarde
(1851–1903); Hôtel Drouot, Paris, Lagarde
sale, 27 March 1903, no. 18, sold for 13,300
francs to Durand-Ruel, who sold it to the
Russian collector Ivan Morosov (1871–
1921), Moscow, 26 November 1904;
Museum of Modern Western Art, Moscow,
from 1918; Pushkin State Museum of Fine
Arts, Moscow, from 1948.

EXHIBITIONS Impressionist Exhibition
1877, no. 191; *Portraits du siècle* 1883, no.
312; Salon d'Automne 1904, no. 25.

REFERENCES Kuznetsova and
Georgievskaya 1979, no. 167; Milan 1996,
no. 10.

30 *Jeanne Samary* 1878
173 × 102 cm
Signed and dated lower left: Renoir. 78.
State Hermitage Museum, Saint Petersburg,
9003
Daulte no. 263

PROVENANCE Purchased from Renoir by
Durand-Ruel for 1,800 francs, 29 December
1886, and sold the same day for 2,000 francs
to the prince Edmond de Polignac (1834–
1901), Paris; bought back for 4,000 francs
by Durand-Ruel, 1 June 1897, and sold to
Monsieur de La Salle, Paris, 4 March 1898;
Bernheim-Jeune, Paris; sold by Bernheim-
Jeune to Mikhail Morosov (1870–1904),
Moscow, brother of Ivan Morosov; gift of
Morosov's widow, Margarita, to the

Tretyakoff Gallery, Moscow, 1910;
Museum of Modern Western Art,
Moscow, from 1918; Hermitage Museum,
Saint Petersburg, from 1948.

EXHIBITIONS Salon 1879, no. 2528; *Renoir*
1883, hors catalogue; New York 1886, no.
73 or no. 165; Brussels 1904, no. 133.

REFERENCES Kostenevich and Bessonova
1986, no. 14; Kostenevitch 1987, 297–298;
Hermitage Masterpieces 1994, II, 286.

NOTES

1 Archives de Paris, V2E/7171, "Acte de nais-
sance," 4 March 1857, Jeanne Samary, born at
17 rue de la Sourdière, in the 3rd arrondisse-
ment. Jeanne's birth certificate suggests that the
names Léontine Pauline were later additions, and
confirms that her family was not living at
Neuilly-sur-Seine, as is generally recorded in
biographical notices (e.g., Lyonnet 1911–12, II,
632).

2 In addition to the three paintings catalogued
here, see Daulte 1971, nos. 230, 231 (most
recently at Christie's, New York, 15 November
1989, no. 363), 262, 264, 277, and 360. For the
pastels see Cincinnati 1984, 203, and Sotheby's,
London, 25 June 1985, no. 7; a third pastel is in
a private collection, New York.

3 "La petite Samari [sic] qui fait la joie des femmes
et surtout des hommes" (Pierpont Morgan
Library, New York, Tabarant collection,
Renoir to Duret, 15 October 1878). "Renoir
qui n'exécuta jamais portrait avec plus de plaisir
que celui-là" (Rivière 1921, 77).

4 For Samary's iconography see Dacier 1905, 142,
192. A portrait in watercolour by Bastien-
Lepage was exhibited in the gallery of the
Théâtre d'Application in 1889 (Claretie 1889,
no. 157). Lagarde donated Carolus-Duran's
Jeanne Samary to the Comédie-Française on 25
November 1890 (Gueullette 1891, 161).

5 According to the "Sépulture familiale," Passy
Cemetery, Paris, Louis Jacques Samary was
born 9 August 1815; he died 10 April 1893
(Mairie du 9ᵉ arrondissement, Paris 492, "Acte
de décès," Louis Jacques Samary). Elisabeth
Brohan was born 18 May 1828 and died 30
August 1891 ("Sépulture familiale," Passy
Cemetery). The matriarch of the family,
Suzanne Augustine Brohan, who died at eighty
at Fontenay-aux-Roses, seems never to have
married (Mairie de Fontenay-aux-Roses, 39,
"Acte de décès," 16 August 1887, Brohan).

6 "Son père . . . est d'abord le fils d'un ménétrier
. . . c'est un méridional dans toute l'acception
de mot . . . il se lave trente-cinq fois les mains
par jour, et se cure les ongles aussitôt qu'il a une
seconde à lui" (Bibliothèque de l'Arsenal, Paris,
RT10576, "Les Contemporains" [c. 1880]).

7 For Bastien-Lepage's portrait of her see
Weisberg 1980, 253. Her obituary published in
Comoedia, 28 June 1941, notes that she had been
Lucien Guitry's partner at the Théâtre de la
Renaissance (Bibliothèque de l'Arsenal, Paris,
RT10578).

8 "Les Contemporains" (as in note 6 above)
described him as a "violoniste à l'Opéra-
Comique." By 1893 he was listed as "anti-
quaire," the profession given in his death

certificate (Mairie du 9ᵉ arrondissement, Paris,
1422, "Acte de décès," 20 October 1921).

9 Lyonnet 1911–12, II, 633.

10 Jahyer 1880.

11 "Qu'elle était jolie! toute petite et déjà un peu
forte, mais le visage si souriant, la bouche si
appétissante, un air de fraîcheur et de gaieté
répandu sur toute cette petite personne ron-
delette!" (Sarcey 1884, 18).

12 "Mlle Jeanne Samary, qui prend peu à peu pos-
session de tous les rôles de soubrette du réper-
toire" (*Annales du Théâtre et de la Musique* [1877],
79). "Jeanne Samary est reçue sociétaire de ce
théâtre . . . 4,500 francs de traitement annuel"
(Bibliothèque de la Comédie-Française, Paris,
Dossier Jeanne Samary, "Arrêté," 9 January
1879).

13 "Un fort galant homme doublé d'une physio-
nomie bien parisienne" (Samary 1931, 50).

14 Archives de Paris, 5Mi3/205, "Acte de
mariage," 9 November 1880, Lagarde and
Samary. The couple's marriage of 25 August
1880 had been contested by Lagarde's father,
chatelain of Saint-Clair, Compiègne, and "a
retired stockbroker." The well-informed New
York correspondent of *The Parisian* (11
November 1880) noted that Lagarde had
refused to comply with his father's plans for his
career: "He hoped to see his son Paul one day
an ornament of the Bourse, selling stocks all day
long, wearing a diamond breastpin, and 'salting
down' cash and scrip against a rainy day."
Claretie's account of the marriage, "cet
envahissement joyeux de l'église par toutes les
fillettes du Conservatoire," is reprinted in
Simond 1901, III, 216.

15 Andrée Lagarde was born 14 September 1882
and died 12 March 1883 ("Sépulture familiale,"
Passy Cemetery, Paris); Blanche Lagarde (21
March 1885–27 July 1913) a *pensionnaire* at the
Théâtre des Celestins, Lyons, married Charles
Louis Comte, known as Moncharmont, for-
merly the director of the theatre (Archives de
l'Enregistrement, Paris, 24 January 1914,
Blanche Lagarde). Madeleine (1 July 1886–10
June 1968) appeared at the Comédie-Française
and married Broussan, the director of the Paris
Opéra (Lyonnet 1911–12, II, 633; Samary 1931,
50).

16 Gueullette 1891, 78–81, 145–148; Bibliothèque
de l'Arsenal, Paris, RT10577, "Recueil d'articles
sur la mort de Jeanne Samary"; Archives de
Paris, 5Mi3/1065, "Acte de décès," 18 Septem-
ber 1890, Samary Lagarde.

17 Between 1877 and 1879 the *Bottin du Commerce*
lists Samary "père et fils" as "professeurs de
musique" at 10 rue Frochot. Jean Renoir (1981,
205) claimed that Samary's parents had pro-
posed her services as a model to his father
("Jeanne vous admire tant"), which is as
unlikely as his anecdote about her family serv-
ing him tea and encouraging a possible match
with their daughter.

18 Rivière 1921, 173. "Amie de Mme Charpen-
tier, elle était des plus assidues à ses soirées"
(Duret 1924, 57).

19 Lora 1877a. This inaugural exhibition num-
bered 246 works, including paintings by
Bastien-Lepage, Henner, and the vicomte
Lepic. Hirsch (1843–1884) was a pupil of
Meissonier and Bonnat; his portrait of Samary is
lost.

292

20 Salon *livret* for 1879, nos. 734, 3692. David d'Angers's marble bust is lost, but his portrait survives in a bronze cast kindly brought to our attention by Laure de Margerie.

21 Vollard 1920, 169, Renoir confiding that he rarely saw Samary on stage ("Je n'aime pas comme on joue au Théâtre Français"); confirmed in Rivière 1921, 76 ("Nous allions rarement au théâtre").

22 See Vollard 1919, 67, for "le portrait, grandeur nature, du poète Félix Bouchor" (presumably a mistake for Maurice) that Renoir painted in his atelier in the rue Saint-Georges, of which there is no further record. The date of Bouchor's bequest is not known, although Renoir's *Jeanne Samary* entered the collection of the Comédie-Française before the fire of March 1900 (Lyonnet 1911–12, II, 633).

23 Rivière 1921, 64–65, 76. Renoir's association with this bohemian circle, which also included Paul Arène, Charles Cros, and Jean-Louis Forain, has yet to be investigated. On Bouchor's poetry see *DBF*, VI, 1233–1234.

24 "M. Spuller n'offre pas, à mon sens, l'idéal, bien qu'il offre la ressemblance; mais son pendant, Mlle Samary, est tout simplement adorable" (Jacques 1877b).

25 "'Un rayon de soleil,' disait Renoir" (Rivière 1921, 77).

26 For an extremely well-illustrated survey of theatrical portraiture at this time, which focusses on Sarah Bernhardt, see Bernier 1984.

27 "Le teint semble fait d'une pâte de roses thé. Les lèvres sont d'un rouge sanglant" (Théodore de Banville, quoted in Castets 1890).

28 "Mlle Samary n'a point ce toison fantaisiste sur le tête. J'ai pu m'en apercevoir, tandis qu'elle se regardait elle-même sur cette toile incomplète et jolie" (Lora 1877b). "Le hasard m'ayant fait rencontrer la jolie comédienne devant son image" (Leroy 1877).

29 "Mais j'avoue ne pas comprendre le *Portrait de Mlle S*. La tête si connue du charmant modèle est comme perdue sur ce fond rosé d'une coloration brutale . . . Rien, ce me semble, n'est plus éloigné de la nature vraie" (Ballu 1877).

30 "Le succès de l'exposition est la tête de Mlle Samary . . . une tête toute blonde et rieuse" (Zola 1991, 358, "Une exposition: Les peintres impressionnistes" [1877]). "Rose, frais, pimpant, clair, gracieux et doux comme le modèle" (O'Squarr 1877).

31 "La blonde tête apparaît souriante sur un fond rose-tendre, d'une transparence très délicate . . . Et cela est étonnante de solidité" (O'Squarr, 1877).

32 "Une ébauche, vous dis-je, un portrait non pas" (Véron 1877). "L'aspect tendre en éveille le souvenir de certaines tapisseries de Beauvais. C'est un portrait de décoration plutôt qu'une sérieuse peinture. Encore est-ce bien inachevé, même pour un morceau décoratif" (Lora 1877b).

33 "La jolie pensionnaire . . . vêtue de gaze bleue pâle, montre sur un fond rose ses épaules marbrées de vert" (Lafenestre 1877).

34 "Où a-t-il vu les bras qu'il lui donnés? Bras rugueux et comme couverts d'écailles?" (Véron 1877).

35 "Le portrait . . . rend si bien une jolie physionomie de soubrette éveillée et évoque si justement l'atmosphère spéciale à la scène" (Burty 1877).

36 *Annales du Théâtre et de la Musique* (1877), 81. For Nadar's photograph of Samary and Got in *L'Amphitryon* see Néagu and Poulet-Allamagny 1979, 441.

37 Edmond Renoir (1879a) noted that the portrait was "bien haut et bien mal placé pour une oeuvre d'une touche aussi délicate." Chesneau (1879) considered the work "un curieux portrait." Banville (1879) complained that Louise Abbéma had given the actress a false expression, but refrained from mentioning Renoir's portrait. Burty (1879), while acknowledging the considerable distance between the two artists (in Renoir's favour), also passed over the portrait in silence.

38 "J'ai fini un portrait en pied de la petite Samari" (Pierpont Morgan Library, New York, Tabarant collection, Renoir to Duret, 15 October 1878).

39 "Exposition presque sans visiteurs" (Alexandre 1933, 8).

40 "Allez donc voir chez Durand-Ruel le portrait de la petite Samary. Je crois qu'ils n'y comprendront rien. Cependant, je le trouve joli, les valeurs de chair avec le rose font bien. À mon avis, c'est curieux à voir" (Braun 1932, 10, Renoir to Duret, undated). Florisoone (1938, 40) referred to this missive as a "court billet" that had already been published, noting furthermore that it was written on the back of Renoir's letter of thanks to Duret.

41 Archives Durand-Ruel, Paris, D3457, "Portrait de Madame Samary" deposited with Durand-Ruel, 27 December 1881; returned to the artist, 29 October 1884; D4640, "Portrait de madame Samary" deposited a second time, 20 January 1886, listed as part of the *envoi* sent to Sutton in America, whence it returned on 8 November 1886; 910, purchased by Durand-Ruel from Renoir for 1,800 francs, 29 December 1886, and sold the same day to the prince Edmond de Polignac (1834–1901) for 2,000 francs. This corrects the information regarding price given in Meier-Graefe 1929, 432, and repeated in Daulte 1971, no. 263. Although not listed as such in *Renoir 1883*, the portrait was discussed by at least two reviewers. Fourcaud (1883) commented: "Y a-t-il rien de plus floral, par exemple, que le portrait de Mlle Jeanne Samary, debout en robe rose, décolletée en rond, les bras nus, les mains gantées de blanc et croisées un peu au-dessous de la ceinture," so accurate a description of the Saint Petersburg portrait that it leaves no doubt that the work was included in Durand-Ruel's retrospective. On the American exhibition of April 1886 see Weitzenhoffer 1986, 40. The reviewer in *The Art Amateur*, May 1886, was driven to ask: "Why, for instance, did he give his clever portrait of Mlle Samary a background of theatrical properties, painted as a scene painter for an East-side concert hall would paint them?"

42 In describing the house he had rented in Montmartre, "une maison entourée d'un grand jardin," Renoir remarked: "C'est aussi dans ce jardin que je fis les différents portraits de Mlle Samary" (Vollard 1919, 72). "C'est dans l'atelier de la rue Saint-Georges que fut peint le portrait en pied de Jeanne Samary" (Rivière 1921, 76–77). "Pour le grand portrait qui est en Russie, il la fit venir dans l'atelier de la rue Saint-Georges" (Renoir 1981, 207).

43 "J'avais pris la précaution de ne pas vernir ma toile, qui était toute fraîche. Le porteur crut que c'était par économie, et comme il lui restait un fond de vernis, il voulut m'en faire profiter. En un après-midi, je dus repeindre tout mon tableau" (Vollard 1920, 168–169).

44 "Le visage, les épaules, la gorge, les bras, sont peints au couteau à palette, les yeux, les sourcils, la bouche, les narines s'y inscrivent avec la précision des dessins japonais" (Mauclair 1902, 182).

45 "Elle est très bien . . . mais comme elle a des salières!" (Rivière 1921, 77).

46 *The Parisian*, 11 November 1880. "On prenait plaisir alors à la comparer à une petite caille grasse" (Sarcey 1884, 22).

47 Bibliothèque de la Comédie-Française, Paris, Dossier Jeanne Samary, "Engagement," 25 July 1878, Samary agreeing to employment as "soubrettes, amoureuses, rôles de convenance."

48 See the review by "H.H." in *Le Constitutionnel*, 15 May 1879: "Quant à Mlle Samary (Toinon), elle est l'ingénuité rieuse, étourdie, folle." A *New York Times* columnist (1 June 1879) noted: "It is said that Mlle Samary plays her part – that of a hoydenish young girl – to perfection."

49 Jahyer 1880. "*L'Étincelle*, dont le succès a été immense là-bas; il a mis en lumière le talent frais et gai de Mlle Samary, qui était adorée du peuple anglais" (d'Heylli 1880, 89, 195, quoting the diary of the eminent theatre critic Francisque Sarcey).

50 "Quant à Samary . . . Quel amour de campagnarde . . . moitié fermière, moitié demoiselle" (*Le Figaro*, 13 May 1879).

51 "Son rire incomparable fut rapidement populaire et les vitrines des magasins élégants – voire même celles des dentistes – s'arrachaient à cette époque la photographie de Jeanne, riant de des trente-deux dents de perle, dans *L'Étincelle* de Pailleron" (Samary 1931, 50). As early as July 1875 she had been praised for "ses lèvres écarlates qui s'écartent avec franchise pour montrer deux superbes rangées de perles blanches" (Jahyer 1880, quoting from his review in *L'Entracte*). Within five years, the smile had become something of a cliché: "She is so constantly possessed with the desire to show her teeth that an enterprising Parisian reporter has dogged her footsteps for the past two years in the hope of surprising her with her lips closed . . . Hitherto that reporter has laboured in vain" (*The Parisian*, 11 November 1880).

52 "L'éternel et insupportable rire de cette actrice" (Huysmans 1883, 58). "C'était le rire de Molière, c'était l'étincelle de l'art contemporain" (Claretie, quoted in Castets 1890).

53 "Dix-sept ans, de grands yeux bleus, une bouche mutine avec les plus jolis dents du monde" (*Le Soir*, 26 August 1875).

54 See Castets 1890 for Banville's description of her chin: "Le menton qui vient en avant . . . hardi comme un page." Of Samary in *Le Petit Hôtel* it was noted: "Physiquement, elle n'a qu'une légère imperfection, celle d'être myope comme on ne l'est guère" (*Le Figaro*, 13 May 1879).

55 "Doucement ébouriffée et comme venue dans une bouffée d'air printanier" (Silvestre 1879). Equally, Renoir gives no hint of the actress's personal untidiness that had disgusted Edmond de Goncourt when he visited her box in June 1881 – "la loge de la petite Samary où il y a de

la femme bohème, avec son plafond fait d'éventails japonais . . . ses croquis de Forain, le désordre cochon de sa toilette" (Goncourt 1956, III, 116).

56 "Je me suis pris à songer à toute la grâce et à toute l'application que les artistes du XVIIIᵉ siècle mettaient dans les images qu'ils nous ont léguées de leurs *étoiles* préférées" (Baudelaire 1961, 1074–1075, commenting on the theatrical portraits at the Salon of 1859).

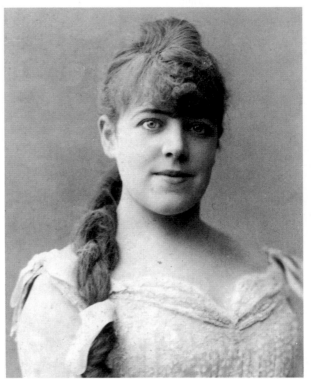

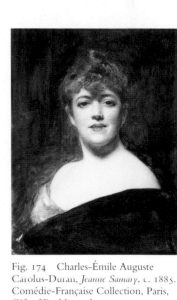

Fig. 174 Charles-Émile Auguste Carolus-Duran, *Jeanne Samary*, c. 1885. Comédie-Française Collection, Paris, Gift of Paul Lagarde

Fig. 172 Jeanne Samary, c. 1877. Bibliothèque de la Comédie-Française, Paris

Fig. 171 Jeanne Samary, c. 1880. Bibliothèque Nationale, Paris

Fig. 175 Jeanne Samary as Antoinette in *L'Étincelle*. From *L'Illustration*, 13 December 1879

Fig. 173 Jeanne Samary in mythological costume, 1877. Bibliothèque Nationale, Paris

294

Fig. 176 Jules Bastien-Lepage, *Marie Samary*, late 1870s. Private collection, Cleveland

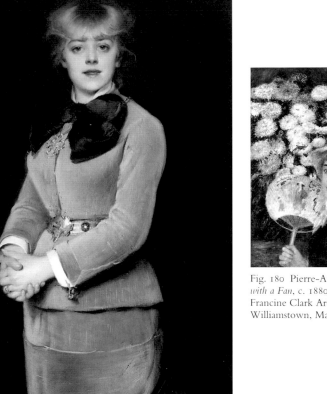

Fig. 178 Louise Abbéma, *Jeanne Samary*, Salon of 1879. Private collection

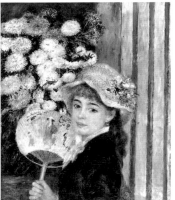

Fig. 180 Pierre-Auguste Renoir, *Girl with a Fan*, c. 1880. Sterling and Francine Clark Art Institute, Williamstown, Mass.

Fig. 177 Henri de Toulouse-Lautrec, *Henry Samary*, 1889. Musée d'Orsay, Paris

Fig. 179 Ferdinand Bach, *Jeanne Samary and Paul Lagarde*. From *Les Actrices de Paris* (Paris, 1882)

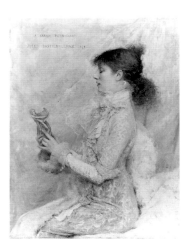

Fig. 181 Jules Bastien-Lepage, *Sarah Bernhardt*, 1879. Private collection

31 *First Portrait of Madame Georges Charpentier* 1876–77
46.5 × 38 cm
Signed upper right: Renoir.
Musée d'Orsay, Paris, Gift of the Société des Amis du Luxembourg, with the participation of Madame Tournon, née Georgette Charpentier, 1919, RF 2244
Daulte no. 226

PROVENANCE Commissioned by the publisher Georges Charpentier (1846–1905), Paris; by 1912 with Charpentier's daughter Madame Jane Dutar, Paris; gift to the Musée du Luxembourg, 1919.

EXHIBITIONS Impressionist Exhibition 1877, no. 187; *Exposition Centennale* 1900, no. 560; *Renoir* 1900, no. 16; *Salon d'Automne* 1912, no. 179.

REFERENCES Distel 1989b, 147–149; Rosenblum 1989, 294; Giraudon 1993, no. 3; Distel 1993, 62–63.

32 *Madame Georges Charpentier and Her Children* 1878
153.7 × 190.2 cm
Signed and dated lower right: Renoir. 78.
The Metropolitan Museum of Art, New York, Catharine Lorillard Wolfe Collection, Wolfe Fund, 1907, 07.122
Daulte no. 266; House/Distel no. 44

PROVENANCE Commissioned by the publisher Georges Charpentier (1846–1905), Paris; Hôtel Drouot, Paris, Charpentier sale, 11 April 1907, no. 21, bought for 84,000 francs by Durand-Ruel, acting on behalf of the Metropolitan Museum of Art.

EXHIBITIONS Salon 1879, no. 2527; Brussels 1886, no. 2; Georges Petit Paris 1886, no. 124; *Renoir* 1892, no. 110; *Renoir* 1900, no. 17; Brussels 1904, no. 129.

REFERENCES Sterling and Salinger 1967, 149–152; Distel 1989b, 144–145; Nochlin 1992, 43–44; Kete 1994, 115–116; Simon 1995, 142, 144–145, 147.

NOTES

1 Apart from the two portraits catalogued here, there are three other seated portraits of the children: *Georgette Charpentier Seated* (1876, fig. 6), *Paul Charpentier* (1878, a pastel exhibited at the Salon of 1879, see Christie's, London, 6 July 1971, no. 31), and *Georgette Charpentier Standing* (1880, see Sotheby's, London, 28 November 1989, no. 9). For two other half-lengths of Marguerite Charpentier (one in pastel), of less certain status, see Drucker 1944, 201, and note 34 below. On the staircase decorations, for which Edmond Renoir and the model Marguerite (Margot) Legrand posed, see Kostenevich 1995, 88–95. On the painted mirror frame in MacLean cement see Rivière 1921, 35. On Renoir's involvement with varnishing and framing see Florisoone 1938, 38: "Vous pouvez faire donner une première couche légère . . . Faites vernir vers 1 heure 1/2 pour que je puisse travailler dans le vernis demi-sec" (Renoir to Madame Charpentier, undated, possibly May 1879, in preparation for the vernissage of the Salon of 1879). "Il viendra demain matin un encadreur avec des moulures noires. Il a travaillé dans le temps pour Durand-Ruel" (ibid., Renoir to Georges Charpentier, undated, probably 1876, relating perhaps to the framing of *Georgette Charpentier*).

2 Pissarro *Correspondance*, I, 110, Pissarro to Caillebotte, undated, March 1878.

3 "Je n'oublierai jamais que si un jour enfin je passe la corde que c'est à elle que je le devrai car moi seul je n'en suis certainement pas capable" (Florisoone 1938, 32, Renoir to Georges Charpentier, undated, c. 1878–79). The best introduction to Renoir and the Charpentiers remains Robida 1958.

4 "L'éditeur des anges et l'ange des éditeurs" (Flaubert, quoted in Robida 1958, 34). On Charpentier's loans to Renoir and Monet in 1876 see Florisoone 1938, 32, and Wildenstein 1974–91, I, 430–431. On his collection see Distel 1989b, 140–149.

5 Renoir's guest list for their "pique-nique," sent to Burty on 5 April 1877 (Archives du Louvre, MS 310 [3], Fonds Henraux, 840) is corroborated by an anonymous article in *L'Événement*, 8 April 1877, which notes the presence at the Impressionist dinner of "deux admirateurs seuls, mais des purs." For Blanche Hoschedé's recollection of the Charpentiers at one of her parents' "dîner de têtes" in 1876, at which both Renoir and Monet were present, see Hoschedé 1960, I, 158. Renoir had made a "tête de chatte" for Madame Charpentier "qui eut beaucoup de succès."

6 Renoir's one-man exhibition of pastels was held at the gallery of *La Vie Moderne* at 7 boulevard des Italiens on 19 June 1879. Monet exhibited there on 6 June 1880, and Sisley in early 1881.

7 "La peinture l'attirait plus que l'édition . . . les peintres étaient ses camarades ou ses amis d'élection" (Hermant 1933, 82).

8 Archives Nationales, Paris, Archives de la Légion d'Honneur, 494/21, 2 February 1898.

9 Vollard 1920, 166. Ferry (1879) characterized Henner as "le maître . . . qui fait revivre en quelque sorte parmi nous les grands maîtres de la Renaissance, et le plus mystérieux du tous, le grand Léonard de Vinci." Rivière (1921, 170) dated Henner's portrait of Charpentier to 1877, the year of Renoir's first portrait of Madame Charpentier.

10 "J'ai rencontré aussi Cézanne chez les Charpentiers, il était venu avec Zola; mais le lieu était trop mondain pour qu'il pût s'y plaire" (Vollard 1919, 92).

11 At a dinner given by the Charpentiers in the Russian restaurant of the newly built Eiffel Tower in July 1889, Paul Robert (1857–1925), a pupil of Bonnat and Henner, whose portrait of Jane Charpentier would be exhibited at the Salon du Champs-de-Mars the following year, was the only artist invited (Becker 1980, 100).

12 "Ma peinture vous déplaît maintenant. Là est toute la difficulté" (Florisoone 1938, 38).

13 On Renoir's failure to procure a curatorship with a monthly income of 200 francs from Gambetta see Vollard 1920, 167. In 1876 Spuller and Charpentier arranged for Renoir to meet Georges Lafenestre, Inspecteur des Beaux-Arts, in order to lobby for an official mural; this proved equally unsuccessful. "Il m'a dit de m'adresser à la ville, mais c'est je crois un four" (Florisoone 1938, 32–34, Renoir to Charpentier, undated).

14 Goncourt 1956, II, 1219, entry for 18 January 1878; ibid., 1231, 3 April 1878, in which he vents his frustration at "Mme Charpentier, qui parle en boutiquière de l'utilité pour nous, pour nos livres, de l'introduction des hommes politiques dans son salon."

15 "Femme remarquablement intelligente" (Rivière 1921, 167).

16 "Elle avait, entre autres avantages, celui d'être jolie, d'avoir l'air très intelligent et aussi très bon, et celui d'être plus intelligente encore qu'elle le paraissait et tout aussi bonne qu'elle en avait l'air . . . Autant son mari était indolent et je 'm'enfichiste,' autant elle était active, ambitieuse et pleine de volonté" (Dreyfous 1913, 176–177). In his memoirs, Maurice Dreyfous (1843–1924) – Charpentier's partner between 1872 and 1877 – also claimed responsibility for introducing Renoir, "alors inconnu et traînant dans la misère," to Marguerite Charpentier.

17 Lemonnier (14 May 1808–16 July 1884) was the adoptive son of Louis Augustin Lemonnier and Thérèse Louise Antoinette Regnault, stars of the Opéra Comique (Archives de Paris, 5Mi3/1449, "Acte de décès," 16 July 1884, Alexandre Gabriel Lemonnier). See also Robida 1955, 86–100. On Lemonnier's work for the Empress Eugénie see Alcouffe 1993, 11–13.

18 Duchatenet (19 September 1822–18 August 1880) was the daughter of Eugène Germain Reygondo Duchatenet and Antoinette Sophie Jombert; on the Jomberts, publishers and print dealers, see Escoffier Robida 1968, 100–107. Sophie married Gabriel Lemonnier on 24 August 1846 (Archives de Paris, V2E/9203, "Reconstitution de l'acte de mariage," Lemonnier and Reygondo Duchatenet).

19 For Manet's *Isabelle Lemonnier with a Muff* (1879–82, Dallas Museum of Art) and his illustrated letters to Isabelle see *Manet* 1983, 452–458. For Manet's *Isabelle Lemonnier* (1879–80) see Kostenevich 1995, 56–59.

20 "Une famille bourgeoise . . . irréductiblement rebelle à une union sans garantie matérielle" (Bergerat 1911, 74).

21 Archives Nationales, Paris, Minutier Central, XXIX/1279, "Inventaire après décès," 24 July 1871, Gervais Charpentier, which gives the date of his marriage as 23 September 1840; he was born 2 July 1805 and died 14 July 1871. Justine Aspasie Générelly (26 October 1819–10 June 1887), "cette vivace mère Charpentier" (Goncourt 1956, III, 683), outlived her husband by sixteen years and was a friend of the Naturalist authors published by her son; she spent her summer holidays in 1876 with the Zolas at Saint-Aubin (Becker 1980, 28–29).

22 Archives Nationales, Paris, Archives de la Légion d'Honneur, 494/21, "Extrait du registre des actes de l'état civil de la commune de Gometz-le-Châtel pour l'année 1871 . . ."

mariage de Georges Auguste Charpentier et Marguerite Louise Lemonnier," 24 August 1871; the correct date of their marriage, often assigned to the spring of 1872, was first published in Distel 1989b, 141.

23 Archives Nationales, Paris, Minutier Central, LXIX/1217, "Contrat de mariage," 18 August 1871, Charpentier and Lemonnier.

24 Dreyfous 1913, 177–181; Mairie de Neuilly-sur-Seine, 231, "Acte de naissance," 30 July 1872, Georgette Berthe Charpentier, giving the family's address as 3 rue Windsor, Neuilly. After moving to 49 rue de Longchamp, Saint James, in April 1875, the family were installed at 11–13 rue de Grenelle by February 1876 (Becker 1980, 15, 26).

25 The Charpentiers had been on holiday in Brittany with Zola and his wife from 18 July until mid-September 1876 (Zola *Correspondance*, II, 465, 470). Renoir's *Madame Charpentier* would most likely have been painted between September 1876 and the opening of the third Impressionist exhibition in April 1877.

26 "Mais je préfère les portraits de Mme G.C. et de Mme A.D. qui me paraissent beaucoup plus solides et d'une qualité de peinture supérieure" (Zola 1991, 358, "Une exposition: Les peintres impressionnistes [1877]"). "Celui de Mme G. Ch., qui porte le nom d'un éditeur bien connu, est composé de main de maître" (Jacques 1877a). "Celui de Mme Georges Charpentier . . . n'est point une oeuvre vulgaire; il est exécuté d'une main intelligente et délicate . . . la figure est bien posée, bien mise dans le cadre, vue avec finesse et distinction" (Bigot 1877).

27 "Sa coloration est moins vive, moins légère que dans celui de Mlle Samary. La facture s'est transformée lorsque le modèle a changé" (Rivière 1877c, 299).

28 Apart from the portraits of his wife and daughter by Renoir, Charpentier also lent Monet's "Corbeille de fleurs" (no. 106) and Sisley's "La Seine, au Pecq" (no. 217) and "Champ de foin" (no. 218), each of whose whereabouts are unknown; see Impressionist Exhibition 1877, reprinted in Moffett 1986, 205–206.

29 Distel (1989b, 142) reproduces the menu that Renoir designed for one of Marguerite Charpentier's dinners; at his most jovial, he would sign his letters to her "le plus dévoué des peintres ordinaires," "A. Renoir et Comp.," "le membre de l'Institut, Renoir" (Florisoone 1938, 35–38).

30 "Une petite femme à la jolie tête, à la mise d'une cocotterie effroyable, mais si minuscule, si courte, si nabote et si enceinte par là-dessus, que dans sa robe de féerie, elle semblait jouer sur un théâtre la *Reine des Culs Bas*" (Goncourt 1956, II, 893–894, entry for 15 May 1872).

31 For the X-radiograph of the original composition of *Madame Charpentier* see Hours-Miédan 1957, 84–85.

32 Bénédite 1907, 132.

33 Archives de Paris, 5Mi3/157, "Acte de décès," 16 April 1876, Marcel Gustave Charpentier; Marcel had died at his home, 13 rue de Grenelle, "âgé de deux ans et trois mois."

34 Jamot (1923, 275) described *Madame Charpentier* as "l'étude, peinte en vue du tableau." Bazin (1958, 168) considered it a preparatory study. The other two portraits, if indeed the first is autograph and the second actually of Marguerite

Charpentier, are *Madame Charpentier* (private collection), which shows the sitter with a red flower in her hair, and the unidentified pastel formerly in the Marczell de Nemès collection.

35 "C'était un essai et le portrait fut restreint à une simple tête . . . Mme Charpentier fut conquise. Elle demande alors à Renoir un très grand portrait" (Duret 1924, 54).

36 "Dimanche prochain, le jour des élections, Mme Charpentier doit . . . passer toute la nuit dans une société des femmes, à laquelle on apportera tous les quarts d'heure le dépouillement de votes" (Goncourt 1956, II, 1202, entry for 8 October 1877).

37 For Zola's announcement to Flaubert that the Charpentiers were at Gérardmer see Zola *Correspondance*, III, 202, 9 August 1878. His next mention of them is on 26 September 1878, from Médan – "Les Charpentier sont venus passer une journée ici dernièrement. Je les ai trouvés très gais" (ibid., III, 223) – which suggests that they returned from holiday in the second half of September.

38 Bénédite 1907, 132.

39 "Le portrait de madame Charpentier est tout à fait terminé mais je ne puis dire ce que j'en pense, je n'en sais absolument rien. Dans un an je pourrai le juger mais pas avant" (Pierpont Morgan Library, New York, Tabarant collection, Renoir to Duret, 15 October 1878). This letter is reproduced in White 1984, 87, and provides the *terminus ante quem* for the portrait.

40 For Renoir's undated letters to the Charpentiers see Florisoone 1938, 38–39 ("Chère Madame, Vous pouvez faire donner une première couche légère" . . . "Cher ami, Je vous envoie un dévernisseur de confiance").

41 Ibid., 35. The letter informing her of Deudon and Ephrussi's visit on Monday is dated "samedi, 30 novembre."

42 "Je suis heureux d'apprendre la bonne réussite de Renoir" (Cézanne *Correspondance*, 181). "Le portrait de Mme Charpentier, une oeuvre charmante par Renoir qui s'est *mondainisé*" (Dax 1879).

43 "J'ai reçu les cent francs que vous m'avez envoyés et qui m'ont fait un plaisir extrême" (Renoir to Duret, as in note 39 above).

44 Distel 1989b, 144. For Marguerite's negotiations with Monet ("quoique je déteste marchander surtout un homme de votre talent, il n'entre pas dans mes moyens de le payer 2000 francs") see Wildenstein 1974–91, I, 446, letter of 22 June 1880. The artist agreed to accept 1,500 francs in three instalments.

45 "Le grand portrait de Mme Charpentier lui a été payé 1500 francs" (Duret 1924, 66). "Je crois bien que ce fut dans le mille francs" (Vollard 1920, 169).

46 *Catalogue des tableaux . . . composant la collection de feu M. Georges Charpentier*, Paris, 11 April 1907, no. 21, price from annotated catalogue in the Knoedler archives. Georges Durand-Ruel informed Renoir on 3 May 1907: "Il paraît que cela a fait crier un peu quelques peintres américains . . . mais l'important est que le tableau soit acheté; une fois qu'il sera en place et qu'on pourra le voir, je ne crois pas que l'on puisse blâmer le Musée d'en avoir fait l'acquisition" (Godfroy 1995, II, 13).

47 "L'ignorance complète du dessin et des procédés artistiques connus" (Bertall 1879, 86).

48 Renoir [Edmond] 1879a.

49 "Madame Charpentier voulait être en bonne situation et connaissait des membres du jury qu'elle secoua vigoureusement" (Moncade 1904). With *Madame Charpentier and Her Children* in mind, perhaps, Blanche has the mother of the hero in *Aymeris* insist: "Il faudrait que Georges eût un portrait de la princesse Peglioso sur la cimaise, ce qui serait la médaille et des commandes assurées" (Blanche 1922, 127).

50 "Au Salon, la *Mme Georges Charpentier avec ses enfants* . . . avait été placée un peu haut. Cabanel . . . fit, de sa propre autorité, descendre à la cimaise ce beau tableau" (Gervex, "Souvenirs sur Manet," *Bulletin de la Vie Artistique*, 15 July 1920, quoted in Fénéon 1970, I, 379).

51 "La famille d'un éditeur bien connu du monde entier et aimé de tous les gens de lettres" (Syène 1879a, 11). "Les débuts d'un ancien intransigeant converti à un art plus sain" (Wolff 1879a). "Mais ne cherchons point chicane à M. Renoir: il est rentré dans le giron de l'église: saluons sa bienvenue, oublions la forme et ne parlons que de coloration" (Baignères 1879, 54).

52 "Une toile d'araignée, mon Dieu, mais tissée par une si matinale ouvrière avec des rayons de soleil!" (Silvestre 1879).

53 "À notre sens, il aurait trop tardé à faire les concessions nécessaires à la fermeté du rendu" (Burty 1879). "Le procédé du peintre est très-particulier: il modèle par le ton sans le secours de la ligne, par la lumière, les reflets et reflets de reflets, à l'exclusion de tout contour arrêté" (Chesneau 1879).

54 "Pas la plus petite trace de convention, ni dans l'arrangement ni dans le faire. L'observation est aussi nette que l'exécution est libre et spontanée" (Castagnary 1892, II, 384, "Salon de 1879").

55 Boggs (*Degas Portraits* 1994, 19, 35) maintains that the painting was never exhibited during Degas's lifetime. The two portraits were recently compared in Nochlin 1992, 43–44.

56 For one example among many, Renoir's comment: "*Les Femmes d'Alger*, il n'y a pas de plus beau tableau au monde . . . ce tableau sent la pastille du sérail" (Vollard 1919, 229).

57 "La pompeuse traîne de velours et de dentelles est un morceau de peinture comparable aux plus beaux de Titien" (Proust 1954, III, 722).

58 Meier-Graefe (1912, 62) was the first to note that "la disposition rivalise avec celle des anciens maîtres." For Renoir's partial copy of Rubens's *Hélène Fourment and Her Children* (1636, Musée du Louvre, Paris) see Adriani 1996, 65–66. Van Dyck's *Children of Charles I*, now considered an eighteenth-century English copy, was catalogued as autograph until 1922 (see Lavergnée, Foucart, and Reynaud 1979, 54).

59 "Le rond visage ombré de frisures . . . de Mme Marguerite Charpentier" (Daudet 1910, 97, entry for 9 November 1880).

60 A comparison first suggested in White 1984, 88–89.

61 Meier-Graefe 1912, 104, recording Renoir's comment that "[il] ne put s'empêcher de jeter de temps en temps un coup d'oeil sur le voisin." On the bequest of the Rivière portraits to the Louvre see Toussaint 1985, 18.

62 Meier-Graefe (1912, 62) and Duret (1924, 54) both mistook the children for two little girls, a confusion made by none of the critics at the

Salon of 1879. It was bourgeois custom not to distinguish between the sexes at this age.

63 Robida 1955, 102.

64 Silvestre (1879) noted "une marguerite au sommet du corsage à gauche."

65 Used perhaps for pills, since Marguerite was increasingly neurasthenic and prone to fainting. In November 1888 Goncourt noted that she was in constant need of smelling salts and that she carried "des sinapismes pour le cas où elle tomberait en syncope" (Goncourt 1956, III, 862–863).

66 Dreyfous 1913, 263. Porthos, the Newfoundland, was a gift of Madame Clotilde Schultz, niece of the writer, translator, and literary critic Philarète Chasles (1798–1873), whose memoirs Charpentier published in 1876. The dog may also have been known as Turc: "Pourquoi les deux beaux enfants bleus ne seraient-ils pas M. Paul et Mlle Georgette Charpentier? Et pourquoi le chien ne serait-il pas le nommé Turc?" (Banville 1879).

67 The glasses are identified as such in Catalogue des tableaux . . . composant la collection de feu M. Georges Charpentier, Paris, 11 April 1907, no. 21.

68 Robida (1955, 131) described the wall as red lacquer alternating with kakemono scrolls. House and Distel (1985, 214) were uncertain whether the background consisted of a screen or "just a hanging embroidered with peacocks." For her painstaking research into the Japanese objects seen in the background of Madame Charpentier and Her Children, I am indebted to Maija Vilcins, librarian at the National Gallery of Canada.

69 "Peint chez elle, sans que ses meubles aient été dérangés de la place qu'ils occupent tous les jours" (Renoir [Edmond] 1879b, reprinted in Venturi 1939, II, 336).

70 "Demain vendredi séance toute la journée chez Charpentier qui part le soir à la campagne . . . Quand je pense qu'il faut que je travaille demain toute la journée debout, j'en suis effrayée d'avance" (Nicolescu 1964, 256–257, Renoir to de Bellio, undated, here assigned to October 1878).

71 "Malheureusement, chez Mme Charpentier, la place était mesurée; les salles de réception était entièrement décorées des japonaiseries, ce qui étaient fort à la mode alors. Et c'est peut-être d'avoir vu tant de japonaiseries que m'est venue cette horreur de l'art japonais" (Vollard 1920, 166).

72 Becker (1980, 34) notes that this took place in March 1874. D'Hervilly's play would be performed at the Odéon on 10 December 1876. In March 1874 Flaubert had thanked Marguerite Charpentier for her "pancarte japonaise" announcing the opening of his comedy Le Candidat (Descharmes 1911, 631).

73 "J'ai appris par Burty – mon fils en japonaiseries – que Madame Charpentier était en train de réaliser un boudoir japonais; si elle avait le désir de voir deux pièces meublées dans ce goût, je me tiendrais à sa disposition" (Bibliothèque Nationale, Paris, Département des Manuscrits, N.A.F., 14558, "Lettres adressées par Edmond de Goncourt à Charpentier," 3 November 1875).

74 "V'là Madame Charpentier qui se met à la Japonaiserie et qui achète des éléphants!" (ibid., 24 November 1876). Goncourt had little respect for Madame Charpentier's aesthetic discernment in matters Japanese, however. Many years later he would recall: "J'ai dans les yeux à

demi fermés les têtes stupidement stupéfiées de la femme et de la fille Charpentier devant ma vitrine aux poteries japonaises" (Goncourt 1956, III, 1084, entry for 11 December 1889).

75 Chesneau 1878, 387; Goncourt 1881, II, 356. "Hier, chez Charpentier, les Japonais ont apporté de la cuisine fabriquée par eux, de petites tartelettes de poissons, des gelées blanches et vertes de poisson, et encore un mets dont ils semblent très friands, des petits rouleaux de riz dans une feuille aquatique grillée" (Goncourt 1956, II, 1268, entry for 6 November 1878).

76 Takashina 1995, 60–62. Yamamoto's motifs are similar to those in the dismembered screen in the background of Renoir's Madame Charpentier and Her Children.

77 "Le petit salon japonais qui servait de fumoir" (Rivière 1921, 172). Banville (1879) situated the painting "dans un petit salon japonais, où d'amusants bibelots font éclater ça et là leurs notes de vermillon et d'or." Huysmans (1883, 58) claimed only that Renoir had shown Madame Charpentier "dans son intérieur."

78 "[Les] parois amusantes d'un boudoir orné à la japonaise" (Burty 1879).

79 Madame Daudet recalled that the Charpentiers lived in "un vieil hôtel du faubourg Saint-Germain . . . dans une suite de pièces relativement étroites" (Daudet 1910, 85).

80 "He is not analytical, scientific and destructive. His is a purely poetical and constructive genius" (Fry 1907, 102). "De fait, on croirait déjà voir une première indication de la manière dont un Bonnard traite les intérieurs" (Meier-Graefe 1912, 62).

81 "J'ai vu hier (et enfin) le fameux portrait, auquel je ne trouve rien à redire" (Flaubert Correspondance, VIII, 269, 12 June 1879, 11 o'clock). Flaubert was more enthusiastic about Carolus-Duran's Madame Vandal and Bonnat's Victor Hugo.

82 See the summary of critical opinions in Sterling and Salinger 1967, 149–152.

83 See Florisoone 1938, 36, for Renoir's letter of January 1882, in which he mentions the commission of a pastel ("que de plus vous pensiez toujours au pastel de votre petite fille"), and Wemaëre-de Beaupuis 1992, no. 86, for his letter of 22 June 1882 informing Berard: "Je suis en train de faire un grand Pastel pour les charpentier [sic], la dernière en pied."

84 Archives de Paris, 5Mi3/1176, "Acte de mariage," 26 November 1888, Hermant and Charpentier. Banville, Goncourt, and Zola were all present at the wedding.

85 "À sa première entrevue avec son mari, elle a débuté par lui dire qu'elle voulait avoir trois enfants. Enfin, ses plus ardents désirs, c'est de manger tout un sac de bonbons pendant sa nuit de noces et d'aller au Théâtre-Libre, le lendemain de son mariage" (Goncourt 1956, III, 862, entry for 26 November 1888).

86 Archives de Paris, 5Mi3/1183, "Acte de décès," 20 January 1890, Marcel Jean Georges Abel Hermant (died 19 January 1890). The date of the divorce appears as an annotation on their marriage certificate; see note 84 above.

87 Becker 1980, 127, who notes that Zola had dedicated Lourdes to Chambolle in July 1894.

88 Annotations to "Acte de naissance," as in note 24 above; Mairie du 7e arrondissement, Paris, "Acte de décès," 20 December 1945, Georgette Berthe Charpentier (died 18 December 1945).

89 "Il y a beaucoup d'éditeurs fort intelligents qui ne sont point bacheliers" (Zola Correspondance, VII, 426–427, 28 August 1893). Zola had received a letter from Paul announcing that if he failed his baccalauréat again, he would enlist in the marines, "car vraiment je ne serai pas digne d'entrer dans la librairie."

90 Ibid., VIII, 220–223, 227–228, 241. Fasquelle had written to Zola on 20 June 1895: "Paul est à présent tiré de l'affaire . . . voilà deux jours qu'il se lève à 2 heures et qu'il mange de la viande" (ibid., 228, n. 6). On 20 July 1895 an obituary appeared in Le Journal: "L'affection à laquelle il succomba s'était déclarée presque au début de son service militaire dans un régiment d'infanterie."

91 "Le petit Paul Charpentier, mort des fatigues endurées au régiment et de l'obstination du chirurgien à ne pas vouloir le reconnaître malade. Dire que ces choses-là se passent encore, malgré tout! Ah! je crois qu'on peut leur parler de la Patrie, maintenant, aux Charpentier!" (Mirbeau 1990, 180, Mirbeau to Monet, 21 July 1895).

92 "Charpentier, qui m'annonce qu'il abandonne la librairie . . . qu'il avait tout combiné pour assurer sa succession à son fils dans de bonnes conditions, mais du moment qu'il n'existe plus, il en a assez, et il veut sortir de cet appartement, de cette librairie, où tout lui rappelle son enfant" (Goncourt 1956, IV, 899, entry for 8 January 1896).

93 Private collection, "Acte de dissolution de société," 31 December 1895, Charpentier and Fasquelle. The jointly held company came to an end on 30 June 1896. See Goncourt 1956, IV, 922, entry for 13 February 1896, for Zola's heartless comments on Charpentier's retirement: "Oui il danserait, si le mort de son fils n'était pas si proche; et le voici faisant tout de suite son entrée dans une vie grandiose, dont le commencement est la location d'un appartement de cinq mille francs à la porte Maillot." It was at 3 avenue du Bois de Boulogne that Marguerite Charpentier died on 30 November 1904 (Archives de l'Enregistrement, Paris, 13 May 1905, "Succession," Marguerite Charpentier). Georges died just under a year later, on 15 November 1905, at 48 avenue Victor Hugo, the home of his younger daughter now Madame Henri Louis Dutar (Archives Nationales, Paris, Archives de la Légion d'Honneur, 494/21).

94 "Cette maison, avec sa maîtresse névropathe et promenant sa névropathie toutes les journées et toutes les soirées dans le monde" (Goncourt 1956, III, 1173, entry for 12 May 1890).

95 "La petite madame Charpentier, l'enfantine agitée, qui, d'après Charcot, sera folle dans deux ans" (ibid., II, 646, 14 February 1887).

96 See Revue Philanthropique 1897, 5–11. Between 1893 and 1903, 861 infants were looked after at La Pouponnière, and 1,095 turned away, "pour manque de place" (Lumet 1903). After her death, Zola's widow, Alexandrine, would succeed Marguerite Charpentier as president of this charity.

97 For a photograph of Madame Charpentier with Carolus-Duran and Gervex, "le Jury du concours des chapeaux," at the pigeon shoot at the Bois de Boulogne to benefit La Pouponnière see Bibliothèque Nationale, Paris, Cabinet des Estampes, Ne63, Collection Laruelle.

98 Rivière 1921, 148.

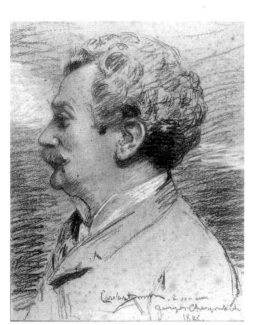

Fig. 182 Charles-Émile Auguste Carolus-Duran, *Georges Charpentier*, 1886, pastel. Private collection

Fig. 184 Madame Marguerite Charpentier, c. 1880. Private collection

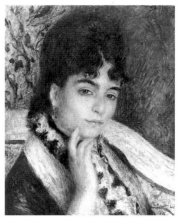

Fig. 186 Pierre-Auguste Renoir, *Madame Daudet*, 1876. Musée d'Orsay, Paris

Fig. 187 X-radiograph of *First Portrait of Madame Charpentier* (cat. no. 31). Musée d'Orsay, Paris

Fig. 183 Schematic floor plan of the Palais de l'Industrie, Paris, showing location of exhibits at the Salon of 1879. From *La Presse*, 11 May 1879

Fig. 188 Jean-Auguste-Dominique Ingres, *Madame Rivière*, 1806. Musée du Louvre, Paris

Fig. 185 Madame Charpentier in her drawing room, c. 1890. Service de Documentation, Musée d'Orsay, Paris

Renoir. /

Distel no. 46

rles Ephrussi (1849–
e work to the first
tive in 1883, until at least
re Rosenberg, Paris, possibly
"objets d'art" (active 1872–
er of Paul Rosenberg (1881–
Bernheim-Jeune, Paris, by 1910;
ding to Daulte, sold by Bernheim-
ne to Durand-Ruel, 1 February 1939,
who sold it the same year to Paul
Rosenberg, Paris; Max Epstein, Hubbard
Woods, Ill., by 1941; Walter Annenberg
collection, after May 1958; Wildenstein and
Co., New York; Mr. and Mrs. André
Meyer, New York, by 1971; Sotheby Parke
Bernet, New York, André Meyer sale,
22 October 1980, no. 19.

EXHIBITIONS *Renoir* 1883, no. 1; *Renoir*
1900, no. 23; *Renoir* 1913, no. 14.

REFERENCES Natanson 1900, 373;
Laforgue 1922–30, IV, 42; *Renoir* 1988,
no. 12; House 1994, no. 14.

NOTES
1 "La première fois que je le vis peindre, c'était à
 Berneval-sur-mer, près de ce château de
 Normandie où M. Paul Berard lui donnait,
 chaque saison, l'hospitalité. Il faisait poser des
 enfants de pêcheurs, en plein air; de ces
 blondins, à la peau rose, mais hâlée, qui ont l'air
 de petits norvégiens" (Blanche 1927, 236, first
 published in *Revue de Paris*, 15 January 1915).
2 House and Distel 1985, 220.
3 Renoir was enthusiastic about a forthcoming
 visit to see the "red-headed daughter" of Dr.
 Monot (Parke Bernet, New York, *Autographs
 and Documents*, 23 April 1963, no. 221, Renoir
 to Paul Berard, undated). It was still some years
 before he would have red-haired children of his
 own.
4 Murphy in *Renoir* 1988, 236; House 1994, 78.
5 House (1994, 78) notes how "the direct gaze of
 the girl, together with her torn skirt and sleeves,
 gives the image a slight erotic *frisson*."
6 See Brettell and Selz 1991, 132–133.
7 *Barnes* 1993, 28.
8 Blanche 1937, 367.
9 Distel (1989b, 165) dates Renoir's first commis-
 sion, the full-length *Marthe Berard* (fig. 22), to
 spring 1879. In an undated letter to Murer,
 written from Wargemont in 1879, Renoir
 notes: "Je pense revenir vers la fin d'août . . .
 jusqu'à maintenant, je n'ai pas beaucoup tra-
 vaillé, au cause du temps" (Pierpont Morgan
 Library, New York, Tabarant collection).
10 Baudot 1949, 74–75.
11 Blanche 1931, 436. "Paul Berard invited these
 'men about town' and on the fringe of society to
 Wargemont, much as he entertained his friends
 among Jewish and Protestant finance, who, fol-

hos, c. 1879.

r, c. 1894. Private collection

Fig. 192 Madame Marguerite Charpentier, c. 1900.
Private collection

lowing his example, bought Impressionist pictures" (Blanche 1937, 39).

12 Laforgue (1922–30, IV, 42, 5 December 1881) noted, in addition to "la sauvageonne ébouriffée de Renoir," two other paintings, "la Parisienne aux lèvres rouges en jersey bleu, et cette très capricieuse femme au manchon, une rose laque à la boutonnière." There is no published catalogue of Ephrussi's collection, but the "Parisienne" mentioned by Laforgue might be the *Portrait of a Young Girl* (1875, Metropolitan Museum of Art, New York; Daulte 1971, 152).

13 See note 21 below.

14 *Renoir* 1883, no. 1. According to this catalogue Ephrussi also lent "Les Deux Soeurs" (cat. no. 40) and "Le Chat endormi" (Sotheby's, New York, 10 November 1983, no. 8).

15 Gautier's phrase, quoted in Brown 1985, 1. "Chacun sait le charme étrange de ces petites têtes brunes . . . aux grands yeux noirs qui vous regardent déjà comme pour lire au fond de votre âme" (Bataillard 1867, II, 1116).

16 House and Distel 1985, 188. For the lost *Petite Bohémienne*, 104 × 44 cm, purchased for 90 francs by Léon Monet, see Bodelsen 1968, 335.

17 Brown 1985, 19–39; *Bouguereau* 1984, 64. The whereabouts of Bouguereau's Salon painting, contemporaneous with Renoir's *Gypsy Girl*, are unknown.

18 Herbert 1970, 44–56, and Thompson 1980, are the best introductions to this large topic.

19 An indication of *Gypsy Girl*'s appeal to a Symbolist generation is Natanson's description of it as one of Renoir's "compositions décoratives" (Natanson 1900, 373).

20 "Le violet rougeâtre dominait. 'De la confiture de groseille' disait-on" (Blanche 1931, 71).

21 "Si Charles Ephrussy [sic] était un homme à mettre des cadres au dessus de trois livres 10 sous on aurait pu mettre la petite fille de Berneval" (Getty Center for the History of Art and the Humanities, Santa Monica, Calif., Special Collections, Renoir to Berard, from Marseilles, undated, early March 1882; for the full letter see Appendix 1 below).

Fig. 193 Pierre-Auguste Renoir, *Studies for "Mussel Fishers at Berneval,"* c. 1879, pen and ink. Location unknown

Fig. 194 Pierre-Auguste Renoir, *Gypsy Girl*, 1879, pastel. Columbus Museum of Art, Gift of Howard D. and Babette L. Sirak, the Donors to the Campaign for Enduring Excellence, and the Derby Fund

Fig. 196 William Bouguereau, *Bohemian*, 1890. Minneapolis Institute of Arts

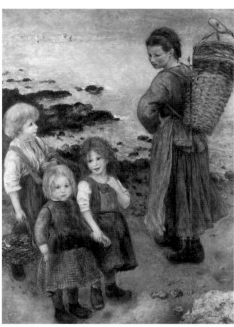

Fig. 195 Pierre-Auguste Renoir, *Mussel Fishers at Berneval*, 1879. The Barnes Foundation, Merion, Pa.

34 *Margot Berard* 1879
41 × 32.4 cm
Signed and dated upper left: Renoir 79.
The Metropolitan Museum of Art, New York, Bequest of Stephen C. Clark, 1960, 61.101.15
Daulte no. 286

PROVENANCE Paul Berard (1833–1905), Paris and Wargemont; Madame Alfred Berard, née Marguerite Berard (1874–1956), Paris; sold by Knoedler and Co., New York, to Stephen C. Clark (1882–1960), New York, 1937; bequeathed by him to the Metropolitan Museum of Art, 1960.

EXHIBITIONS *Renoir* 1883, no. 19; Brussels 1886, no. 4; *Renoir* 1913, no. 15.

REFERENCES Sterling and Salinger 1967, 152–153.

NOTES

1 Critical of the deep-green background in Henner's "Portrait de Mme XXX," Burty (1874) complained that such backdrops had become conventional in fashionable portraiture but were "comme un fond banal de carte de visite." A decade later, Geffroy (1884) expressed similar irritation: "Bien perspicace qui découvrirait si l'on est en face d'un mur de briques, d'un édredon ou d'une ouverture de cave." Renoir employed an even more striking red

background in *Fernand Halphen* (1880, Musée d'Orsay, Paris).

2 This photograph was reproduced for the first time in Daulte 1974, 8.

3 Ibid., 7. In January 1886 Renoir referred to *Margot Berard* as "la petite fille au tablier" (Venturi 1939, II, 229).

4 "Pour la consoler, il avait voulu faire son portrait avec les traits d'une petite fille réjouie!" (Berard 1956, 5).

5 Archives de Dieppe, 12, "Acte de naissance," 26 July 1874, Marguerite Thérèse Berard.

6 Mairie du 9ᵉ arrondissement, Paris, 404, "Acte de mariage," 18 April 1896, Berard and Berard.

7 Archives du Quai d'Orsay, PER DI, vol. 28, where in a report of 11 February 1902 he is described as "agent doué d'aptitudes moyennes, mais correct et consciencieux dans le service."

8 Berard 1937, 51. Margot died at Wargemont on 6 April 1956; the date of her death appears as an annotation on her "acte de naissance" cited in note 5 above.

9 "Ma tante faisait tous les jours, qu'il fasse beau ou un temps affreux, 14 miles à bicyclette – faute d'essence pour alimenter les autos – pour se rendre à l'hôpital de Dieppe pour soigner des blessés de la guerre" (Sterling and Francine Clark Art Institute, Williamstown, Mass., Curatorial Archives, letter of 20 April 1976 from Christian Thurneyssen).

10 Berard 1956, 5.

11 "Je lui flanque une gifle. Elle ne bronche plus pendant une heure" (Blanche 1949, 199–200).

12 "Je crois que votre petite Margot a fini par attraper les oreillons. En tout cas je l'ai fait rester dans sa chambre et soigner. Du reste elle accepte très bien sa nouvelle situation et elle n'a rien perdu de son appétit. Ce n'est peut-être qu'une simple petite enflure. Demain je vous mettrai au courant. Pour le moment, rien de grave, elle est très gaie et joue avec ses poupées, et je vous le répète je ne l'ai fait rentrer dans sa chambre que par précaution" (private collection, Renoir to Berard, undated, marked "jeudi"). Renoir addresses Berard formally as "cher Monsieur Berard," which suggests a date very early in their correspondence; it is a little surprising that Renoir is staying at Wargemont in the absence of both Berard and his wife.

Fig. 197 Marguerite (Margot) Berard, 1879. Private collection

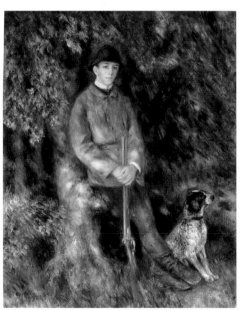

Fig. 198 Pierre-Auguste Renoir, *Alfred Louis Berard as a Hunter*, 1881. Philadelphia Museum of Art, Tyson Collection

35 *Acrobats at the Cirque Fernando (Francisca and Angelina Wartenberg)*
1878–79
131.5 × 99.5 cm
Signed lower left: Renoir.
The Art Institute of Chicago, Mr. and Mrs. Potter Palmer Collection, 1922.440
Daulte no. 297

PROVENANCE Deposited by Renoir with Durand-Ruel 7 April 1881, as "Les Petites Acrobates"; purchased from Renoir by Durand-Ruel, as "Les Saltimbanques," 12 May 1882, for 2,000 francs; sold to Mrs. Berthe Honoré Potter Palmer (1849–1918), Chicago, as "Dans le Cirque," 11 May 1892, for 8,000 francs ($1,750); bequeathed by her to the Art Institute of Chicago, 1922.

EXHIBITIONS *Renoir* 1879; Impressionist Exhibition 1882, hors catalogue; New York 1886, no. 209; *Renoir* 1892, no. 3.

REFERENCES *Renoir* 1973, no. 24; Moffett 1986, no. 134.

NOTES

1 Maxon in *Renoir* 1973, no. 24.

2 The custom of throwing oranges must have been fairly well established, since in *Les Frères Zemganno* (1879, 151) Goncourt describes "un gymnaste minuscule de cinq ans [qui] mordait une orange qu'on lui avait jeté."

3 Meier-Graefe (1929, 56) dated the painting to 1868 on the basis of its perceived similarity to *The Clown*.

4 "À la première exposition de l'Art Moderne nous avions eu les deux fillettes acrobates, des séries de minois d'enfants (Blanche 1931, 73, the latter referring to Renoir's pastel portraits). Edmond Renoir (1879b, reprinted in Venturi 1939, II, 336) noted of this exhibition: "Vous n'avez guère que des pastels."

5 Archives Durand-Ruel, Paris, D3155, "Les petites acrobates" deposited by Renoir, 7 April 1881.

6 See Moffett 1986, 394–395 (reprinting Impressionist Exhibition 1882), where it is noted that *Acrobats at the Cirque Fernando* was not among the twenty-five works by Renoir listed in the catalogue. Darragon (1989, 57, n. 68) confuses this picture with no. 138, "les Deux Soeurs" (see cat. no. 40). Isaacson in Moffett 1986, 379–380, provides an acute discussion of Renoir's *envoi* to the seventh exhibition, but fails to point out that the choice of works had rested entirely with Durand-Ruel, Renoir having categorically refused to participate.

7 "M. Renoir expose également deux pauvres petites *Saltimbanques*, qui sont nées avec des jambes trop courtes, mais à qui, pour les consoler, l'artiste a fait des mains trop longues et pleines de grosses oranges" (Fichtre 1882).

8 Archives Durand-Ruel, Paris, purchase of "Les saltimbanques" from Renoir for 2,000 francs, 12 May 1882; *The Impressionists of Paris*, 1886, no. 209, "Au Cirque"; *Exposition A. Renoir*, May 1892, no. 3, "Au Cirque"; entitled "Dans

le cirque," it was sold to Mrs. Potter Palmer on 11 May 1892 for 8,000 francs (equivalent of $1,750), information from the Art Institute of Chicago Archives, kindly supplied by Gloria Groom.

9 "Ainsi pour les *Acrobates*, l'arrangement n'y est réellement pour rien. On dirait que par un procédé d'une subtilité et d'une instantanéité incompréhensibles, il a saisi sur le fait le mouvement des deux enfants. C'est bien comme cela qu'elles marchaient, saluaient, souriaient, sur la piste du cirque" (Renoir [Edmond] 1879b, reprinted in Venturi 1939, II, 337).

10 *Impressionist Drawings* 1986, no. 67. "Pour en revenir à la rue Saint-Georges, parmi les tableaux que j'exécutai dans cet atelier, je me rappelle aussi un *Cirque* où des fillettes jouaient avec des oranges" (Vollard 1919, 67).

11 "Renoir, que le cirque Fernando amusait comme tous les spectacles populaires, ne fut jamais tenté d'en peindre l'aspect" (Rivière 1921, 146).

12 *Le Figaro* of 30 January 1874 reported that the Cirque Fernando "va se mettre dans ses meubles, c'est-à-dire qu'il va construire un cirque en maçonnerie sur l'emplacement même qu'il occupe maintenant." Documentation on the Cirque Fernando is suprisingly extensive and has been thoroughly studied by historians of late-nineteenth-century painting; see, in particular, Darragon 1989, 44–57, and Thomson in *Toulouse-Lautrec* 1991, 231–236.

13 Darragon 1989, 50, further noting that Puvis de Chavannes and Degas were also regulars at this time.

14 For Toulouse-Lautrec's *At the Cirque Fernando: Bareback-rider* (1887–88, Art Institute of Chicago) see Thomson in *Toulouse-Lautrec* 1991, 234–236. On Seurat's *Cirque* (1890–91, Musée d'Orsay, Paris) see Distel in *Seurat* 1991, 363–365. Darragon (1989, 50) published Goupil's photograph of Blum's *Rehearsal at the Cirque Fernando*.

15 *Degas* 1988, 204–5, 217–218.

16 The interior was redecorated in the autumn of 1878. "C'est une vraie bonbonnière où le monde élégant se donne rendez-vous" (*Le Figaro*, 16 October 1878, quoted in Darragon 1989, 50). Performances took place every evening at 8:30 PM.

17 "Au cirque, l'éclairage incertain rend les visages grimaçants, déforme les gestes . . . Il a peint *les jongleuses*, cependant, des acrobates, mais vues au jour, en plein air" (Rivière 1921, 146).

18 Art Institute of Chicago, curatorial files, letter from Marguerite Streckfus, 22 January 1942, partially published in Chicago 1961, 394–395.

19 Berlin, Evangelisches Zentralarchiv, baptismal record, Angelina Joséphine Hermine Wartenberg, giving the names of her parents and the designation of her father's profession as "gymnastic artist."

20 *Cirque Fernando* 1875, 99–118; Maxon in *Renoir* 1973, no. 24, claimed that Francisca and Angelina were the daughters of the proprietor of the Cirque Fernando; he is followed by Moffett (1986, 417) and Herbert (1988, 62).

21 City and County of San Francisco, affidavit of birth, 21 September 1934, Marguerite Georgina Miehling, noting that Frances Charlotte Wartenberg was aged 41 at the time of her daughter's birth (13 January 1902); as she does not sign the affidavit, it may be presumed that

Frances Wartenberg was no longer living. Jack Streckfus, a grandson of Frances Wartenberg, very kindly provided me with the original document.

22 Berlin, Evangelisches Zentralarchiv, baptismal record, Angelina Joséphine Hermine Wartenberg, baptized in the Dorotheenstadtkirche 13 March 1864; Chicago 1961, 394–395, for Angelina Wartenberg's letter of 26 December 1938 to her niece, Marguerite Streckfus (Angelina was living in London at the time).

23 For these previously unpublished photographs, each of which is dated and inscribed, I especially thank Jack Streckfus, grandson of Francisca Wartenberg.

24 "Le Réalisme . . . n'a pas en effet l'unique mission de décrire ce qui est bas, ce qui est répugnant, ce qui pue" (Goncourt 1879, 10).

25 "La nature rêveuse, contemplative, et je dirai, littéraire . . . la rêverie poétique est le lot et le privilège absolus des classes supérieures et éduquées" (ibid., 146).

26 "C'est là de l'existence réelle avec toute sa poésie et toute sa saveur" (Renoir [Edmond] 1879b, reprinted in Venturi 1939, II, 337).

Fig. 200 Maurice Blum, *Rehearsal at the Cirque Fernando*, Salon of 1874. Départment des Estampes, Bibliothèque Nationale, Paris

Fig. 199 Pierre-Auguste Renoir, *The Acrobats*, black chalk, c. 1879. Saltwood Castle Collection, Kent

Fig. 201 Edgar Degas, *Mademoiselle La La at the Cirque Fernando*, 1879. National Gallery, London

Fig. 202 The Wartenberg sisters in Saint Petersburg, Russia, 1880. Private collection

Fig. 204 Family of Francisca Wartenberg (Frances Miehling). Left to right: Richard, Francisca, Marguerita, George Miehling, and George Jr., c. 1910, San Francisco. Private collection

Fig. 203 Francisca Wartenberg performing as "Mademoiselle Mazella" in San Francisco, c. 1893. Private collection

36 Girl with a Fan 1880

65 × 50 cm
Signed upper right: Renoir.
State Hermitage Museum, Saint Petersburg, 6507
Daulte no. 332

PROVENANCE Purchased from Renoir by Durand-Ruel, 6 January 1881, for 500 francs; sold by Durand-Ruel to the collector Ivan Morosov (1871–1921), Moscow, 1 October 1908, for 30,000 francs; Museum of Modern Western Art, Moscow from 1918; Hermitage Museum, Saint Petersburg, from 1930.

EXHIBITIONS Impressionist Exhibition 1882, no. 160; Berlin 1883; Durand-Ruel Paris 1888, no. 15; Renoir 1892, no. 96; Durand-Ruel Paris 1899, no. 96; Salon d'Automne 1904, no. 17; London 1905, no. 237.

REFERENCES Moffett 1986, 376, 379, 394–395; Kostenevich 1987, 298–299; Distel 1993, 164; Adriani 1996, no. 62.

NOTES
1 House and Distel 1985, 220.
2 Archives Durand-Ruel, Paris, "Journal," 6 January 1881, no. 726, "Femme à l'éventail," 500 francs. Sleeping Girl with a Cat (1880, fig. 23) was acquired on the same day for 2,500 francs; see House and Distel 1985, 218.
3 See Daulte 1971, no. 332, for a listing of all the exhibitions except the one held at Fritz Gurlitt,

Kunsthandlung, Berlin, to which Durand-Ruel sent Girl with a Fan on 25 September 1883 (and for which no catalogue is recorded).
4 Archives Durand-Ruel, Paris, "Journal," 6 January 1881, annotation to no. 726.
5 The dating in Daulte 1971, no. 332, has been followed in Kostenevich 1987, 298, and, most recently, Adriani 1996, 208.
6 Archives Durand-Ruel, Paris, 25 August 1891, "Tableaux achetés à M. Durand-Ruel et mis en dépôt, 35 rue de Rome." "Femme à l'éventail," dated 1880 in Durand-Ruel's records, is now assigned the stock number 1273.
7 Isaacson in Moffett 1986, 379, 387.
8 "Maintenant vous pouvez y mettre les toiles que vous possédez sans mon autorisation. Elles sont à vous et je me refuse le droit de vous empêcher d'en disposer, comme vous l'entendrez, si c'est en votre nom propre" (Godfroy 1995, I, 27, draft of Renoir's letter, sent by his brother Edmond to Durand-Ruel, from L'Estaque, 26 February 1882).
9 "Je suis en train de travailler et j'ai des choses en train dans la manière de la Femme à l'éventail . . . très doux et coloré, mais claire" (ibid., I, 64, Renoir to Durand-Ruel, from Essoyes, November 1888).
10 See Isaacson in Moffett 1986, 379 and n. 50.
11 "Malgré ses yeux de garance brûlée et ses cheveux dont une teinture récente expliquerait seule la tonalité violâtre" (Hutin 1882).
12 "La vigueur de son coloris est surprenante notamment dans 'Femme à l'éventail'" (Sallanche 1882).
13 "Charmante de modernité et de feminéité [sic] la jeune femme à l'éventail" (Silvestre 1882).
14 "Je ne connais rien de plus joli et de plus vrai que l'Enfant à l'éventail. C'est d'une charmante et délicate couleur" (Katow 1882).
15 "Eugène Delacroix se fût attardé devant cette Femme à l'éventail . . . Personne ne sait rendre aussi franchement comme Renoir les mystérieux attraits des ombres sur les visages, les cous, les épaules de jeunes femmes brunes" (Burty 1882).
16 Huysmans (1883, 266) went so far as to prefer it to the multifigured composition ("J'aime moins, par exemple, son Déjeuner à Bougival"), an opinion that would not be endorsed today.
17 Daulte 1971, nos. 159, 277, 278, 301, 331. See also "Les Portraits des Fournaise," in Association des Amis de la Maison Fournaise, 1 (1991), 24–26. It is unlikely that Alphonsine is the girl at left leaning against the balustrade in Luncheon of the Boating Party; see House and Distel 1985, 223, and Distel 1993, 75.
18 Mairie de Chatou, "Acte de mariage," 20 September 1864, Louis Joseph Papillon and Louise Alphonsine Fournaise. In his discussions with Vollard, Renoir would refer to Alphonsine as "la gracieuse madame Papillon" (Vollard 1919, 46).
19 Archives de Paris, 5Mi3/39, "Acte de décès," 12 January 1871, Papillon. It is unclear whether the couple was still together at this time, since Papillon's death certificate lists Alphonsine's address as unknown.
20 The lascivious Madame Obardi invites her two guests to lunch "au restaurant Fournaise, à Chatou" (Maupassant 1988, 40).
21 Rathbone 1996 is the most thorough treatment of this painting to date.

22 His undated letter to de Bellio, written in the autumn of 1880, is signed "chez Madame Fournaise, dans l'île de Chatou" (Institut Néerlandais, Paris, Fondation Custodia, Collection d'Autographes). The "Madame Fournaise" referred to here is, of course, Alphonsine's mother.

23 For example, Renoir has recourse to stock props. The model of *Girl with a Fan* is seated in the same armchair that had been used in *Sleeping Girl with a Cat* (fig. 23); she holds a tricolour fan of the type that had appeared in *Camille Monet and Her Son Jean* (cat. no. 17).

24 First published in Meier-Graefe 1929, 150, as "Studienkopf" and dated 1878. Daulte (1971, no. 277) catalogued it as having been modelled for by Mademoiselle Samary, which is implausible, as has been noted in "Les Portraits des Fournaise," cited in note 17 above.

25 "Avec la fine étincelle de ses grands yeux noirs" (Huysmans 1883, 266).

26 House and Distel 1985, 88–89, 217.

27 Catinat 1952, 65–73.

28 "Après un déjeuner où Renoir évoqua ses souvenirs d'autrefois, il nous fit faire la connaissance de la 'Femme fatale' – qui avait perdu tous ses pouvoirs" (Baudot 1949, 48–49).

Fig. 206 Pierre-Auguste Renoir, *Alphonsine Fournaise*, 1875. Museu de Arte de São Paulo Assis Chateaubriand

Fig. 207 Pierre-Auguste Renoir, *Alphonsine Fournaise*, 1880. Private collection

Fig. 205 Jules Draner, *Une visite aux impressionnistes*. From *Le Charivari*, 9 March 1882

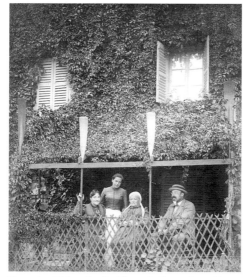

Fig. 208 Alphonsine Papillon, née Fournaise, with her mother, Louise, and brother Jules-Alphonse and his wife Joséphine Marchand, 1893. Les Amis de la Maison Fournaise, Chatou, Gift of Mariette Fiant

37 *Albert Cahen d'Anvers* 1881
79.8 × 63.7 cm
Signed and dated lower right: Renoir / Wargemont 9.S^{bre}.81.
The J. Paul Getty Museum, Malibu, Calif., 88.PA.133
Daulte no. 362

PROVENANCE Albert Cahen d'Anvers (1846–1903), Paris; by inheritance to Albert's nephew Hubert Cahen d'Anvers; Dr. Joseph Steegman, Zurich; Galerie Beyeler, Basel, by 1971; private collection, Geneva; Galerie Beyeler, Basel; purchased by the J. Paul Getty Museum from Galerie Beyeler, Basel, October 1988.

EXHIBITIONS Not exhibited in Renoir's lifetime.

REFERENCES House 1994, no. 18; Adler 1995.

NOTES
1 For the most thorough treatment of this portrait to date see Adler 1995.
2 First published in Berard 1938.
3 Manufactured cigarettes, sold in packs of twenty, were introduced into France only in 1872; it would be another decade before the machine-rolled cigarette, invented by the American company W. Duke and Sons, would flood the European market (Larousse 1866–90, VIII, 1359, and Berman 1993, 633).
4 "[Ils] sont d'apparence maigriotte, petits, et sans cesse en mouvement" (Chirac 1883–86, I, 249, from the chapter devoted to the Cahen d'Anvers family).
5 "Ils ont des tailleurs irréprochables" (ibid., 250).
6 Bibliothèque Nationale, Paris, Département des Manuscrits, N.A.F., 14695, fol. 97, for Cahen d'Anvers's visit to Nadar's studio on November 1896. Bonnat's portrait (whereabouts unknown) is after Pirou's photograph, first published in Martin 1897.
7 "Le portrait donne" (Distel 1989a, 61, n. 20, Berard to Deudon, 7 September 1881).
8 Archives de Paris, DQ7/11830, 21 October 1881, "Succession," Meyer Joseph, comte Cahen d'Anvers; this document gives the date and place of death, and notes that Albert Henri Cahen d'Anvers was living at 35 rue de Bourgogne at the time.
9 Cahen d'Anvers 1994.
10 Révérend 1897, 384–385.
11 On Ephrussi's complicated relationship with the Cahen d'Anvers see my essay above, page 8.
12 Davies 1970, 137–138; Trevitt in *Grove* 1980, III, 604–605.
13 *Le Figaro*, 12 October 1880 ("artiste par vocation, quoique possesseur d'une jolie fortune"); Davies 1970, 138. Cahen d'Anvers also tried his hand as a playwright – his one and only comedy, *À l'essai*, was performed at the Théâtre de Campagne in 1881 – after which he returned to writing orchestral music for the theatre.
14 Davies 1970, 138.
15 "Je vais assister à la première représentation du *Vénitien*, oeuvre d'un de mes bons amis. Je veux, de plus, séduire la Presse rouennaise pour cet

opéra" (Maupassant *Correspondance*, III, 141). Cahen d'Anvers would be among the last to see Maupassant alive during his hospitalization in Dr. Blanche's mental asylum at Passy.

16 Trevitt in *Grove* 1980, III, 605.

17 See page 155 above.

18 Révérend (1897, 385) gives the date of his wedding as 5 April 1876. "Mme Albert Cahen, à chaque fois qu'elle ouvre la bouche, appelée la *petite perfection*" (Goncourt 1956, II, 140, entry for 7 January 1882).

19 Troyat 1989, 150–152.

20 "Ces juives ont tenu dans la société, sous la République, une place qu'il est difficile d'imaginer aujourd'hui" (Blanche 1949, 171). "L'immensité des appartements, la succession des salons aux murs de soie" (Goncourt 1956, III, 510, entry for 7 December 1885, adding maliciously that such furnishings "vous disent que vous êtes dans un logis de la banque israélite").

21 Archives de l'Enregistrement, Paris, 12 April 1903, "Succession," Albert Henri Cahen d'Anvers, where his estate is valued at 2,307,604 francs. On his funeral convoy, which included Charles and Ignace Ephrussi, see *Le Figaro*, 4 March 1903.

22 For Cahen d'Anvers's collection, sold two years after his wife's death, and in which no family portraits appear, see *Catalogue des tableaux modernes . . . provenant de la collection de feu Madame A. C. . . . d'A. . . .*, Paris, 14 May 1920. Duparc (1873, 425–427) listed two paintings and two watercolours by Regnault already in Cahen d'Anvers's collection. See also Venturi 1939, II, 138, for Durand-Ruel's mention of Cahen d'Anvers in his memoirs; Wildenstein 1974–91, II, 1032, for *L'Aiguille d'étretat* 1885; and Mathieu 1976, 299, no. 67, for Moreau's *Young Man and Death*.

23 Luxenberg 1991, 150–151. Bonnat's oval portraits of Cahen d'Anvers (1883) and Madame Cahen d'Anvers (1881), which are known from photographs in the Cabinet des Estampes, were kindly brought to my attention by Alisa Luxenberg.

24 House 1994, 86.

25 The phrase is from G.M. Beard's study of the cigarette's deleterious effect on the nervous system, published the year that Renoir's portrait was painted, and quoted in Berman 1993, 633.

Fig. 209 Château de Wargemont, Petit Salon. Location unknown

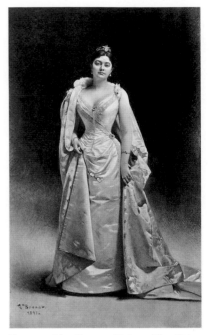

Fig. 211 Léon Bonnat, *Madame Albert Cahen d'Anvers*, 1891. Musée Bonnat, Bayonne

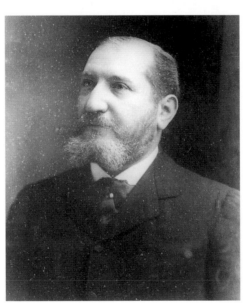

Fig. 210 Albert Cahen d'Anvers, c. 1896, photograph by Nadar. Bibliothèque Nationale, Paris

38 *Alice and Elisabeth Cahen d'Anvers*

1881

120 × 75 cm

Signed and dated lower right: Renoir. 81.

Museu de Arte de São Paulo Assis Chateaubriand

Daulte no. 361; House/Distel no. 53

PROVENANCE Commissioned by the banker Louis-Raphael, comte Cahen d'Anvers (1837–1922), Paris, for 1,500 francs; acquired by Bernheim-Jeune, Paris, about 1913; Gaston Bernheim de Villers (1870–1953), Monte Carlo; acquired by Francisco de Assis Chateaubriand Bandeira de Mello (1891–1968), São Paulo, after 1940; given by him to the Museu de Arte de São Paulo, 1952.

EXHIBITIONS Salon 1881, no. 1986 or no. 1987 (both cited as "Portrait de Mlle ***"); *Renoir* 1900, no. 15, as "Rose et Bleu"; *Renoir* 1913, no. 20.

REFERENCES Jullian 1962; Adriani 1996, no. 64.

NOTES

1 Chirac 1883–86, I, 246–256; Révérend 1897, 384–385; Coston 1975, 116–118. For Cahen d'Anvers's estate, valued at over 65 million francs, and the bequests he left at his death, see Archives de l'Enregistrement, Paris, 6 June 1923, "Succession," Louis Raphaël Cahen d'Anvers.

2 This genealogy was compiled by John Collins and Marina Ferretti.

3 "J'ai fait deux tentatives pour voir madame Cahen, je n'ai pas encore réussi" (Archives Durand-Ruel, Paris, Renoir to unnamed corre-

spondent ["Mon cher ami," most likely Charles Ephrussi], undated, c. 1880.

4 See my essay above, page 6 and note 58.

5 "J'ai fini les portraits des petites Cahen. Je suis parti aussitôt après, fatigué et je ne puis dire si c'est bon ou mauvais" (Braun 1932, 11, Renoir to Théodore Duret, from Algiers, 4 March 1881).

6 See my essay above, page 8 and notes 79 and 86.

7 "Quant au quinze cents francs des Cahen je me permettrai de vous dire que je la trouve raide" (Schneider 1945, 99, Renoir to Charles Deudon, from L'Estaque, 19 February 1882). The post-script to this letter adds, in a jocular tone: "Comme je ne ferai pas un procès au Cahen, voulez-vous dire à Berard qu'il me mette mille francs chez Rémont" (Rémont was Renoir's stockbroker).

8 "C'est ainsi que mes parents retrouvèrent dans un sixième de l'avenue Foch le fameux tableau *Portrait de Mesdemoiselles Cahen d'Anvers*" (Dauberville 1967, 219).

9 "Décidément M. Renoir s'assagit" (Havard 1881).

10 "Ça m'ennuyait tellement de poser, ma seule consolation était de mettre cette robe en point d'Irlande que j'aimais beaucoup" (Jullian 1962). See also my essay above, page 40.

11 "M. Renoir a baigné ses figures dans la vraie lumière" (Huysmans 1883, 184, "Le Salon officiel de 1881").

12 A point first made in House and Distel 1985, 224.

13 "Dans les tons clairs" (Duret 1924, 62). For Carolus-Duran's portrait of Cornelia Martin (1881) see Phillips, London, 19 March 1985, no. 96.

14 For the favourable commentary on it see my essay above, page 46, note 86.

15 "Deux fillettes debout, et un portrait d'enfant. Les deux fillettes sont charmantes de naïveté, de gentillesse, de grâce enfantine et surtout de fraîcheur. Vues à la distance requise, elles sont, ce qui est rare chez M. Renoir, bien d'aplomb, modelées avec soin et pleines de vie. Leurs petites frimousses rieuses, leurs tresses blondes, leurs robes roses et bleues, composent un vrai bouquet et des plus frais et des plus brillants" (Havard 1881).

16 Daulte 1971, no. 361; White 1984, 102. For the history of this mansion see Rousset-Charny 1990, 150–153.

17 Archives de Paris, D1P4/75, "Cadastre de 1876," 4/2 rue Bassano, where it is noted, "1000 m acheté le 2 8bre 1880, 326 m (maison Baudin) acheté le 27 7bre 1881." Louis Cahen d'Anvers is entered on the cadastral records in 1884.

18 Archives de Paris, D1P4/747, "Cadastre de 1876," 66 avenue de Montaigne; the rent was 16,000 francs per annum. It is at this address that Louis Raphaël was noted as living at the time of his father's death on 11 September 1881 (ibid., DP7/11830, 21 October 1881, "Succession," Meyer Joseph Cahen d'Anvers).

19 Ephrussi published several of her pieces in his article "Les Laques Japonais au Trocadéro," *Gazette des Beaux-Arts*, 1 December 1878.

20 Rousset-Charny 1990, 152.

21 *Archives Israélites*, 22 October 1891. Bonnat was among those who attended the wedding.

22 *Burke's Peerage* (1967), 2498. See also Jullian 1962.

23 Daulte 1971, no. 410.

24 Archives de l'Enregistrement, Paris, 6 June 1923, "Succession," Louis Cahen d'Anvers. Both marriages were at an end by 1923.

25 Marcel Proust informed his mother on 17 September 1896: "J'y ai donc appris qu'Elisabeth Cahen était catholique depuis l'accident de cheval où elle a failli mourir. Elle ne s'est pas convertie toute de suite à ce moment-là mais a commencé alors à le désirer" (Kolb 1953, 78–79).

26 The date of her death is given by her great-nephew Jean de Monbrison, and was kindly made available by Mrs. Esmeraldo, Loans Co-ordinator at the Museu de Arte de São Paulo.

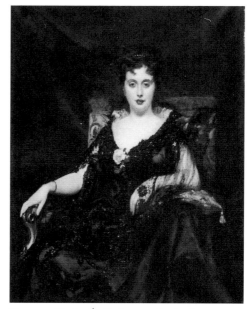

Fig. 213 Charles-Émile Auguste Carolus-Duran, *Louise Cahen d'Anvers*. Château de Champs, Champs-sur-Marne

Fig. 212 Léon Bonnat, *Louis Cahen d'Anvers*, 1901. Château de Champs, Champs-sur-Marne

Fig. 214 Alice Cahen d'Anvers on her wedding day, 22 November 1898. Private collection, London

39 Studies of the Children of Paul Berard

1881
62.6 × 82 cm
Signed and dated lower right: Renoir. 81.
Sterling and Francine Clark Art Institute,
Williamstown, Mass., 590
Daulte no. 365; House/Distel no. 60

PROVENANCE Paul Berard (1833–1905),
Wargemont and Paris; Galeries Georges
Petit, Paris, Berard sale, 8 May 1905, no.
16, bought for 8,700 francs by Albert Pra;
Galerie Charpentier, Paris, Pra "Succession"
sale, 17 June 1938, no. 52, bought for
512,000 francs by Knoedler and Co.,
London, New York, and Paris; acquired
from Knoedler, London, by Robert Sterling
Clark, Paris, 30 June 1938.

EXHIBITIONS Renoir 1883, no. 11; Saint
Petersburg 1912, no. 540.

REFERENCES Rosenblum 1988, 50; Kern
1996, 62–65.

NOTES

1 Studies of the Children of Paul Berard was shown
at Durand-Ruel's in April 1883 as "Croquis de
têtes," (Renoir 1883, no. 11). For examples of
Renoir's method of working out ideas (or
simply working) in a similar format see Daulte
1971, nos. 571, 615, 616, and 638.

2 "Il a fait de cette ensemble très clair une sorte de
salade pleine de vie" (Duret 1922, 100).

3 In 1879 Renoir painted three portraits of
André, Le Petit Collégien (fig. 53), the half-
length André Berard (Daulte 1971, no. 285), and
Le Petit Berard, a half-length portrait in pastel
(fig. 215), and three portraits of Marthe Berard,
La Petite Pêcheuse (Daulte 1971, nos. 281, 282),
the full-length Marthe Berard (fig. 22), and a pas-
tel half-length, probably the work exhibited as
"Mademoiselle Bxxx" at the Salon of 1880
(reproduced in Meier-Graefe 1929, 117).

4 Archives de Paris, V4E/1063, "Acte de nais-
sance," 18 March 1868, André Victor Berard,
noting that he was born at 20 rue Pigalle on 16
March 1868.

5 Ibid., "Acte de naissance," 10 May 1870, Marthe
Marie Berard, noting that she was born at 20
rue Pigalle on 8 May 1870. An annotation on
the birth certificate gives the date of her death
as 19 January 1946, at the château d'Hybouville
at Envermeu (Seine Inférieure).

6 House and Distel 1985, 230.

7 See Sotheby's, New York, 24 April 1985, no.
33, and my essay above, page 21.

8 Rosenblum 1988, 45.

9 See, most recently, Los Llanos 1992, 22–24.

10 The exhibition was co-organized by Ephrussi and
Gustave Dreyfus to benefit students at the
École des Beaux-Arts during their year of
military service. In his highly enthusiastic
review, Albert Wolff (1879b) wrote: "Le succès
dépasse tout ce qu'on pouvait rêver."

11 "Nous le trouvions en robe de chambre ayant
passé sa matinée à ranger des porcelaines du
XVIIIᵉ siècle, des pièces d'orfèvrerie, des minia-
tures, des bibelots de ses collections qui paraient
un intérieur auquel il était attaché de toute son

âme" (Berard 1956, 2, Monet's recollection to
Maurice Berard made during a visit to Giverny).

12 "Faites donc faire le pastel à Mlle Cassatt. Je ne
serais pas fâché d'avoir un voisin" (Berard 1968,
56, Renoir to Berard, dated "Alger 1881").

13 Lindsay 1985, 52–53. The friendship between
the Cassatts and the Berards reached its height
in the summer of 1886, when Cassatt rented a
summer house in Arques-la-Bataille, about ten
kilometres from Wargemont (Mathews 1984,
199).

14 "Tout le charme de l'enfance, sa fraîcheur, son
rayonnement sont ici exprimés avec une ten-
dresse profonde" (Berard 1956, 6).

Fig. 215 Pierre-Auguste Renoir, Le Petit Berard,
1879–80, pastel. Location unknown

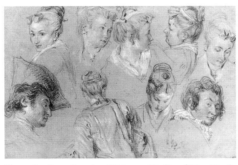

Fig. 216 Jean-Antoine Watteau, Studies of Nine Heads,
1717–18, black and red chalk with white highlights.
Musée du Petit Palais, Paris

40 Two Sisters (On the Terrace) 1881

100.5 × 81 cm
Signed and dated lower right: Renoir. 81.
The Art Institute of Chicago, Mr. and Mrs.
Lewis Larned Coburn Memorial Collection,
1933.455
Daulte no. 378

PROVENANCE Sold by Renoir to Durand-
Ruel, 7 July 1881, for 1,500 francs; possibly
owned by Charles Ephrussi (1849–1905)
in 1883; with the Durand-Ruel family by
1892; purchased from Joseph Durand-Ruel,
New York, by Mrs. Lewis (Annie S.)
Coburn (d. 1932), Chicago,
4 February 1925, for $100,000.

EXHIBITIONS Impressionist Exhibition
1882, no. 138; Renoir 1883, no. 2 ("Les
deux Soeurs," as belonging to Charles
Ephrussi); New York 1886, no. 181, as
"On the Terrace"; Renoir 1892, no. 92;
Durand-Ruel Paris 1899, no. 81; Brussels
1904, no. 130; Salon d'Automne 1904,
no. 12; London 1905, no. 239; Zurich 1917,
no. 169.

REFERENCES Renoir 1973, no. 34; Moffett
1986, 387; Brettell 1987, 70–71, 119.

NOTES

1 "L'endroit le plus joli des alentours de Paris"
(Institut Néerlandais, Paris, Fondation Custodia,
Collection d'Autographes, Renoir ["chez
Madame Fournaise, dans l'île de Chatou"] to de
Bellio, undated, autumn 1880). On Renoir's
paintings done at Chatou see the magisterial
analysis in Herbert 1988, 246–254.

2 "Il clôt, en effet, la série des scènes de la vie
populaire des parisiens. À partir de ce moment-
là, on ne reverra guère le peintre travailler au
Moulin, à Bougival, ou Place Pigalle" (Rivière
1921, 187).

3 House and Distel 1985, 222–223; Herbert 1988,
246.

4 Laÿ 1993, 281–286.

5 "Il en affectionnait particulièrement le ciel
léger, la rivière au cours ondoyant, les arbres au
feuillage clair et les collines basses, dont la lignée
se perd dans l'horizon vaporeux" (Rivière 1921,
182).

6 "Je suis en lutte avec des arbres en fleurs, avec
femmes et enfants, et je ne veux rien voir au
delà . . . Il fait bien beau et j'ai des modèles:
voilà ma seule excuse" (Florisoone 1938, 40).

7 Gachet (1957, 93) published Renoir's letter to
Murer, dated "Chatou, 15 juin," in which he
noted "je travaille pas mal, et suis assez con-
tent."

8 Archives Durand-Ruel, Paris, 8 July 1881, no.
1451, "Femme sur une terrasse au bord de la
Seine, 1500 francs." The Rowers'Lunch (1875–76,
Art Institute of Chicago), entitled "Conversation
(bords de la Seine)," was purchased from
Renoir on the same day for 600 francs.

9 Daulte (1971, 411) and Distel (1993, 77) claim
that Two Sisters is set on the same terrace as
Luncheon of the Boating Party. Photographs and
plans of the Hôtel Fournaise (restored in 1988)

would suggest otherwise; see Lablaude 1983, 68–70, and Crespelle 1990, 83.

10 Herbert 1988, 246, citing Maupassant's "Yvette" for the identification of the *canotières*' dress.

11 See Marigene Butler's technical analysis of this painting in *Renoir* 1973, 209–214.

12 Dargenty (1883), referring in a vicious review of Durand-Ruel's exhibition to "la très modeste place qui lui assigne son petit talent," cited *Les Deux Soeurs* as one of the few paintings "que je me ferais un plaisir de louer sans réserve." Katow (1882) grouped the painting with *Luncheon of the Boating Party* and *At the Concert* as "des oeuvres d'un grand mérite."

13 On Hoschedé's brief tenure as editor-in-chief of this fashion magazine, launched in April 1880, see Wildenstein 1974–91, I, 116. "Parmi les pages capitales de l'oeuvre" (Alexandre 1892, 33); a full listing of the various titles under which *Two Sisters* was exhibited during Renoir's lifetime is provided at the beginning of this entry.

14 "Parmi toutes les femmes et tous les enfants que Renoir a peints depuis plus de vingt ans . . . il n'en est pas une seule qui ne soit demeurée d'une ineffable jeunesse. Elles sont . . . si effrontément modernes, quelle que soit la date de leur chapeau et de leur mantelet, que nous nous refuserons toujours, et bien d'autres après nous, à voir en elles des grand'mères" (Alexandre 1892, 26–27).

15 Renoir's construction of femininity is a contentious issue; see Garb 1985, 3–15, and Callen in House 1994, 41–51, for examples of the prevailing opinion on the subject.

16 "Les *Deux Soeurs*, deux bons portraits" (La Fare 1882).

17 "Les jeunes artistes cherchent . . . à dégager le contemporain des centres où il évolue" (Burty 1883).

18 Daulte 1971, 411.

19 Archives de Paris, 5Mi3/621, "Acte de naissance," Eugénie Marie Darlaud, born 25 January 1863 to Jean-Baptiste Darlaud, "relieur" (born 15 March 1838), and Adèle Colombe Marie Gabrielle Huard, "brocheuse" (born 11 February 1846). A younger sister, Anne Darlaud (1865–1937), posed for Manet's *Springtime* (private collection, New York) in the autumn of 1881, sitting to Renoir the following year (fig. 222). Anne Darlaud, best known by her stage name Jane Demarsy, was confused with the actress Marie-Louise Marsy (Mademoiselle Mars-Brochard) by Daulte (1971, 412) and Monneret (1978–81, I, 173). I hope to publish a more complete biography of her in a future article; for Renoir's *Mademoiselle Demarsy* (*Femme accoudée*) see, most recently, Christie's, New York, 11 May 1995, no. 112.

20 Her letter is published in *L'Entracte*, 11 August 1883.

21 Martin 1895, 104; Bibliothèque de l'Arsenal, Paris, RT6759–60, for press clippings relating to the actress.

22 Delhuis 1888; in the catalogue of the World Columbian Exposition it was noted that this portrait had made Brouillet (1857–1914), a pupil of Gérôme, "quite fashionable" (Hitchcock 1896, II, 181). To Penny Sullivan goes the credit for discovering Brouillet's forgotten portrait of Mademoiselle Darlaud.

23 Bibliothèque de la Comédie-Française, Paris,

"Engagement," 1899–1900, Mademoiselle Darlaud. Her contract, which ran from 1 April 1899 to 31 March 1900, stipulated "amoureuses, jeunes secondes rôles," and her monthly stipend was 300 francs.

24 "Nous voici dans une petite pièce avec trois chefs-d'oeuvre de Renoir . . . L'autre toile est le portrait d'une fille délicieusement joli dont Durand-Ruel ne se rappelle pas le nom. Renoir l'avait découverte à Argenteuil dans la misère et il lui demanda de poser en lui assurant ses repas. Elle fit plus tard du théâtre et devint une des étoiles du demi-monde" (Gimpel 1963, 181, entry for 16 October 1920). Although Gimpel does not give the title of the painting, its place in the inner sanctum of Durand-Ruel's apartment, alongside *Luncheon of the Boating Party* and *At the Concert*, identifies it as the *Two Sisters*.

25 Darlaud is listed as "menuisier-ébéniste" in the documents and was living in the rue Saint-André-des-Arts in Paris at the time of his death at age 74 (Archives de Paris, 5Mi3/1163, "Acte de décès," 12 May 1883, Léonard Darlaud).

26 "En possession, comme sa soeur, d'un puissant seigneur et maître, sans préjudice d'un élégant amant de coeur" (Peter 1945, 227).

27 Bibliothèque de la Comédie-Française, Paris, Dossier Darlaud, undated letter to Nepveu-Degas (librarian of the Comédie-Française between 1942 and 1949); Archives de Paris, DIP4/471, "Cadastre de 1876," 43 avenue de Friedland, for the date and price of Darlaud's purchase; Archives de l'Enregistrement, Paris, 22 March 1915, "Succession," Mademoiselle Darlaud, in which Menier is listed as the trustee of this *hôtel particulier*.

28 "Succession," as in note 27 above, her cash bequests totalling 574,000 francs. "La charmante Darlaud était aussi la bonne Darlaud" (Bibliothèque de l'Arsenal, Paris, RT6759–60, obituary notice, 30 April 1915).

29 "M. Menier a opté pour la nue propriété de l'hôtel dont la délivrance lui a été consentie par Mlle Demarsy" ("Succession," as in note 27 above).

30 Maxon in *Renoir* 1973, no. 34; Kelder 1980, 260.

31 Archives Durand-Ruel, Paris, as in note 8 above. Although it was still called "Les Deux Soeurs" in the 1883 retrospective, for the New York exhibition *The Impressionists of Paris* it was given the title "On the Terrace," by which it would be known henceforward; the one exception is Vollard's catalogue, where it is called "Sur le bord de l'eau" (Vollard 1918b, I, 84, no. 334).

32 "'Les deux Soeurs,' dit le Catalogue; 'Et ta Soeur!' dit le Public" (reproduced in Moffett 1986, 387).

33 "Son visage chafouin a une grâce mièvre et futée qu'accentuent l'obliquité malicieuse et l'affolant sourire des yeux. Elle a un regard de Joconde moderne qui sait l'amour, la séduisante effronterie d'une oeillade" (Lecomte 1892, 207).

34 Brettell 1987, 71.

35 "Cette esquisse molle et transparente, qui semble faite avec des ouates de différentes couleurs" (Bertall 1879, 86). Huysmans (1883, 59) had expressed similar reservations, referring to Renoir's handling as "d'un faire un peu mince et tricoté."

36 "C'était un 'tricotage' disait-on, comme de laines ou de soies multicolores" (Blanche 1921, 34).

37 "Estompées par des irisations isolées évoquant l'aspect de pelotes de laine semées sur le sol ou entassées dans une large corbeille" (Burty 1883).

38 "Renoir . . . il peut faire tout ce qu'il veut. Vous avez déjà vu un chat qui joue avec des pelotes de laine multicolore?" (Vollard 1938b, 115).

39 Herbert 1988, 246.

Fig. 217 Restaurant Fournaise, Chatou, c. 1890. Les Amis de la Maison Fournaise, Chatou, Collection Sirot-Angel

Fig. 218 Jeanne Darlaud, 1890s. Bibliothèque de l'Arsenal, Paris

Fig. 219 Jeanne Darlaud, 1890s. Bibliothèque de l'Arsenal, Paris

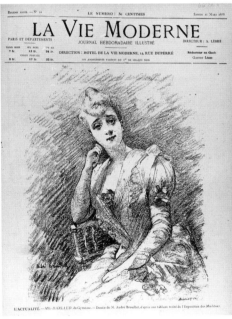

Fig. 220 André Brouillet, *Jeanne Darlaud*, 1888. From *La Vie Moderne*, 11 March 1888

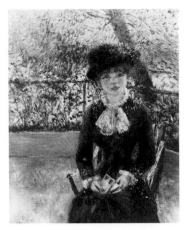

Fig. 221 Pierre-Auguste Renoir, *Young Girl Seated*, c. 1880. Private collection

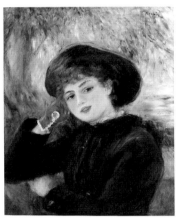

Fig. 222 Pierre-Auguste Renoir, *Mademoiselle Demarsy (Femme accoudée)*, 1882. Private collection

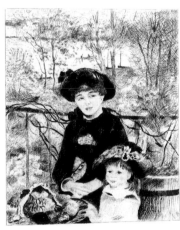

Fig. 223 A.-M. Lauzet, *La Terrasse (Two Sisters)*, etching after Renoir. From Lecomte 1892

41 *Joseph Durand-Ruel* 1882
81 × 65 cm
Signed and dated upper right: Renoir 82
Private collection, loan obtained with the
assistance of Durand-Ruel et Cie, Paris
Daulte no. 408

PROVENANCE Commissioned by
Paul Durand-Ruel (1831–1922), Paris;
Joseph Durand-Ruel (1862–1928), Paris;
Charles Durand-Ruel (1905–1985), Paris;
private collection.

EXHIBITIONS Munich 1912, no. 12;
Berlin 1912, no. 12; *Renoir* 1912, no. 5.

REFERENCES Adriani 1996, no. 67.

42 *Charles and Georges Durand-Ruel*
1882
65 × 81 cm
Signed and dated upper right: Renoir. 82.
Private collection, loan obtained with the
assistance of Durand-Ruel et Cie, Paris
Daulte no. 410; House/Distel no. 66

PROVENANCE Commissioned by
Paul Durand-Ruel (1831–1922), Paris;
Georges Durand-Ruel (1866–1931), Paris;
Charles Durand-Ruel (1905–1985), Paris;
private collection.

EXHIBITIONS Munich 1912, no. 11;
Berlin 1912, no. 11; *Renoir* 1912, no. 44.

REFERENCES *Renoir* 1973, no. 40; Adriani
1996, no. 68.

43 *Mademoiselle Marie-Thérèse Durand-Ruel Sewing* 1882
64.8 × 53.8 cm
Signed and dated lower left: Renoir. 82.
Sterling and Francine Clark Art Institute,
Williamstown, Mass., 613
Daulte no. 409

PROVENANCE Commissioned by Paul
Durand-Ruel (1831–1922), Paris; Madame
Félix André Aude, née Marie-Thérèse
Durand-Ruel (1868–1937), Paris; Knoedler
and Co., New York, London, and Paris;
acquired from Knoedler, Paris, by Robert
Sterling Clark, New York, 23 July 1935.

EXHIBITIONS *Renoir* 1883, no. 3; New
York 1886, no. 149; *Renoir* 1892, no. 89;
Durand-Ruel Paris 1899, no. 87; London
1905, no. 221; *Renoir* 1912, no. 45.

REFERENCES Kern 1996, 39, 41.

44 *The Daughters of Paul Durand-Ruel*
(Marie-Thérèse and Jeanne) 1882
81.3 × 65.4 cm
Signed and dated lower right: Renoir. 82.
The Chrysler Museum of Art, Norfolk, Va.,
Gift of Walter P. Chrysler, Jr., in memory
of Thelma Chrysler Foy, 71.518
Daulte no. 411

PROVENANCE Commissioned by Paul
Durand-Ruel (1831–1922), Paris; Madame
Félix André Aude, née Marie-Thérèse
Durand-Ruel (1868–1937), Paris; Wilden-
stein and Co., New York; purchased by
Thelma Chrysler Foy (d. 1957) from
Wildenstein, 1944; Parke Bernet Galleries,
New York, Foy sale, 13 May 1959, no. 15,
for $255,000, to Mrs. Foy's brother, the
collector Walter P. Chrysler, Jr. (1909–
1988), outbidding Charles Durand-Ruel,
Paris; given by Chrysler to the Chrysler
Museum of Art, 1971.

EXHIBITIONS *Renoir* 1883, no. 5; New
York 1886, no. 207; *Renoir* 1892, no. 1;
Durand-Ruel Paris 1899, no. 86; Munich
1912, no. 10; Berlin 1912, no. 10; *Renoir*
1912, no. 2; Zurich 1917, no. 170.

REFERENCES Amaya and Zafran 1978,
no. 24; Harrison 1986, no. 38.

NOTES

1 The phrase "des portraits en plein soleil" was
used by Renoir in an earlier letter to Madame
Charpentier (Florisoone 1938, 36).
2 Blanche 1927, 63.
3 "Les enfants Durand-Ruel posaient pour lui
dans un jardin de la côte de Rouen, sous des
marronniers aux feuilles mouvantes; le soleil
tachetait leurs joues de reflets incompatibles
avec le beau 'modelé plat' des éclairages d'ate-
lier" (ibid., 64).
4 For a sensitive appraisal of Renoir's *Charles and
Georges Durand-Ruel* see House and Distel 1985,
235.
5 "Vous pouvez y mettre les toiles que vous pos-
sédez sans mon autorisation. Elles sont à vous, et
je me refuse le droit de vous empêcher d'en dis-
poser comme vous l'entendrez, si c'est en votre
nom propre" (Venturi 1939, I, 121, Renoir to
Durand-Ruel, 26 February 1882).
6 "Je vous prierai de garder le restant pour quand
je rentrerai ou pour mes besoins à Alger si
Durand me lâchait" (Archives Durand-Ruel,
Paris, Renoir to Berard, from Algiers, undated,
early March 1882; see Appendix I).
7 "Durand-Ruel qui veut me faire faire toute sa
famille, et qui m'a retenu le mois d'août"
(Wemaëre-de Beaupuis 1992, no. 86, Renoir to
Berard, 22 June 1882). Blanche (1949, 441)
publishes a letter to his father from Dieppe,
dated 15 August 1882: "Dans ce moment, je
vois beaucoup Renoir." White (1984, 126), fol-
lowed by Adriani (1996, 222), curiously dates
Durand-Ruel's commission to mid-September,
despite the evidence of these letters.
8 On Renoir's *Jeanne Durand-Ruel* (1876, Barnes
Foundation, Merion, Pa.) see Distel in *Barnes*

1993, 48–49. On Durand-Ruel's background
and earlier career see Whiteley 1979 and the
concluding chapter in Whiteley 1995, 143–193.
9 "Je compte toujours sur vous pour me faire mes
petits panneaux de porte le plus tôt qu'il vous
sera possible" (Wildenstein 1974–91, II, 293,
Durand-Ruel to Monet, 26 May 1882).
10 Perruchot (1964, 202) noted that Durand-Ruel
deposited 17,761 francs with Renoir in 1882;
Monet had received over 31,000 francs from him
that year (Wildenstein 1974–91, II, 9).
11 Wildenstein 1974–91, II, 219, Monet to
Durand-Ruel, 6 July 1882, informing him that
he had found a house for August, "fort joliment
située," at a rent of 900 francs; ibid., II, 220,
Monet to Pissarro, 16 September 1882, noting
that he was "tout à fait en pays de connais-
sance," Renoir having visited the Villa Juliette
with Durand-Ruel. See also Herbert 1994, 44.
12 Blanche 1927, 62; Blanche 1949, 152, 443–444.
13 "Je suis encore dans la maladie des recherches"
(Venturi 1939, I, 116, Renoir to Durand-Ruel,
from Naples, 21 November 1882). "Plongé
dans ses recherches artistiques" (Drouot Rive
Gauche, Paris, *Livres anciens et modernes*, 22 June
1979, no. 70, Renoir to Berard, 26 November
1882).
14 See cat. no. 46.
15 "J'ai fait un fort four. Durand n'est pas je crois
très content des siens . . . je vais aller dans l'ate-
lier de Bonnat . . . Ne me parlez plus de por-
traits au soleil. Le joli fond noir, voilà le vrai"
(Archives Durand-Ruel, Paris, Renoir to
Berard, undated, autumn 1882).
16 "Votre portrait a besoin encore d'un an de
bouteille" (private collection, Renoir to Berard,
from Algiers, undated, mid-March 1882; see
Appendix I).
17 Archives departementales de la Dordogne,
5E317/105, "Acte de naissance," 14 November
1841, Jeanne Marie Lafon, where her father is
described as "horloger." On the connection
with Émile Lafon see Whiteley 1979, 27.
18 Whiteley 1979, 27; Archives de Paris,
5Mi3/527, "Acte de mariage," 4 January 1862,
Durand and Lafon, with Émile Lafon as one of
the bride's witnesses.
19 Archives de Paris, 5Mi3/188, "Acte de décès,"
27 November 1871, Lafon, femme Durand;
Godfroy 1995, II, 205–206. See also cat. no. 64.
20 Archives de Paris, 5Mi3/527, "Acte de nais-
sance," 26 November 1862, Joseph Marie Pierre
Durand, witnessed by his paternal grandfather,
Jean Marie Fortuné Durand, and a neighbour,
Georges Bruneau, "marchand de thé."
21 Archives Durand-Ruel, Paris, "Diplôme de
licencié ès lettres," awarded by the Faculté des
Lettres de Clermont, 28 February 1882; "Di-
plôme de bachelier en droit," awarded by the
Faculté de Droit de Paris, 21 November 1885.
22 Ibid., "Carnet militaire," 12th *regiment des chas-
seurs*, 4 November 1882.
23 Adriani 1996, 221.
24 "Il est très marchand parait-il, il a de l'influence
sur son père" (Pissarro *Correspondance*, II, 251).
25 "Joseph Durand-Ruel, le fils, plaisait à Renoir
par sa précision" (Renoir 1981, 357).
26 Archives Durand-Ruel, Paris, "Certificat de
mariage" (Mairie du 9ᵉ arrondissement, Paris),
22 September 1896. *L'Indicateur de Bayeux* (29
July 1887), in reporting that Jenny Lefébure had
won first prize at the Conservatoire de Paris,

noted that she was the granddaughter of
Madame Auguste Lefébure, "qui dirige depuis
de longues années l'importante maison de den-
telles si connue dans le monde entier."
27 *Le Monde Musical* (30 September 1896) reported
that the wedding had taken place at the Église
Saint Vincent-de-Paul, "au milieu d'un nom-
breux et très brillant auditoire," with Puvis de
Chavannes and Degas as the groom's witnesses.
On Pissarro's invitation to the wedding see
Pissarro *Correspondance*, IV, 256.
28 Pissarro *Correspondance*, IV, 292–293, Pissarro to
Durand-Ruel, 6 November 1896, asking for
news of "les jeunes mariés" in New York.
"Joseph est toujours gardien de la maison à
New York. Il y a souffert énormément de la
chaleur" (Godfroy 1995, I, 82, Durand Ruel to
Renoir, 31 August 1892).
29 Sotheby's, London, 22 June 1993, no. 9;
Godfroy 1995, II, 86, 254, for Renoir's portrait
of Madame Joseph Durand-Ruel (private col-
lection), which advanced slowly since Renoir
was "très fatigué actuellement et travaille à
peine une heure et demie par jour."
30 Archives de Paris, 5Mi3/531, "Acte de nais-
sance," 11 January 1865, Charles Marie Paul
Durand, witnessed by Eugène Quevauvillers,
jeweller, and Claude Paris, "garçon de maga-
sin"; ibid., 5Mi3/533, "Acte de naissance," 4
August 1866, Georges Marie Jean Hugues
Durand, witnessed by Georges Bruneau,
"marchand de thé," and Hugues Merle, "artiste
peintre."
31 Pissarro *Correspondance*, II, 35, 64, 73; Weitzen-
hoffer 1986, 40–42.
32 Godfroy 1995, I, 59, for Renoir's letter of 18
January 1888 addressed to "cher Monsieur
Charles"; Mathews 1984, 231, Cassatt to Sara
Hallowell, 23 July 1892. "Sans avoir de titre
officiel, il était pour la section française des
Beaux-Arts l'un des organisateurs les plus
occupés de la prochaine exposition universelle
de Chicago" (*Journal des Arts*, 23 September
1892).
33 "Nous allons tous bien. Charles et Georges sont
en Hollande" (Godfroy 1995, I, 82, Durand-
Ruel to Renoir, 31 August 1892). See Pissarro
Correspondance, III, 258, for Lucien's letter of 16
September 1892 to his father: "Charles Durand
est au lit avec une inflammation des intestins."
34 "La mort du fils Durand-Ruel qui était l'âme de
la maison Durand-Ruel" (Pissarro *Correspon-
dance*, III, 264). For Cassatt's letter to Bertha
Palmer, 1 December 1892, see Mathews 1984,
241.
35 *New York Tribune*, 8 May 1931, for information
about his schooling; Archives Durand-Ruel,
Paris, "Demande de la Légion d'Honneur," 6
November 1929, for his university education.
36 Weitzenhoffer 1986, 135. His obituary in the
New York Tribune, 8 May 1931, noted that he
and Joseph spent alternate years in New York.
37 Renoir 1981, 360–361.
38 "Ma mère aurait voulu marier Jeanne Baudot et
Georges Durand-Ruel" (ibid., 358). Jeanne
Baudot was Jean's godmother.
39 Mairie de Brantôme, "Acte de mariage," 24
July 1918, Durand-Ruel and Tierney.
40 Archives of the Metropolitan Museum of Art,
New York, Cassatt to Mrs. H.O. Havemeyer,
16 August 1918.
41 Archives de Paris, 5Mi3/539, "Acte de naissance,"

1 September 1868, Marie Thérèse Durand. Her great-uncle, the painter Émile Lafon, was her godfather.

42 Parker 1984, 11.

43 Marie Ferdinande Ruel (1795–1870) had been born in Leghorn (Delavenne 1955, II, 163).

44 Daulte 1971, no. 549; Godfroy 1995, I, 63, Renoir to Durand-Ruel, undated, autumn 1888, referring to the "portrait monotone de votre fille."

45 "Durand marie une de ses filles à un ingénieur, il doit être comme tu pense très occupé car cela doit avoir lieu bientôt m'a-t-on dit, cela m'étonne après le deuil si récent du fils" (Pissarro *Correspondance*, IV, 532, Pissarro to Lucien, 28 February 1893). Pissarro seems to have been in error as to the profession of Marie-Thérèse's future husband. For Cassatt's fine pastel *Madame Aude and Her Two Daughters* (1899) see Breeskin 1970, 136, no. 307.

46 Mairie du 8ᵉ arrondissement, Paris, "Acte de mariage," 23 May 1893, Aude and Durand.

47 Archives de Paris, 5MI3/690, "Acte de naissance," 30 May 1970, Jeanne Marie Aimée Durand, witnessed by the landscape painter Émile van Marcke (1827–1893), a protégé of Durand-Ruel's from a prior generation.

48 Renoir's comment to Madame Charpentier; see note 66 below.

49 "J'apprends avec grand plaisir la nouvelle du prochain mariage de votre fille Jeanne avec M. Dureau" (Pissarro *Correspondance*, III, 340, Pissarro to Durand-Ruel, 3 July 1893).

50 Mairie du 8ᵉ arrondissement, Paris, "Acte de mariage," 5 September 1893, Dureau and Durand; "Ce que je ne comprends pas, c'est que m'ayant écrit une lettre exprès pour m'annoncer les fiançailles, je n'ai pas été invité au mariage" (Pissarro *Correspondance*, III, 366, Pissarro to Lucien, 10 September 1893).

51 "Je reçois une lettre de Vollard, me disant que vous avez quelqu'un qui vous touche très malade. Je crois deviner qui et ce serait bien malheureux" (Godfroy 1995, II, 88, Renoir to Durand Ruel, 12 January 1912).

52 "J'écris de suite à ma femme . . . Elle va être très affectée de la mort de cette pauvre Jeanne qui a tant souffert" (ibid., II, 144, Renoir to Durand-Ruel, 30 April 1914).

53 White (1984, 126) characterized the group as having "a new sculptural and hard edge quality, as well as a stiffness of posture." Venturi (1939, I, 62) described the commission as an opportunity for Renoir "de souligner son réalisme."

54 See House and Distel 1985, 235, and Maxon in *Renoir* 1973, no. 40.

55 White 1969 remains the standard account.

56 "Mais les fresques, c'est admirable de simplicité et de grandeur" (Godfroy 1995, I, 15, Renoir to Durand-Ruel, 21 November 1881). "Allez voir le musée de Naples. Pas les peintures à l'huile, mais les fresques. Passez-y votre vie" (White 1969, 347, Renoir to Deudon, December 1883).

57 "Je parie que l'on dira que j'ai été influencé!" (ibid., 347).

58 "Les sculpteurs sont des veinards, leurs statues sont en soleil et quand elles sont de forme pure elles font partie de la lumière, elles existent dans la nature comme un arbre" (Drouot Rive Gauche, Paris, *Livres anciens et modernes*, 22 June 1979, no. 69, Renoir to Berard, from Venice, 1 November 1881 [not in White 1969]).

59 "Les sculptures mutilées éparses dans les musées, les ruines des monuments antiques lui répétaient la leçon donnée par les peintres" (Rivière 1921, 193).

60 Spinazzola 1928, 46.

61 Although Renoir did not visit Tuscany in 1881–82, he would have been alerted to the "great Florentines" by Ephrussi, who in February 1882 had acted as the Louvre's intermediary in the acquisition of Botticelli's frescoes *Giovanna degli Albizzi Receiving a Gift of Flowers from Venus* and *Lorenzo Tornabuoni Presented by Grammar to Prudentia and the Other Liberal Arts* (Lightbown 1978, I, 60–61).

62 White 1969, 69.

63 Meier-Graefe (1912, 106) noted astutely that while Renoir's Italian sojourn was responsible for the new direction in his art, "les tableaux qu'il peignit en Italie n'apportent aucun trait important nouveau à l'évolution qui nous occupe."

64 Adriani 1996, 224. Manet's *In the Conservatory* had appeared at the Salon of 1879, albeit in a different room from Renoir's *Madame Charpentier and Her Children* (cat. no. 32).

65 Rivière 1921, 198.

66 "Les grandes harmonies sans plus me préoccuper de petits détails qui éteignent le soleil au lieu de l'enflammer" (Florisoone 1938, 36, Renoir to Madame Charpentier, undated, January–February 1882).

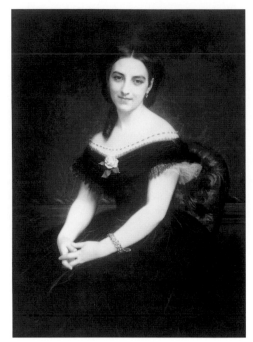

Fig. 225 Hugues Merle, *Madame Paul Durand-Ruel, née Eva Lafon*, 1865. Private collection

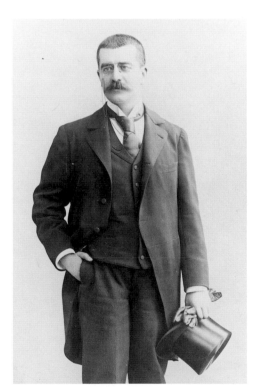

Fig. 224 Joseph Durand-Ruel, August 1896, photograph by Reutlinger. Archives Durand-Ruel, Paris

Fig. 226 Hugues Merle, *Joseph Durand-Ruel*, 1864. Private collection

Fig. 227 Charles Durand-Ruel, second son of Paul
Durand-Ruel, c. 1886. Archives Durand-Ruel, Paris

Fig. 229 Georges Durand-Ruel, third son of Paul
Durand-Ruel, c. 1886. Archives Durand-Ruel, Paris

Fig. 232 Marie-Thérèse Durand-Ruel, summer 1890.
Archives Durand-Ruel, Paris

Fig. 228 Madame Joseph (Jenny) Durand-Ruel posing for her portrait with
Renoir, at Saint-Cloud, July 1911. Archives Durand-Ruel, Paris

Fig. 230 *Portrait of a Baker and His
Wife*, Pompeian fresco. Museo
Archeologico Nazionale, Naples

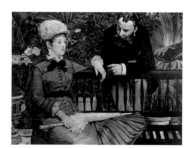

Fig. 233 Édouard Manet, *In the
Conservatory*, 1879. Nationalgalerie,
Berlin

Fig. 231 *Young Girl Sewing*,
Hellenistic relief. Museo Archeologico
Nazionale, Naples

45 *Dance at Bougival* 1883
182 × 98 cm
Signed and dated lower right: Renoir. 83.
Museum of Fine Arts, Boston, Picture
Fund, 37.375
Daulte no. 438; House/Distel no. 67

PROVENANCE Deposited by Renoir with
Durand-Ruel 16 April 1883, but not
acquired by him until late 1886; sold by
Durand-Ruel to the collector Félix-
François Depeaux (1853–1920), Rouen,
2 January 1894, for 13,000 francs; Galerie
Georges Petit, Paris, Depeaux sale,
31 May–1 June 1906, no. 38, bought for
47,000 francs by his brother-in-law,
Edmond Decap; Barret-Decap collection,
Biarritz; sold by Barret-Decap to Paul
Brame (1898–1971), Paris; Anthony H.
Manley, Paris, 1936, a lawyer associated
with the American Embassy; acquired
through Seligmann and Co., New York, by
the Museum of Fine Arts, Boston, 15 April
1937.

EXHIBITIONS London 1883; New York
1886, no. 204; *Renoir* 1892, no. 83.

REFERENCES Cooper 1954, 26; Adhémar
1978; Shapiro 1991, no. 152; Berman 1993,
633–634.

NOTES

1 *The Academy*, 5 May 1883, quoted in part in
Cooper 1954, 26. *Dance at Bougival* had not
arrived in time for the opening of the exhibi-
tion on 20 April 1883, which was reviewed in
The Academy on 28 April 1883.

2 See Rewald 1973, 482, and House and Distel
1985, 236; these exhibitions are not included in
Daulte 1971, no. 438.

3 *Renoir* 1892, no. 83. It seems to have received
less attention at this exhibition than *Dance in the
Country* and *Dance in the City* (figs. 235, 237),
which now hung as a pair in Durand-Ruel's
salon; see, for example, Lecomte 1892,
147–152, and Alexandre 1892, 33.

4 Archives Durand-Ruel, Paris, D3958, 16 April
1883; House and Distel 1985, 236. Adhémar
(1978, 201) erroneously dated Durand-Ruel's
acquisition of all three "Dance" pictures to 25
August 1891.

5 "*La Danse* et le *Bouquet de chrysanthèmes* qui fai-
saient partie de ma collection particulière n'en
sont sortis que sur l'affirmation que vous
désiriez les présenter au Musée de Rouen. Sans
cette promesse formelle je n'aurais pas consenti
à m'en dessaisir" (House and Distel 1985
[French edition], 28, n. 59, Durand-Ruel to
Depeaux, 10 February 1906).

6 See Adhémar 1978, 201–204, and House and
Distel 1985, 235–238.

7 Adhémar 1978, 201; Gaunt and Adler 1982, no.
38; Monneret 1989, 96.

8 Somewhat perversely, Renoir refrained from
sending full-length subject pictures to the Salon,
ignoring Berard's suggestion that he exhibit
Deudon's *Dancer* (1874, National Gallery of
Art, Washington) at the Salon of 1882: "Je crois

que ça ne fera aucun effet dans ces grandes
salles" (Getty Center for the History of Art and
the Humanities, Santa Monica, Calif., Special
Collections, Renoir to Berard, from Marseilles,
undated, early March 1882; see Appendix I).

9 "Rue d'Orchampt, j'ai posé aussi pour un motif
de Bougival" (Tabarant 1921, 627). This is the
only record of Renoir having painted at this
address.

10 House and Distel 1985, 235, following Gaunt
and Adler 1982, no. 38. Rivière (1921, 64) mis-
takenly dated all three panels to 1882.

11 House in House and Distel 1985, 221.

12 Ibid., 236.

13 "Les éléments du style qui donne aux danseurs
une fermeté statuaire" (Meier-Graefe 1912, 110).

14 Considered by House (House and Distel 1985,
236) – though not by the present author – to
show the influence of Cézanne's diagonal
hatchings, thus supporting an earlier dating,
since Renoir had worked alongside Cézanne at
L'Estaque in January 1882.

15 There are slight shiftings of the contours at the
dancer's bustle, just below the oarsman's hand,
and at the lower edge of the dress at right.
Renoir also made revisions to the thinly applied
foreground by scraping away the paint from this
area.

16 On the drawing see Plaut 1937, 31, and Rishel
1987, 34. House (House and Distel 1985, 236)
was the first to relate this inscription ("She was
waltzing deliciously abandoned, in the arms of
a fair-haired man with the air of an oarsman")
to Lhote's short story.

17 For the rare first etching see Frost 1944, 5. The
two preparatory drawings are reproduced in
Vollard 1918b, I, nos. 40, 161, where they are
both dated incorrectly to 1883.

18 See François Fossier's careful analysis of the dif-
ferences between the etching and the original
composition in *Renoir* 1993, 154; however,
Fossier is in error in suggesting that the model
for the female dancer was Aline Charigot.

19 The drawing appeared most recently at Sotheby
Parke-Bernet, New York, 11 April 1963, no.
36.

20 "Lhote servit de modèle à Renoir dans les trois
panneaux" (Rivière 1921, 64). Rewald (1973,
483) is the only author to have disputed this,
claiming that the oarsman was modelled for by
Edmond Renoir.

21 Lhote's "Mademoiselle Zélia" was published in
La Vie Moderne on 3 November 1883; "Un idéal"
appeared in the same magazine on 8 December
1883. Both were illustrated by Renoir.

22 Rivière 1921, 63–64, noting furthermore that
Lhote died of pneumonia (it has not been pos-
sible to reconstruct his *état civil*).

23 Archives de Paris, V4E/6227, "Acte de mariage,"
14 April 1890, Renoir and Charigot, where
Lhote is described as "journaliste, âgé de 39 ans"
and his address is given as 34 rue Notre-Dame-
des-Victoires, the headquarters of the Agence
Havas; see Frédérix 1959, 149.

24 Rivière 1921, 187.

25 "Lauth [sic] qui était myope comme une taupe"
(Vollard 1919, 106). Similar stories are told in
Renoir 1981, 197–198.

26 There is something of a cottage industry in
Valadon studies. Pétridès 1971 remains the stan-
dard biography. Also useful are Beachboard
1952, 16–38; Rosinsky 1994, 15–24, 120–125;

Brade 1994, 11–28; and Rosinsky's chronology
in *Suzanne Valadon* 1996, 247–259.

27 Mairie de Bessines (Haute-Vienne), "Acte de
naissance," 23 September 1865, Marie Valadon.
Marie-Clémentine was born to Madeleine
Valadon, "lingère," aged 34 years; the name of
her father was not recorded ("et de père
inconnu"). Pétridès (1971, 17) is the only
author to suggest that Valadon performed with
the Cirque Fernando, which Renoir was
known to have frequented (see cat. no. 35).

28 This is how she is identified in the birth certifi-
cate of her son Maurice Utrillo; see Archives de
Paris, 5Mi3/1487, "Acte de naissance," 23
December 1883, Maurice Valadon (surname
changed to Utrillo), "fils de Marie Valadon,
âgée de dix-huit ans, couturière."

29 *Puvis de Chavannes* 1977, 191–195.

30 His letters to her are reproduced in Rey 1922,
8–10.

31 Much of her wealth was squandered by her
second husband, André Utter (1886–1948), a
mediocre painter twenty-one years her junior
whom she married in September 1914 and who
acted as Utrillo's dealer until his contract was
taken over by Bernheim-Jeune (Dauberville
1967, 469–472).

32 As well as posing for *La Natte* (1885, Stiftung
"Langmatt," Baden), Suzanne Vala don was the
principal model for Renoir's *Great Bathers*
(1884–87, Philadelphia Museum of Art; prepa-
ratory red-chalk drawing in the Fogg Art
Museum, Cambridge, Mass., Wertheim collec-
tion), for which she posed in his studio on the
boulevard de Clichy (Tabarant 1921, 627).
Renoir's small profile portrait of her, painted in
1885, is now in the National Gallery of Art,
Washington.

33 "Il m'emmenait chez les modistes; il ne cessait
pas d'acheter beaucoup de chapeaux" (Coquiot
1925, 96–97).

34 Archives Durand-Ruel, Paris, D3958, 16 April
1883.

35 House and Distel 1985, 236; New York 1886,
no. 204; *Renoir* 1892, no. 83; *Catalogue des tableaux
modernes . . . composant la collection Depeaux*, Paris,
31 May 1906, no. 38.

36 Lhote (1883, 708) describes the dancer "aux
allures de canotier" as "le plus savant valseur du
Moulin," by which he refers to the Moulin de
la Galette, Debray's dance hall on the butte
Montmartre.

37 Baedeker 1884, 293. Edmond Renoir insisted
upon the difference between Bougival, where a
day's outing could cost "une centaine de francs
de dépense," and the less salubrious La
Grenouillère, preyed upon by "une vieille
garde mal mise, jalouse, acerbe . . . le soir quand
on danse, c'est elle qui fait des folies" (Renoir
[Edmond] 1883a, 557).

38 Baedeker 1884, 293. "De tous temps Bougival a
été adoré des gens de lettres et des artistes"
(Renoir [Edmond] 1883c, 622). Brettell (1984,
79–87) provides a good summary of the
Impressionists in Bougival.

39 "Bougival est avec Montmartre et ses artistes . . .
un des trois endroits où se refait (!) la langue"
(Renoir [Edmond] 1883a, 557).

40 Herbert 1988, 136–139.

41 Berman 1993, 633.

42 Lhote (1883, 703) described Mademoiselle
Zélia's scarlet hat with its wide flaps as "un cha-

peau de grand'mère." The entry on *Le Bal* in the Depeaux sale catalogue (cited in note 35 above) referred to Valadon's hat as "un chapeau Niniche." See also Auvers 1993, 98.

43 The Depeaux catalogue (cited in note 35 above) described her hair as "les cheveux à la chien," a style introduced in Paris in 1883, according to the *Grand Robert* (Paris, 1985), II, 564.

44 These positions correspond to the photographic demonstrations of "Low Class Style" and "Good Style" in Edward Scott's *Dancing as an Art and Pastime* (London, 1892), plates 27, 29.

45 "Ces républicaines qui s'habillent à neuf avec un louis et s'embaument avec un bouquet d'un sou" (Vallès 1971, 363, from his article "Le Dimanche," published in *Gil Blas*, 25 May 1883).

46 Gasnault 1982, 8–18; Gasnault 1986.

47 Gasnault (1980, 395–396) notes that Paris boasted over 320 balls in the 1840s and that by 1851 their number had fallen to around 200; for an excellent summary of the fortunes of the dance hall in the 1880s see Thomson in *Toulouse-Lautrec* 1991, 238–239.

48 Berlanstein 1984, 124–128; Thomson in *Toulouse-Lautrec* 1991, 226–230, 242–243.

49 As in, for example, *Bal du Moulin de la Galette* (1889, Art Institute of Chicago) and *At the Moulin-Rouge: The Dance* (1889–90, Philadelphia Museum of Art). Toulouse-Lautrec's most poignant dance painting, *Au Moulin Rouge, les deux valseuses* (1892, Narodni Gallery, Prague), shows two lesbians waltzing.

50 On Toulouse-Lautrec's painting see O'Brian 1988, 81–83.

51 "Les bals sont restés ce qu'ils ont toujours été, les seuls endroits où l'amusement soit de bon aloi" (Renoir [Edmond] 1883b, 590).

52 "On dit que c'est un petit rendez-vous très agreste d'un monde très léger et que, si l'on y va seul on revient au moins deux" (Morisot *Correspondance*, 20, Marie-Cornélie Morisot to Berthe Morisot, 19 August 1867).

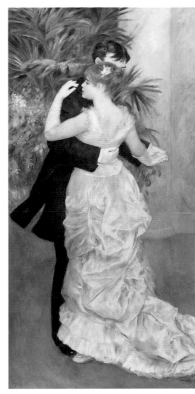

Fig. 235 Pierre-Auguste Renoir, *Dance in the City*, 1883. Musée d'Orsay, Paris

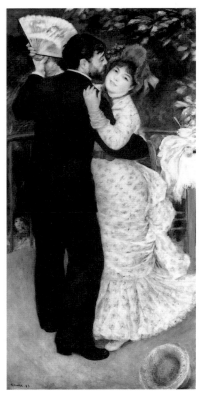

Fig. 237 Pierre-Auguste Renoir, *Dance in the Country*, 1883. Musée d'Orsay, Paris

Fig. 234 After Winslow Homer, *A Parisian Ball – Dancing at the Mabille, Paris*, 1867, wood engraving. Museum of Fine Arts, Boston, Gift of Edward J. Holmes

Fig. 236 Pierre-Auguste Renoir, *Dancing Couple: Dance at Bougival*, 1883, pen and ink. Philadelphia Museum of Art, The Henry P. McIlhenny Collection in memory of Frances P. McIlhenny

Fig. 238 *Bal des Canotiers*, colour poster, c. 1880. Les Amis de la Maison Fournaise, Chatou, Collection Jean Hournon

Fig. 239 Suzanne Valadon and her son Maurice Utrillo, c. 1890. Galerie Gilbert et Paul Pétridès, Paris

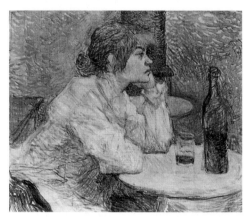

Fig. 240 Henri de Toulouse-Lautrec, *The Drinker* (*Suzanne Valadon*), c. 1887–88. Fogg Art Museum, Harvard University Art Museums, Cambridge, Mass., Bequest of Maurice Wertheim, Class of 1906

46 *Madame Clapisson* 1883
81.8 × 65.2 cm
Signed and dated upper left: Renoir 83.
The Art Institute of Chicago, Mr. and Mrs. Martin A. Ryerson Collection, 1933.1174
Daulte no. 433; House/Distel no. 70

PROVENANCE Commissioned by Louis Léon Clapisson (1836–1894) for 3,000 francs; sold to Durand-Ruel by Madame Clapisson (1849–1830), 12 November 1908, for 15,000 francs; purchased from Durand-Ruel by Martin A. Ryerson (1856–1932), Chicago, 8 July 1913, for $12,000; given by Mr. and Mrs. Ryerson to the Art Institute of Chicago, 1933.

EXHIBITIONS Salon 1883, no. 2031; Georges Petit Paris 1886, no. 125; Durand-Ruel Paris 1910, no. 43.

REFERENCES *Renoir* 1973, no. 45.

NOTES

1 "Le portrait deuxième édition de Madame Clapisson" (Drouot Rive Gauche, Paris, *Lettres et manuscrits autographes*, 22 June 1979, no. 119, Renoir to Berard, undated, probably early 1883).

2 On Clapisson see the essay above by Anne Distel, pages 77–86.

3 Archives de Paris, V2E/5476, "Acte de naissance," 24 October 1849, Marie Henriette Valentine Billet, born 20 October 1849 in the rue d'Anjou Dauphine (now the rue de Nesle), attached to the act of 28 April 1865 by which Henri Hippolyte Sophie Romain Billet recognized his daughter; in the birth certificate, Valentine's mother, Virginie Marie Eléonore Louise Roch, is described as "rentière."

4 Mairie de Sannois, "Acte de mariage," 20 May 1865, Clapisson and Billet.

5 Service Historique de l'Armée de Terre, Vincennes, 29099, "Clapisson, Léon, Rentier, Marié, Père d'un enfant." This document, which is undated, seems to have been drawn up in March 1877, when Clapisson resigned his commission of lieutenant in the 11th *régiment d'infanterie* in the Armée Territoriale.

6 See Distel above, page 85, note 19.

7 Vollard 1919, 92–93; Robida 1958, 23.

8 "Chez ceux-ci (Georges Charpentier excepté), ç'a été du cambouis décoloré; chez ceux-là (Léon Clapisson excepté), ç'a été du cold-cream réchauffé" (d'Hervilly, "La Maison, la question de la sauce blanche!" *La Vie Moderne*, 5 June 1879).

9 "Le malheureux portrait qui ne vient pas" (Wemaëre-de Beaupuis 1992, no. 86, Renoir's annotation to the pen sketch of *Dans les roses* [fig. 94], illustrating his letter to Berard of 22 June 1882; the drawing was published without the accompanying letter in Berard 1968, 54).

10 "Je passe toutes mes journées à rentrer ma toile . . . Je fais mettre tous les jours une robe printanière à une femme exquise . . . et tous les jours la même chose" (Renoir to Berard, as in note 9 above).

11 The date of Clapisson's rejection of the portrait of his wife is not known, but in the autumn of

1882 Renoir admitted to Berard: "Ça ne va pas dans ce moment. Il faut que je recommence le portrait de Madame Clapisson. J'ai fait un fort four" (Archives Durand-Ruel, Paris, Renoir to Berard, undated).

12 "Un premier portrait de Madame Clapisson, exécuté dans les tons très clairs et avec des fleurs de couleurs vives mises autour du modèle, était trop hardi" (Duret 1924, 70).

13 As Renoir noted to Berard in early June 1882, Clapisson would also have bought *Seated Algerian Girl* (1881, Museum of Fine Arts, Boston): "Ce monsieur vient d'acheter à Durand la petite mosquée, mon petit domestique Kabile et un buste de négresse, il voulait acheter la Jeune fille algérienne, mais Durand n'a pas voulu" (Archives Durand-Ruel, Paris, Renoir to Berard, undated).

14 *Manet* 1983, 477. I owe this suggestion to John Collins.

15 "MM. les membres du jury n'ont pas pu (pour l'admission) s'empêcher de s'écrier que sa peinture était un Delacroix 'blond.' Quelle médaille peut valoir cette appréciation d'adversaires" (Venturi 1939, II, 97, Brown to Durand-Ruel, 5 September 1883).

16 The price is recorded in Clapisson's account book; see Appendix II below.

17 Renoir lunched with Monet "chez M. Clapisson" on 4 May 1884 (Venturi 1939, I, 278), and as late as October 1886 he may have hoped to sell him a landscape of Brittany. "Clapisson m'a toujours embêté avec la mer sauvage. Il sera content de voir des études de ce coin-là" (Hôtel Drouot, Paris, *Lettres autographes*, 19 June 1970, no. 138, Renoir to Monet, 15 October 1886).

18 "Cette charmante Madame Clapisson, dont je fis deux portraits, avec quel plaisir!" (Vollard 1919, 92–93).

19 "Je ne vois pas bien comment il viendra en ressemblance, je n'y vois plus rien" (Drouot Rive Gauche, Paris, *Lettres et manuscrits autographes*, 22 June 1979, no. 119, Renoir to Berard, undated, early 1883).

20 House and Distel 1985, 238.

21 Duret 1924, 70.

22 See the useful technical analysis by Marigene Butler in *Renoir* 1973, 209–214. The observation that Renoir is far from adopting the solution of a Bonnat was first made in House and Distel 1985, 238. On Renoir's allusion to "le joli fond noir," see also note 15 at cat. nos. 41–44 above.

23 Duret 1924, 70, describing the second portrait as "de tons plus sobres."

Fig. 241 Édouard Manet, *The Bench* (*Un jardin*), 1881. Private collection

Fig. 242 Jean Béraud, *Coquelin the Younger Reciting a Monologue*, 1882. Private collection

Fig. 243 Henri Gervex, *Avant le bal*, 1888. Private collection

47 *Child in a White Dress* (*Lucie Berard*)

1883

61.7 × 50.4 cm

Signed and dated upper right: Renoir. 83.
The Art Institute of Chicago, Mr. and Mrs.
Martin A. Ryerson Collection, 1933.1172
Daulte no. 449

PROVENANCE Paul Berard (1833–1905),
Wargemont and Paris; Galeries Georges
Petit, Paris, Berard sale, 8 May 1905,
no. 20, sold for 10,030 francs to the husband
of the sitter, J.E.D. Pieyre Lacombe de
Mandiargues (1879–1916); purchased from
Bernheim-Jeune, Paris, by Martin A.
Ryerson (1856–1932), Chicago, 26
February 1913, for 23,500 francs; given by
Mr. and Mrs. Ryerson to the Art Institute
of Chicago, 1933.

EXHIBITIONS Salon d'Automne 1905,
no. 1322; *Renoir* 1913, no. 25.

REFERENCES *Renoir* 1973, no. 46; Daulte
1974, 5.

NOTES

1 Archives de Dieppe, 12, "Acte de naissance," 12
July 1880, Lucie Louise Berard, noting that she
had been born at the château de Wargemont on
10 July 1880. Cassatt's portrait of Lucie, *Baby in
a Striped Armchair* (1880–81, private collection),
is discussed in Lindsay 1985, 52.

2 Mairie du 9ᵉ arrondissement, Paris, 390, "Acte
de mariage," 11 April 1905, Pieyre Lacombe de
Mandiargues and Berard, noting that the bans
were published at the 8th and 9th arrondisse-
ments on 12 and 19 March, and that the mar-
riage contract was notarized by Maître Tollu on
23 March 1905.

3 Archives Nationales, Paris, Archives de la
Légion d'Honneur, 184/50, "Acte de décès,"
Berard, which notes that he died "à son domi-
cile, rue Pigalle 20, le trente-un [sic] mars
dernier"; his son-in-law Alfred Berard and son-
in-law designate David Pieyre de Mandiargues
are listed as witnesses.

4 Berard 1937, 58, noting that he received the
Médaille Militaire, the Croix de Guerre, and
the Military Cross; his record states that "[il]
s'est signalé par sa bravoure et a toujours donné
le meilleur exemple de sang-froid et d'entrain."

5 I am grateful to Alain Pieyre de Mandiargues for
this information.

6 For a sensitive analysis see *Renoir* 1973, 46.

7 Ibid., 211, for a listing of the pigments used in
Child in a White Dress.

8 "J'ai commence le portrait deuxième édition de
Madame Clapisson et je ne vois pas bien com-
ment il viendra en ressemblance, je n'y vois plus
rien. Ça me remettra la main pour dès que vous
serez arrivés commencer Lucie" (Drouot Rive
Gauche, Paris, *Lettres et manucrits autographes*, 22
June 1979, no. 119, Renoir to Berard, undated,
assigned to early 1883 in White 1984, 129).

9 See my essay above, page 19.

10 "Je suis, d'ailleurs, épouvanté de la difficulté
qu'on rencontre à faire accepter sa peinture. J'ai
fait les frais d'un beau cadre pour le portrait de
Lucie, je l'ai accroché en bonne place dans mon

cabinet et Marguerite et moi nous pâmons de
contentement devant lui. Mais nous ne pou-
vons faire partager notre satisfaction et ce por-
trait, si différent des portraits genre Hencker
[sic], épouvante les gens" (Distel 1989a, 62,
Berard to Deudon, 12 December 1883). As
Anne Distel has noted, "Hencker" is probably a
misprint for "Henner."

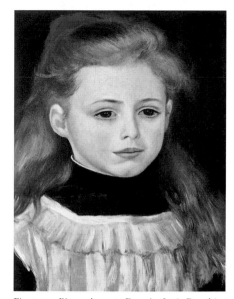

Fig. 244 Pierre-Auguste Renoir, *Lucie Berard in
a White Pinafore*, 1884. Private collection

Fig. 245 Jean-Jacques Henner, *Alsatian Girl*,
1873. National Gallery of Art, Washington,
Chester Dale Collection

48 *Paul Haviland* 1884
57 × 43 cm
Signed and dated lower left: Renoir 84
The Nelson-Atkins Museum of Art, Kansas
City, Mo., Purchase: Nelson Trust, 55-41
Daulte no. 454; House/Distel no. 73

PROVENANCE Commissioned by the
porcelain manufacturer Charles Haviland
(1839–1921), Paris; Paul Haviland (1880–
1950), Paris and Yzeures-sur-Creuse; Paul
Haviland's widow, Suzanne Lalique (1892–
1989), Paris, until 1952; purchased from
Wildenstein and Co., New York, by the
William Rockhill Nelson Gallery of Art,
Kansas City (now the Nelson-Atkins
Museum of Art).

EXHIBITIONS Not exhibited in Renoir's
lifetime.

REFERENCES Gerstein 1989, no. 74;
House 1994, no. 24.

NOTES
1 Fry 1907, 104.
2 Maxon in *Renoir* 1973, no. 48.
3 For a rather different view of the degree of
 "specificity of either personality or physiog-
 nomy" in this portrait see the otherwise well-
 documented account in Gerstein 1989, 170.
4 On Renoir's allusion to "le joli fond noir" fav-
 oured by Bonnat see note 15 at cat. nos. 41–44
 above.
5 Renoir's "concessions à la fermeté du rendu"
 had been encouraged by Philippe Burty, coin-
 cidentally Paul Haviland's grandfather, as early
 as 1879; see Burty 1879. On Renoir's technique
 in *Paul Haviland* see House and Distel 1985, 244.
6 Archives de Paris, 5Mi3/182, "Acte de nais-
 sance," 17 June 1880, Paul Haviland. By 1884,
 the year in which Renoir's portrait was painted,
 the family had moved to the "petit hôtel go-
 thique" at 29 avenue de Villers, which Haviland
 built in 1880–81; see Valiere 1992, 49–50, 73–75.
7 D'Albis 1969, 197–206; d'Albis and d'Albis 1974,
 46–52.
8 "Haviland, alors ignorant comme tout, et ne
 fabriquant guère que des pots de chambre pour
 l'Amérique" (Goncourt 1956, III, 1127, entry
 for 19 February 1890, reminiscing about
 Haviland's encounter with Bracquemond in the
 early 1870s). On Degas's designs for Haviland's
 vases see d'Albis and d'Albis 1974, 48.
9 Valiere 1992, 85–94; Akiko 1983, 49–50. It is
 worth noting that neither Manet's *Café-concert*
 nor Renoir's *Onions* appeared in Haviland's
 posthumous sale of 7 December 1922, since
 they had been sold back to dealers during his
 lifetime.
10 Le Curieux 1923, 70. At Haviland's sale, Puvis
 de Chavannes's *Woman at Her Toilette* sold for
 213,000 francs; Degas's *Jockeys before the Start*
 made 100,000 francs.
11 Valiere 1992, 48. Georges Haviland, who later
 took over the company, was once thought to be
 the sitter in Renoir's portrait; see Kansas City
 1959, 120. The correct identification was first
 made in Daulte 1969, 30.
12 "Ce jour-là, la famille Burty dînait chez

Bracquemond, et le sensuel Américain avait un
tel regard obstiné, pendant tout le dîner, sur la
fillette que, lorsque Bracquemond rentrait de
reconduire la famille Burty à la voiture, Mme
Bracquemond disait: 'M. Haviland va épouser
Madeleine!'" (Goncourt 1956, as in note 8
above). Goncourt had first mentioned Haviland
as buying Japanese prints in Burty's company in
October 1876.
13 Valiere 1992, 49–50, 60–61.
14 Ibid., 52–53.
15 See Gimpel 1963, 226, for Joseph Durand-
 Ruel's comment, made on 16 January 1923 –
 "Savez-vous qu'il a peint des assiettes chez
 Haviland! Il gagnait cinquante francs par jour"
 – which mistakenly identifies Haviland as
 Renoir's employer: in the 1850s Renoir had
 worked for Levy Frères et Cie in Paris.
16 White (1984, 73–74) claims that Renoir's *Girl in
 a Boat* (1877, private collection, New York) was
 a wedding present from Burty, but without cit-
 ing a source. In fact, Madeleine's dowry of
 35,000 francs, which had included 25,000 francs
 "en tableaux et objets d'art," was still outstand-
 ing a decade later, Goncourt noting in April
 1887 that Burty had no intention of paying it;
 see Valiere 1992, 50, and Weisberg 1993, 7.
17 The editors of Pissarro *Correspondance* (I, 198)
 conveniently list the lenders to the *Exposition
 japonaise* of March–April 1883, in which Duret
 and Deudon also participated.
18 Daulte 1971, nos. 261, 462.
19 "Je me rappelle les châtaigneraies admirables sur
 des petits coteaux" (Morisot *Correspondance*,
 174). Referring to this visit, on 8 September
 1893, Julie Manet noted in her diary: "Renoir
 aussi a été une fois à moitié invité à aller dans le
 Limousin par M. Haviland, le mari de Mlle
 Burty" (Manet 1979, 18).
20 I am thinking not only of Berard, but also of
 Grimprel, Goujon, Cahen d'Anvers, and Nunès.
21 Paul's youngest brother, Franck, a self-taught
 painter of some talent, who befriended Picasso
 and sat to Modigliani in 1914, was one of the
 first collectors of African and Oceanic art
 (d'Albis 1988, 50; Valiere 1992, 61).
22 There is an abundant literature on Haviland as a
 photographer that has been overlooked by
 Renoir scholars; see Norman 1973, 48, 78–79,
 Galassi 1977, 5–11, Naef 1978, 368–369, and
 Homer 1983, 141–151. The Musée d'Orsay has
 very recently acquired photographs and docu-
 ments relating to Paul Haviland's career, and
 Françoise Heilbrun generously allowed me to
 consult a draft of her biographical essay on him
 (cited as Heilbrun 1996), which contains much
 new material.
23 Galassi 1977, 7; Doty 1978, 56.
24 Homer 1983, 141; Borcoman 1993, 126.
25 "L'intérêt des Haviland exige et le tient aussi car
 tu pourras être utile à Limoges . . . Tu es sans
 défense contre tous ceux qui veulent tirer de toi
 ou de Haviland poil et plumes" (Archives du
 Musée d'Orsay, Paris, Charles Haviland to his
 son, 15 May 1915, quoted in Heilbrun 1996).
26 Galassi 1977, 8–9.
27 Green 1973, 285, quoting from the list of con-
 tributors in *Camera Work*, 47 (1914–15).
28 Heilbrun 1996; Mairie de Paris, "Extrait des
 actes de mariage," 17 December 1917, Haviland
 and Ledru. It should be noted that Suzanne
 Renée Lalique was born Suzanne Ledru; her

parents married on 1 July 1902, when she was
ten years old.
29 Heilbrun 1996.
30 Valiere 1992, 65, citing the "État liquidatif,"
 notes that Paul's portion of his father's estate
 was 230,666 francs.
31 Mairie de Yzeures-sur-Creuse, "Acte de
 décès," 18 January 1951, which states that Paul
 Haviland had died in Paris, 40 cours Albert 1er,
 on 21 December 1950 at 8 PM.

Fig. 246 Charles Edward Haviland, 1880.
Service de Documentation, Musée
d'Orsay, Paris

Fig. 247 Madeleine Burty-Haviland,
1880. Private collection, Paris

49 *Children's Afternoon at Wargemont (Marguerite, Lucie, and Marthe Berard)*
1884
127 × 173 cm
Signed and dated centre right: Renoir. 84.
Nationalgalerie, Berlin, AI 969
Daulte no. 457; House/Distel no. 74

PROVENANCE Commissioned by Paul Berard (1833–1905), Wargemont and Paris; Galeries Georges Petit, Paris, Berard sale, 8 May 1905, no. 15, for 14,000 francs to Bernheim-Jeune, Paris; purchased from Bernheim-Jeune for 16,000 francs, 14 June 1905, by the Berlin art dealer Paul Cassirer (1871–1926); accepted by Emperor Wilhelm II, 6 December 1906, as a gift from Karl Hagen, a partner in Wiener Levy and Co., Berlin, to the Nationalgalerie.

EXHIBITIONS Not exhibited in Renoir's lifetime.

REFERENCES Feilchenfeldt 1988, 18; Distel 1993, 92–93; Adriani 1996, no. 70; Hohenzollern and Schuster 1996, no. 37.

NOTES

1 "Qui ne fut certes payé à Renoir qu'un prix très modeste" (Duret 1924, 67–68).
2 "At Wargemont, then, Renoir felt at home, they were all amused at his greed, his confidential attitude towards the butler, the chef, the gardener" (Blanche 1937, 37).
3 Berard 1937, 48; Bergeron 1978, 218–219.
4 For Margot and Lucie's birth certificates see cat. no. 34, note 5, and cat. no. 47, note 1. Marthe was born in Paris, at 20 rue Pigalle, on 8 May 1870; see cat. no. 39, note 5.
5 Blanche 1937, 37–38.
6 Riopelle (1990, 12) dates the beginning of Renoir's work on *The Great Bathers* to "spring 1884."
7 "Renoir se trouva favorisé par sa connaissance approfondie des personnages représentés" (Meier-Graefe 1912, 128). For the most thorough discussion of the gestation of *The Great Bathers* see Riopelle 1990, 12–31.
8 "Éclairé comme une lanterne" (Blanche 1933).
9 An affinity with Ensor was first suggested in House and Distel 1985, 245.
10 Hills 1986, 63. Sargent's portrait was exhibited at the Salon of 1883 as no. 2165, "Portraits d'enfants"; Renoir had submitted *Madame Clapisson* (cat. no. 46) to the same Salon.
11 On Hugo von Tschudi's struggles to acquire modern French painting for the Nationalgalerie see Paret 1981. In his wholehearted support for the beleaguered director, Meier-Graefe's patriotism tended to get the better of him, as, for example, when he compared Renoir's "hauptwerk" with the "lesser" *Madame Georges Charpentier and Her Children* (cat. no. 32), purchased for 84,000 francs by the Metropolitan Museum of Art in April 1907. "On pourrait dire que la 'Famille Charpentier' a été saisi avec l'oeil, les 'Enfant Berard' avec l'esprit; c'est une création à un bien plus haut degré" (Meier-Graefe 1912, 131).

12 Meier-Graefe 1912, 128.
13 "Une lumière qui n'éblouit pas, qui n'échauffe pas, qui n'abat pas, qui permet de se passer d'ombre" (ibid., 126).
14 "Les murs n'empêchent pas au soleil et à la joie d'entrer. Une résidence de soleil" (ibid., 126).
15 "Un portrait qui, en dépit de toute son exactitude, semble relever du monde des contes" (ibid., 130). In this account, brilliant though it is, Renoir is beginning to appear as something of an Abstract painter *avant la lettre*, a suggestion that would have appalled Meier-Graefe, whose opposition to Cubism was implacable (see Moffett 1973, 108–113). Yet the point is well made that in *Children's Afternoon at Wargemont* Renoir's handling of paint aspires to an independence from subject matter that allows it to communicate beyond the dictates of representation. Hence, for Meier-Graefe, the composition evokes qualities of "l'élégance, la pompe, le piquant," in spite of "des formes rien moins qu'élégantes des deux filles devant la table," and "sans dissimuler le moins du monde sa simplicité de chambre d'une villa d'été."
16 House and Distel 1985, 244–245.
17 Meier-Graefe (1912, 127) described the paint surface as "une matière rude et pâteuse."
18 "Les accessoires sont chargés de la même densité de couleurs que les figures, elles-mêmes très simplifiées" (Distel 1993, 93).
19 "C'était, en 1884, une audace extraordinaire que de former des êtres humains sur le schème d'un jouet" (Meier-Graefe 1912, 128).
20 Renoir's draft manifesto, circulated in May 1884 but never published, is reproduced in Venturi 1939, I, 128–129. Renoir envisaged exhibitions that would bring together the work of "tous les artistes, peintres décorateurs, architectes, orfèvres, brodeurs . . . ayant l'irrégularité pour esthétique." House (1992, 581–582) relates these claims to the activities of the Union Centrale des Beaux-Arts, one of whose "leading lights" was Charles Ephrussi.
21 "Je ne puis encore me permettre de commencer des portraits avant d'être sûr et de chercher encore . . . Si je vous fais quelque chose dorénavant je veux que ce soit le dernier mot de l'art" (photocopy of unpublished letter provided by Madame Boulart; partially reproduced in Hôtel Drouot, Paris, *Autographes littéraires, historiques, artistiques*, 11 August 1980, no. 96).
22 "Je suis incapable de dire si ça vaut quelque chose, étant trop frais . . . je ne sais non plus si je dois apporter la grande toile pour effrayer les enfants" (Hôtel Drouot, Paris, *Autographes littéraires, historiques, artistiques*, 11 August 1980, no. 106; the letter bears Renoir's new address of 37 rue Laval).
23 Renoir noted to Catulle Mendès in April 1888: "Je ferai les dessins chez vous et la peinture chez moi" (Hôtel Drouot, Paris, *Livres, belles reliures, autographes*, 1 June 1953, no. 410).
24 "Il n'y a pas eu auparavant de chambres pareilles dans la peinture, et l'on est tenté de se demander, en présence de la toile, s'il y en a eu aussi dans la réalité" (Meier-Graefe 1912, 126).
25 See Berard 1938 (unnumbered plate) for a reproduction of the interior of the library at Wargemont as it was in the 1930s. Although Renoir's flower painting was sold, the room has otherwise remained unchanged.
26 "Les figures, d'une expression réelle et vive,

sont indiquées par des procédés de synthèse qui évoquent le souvenir de l'école du Primatice" (*Catalogue des tableaux modernes . . . provenant de la collection de feu M. Paul Berard*, Paris, 8 May 1905, no. 15). The best summary of Renoir's Italianate sources is in House and Distel 1985, 245.

27 Examples are illustrated in Spinazzola 1928, 71, 75.

Fig. 250 Château de Wargemont. Private collection

Fig. 251 Louis XVI canapé, Château de Wargemont, 1996.

Fig. 252 John Singer Sargent, *The Daughters of Edward D. Boit*, 1882. Museum of Fine Arts, Boston, Gift of the daughters of Edward D. Boit, in memory of their father

Fig. 253 *Seated Woman with a Bird and Visitor*, Hellenistic relief. Museo Archeologico Nazionale, Naples

50 *Aline Charigot, later Madame Renoir*
1885
65.4 × 54 cm
Signed upper left: Renoir
Philadelphia Museum of Art,
W.P. Wilstach Collection, W57-1-1
Daulte no. 484; House/Distel no. 78

PROVENANCE In Renoir's collection until his death; Pierre Renoir (1885–1952), Paris; purchased from the Marie Harriman Gallery, New York, by the Philadelphia Museum of Art in 1930 with funds provided by the George W. Elkins bequest.

EXHIBITIONS Renoir 1912, no. 1 (possibly the "Portrait de Mme Renoir," dated 1880).

REFERENCES House 1994, no. 25; Adriani 1996, no. 76.

NOTES

1 Mairie d'Essoyes, "Acte de naissance," 23 May 1859, Aline Victorine Charigot, witnessed by Joseph Hélène Duban and Joseph Léon Tassin, both "aubergistes" living in Essoyes. Claude Charigot and Thérèse Émilie Maire had married on 15 November 1858.

2 Renoir 1981, 341–342, where his departure is dated to 1865.

3 Ibid., 230.

4 Ibid., 342; Mairie d'Essoyes, "Acte de mariage," 15 November 1858, Charigot and Maire, to which is appended the divorce decree from the 2ᵉ Chambre du Tribunal Civil de la Seine, dated 21 March 1887. Divorce had only been reestablished in France in 1884 and was "so difficult and so expensive to obtain that it was limited to the middle class" (Hutton 1986, 355); this suggests a certain determination on Thérèse Charigot's part.

5 "Ma grand-mère maternelle était en effet insupportable. Fortement retranchée derrière son honorabilité et ses qualités ménagères, elle ne ratait pas la moindre faiblesse chez les autres" (Renoir 1981, 231).

6 *Oarsmen at Chatou* (1879, National Gallery of Art, Washington) is the first painting for which Aline is said to have posed (Daulte 1971, no. 307). "C'est elle qui s'apprête à monter dans la barque, dans un petit tableau peint bien avant *le Déjeuner*" (Renoir 1981, 230).

7 "Madame Renoir parlait de son voyage en Italie

après son mariage, cela nous amuse lorsque nous l'entendons raconter tout cela, car nous avons entendu si souvent M. Renoir nous en parler comme s'il l'avait fait seul" (Manet 1979, 66, entry for 19 September 1895).

8 House and Distel 1985, 232.

9 "[M. Renoir] nous dit qu'il a fait la Danse d'après Mme Renoir et son ami Lauth, [sic] dont il parle toujours avec affection et regret" (Manet 1979, 167, entry for 16 June 1898).

10 See André and Elder 1931, II, no. 502, *Madame Renoir* (1915); a fine drawing for this work is in the Woodner collection, New York, and a preparatory painted study, not in André and Elder, was reproduced as the frontispiece in André 1928.

11 House and Distel 1985, 248; House 1994, 98. It should be noted, however, that in André and Elder 1931, I, no. 16, the portrait is dated to 1884. A precise dating, which may be impossible to arrive at, is of interest for reasons beyond connoisseurship: if it was painted in the winter or early spring of 1885, then this portrait represents Aline in an advanced stage of pregnancy.

12 "Les deux yeux du plus beau visage seront toujours légèrement dissemblables, aucun nez ne se trouve exactement placé au dessus du milieu de la bouche" (Venturi 1939, I, 128, "La Société des Irrégularistes" [May 1884]).

13 House and Distel 1985, 304; Archives de Paris, V4E/6227, "Acte de mariage," 14 April 1890, Renoir and Charigot.

14 "La bru de ses rêves, la grosse et fraîche fermière, rouge comme une pomme et ronde comme une jument poulinière" (Maupassant 1973, 248). *Bel-Ami* was first published serially in *Gil Blas* between 6 April and 30 May 1885, and so is exactly contemporary with Renoir's portrait.

15 House 1992, 584–585.

16 "Ce sont presque toujours des couturières ambitieuses, des fleuristes découragées, des repasseuses en rupture de fer . . . qui ont planté là le métier appris avec tant de peine, pour courir après les aventures et gourgandiner la vie" (Patrick 1886, 7).

17 Jean Renoir (1981, 194) goes so far as to have his mother sight-reading Schumann, since Renoir "avait bien connu madame Schumann avant la guerre de 70."

18 Archives de Paris, D1P4/545, "Cadastre de 1876," 15 rue Bréda, where "dame Charugo" is noted as being in one of the many single-room apartments on the first floor. In Renoir's marriage certificate (cited in note 13 above) Aline is listed as "couturière domiciliée à Paris, rue Bréda 15, avec sa mère."

19 "En 1876, le succès de la jolie Théo, dans la *Timbale d'Argent*, avait amené la mode d'un chapeau de paille porté par l'actrice dans cette opérette . . . Avoir une timbale . . . était le rêve de toutes les jeunes Montmartroises" (Rivière 1921, 132).

20 "Une jeune dame, toute la rondeur et la bonhomie de certains pastels de Perronneau, dans ses bourgeoises du temps de Louis XV" (Vollard 1919, 9).

21 "Franchement grosse et paysanne" (Manet 1979, 130, entry for September 1897).

22 On this series see House and Distel 1985, 248–249, and Adriani 1996, 249–253.

23 "Elle nous a dit aussi la première fois qu'elle

avait vu M. Renoir, il était avec M. Monet et Sisley; tous trois portaient de longs cheveux et on les regardait passer comme des événements dans la rue St Georges qu'elle habitait" (Manet 1979, 66, entry for 19 September 1895).

24 Ville de Nice, "Acte de décès," 27 June 1915, Renoir, née Charigot. Haesaerts (1947, 42, no. 18) incorrectly relates the bust to Renoir's "Maternité" series.

Fig. 254 Pierre-Auguste Renoir, *Blond Bather*, 1881. Sterling and Francine Clark Art Institute, Williamstown, Mass.

Fig. 255 Pierre-Auguste Renoir, *Maternité*, 1886. Private collection

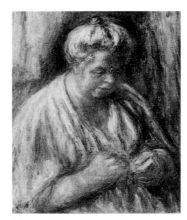

Fig. 256 Pierre-Auguste Renoir, *Madame Renoir*, 1915. Location unknown

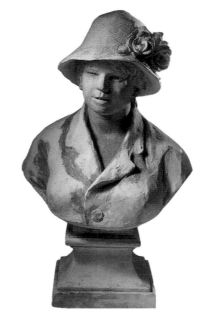

Fig. 257 Pierre-Auguste Renoir and Richard Guino, *Madame Renoir*, plaster, 1916. Los Angeles County Museum of Art, Bequest of Madame Dido Renoir

51 *Child with a Whip (Étienne Goujon)*

1885

105 × 75 cm

Signed and dated lower right: Renoir. 85.
State Hermitage Museum, Saint Petersburg, 9006
Daulte no. 471; House/Distel no. 76

PROVENANCE Commissioned by Senator Dr. Étienne Goujon (1839–1907), Paris; Ambroise Vollard (1866–1939), Paris; sold by Vollard to the collector Ivan Morosov (1871–1921), Moscow, 1913; Museum of Modern Western Art, Moscow, from 1918; Hermitage Museum, Saint Petersburg, from 1948.

EXHIBITIONS Not exhibited in Renoir's lifetime.

REFERENCES *Paintings from the U.S.S.R.* 1973, no. 37; Kostenevich 1987, 299.

NOTES

1 Blanche 1931, 198.

2 "Renoir et Sisley sont sans rien, Monet est venu et reparti le jour même" (Pissarro *Correspondance*, II, 18, Pissarro to Lucien, 21 January 1886). White (1984, 163) misinterprets this ambiguously worded letter to mean that Renoir was "penniless."

3 Daulte 1971, nos. 472, 473. *Pierre Goujon* reappeared most recently in Sotheby's, New York, 17 May 1983, no. 8.

4 House and Distel 1985, 247. *Child with a Whip* measures 105 by 75 cm, *Girl with a Hoop (Marie Goujon)* 125 by 75 cm; neither is a standard stretcher size.

5 Archives de Paris, 5Mi3/303, "Acte de naissance," 7 November 1876, Marie Isabelle Henriette Goujon, born 4 November 1876; ibid., 5Mi3/312, "Acte de naissance," 23 October 1880, Étienne Léon Denis Goujon, born 21 October 1880.

6 See also the examples illustrated in Moreau-Vauthier 1901, 333 (Baudry, *Louis de Montebello*) and Lambotte 1913 (Wauters, *Cosmé de Somzee*).

7 Wadley 1987, 291.

8 "J'étais allé jusqu'au bout de 'l'impressionnisme' et j'arrivais à cette constatation que je ne savais ni peindre ni dessiner" (Vollard 1919, 127).

9 See John House's comments (House and Distel 1985, 246) on the "composed" quality of Renoir's nudes of this period, for example *Bather* (known as *La Coiffure*, Sterling and Francine Clark Art Institute, Williamstown, Mass.), conceived and executed in the studio.

10 Mairie de Pont-de-Veyle (Ain), "Acte de naissance," 29 April 1839, Étienne Goujon, born 28 April 1839 to Denis Goujon, "Blattier [sic] au dit lieu," and Pierrette Lorbet.

11 Robert and Cougny 1889–91, III, 216–217; Curinier 1899–1905, IV, 228. Goujon's "Étude d'un cas de hermaphrodisme bisexuel imparfait chez l'homme" was published in 1870.

12 Archives Nationales, Paris, Minutier Central, XXXVIII/1153, "Contrat de mariage," 20 October 1873, Goujon and Rouen; the groom's wedding portion included "ses objets d'art, bibliothèque et instruments de chirurgie," valued at 20,000 francs. It did not go unnoticed that Goujon was "possesseur par son mariage d'une fortune importante" (Robert and Cougny 1889–91, III, 216).

13 Robert and Cougny 1889–91, III, 216–217; Curinier 1899–1905, IV, 228; Mairie du 12ᵉ arrondissement, Paris, "Acte de décès," 7 December 1907. The rue du Docteur Goujon in the 12th arrondissement is named for him.

14 Monneret (1978–81, I, 252) notes Goujon's friendship with Proust, who would have been present, with Renoir, at the anniversary banquet for Manet at Père Lathuille's on 5 January 1885. White (1984, 162) quotes from Renoir's letter to Berard, which she mistakenly dates to 29 October 1885 (it was written Thursday, 28 October 1886). In it Renoir mentions having visited the Goujons twice that week without

finding them at home, and notes that he is determined to see them before returning to Wargemont. I am most grateful to Caroline Durand–Ruel Godfroy for having provided me with a transcript of this letter.

15 Monneret 1978–81, I, 252, II, 112; *Paulin* 1983, 9–10, where the sculptor's son notes that Goujon, "grand ami de mon père . . . tenait table ouverte deux fois par semaine: une fois pour les amis et une fois pour les hommes politiques."

16 "Paulin devait me donner une réponse de la vente probable d'un éventail; malheureusement, c'est la femme du Dr. Goujon dont il était question pour cette affaire . . . elle n'a pas pu venir comme c'était convenu, étant malade avec la joue enflée (c'est grave)" (Pissarro *Correspondance*, II, 17, Pissarro to Lucien, 21 January 1886).

17 Daulte 1971, no. 111; *Paulin* 1983, 10; *Madame Paulin* (*La Dame aux gants noirs*), formerly in the Bernheim-Jeune collection, was most recently exhibited at the Galleria d'Arte Moderna, Medea Cassinarini, Milan.

18 House and Distel 1985, 241, 247.

19 Ibid., 246.

20 On Goujon's elder son Pierre Étienne Henri, a discriminating collector of modern painting who bequeathed Van Gogh's *La Guinguette* and Toulouse-Lautrec's *La Toilette* to the Louvre in 1914, see Laclotte 1989, 220.

21 Daulte 1971, nos. 471, 473.

22 Archives de l'Enregistrement, Paris, 5 December 1908, "Succession," Étienne Goujon.

23 Mairie de La Ferté-Saint-Aubin, "Acte de décès," 19 November 1945, Étienne Léon Denis Goujon; the sole witness was Henri Gaillard, a forty-nine-year-old cabinet-maker ("ébéniste").

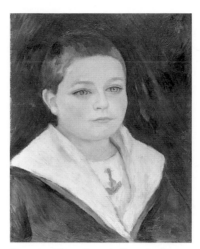

Fig. 259 Pierre-Auguste Renoir, *Pierre Jean Léon Goujon*, 1885. King's College, Cambridge

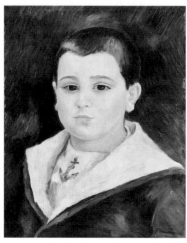

Fig. 260 Pierre-Auguste Renoir, *Pierre Étienne Henri Goujon*, 1885. Private collection, Philadelphia

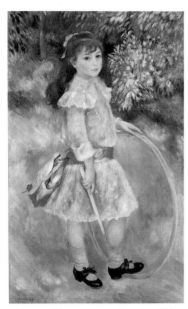

Fig. 258 Pierre-Auguste Renoir, *Girl with a Hoop* (*Marie Goujon*), 1885. National Gallery of Art, Washington, Chester Dale Collection

Fig. 261 Félix Vallotton, *Jean Dauberville*, 1906. Private collection

52 *Madame Paul Gallimard* 1892
80 × 63.5 cm
Signed and dated lower left: Renoir. 92.
The Robert B. Mayer Family Collection, Chicago

PROVENANCE Commissioned by the collector and bibliophile Paul Gallimard (1850–1929); in Renoir's studio at the time of his death; Ambroise Vollard (1866–1939), Paris; Ralph Bellier, Paris; Sam Salz Gallery, New York; purchased from the Sam Salz Gallery by Mr. and Mrs. Robert B. Mayer, Winnetka, Ill., 27 December 1951; The Robert B. Mayer Family Collection, Chicago.

EXHIBITIONS Not exhibited in Renoir's lifetime.

REFERENCES André and Elder 1931, I, pl. 22, no. 55; *Renoir* 1973, no. 63; Distel 1993, 104.

NOTES
1 Ville de Suresnes, no. 46, "Acte de naissance," 21 July 1850, Paul Sebastien Gallimard. On Gallimard as a collector see Monneret 1978–81, I, 220–221, and Distel in House and Distel 1985, 23–24.

2 Assouline 1984, 18–20, is the indispensable source, although in error in claiming that Chabrier was Madame Lucie Gallimard's grandfather.

3 Archives de Paris, D1P4/1029, "Cadastre de 1862," 79 rue Saint-Lazare, where it is noted that the house was completed in November 1869. Gaston Gallimard informed Proust on 6 September 1916: "C'est également là que sont les tableaux de mon père et de mon grand-père, mais aux étages supérieurs de la maison, actuellement fermés" (Fouché 1989, 55).

4 *Archives biographiques contemporaines* 1906, I, 71. "C'est ensuite Louis Lépine [sic] qui enseigna à M. Paul Gallimard à tenir un pinceau" (Vauxcelles 1908, 20).

5 Archives de Paris, V2E/7599, "Acte de naissance," 16 August 1858, Lucie Duché; Archives de l'Enregistrement, Paris, 18 October 1929, "Succession," Paul Sébastien Gallimard, for their marriage contract of 7 April 1880. Lucie Duché's dowry had been on the order of 120,000 francs.

6 Archives de Paris, 5Mi3/205, "Acte de naissance," 18 January 1881, Gaston Sébastien Gallimard; ibid., 5Mi3/1204, "Acte de naissance," 29 September 1883, Raymond Pierre Henri Gallimard; ibid., 5Mi3/1206, "Acte de naissance," 29 August 1886, Jacques Marie Gallimard.

7 "Cet art veule et sentimental" (Pissarro *Correspondance*, IV, 201, Pissarro to Lucien, 2 May 1896).

8 On the "Dîner de la Banlieue" held on the evening of the vernissage of Petit's Monet-Rodin exhibition see Goncourt 1956, III, 989, entry for 15 June 1889. Goncourt described "le paysagiste" Monet, as "un silencieux, à la forte mâchoire d'un carnassier, aux terribles yeux noirs d'un *tapeur* des Abruzzes." Daudet (1992,

211–212) provided a detailed account of this dinner, at which Jules Chéret was also present, describing "le riche" Gallimard as "rouge de visage, imberbe, moustachu et collectionneur. Il ressemble à une longue pivoine, au milieu de laquelle serait fiché un nez humain."

9 House and Distel 1985, 234. Durand-Ruel's stock book lists the purchase on 13 December 1889 to "Gallimard fils," without indicating the sum paid.

10 Wildenstein 1974–81, III, 138, no. 1272, for *Grainstacks, Sunset* (1890); Pissarro and Venturi, 1939, I, 186, no. 744, for *The Serpentine, Hyde Park*, 1890. By February 1891, Monet was recommending Gallimard to Pissarro as "un amateur, ami de Geffroy et de moi, très épris de ce que vous faites et qui peut acheter" (Wildenstein 1974–81, III, 260, Monet to Pissarro, 7 February 1891).

11 See Vauxcelles 1908, 2–32, for the most complete listing of a collection that would never come to auction. Gallimard's Poussin was a copy of *A Dance to the Music of Time* in the Wallace Collection; his El Greco is one of numerous studio replicas of *Saint Francis and Brother Leo Meditating on Death*, the prime version of which is in the National Gallery of Canada. Goya's *Diplomat*, whose acquisition was recommended by Renoir, is a weak copy after the figure of the Prince of Asturias in *The Family of Carlos IV* in the Prado.

12 As Renoir explained to Durand-Ruel on 18 April 1903, when he had been alerted to the possibility of thirty of his paintings coming on to the market, "Je ne vois pas bien qui peut avoir 30 toiles. Ceux qui en ont le plus, Viau et Gallimard, n'en ont pas tant" (Godfroy 1995, I, 184).

13 On the announcement of this project see Goncourt 1956, III, 867, entry for 1 December 1888. The book appeared early in 1891.

14 "C'est vraiment un révolutionnaire que ce Gallimard, qui va dépenser 3,000 francs pour se donner à l'instar d'un fermier-général, pour se donner à lui seul une édition de luxe d'un livre moderne" (ibid., 992, entry for 21 June 1889). "Un vrai français du XVIIIᵉ siècle" (Renoir 1981, 363).

15 The anonymous interviewer in *L'Éclair*, 9 August 1892, noted: "Puis cette année même, après son exposition, une excursion à Madrid pour voir les Vélasquez en compagnie de M. Paul Gallimard, un amateur bien connu des artistes audacieux et sincères." Vollard (1919, 137) dated this visit to 1889, immediately after Renoir had finished the portrait of Madame de Bonnières, and thus three years too early.

16 For Renoir's letter to Berard from London, in which he describes "ces horizons dans la brume où traverse du soleil tamisé," see Hôtel Drouot, Paris, *Autographes littéraires, historiques, artistiques*, 11 August 1980, no. 109 (dated to 1895 in White 1984, 201). On Renoir's impressions of Holland, confined largely to the Rembrandts in the Rijksmuseum, see Vollard 1919, 149–150.

17 See Morisot *Correspondance*, 173, for Renoir's letter of June 1893, "expédiée de chez les Gallimard dans le Calvados," and ibid., 180, for Morisot's letter of 1 September 1894 informing Mallarmé that "[Renoir] se console à Deauville avec Gallimard."

18 On *Reclining Nude* ("*La Source*") (c. 1895,

Barnes Foundation, Merion, Pa.), which was also commissioned by Gallimard, see Riopelle in *Barnes* 1993, 74. The Oedipus panels, along with their many preparatory sketches, remained in Renoir's possession until his death, and are illustrated in Vollard 1918b, I, 128, no. 510, and André and Elder 1931, I, nos. 107–114, II, nos. 115–119, 121, 124–125, 129.

19 "Tu n'as pas idée de la ladrerie, jusqu'à se faire payer des consommations! . . . Et il vient d'hériter des millions de son père! Il a tapé ce pauvre Renoir des toiles payées moins cher que Renoir ne les donne à Durand" (Pissarro *Correspondance*, III, 382, Pissarro to Lucien, 5 October 1893).

20 For Renoir's letter to Mallarmé of 28 April 1896 see Mallarmé *Correspondance*, VIII, 118. A similar letter to Dierx, in the Cabinet des Dessins, Musée du Louvre, Paris (L25), in which Renoir asks the poet "si vous voulez participer à son exposition de manuscrits qui se fera chez Bing le vingt de ce mois," can now be assigned to early May 1896.

21 Baudot 1949, 8; Monneret 1978–81, I, 221. Assouline (1984, 53) states that Maurice Gangnat (1856–1924) was related to Gallimard through Lucie Duché. Proust, who had been an admirer of Gangnat's brother Robert, let it be known to Gaston Gallimard in February 1916 that he was eager to see his uncle's collection of Renoirs, which numbered a hundred and fifty by the time of his death (Fouché 1989, 23–25).

22 "Tous les deux on a été à Croissy chez Gallimard-Dieterle où il a fait un magnifique tableau dans le jardin au soleil, une toile de 30. Dieterle en robe blanche décolletée et un turban de soie à fleurs dans les cheveux, moi en rouge, une table, service de thé à cerises" (Bibliothèque du Musée du Louvre, Paris, Archives Vollard, MS 422 [311], Gabrielle to Vollard, undated, September 1911).

23 "Peintre amateur, et tentée par l'éclatante blondeur qui lui rappelait telle toile de son maître Renoir, madame Paul chargea son mari de demander à cette jeune fille si elle accepterait de poser pour elle" (Jourdain 1953, 59). The memoirist was the son of the architect and critic Frantz Jourdain (1847–1935), an intimate of Goncourt and Rodin and founder of the Salon d'Automne.

24 Hôtel Drouot, Paris, *Autographes littéraires, historiques, artistiques*, 11 August 1980, no. 97, Renoir to Berard, from Cagnes, 29 March 1899, noting that Madame Gallimard was returning to Paris from Naples.

25 "Mme Gallimard, une brune avec de doux yeux noirs, des yeux parfois interrogateurs à la façon des yeux des femmes-sphinx" (Goncourt 1956, III, entry for 21 June 1889).

26 "Cette femme si hystérique, qu'une course en voiture avec elle force les gens pratiques à crier: 'Arrêtez, cocher, j'ai besoin de descendre!'" (ibid., III, 1164, entry for 24 April 1890).

27 "Elle vient de subir une douloureuse et très grave opération, on ne sait encore si ce ne sera pas fatal" (Pissarro *Correspondance*, III, 164, Pissarro to Lucien, 13 December 1891).

28 Murphy in *Renoir* 1988, 118, no. 42, 245.

29 *Renoir* 1892, no. 50, "Portrait d'enfant, Appartient à M. Paul Gallimard."

30 "Mon cher ami . . . J'irai quand madame Gallimard sera revenue. Je louerai une chambre

sur la route de Dieppe et je viendrai faire un portrait de madame Gallimard pour faire pendant à celui de madame Manet et c'est tout. Si madame Gallimard me refuse de poser pour une tête – 3 scéances [sic] – je ferai du paysage et c'est tout. Je ne puis réellement habiter cette villa à moi tout seul. C'est donc bien entendu: ne vous occupez plus de moi. Jusqu'à l'automne, où nous commencerons les grands portraits espagnols" (Archives Durand-Ruel, Paris, Renoir to Gallimard, undated). The Grand Hôtel Terminus had been built for the Exposition Universelle of 1889 and was within walking distance of the Gallimard mansion at 79 rue Saint-Lazare.

31 "Je suis allé faire un portrait et je vais revenir bientôt" (Godfroy 1995, I, 90, Renoir to Paul Durand-Ruel, 29 August 1894).

32 Morisot's pastel *Jeune fille en robe rose* is reproduced in Vauxcelles 1908, 21, and catalogued in Bataille and Wildenstein 1961, 58, no. 529.

33 "Deux bons portraits, dont celui de Mme G. . . , la femme du bibliophile . . . Mme G. . . est le type de la petite bourgeoise qui met la main à la pâte avec la bonne à 'tout faire.' Ces vertus familiales ont poussé le mari vers l'actrice. Renoir, un bon ami de la légitime, fit aussi le portrait de l'illégitime" (Gimpel 1963, 200, entry for 20 April 1921). This would also explain the appearance of the portrait among the works in Renoir's studio; see André and Elder 1931, I, no. 55.

34 "Un des caractères de Renoir, c'est l'abandon à son propre tempérament . . . Les défauts qui en résultent sont plus sensibles lorsqu'il se trouve en face d'un modèle et de ses exigences . . . ce coloriste-né n'a goût que de couleur. La forme lui est indifférente . . . Il peint les figures comme des 'natures mortes' . . . Les voilà tous, hommes, femmes, jeunes filles, enfants . . . lourdement collés à la toile" (Gallimard 1912, 371–372).

Fig. 262 Lucie Gallimard with an unidentified couple, c. 1900. Private collection, Paris

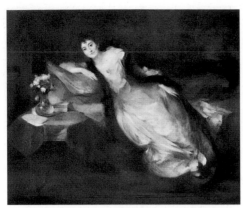

Fig. 263 Eugène Carrière, *Madame Gallimard*, 1889. Private collection

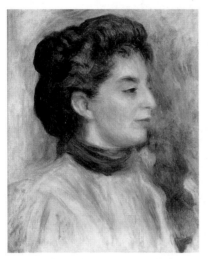

Fig. 264 Pierre-Auguste Renoir, *Madame Paul Gallimard*, 1892. Private collection

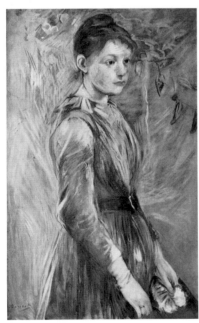

Fig. 265 Berthe Morisot, *Young Girl in a Red Dress*, 1888, pastel. Private collection

53 *Berthe Morisot and Her Daughter Julie Manet* 1894
81 × 65 cm
Signed lower right: Renoir.
Private collection

PROVENANCE Presented by Renoir as a gift to Berthe Morisot (1841–1895); Madame Ernest Rouart (1878–1966), née Julie Manet.

EXHIBITIONS *Renoir* 1896, no. 34.

REFERENCES Jourdain 1896; Drucker 1944, 210; Rouart 1952, no. 30; Montalant 1985; Stuckey 1987, 166, 170.

NOTES

1 Berthe Morisot was born in Bourges on 14 January 1841 and died in Paris on 2 March 1895 (Mairie de Bourges, "Acte de naissance," 15 January 1841; Mairie du 16ᵉ arrondissement, Paris, "Acte de décès," 4 March 1895). Her husband Eugène Manet, whom she married on 22 December 1874, was born in Paris on 21 November 1833 and died there on 13 April 1892.

2 Mallarmé joked in his quatrains about "le chapeau Liberty," and "Julie en chapeau Gainsborough" (Mallarmé *Correspondance*, VII, 122 [1 January 1895] and 129 [7 January 1895]).

3 "Des cheveux comme une perruque de pédant du XVIIIᵉ siècle" (Régnier, unpublished diary, entry for December 1893, quoted in Mallarmé *Correspondance*, VI, 192).

4 "Enfin, ma pauvre amie, je finis ma vie dans le veuvage que vous avez connu dans la jeunesse, je ne dis pas l'isolement puisque j'ai Julie, mais c'est une espèce de solitude néanmoins" (Morisot *Correspondance*, 172, Berthe Morisot to Sophie Canat, 7 October 1892).

5 White 1984, 200, 203.

6 "Je voudrais, si ça ne vous est pas trop désagréable, au lieu de faire Julie seule, la faire avec vous. Mais voilà le côté ennuyeux; c'est que si je vais chez vous, j'aurai tout le temps quelque chose qui m'empêchera, mais si vous vouliez me donner deux heures, c'est-à-dire deux matinées ou après-midi par semaine, je pense pouvoir faire le portrait en six séances au plus" (Morisot *Correspondance*, 179, Renoir to Berthe Morisot, undated, shortly after 31 March 1894).

7 "Nous posions le matin et nous montions ensuite déjeuner chez lui" (Bernier 1959, 42).

8 Vollard 1919, 160–163, noting that Chéramy was reluctant to commit the Amis du Musée, even to a "prix d'ami." The pastel is published in Daulte 1959a, 17–18, and in Wadley 1987, 289 (where it is incorrectly dated to 1886).

9 Shortly after Morisot's death, Régnier recalled the evenings spent at her home, "les dîners dans la salle à manger où étaient pendus des tableaux de Manet, de Monet, de Renoir" (unpublished diary, entry for 3 March 1895, quoted in Mallarmé *Correspondance*, VII, 174).

10 Amornpichetkul 1989, 101.

11 Although here it makes sense to speak of mutual artistic influence; see Stuckey 1987, 170–172, 185, n. 318.

12 Berhaut 1983, 209–211.

13 Renoir's letter of 18 April 1894 is quoted in

House and Distel 1984, 306. Roujon, an intimate of Mallarmé's who had commissioned Renoir's *Young Girls at the Piano* (Musée d'Orsay, Paris) for the Luxembourg in April 1892, discussed the terms of the bequest with Martial Caillebotte and Renoir in his study in Paris on 27 April 1894; his report of this meeting, dated 2 May 1894, is published in Berhaut 1983, 227.

14 Alternatively, of course, the portrait could have been painted in late April–early May; Morisot and Julie did leave for Portrieux, near Saint-Brieuc, staying away until 8 August (Morisot *Correspondance*, 180).

15 "Je dois même dire que Madame Morisot a été une des amitiés les plus solides que j'aie jamais rencontrées" (Vollard 1919, 160). Jean Renoir (1981, 332) noted that Morisot was "le peintre avec lequel [mon père] avait gardé les relations les plus étroites."

16 Higonnet (1989, 15–16) notes that after the revolution of 1848, Tiburce Morisot was stripped of his office; he was named Préfet du Calvados on 10 January 1849, a post he held for a little under two years. The family moved to Rennes in January 1852, and settled permanently in Paris towards the end of that year. Baubérot (1953, 263) notes that Tiburce Morisot founded the Société Archéologique et Historique du Limousin in 1845.

17 On Léonard Renoir see cat. no. 6.

18 Morisot's early biography is conveniently summarized in Stuckey 1987, 16–20; see also Higonnet 1989. For her submissions to the seven Impressionist exhibitions see Moffett 1986, 121–122, 163, 205, 312, 354, 394, 445. Julie's birth on 14 November 1878 prevented Morisot from participating in the fourth Impressionist exhibition of April 1879.

19 "Dire qu'une autre femme avec tout cela trouverait moyen d'être insupportable" (Manet 1979, 122, entry for 31 December 1896).

20 See Morisot *Correspondance*, 98, for Renoir and Caillebotte's undated joint letter, which should probably be assigned to March 1877.

21 After visiting the rue Laval on 11 January 1886, Morisot saw a "whole series" of drawings for Renoir's *Maternité*, and noted: "Toutes ces études préparatoires pour un tableau seraient curieuses à montrer au public qui s'imagine généralement que les Impressionnistes travaillent avec la plus grande désinvolture" (Morisot *Correspondance*, 128).

22 In her invitation of 10 December 1886 to Mallarmé, Morisot wrote: "Monet sera des nôtres, Renoir aussi et tous deux enchantés de passer quelques instants avec vous" (Morisot *Correspondance*, 130). Of Renoir's portrait of Julie in an embroidered English dress with a cat on her lap, Degas had exclaimed: "À force de faire des figures rondes, Renoir fait des pots de fleur!" (Julie Rouart in Bernier 1959, 42).

23 In December 1888, facial paralysis obliged Renoir to refuse Morisot's invitation to stay at the Villa Ratti in Cimiez. In September 1890 he spent "several weeks" at Mézy, the Manets' country house on the Seine. It was there in July 1891 that he would finally introduce Aline and Pierre to his hosts. In August 1894 Renoir and his family were invited to join Morisot and Julie in Portrieux, Brittany, but declined. In January 1895, holidaying near Martigues with Jeanne Baudot and her family, Renoir invited Morisot

to join him; she could not accept because of Julie's cold, which she feared might be the beginning of typhoid fever (Morisot *Correspondance*, 142, 156, 160, 180, 184).

24 On the Impressionists' anger at the publicity surrounding the Duret sale see Distel 1989b, 64–68.

25 Manet 1979, 30, entry for 17 March 1894. Morisot had gone to Brussels for Octave Maus's exhibition at La Libre Esthétique, in which both she and Renoir had participated.

26 *Manet* 1983, 318, 336. Manet 1979, 30, under the entry for 19 March 1894, gives the prices fetched by Manet's portraits of her mother.

27 In his letter to Morisot of 31 March 1894 Renoir informed her: "Je voulais inviter Degas; je n'ose pas, je l'avoue" (Morisot *Correspondance*, 179).

28 "La petite Julie, enfant silencieuse et farouche aux joues naïvement coloriées" (Régnier 1923, 9).

29 "La svelte et nerveuse femme à cheveux blancs, un peu crispée et délicate, hautaine avec un rien de militaire et de bref et le regard profond, noir et presque hagard des yeux et l'allure de mère tragique" (Régnier, unpublished diary, undated entry, shortly after Morisot's death, quoted in Mallarmé *Correspondance*, VII, 174).

30 Manet 1987, 20–22.

31 Julie and her cousins Paule and Jeanne Gobillard spent August and September 1894 in Brittany with Renoir and his family; see Manet 1979, 54–70.

32 "Pendant que je regardais attentivement le si admirable Delacroix, [M. Degas] me prend par le bras en me disant: 'Un jeune homme à marier.' Je me retourne et aperçois Ernest Rouart avec lequel je ris. Voilà une façon intimidante d'être présenté" (Manet 1979, 228, entry for 25 April 1899). Julie and Ernest were married just over a year later in a double ceremony with her cousin Paule Gobillard and the poet Paul Valéry.

33 "Une toile sobre où s'exprime une rare émotion" (Rivière 1921, 200).

34 "Lorsqu'il fit son portrait, auprès de sa fille Julie, il éprouva une sorte de contrainte qui l'empêcha de se surpasser, comme il désirait" (Baudot 1949, 78).

35 "The Great Ones All Painted Us," *Life*, 10 May 1963, interview with Madame Ernest Rouart.

36 "Nous avons toutes les deux l'air apprêté, je crois que nous aurions été plus naturelles à la maison" (Bernier 1959, 42).

37 Renoir's portrait of Berthe Morisot is generally dated to 1892, which leads even the most sensitive cataloguers into circuitous argument; see Fossier in *Renoir* 1993, 154. Stuckey (1987, 166, 170) is the first to make the more reasonable suggestion that Renoir executed this etching for Durand-Ruel's exhibition catalogue.

38 "Tante Edma et Paule trouvent difficile que j'écrive à M. Renoir que l'on ne mettra pas sa pointe sèche dans le catalogue; elles pensent qu'il serait très blessé étant assez susceptible" (Mallarmé *Correspondance*, VIII, 68, where Julie's letter of 28 February 1896 is published in full).

39 Ibid., VIII, 68–69, for Mallarmé's letter to Renoir of 29 February 1896, his curious salutation referring to the measles that had taken hold of the artist's household. Duret's *Renoir* was published by Bernheim-Jeune; see Fossier in *Renoir* 1993, 154.

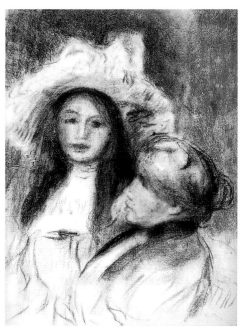

Fig. 266 Pierre-Auguste Renoir, *Berthe Morisot and Julie Manet*, 1894, pastel. Musée du Petit Palais, Paris

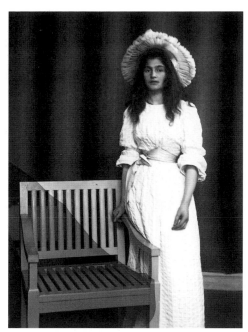

Fig. 268 Julie Manet, 1894. Private collection

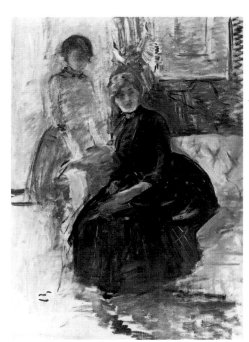

Fig. 267 Berthe Morisot, *Self-portrait with Daughter*, 1885. Private collection

Fig. 269 Berthe Morisot, 1894. Private collection

54 *Gabrielle and Jean* 1895
65 × 54 cm
Signed lower left: Renoir.
Musée National de l'Orangerie, Paris, Jean
Walter and Paul Guillaume Collection,
RF 1960-18

PROVENANCE Possibly Ambroise Vollard
(1866–1939), Paris; Paul Guillaume (1891–
1934), Paris; Guillaume's widow, née
Juliette-Domenica Lacaze (d. 1977), who
subsequently married the architect Jean
Walter (1883–1957), Paris; donated by her
to the Musée de l'Orangerie, 1960, as part
of the Walter-Guillaume Collection.

EXHIBITIONS Possibly *Renoir* 1896, no. 17
or no. 29.

REFERENCES Hoog and Guicharnaud
1984, 196–199; House 1994, no. 38.

NOTES

1 The painting is thoroughly catalogued in Hoog
and Guicharnaud 1984, 196–199.

2 "Nous avons vu le portrait de Jean avec Gab-
rielle, il est charmant" (Manet 1979, 72, entry
for 17 November 1895).

3 "Il faut être emballé soi-même pour ce que l'on
fait bien avec la cervelle propre, pour entraîner
les autres . . . Je suis dans ce moment à faire des
moues de Jean, et je vous assure que ce n'est pas
une cynécure, [sic] mais c'est si joli, et je vous
assure que je travaille pour moi, rien que pour
moi" (Getty Center for the History of Art and
the Humanities, Santa Monica, Calif., Special
Collections, Renoir to Congé, 1 February 1896).

4 House's excellent analysis (House and Distel
1985, 264) of the related *Gabrielle, Jean, and a
Girl* is also relevant to the Orangerie painting.

5 Although signed at lower left, this signature was
probably applied towards the end of Renoir's
life; there is no evidence that the painting was
sold during Renoir's lifetime, as claimed in
House 1994, 122.

6 As House has also noted (House and Distel
1985, 264), Renoir's handling reflects his
renewed interest in Rubens, whose paintings at
the Louvre he was reexamining in the company
of Jeanne Baudot at this time.

7 Reproduced in *Renoir* 1944, 40, as in a private
collection in San Francisco; for the preparatory
pastel, last documented in the Roniger collec-
tion in Rheinfelden, see Daulte 1959a, 19–20.

8 Reproduced in Vollard 1918b, I, 36, no. 141,
and 45, no. 178.

9 See Sotheby Parke Bernet, New York, 6 Decem-
ber 1972, no. 5, where it is incorrectly titled
Gabrielle et Coco and dated to c. 1901. See also
the related drawing *Femme et enfant* (1895) in
Vollard 1918b, I, 132, no. 525.

10 Reproduced in *Burlington Magazine* xxxvi:204
(March 1920), 147.

11 Reproduced in Mongan 1949, 194.

12 House and Distel 1985, 145, 264; Meier-Graefe
1929, 207, for the pastel, incorrectly dated to
1885; Vollard 1918b, II, 51, for the painted
sketch.

13 Leymarie and Melot 1972, no. R10; André and
Elder 1931, II, 155, no. 169, for the painting,

now in the Bührle Collection, Zurich, upon
which this etching is based. The roughly
sketched pastel of *Jean and Gabrielle* appeared
most recently in Sotheby Parke Bernet,
London, 31 March 1982, no. 62.

14 Daulte 1964, 75.

15 Mairie d'Essoyes, "Acte de naissance," 1 August
1878, Fernande-Gabrielle Renard; ibid., "Acte
de mariage," 9 March 1882, Renard and Prélat;
ibid., "Acte de naissance," 12 April 1887, Louis
Victor Charles Paul Renard, born 10 April
1887.

16 Ibid., "Acte de mariage," 25 May 1895,
Pharisien and Maire. Prudent Joseph Louis
Pharisien was the only son from Marie Céleste's
first marriage to Joseph Edmond Pharisien
(1841–1874); Prudent's father-in-law was
Charles Victor Maire, the brother of Aline's
mother, Thérèse Émilie Maire. As can be seen,
the family connection between Gabrielle and
the Renoirs was very slight indeed.

17 Although she occasionally lacked decorum,
Bonnard was struck by her manner of sum-
moning "le patron," when he was tarrying with
friends, to get ready for an appointment:
"Allons, venez pisser" ("Souvenirs sur Renoir"
[1941], quoted in Distel 1993, 151).

18 "Lui est gentil mais sa femme bien embêtante,
elle sera tout le temps à vous embêter" (Biblio-
thèque du Musée du Louvre, Paris, Archives
Vollard, MS 422 [316], Gabrielle to Vollard,
undated, June 1912).

19 Archives of the Metropolitan Museum of Art,
New York, Cassatt to Mrs. H.O. Havemeyer,
16 July 1913.

20 Ibid., 28 December 1913.

21 Mairie d'Essoyes, "Acte de naissance," 1 August
1878, Renard, Fernande-Gabrielle, to which is
appended notice of her marriage to Slade, in
Cagnes, on 18 May 1921.

22 Bergan (1994, 234) notes that the Slades arrived
in California in July 1941, having initially
intended to move to Boston.

23 "I started a few weeks ago what I should have
started long ago. I gather notes for a book about
my father. I do it now with Gabrielle" (Thomp-
son and LoBianco 1994, 308, Jean Renoir to
Clifford Odets, 19 May 1953).

24 Bergan 1994, 30.

25 "Renoir . . . eût trouvé indécent de faire part de
ses sentiments à qui que ce fût, même peut-être
à lui-même. Il se rattrapait devant son chevalet"
(Renoir 1981, 319).

26 "De son pinceau aigu et tendre il s'en payait à
coeur joie de caresser les fossettes du cou, les
petits plis des poignets de ses gosses, et de crier
à l'univers tout son amour paternel" (ibid.,
319).

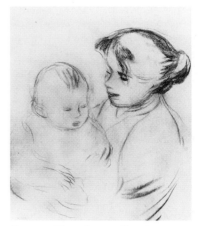

Fig. 270 Pierre-Auguste Renoir,
Gabrielle and Jean, 1895, charcoal. Location
unknown

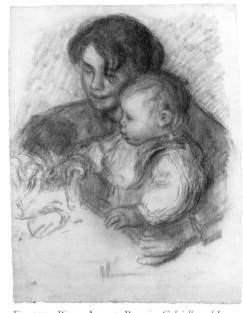

Fig. 271 Pierre-Auguste Renoir, *Gabrielle and Jean*,
1895, black chalk. National Gallery of Canada,
Ottawa, Gift of Martin Fabiani, Paris, 1956

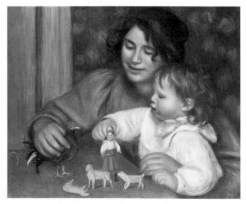

Fig. 272 Pierre-Auguste Renoir, *Child with Toys
(Gabrielle and Jean)*, 1895–96. National Gallery of Art,
Washington, Collection of Mr. and Mrs. Paul Mellon

Fig. 273 Gabrielle Renard with her husband Conrad Slade and Jean Renoir. From *Life*, 3 August 1942

Fig. 274 Gabrielle Renard. Private collection, Essoyes

55 *Christine Lerolle Embroidering* 1897

82.6 × 65.8 cm

Signed lower left: Renoir.

Columbus Museum of Art, Ohio, Gift of Howard D. and Babette L. Sirak, the Donors to the Campaign for Enduring Excellence, and the Derby Fund, 91.1.57

PROVENANCE In Renoir's collection until his death; Durand-Ruel; sold by Durand-Ruel to Charles Sessler, London, 1 September 1929; private collection, Switzerland, by 1958; Sam Salz, New York; Howard and Babette Sirak, March 1973; acquired by the Columbus Museum of Art, 1990.

EXHIBITIONS *Renoir* 1902, no. 20.

REFERENCES André and Elder 1931, I, pl. 36, no. 101; Brettell and Selz 1991, no. 57.

NOTES

1 The phrase is Julie Manet's, who described the Degas in the background of *Yvonne and Christine Lerolle at the Piano* (fig. 275) as "peint avec amour" (Manet 1979, 138, entry for 25 October 1897).

2 See Renoir's letter to Berthe Morisot of 21 November 1894, declining an invitation to dinner: "Mes excuses . . . à M. et Mme Lerolle qui me faisaient l'honneur de désirer ma connaissance, en leur disant qu'ils ne perdent pas énormément" (Morisot *Correspondance*, 183).

3 Denis 1930, 91–107, remains the fullest account of Lerolle's career; see also Loyrette 1991, 480–483.

4 *Before the Race* (1882, Sterling and Francine Clark Art Institute, Williamstown, Mass.) and *Pink Dancers* (1878, Norton Simon Art Foundation, Pasadena, Calif.) are the two of Lerolle's several Degas to be featured in Renoir's painting. Lerolle and his wife bought their first Degas from the artist himself in 1878, but a friendship did not develop until five years later (*Degas* 1988, 232; Loyrette 1991, 481–482).

5 "Nous voyons ce qu'a fait M. Renoir d'après les Lerolle au piano, c'est ravissant" (Manet 1979, 138, entry for 25 October 1897).

6 "Nous passons une bonne partie de la journée chez M. Renoir. Que de jolies choses il y a dans son salon. *Yvonne et Christine Lerolle* attire mes regards chaque fois que j'y vais" (ibid., 215, entry for 31 January 1899).

7 In the inventory drawn up after Aline's death at the end of December 1915, the painting, entitled "Jeune fille faisant de la tapisserie," was included among "les toiles de vingt-cinq en dépôt chez Durand-Ruel," where it was valued at 1,500 francs. On the destruction by enemy cannon fire of the house opposite Durand-Ruel's gallery in the rue Laffitte; see Godfroy 1988, 267.

8 House 1994, 23–26.

9 On the five versions of *Young Girls at the Piano*, commissioned by Henri Roujon, directeur des Beaux-Arts, in 1892, see House and Distel 1985, 262.

10 Baudot 1949, 48. The painting, which may have been inspired by Maurice Denis's *Yvonne Lerolle in Three Guises* (1897, Josefowitz collec-

tion), never materialized, despite Jeanne's hopes ("Je vécus un mois bercée par cette perspective réjouissante, puis mes illusions s'envolèrent: Renoir avait changé d'avis.")

11 "Outre ses Degas, des toiles de Fantin, de Puvis, de Besnard, de Corot, de Renoir . . . sur des murs tapissés de papiers clairs de William Morris" (Denis 1930, 93).

12 "Un ensemble harmonieux de meubles de famille et de meubles modernes, d'oeuvres d'art très choisies" (ibid.).

13 An observation first made in Adriani 1996, 260.

14 Devillez, whose portrait was painted by Lerolle in 1893, was born in Mons on 19 July 1855; the date of his death is unknown. On his donation of forty works by Carrière to the Louvre in 1931 see Laclotte 1989, 190–191.

15 Meier-Graefe (1929, 167) and Drucker (1944, 210) identified the second man as Louis Rouart, Christine's future husband, who would have been twenty-two at the time. In *Renoir* 1969, no. 36, and Adriani 1996, 260, this figure is referred to as the collector Henri Rouart.

16 Vapereau (1893, 980) noted that Lerolle had been awarded this honour for having served on the "jury d'admission" of the Exposition Universelle of 1889. As noted by Adriani (1996, 259), Renoir's portrait of Lerolle was originally horizontal in format, with a garland of roses at left, and has only recently been cut down; the complete canvas was last reproduced in Galerie Charpentier, Paris, 17 June 1960, no. 101 bis.

17 "M. Renoir nous a raconté comment lorsqu'il faisait le portrait de Christine Lerolle, le père de Mme Lerolle était arrivé devant le tableau en riant, disant: 'Ah, c'est de la peinture nouvelle,' Madame Lerolle s'efforçait de lui dire: 'Papa, je te présente M. Renoir, l'auteur du portrait,' mais il continuait toujours, enfin lorsqu'il comprit la boulette qu'il venait de faire, il s'excusa: 'Mais continuez,' répondit M. Renoir" (Manet 1979, 133–134, entry for 10 October 1897). Madeleine Lerolle's father, Philippe Escudier, "rentier," was aged seventy at the time, and might be forgiven his outburst.

18 Denis (1930, 92) notes that he had been "discovered and protected by Lerolle," who commissioned a ceiling decoration from him in 1892. In April 1890 Gauguin encouraged Theo van Gogh to approach Lerolle to buy a group of his sculpted wood reliefs and paintings that were languishing on consignment with Boussod et Valadon (Rewald 1986b, 56–57). It should also be noted that Lerolle, a talented violinist and amateur composer, was the brother-in-law of Ernest Chausson, who was married to Madeleine Escudier's younger sister.

19 Archives de Paris, 5MI3/161, "Acte de naissance," 14 November 1879, Christine Lerolle, born 13 November 1879, witnessed by her uncle, the lawyer Paul Lerolle, and by the sculptor Charles Alfred Lenoir.

20 Ibid., 5MI3/158, "Acte de naissance," 16 April 1877, Yvonne Lerolle. Jacques Lerolle was a music publisher. Guillaume Lerolle, a friend of Gide's and the translator of Santayana, is listed as working for the Carnegie Institute in 1929. See Archives de l'Enregistrement, Paris, 27 February 1930, "Succession," Henri Lerolle.

21 The painting appeared most recently in Christie's, London, 28 June 1968, no. 95. A fine preparatory drawing is reproduced in Rewald

1958, no. 79, entitled *Portrait of a Lady* and incorrectly dated to "c. 1905."

22 Terrasse 1983, 94, 103–104.

23 *Degas Portraits* 1994, 79.

24 Notification of her marriage to Henri Louis Rouart is appended to her birth certificate, cited at note 19 above. It was at the wedding reception two days later that Degas told Maurice Denis of his meetings with Ingres (Denis 1957–59, I, 166–167, entry for 14 February 1901). The *soirée de contrat* for Yvonne Lerolle's marriage two years earlier had been held on 22 December 1898 at Degas's apartment (Manet 1979, 207).

25 The Rouarts' second son, Philippe, was born on 14 January 1904; their third child, Marie Henriette, would be born on 9 December 1905. Degas's pastel portrait of Monsieur and Madame Louis Rouart, and the seven preparatory drawings, are dated to between 1904 and 1905 (*Degas Portraits* 1994, 79–80).

26 "Thé chez les Lerolle; effarante insignifiance de la conversation" (Gide 1951, 374, entry for February 1912).

27 "Vous devez être bien contente, disait-on à sa femme, de le voir devenu si religieux. – Moi! mais j'en suis désolée! s'écriait-elle; tant qu'il ne l'était pas j'ai pu compter sur la religion pour adoucir son caractère; à présent je ne compte plus sur rien" (Gide 1951, 290).

28 *Degas Portraits* 1994, 80. Christine Lerolle died at 6 avenue Watteau in Nogent-sur-Seine on 26 July 1941, aged sixty-two (Mairie du 6ᵉ arrondissement, Paris, "Acte de décès," 24 August 1941, Lerolle, femme Rouart).

29 Reproduced most recently in Christie's, London, 29 March 1977, no. 25, where it is incorrectly dated to 1892. A drawing of Christine in profile, sewing – but without her embroidery stand – is reproduced in Vollard 1918b, II, 125.

30 "Il était sensible au charme de la vie quotidienne exprimé avec tant de ferveur par les Flamands et les Hollandais. Il aimait tout particulièrement Terburg, de Hoog et surtout *la Dentellière* de Vermeer" (Baudot 1949, 29).

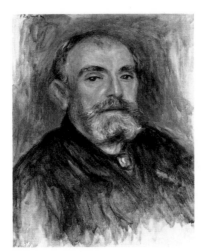

Fig. 276 Pierre-Auguste Renoir, *Henri Lerolle*, 1890–95. Fondation Rau pour le Tiers-Monde, Zurich

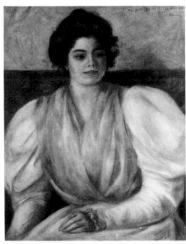

Fig. 277 Pierre-Auguste Renoir, *Christine Lerolle*, 1897. Location unknown

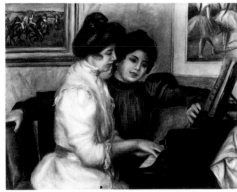

Fig. 275 Pierre-Auguste Renoir, *Yvonne and Christine Lerolle at the Piano*, 1897. Musée National de l'Orangerie, Paris, Walter-Guillaume Collection

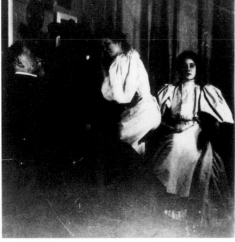

Fig. 278 Edgar Degas with Yvonne and Christine Lerolle, c. 1898, photograph by Edgar Degas. Private collection, Paris

Fig. 279 Edgar Degas, *Monsieur and Madame Louis Rouart*, 1904, pastel. Private collection

56 *Self-portrait* 1899
41 × 33 cm
Signed upper left: Renoir.
Sterling and Francine Clark Art Institute, Williamstown, Mass., 611
House/Distel no. 99

PROVENANCE In Renoir's collection until his death; Pierre Renoir (1885–1952), Paris, until 1935; consigned to Durand-Ruel, New York, 1936; sold by Durand-Ruel to Robert Sterling Clark, 10 April 1937.

EXHIBITIONS Not exhibited in Renoir's lifetime.

REFERENCES André and Elder 1931, I, pl. 59, no. 182; Kern 1996, 57–58.

NOTES

1 First pointed out by House in House and Distel 1985, 270; White (1984, 213) gives the address. Julie Manet, who noted on 14 June that Renoir was "très bien installé" at Saint-Cloud, stayed with him between 28 July and 12 August 1899 (Manet 1979, 234, 246–250).

2 "Il termine un portrait de lui qui est très joli, il s'était d'abord fait un peu dur et trop ridé; nous avons exigé qu'il supprimât quelques rides et maintenant c'est plus lui. 'Il me semble que c'est assez ces yeux de veau,' dit-il" (Manet 1979, 249, entry for 9 August 1899).

3 "Le dessus de son crâne était complètement dégarni. Mais on ne le voyait pas, car il avait pris l'habitude de rester constamment couvert, même à l'intérieur de la maison" (Renoir 1981, 36).

4 "Je considère qu'un art est inférieur lorsqu'il y a un secret: dans la peinture de Rubens comme celle de Vélasquez il n'y a rien de caché, pas de dessous, c'est peint du coup" (Manet 1979, 248, entry for 7 August 1899).

5 "Puis M. Renoir parle de Vélasquez, de ses collerettes si légères faites de blanc et de noir" (ibid.).

6 House and Distel 1985, 270.

7 "Lorsque nous rentrons M. Renoir nous dit avoir vu le Dr. Baudot qui l'engage à partir dimanche pour Aix" (Manet 1979, 248, entry for 8 August 1899). The next day, she notes Renoir's comment: "Si le traitement m'ennuie trop, je le ferai suivre par Gabrielle" (ibid., 249). Madame Renoir remained in Essoyes.

8 "Le visage de Renoir était déjà ravagé, creux, plissé, les poils de sa barbe clairsemés, et deux petits yeux clignotants brillaient, humides, sous des sourcils que cette broussaille ne parvenait à rendre moins doux et moins bons" (Blanche 1927, 237).

9 "Renoir une tête à la fois nerveuse et morte d'hémiplégique a l'un des yeux mi-clos; la barbe clairsemée, l'air comme à demi cabré avec une délicate et fine simplicité" (Régnier, un-published diary, quoted in Mallarmé Correspon-dance, VI, 191).

10 House and Distel 1985, 270.

11 "Il va, vient, s'assied, se relève, et, debout, se rassied, se relève, poursuit la dernière cigarette oubliée, sur cet escabeau, ou là-bas, ou au chevalet, non sur cette table, et se décide à en rouler une qu'il pourra bien tantôt perdre encore, avant qu'il ait trouvé le moyen de l'al-lumer" (Natanson, "Renoir," La Revue Blanche, June 1896, quoted in Distel 1993, 148). Thadée Natanson (1868–1951), whose ex-wife Misia would later sit to Renoir several times as Madame Edwards, was the founder of the Revue Blanche, copies of which, still in their wrappers, were used by Renoir as a footstool for his mod-els (Vollard 1919, 10).

12 For his two early self-portraits, see cat. nos. 24 and 25. For the two self-portraits painted in 1910 see House and Distel 1985, 280–281, and Adriani 1996, 304–306.

13 "Renoir . . . eût trouvé indécent de faire part de ses sentiments à qui que ce fût, même peut-être à lui-même" (Renoir 1981, 319).

14 "Mon père avait quelque chose d'un vieil Arabe" (ibid., 35).

15 "'Il pourrait biser une bique entre les cornes,' pensaient-elles en voyant sa figure maigre" (ibid., 381).

Fig. 280 Pierre-Auguste Renoir, c. 1899. Archives Durand-Ruel, Paris

Fig. 281 Renoir with Pierre Bonnard and Misia Natanson at Le Relais, home of Thadée Natanson, after Mallarmé's funeral, 10 September 1898. Location unknown

57 Jean Renoir Drawing 1901
45 × 54.5 cm
Signed and dated lower right: Renoir. 01.
Virginia Museum of Fine Arts, Richmond, Collection of Mr. and Mrs. Paul Mellon, 83.48

PROVENANCE In Renoir's collection until his death; sold to Sir Thomas Barlow (1883–1964), London, through the art dealer Alfred Flechtheim (1878–1937), Berlin, in the early 1920s; his son, Basil Barlow (b. 1918), London, by 1953; sold to Paul Mellon through Thomas Agnew and Sons, Ltd., London, 4 August 1961.

EXHIBITIONS Renoir 1912, possibly no. 17.

REFERENCES Vollard 1918b, II, 183; André and Elder 1931, I, pl. 80, no. 260; Near 1985, 78–79; Renoir 1988, no. 55.

58 The White Pierrot (Jean Renoir)
1901–02
81 × 62 cm
Signed lower right: Renoir
The Detroit Institute of Arts, Bequest of Robert H. Tannahill, 70.178

PROVENANCE In Renoir's collection until his death; Claude Renoir (1901–1963), Cagnes-sur-mer; Paul Guillaume (1891–1934), Paris, by 1932; Robert Hudson Tannahill, Detroit, by 1952; part of the Tannahill bequest to the Detroit Institute of Arts, 1970.

EXHIBITIONS Not exhibited in Renoir's lifetime.

REFERENCES André and Elder 1931, I, pl. 108, no. 342.

NOTES
1 House and Distel 1985, 309. On Renoir's stu-dio at 73 rue Caulaincourt see also Milner 1988, 156.
2 "L'époque de la rue Caulaincourt est celle où j'ai posé le plus" (Renoir 1981, 432).
3 Renoir 1981, 440. Jean did not stay there long; by 1903 he was attending Sainte-Marie de Monceau (Renoir 1974, 26).
4 Renoir 1981, 437.
5 Renoir 1974, 16.
6 Near 1985, 458–459, quoting from Jean Renoir's letter of 1 January 1952 to John Roberts, managing director of the Ganymed Press, which had just published a colour repro-duction of Jean Renoir Drawing. The letter, writ-ten in English, is in the curatorial files of the Virginia Museum of Fine Arts, Richmond.
7 Schapiro 1940–41 remains the classic account.
8 Georgel 1988, 36.
9 André and Elder 1931, I, no. 342, "Jean Renoir en pierrot, 1906." Fezzi (1985, no. 664) and Monneret (1989, 155, no. 8) both date the painting to "c. 1892."
10 Jean Renoir recalled: "J'ai souvent préparé les toiles de mon père avec du blanc d'argent et un mélange d'un tiers d'huile de lin et deux tiers d'essence de térébenthine" (Renoir 1981, 217).
11 White 1984, 223; Distel 1993, 106.
12 First reproduced in Dussaule 1995, 10.
13 Haskell 1972, 6.
14 Ibid., 9–10. The literature on Pierrot and the visual arts is extensive; for a good introduction see Borowitz 1984. In 1854–55, Debureau's son Charles was photographed as Pierrot by Nadar in an unforgettable series; see Hambourg in Nadar 1995, 224–227.
15 Jones 1984, chapter 6.
16 Haskell 1972; Storey 1978.
17 "Quand j'étais encore tout petit, trois, quatre, ou cinq ans, il ne choisissait pas lui-même la pose, mais profitait d'une occupation qui sem-

blait me faire tenir tranquille" (Renoir 1981, 433).

18 Thompson and LoBianco 1994, xxiv, from a questionaire personally compiled by Jean and Dido Renoir for publicity purposes on 27 March 1958.

19 Renoir 1974, 25–27.

20 Ibid, 25.

21 "Je ne l'aimais que sous sa forme napolitaine, avec des vêtements blancs trop grands" (Renoir 1981, 360).

Fig. 282 Pierre-Auguste Renoir, *Pierre Renoir Drawing*, 1888. Private collection

Fig. 283 Pierre-Auguste Renoir, *Coco (Claude Renoir Drawing)*, 1905. The Hyde Collection, Glens Falls, N.Y.

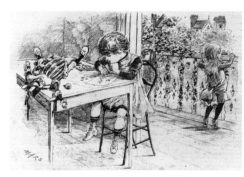

Fig. 284 Mars [Maurice Bonvoisin], *Child Drawing*. From *La Vie Moderne*, 2 December 1882

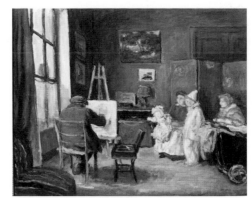

Fig. 285 Albert André, *Renoir Painting His Family*, 1901. Musée Renoir, Cagnes-sur-Mer, Gift of Madame Bret-André

Fig. 286 Albert André, *Jean Renoir as Pierrot*, 1901, pen and ink. Private collection

59 *Claude and Renée* 1903
78.7 × 63.5 cm
Signature stamp lower right
National Gallery of Canada, Ottawa, 4989

PROVENANCE In Renoir's studio at the time of his death; Jean Renoir (1894–1979), Marlotte, until 1938; purchased by the National Gallery of Canada from E.J. van Wisselingh and Co., Amsterdam, 17 March 1949.

EXHIBITIONS Not exhibited in Renoir's lifetime.

REFERENCES André and Elder 1931, I, pl. 88, no. 284; Hubbard 1959, 45; House 1994, no. 41.

NOTES
1 Mairie d'Essoyes, "Acte de naissance," 4 August 1901, witnessed by Théophile Maire, "vigneron, cousin du déclarant," and Clément Joseph Munier, "vigneron, ami du déclarant."

2 "Je suis très content de savoir Clo Clo si bien portant" (University of Texas at Austin, Harry Ransom Research Center, Carlton Lake Collection, Renoir to Aline, from Paris, 22 February 1904; quoted in part in White 1984, 22).

3 "Coco fut certainement l'un des modèles les plus prolifiques de Renoir" (Renoir 1981, 432).

4 House 1994, 126.

5 House and Distel 1985, 309.

6 Reproduced most recently in White 1984, 217.

7 See Sotheby's, London, 30 March 1988, no. 314.

8 Jean Renoir noted: "Je n'ai vu employer le système des calques que rarement. C'était quand mon père était satisfait de la position d'un corps ou d'un groupe, mais mécontent de la façon dont il s'équilibrait avec le fond" (Renoir 1981, 431).

9 For *Bébé au chapeau blanc* see Sotheby's, London, 21 April 1970, no. 20, where it is incorrectly dated to 1912. This painting had been cut out of a horizontal composition, which originally included a second smaller study of Claude, and a study of apples (see André and Elder 1931, II, pl. 141, no. 437). For a different composition, with Claude, looking to the left, set against a dark-green background, see Adriani 1996, 282.

10 "Renée Jolivet, née à Essoyes, devint actrice, voyagea beaucoup, habita l'Égypte et fut aussi un modèle superbe" (Renoir 1981, 413).

11 Mairie de Châtillon-sur-Seine (Côte d'Or), "Acte de naissance," 20 December 1885, Marie Renée Suzanne Jolivet.

12 Mairie d'Essoyes, "Acte de naissance," 6 October 1892, Yvonne Eugénie Jolivet; ibid., "Acte de décès," 5 September 1893, Auguste Jolivet.

13 "Ma chère amie, Je suis très content du mariage de Renée. J'ai voulu la reprendre par principe, mais sans grand désir" (Renoir to Aline, as in note 2 above).

14 Mairie d'Essoyes, "Acte de mariage," 22 August 1904, Alphonse Cayat and Marie Renée Suzanne Jolivet.

15 Mairie d'Essoyes, "Acte de divorce," 9 June 1921, which notes that judgement in favour of Renée Jolivet had been given by the Tribunal Civil de Première Instance du Département de la Seine on 8 June 1920. Her marriage to Arquier took place at the mairie of the 18th arrondissment in Paris on 17 March 1934 (annotation to her "Acte de naissance," cited at note 11 above).

16 Mairie de Montluçon, "Acte de décès," 25 October 1973, which further notes that she resided at 59 rue Lepic, Paris, in the 18th arrondissement.

17 House 1994, 126.

18 "C'est ainsi que les sculpteurs anciens ont mis dans leurs oeuvres le moins possible de mouvements, pour rendre la chose éternelle. Mais si leurs statues ne font pas de mouvements, on a la sensation qu'elles pourraient en faire" (Renoir's comment to Vollard, recorded in Vollard 1919, 129).

19 "Jamais pourtant il ne semblait avoir éprouvé tant de joie à suivre les jeux du jeune animal humain qui s'éveille, gonflé de lumière et de lait" (Roger-Marx 1933, 152).

20 Ibid., 155.

Fig. 287 Pierre-Auguste Renoir, *Claude Renoir and His Nurse*, 1903, charcoal. Location unknown

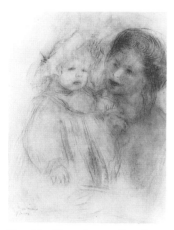

Fig. 288 Pierre-Auguste Renoir, *Claude Renoir and His Nurse*, 1903, charcoal. Location unknown

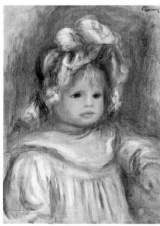

Fig. 289 Pierre-Auguste Renoir, *Claude Renoir*, 1903. Location unknown

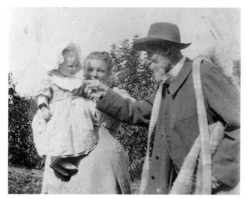

Fig. 290 Renoir, his wife, and Claude at Le Cannet, 1902. Archives Durand-Ruel, Paris, Jacqueline Besson-André Collection

60 *Ambroise Vollard* 1908
81.6 × 65.2 cm
Signed and dated upper left: Renoir. 08.
Courtauld Institute Galleries, London,
Samuel Courtauld Collection
House/Distel no. 107

PROVENANCE Presented by Renoir as a gift to Ambroise Vollard (1866–1939), Paris; purchased from Vollard by the English textile manufacturer Samuel Courtauld (1876–1947), London, June 1927, for 800,000 francs; gift of Samuel Courtauld to the Home House Trustees (Courtauld Institute of Art), 16 December 1932.

EXHIBITIONS *Renoir* 1912, no. 48.

REFERENCES Vollard 1918b, I, 62, no. 247; *Courtauld* 1994, 140.

NOTES
1 White (1984, 241) reproduces Renoir's letter to Vollard of 7 May 1908: "Venez quand vous voulez. Je suis maintenant en état de travailler."
2 House and Distel 1985, 310. Renoir vented his frustation to Rivière: "J'en ai en ce moment la tête brouillée par mes architectes entrepreneurs . . . J'espère un jour que cette maison sera finie, cela me casse la tête" (University of Texas at Austin, Harry Ransom Humanities Research Center, Carlton Lake Collection, Renoir to Georges Rivière, from Cagnes, 13 May 1908).
3 White 1984, 241, 300.
4 Vollard (1919, 217), describing the genesis of Renoir's fourth portrait of him, wearing a hat and stroking a cat (1915, private collection), noted: "Il avait fait d'après moi une lithographie et trois études peintes dont une très poussée, où il me représentait accoudé à une table et tenant à la main une statuette de Maillol (1908)." Renoir's four other portraits of Vollard are reproduced in Vollard 1938a.
5 On Cézanne's portrait of Vollard, which required a hundred and fifteen sessions, see, most recently, Cachin in *Cézanne* 1995, 422–423. Although dated to 1911–12 in Laffon 1981–82, II, 706, Renoir's panel portrait of Vollard as

a bandit was done several years earlier; it is dated to 1906 in Vollard 1938a, 43.
6 Vlaminck (1943, 88) noted that "le point de vue vestimentaire ne l'intéressait en aucune façon," an observation confirmed by the dealer himself: "Cette manie que j'ai toujours eue de garder indéfiniment mes vieux vêtements" (Vollard 1937, 190).
7 See the Ming waterdropper reproduced in Hong Kong 1975, no. 49. I am greateful to Jennifer Casler, Curator of Asian and Non-Western Art at the Kimbell Art Museum, Fort Worth, for helping me with this identification.
8 "Vollard déjeunait dans sa cave, la serviette au cou, dans la société d'un Renoir qu'il avait fait dresser devant lui" (Salmon 1956–61, III, 204).
9 House and Distel (1985) refer to Renoir's presentation of Vollard as of the "archetypal connoisseur." Whether Renoir knew Titian's portrait through reproduction – he had never visited the Kunsthistorisches Museum – is impossible to document with any certainty, although one of Vollard's ruses on his visits to Cagnes and Essoyes was to bring museum catalogues for Renoir to browse, since "no-one loved the old masters as much as he did" (Vollard 1936, 267).
10 As is apparent, I take the opposite point of view to John House's curiously unsympathetic reading of the Courtauld portrait, which he considers "among [Renoir's] least acute either as a record of physiognomy or as an evocation of character" (House and Distel 1985, 275, and *Courtauld* 1994, 140).
11 Centre des Archives d'Outre-mer, Aix-en-Provence, "Acte de naissance," 12 July 1866, Henri Louis Ambroise Vollard, born 3 July 1866 in the rue du Conseil. Distel (1989b, 48) was the first to publish Vollard's date of birth accurately.
12 Vollard 1937, chapters 1–4; Johnson 1977, 46.
13 Vollard 1937, 57.
14 "Le petit marchand, il est intelligent, et un enthousiaste" (Pissarro *Correspondance*, III, 439, Pissarro to Lucien, 7 March 1894).
15 Welsh-Ovcharov (1976, 214) noted that Vollard acquired Van Gogh's *Les Brodequins* (F333) for 30 francs; three of Vollard's acquisitions at the Tanguy sale are identified in *Cézanne* 1995, 550.
16 Distel (1995, 43) establishes the chronology of Vollard's addresses in the rue Laffitte using the Vollard archives acquired by the Musée d'Orsay in 1988.
17 "Berthe Morisot fit à mon père un cadeau posthume en la personne d'Ambroise Vollard" (Renoir 1981, 336).
18 Vollard 1937, 202–208; Rouart and Wildenstein 1975, I, 254. Manet's *Monsieur Brun* (1879–80) was acquired by the National Museum of Western Art, Tokyo, in 1984.
19 "Pour en revenir à cette première entrevue, mon père eut l'idée brillante de lancer Vollard sur Cézanne . . . Bien entendu Vollard connaissait la peinture de Cézanne. Il est possible que ce soit Renoir qui lui en ait fait comprendre la valeur, 'inégalée depuis la fin de l'art roman'" (Renoir 1981, 338–339).
20 In the absence of a much-needed monograph on Vollard, I have relied upon the chronologies established in *Cézanne* 1995, 550–554; *Gauguin* 1988, 380 (late November 1896); Feilchenfeldt

331

1988, 12 (two Van Gogh exhibitions, summer and November 1896); Rubin 1980, 29 (joint Picasso-Iturrino exhibition); *Matisse* 1992, 87; and Freeman 1990, 66, 67 (for Vollard's contracts with Derain and Vlaminck). See also the useful, but incomplete, chronology in Bouillon et al. 1990, 326–329.

21 "Ce gueulard de Vollard" (Drucker 1944, 140–141, Renoir to Vollard, 3 May 1901). Werth (1921, xi) recalled Renoir making excuses for the ubiquitous Vollard: "Il est là le matin pour me mettre mes chaussettes. Il est là le soir pour me les ôter."

22 "Renoir criait joyeusement à son domestique: 'S'il nous manque de l'argenterie, ne manquez pas de crier au Vollard,' ce que le marchand n'appréciait qu'à moitié" (Julie Rouart's reminiscence in Bernier 1959, 46).

23 Reproduced in Vollard 1936, 268.

24 "Ce dernier s'amusait de lui, en faisait sa tête de turc et son bouffon" (Dauberville 1967, 167). Gimpel (1963, 65), in his entry for 15 August 1918, made the same point more crudely: "Vollard lui tient son crachoir, lui apporte son vase de nuit et l'aide à faire . . . pipi!"

25 "Votre portrait, vous voulez encore un portrait! Allez me chercher un cocotier. Je vous peindrai suspendu et vous grattant le derrière" (Besson 1921, ii).

26 "Il attendait la vengeance d'un marchand mille fois humilié" (ibid.).

27 "Un grand bonhomme maigre, avec une petite barbe, m'appela par-dessus la clôture . . . J'ai cru que c'était un marchand de tapis et je lui dis qu'on n'avait besoin de rien" (Renoir 1981, 337).

28 Stein 1933, 33.

29 "'Maman, c'est le singe!' ou bien: 'Maman, c'est le Nègre!'" (Renoir 1981, 353).

30 Richardson 1991, 195.

31 "Le spirituel créole de la rue Laffitte" (Carré 1912, 408).

32 Renoir 1981, 441. "Ce brave Créole est épatant, il virevolte d'une chose à l'autre" (Pissarro *Correspondance*, IV, 245, Pissarro to Lucien, 4 September 1896).

33 "C'est un homme d'un grand flair, de tenu, et sachant se conduire" (Cézanne *Correspondance*, 285, Cezanne to Charles Camoin, 11 March 1902).

34 Fenton 1996, 14. This tasteless remark earned him Renoir's rebuke.

35 George 1965, 220.

36 Baudot 1949, 112.

37 On this rather confused issue see, most recently, O'Brian 1988, 136–138. On 12 September 1906 Renoir had reassured Vollard from Essoyes: "Mon buste va admirablement" (Cabinet des Dessins, Musée du Louvre, Paris, "Autographes, Renoir," L24). After Maillol's first portrait collapsed for lack of a proper armature, a second bust, less animated, was modelled successfully and cast in bronze the following year. Rivière (1921, 247) mistakenly dated Maillol's visit to Essoyes to the summer of 1908.

38 "Vous dirai-je, interrompit Renoir, qu'entre Maillol et Rodin, c'est encore Maillol que je préfère par goût personnel" (Vollard 1937, 232). But it was Degas whom he considered "le premier sculpteur . . . J'ai vu de lui un bas-relief qu'il laissait tomber en poussière, c'était beau comme l'antique" (Vollard 1924, 63).

39 "Cette sculpture de Maillol est un des rares objets d'art qui orne la maison de Renoir en Provence" (Carré 1912, 408).

40 Vollard 1937, 109.

41 "Ce qui me plaisait surtout, c'était les fragments de porcelaine bleue" (Vollard 1937, 14, 280, for the ceramics decorated by Bonnard, Denis, Derain, and Matisse).

42 "Dites-moi, monsieur Renoir, pourquoi n'y a-t-il pas de courses de taureaux en Suisse? . . . avec leurs vaches" (Renoir 1981, 338).

43 Rubin 1989, 175; Kostenevich and Bessonova 1986, 120.

44 Archives de l'Enregistrement, Paris, 26 January 1940, "Succession," Ambroise Vollard, where his will is transcribed: "Je laisse mon portrait par Cézanne, toile de 30 figure, mon portrait par Renoir, toile de 25 figure . . . à la Ville de Paris, pour le Petit Palais." Of Renoir's five portraits of Vollard, only the dimensions of the Courtauld portrait – 82 × 65 cm – conform to a size 25. On Courtauld's purchase see Prettejohn in *Courtauld* 1994, 223.

45 "Mr. Heyligers m'avait déjà dit que vos tableaux français devaient aller plus tard à la National Gallery de Londres et cela m'avait fait beaucoup de plaisir" (Courtauld Institute Archives, Vollard to Samuel Courtauld, from Paris, 23 June 1937; I am indebted to John Murdoch for this letter). Heyligers, a Parisian dealer established at 28 rue de Grammont, received a commission of 80,000 francs from Vollard for having acted as the intermediary in this sale (Bibliothèque du Musée du Louvre, Paris, Archives Vollard, MS 421 [297]).

46 "Je me permettrai dans quelques jours de vous écrire à nouveau au sujet du vernissage éventuel de ce tableau. Et s'il doit être mis sous verre peut-être faudrait-il ne pas le vernir?" (Vollard to Samuel Courtauld, as in note 45 above).

Fig. 292 Ambroise Vollard, c. 1915. Musée du Louvre, Paris, Archives Vollard

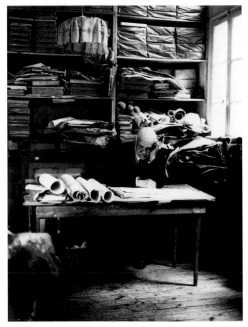

Fig. 293 Ambroise Vollard, c. 1930. Stiftung "Langmatt" Sidney und Jenny Brown, Baden, Switzerland

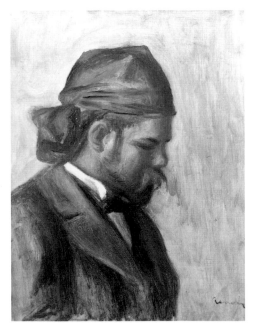

Fig. 291 Pierre-Auguste Renoir, *Ambroise Vollard*, 1906. Musée du Petit Palais, Paris

Fig. 294 Aristide Maillol, *Crouching Woman*, c. 1900, terracotta. Location unknown

Fig. 295 Titian, *Jacopo Strada*, 1567–68. Kunsthistorisches Museum, Vienna

61 *The Clown (Claude Renoir)* 1909
120 × 77 cm
Signed and dated lower right: Renoir. 09.
Musée National de l'Orangerie, Paris,
Jean Walter and Paul Guillaume Collection,
RF 1960-17
House/Distel no. 110

PROVENANCE In Renoir's studio at the time of his death; Claude Renoir (1901–1963), Cagnes-sur-mer; possibly Ambroise Vollard (1866–1939), Paris; Paul Guillaume (1891–1934), Paris; Guillaume's widow, née Juliette-Domenica Lacaze (1898–1977), who remarried the architect Jean Walter (1883–1957), Paris; donated by her to the Musée de l'Orangerie, 1960, as part of the Walter-Guillaume Collection.

EXHIBITIONS *Renoir* 1913.

REFERENCES André and Elder 1931, II, pl. 120, no. 374; Hoog and Guicharnaud 1984, 218–219.

NOTES

1 In fact, Claude was probably just eight years old. He was born in Essoyes on 4 August 1901, and Renoir's portrait is dated 1909.

2 "Je me souviens des instants dramatiques qui ont marqué les dernières séances pour mon portrait en clown rouge. Je devais avoir neuf ou dix ans; ce costume était complété de bas blancs que je refusais obstinément à mettre. Pour terminer la toile, mon père exigea les bas; il n'y eut rien à faire; ils me piquaient. Ma mère apporta alors des bas de soie; ils me chatouillaient. Ce furent des menaces, puis des négociations; tour à tour on me promit une fessée, un chemin de fer électrique, le collège comme pensionnaire, une boite de couleurs à l'huile. Enfin, je consentis à mettre des bas de coton pendant quelques instants; mon père, contenant une fureur prête à éclater, termina le tableau malgré les contorsions que je faisais pour pouvoir me gratter" (Renoir 1948, 6–7).

3 "Mon père, me dit-il, me laissait une grande liberté . . . parfois je devais seulement être immobile pendant trois minutes" (Robida 1959, 44).

4 For Renoir's *La Collerette*, listed neither by Vollard (1918b) nor by André and Elder (1931), see Hoog and Guicharnaud 1984, 218.

5 "Il a une énergie que je suis loin de posséder" (Godfroy 1995, II, 41, Renoir to Paul Durand-Ruel, 11 February 1909).

6 The artist is recorded as saying: "C'est maintenant que je n'ai plus ni bras ni jambes que j'aimerais peindre de grandes toiles" (André 1928, 45).

7 White (1984, 241) reproduces a photograph, dated to 1909, of Renoir being carried around in a chair at Les Collettes.

8 "Pour mon voyage d'Italie, il n'est pas encore fait. Je crains de me trimbaler dans les hôtels et d'y prendre plus de mal que de bien" (Renoir to Paul Durand-Ruel, as in note 5 above).

9 "Je ne rêve que de Véronèse, de Noces de Cana!" (André 1928, 45). Gangnat's dancing

figures are in the National Gallery, London; see House and Distel 1985, 277.

10 André 1928, 46; Gimpel 1963, 29, entry for March 1918, noting that "le châssis sur le chevalet, au lieu d'être soutenu par une tablette, est accroché et maintenu par un contrepoids qui permet à Renoir de monter et de descendre sa toile lui-même avec facilité."

11 "La paralysie ne lui permettait pas de faire un mouvement de plus vingt centimètres d'ampleur, il fallait déplacer la toile continuellement sous son pinceau" (Éparvier 1933).

12 "Cette scrupuleuse probité de Renoir envers son modèle" (Robida 1959, 44). Michel Robida, great-nephew of Marguerite Charpentier, had interviewed Claude Renoir in his pottery studio in Menton.

13 See also the moving photograph of Claude with his parents taken in 1912, in White 1984, 246.

14 Three examples of Claude with short hair are *Claude au chevalet* (c. 1907, private collection, Hamburg), reproduced in Adriani 1996, 290–291; *Coco* (1908, Boston, Museum of Fine Arts), reproduced in House 1994, 129; and *Claude Renoir* (c. 1909, Museu de Arte de São Paulo), reproduced in Bardi 1956, 249.

15 House and Distel 1985, 277; Hoog and Guicharnaud 1984, 218.

16 Rosenberg and Grasselli 1984, 430.

17 Ibid., 433–434.

18 Rubin 1983, 622; see also Weiss in *Barnes* 1993, 194–197.

19 "Le clown reste une spécialité anglaise, parce qu'il personnifie ce penchant extraordinaire pour l'excentricité, qui est un des symptômes de la mélancolie anglo-saxonne" (Larousse 1866–90, VII, 70).

20 "Je suis très content de savoir Clo Clo si bien portant, il doit avoir du lait qui lui plaît" (University of Texas at Austin, Harry Ransom Humanities Research Center, Carlton Lake Collection, Renoir to Aline, from Paris, 22 February 1904). By 1910 Renoir was using the term Coco: "J'ai reçu la machine à faire des cigarettes qui fait la joie des enfants. C'est Coco qui les confectionne" (Godfroy 1995, II, 52, Renoir to Georges Durand-Ruel, 14 February 1910).

21 Hoog and Guicharnaud 1984, 218. The description is taken from the inventory of Renoir's possessions drawn up in December 1915, after Aline's death the previous June.

22 See House's observations on *Young Woman with a Guitar* (1898, National Gallery of Art, Washington) in House 1994, 125.

23 For Cartier-Bresson's memoir of June 1993 see Thompson and LoBianco 1994, 559. Having trained as a potter and ceramist with his father, Claude also dabbled in film-making. By 1933, he had acquired the Cinéma Antipolis in Antibes, but was obliged to sell it just before the venture became profitable (ibid., 183). Jean Renoir's most recent biographer judges Claude rather harshly as "intelligent and likeable, but ineffectual and talentless" (Bergan 1994, 33).

24 "Ces dernières oeuvres, tant elles sont calmes, sereines et mûres," Apollinaire's assessment of Renoir's late work, inspired by Bernheim-Jeune's *Exposition Renoir* of March 1913; see Apollinaire 1960, 366–367.

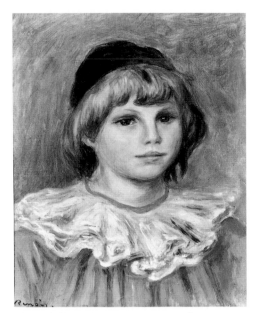

Fig. 296 Pierre-Auguste Renoir, *La Collerette*, 1909. Private collection

Fig. 297 Claude Renoir with Pierre-Auguste Renoir at Les Collettes, 1913. University of California, Los Angeles, Arts Library Special Collections

Fig. 298 Jean-Antoine Watteau, *Gilles*, c. 1715–21. Musée du Louvre, Paris

62 *Madame Renoir and Bob* c. 1910
81 × 65 cm
Signature stamp lower left
Wadsworth Atheneum, Hartford, Conn.,
The Ella Gallup Sumner and Mary Catlin
Sumner Collection, 1953.251
House/Distel no. 114
Not exhibited

PROVENANCE In Renoir's studio at the time of his death; Jean Renoir (1894–1979), Marlotte and Beverly Hills; with Arthur Tooth and Sons, Ltd., London, 1953; purchased by the Wadsworth Atheneum for the Sumner Collection, 1953.

EXHIBITIONS Not exhibited in Renoir's lifetime.

REFERENCES Meier-Graefe 1929, 364; André and Elder 1931, II, pl. 126, no. 391; *Goya to Matisse* 1991, no. 40.

NOTES

1 Maurice Denis's lapidary journal entry for 21 March 1910 – "Renoir a fait de beaux portraits, sa femme, le ménage G. Bernheim" (Denis 1957–59, II, 118) – provides a *terminus ante quem* for the undated *Madame Renoir and Bob*. Gaston Bernheim de Villers (1940, 85) recalled being invited by Renoir, once painting was under-way, to join his wife in what became a double portrait: "Je ne sais par quelle prodigieuse adresse il put m'insérer dans cette toile géniale." On *Madame Josse Bernheim and Her Son Henry* (Musée d'Orsay, Paris) see Distel 1993, 117.
2 On Renoir's *Self-portrait* (1910) see House and Distel 1985, 280–281.
3 A point first made by House in House and Distel 1985, 281.
4 Ibid.
5 "Renoir est l'homme qui a le plus influencé la sculpture moderne, bien plus que Rodin, qui est resté un isolé. C'est par son pinceau qu'il eut cette influence, par sa forme, ses masses, son ampleur et l'esprit sculptural de sa figure" (Gimpel 1963, 181, entry for 16 October 1920).
6 Berthe Morisot had apparently not noticed that Aline was pregnant with Jean, "parce qu'elle était si énorme, qu'elle ne paraissait pas plus grosse que d'habitude." Julie Manet (now Madame Rouart) remarked also: "Elle portait des robes flottantes" (Bernier 1959, 42).
7 At the end of her life, Jean Renoir recalled, "ma mère était devenue très grosse et bougeait diffi-cilement. Elle ne quittait pour ainsi dire plus son peignoir rouge à pois blancs" (Renoir 1981, 496–497).
8 "J'ai laissé ma femme très bronchitée et emphysémée. Cela à force finira par mal tour-ner, mais faire soigner une femme est au dessus des forces humaines" (Bibliothèque Municipale de Troyes, MS 2977, Renoir to Georges Rivière, 25 August 1908).
9 Mary Cassatt informed Durand-Ruel in Feb-ruary 1915: "La cuisinière a dit . . . que non, elle n'était pas elle-même et qu'elle [la cuisinière] croyait que le diabète lui montait à la tête. Main-tenant elle ne veut aucun régime" (Venturi 1939, II, 135–136).

10 Renoir 1981, 498–499.
11 "Ma femme déjà malade est revenue de Gérardmer bouleversée. Elle n'a pas pu se remettre. Elle est morte hier, heureusement sans le savoir" (Godfroy 1995, II, 161, Renoir to Paul Durand-Ruel, 28 June 1915).
12 "Ma mère apporta beaucoup à mon père: la paix de l'esprit, des enfants qu'il pouvait peindre, et un bon prétexte pour ne plus sortir le soir" (Renoir 1981, 255).
13 On the death of Quiqui, Aline wrote to Renoir: "Je crois que je porte malheur aux ani-maux. J'ai envie de le faire empailler" (Renoir 1981, 343, quoting an undated letter).
14 Renoir 1981, 483–484.
15 "Malgré sa corpulence elle battait régulièrement mon père" – although it is hard to believe that Renoir himself was in any condition to play bil-liards (ibid., 386). "Ma mère préférait la pêche à la ligne" (ibid., 401).
16 "Plus tard, quand ma mère acheta une automo-bile, elle lui fit apprendre à conduire et il devint notre chauffeur" (ibid., 476–477).
17 "Dîné chez Renoir. Sa femme ne tarit pas d'his-toires drôles" (Denis 1957–59, II, 35, entry for February 1906).
18 For *Gabrielle with Jewellery* (c. 1910, private col-lection) and *Gabrielle with a Rose* (1911, Musée d'Orsay, Paris) see House and Distel 1985, 282–283.
19 "Madame Renoir est à Vichy avec son automo-bile. Tout va comme elle veut, elle est contente" (Bibliothèque du Musée du Louvre, Paris, Archives Vollard, MS 422 [311], Gabrielle to Vollard, undated, September 1911).
20 "Lui est gentil mais sa femme bien embêtante, elle sera tout le temps à vous embêter" (ibid., MS 422 [311], Gabrielle to Vollard, undated, summer 1912).
21 "Elle est venue pendant que le patron n'était pas là et elle m'a barboté quelques eaux-fortes qu'il voulait garder" (ibid.).
22 Of Renoir's having failed to thank Louisine Havemeyer for a present of macadamia nuts, she exploded: "He cannot write and she hardly knows how" (Archives of the Metropolitan Museum of Art, New York, Cassatt to Mrs. H.O. Havemeyer, 16 July 1913).
23 Ibid., Cassatt to Mrs. H.O. Havemeyer, 28 December 1913.
24 "Non seulement il saisit les traits extérieurs, mais, sur les traits, il fixe le caractère et la manière d'être intime du modèle" (Duret 1922, 186–187, "Les Peintres impressionnistes" [1878]).

Fig. 299 Renoir, Aline, and Claude, 1912. University of California, Los Angeles, Arts Library Special Collections

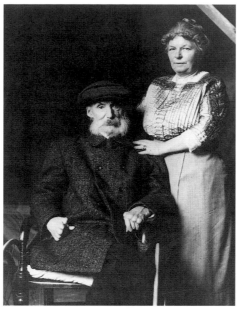

Fig. 301 Renoir and Aline, c. 1910. University of California, Los Angeles, Arts Library Special Collections

Fig. 300 Pierre-Auguste Renoir, *Self-portrait*, 1910. Private collection, Buenos Aires

Fig. 302 Pierre-Auguste Renoir, *Monsieur and Madame Gaston Bernheim de Villers*, 1910. Musée d'Orsay, Paris

63 *Jean Renoir as a Hunter* 1910
173 × 89 cm
Signed and dated lower right: Renoir. 1910
Los Angeles County Museum of Art, Gift of Jean Renoir and Dido Renoir, M.79.40

PROVENANCE In Renoir's studio at the time of his death; Jean Renoir (1894–1979), Marlotte and Beverly Hills; bequeathed to the Los Angeles County Museum of Art upon Jean Renoir's death, but remained in the family estate until the death of his widow, Dido Renoir, 7 May 1990.

EXHIBITIONS Munich 1912, possibly no. 37.

REFERENCES Read 1926, 205, 208; Thompson and LoBianco 1994, 175, 185, 188–189, 426.

NOTES

1 "Comme on avait dit un jour que Renoir, complètement perclus et ne pouvant plus se tenir debout devant son chevalet, ne peignait alors que des figures couchées, sur des toiles en largeur, il fit installer sa chaise sur des tréteaux et peignit sur des toiles en hauteur les grandes figures dansantes de la collection Gangnat, le portrait de son fils Jean en chasseur et plusieurs autres grandes toiles" (André 1923, 36–38).

2 It should be noted, however, that Renoir had tackled a similarly ambitious vertical composition in *The Promenade* (c. 1906, Barnes Foundation, Merion, Pa.) in which Coco is portrayed in the company of the maid/model Adrienne; see Riopelle in *Barnes* 1993, 84–85 (where the child is incorrectly identified as a girl from Essoyes).

3 "C'était un des avantages du succès qu'il appréciait, de pouvoir peindre ce qu'il voulait et aux dimensions qui convenaient à sa fantaisie. Il achetait la toile en grands rouleaux, en général d'un mètre de large, en découpait un morceau avec des ciseaux de tailleur . . . Il avait aussi des rouleaux plus larges pour les 'grandes machines.'" (Renoir 1981, 430–431).

4 "Il pensait que cette masse était nécessaire pour bien isoler le tableau. 'Surtout dans un salon du Midi, où tant d'autres tentations vous tirent l'oeil'" (Ibid., 299).

5 Jean's hunting attire is identified by Maxon in *Renoir* 1973, no. 76.

6 "Déjeuné chez Renoir . . . Jean Renoir, qui va s'engager dans les dragons, grand, bien bâti, conduit l'automobile" (Denis 1957–59, II, 150, entry for February 1913).

7 "Heureuse peinture qui très tard nous donne encore des illusions et quelquefois de la joie" (Institut Néerlandais, Paris, Fondation Custodia, Collection d'Autographes, Renoir to Albert André, 12 January 1910).

8 "Renoir a fait de beaux portraits, sa femme, le ménage G. Bernheim" (Denis 1957–59, II, 118, entry dated Siena, 21 March 1910).

9 Renoir 1952, 98.

10 In a 1958 biographical questionnaire intended for publicity purposes, Renoir had given his "youthful ambition" as "to be a cavalry officer" (Thompson and LoBianco 1994, xxiv). In April 1915, one month after his promotion to *sous-lieutenant*, he was wounded in the leg for a second time; hospitalized in Gérardmer, he was visited by his mother, who died shortly after returning home, "heureusement sans le savoir" (Godfroy 1995, II, 161, Renoir to Paul Durand-Ruel, 28 June 1915).

11 See Riopelle in *Barnes* 1993, 60–63.

12 The six-year-old Baltasar Carlos, son of Philip IV, is a more diminutive figure than Renoir's first-born, and it seems likely that Renoir also looked to Velázquez's portrait of the king in hunting costume, *Philip IV as a Hunter* (1634–36), and to that of his brother, *The Cardinal Infante Don Fernando as a Hunter* (1632–33, both Prado, Madrid).

13 "J'aurais quitté l'Espagne le jour même de ma venue, s'il n'y avait pas eu le musée de Madrid. Ah! les Vélasquez!" (Vollard 1919, 138). Jean Renoir reported his father saying: "Quand on voit les Vélasquez, on n'a plus envie de peindre. On se rend compte que tout a déjà été dit!" (Renoir 1981, 298). Compare also Count Harry Kessler's record of Renoir's conversation at a dinner given by Vollard on 27 June 1907: "Every artist puts something of himself into what he does, whether he wants to be a Realist or not . . . When Velázquez paints the members of the Royal family, they all become noblemen, because Velázquez himself was a nobleman" (quoted in Fenton 1996, 14).

14 "Ce que j'aime tant, dans ce peintre, c'est cette aristocratie qu'on retrouve toujours dans le moindre détail, dans un simple ruban" (Vollard 1919, 138).

15 "Encore une chose dans Vélasquez qui me ravit: cette peinture qui respire la joie que l'artiste a eue à peindre!" (ibid.).

16 White (1984, 250) shows that Renoir had begun work on his introduction, published as a letter to the translator's son Henri Mottez, in July 1909 and that by March 1910 he was discussing the final draft with Maurice Denis.

17 "Celui-ci pouvait mettre alors beaucoup de lui-même dans son travail, s'y intéresser, puisqu'il l'exécutait entièrement. Les difficultés qu'il devait vaincre, le goût dont il voulait faire montre tenaient son cerveau en éveil et la réussite de ses efforts le remplissait de joie" (Renoir in Mottez 1911, xi).

18 "L'école française, cette école que j'aime tant, qui est si gentille, si claire, de si bonne compagnie" (André 1923, 21).

19 See House and Distel 1985, 278–279.

20 "Regardez donc la lumière sur les oliviers . . . ça brille comme du diamant. C'est rose, c'est bleu . . . Et le ciel qui joue à travers. C'est à vous rendre fou. Et ces montagnes là-bas qui passent avec les nuages . . . on dirait des fonds de Watteau" (André 1923, 24).

Fig. 304 Jean Renoir in his Beverly Hills home, 1951. Motion Picture and TV Photo Archives, Los Angeles

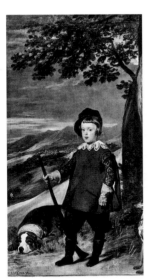

Fig. 303 Velázquez, *Prince Baltasar Carlos as a Hunter*, c. 1635–36. Museo del Prado, Madrid

Fig. 305 Jean Renoir in cavalry uniform, 1913–14. University of California, Los Angeles, Arts Library Special Collections

64 *Paul Durand-Ruel* 1910
65 × 54 cm
Signed and dated lower left: Renoir 1910.
Durand-Ruel, Paris
House/Distel no. 113

PROVENANCE Commissioned from Renoir by the sitter; Joseph Durand-Ruel (1862–1928), Paris; Charles Durand-Ruel (1905–1985), Paris.

EXHIBITIONS Munich 1912, no. 41; Berlin 1912, no. 41; *Renoir* 1912, no. 38.

REFERENCES Adriani 1996, no. 102.

NOTES

1 "Un homme de taille moyenne, avec un visage rond, rasé, surmonté de courts cheveux blancs, coupé d'une moustache en brosse et de sourcils en broussaille abritant des yeux extrêmement vifs, tour à tour graves et interrogateurs, et pétillants de malice. Voix un peu voilée, mais nette, et parole précise. Manières douces et courtoises, mains derrière le dos, tête un peu penchée en avant et inclinée légèrement de côté, pour mieux prêter l'attention à l'interlocuteur. Fréquente ironie; peu de grands mots, pas de grandes phrases; mais, en revanche, tous les signes d'une obstination sans pareille, et d'une volonté exempte de violence, que rien ne saurait faire plier, s'exerçant en souriant" (Alexandre 1911, 5–6).

2 "Soigné et sentant bon le propre" (Renoir 1981, 356).

3 In an interview with Félix Fénéon published in April 1920, Durand-Ruel explained that he had given up running the family firm only in 1913, after an attack of apoplexy (Fénéon 1920, 269).

4 In Somerset Maugham's *Of Human Bondage*, published in 1915, the hero, Philip Carey, speaks admiringly of Durand-Ruel as "always pleased to show the shabbiest student whatever he wanted to see." Even "his private house, to which it was not difficult to get a card of admission on Tuesdays," was accessible, and there "you might see pictures of world-wide reputation" (Maugham 1992, 197–198). Alexandre (1911, 5) had made the same point: "Personne n'est plus abordable parmi les grandes notoriétés parisiennes."

5 Jean Renoir (1981, 356) spoke of "une peau à la Renoir . . . des vêtements de 'monsieur.'"

6 "À le voir serré dans une éternelle redingote noire . . . on le prendrait pour un notaire de province ou pour un avoué de la banlieue, ponctuel, méthodique et compassé" (*Le Guide de l'amateur d'oeuvres d'art*, June 1892, quoted in Venturi 1939, I, 92).

7 "J'ai l'intention la semaine prochaine de faire une tournée avant de rentrer . . . pour être à Paris vers le 15 juin . . . C'est pourquoi je ne vous engage pas à venir dans cette saison" (Godfroy 1995, II, 62, Renoir to Paul Durand-Ruel, 28 May 1910). In August Renoir would travel to Wessling am See, the last trip abroad that he would be able to undertake (see cat. nos. 65–67).

8 See Georges Durand-Ruel's letter to Renoir of 10 January 1911 in Godfroy 1995, II, 71.

9 "Je crois que cela lui ferait du bien d'aller vous

voir et je tâcherai de l'y décider" (ibid., II, 43–44, Georges Durand-Ruel to Renoir, 16 February 1909).

10 *Tableaux par Monet, C. Pissarro, Renoir et Sisley*, listed in House and Distel 1985, 317. Renoir was represented by thirty-five paintings, all from Durand-Ruel's stock.

11 "Les peintres impressionnistes, dont il est le Saint-Vincent de Paul attitré" (*Le Guide de l'amateur d'oeuvres d'art*, as in note 6 above). Only three other portraits of the dealer are known. He sat to the obscure Jean Paulin Lassouquère in 1844, at the age of thirteen (reproduced in Daulte 1960, 55); there is a full-length portrait by Hugues Merle painted in 1866 (private collection, reproduced in Distel 1989b, 21) and a portrait bust in drypoint by Marcellin Desboutin, done in 1882 (ibid., 23).

12 "Il nous fallait un réactionnaire, pour défendre notre peinture que les salonnards disaient révolutionnaire. Lui au moins ne risquait pas de se faire fusiller comme communard!" (Renoir 1981, 169).

13 "Nous aspirons tous, et comme Français et comme commerçants, au rétablissement de la monarchie héréditaire qui seule peut mettre fin à nos maux" (Durand-Ruel's letter published in *Le Figaro*, 31 October 1873, quoted in Distel 1989b, 25). Jean Renoir (1981, 170) recalled his father remarking: "Il faut dire que Durand est un vieux Chouan et qu'il était tout dévoué au comte de Chambord qu'il allait voir en Hollande!" Zola, in his research notes for *L'Oeuvre*, published in 1886, alluded to Durand-Ruel's religious fervour – "petit homme froid, imberbe, alimenté par les cléricaux" (Mitterand 1986, 244).

14 See Venturi's excellent biographical study, which is accompanied by an edited version of Durand-Ruel's memoirs (Venturi 1939, I, 10–111, II, 143–219). This should be supplemented by Whiteley 1979; Distel 1989b, 21–31; and Whiteley 1995, 143–193 ("The Early Years of an Impressionist Dealer").

15 Distel 1989b, 21–22. Jean Marie Fortuné Durand (1800–1865) married Marie Ferdinande Ruel (1795–1870) on 11 October 1825. Their first child, Marie Thérèse, died at the age of twenty-nine in July 1859.

16 "Quant à moi, qui avais tout négoce en aversion, qui rêvais d'être officier ou missionnaire" (Fénéon 1920, 265).

17 Archives Durand-Ruel, Paris, "Certificat d'acceptation, délivré par l'autorité militaire de Saint-Cyr," 10 November 1851, Paul Marie Joseph Durand. In later years, Durand-Ruel would claim that a medical commission had judged him to be too weak for the army; see, for example, Fénéon 1920, 265.

18 "J'ai été fort lié avec Bouguereau: je n'eus jamais de lui que d'excellentes offices: jusqu'en 1867 ou 1868 et pendant des années il me donna toute sa production" (Fénéon 1920, 267). Whiteley (1995, 147–154) is surely right to associate Durand-Ruel's taste for uplifting genre painting (Baudelaire's "réligion aimable") with his deeply held monarchist and Catholic beliefs.

19 Whiteley 1995, 147, n. 12.

20 Distel 1989b, 24.

21 "Daubigny me présenta Claude Monet en 1870, à Londres, et je me suis tout de suite intéressé à ce peintre" (Coquiot 1910, 3).

22 Jeanne Marie Lafon, known as Eva (1841–1871), had been taken ill at a performance of Gounod's *Faust* at Covent Garden. "Elle se trouva subitement prise d'une indisposition aggravée par l'état de grossesse où elle se trouvait" (Durand-Ruel's memoirs, quoted in Venturi 1939, I, 181). She died of an embolism on 27 November 1871.

23 "Deux ans plus tard [1872] je connus Renoir en même temps d'ailleurs que Manet" (Coquiot 1910, 3). On Durand-Ruel's purchase of *Pont des Arts* see House and Distel 1985, 297.

24 Whiteley 1995, 188–189. On 22 January 1876 Courbet informed Castagnary: "You have learned from my letter and other sources that Monsieur Durand-Ruel has been obliged to liquidate" (Chu 1992, 561).

25 Distel 1989b, 26–27.

26 As he pointed out in an interview with Gustave Coquiot in November 1910: "Oh! sans l'Amérique, j'étais perdu, ruiné, d'avoir acheté tant de Monets et de Renoirs! Deux expositions faites là-bas, en 1886, me sauvèrent" (Coquiot 1910, 4).

27 Distel 1990, 23, quoting from Durand-Ruel's "Les Faux Tableaux," published in *L'Événement*, 5 November 1885. "J'ai été et le suis encore l'ami de Bouguereau, de Cabanel, de Bonnat, de Baudry . . . Un des premiers, j'ai reconnu leur mérite et contribué à leur célébrité . . . Était-ce une raison pour mépriser de grands artistes comme Millet, Corot, Delacroix, Rousseau, Courbet, et les laisser dans l'oubli? Depuis cette époque . . . j'ai cherché parmi les jeunes artistes ceux qui sont appelés à devenir des maîtres, à leur tour . . . Lhermitte, Fantin-Latour, Boudin, Roll, Duez, je pourrais dire tous nos grands artistes, savent ce que j'ai fait pour eux et m'honorent de leur amitié. J'arrive à mon grand crime, celui qui domine tous les autres. J'achète depuis longtemps et j'estime au plus haut degré les oeuvres de peintres très originaux et très savants, dont plusieurs sont des hommes de génie, et je prétends les imposer aux amateurs. J'estime que les oeuvres de Degas, de Puvis de Chavannes, de Monet, de Renoir, de Pissarro et de Sisley sont dignes de figurer dans les plus belles collections" (Distel 1989b, 23).

28 "J'ai par exemple une vieille dette de reconnaissance envers Durand-Ruel, car lui seul m'a aidé à manger quand j'avais faim" (Gimpel 1963, 34, entry for 23 April 1918).

29 "On a terriblement surfait la réputation de cet excellent et consciencieux peintre. Et les farceurs, qui prétendent que trois artistes seuls, Cézanne, Gauguin et van Gogh sont des grands maîtres, ont malheureusement trop mystifié le public" (Godfroy 1995, II, 29, Paul Durand-Ruel to Renoir, 27 April 1908).

30 Venturi 1939, I, 92–93.

31 Distel 1989b, 31.

32 Renoir seems to have been incapable of keeping track of the rent on his Paris apartment and studio. In one of his last letters, he asks his landlord to deal directly with Durand-Ruel, "qui veut bien avoir l'obligeance de me remplacer pendant mon absence pour ce motif" (University of Texas at Austin, Harry Ransom Humanities Research Center, Carlton Lake Collection, Renoir to Monsieur Crettes [?], 29 October 1917).

33 Havemeyer 1993, 252.

34 "Je suis furieux de ce qui s'est passé hier à l'Hôtel Drouot. On a vendu plusieurs esquisses, pastels, et dessins signés de vous et presque tous repeints d'une façon outrageante . . . Vous avez eu bien tort de donner ou de vous laisser prendre toutes ces esquisses ou pochades que l'on fait circuler partout pour empêcher la vente de vos belles oeuvres" (Godfroy 1995, I, 193–194, Paul Durand-Ruel to Renoir, 25 November 1903).

35 "Enfin connaissez-vous un grand capitaine, un seul, qui ait vécu aussi longtemps que moi?" (Fénéon 1920, 265).

36 "The D.Rs. have improved since the old man's warm rule has gone" (Archives of the Metropolitan Museum of Art, New York, Cassatt to Mrs. H.O. Havemeyer, 11 September 1918).

37 Ibid., Cassatt to Mrs. H.O. Havemeyer, 30 March 1913.

38 Ibid., Cassatt to Mrs. H.O. Havemeyer, 28 April 1920.

39 Renoir 1981, 319.

40 "Ils ne vous tueront pas votre vraie qualité: l'amour de l'art et la défense des artistes avant leur mort. Dans l'avenir ce sera votre gloire" (Godfroy 1995, I, 47, Renoir to Paul Durand-Ruel, November 1885).

Fig. 306 Paul and Georges Durand-Ruel, c. 1910, photograph by Dornac. Archives Durand-Ruel, Paris

Fig. 307 Paul Durand-Ruel, c. 1910, photograph by Eugène Pirou. Archives Durand-Ruel, Paris

65 *Wilhelm Mühlfeld* 1910
55 × 45 cm
Signed and dated upper left: Renoir 1910.
Southampton City Art Gallery, England,
3/1964

PROVENANCE With the art dealer Georg
Caspari (1878–1930), Munich; sold to the
Japanese industrialist and collector of
Impressionist painting Kōjirō Matsukata
(1865–1950), Tokyo, by 1929; The Lefevre
Gallery, London, 1948; Captain R.A. Peto
(1882–1963), Bembridge, Isle of Wight;
purchased by the Southampton City Art
Gallery, 1964, through Arthur Tooth and
Sons, Ltd., London.

EXHIBITIONS Not exhibited in Renoir's
lifetime.

REFERENCES *Gifts to Galleries* 1968, no.
70; Weston 1971, 224.

NOTES
1 "Il a fait quelques vues du lac et un beau por-
trait de M.ʳ Mulfield. Il n'a pas beaucoup d'ap-
pétit c'est peut-être la bière" (Munich 1958, 59,
Gabrielle to Maurice Gangnat, undated).
Heinrich Brüne's two drawings of Renoir at
work on the portrait of Madame Thurneyssen
and her daughter (figs. 313, 314) are inscribed
"nach dem Leben gezeichnet" and are dated
"17 August 1910," which situates Gabrielle's
letter quite precisely.
2 Renoir did not speak German, and Mühlfeld
was known to have a certain proficiency in
English. "In Wiesbaden, he ever more practised
himself in music and in English – for better
understanding his English pupils" (Southamp-
ton City Art Gallery, curatorial files, Wilhelm
Mühlfeld's biography by his brother Christian,
as translated by Christian's son).
3 The original German version of Christian
Mühlfeld's unpublished biography of his
brother Wilhelm is to be found in the collection
of the Landesbibliothek Coburg, and was
kindly made available by Herta Müller, curator
of the Max Reger-Archiv, Staatliche Museen
Meiningen.
4 Weston 1971, 210–211.
5 Not mentioned in the *New Grove Dictionary of
Music and Musicians*, Mühlfeld's symphony in E
minor was performed in Meiningen under his
direction in 1907. Jean Renoir (1981, 469)
exaggerated when he referred to Mühlfeld as
"chef d'orchestre connu."
6 Alexander Thurneyssen, the father of Friedrich
(Fritz), is listed in the Wiesbaden census records
for 1887 to 1904 as living at Martinstrasse 5; see
Hessisches Hauptstaatarchiv, communication
from Dr. Schulz-Luckenbach.
7 Landeshauptstadt Wiesbaden, wɪ/p Nr. 1203,
"Todes Anziege," Wilhelm Mühlfeld.
8 Weston (1971, 224) was the first to provide the
correct identification of Renoir's portrait. On
the celebrated clarinettist see also her entry in
Grove 1980, XII, 765.
9 Weston 1971, 210.
10 Ibid., 209. In 1894 Brahms wrote the two
sonatas for piano and clarinet, opus 120; they

were performed by him and Mühlfeld in
Vienna in January 1895.
11 Ibid., 223–224.
12 "Il prétendait que cet instrument primitif . . .
constituait la meilleure introduction aux grands
maîtres" (Renoir 1981, 469).
13 "Il s'indignait que la détentrice d'une pareille
voix fût aussi peu désireuse de la consacrer au
culte de Mozart et de Bach" (ibid.).
14 "Tu diras à Renée qu'elle apporte sa musique,
surtout celle un peu canaille. J'ai un peu soupé
de la belle musique" (University of Texas at
Austin, Harry Ransom Humanities Research
Center, Carlton Lake Collection, Renoir to
Georges Rivière, 3 April 1909).

Fig. 308 Wilhelm Mühlfeld, c. 1901. Southampton
City Art Gallery

Fig. 309 The Mühlfeld brothers, 1870s. Left to right:
Martin, Wilhelm, Richard, and Christian. Staatliche
Museum, Meiningen

66 *Madame Thurneyssen and Her
Daughter* 1910
100 × 80 cm
Signed and dated lower left: Renoir. 10.
Albright-Knox Art Gallery, Buffalo, N.Y.,
General Purchase Funds, 40:6

PROVENANCE Commissioned by Dr.
Friedrich (Fritz) Thurneyssen (1872–1947),
Munich; remained in the Thurneyssen
collection until at least 1929; private
collection, Switzerland, by 1936; purchased
by the Albright Art Gallery from the
Bignou Gallery, New York, 1940.

EXHIBITIONS Not exhibited in Renoir's
lifetime.

REFERENCES Nash 1979, 246–247;
Hohenzollern and Schuster 1996, 429.

67 *Young Shepherd in Repose (Alexander
Thurneyssen)* 1911
75 × 93 cm
Signed and dated lower right: Renoir. 1911
Museum of Art, Rhode Island School of
Design, Providence, Museum Works of Art
Fund, 45.199

PROVENANCE Commissioned by Dr.
Friedrich (Fritz) Thurneyssen (1872–1947),
Munich; remained in the Thurneyssen
collection until at least 1929; Paul
Rosenberg, Paris and New York; Durand-
Ruel, New York, by 1941; purchased by
the Museum of Art, Rhode Island School
of Design, by October 1945, with the
proceeds of the sale of Picasso's *La Vie*,
now in the Cleveland Museum of Art.

EXHIBITIONS Not exhibited in Renoir's
lifetime.

REFERENCES D'Argencourt 1987,
190–191; *Renoir* 1988, no. 64; Rosenfeld
1991, 12, 154–156; House 1994, no. 49.

NOTES
1 On Wessling am See, a flourishing resort and
artist's colony twenty-five kilometres southwest
of Munich, connected to the city by rail since
1903, see Porkert 1986.
2 Meier-Graefe 1929, 315–316; Renoir 1981,
468–470. Porkert (1986, 370) recounts the
weather conditions for 1910, which included
the occurrence on 13 July 1910 of a "short, but
distinctly noticeable earthquake."
3 Meier-Graefe 1929, 316.
4 Pach 1912, 613. In discussing the visit to
Munich with Vollard, Renoir had been quick
to mention the outstanding Rubens in the
Louvre: "De ce côté-là, n'avons-nous rien à
envier à personne, avec *Hélène Fourment et ses
enfants*" (Vollard 1919, 152). Renoir had copied
that painting as a student in 1863; see Adriani
1996, 64–66.

5 Meier-Graefe 1929, 315; Pach 1958. Most recently, *Madame Thurneyssen* (1908) has been published in *Renoir* 1979, no. 74.

6 Meier-Graefe (1929, 320) is categorical on this point: "Renoir hatte Thurneyssen das Bildnis seines Jungen versprochen und malte es im nächsten Jahre in Cagnes."

7 In a letter of 3 March 1912 to Heinz Braune, Tschudi's successor at the Neue Pinakothek, Thurneyssen noted that Renoir was operated on in late January: "Ende Januar wurde eine zweite Operation gemacht, die bestens geglückt ist, die vollständige Heilung scheint nur noch eine Frage von Tagen" (Neue Pinakothek, Bayerische Staatsgemäldesammlungen, Munich, Akt Tschudi, 24/1, quoted by Pophanken in Hohenzollern and Schuster 1996, 429). I am very grateful to Dr. Pophanken for providing me with copies of Thurneyssen's letters and to Beate Stock for transcribing and translating them.

8 "Ich habe mit Renoir wegen ihres Anliegens gesprochen. Er ist bereit ein Bild für ihre Sammlung zu stiften, sobald er etwas Passendes fertig hat" (Neue Pinakothek, Bayerische Staatsgemäldesammlungen, Munich, Akt Tschudi, 24/1, Thurneyssen to Braune, 3 March 1912). Although the connection cannot be proved, it would seem likely that Renoir encouraged Durand-Ruel to donate his *Monsieur Bernard* (c. 1880), which was accessioned by the Neue Pinakothek on 25 November 1912; see Hohenzollern and Schuster 1996, 112–113, 436.

9 "J'ai appris à connaître le vieux Renoir devant les cent tableaux de la collection Gangnat . . . À Munich, la collection Thurneyssen promet de devenir quelque chose de pareil, en plus petit. C'est jusqu'à aujourd'hui le seul endroit d'Allemagne où l'on puisse s'orienter sur le terme où le maître est arrivé" (Meier-Graefe 1912, 183). Meier-Graefe noted that Thurneyssen now owned ten paintings by Renoir, all executed during the previous decade. In the absence of a published catalogue, such a claim is impossible to substantiate.

10 Vollard 1925, 228.

11 Fosca 1961, 251.

12 On the marriage of Thérèse Berard and Albert Thurneyssen see Berard 1937, 52, and Daulte 1971, no. 410. Even the most scrupulous of Renoir's historians have been led astray by this coincidence of surnames: see House and Distel 1985, 311, Distel 1993, 122, and House 1994, 136. The most recent discussion of Thurneyssen as a collector (Pophanken in Hohenzollern and Schuster 1996, 429) fails to identify the Munich collector correctly. Thérèse Berard (1866–1959) and Albert Thurneyssen (1858–1936), an *officier* of the Légion d'Honneur, had six children, all of whom grew up in France. In a letter of 20 April 1976, their middle son, Christian Thurneyssen (born 1898), stated: "Ma mère a suivi mon père pendant toute sa carrière militaire dans les différentes villes de France où son régiment tenait garnison" (Sterling and Francine Clark Art Institute, Williamstown, Mass., curatorial files).

13 Ludwig-Maximilians-Universität, Munich, Universitätsarchiv, "Promotionsakt," for Thurneyssen's curriculum vitae written in December 1895, upon being awarded his doctoral degree; Stadtarchiv, Munich, "Polizeimeldebögen,"

D241 (1891–1896), for details of his parents and elder brother Ferdinand (born 13 February 1869). Fritz's date of death was kindly given to me by his family.

14 Thurneyssen 1897.

15 Stadtarchiv, Munich, "Stadt Civilconscription," 183878, Thurneyssen and Dörr, which gives the date of their marriage and the dates of birth of their two children. Josefine Thurneyssen died unmarried in 1993.

16 "Histoire de l'Allemand qui veut que Renoir fasse un portrait intime de sa femme, et comme Renoir remonte le corsage: 'Alors, on ne foit plus du tout le mamelle'" (Denis 1957–59, II, 117, entry for 23 January 1910).

17 Vollard 1919, 226–227.

18 "Mais non, mais non! protesta l'Allemand. Tout à fait *indime*, je *fous* dis . . . Qu'on voie au moins une mamelle" (Vollard 1937, 245).

19 "Man könnte sich ein neues Madonnenbild denken mit einem Kinde, von dessen Göttlichkeit die Mutter nichts weiss" (Meier-Graefe 1929, 318). Meier-Graefe, whose enthusiasm for this painting seems to have got the better of him, compared the roses in the wall hanging to "clouds of onlooking angels in a painting by Raphael."

20 The phrase comes from House 1994, 136, where it describes Renoir's handling in *Young Shepherd in Repose*.

21 Pach 1912, 613.

22 Munich 1958, 7. For information on Brüne I am grateful to Dr. Erich Rübe.

23 Ibid., 8. Brüne remembered a dozen people in Renoir's entourage, including his wife (whom he found "almost too petit bourgeois and homely"), his three sons, and the "soon-to-be-famous Gabrielle." Their sole purpose was to encourage Renoir and to put on a show for the model, "Ein Puppentheater, eine richtige Drehorgel [barrel organ]!"

24 The drawing, most recently published by Pophanken in Hohenzollern and Schuster 1996, 429, is inscribed "Renoir 68 Jahre alt / n[ach] dem Leben gezeichnet / 17 August 1910. Brüne / Oberpfaffenhofen."

25 "Die Anordnungen zur Arbeit sind schnell gemacht, mit wenig Winken das Modell zurechtgestellt – ein echt Pariser Morgenrock aus weissem Tüll und rosa Schleifchen lässt schon das kommende Werk erahnen" (Munich 1958, 11).

26 "Unablässig wandert der Blick zwischen Modell und Leinwand, die Massen in den gegebenen Raum zu zwängen" (ibid).

27 "Immer wieder umfährt der leise Strich die Rundungen des Körpers, das Oval des Kopfes, die Fülle der Brust" (ibid).

28 "Linsengross sind die Häufchen Farbe, die man ihm nun auf die Palette setzt: Schwarz, Weiss und Zinnoberrot, nur diese drei . . . Erst viel später erscheint ein wenig Blau und Ocker zu grünlicher und goldiger Tönung im Hintergrund" (ibid).

29 "Von Tag zu Tag ist kaum ein Fortschritt sichtbar, selbst nach drei Wochen täglicher Arbeit erscheint die Leinwand wie eben erst begonnen – nichts ist vorgetrieben, Schritt für Schritt wächst das Werk wie eine Pflanze" (ibid).

30 "Le patron va mieux, il a bien avancé son portrait, je voudrais que vous voyiez comme c'est joli. Mme Thurneyssen en robe blanche et rose

beaucoup ouverte et sa petite fille sur ses genoux. La petite est blonde et toute frisée, elle n'est pas jolie mais le patron en a fait quelque chose de bien" (Munich 1958, 59, Gabrielle to Maurice Gangnat, undated, mid-August 1910).

31 Jean Renoir (1981, 469) stated that his father also painted a portrait of Fritz Thurneyssen himself, "qu'il jugeait très intéressant," but this is the sole reference that I have come across to such a commission.

32 "Alexandre beau comme un berger grec et que d'ailleurs il représenta en berger" (ibid). For a thorough discussion of this painting see Michie in Rosenfeld 1991, 154–156.

33 The comparison with the Parthenon frieze was first made by Maxon in *Renoir* 1973, no. 81, and is repeated in House 1994, 136.

34 "Ein Daphnis, bevor er Chloe findet" (Meier-Graefe 1929, 320).

35 House 1994, 136.

36 The subject of Paris had entered Renoir's repertoire in 1908, with *The Judgement of Paris* (private collection, Japan), the hero of which was posed for by Gabrielle. Guino would produce a bust of Paris, based on Renoir's design, in 1915. Maxon (*Renoir* 1973, 81) compares Renoir's portrait of Thurneyssen to a "young Orpheus at his ease." No specific narrative is implied in *Young Shepherd in Repose*.

37 Pach (1958, 279), quoting Anthony Clark, noted that the painting was made "after Renoir's return from Munich, using memory or sketches, and a female model."

38 "Aujourd'hui les Thurneyssen sont partis, ils ont regretté de ne pas vous avoir vu. Le portrait d'Alexandre est toujours de plus en plus joli, à ce qu'il paraît" (Bibliothèque du Musée du Louvre, Paris, Archives Vollard, MS 422 [311], Gabrielle to Vollard, undated, September 1911).

39 I am indebted to Klelia Topaloglou, founder of the Alexander Thurneyssen Conservatory, for information on Thurneyssen's career in Athens.

40 Grimal 1963, 345–346.

Fig. 310 Pierre-Auguste Renoir, *Madame Barbara Thurneyssen*, 1908. Private collection, Switzerland

Fig. 312 Pierre-Auguste Renoir, *Alexander Thurneyssen*, 1908. Private collection

Fig. 315 Alexander Thurneyssen in Athens, 1926, photograph by Eva. Private collection

Fig. 311 Barbara, Friedrich, and Alexander Thurneyssen, Munich, c. 1902–03, photograph by Atelier Elvira. Private collection

Fig. 313 Heinrich Brüne, *Renoir*, 1910, black chalk. Staatliche Graphische Sammlung, Munich

Fig. 314 Heinrich Brüne, *Renoir in Brüne's Studio*, 1910, black chalk. Private collection, Wessling

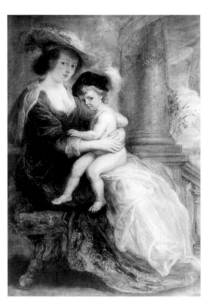

Fig. 316 Peter Paul Rubens, *Hélène Fourment with Her Eldest Son, Frans*, c. 1635. Alte Pinakothek, Munich

Fig. 317 Dionysus, from the east pediment of the Parthenon. British Museum, London

Fig. 318 Alexander Thurneyssen and his sister Josefine, 1910, photograph Georg Köstner, Grafing. Private collection

68 *Tilla Durieux* 1914
92 × 74 cm
Signed and dated lower left: Renoir. / 1914.
The Metropolitan Museum of Art, New York, Bequest of Stephen C. Clark, 1960, 61.101.13
House/Distel no. 122

PROVENANCE Commissioned by the Berlin art dealer Paul Cassirer (1871–1926); his widow, Tilla Durieux (1880–1971), Berlin, until about 1933; the art dealer Étienne Bignou (1891–1950), Paris and New York; acquired by Stephen C. Clark (1882–1960), New York, from the Bignou Gallery, New York, 1935; bequeathed by him to the Metropolitan Museum of Art, 1960.

EXHIBITIONS Not exhibited in Renoir's lifetime.

REFERENCES Durieux 1964, 156–162; Sterling and Salinger 1967, 161–163.

NOTES

1 Durieux 1964, 161. Blanche (1915–20, I, 184, entry for 5 September 1914), noting that Renoir, "par peur des Italiens," had transported all of his paintings from Cagnes to Paris, claimed that he was painting Frau Cassirer's portrait "jusqu'à la mobilisation!" House (House and Distel, 1985, 287) notes that the portrait was deposited with Durand-Ruel for safekeeping on 31 July 1914.

2 Durieux had gone to Poiret to buy two dresses "für die Szenen, in denen Eliza schon zur eleganten Frau umgewandelt sein muss" (Durieux 1964, 147). It was the dress that she wore "im

vorletzten Akt von 'Pygmalion'" that she took to Renoir's studio (ibid., 157–158).

3 Mander and Mitchenson 1977, 158–160. The German production was directed by Victor Barnovsky. In London it would open at His Majesty's Theatre on 11 April 1914.

4 Laurence 1965–88, III, 146, Shaw to Siegfried Trebitsch (translator of *Pygmalion*), 29 January 1913.

5 On Cassirer see the monumental study by Brühl (1991). Vollard (1937, 151) considered Cassirer's Berlin gallery "un prolongement de la rue Laffitte."

6 Godfroy (1995, II, 253) notes that Cassirer had started doing business with Durand-Ruel in 1898. As Joseph Durand-Ruel observed to Renoir on 4 November 1914: "Quant aux tableaux que nous avons en Allemagne et aux sommes qui nous sommes dues par les particuliers ou musées allemands, nous préférons ne pas y songer" (ibid., 151).

7 On the collecting of Impressionist paintings at the turn of the century in Germany see, most recently, Hohenzollern and Schuster 1996.

8 "Das Bild konnten wir nicht mitnehmen, denn es war noch nicht trocken" (Durieux 1964, 161).

9 "Auf der Staffelei stand das grosse Porträt der Tilla Durieux. Die kühle Besinnung dieser Frau lag ihm nicht, und er begnügte sich, sie zu schmücken" (Meier-Graefe 1929, 424).

10 "Ich sass ruhig wie ein Steinbild, das hatte ich bei den verschiedenen anderen Maler schon gelernt, die mein Porträt machten" (Durieux 1964, 159).

11 Durieux (1971), recalling her own "rote grosse Hände."

12 "Die rassige Schönheit einer Indierin, Kreolin" (Turszinsky 1910, 606). Racial accounts of Durieux's distinctive physiognomy were legion. Bab (1926, 96) described her as "ein östlicher Typ, der vom slawischen fast ins tatarisch-mongolischen reicht . . . die breiten Lippen, die gewölbte Stirn, die unter hohen Brauen etwas gekniffenen Augen . . ."

13 House and Distel 1985, 287.

14 "Bald waren zwei Stunden vergangen, und Renoir brach die Arbeit ab und bestellte mich für den Nachmittag . . . Vierzehn Tage war ich schon jeden Vor- und Nachmittag im Atelier gewesen; der halbe Juli lag hinter uns" (Durieux 1964, 159, 161).

15 "Dann schob ihm das junge Mädchen in die linke Hand die Palette, in die rechte den Pinsel und band ihn an der Hand fest" (Durieux 1964, 157, 158).

16 "Nun schien alles verloren; es würde bei dem kleinen Bild bleiben. Da wurde die Pflegerin von ihm herbeigerufen, und nach einigen von ihr mit dem Meister geflüsterten Worten verschwand die Leinwand von der Staffelei, und eine grössere wurde hingestellt" (ibid.).

17 Shaw 1955, 72, act 4.

18 "Es bestand aus einem engen Rock aus weissem Chiffon, der aber nur als Vorderbahn erschien, denn hinten und an den Seiten war er von einem herrlichen dunkelgrünen Brokat mit eingewebten steifen französischen Lilien in Dunkellila bedeckt. Oben liess ein durchsichtiger goldbestickter Schleierstoff nur wenig vom Halse frei, weite offene érmel aus demselben durchsichtigen Gewebe verhüllten die

Arme. Das Ganze sah eher einem orientalischen Kostüm als einem Abendkleid ähnlich" (Durieux 1964, 158).

19 Published in Durieux 1954, 82.

20 Zeldin (1993, II, 439) notes perceptively that while Poiret revealed something of women's "natural shapes," he hardly liberated them: "He put them into sheath dresses in which they could not walk and he bared their backs so they froze."

21 "Dann richtete er zum erstenmal das Wort an mich, deutete auf einen Strauss rosa Rosen und bat mich, eine der Blüten ins Haar zu stecken" (Durieux 1964, 158–159).

22 It is worth pointing out, however, that it was her "Germanic" qualities that most impressed Renoir's Parisian contemporaries. Duret (1922, 110–111), recognizing the work as one of Renoir's late masterpieces, noted that "tout en conservant au modèle son type caractéristique de femme allemande, il a su l'envelopper d'un charme caressant, d'une grâce voluptueuse, qu'aucun peintre allemand n'aurait pu lui donner."

23 "Her parents wanted her to become a pianist, but when she was fifteen she saw Sarah Bernhardt perform and decided upon the stage" (*New York Times*, obituary, 22 February 1971).

24 "Es ist in den letzten fünfzehn Jahren sicherlich keine Frau in Deutschland so viel gemalt und gemeisselt worden wie diese Durieux" (Bab 1926, 101).

25 Kokoschka (1974, 63) recalled that his portrait of Durieux had been commissioned by Cassirer and was painted in her apartment, in a setting that reminded him of Manet's *Nana*: "I painted her in another fashion; but she had considerable powers of seduction and I don't believe I ever finished the picture. It was left behind in her flat together with my paint box."

26 Barlach received the commission in June and left for Holland on 24 July 1912; see Barlach 1968–69, I, 401, 403.

27 Durieux 1971, 19–21; Preuss 1965, 22–23.

28 Durieux 1964, 33–40.

29 Ibid., 40–41.

30 Ibid., 48–75; Brühl 1991, 71–82.

31 Patterson 1981, 78–79.

32 For a chronology of Durieux's performances in these years see Preuss 1965, 84–88, 113–114.

33 "Als P.C. [Paul Cassirer] mich eines Tages fragte, ob ich schon gehört hätte, dass es so etwas wie eine deutsche Sprache gebe. Ich war fassungslos, er aber machte mir klar, dass ich den Dialekt meiner Heimatstadt noch nicht ganz abgelegt, dass ich von Stimme und Atem keine Ahnung hätte und dass es nun Zeit sei, daran zu denken, wenn ich wirklich ein Künstler werden wollte" (Durieux 1964, 62).

34 Durieux 1964, 244–255; Preus 1965, 29.

35 Count Harry Kessler, an old friend of both Durieux and Cassirer, who gave the eulogy at Paul's funeral, noted Durieux's bitterness at the way she was treated by the Cassirers, another example of the actress's total self-absorption: "After twenty years she and Cassirer parted over an utterly petty incident, but she might have returned to him after a couple of months. Evidently indignation against the family dams up for the moment greater anguish, and she is by nature cool and unbending" (Kessler 1971, 274, entry for 13 January 1926).

36 Willett 1978, 66–73.
37 Durieux 1964, 251–266.
38 Ibid., 290.
39 Preuss in Durieux 1971, 466–472.
40 "Als er aber erfuhr, dass ich Rabelais gelesen
hatte, kannte sein Erstaunen keine Grenzen . . .
Er erzählte mir, er sei eine Zeitlang ein
Anhänger Wagners gewesen, aber er könne ihn
jetzt nicht mehr hören" (Durieux 1964,
159–160).
41 "Ich wollte kein Porträt mehr machen, aber ich
freue mich, dass ich diese Arbeit angefangen.
Ich habe dabie Fortschritte gemacht, finden Sie
nicht?" (ibid., 160).

Fig. 320 Tilla Durieux as Eliza Doolittle in *Pygmalion*
at the Lessingtheater, Berlin, 1913

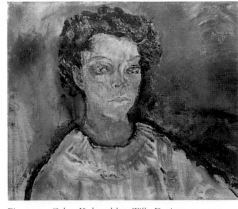

Fig. 322 Oskar Kokoschka, *Tilla Durieux*, c. 1910.
Museum Ludwig, Cologne

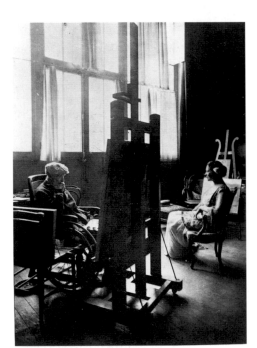

Fig. 319 Renoir painting Tilla Durieux in his
boulevard Rochechouart studio, Paris, July 1914.
Hulton-Deutsch, London

Fig. 321 Tilla Durieux as the Countess in *The Count
of Gleichen*, Kammerspiele, Berlin, 1908. Bildarchiv
Preussischer Kulturbesitz, Berlin

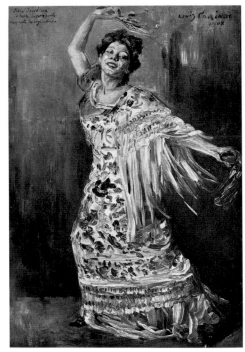

Fig. 323 Lovis Corinth, *Tilla Durieux as a Spanish
Dancer*, 1908. Private collection

Fig. 324 Ernst Barlach, *Tilla Durieux*, 1912, bronze.
Busch-Reisinger Museum, Harvard University Art
Museums, Cambridge, Mass., Gift of Naomi Jackson
Groves, Radcliffe, Ph.D., 1950, and Museum
Association Fund

342

69 *Ambroise Vollard Dressed as a Toreador* 1917

102 × 83 cm
Signed and dated lower left: Renoir 1917.
Nippon Television Network Corporation,
Tokyo

PROVENANCE Given by Renoir to
Ambroise Vollard (1866–1939); remained in
Vollard's collection until his death in an
automobile accident; seized in Bermuda,
1940, by the British Navy with the Vollard
collection and held until 30 May 1949, at
the National Gallery of Canada, Ottawa,
under order of the British Admiralty;
released to the Vollard heirs and by 1952
with Édouard-Léon Jonas (1883–1961),
Paris, who had acted on behalf of the
Vollard family; acquired from the Jonas
collection by the collector Walter P.
Chrysler, Jr. (1909–1988), New York, 1954;
Sotheby and Co., London, Walter P.
Chrysler, Jr., sale, 1 July 1959, no. 32,
bought for £22,000 by L. Felheimer; Mr.
and Mrs. B.E. Bensinger, Chicago, by 1972;
E.V. Thaw and Co., New York, by
November 1976; Stephen Hahn, New
York, by September 1979; the Nippon
Television Network Corporation, Tokyo,
by 1984.

EXHIBITIONS Not exhibited in Renoir's
lifetime.

REFERENCES *Vollard Collection* 1950,
no. 17; Detroit 1976, no. 279; *Renoir* 1979,
no. 83; Adriani 1996, no. 104.

NOTES

1 "Vollard, le plus riche des marchands de tab-
leaux modernes" (Gimpel 1963, 37, entry for 14
May 1918). Gimpel estimated Vollard's fortune
at this date to be 10 million francs.

2 Dauberville 1967, 165.

3 Vollard 1937, 244–245; Vollard 1938a, 39–40.

4 "Même rasé, s'écria Renoir, croyez-vous que
l'on vous prendra pour un vrai toréador? Ce
que je vous demande, par exemple, c'est de ne
pas vous endormir pendant que vous poserez"
(Vollard 1937, 245).

5 "La rose me gènerait pour peindre vos mains.
Jetez-la. Elle fera une note sur le tapis" (ibid.).

6 "En fouillant les tiroirs de la commode où il
empilait des tas de vieilleries, mon père trouva
un costume de toréador qu'il avait acheté en
Espagne pendant son voyage avec Gallimard"
(Renoir 1981, 443).

7 "Vollard n'a pas l'air d'un toréador mais la
couleur lui conviendra" (ibid.).

8 Renoir 1991.

9 "Vollard, pris de panique à la vue de ces pai-
sibles animaux, courut grimper dans un arbre
où il resta perché jusqu'au départ des bovins . . .
[Renoir], pris d'une inspiration soudaine, dit à
Vollard: 'Cher Ami, vous m'avez demandé à
maintes reprises de faire votre portrait, j'accepte
de le faire mais . . . en habit de toréador" (ibid.).

10 Dauberville (1967, 209) gives yet another ver-

sion, in which Renoir, fed up with Vollard's
importuning, exclaims: "Foutez-vous en
toréador et je fais votre binette." Vollard takes
him at his word, and after discovering "chez un
fripier niçois un superbe costume," Renoir is
obliged, "en beau joueur," to paint his portrait.

11 Vollard 1920, 217; Vollard 1938b, 288. See also
Drucker 1944, 215.

12 "Sautant dans un taxi, je me fis conduire chez
Renoir" (Vollard 1937, 244). The trip to
Essoyes was a little more complicated; only one
train a day left for there from Paris, at noon, with
changes at Troyes and Polisot. See Renoir's let-
ter of 22 August 1917 to Georges Durand-Ruel
in Godfroy 1995, II, 208.

13 See Renoir 1991, where the photograph is cap-
tioned "Ambroise Vollard, chez Auguste
Renoir, aux Collettes à Cagnes-sur-mer" and
dated to 1915.

14 Thompson and LoBianco 1994, 15.

15 "En voilà un qui sait le prendre! Un jour, il lui
apporte du marché un lot de poissons qu'il jette
sur une table, en lui disant: 'Peignez-moi ça.'
Renoir, amusé, s'exécute et Vollard emporte la
toile. Une autre fois, Vollard surgit devant le
peintre, déguisé en toréador, et Renoir, en-
thousiasmé par la couleur, fait son portrait"
(Gimpel 1963, 65, entry for 15 August 1918).

16 Duret 1922, 111–112.

17 The *Exposició d'art francès contemporani* ran from
April to July 1917 (House and Distel 1985, 318).
In February Renoir had asked Georges Durand-
Ruel to organize the loans for him, "pour cette
exposition de Barcelone, je ne puis m'en occu-
per. Les tableaux reviennent souvent crevés et
les cadres esquintés" (Godfroy 1995, II, 187, let-
ter of 21 February 1917).

18 Duret 1922, 113; Vollard 1937, 357–358.

19 Baudot 1949, 70. For Renoir's *Guitarist* (1897,
formerly with Knoedler) see *Renoir* 1944, 41;
for *Young Woman with a Guitar* (1898, National
Gallery of Art, Washington) see House 1994,
125.

20 "Le lendemain, Renoir courut acheter tout un
équipement pour entreprendre des oeuvres in-
spirées par la belle Otéro" (Baudot 1949, 70).

21 Vollard 1918b, II, 60.

22 "Renoir l'a peint en toréador, me chipant ma
spécialité" (Gilot 1965, 38). The subject came
up again in 1938 in conversation with Sabartés:
"We resumed our discussion of the portrait
which he had done the previous day and of the
one which Renoir did of Vollard dressed as a
bullfighter. That made us forget the original
subject of our conversation, and we began to
discuss bullfighting" (Sabartés 1949, 150).

23 In the eighteenth century, "Spanish costume"
(or "Van Dyck costume") was a style of histori-
cizing fancy dress that had nothing to do with
contemporary Spanish customs.

24 As well, Fernande Olivier noted that among the
contents of Picasso's studio that Vollard
acquired between 1903 and 1907 was the bust of
a toreador with a broken nose, "d'une force,
d'une vie très intense," which Renoir conceiv-
ably could have seen (Olivier 1973, 59).

25 "Quant à Renoir, il est toujours épatant. On le
dit très malade et puis subitement on le sait tra-
vaillant et vaillant quand même. Il est admirable
tout simplement" (Venturi 1939, I, 444, Monet
to Georges Durand-Ruel, 13 December 1916).

26 Duret (1922, 112) noted: "Ce qu'il y a de

remarquable dans ce portrait, exécuté par un
homme de 76 ans, ce n'est pas seulement qu'on
y reconnait une facture pleine de vigueur mais
que la fraîcheur, l'acuité du coloris montrent
que l'artiste a conservé toute sa netteté de
vision."

27 "Vous voyez bien, Vollard, qu'on n'a pas
besoin de main pour peindre! La main, c'est de
la 'couillonnade'!" (Vollard 1919, 220). The
comment was made in 1915, when Vollard was
sitting for his portrait with a cat.

Fig. 325 Ambroise Vollard sitting to his portrait as a
toreador, 1917. Galerie Utermann, Dortmund

Fig. 326 Pablo Picasso, *Ambroise Vollard*,
1915, graphite. The Metropolitan
Museum of Art, New York, The Elisha
Whittelsey Collection, The Elisha
Whittelsey Fund, 1947

343

APPENDIX I: THREE LETTERS FROM RENOIR TO PAUL BERARD

Colin B. Bailey

At the Salon of 1882, Renoir was represented by one work, the beautiful but diminutive *Yvonne Grimprel* (fig. 9), listed in the *livret* as no. 2268, "Portrait de Mlle Y.G." The following letters, here published in full for the first time, throw light on the somewhat chaotic procedure by which this portrait made its way to the Palais des Champs-Élysées.

The letters have been faithfully transcribed here; only the accents have been standardized.

LETTER 1

Renoir to Berard, from L'Estaque, undated, early March 1882 (Archives Durand-Ruel, Paris)

Mon cher ami,
Le médecin ne veut décidément pas que je rentre à Paris, alors tant qu'à m'ennuyer à Menton ou Yeres [Hyères], j'aime mieux aller à Alger une 15 de jours. Là, je me plairai mieux. Je dépenserai moins d'argent et je travaillerai un peu. Alors, mon cher ami, il faut que je vous charge d'une commission pressée. Il faut que j'aie cinq cent francs à Marseille samedi avant 3 heures car je prends le bateau à 5 heures pour Alger et je n'ai plus le sou. Donc ma lettre va vous arriver vendredi matin. Si vous pouvez écrire avant 3 heures pour que la lettre parte par le rapide de 7 h. 20, je l'aurai à Marseille samedi à 2 h. environ, poste restante. C'est je crois ce qui est le plus pratique, lettre chargée, poste restante, Marseille. Si vous préférez un autre système, et si vous pouvez par télégraphe au Comptoir d'Escompte, envoyez-moi une dépêche explicative à Marseille, Poste restante.

Je vous prierai de garder le restant pour quand je rentrerai, ou pour mes besoins à Alger *si Durand me lâchait*. J'aurai une masse de choses à vous raconter. Mes luttes avec Durand Ruel pour ne pas faire partie de l'Exposition des Indépendants. J'ai été obligé de céder en partie. C'est-à-dire que je n'ai pas pu lui refuser l'autorisation d'exposer les toiles lui appartenant.

Je vous chargerai de mes envois au Salon, à moins que vous ne cédiez votre commission à Grimprel. J'ai l'intention d'exposer la petite Yvonne Grimprel et soit votre portrait, soit ce que vous voudrez de chez vous. Je crois que c'est votre portrait que je préfère, avec la petite Grimprel ça fera une gentille exposition. Vous n'aurez qu'à prendre une feuille chez un marchand de couleur. Remplir les vides, et signer Renoir, Pierre Auguste.

Renoir
Pierre Auguste
Élève de Gleyre
né à Limoges. 1841.
Exposé aux trois derniers Salons 1879, 1880, 1881
N° 1 Portrait de Mlle Y.G. ou X.
N° 2 Portrait de M. X. ou P.B.

Renoir

En tout cas je vous nomme mon fondé de pouvoir.
Je vais de mieux en mieux, et vous voyez je recommence à écrire lisiblement à peu près. Sans ce diable de médecin je serais rentré. J'ai reçu une lettre très aimable de Deudon. Je lui écrirai demain, mais si vous le voyez vous lui ferez bien mes compliments de ne s'être rien cassé en tombant. C'est tellement effrayant de rester sur le dos environ deux mois.

Dieu que c'est bête une maladie. Dehors, je suis étourdi. J'ai maigri c'est incensé et j'ai l'air d'être empaillé. J'ai essayé de peindre un peu dans ma chambre la tête tourne au bout de cinq minutes. C'est idiot.

Mille choses aimables à Madame P. Berard et j'embrasse bien cette bonne Marthe et les autres aussi.
Ami
Renoir

LETTER 2

Renoir to Berard, from Marseilles, undated, early March 1882, the day after the above letter (Getty Center for the History of Art and the Humanities, Santa Monica, Calif., Special Collections)

Marseille samedi
Mon cher ami,
Reçu les 500 francs. Je pars par les messageries maritimes à 5 heures pour Alger. Je vous prie de donner aux amis ma nouvelle adresse Alger poste restante, jusqu'à nouvel ordre. Maintenant parlons *art*. J'ai dit à Deudon ce que je pensais d'Ephrussy comme critique d'art. Je vous supplie de ne l'écouter en rien. Tant qu'à votre portrait, vous n'êtes qu'un simple commissionnaire et vous n'avez aucun scrupule à avoir. C'est peut-être trop fort pour Ephrussy Charles, voilà la raison. À tout prix n'envoyez pas Ignace. Je vous laisse le choix entre André et vous. Si vous tenez à la danseuse allez-y, mais je crois que ça ne fera aucun effet dans ces grandes salles. Si Charles Ephrussy était un homme à mettre des cadres au dessus de 3 livres 10 sous, on aurait pu mettre la petite fille de Berneval. Mais j'aime votre portrait, voilà mon avis. Si vous êtes trop combattu envoyez André. Mon cher ami je vous ennuie beaucoup. Mais ne vous préoccupez pas trop tout ce que je mettrai au Salon fera mal. Mais comme je m'en fiche si c'est un four nous en rirons ensemble. Consultez vous avec Deudon mon cher ami. Une idée pourquoi ne mettriez vous pas Madame Berard. C'est très bien. C'est entendu. Envoyez si ça ne contrarie pas Madame Berard. Envoyez. C'est verni, fixé, avec des couleurs fixes.
Amitiés
Renoir

P.S. Envoyez Madame Berard. Surtout pas de tableaux des portraits. Vous, André ou Madame Berard. Si les oreilles sont suffisamment faites.

Renoir to Berard, from Algiers, undated, mid-March 1882 (private collection)

Mon cher ami

Deux mots, car voici le bateau qui part. Je suis trop heureux car j'adore Alger. Mangé ce matin petits pois exquis chez moi 30 rue de la Marine, Alger. J'ai lu l'article de Wolf. Épatant. Je vais lui écrire pour le couvrir de compliments. Les peintres sont assommants avec leurs expositions. C'est on ne peut plus vrai.

J'ai dû bien vous ennuyer avec mon envoi. Mais je veux encore vous en parler s'œil en est encore temps. Je suis Wolf. Il trouve mes vues de Venise mauvaises. Dans 5 ans il fera un article exquis pour elles et les couvrira de compliments. Exemple à suivre. *Votre portrait a besoin encore d'un an de bouteille. Ne suivez pas mes conseils et écoutez Ephrussy.* Ce juif plus que Bourgeois a l'œil qu'il faut pour ce qu'on appelle le Salon (de coiffure). Écrivez-moi et dites-moi que je vous ai bien ennuyé. Mais ce doit être fini et je vous l'ai dit, ça m'est égal. Je ne suis pas à un *four* près.

Ami

Renoir

Je vous écrirai plus long demain.

Mardi.

APPENDIX II: THE NOTEBOOKS OF LÉON CLAPISSON

Anne Distel

The following table presents the contents of two recently discovered notebooks of the collector Léon Clapisson (see my essay above, pages 77–86). The first, measuring 19.5 × 12.5 cm, is bound in black morocco. On the cover are the English words "Where is it?" in gold lettering. Its opening page contains the handwritten inscription "Collection de tableaux de Léon Clapisson – commencée en mars 1879." The second notebook, measuring 19.8 × 13 cm and bound in red morocco, displays the words "Catalogue des tableaux de la collection de Mr L. Clapisson 1882" in gold lettering.

Following Clapisson's more or less alphabetical ordering, the first three columns of the table give the name of each artist (with the corrected spelling and dates of birth and death supplied in brackets), and, as listed by him, the title of each work and its purchase price in francs. The table brings together the corresponding entries in each of the two notebooks. After the artists listed by Clapisson I have inserted, in alphabetical sequence, artists whose works appear in the Clapisson sales of 14 March 1885 and 28 April 1894. Titles followed by an asterisk belong to a group of works listed on folio 4v of the first notebook whose prices totalled 60,500 francs.

The fourth column traces, insofar as possible, the provenance of the work in question. The fifth column notes the work's appearance in either of the two Clapisson sales, and also gives the selling price and the name of the purchaser, as recorded in the *procès-verbal*, or transcript, of the sale (Archives de Paris). The catalogues of the sales are, respectively: *Catalogue de tableaux modernes par Barye, Boggs, Bonvin, Charlemont, Corot, Courbet, Couture, Daubigny, Diaz, J. Dupré, Harpignies, Jacquemart, Jongkind, Luminais, de Pene, Th. Rousseau, Alfred Stevens, Tassaert composant la collection de M. C.* (Hôtel Drouot, Paris, 14 March 1885, Maître Chevalier auctioneer, Georges Petit appraiser, 35 items, unillustrated) and *Catalogue de tableaux modernes, pastels, aquarelles et dessins anciens composant la collection de M. X . . .* (Hôtel Drouot, Paris, 28 April 1894, Maître Chevalier auctioneer, Durand-Ruel appraiser, 81 items, unillustrated). It is sometimes difficult to establish a firm correspondence between Clapisson's often imprecise titles and the descriptions given in these sale catalogues; for the more uncertain cases, I have recorded the sale catalogue descriptions in full.

The sixth column is reserved for comments and references. The present whereabouts of a work are noted only if it is in a public collection.

All dimensions are in centimetres.

Antigna [Alexandre Antigna, 1817–1878]	Petite bretonne en prière – 200	Petite Bretonne en prières – 200		1894, no. 1, "Antigna, *La prière*, signé à gauche du monogramme, encadrement cintré, 29 × 20" (Transcript, no. 74: Fr 55, to Simon)	
Barie [Antoine Louis Barye, 1795–1875]	Tigre au bord d'une source – 1,700	Tigre au bord d'une source – 1,700		1885, no. 1, "Barye, *Tigre au bord d'une source*, 25 × 35" (Transcript, no. 20: Fr 4,800, to Petit)	
Bonvin [François Bonvin, 1817–1887]	Le petit forgeron – 1,000	Le petit forgeron – 1,000			
[Bonvin]	La musique	La musique – 500		1885, no. 4, "Bonvin, *La Musique*, 18 × 25" (Transcript, no. 4: Fr 350, to Levéque)	
[Bonvin]	Les Sciences – 750 [*with La musique*]	Les Sciences – 500		1885, no. 3, "Bonvin, *Les Sciences*, 18 × 25" (Transcript, no. 2: Fr 240, to Beugniet)	
[Bonvin]	La Lessiveuse (dessin) – 200	La Lessiveuse (dessin) – 200			
Bachelier [Jean-Jacques Bachelier, 1724–1806]	Chat blanc guettant un oiseau – 450	Chat blanc guettant un oiseau – 450	*Catalogue des tableaux, pastels, dessins . . . collection de feu M. Laperlier*, Hôtel Drouot, Paris, 17–18 February 1879, no. 2, "J.J. Bachelier, *Un chat*. Un gros chat entièrement blanc aux aguets devant une treille lève la tête vers un oiseau qui vient de s'envoler. Signé à gauche: *Bachelier 1760*, 74 × 92"	1894, no. 77, "Bachelier, *La convoitise*, signé, daté en bas à gauche: *Bachelier 1760*, toile, 72 × 92, mentionné dans E. Bellier de la Chavignerie, *Dictionnaire des peintres*, p. 34, sous le titre *Chat angora guettant un oiseau*" (Transcript, no. 75: Fr 100, to Mme Besnard)	
Boucher [François Boucher, 1703–1770]	Deux têtes de jeunes filles – 250 (vente Maheraut [*sic*])	Deux têtes de jeune fille (vente Maheraut [*sic*]) – 250	*Catalogue de dessins anciens et modernes [formant] la collection de feu M. Mahérault*, Hôtel Drouot, Paris, 25–26 May 1880, unidentified work	1894, no. 78, "Boucher, *Les deux jeunes filles*, dessin au crayon rehaussé de pastel, 22 × 20" (Transcript, no. 21: Fr 115, to Hoche)	
Brun [Alexandre Brun, 1854–after 1937]	Goélette passant sous le Fort St Jean (Marseille) – 300	Goélette passant sous le fort St Jean – 300		1894, no. 2, "Brun, *Le Fort de Saint-Jean*, signé en bas à gauche: *A. Brun*, bois, 21 × 32" (Transcript, no. 70: Fr 65, to Mme Robel)	

Besnard [Albert Besnard, 1849–1934]		Desdémone (pastel) – 1,000		Possibly 1894, no. 46, "Besnard, *L'oreille au guet*, signé, daté en haut à gauche: *A. Besnard 1886*, pastel, 44 × 37" (Transcript, no. 27: Fr 1,500, to Brown)	
[Besnard]		La frileuse (pastel) – 200		1894, no. 47, "Besnard, *Frileuse*, signé, daté en haut à gauche: *A. Besnard 1887*, pastel, 44 × 37" (Transcript, no. 26: Fr 1,550, to Montaignac)	
[Frank Boggs, 1855–1926]				1885, no. 2, "Boggs, *Le Port de Dieppe* [tableau], 37 × 55" (Transcript, no. 1: Fr 200, to Riffard from Mantes)	
[Louise Breslau, 1856–1927]				1894, no. 48, "Breslau, *Chien au repos*, signé, daté en haut à gauche: *Louise Breslau 1882*, pastel rehaussé de gouache, 55 × 38" (Transcript, no. 59: Fr 150, to Mme Adam)	
Corot [Jean-Baptiste Camille Corot, 1796–1875]	La Seine à Andelys – 3,000				
[Corot]	Le matin – 1,500 ★	Le matin – 1,500			
[Corot]	La femme au tigre – 12,500 ★	La femme au tigre – 12,500	*Catalogue des tableaux modernes composant la collection de M. le baron E. de Beurnonville*, Hôtel Drouot, Paris, 29 April 1880, no. 5, "Corot, *La Chasse, sujet allégorique*, tableau ayant fait partie de la collection de Daubigny, 53 × 93" (Transcript, no. 36: Fr 9,500, to Brame)	1885, no. 11, "Corot, *La Femme au Tigre*. Cette composition allégorique est présentée au milieu d'un paysage plein de calme et de poésie. Une femme nue à demi couchée sur son manteau, présente au jeune Bacchus monté sur un tigre l'oiseau qu'elle vient de tuer. Près d'elle son arc et ses flèches. 55 × 95" (Transcript, no. 23: Fr 14,000, to Levêque)	Robaut 1965, no. 1276, *La Bacchante à la panthère*, c. 1855–60, 54 × 95, Shelburne Museum, Shelburne, Vt. Clapisson lent this work to the exhibition *Cent chefs-d'oeuvre*, Galeries Georges Petit, Paris, June–July 1883, no. 4.
[Corot]	Bords du canal à Arleux [?] (Somme) – 12,000				
[Corot]	La Saulaie – 7,000				
[Corot]	Le Pont-Neuf (1845) – 6,200				
[Corot]	Le chemin de Ville d'Avray – 16,000				
[Corot]	Une cour de ferme – 6,000 ★	Une cour de ferme (à Fontainebleau) – 6,000			Robaut 1965, no. 1316, *Fontainebleau, Maisons de paysans*, 1860–70, 55 × 45, Art Gallery and Museum, Glasgow
[Corot]	Le Lac de Gardes – 35,000			1885, no. 6, "Corot, *Souvenir d'Italie*. Un arbre touffu sort du feuillage derrière une roche grisâtre et se détache vigoureusement sur un beau ciel bleu. L'oeil se perd au loin sur les eaux d'un lac bordé par des côteaux éclairés en pleine lumière. Au premier plan, une chèvre broute les jeunes pousses d'un arbre. 60 × 50" (there is no transcript)	
[Corot]	Petite saulaie – 20,000				
[Corot]	La Rochelle – 7,500 ★	La Rochelle – 7,500			Robaut 1965, no. 670, *La Rochelle, entrée du port*, 1851, oil on panel, 26 × 38
[Corot]	Entrée de village – 4,800 ★	Entrée de village – 4,000		1885, no. 7, "Corot, *Entrée de village*. À droite un arbre au feuillage touffu ombrage les chaumières et le talus qui borde le chemin; à gauche apparaissent les premières maisons du village. Le ciel parsemé de légers nuages floconneux est d'un bleu fin et transparent. 40 × 30" (Transcript, no. 17: Fr 3,600, to Clapisson)	Robaut 1965, no. 1003, *Environs de Beauvais du côté de Voisinlieu*, c. 1855–65, 40 × 30, Musée du Louvre, Paris (R.F. 1357)
[Corot]	Le Passeur [*Pêcheur napolitain crossed out*] – 6,000 ★	Le Passeur – 6,000	*Catalogue de 30 tableaux modernes dépendant de la collection de M. Th. Leroy*, Hôtel Drouot, Paris, 13 May 1882, no. 6, "Corot, *Pêcheur napolitain*. Coiffé d'un grand bonnet et tenant un long croc qu'il appuie à terre, le passeur est vu de face, à mi-jambes dans l'eau. Toile, 78 × 58" (Transcript, no. 23: Fr 5,000, to Petit)	1885, no. 8, "Corot, *Le Passeur*. Coiffé d'un grand bonnet et tenant un long croc qu'il appuie à terre le passeur est vu de face à mi-jambe dans l'eau. 78 × 58" (Transcript, no. 24: Fr 4,000, to Desfossés)	Robaut 1965 n. 1572, *Un marinier napolitain*, 1873, 80 × 60
[Corot]	Le Pêcheur – La levée du filet – 23,000 ★	La levée du filet – 23,000			Robaut 1965, no. 1671, *Le batelier de Mortefontaine*, 1865–70, 60 × 87, Frick Collection, New York
[Corot]			*Catalogue de tableaux anciens et modernes . . . Succession de M. Adolphe Dugléré (gérant du Café Anglais)*, Hôtel Drouot, Paris, 11 June 1884, no. 5, "Corot, *Vue d'Amsterdam effet de soleil couchant*, 23 × 45" (Transcript, no. 49: Fr 650, to Mallet)	1885, no. 9, "Corot, *Vue d'Amsterdam*. Le soleil couchant éclaire les quais, les navires à l'ancre et les monuments qui dominent la ville. Sur la droite, un bateau à voiles rentre dans le port en longeant les brise-lames. 23 × 45" (Transcript, no. 18: Fr 2,820, to Dielafoy, 16 [rue] Caumartin)	Robaut 1965, no. 746, *Vue d'Amsterdam*, 1854, 34 × 45
[Corot]				1885, no. 10, "Corot, *Chaumière au bord d'une mare*. Au centre du tableau un groupe de chaumières; à droite un arbre se détachant sur le ciel; à gauche une vache au bord de l'eau. 30 × 42" (Transcript, no. 15: Fr 2,800, to Desfossés)	
Mary Cassat [Mary Cassatt, 1844–1926]	Jeune femme en visite – 1,000	Jeune femme en visite – 1,000	Bought from Durand-Ruel 3 April 1882, *Le Thé*		Breskin 1970, no. 78, *Five O'Clock Tea*, 1880, 64 × 92, Museum of Fine Arts, Boston, or more likely Breskin 1970, no. 65, *The Cup of Tea*, 1879, 92 × 65, Metropolitan Museum of Art, New York

Caillebotte [Gustave Caillebotte, 1848–1894]		2 dessins – 400		1894, no. 49, "Caillebotte, *La route*, signé, daté à droite: *Caillebotte 1880*, pastel, 54 × 44" (Transcript, no. 24: Fr 700, to Durand-Ruel); 1894, no. 50, "Caillebotte, *Le Verger*, signé, daté à gauche: *Caillebotte 1880*, pastel, 54 × 44" (Transcript, no. 25: Fr 780, to Durand-Ruel)	Bérhaut 1994, no. 171, *Verger en Normandie*, pastel, 54 × 44, and no. 172, *Route en Normandie*, pastel, 54 × 44
Courbet [Gustave Courbet, 1819–1877]	Les demoiselles de village – 4,000	Les demoiselles de village – 4,000		1885, no. 12, "Courbet, *Les demoiselles du village*. Le vallon en pleine lumière est entouré de côteaux verdoyants coupés çà et là par des roches aux couleurs de granit; quelques jeunes femmes causent avec une petite gardeuse de vaches qui paissent au bord d'un ruisseau. Réduction du tableau célèbre appartenant au Musée de Boston, 52 × 33" (Transcript, no. 25: Fr 2,020, to Gérard, [rue] La Fayette)	Fernier 1977, no. 126, *Les demoiselles de village*, 1851, 54 × 65, Leeds City Art Gallery. Clapisson lent this work to the Courbet exhibition at the École des Beaux-Arts, Paris, May 1882, no. 177.
[Courbet]	Effet de neige – 1,000	Effet de neige – 1,200			
Cazin [Jean-Charles Cazin, 1841–1901]		Le nuage – 4,000			
Th. Couture [Thomas Couture, 1815–1879]	La Comédie – 2,000	La Comédie – 2,000		1885, no. 13, "Couture, *La Comédie*. Elle est représentée sous la figure d'une femme drapée dans une tunique blanche dont elle soulève un des pans. Dans la main droite elle tient son masque; une corbeille de fleurs est déposée à ses pieds et derrière elle sont accroupis des personnages secondaires. 24 × 16" (Transcript, no. 14: Fr 650, to Brame)	
Charlemont [Eduard Charlemont, 1848–1906]	Bouquet fané – 700				Charlemont was a Viennese artist who exhibited at the Salon in Paris.
[Charlemont]	Jeune femme lisant (dessin à la plume) – 500	Jeune femme lisant (dessin) – 500		1894, no. 51, "Charlemont, *La lecture*, signé, daté à droite: *E. Charlemont 1879*, dessin à la plume, 23 × 18" (Transcript, no. 4: Fr 150, to Faure [?])	
[Charlemont]		La mandoline – 700		1885, no. 5, "Charlemont, *La Mandoline, nature-morte*, 18 × 13" (Transcript, no. 3: Fr 300, to Lepké)	Possibly the *Bouquet fané* mentioned by Clapisson.
[Adolphe Félix Cals, 1810–1880]				1894, no. 3, "Cals, *Paysan au repos*, signé, daté à droite: *Cals 8 novbre 76*, toile, 33 × 38" (Transcript, no. 31: Fr 130, to Viau, 47 [boulevard] Haussmann)	
Daubigny [Charles François Daubigny, 1817–1878]	Village des Andelys et ruines du Château Gaillard – 6,000				
[Daubigny]	Une belle journée – 12,500				
[Daubigny]	Pommiers en fleurs – 3,250				
[Daubigny]	Le village d'Auvers – 2,500				
[Daubigny]	Une habitation à Cordoue (étude) – 1,050	Une habitation à Cordoue – 1,100	*Catalogue de tableaux modernes . . . collection baron E. de Beurnonville*, Hôtel Drouot, Paris, 29 April 1880, no. 8, "Daubigny, *Une habitation à Cordoue*, 23 × 32" (Transcript, no. 2: Fr 1,000, to A. Stevens)	1885, no. 18, "Daubigny, *Une habitation à Cordoue*, étude, 23 × 32" (Transcript, no. 28: Fr 505, to Tabourier)	
[Daubigny]	L'Église des Andelys (étude) – 1,000	L'Église des Andelys au clair de lune – 1,000			
[Daubigny]	Les marais (étude) – 1,250	Les marais – 1,250			
[Daubigny]	Lisière de bois [le crépuscule (étude) *crossed out*] – 750	Lisière de bois – 1,000 –		1885, no. 17, "Daubigny, *Lisière de bois*. Le ciel d'une tonalité grise répand sur les terrains et les arbres une lumière douce et harmonieuse. 19 × 25" (Transcript, no. 11: Fr 1,800, to Lehman, [rue] Taitbout)	
[Daubigny]	Crépuscule Île St Denis (étude) – 500	Crépuscule à Île St Denis – 500			
[Daubigny]	[*title crossed out, illegible*] étude – 1,500				
[Daubigny]	Coucher de soleil (marine étude) – 1,500	Coucher de soleil en mer – 1,500			
[Daubigny]	Effet d'automne (étude) – 250	Effet d'automne – 250			
[Daubigny]	Les Bords de l'Oise – 8,500	Bords de l'Oise au soleil couchant – 8,500		1885, no. 15, "Daubigny, *Bords de l'Oise*. La berge couverte de prairies et bordée d'arbres touffus descend en pente douce vers la rivière. Un troupeau de vaches vient s'abreuver. Le ciel parsemé de légers nuages se reflète dans l'eau et illumine tout le paysage. 33 × 57" (Transcript, no. 21: Fr 15,000, to Gondouin)	

[Daubigny]	Village au bord de la Seine – 6,200	Village au bord de la Seine – 6,500			
[Daubigny]	La Pêcherie à Poissy – 1,700	La Pêcherie à Poissy – 1,700	*Catalogue de 30 tableaux modernes dépendant de la collection de M. Th. Leroy*, Hôtel Drouot, Paris, 13 May 1882, no. 12, "Daubigny, *La Pêcherie à Poissy*, Effet de soir. La construction en pilotis se détache sur un horizon foncé. Esquisse d'une grande vigueur et d'un bel effet. Bois, 24 × 49, vente après décès de l'artiste" (Transcript, no. 12: Fr 1,200, to Brame)	1885, no. 14, "Daubigny, *La pêcherie de Poissy*, Effet de soir. La construction en pilotis se détache sur un horizon foncé. Esquisse d'une grande vigueur et d'un bel effet. 24 × 49" (Transcript, no. 13: Fr 1,200, to Tabourier)	
[Daubigny]				1885, no. 16, "Daubigny, *Effet du matin*. Un soleil matinal éclaire les prairies, les bosquets d'arbres et les toitures rouges de toute une petite ville cachée dans la verdure. 31 × 40" (Transcript, no. 16: Fr 1,250, to Bague)	
[Daubigny]				1885, no. 19, "Daubigny, *Bateaux sur l'Oise*, 18 × 36" (Transcript, no. 6: Fr 1,100, to Leroux)	
[Daubigny]				1885, no. 20, "Daubigny, *La vallée*, 18 × 35" (Transcript, no. 7: Fr 820, to Brown)	
Jules Dupré [Jules Dupré, 1811–1889]	Marine – 3,000	Marine – 3,000			
[Dupré]	Cabane à Cayeux – 750	Cabane à Cayeux – 750		1885, no. 22, "Dupré, *Paysage*. Derrière la chaumière apparaît la mer sous un ciel chargé de nuages orageux. 11 × 22" (Transcript, no. 9: Fr 570, to Lamare, [rue] Feydeau, or Feydeau, [rue] Lamare)	
[Dupré]	Vaches [or Vacher] à l'abreuvoir – 5,500				
E. Delacroix [Eugène Delacroix, 1797–1863]	Lion prêt à s'élancer (vente Hartmann) – 12,000		*Catalogue de tableaux modernes composant la collection de M. Fr. Hartmann*, 18 rue de Courcelles, Paris, 7 May 1881, no. 2, "Delacroix, *Lion attaqué*. Ployé sur les jarrets un superbe lion, la crinière hérissée, l'oeil étincelant, pousse des rugissements et s'apprête à bondir sur un ennemi caché. Derrière lui un fond de montagnes bleuâtres et un ciel gris. Gravé par Courtry, 27 × 34" (Transcript, no. 7: Fr 10,000, to Brame)		Johnson 1981–89, III, no. 183, *Lion in the Mountains*, 1851, 27.5 × 35.5, Ordrupgaardsamlingen, Copenhagen (Clapisson is not shown in the provenance, but Johnson indicates that in 1888 Brame resold the work to E. Kegel)
Degas [Edgar Degas, 1834–1917]	La femme au parapluie (dessin) – 500	La femme au parapluie – 500		Bought by Durand-Ruel from Clapisson 21 April 1892, Fr 6,000 (*L'Attente*, stock no. 2124; see G. Wold in *Splendid Legacy: The Havemeyer Collection* [New York, 1993], Appendix, no. 237)	Lemoisne no. 698, *L'Attente*, pastel, 48 × 61, J. Paul Getty Museum, Malibu, and Norton Simon Foundation, Pasadena, Calif. The date is probably slightly earlier than the c. 1882 proposed by Lemoisne.
[Degas]	Deux danseuses – 500	Deux danseuses – 500		Pastel bought by Durand-Ruel from Clapisson 19 May 1891	Lemoisne no. 527, *L'Entrée des masques*, 1879, pastel, 50 × 65, Sterling and Francine Clark Art Institute, Williamstown, Mass.
[Degas]	Petite danseuse (Effet de lumière électrique) – 250	Petite danseuse (Effet de lumière électrique) – 200		Bought by Durand-Ruel from Clapisson 21 April 1892, Fr 500	
[Degas]	Éventail (camaïeu) – 400	Éventail – 400	Adolphe Beugniet, Paris, according to Brame and Reff 1984	*Éventail*, drawing bought by Durand-Ruel from Clapisson 19 May 1891	Brame and Reff 1984, no. 86, *Le Foyer de la danse*, c. 1879–80, pencil and watercolour, 30 × 57
[Degas]		Melle Chabot dans la farandole – 800		Bought by Durand-Ruel from Clapisson 21 April 1892, Fr 3,000	Lemoisne no. 736, *Danseuse basculant*, c. 1883, pastel, 70 × 51
Decamps [Alexandre Gabriel Decamps, 1803–1860]	Cabane de pêcheurs – 5,000				
[Decamps]	Petit berger (sépia) – 150			1894, no. 52, "Decamps, *Le jeune pâtre*, signé à droite du monogramme, dessin à la sépia, 14 × 10,5" (Transcript, no. 7: Fr 40, to Durand-Ruel)	
Dauzats [Adrien Dauzats, 1804–1868]	Une Mosquée à Damanhour – 500	Une mosquée à Damanhour – 500		Possibly 1894, no. 67, "Dauzats, *Vue de l'Alhambra à Grenade*, signé à droite: A. Dauzats, aquarelle, 22 × 16" (Transcript, no. 3: Fr 32, to M. Fouque [?])	
Louis Dumoulin [1860–1924]		Souvenir Fontarabie – 400		Possibly 1894, no. 4, "Dumoulin, *Village au bord de la mer*, signé, daté à droite: Louis Dumoulin 1863, toile, 47 × 32" (Transcript, no. 72: Fr 65, to Robel)	
[Honoré Daumier, 1808–1879]				1894, no. 61, "Daumier, *Une fâcheuse rencontre*, signé à droite du monogramme, dessin à la plume, 21 × 27" (Transcript, no. 77: attributed to Daumier without guarantee, Fr 16, to Feydeau)	None of these drawings by Daumier is mentioned in Maison 1968.
[Daumier]				1894, no. 62, "Daumier, *Un ministère sous l'eau*, signé à droite du monogramme, dessin à la plume, 13 × 25" (Transcript, no. 81: attributed to Daumier without guarantee, Fr 10, to Dachery)	

[Daumier]				1894, no. 63, "Daumier, *Les politiciens*, signé à droite du monogramme, dessin à la plume, 21 × 25" (Transcript, no. 76: attributed to Daumier without guarantee, Fr 11, to Micheau [?])	
[Daumier]				1894, no. 64, "Daumier, *Les chasseurs*, signé à droite en toutes lettres, à gauche du monogramme, dessin à la plume, 15 × 23" (Transcript, no. 80: attributed to Daumier without guarantee, Fr 15, to Micheau)	
[Daumier]				1894, no. 65, "Daumier, *La Tragédie*, signé à droite du monogramme, dessin à la plume, 20 × 24" (Transcript, no. 79: attributed to Daumier without guarantee, Fr 10, to Lutz)	
[Daumier]				1894, no. 66, "Daumier, *L'indignation du peintre*, signé à droite du monogramme, dessin à la plume, 28 × 22" (Transcript, no. 78: attributed to Daumier without guarantee: Fr 16, to Lutz)	
[Charles Melchior Descourtis, 1753–1820]				1894, no. 81, "Descourtis, *La foire de village*, gravure en couleurs d'après Taunay, 31 × 24" (Transcript, no. 22: Fr 70, to Oulmont, 5 [boulevard] Malesherbes)	
[Narcisse Diaz de La Peña, 1807–1876]				1885, no. 21, "Diaz, *La mare*. Un bouquet de jeunes chênes se dresse au milieu de la prairie brûlée par le soleil et se reflète dans une petite mare. Au-delà, la plaine s'étend à perte de vue sous un ciel d'un bleu pâle parsemé de légers nuages; à droite, au pied d'un arbre au feuillage doré, est assise une bûcheronne. 38 × 54" (Transcript, no. 22: Fr 9,800, to Petit)	
Fragonard [Jean Honoré Fragonard, 1732–1806]	Joas et Joad (vente Valferdin [sic]) (étude) – 700	Joas et Joad (vente Valferdin [sic]) – 1,000	*Collection de feu M. [Hippolyte] Walferdin: Tableaux et dessins de l'école française, oeuvres importantes de Fragonard*, Hôtel Drouot, Paris, 12–16 April 1880, no. 21, "Fragonard, *Joas et Joad*, peinture empâtée et vigoureuse, bois, 22 × 17.5"	1885, no. 23, "Fragonard, *Joas et Joad*, peinture vigoureuse provenant de la vente Walferdin, 22 × 17" (Transcript, no. 23: Fr 270, to Fouard)	
Tony Faivre [1830–1905]	Jeune femme turque – 500	La Mauresque – 500			
Fantin Latour [Henri Fantin-Latour, 1836–1904]	Dessin de son tableau de l'exposition 1879 – 300	Dessin de son tableau de l'exposition 1879 – 300		1894, no. 68, "Fantin-Latour, *La leçon de dessin*, signé en haut à gauche et daté: *Fantin 79*, dessin au crayon noir, 43 × 45" (Transcript, no. 19: Fr 235, to Tempelaere)	Besides preparatory sketches, there are several known finished drawings that were made for purposes of reproduction of *Portraits* (*La Leçon de dessin dans l'atelier*). The painting is in the Musées Royaux des Beaux-Arts de Belgique, Brussels. See Druick and Hoog 1983, no. 93.
[Fantin Latour]	Lohengrin (étude) – 250	Lohengrin (étude) – 250			
[Fantin-Latour]				1894, no. 5, "Fantin-Latour, *L'Hommage*, signé en bas à gauche: *Fantin*, daté en haut à gauche, *janvier 69*, toile, 32.5 × 24" (Transcript, no. 32: Fr 180, to Tempelaere)	Fantin-Latour 1911, no. 324, *Hommage à Delacroix*, 1869, 23.5 × 31 (the description makes reference to the 1894 sale)
[Fantin-Latour]			*Vente après décès de M. Cottier de Londres*, Galerie Durand-Ruel, Paris, 27–28 May 1892, no. 60, "Fantin Latour, *Le Rêve du poète*," Fr 100 according to the *Gazette de l'Hôtel Drouot*	1894, no. 6, "Fantin-Latour, *Le rêve du poète*, vente Cottier, 27 May 1892, no. 60 au catalogue, toile, 24 × 32.5" (Transcript, no. 30: Fr 520, to Tempelaere)	Fantin-Latour 1911, possibly no. 321, *Le Rêve du poète*, 1869, 23 × 32
[Fantin-Latour]				1894, no. 7, "Fantin-Latour, *Baigneuse*, signé en haut à droite: *Fantin*, toile, 21 × 24" (Transcript, no. 29: Fr 620, to Picard [or Gérard], [rue] Chauchat)	
[Eugène Fromentin, 1820–1876]			*Catalogue de la vente qui aura lieu par suite du décès de Eugène Fromentin*, Hôtel Drouot, Paris, 2–3 February 1877, possibly no. 303, *Arabe, Laghouat, 1853*	1894, no. 53, "Fromentin, *Arabe assis*, daté à droite: *Laghouat 53*, dessin au crayon noir, 18 × 15, vente Fromentin" (Transcript, no. 5: Fr 27, to Briche, 4 [rue de] Phalsbourg)	
Gassiès [Georges Gassiès, 1829–1919]	Chasseur demandant son chemin (aquarelle) – 200				
Gauguin [Paul Gauguin, 1848–1903]		Pêcheurs bretons – 400	Bought from Gauguin by Boussod et Valadon et Cie (Théo van Gogh) 4 December 1888, Fr 250, and sold the same day to Clapisson, Fr 400 (see Rewald 1986b, Appendix 1, 90)	1894, no. 8, "Gauguin, *Pêcheurs bretons*, signé, daté à gauche: *P. Gauguin 88*, toile, 72 × 60" (Transcript, no. 35: Fr 500, to Durand-Ruel)	Wildenstein 1964, no. 262, *Pêcheurs à la ligne*, 1888, 72 × 60
Harpignies [Henri Harpignies, 1819–1916]	La Promenade (aquarelle) – 400	La promenade – 400		Possibly 1894, no. 54, "Harpignies, *Paysage aux environs de Famars*, signé, daté à gauche: *E. Harpignies juin 1880*, aquarelle, 32 × 27" (Transcript, no. 11: Fr 140, to Oudin, 9 [rue] Louis le Grand)	The banker Alfred Alexandre Oudin, 9 rue Louis le Grand, was a friend of Clapisson and one of the witnesses to the attestation of his death. At this sale he also bought the Leblant and the Ziem (q.v.).
[Harpignies]	Le Pont Royal (éventail) – 400	Le Pont Royal (éventail) – 400		1894, no. 55, "Harpignies, *Les bords de la Seine*, signé, daté à gauche: *Harpignies 1881*, aquarelle, éventail, 15 × 57" (Transcript, no. 15: Fr 410, to Durand-Ruel)	
[Harpignies]	Le château de Béguin (vente Fould) – 400	Le château de Béguin – 400	*Catalogue des tableaux modernes . . . par suite du décès de M. E[douard] Fould*, Hôtel Drouot, Paris, 27 February–3 March 1882 [nos. 33 to 40]	1885, no. 24, "Harpignies, *Le château de Béguin, effet d'hiver*, aquarelle, provient de la collection Fould" (Transcript, no. 30: Fr 310, to Bex, 13 [rue] Monsieur)	The stockbroker Henri Frédéric Bex was a friend of Clapisson (see my essay above, page 85).

[Harpignies]	d° – 400	d° – 400	*Catalogue des tableaux modernes . . . par suite du décès de M. E[douard] Fould*, Hôtel Drouot, Paris, 27 February–3 March 1882 [nos. 33 to 40]	1885, no. 25, "Harpignies, *Le château de Béguin, effet d'automne*, aquarelle, provient de la collection Fould" (Transcript, no. 32: Fr 340, to Bex)	
[Harpignies]	Un Clair de lune – 500	Clair de lune – 500			
Jacquemart [Jules Ferdinand Jacquemart, 1837–1880]	Montagnes après la pluie (aquarelle) – 570	Montagnes après la pluie – 570	*Aquarelles, dessins . . . de feu Jules Jacquemart*, Hôtel Drouot, Paris, 4–8 April 1881, no. 7, *Montagnes après la pluie* (Transcript, no. 62: Fr 550, to Clapisson)		
[Jacquemart]	Jeune femme de Vintimille allaitant son enfant – 450	Jeune femme de Vintimille allaitant son enfant – 570	*Aquarelles, dessins . . . de feu Jules Jacquemart*, Hôtel Drouot, Paris, 4–8 April 1881, no. 10, *Jeune femme de Vintimille allaitant son enfant* (Transcript, no. 61: Fr 480, to Clapisson)		
[Jacquemart]	Jeune fille de Menton à la fontaine – 525	Jeune fille de Menton à la fontaine – 525	*Aquarelles, dessins . . . de feu Jules Jacquemart*, Hôtel Drouot, Paris, 4–8 April 1881, no. 8, *Jeune fille de Menton à la fontaine* (Transcript, no. 57: Fr 520, to Clapisson)		
[Jacquemart]	Dans les montagnes – 6,500	Dans les montagnes – 6,500			
[Jacquemart]	Paysage – 6,500	Prairies effondrées – 6,500			
[Jacquemart]		Barque au bord de l'eau – 2,000			
[Jacquemart]				1885, no. 26, "Jacquemart, *La Seine près de Courbevoie*, aquarelle" (Transcript, no. 33: Fr 295, to Bex)	On Bex see under Harpignies.
Ch Jacques [Charles Jacque, 1813–1894]	Cochons à l'auge (dessin) – 150	Cochons à l'auge (dessin) – 200			
[Roger Jourdain, 1845–1918]				1894, no. 69, "Jourdain, *La Plage*, signé en toutes lettres, aquarelle, 27 × 38" (Transcript, no. 20: Fr 47, to Brown)	
Luminais [Évariste Luminais, 1822–1896]	Le Guetteur (aquarelle) – 700	Le guetteur – 700		1885, no. 30, "Luminais, *Le guetteur*, aquarelle" (Transcript, no. 34: Fr 210, to [*name illegible*], 17 [rue du] Gal Foy)	
Luiggi Loir [Luigi Loir, 1845–1916]	Le Kiosque de la Bourse Effet de neige – 600	Le Kiosque à la Bourse Effet de neige – 600		1894, no. 19, "Loir, *Vue de Paris, effet de neige*, signé, daté à gauche: *Loir Luigi 1875*, toile, 44 × 27" (Transcript, no. 66: Fr 310, to Petit)	
Lancret [Nicolas Lancret, 1690–1743]	La Déclaration (sépia) – 600	La déclaration – 600			
Lebourg [Albert Lebourg, 1849–1928]	Deux bateaux Mouches – 125	Deux bateaux Mouche – 125		1894, no. 17, "Lebourg, *Les Bateaux-Mouches* [*sic*], signé à droite: *A. Lebourg Paris*, toile, 30 × 47" (Transcript, no. 57: Fr 180, to Roux)	
[Lebourg]	Le Pont-Marie (Paris) – 275	Le Pont-Marie – 275		Possibly 1894, no. 18, "Lebourg, *Vue de Paris*, signé, daté à droite: *A. Lebourg 1880*, toile, 28 × 46" (Transcript, no. 58: Fr 260, to Bernheim-Jeune)	
[Lebourg]	Charenton, une matinée – 275			Possibly 1894, no. 13, "Lebourg, *Le Ponton de l'Octroi au Pont National*, signé à droite: *A. Lebourg*, toile, 35 × 65" (Transcript, no. 34: Fr 325, to Roux)	
[Lebourg]	Ciel gris – 125				
[Lebourg]	Dieppe, Maison du port – 275	Dieppe (maisons du port) – 275		Possibly 1894, no. 16, "Lebourg, *Vue de Dieppe*, signé, daté à droite: *A. Lebourg 1880*, toile, 29 × 57" (Transcript, no. 53: Fr 310, to Cahen)	
[Lebourg]	d° la jetée – 275	[d° la jetée *crossed out*] – 275 Rouen plein soleil		Possibly 1894, no. 15, "Lebourg, *Les bords de la Seine aux environs de Rouen*, signé à gauche: *A. Lebourg*, toile, 31 × 59" (Transcript, no. 40: Fr 300, to Viau)	
[Lebourg]		Le départ d'un bateau, Effet de brume (Havre) – 500		Possibly 1894, no. 12, "Lebourg, *Le matin dans l'avant-port du Havre*, signé à droite: *A. Lebourg*, toile, 39 × 72" (Transcript, no. 33: Fr 450, to Roux, 22 boulevard Voltaire)	
[Lebourg]		Étude, temps d'orage – 250			
[Lebourg]		Étude Seine Lisieux – 300			
[Lebourg]		Coucher de soleil sur la Seine – 300		1894, no. 14, "Lebourg, *Soleil couchant*, signé à droite: *A. Lebourg*, toile, 31 × 59" (Transcript, no. 39: Fr 170, to Sainsère)	
Leblant [Julien Le Blant, 1851–1936]	Soldat de la République – 500	Soldat de la République – 500		1894, no. 11, "Le Blant, *Soldat de la Première République*, signé à gauche: *J. Leblant*, bois, 35 × 27" (Transcript, no. 41: Fr 150, to Oudin)	On Oudin see under Harpignies.

Lhermitte [Léon Lhermitte, 1844–1925]		Petit-Village environs de Laon – 1,100			
[Lhermitte]		L'Eau de vie de marc – 500	Bought from Durand-Ruel 24 November 1883, *Chateau-Thierry, les goûteurs d'eau de vie*, drawing (Archives Durand-Ruel, Paris)		Presumably the drawing *Le Pressoir*, 31 × 48, engraved by H. Lefort in *Galerie Durand-Ruel, recueil d'estampes*, 26ᵉ livraison, 1875, no. CCLII, or *L'eau de vie de marc*, 31 × 46, engraved by Lhermitte in *Galerie Durand-Ruel, recueil d'estampes*, 27ᵉ livraison, 1875, no. CCLXI
Lavieille [Eugène Lavieille, 1820–1889]		Coucher de soleil (cadre fin bois sculpté) – 250		1894, no. 10, "Lavieille, *Coucher de soleil*, signé à droite: *Eug. Lavieille*, cadre en bois sculpté, toile, 18 × 30" (Transcript, no. 65: Fr 150, to [*illegible*])	
[Lavieille]		Vaches sous bois – 150		1894, no. 9, "Lavieille, *Paysage avec vaches*, signé à droite: *Eug. Lavieille*, toile, 41 × 32" (Transcript, no. 71: Fr 72, to David, Bourg-la-Reine)	
Meisonnier [Ernest Meissonier, 1815–1891]	Deux cavaliers cotoyant un étang se dirigent vers un petit bouquet de bois pour se mettre à l'abri de l'orage menaçant – 9,000		*Catalogue des tableaux modernes composant la collection de M. le baron E. de Beurnonville*, Hôtel Drouot, Paris, 29 April 1880, no. 36, "Meissonier, *Les cavaliers*. Le vent souffle à travers la plaine et le ciel chargé de nuages fait prévoir l'orage. Deux cavaliers longent la berge d'un étang et gagnent un petit bois qu'on aperçoit à l'horizon. 10 × 14½" (Transcript, no. 41: Fr 6,600, to Everard)		
Munckizy [presumably Mihály Munkácsy, 1844–1900]	(25 octobre 1881) Seule au rendez-vous! – 6,000				
Moreau [Gustave Moreau, 1826–1898]	L'Enlèvement de Déjanire – 5,500		*Catalogue des tableaux . . . collection de feu Lepel-Cointet*, Hôtel Drouot, Paris, 9–10 June 1881, no. 30, "Gustave Moreau, *Enlèvement de Déjanire par le centaure Nessus*, 54 × 45" (Transcript, no. 19: Fr 4,550, to Brame)		Mathieu 1976, no. 128, *Déjanire*, 1872, oil on panel, 53 × 45"
Ed. Morin [Edmond Morin, 1824–1882]	Une visite à l'École des Beaux-Arts (aquarelle) – 400	Une visite à l'École des Beaux-Arts – 400			
Millet [Jean-François Millet, 1814–1875]	Femme étendant du linge dans un verger (aquarelle) – 1,500				
[Millet]	La femme à la vache (dessin) – 1,500				
[Millet]	Les Batteurs en grange (dessin) – 500	Les batteurs en grange – 500			
[Millet]	Le retour des fagotiers (dessin) – 350	Les Fagotiers – 500			
[Millet]	Les Pêcheurs de varech – 5,250	Les Pêcheurs de varech – 5,200			
[Millet]	Eau-forte – 100				
Claude Monet [1840–1926]	Église de Varangeville – 1,500	Église de Varangeville – 1,500	Bought from Durand-Ruel 26 May 1882	Bought by Durand-Ruel from Clapisson 19 May 1891	Wildenstein 1974–91, no. 725, *Église de Varangeville, temps gris*, 1882, 65 × 81, J.B. Speed Art Museum, Louisville
[Monet]	Veteuil [*sic*] – 400	La Seine à Véteuil [*sic*] – 400		1894, no. 22, "Monet, *Vétheuil*, signé à droite en toutes lettres, toile, 54 × 65" (Transcript, no. 50: Fr 1,700, to Lebel)	Wildenstein 1974–91, no. 500, *Le bord de la Seine à Lavacourt*, 1878, 54 × 65
[Monet]	La Seine à Argenteuil – 1,200	Vue d'Argenteuil – 1,200	Bought from Durand-Ruel 10 July 1882	Bought by Durand-Ruel from Clapisson 19 May 1891	Wildenstein 1974–91, no. 198, *La Seine à Argenteuil*, 1872, 50 × 61, Musée d'Orsay, Paris (RF 1951-13)
[Monet]	Village de Bonnières – 500	Village de Bonnière [*sic*] – 500		Bought by Durand-Ruel from Clapisson 21 April 1892, Fr 1,500	Wildenstein 1974–91, no. 110, *Au bord de l'eau, Bennecourt*, 1868 (lent by Clapisson to the Monet-Rodin exhibition, Galeries Georges Petit, Paris, 1889), 81 × 100, Art Institute of Chicago (22427)
[Monet]	Gare au Soleil – 500	Gare au soleil – 500			
[Monet]	Coucher de soleil sur la Seine à Lavacourt – 1,800	Soleil dans le brouillard sur la Seine à Lavacourt près Vétheuil – 1,800	Bought from Durand-Ruel July 1882	Bought by Durand-Ruel from Clapisson 19 May 1891	Wildenstein 1974–91, no. 576, *Soleil couchant sur la Seine, effet d'hiver* (lent by Clapisson, as *Coucher de soleil sur la Seine, effet d'hiver*, 1880, to the Monet-Rodin exhibition, Galeries Georges Petit, Paris, 1889), 100 × 152, Petit-Palais, Paris
[Monet]		Falaises de Pourville [Varangeville *crossed out*] – 2,000	Bought from Durand-Ruel 8 May 1882, *Sur la Falaise*	Bought by Durand-Ruel from Clapisson 19 May 1891	Wildenstein 1974–91, no. 751, *Bord des falaises à Pourville*, 1882 (lent by Clapisson, as *Pourville*, 1882, to the Monet-Rodin exhibition, Galeries Georges Petit, Paris, 1889), 61 × 100

[Monet]		Les tulipes – 1,500	Bought from Monet in 1886, Fr 1,500	Bought by Durand-Ruel from Clapisson 19 May 1891	Wildenstein 1974–91, no. 1070, *A Sassenheim près de Harlem, champ de tulipes*, 1886 (lent by Clapisson, as *Culture de tulipes Hollande*, to the *Monet-Rodin* exhibition, Galeries Georges Petit, Paris, 1889), 60 × 73, Sterling and Francine Clark Art Institute, Williamstown, Mass.
[Monet]		Déville usines près Rouen – 800		Bought by Durand-Ruel from Clapisson 21 April 1892, Fr 1,500	Wildenstein 1974–91, no. 213, *Le convoi de chemin de fer*, 1872, 48 × 76
[Monet]		La mer sauvage (Belle Île) – 1,800	Bought from the artist by Boussod et Valadon et Cie (Théo van Gogh) 23 April 1887, Fr 1,200, and sold the same day to Clapisson, Fr 1,800 (see Rewald 1986b, Appendix 1, 91)	Bought by Durand-Ruel from Clapisson 19 May 1891	Wildenstein 1974–91, no. 1112, *Belle-Île, effet de pluie*, 1886, 60 × 73, Bridgestone Museum of Art, Tokyo
Manet [Édouard Manet, 1832–1883]	Un Jardin – 2,500	Son jardin de Versailles – 2,500	Bought from Durand-Ruel 10 May 1882, Fr 2,500, *Un jardin* [see *Manet* 1983, 477]	Bought by Durand-Ruel from Clapisson 21 April 1892, Fr 6,000 [see *Manet* 1983, 477]	Rouart and Wildenstein 1975, no. 375, *Le banc (le jardin, à Versailles)*, 1881, 65 × 81
[Manet]	La jetée de Boulogne – 1,000	La jetée de Boulogne – 1,000	Bought from Durand-Ruel 12 July 1882, *La jetée artificielle*	Bought by Durand-Ruel from Clapisson 21 April 1892, Fr 2,000 [see Rouart and Wildenstein 1975]	Rouart and Wildenstein 1975, no. 144, *La jetée de Boulogne*, 1869, 33 × 45
Berthe Morizot [Berthe Morisot (Madame Eugène Manet), 1841–1895]	Jeune femme grise [or assise] – 1,000	Jeune femme assise sur un canapé – 1,000		Bought by Durand-Ruel from Clapisson 21 April 1892, Fr 1,500	Bataille and Wildenstein 1961, pl. 44, no. 78, *Jeune femme assise*, 1879, 80 × 100
[Morisot]	Marine Île de Wight – 350	Souvenir de l'Île de Wight – 350			
Pelouse [Léon-Germain Pelouse, 1838–1891]	Ville de Dordrecht (effet d'automne) – 600				
de Penne [Charles de Penne, 1831–1897]	Chiens de chasse buvant à la rivière (aquarelle) – 450	Chiens buvant à la rivière – 450		1885, no. 31, "de Penne, *Chiens de chasse*, aquarelle" (Transcript, no. 31: Fr 255, to Fouard)	
[de Penne]	Petits bassets anglais – 500	Petits bassets anglais – 500			
Pissaro [Camille Pissarro, 1830–1903]	Les moissonneuses – 300	Les moissonneuses – 300		Gouache bought by Durand-Ruel from Clapisson 21 April 1892, *La Moisson*, Fr 500	Gouache lent by Clapisson to the sixth Impressionist exhibition, Paris, 1881, no. 74, as *La Moisson*
[Pissarro]		La cueillette – 2,000		Bought by Durand-Ruel from Clapisson 21 April 1892, *Paysannes ramassant des herbes*, Fr 2,500	In view of the price, this would have been an important painting, but it is unidentifiable.
[Pissarro]		Bergère couchée dans l'herbe – 400		1894, no. 71, "Pissarro, *La gardeuse de vaches*, signé, daté à gauche: C. Pissaro 1885, gouache, 44 × 53" (Transcript, no. 16: Fr 200, to Durand-Ruel)	Pissarro and Venturi 1939, no. 1398, *Gardeuse de vaches étendue dans l'herbe*, gouache, 44 × 54, Gösta Serlachius Fine Arts Foundation, Mänttä, Finland (638)
Piette [Ludovic Piette, 1826–1877]		Étude paysage (Mayenne) – 100		1894, no. 23, "Piette, *Paysage dans la Mayenne*, signé à gauche: L. Piette, daté à droite: 20 9bre 66, toile, 34 × 24" (Transcript, no. 69: Fr 40, to Mme Adam)	
[Piette]		Paysanne de Dinan (aquarelle) – 75		1894, no. 70, "Piette, *Paysanne de Dinan*, signé, daté à droite: E. Piette 1873, aquarelle, 25 × 14" (Transcript, no. 2: Fr 51, to Dollfus)	See *Collection de feu Jean Dollfus, deuxième vente, aquarelles, dessins modernes*, Galeries Georges Petit, Paris, 4 March 1912, no. 104, "Piette, *Paysanne et fillette*, signé vers la droite et daté: *Laden près Dinan*, L. Piette, 1873, aquarelle, 25 × 14, vente Clapisson 28 April 1894 no. 70."
Roybet [Ferdinand Roybet, 1840–1920]	Gentilhomme au manteau violet – 2,000				
Th. Rousseau [Théodore Rousseau, 1812–1867]	Un coucher de soleil – 7,500			Transcript of the sale of the baron E. de Beurnonville, Hôtel Drouot, Paris, 29 April 1880, indicates that Clapisson bought no. 52, "Rousseau, *Forêt de Fontainebleau (grisaille)*. Un sentier qui descend d'un monticule couronné de chênes et de peupliers conduit au bord d'une mare. 27 × 35" (Transcript, no. 11: Fr 4,400, to Clapisson); however, this work does not appear in the notebooks. It is possible that he exchanged it for no. 53 of the same sale, "Rousseau, *Soleil couchant*, adjugé Fr 5,900 au marchand Petit".	
[Rousseau]	Coucher de soleil – 13,000				
[Rousseau]	Étude en Auvergne – 1,500 Le hameau	Le hameau 1,800		1885, no. 32, "Rousseau, *Les chaumes*. Au premier plan sont groupées les chaumières d'un village d'Auvergne. Plus loin apparaît sous un ciel gris la pleine campagne avec ses cultures et ses champs semés çà et là de bouquets d'arbres. Très belle étude. 28 × 42" (Transcript, no. 19: Fr 1,855, to Tabourier)	
Rafaelli [Jean-François Raffaelli, 1850–1924]	La Barrière de Clichy (aquarelle) – 400	La Barrière de Clichy – 400		Possibly 1894, no. 72, "*Aux Buttes Chaumont l'hiver*, signé à gauche: J.F. Raffaelli, gouache, 18 × 12" (Transcript, no. 28: Fr 620, to Montaignac)	

F. Rops [Félicien Rops, 1833–1898]	Folies Bergère (1879) 500	Folies Bergère	Armand Gouzien sale, Hôtel Drouot, Paris, 18–20 May 1893; from the titles of Rops's graphic works listed in the catalogue it is impossible to identify the one from Clapisson's sale.	Possibly 1894, no. 75, "Rops, *Japonaiserie*, signé à droite du monogramme, au bas la légende: *Qui aime les japonaiseries*, vente Armand Gouzien [oeuvre graphique], 23 × 14" (Transcript, no. 1: Fr 150, to Brame fils)	
[Rops]	Plage de Berck – 500	Plage de Berck – 500 [*with Folies Bergère*]		1894, no. 28, "Rops, *Marine, soleil couchant*, signé à droite du monogramme, toile, 23 × 37" (Transcript, no. 54: Fr 70, to Gérard, 1 [rue] Drouot)	
Renoir [Pierre-Auguste Renoir, 1841–1919]	La Mosquée d'Abdel-Rhaman – 2,000	La Mosquée d'Abdel-Rhaman (Alger) – 2,000	Bought from Durand-Ruel 25 and 30 May 1882 with the two following works	Sold to Durand-Ruel 21 April 1892, Fr 2,000	Drucker 1944, pl. 59, *La Mosquée à Alger*, 1882, 49.5 × 67
[Renoir]	Femme arabe Fathma – 1,000	Vieille femme arabe – 1,000	Bought from Durand-Ruel 25 and 30 May 1882	Sold to Durand-Ruel 21 April 1892, Fr 1,500. Durand-Ruel included it in the 1894 sale, no. 25, "Renoir, *Femme arabe*, signé en haut à gauche et daté: *Alger 1882*, toile, 30 × 24" (Transcript, no. 45: Fr 2,850, to Durand-Ruel, owner and seller)	Daulte 1971, no. 400, *Vieille femme arabe*, 1882, 30 × 24
[Renoir]	Jeune kabyle – 1,000	Jeune kabyle – 1,000	Bought from Durand-Ruel 25 and 30 May 1882	Sold to Durand-Ruel 21 April 1892, Fr 1,500. Durand-Ruel included it in the 1894 sale, no. 26, "Renoir, *Jeune garçon arabe*, signé à droite et daté: *82*, toile, 52 × 28" (Transcript, no. 44: Fr 2,850, to Durand-Ruel, owner and seller)	Daulte 1971, no. 406, *Ali jeune garçon arabe*, 1882, 52 × 28
[Renoir]		Matinée de Printemps – 500		1894, no. 24, "Renoir, *Paysage avec figures; effet de printemps*, signé à droite: *Renoir*, toile, 38 × 53" (Transcript, no. 38: Fr 700, to Durand-Ruel)	*Paysage de printemps*, c. 1877, 38 × 53, Musée des Beaux-Arts, Algiers
[Renoir]		Portrait – 3,000 [*with the following one*]	Commissioned by Clapisson from Renoir	Sold to Durand-Ruel by Mme Clapisson 12 November 1908, Fr 15,000	See cat. no. 46.
[Renoir]		Boby			Daulte 1971, no. 426, *Tête d'enfant*; see my essay above, note 35, and fig. 96
C. Roqueplan [Camille Roqueplan, 1803–1855]		Portrait de femme – 200		Possibly 1894, no. 30, "Roqueplan, *Buste de jeune fille*, bois, ovale, 22 × 17" (Transcript, no. 73: Fr 65, to Lebel)	
[Roqueplan]		Petite marine – 200		1894, no. 31, "Roqueplan, *Port de mer*, signé à gauche: *Clle Roqueplan*, bois, 15 × 25" (Transcript, no. 67: Fr 115, to Simon, 1 [rue] G[range] Batel[ière])	
[Roqueplan]				1894, no. 29, "Roqueplan, *Jeune paysanne*, signé à gauche: *Clle Roqueplan*, bois, 21 × 26,5" (Transcript, no. 62: Fr 220, to Durand-Ruel)	
E. Renouf [Émile Renouf, 1845–1894]		Bateaux de pêche – 300		1894, no. 27, "Renouf, *Marine*, signé à droite: *E. Renouf*, toile, 65 × 36" (Transcript, no. 60: Fr 200, to Mme Robel, 2 [rue] Fortuny)	
A. Stevens [Alfred Stevens, 1823–1906]	La femme au papillon – 2,500	La femme au papillon – 2,500	*Catalogue des tableaux modernes formant une partie de la collection de M. le Baron J. de H.* [Hauff], Hôtel Drouot, Paris, 13 March 1877, no. 35, "Stevens, *Rêverie*. Une jeune femme regarde un papillon qui vient d'entrer par sa fenêtre; figure à mi-corps. 35 × 25" (Transcript, no. 42: Fr 1,610, to Everard)	1885, no. 34, "Stevens, *Rêverie*. Une jeune femme blonde, vêtue d'une tunique bleue et la tête enveloppée d'une mousseline blanche, regarde un papillon qui vient d'entrer par la fenêtre. Figure à mi-corps. Provenant de la vente du baron J. de Hauff, 1878 [*sic*], 35 × 28" (Transcript, no. 26: Fr 700, to Mallet c/o M. Petit)	
[Stevens]		Saint-Adresse – 4,000		1885, no. 33, "Stevens, *Les bains de Sainte-Adresse (Havre)*. Sur la droite s'étagent les jolis chalets de Sainte-Adresse au milieu de la verdure. La plage et la passerelle qui domine la mer sont couvertes de nombreux baigneurs. 25 × 2" (Transcript, no. 27: Fr 750, to Desfossés)	*Vente après décès, collection de M. Victor Desfossés*, Paris, 6 rue de Galilée, 26 April 1899, no. 63, "Stevens, *La Plage du Havre*, signé à droite et daté *82*, bois, 23 × 32", Fr 560
Sisley [Alfred Sisley, 1839–1899]	Ruines à St Cloud – 200	Ruines de St Cloud – 200			
[Sisley]	Un dégel – 200	Un dégel (Suresnes) (1880) – 200		1894, no. 37, "Sisley, *Bords du Loing en hiver*, signé à gauche: *Sisley*, toile, 46 × 56" (Transcript, no. 36: Fr 860, to Durand-Ruel)	Daulte 1959, no. 348, *Bords de la Seine en hiver*, c. 1879, 46 × 55
[Sisley]	Le mur violet – 200	Un chemin à Louveciennes – 200			Possibly no. 32 in the 1894 sale (q.v.)
[Sisley]	Bords de la Seine à la Celle St Cloud – 1,500	Bords de la Seine à la Celle St Cloud – 1,500	Bought from Durand-Ruel, *Saint-Mammès et les côteaux de la Celle*, 8 May 1882	1894, no. 34, "Sisley, *Saint Mammès et les côteaux de la Celle matin de juin*, signé à droite: *Sisley*, toile, 54 × 74" (Transcript, no. 42: Fr 1,950, to Viau)	Daulte 1959, no. 545, *Saint-Mammès et les côteaux de la Celle, matin de juin*, 54 × 73, Bridgestone Museum of Art, Tokyo, where provenance is given as Georges Viau and dated too late to 1884
[Sisley]	Temps gris [*price crossed out, illegible*]	Temps gris aux Sablons – 250			Possibly no. 33 or no. 39 in the 1894 sale (q.v.)
[Sisley]	Route de Versailles – 500	Route de Versailles – 500			Possibly no. 35 in the 1894 sale (q.v.)
[Sisley]		[*title illegible*] – 500			
[Sisley]		Fin d'automne – 250			

[Sisley]				1894, no. 32, "Sisley, *Paysage aux environs de Louveciennes*, signé à gauche: *Sisley*, daté: 75, toile, 60 × 74" (Transcript, no. 43: Fr 1,000, to Durand-Ruel)	Daulte 1959, no. 175, *La Route de Marly-le-Roi*, 1875, 60 × 74 (incorrectly identified as no. 35 in the 1894 sale)
[Sisley]				1894, no. 33, "Sisley, *Soir de printemps dans la campagne des Sablons*, signé à gauche: *Sisley*, daté: 86, toile, 54 × 74" (Transcript, no. 48: Fr 1,450, to Lebel, rue de Provence)	Possibly Daulte 1959, no. 644, *Aux environs des Sablons, temps gris*, 1886, 60 × 73 (Clapisson not listed in provenance)
[Sisley]				1894, no. 35, "Sisley, *La Route de Marly*, signé, daté à droite: *Sisley 74*, toile, 61 × 46" (Transcript, no. 51: Fr 550, to Durand-Ruel)	Daulte 1959, no. 222, *Environs de Louveciennes*, 1876, 61 × 46 (incorrectly identified as no. 32 in the 1894 sale)
[Sisley]				1894, no. 36, "Sisley, *Décembre; bords de la forêt*, signé à gauche: *Sisley*, toile, 50 × 65" (Transcript, no. 52: Fr 560, to Durand-Ruel)	Daulte 1959, no. 438, *Décembre – Bord de forêt*, 1881, 50 × 65
[Sisley]				1894, no. 38, "Sisley, *Vallée de la Seine (Moret)*, signé à gauche: *Sisley*, toile, 38 × 55" (Transcript, no. 37: Fr 660, to Dollfus)	
[Sisley]				1894, no. 39, "Sisley, *Une route aux Sablons*, signé, daté à droite: *Sisley 86*, toile, 38 × 55" (Transcript, no. 56: Fr 400, to Blot, 84 [*illegible*])	Daulte 1959, no. 633, *Les Sablons*, 1886, 38 × 73
Séré [Charles Serret, 1824–1900]		2 Dessins pastels – 800		1894, no. 74, "Serret, *La récréation*, signé à droite: *C. Serret*, pastel, 26 × 34" (Transcript, no. 18: Fr 200, to Durand-Ruel); 1894, no. 75, "Serret, *La promenade*, signé à droite; *C. Serret*, pastel, 26 × 34" (Transcript, no. 17: Fr 200, to Durand-Ruel)	
O. Tassaert [Octave Tassaert, 1800–1874]	Le rêve d'une Bacchante – 2,000	Le rêve de la Bacchante – 2,500		1885, no. 35, "Tassaert, *Le rêve de la bacchante*. Elle s'est endormie demie-nue, le bras gauche soutenant sa tête couronnée de fleurs et laissant retomber le bras droit qui tient sa coupe. Au-dessus d'elle apparaît un sylvain qui écarte le feuillage et fait tomber un rayon de lumière sur la belle dormeuse. 31 × 24" (Transcript, no. 12: Fr 1,405, to Levêque)	
Tiepolo [Giovanni Battista Tiepolo, 1696–1770]	Descente de Croix (sépia) – 500 [*with the following one*]	Descente de Croix – 250		1894, no. 80, "Tiepolo, *Descente de croix*, dessin à la plume et à la sépia, 17 × 24" (Transcript, no. 6: Fr 50, to Durand-Ruel)	
[Tiepolo]	Glorification de la Vierge (sépia)	Glorification de la Vierge – 250		1894, no. 79, "Tiepolo, *Le triomphe*, dessin à la plume et à la sépia, signé à gauche, ovale, 39 × 27" (Transcript, no. 23: Fr 120, to Brame fils)	
Tillot [Charles Tillot, 1825–after 1900]	St Malo (Étude) – 200	St Malo (Étude) – 200		1894, no. 40, "Tillot, *Saint-Malo*, signé à droite: *C. Tillot*, toile, 36 × 45" (Transcript, no. 68: Fr 50, to Dachery)	
[Constant Troyon, 1810–1865]				1894, no. 76, "Troyon, *Le Moulin*, signé à gauche: *C. Troyon*, dessin au crayon noir, 31 × 23,5" (Transcript, no. 12: Fr 190 to [*illegible*])	
Vollon [Antoine Vollon, 1833–1900]	Marée basse – 1,500				
Vidal [Eugène Vidal, 1850–1908]	Tête de jeune fille – 500	Tête de jeune fille – 500		1894, no. 41, "Vidal, *Buste de jeune fille*, signé à gauche: *E. Vidal*, toile, 40 × 50" (Transcript, no. 64: Fr 260, to Gaillard, 18 [or 8 rue] Taitbout)	
V. Vignon [Victor Vignon, 1847–1909]	Les Côteaux d'Herblay – 150	Le Côteau d'Herblay – 150		1894, no. 43, "Vignon, *Bords de rivière*, signé à droite: *V. Vignon*, toile, 21 × 29" (Transcript, no. 61: Fr 155, to Sainsère [?])	
[Vignon]	Arbrisseaux – 100	Arbrisseaux – 100		1894, no. 42, "Vignon, *Paysage*, signé à gauche: *V. Vignon*, toile, 40 × 50" (Transcript, no. 55: Fr 210, to Delineau)	
[Vignon]	Entrée de village – 300	Entrée de village – 300		1894, no. 44, "Vignon, *La route*, signé à droite: *V. Vignon*, bois, 15 × 23" (Transcript, no. 63: Fr 80, to Delineau [?])	
Vibert [Jean Vibert, 1840–1902]	Jeune [moine?] admirant un bas-relief de Clodion (dessin plume) – 500				
Yonkind [Johan Barthold Jongkind, 1819–1891]	Port de Rotterdam (Effet de nuit) – 1,000	Port de Rotterdam (effet de nuit) – 1,000		1885, no. 27, "Jongkind, *Le Port de Rotterdam*. La lune se reflète dans les eaux d'un canal et éclaire les arbres et les maisons du quai. Sur la gauche, deux navires amarrés détachent leur mâts sur le ciel. 31 × 44" (Transcript, no. 10: Fr 1,650, to Levêque)	
[Jongkind]	Moulins à Dordrecht – 1,000	Moulins à Dordrecht – 1,000			
[Jongkind]	Effet lune – 1,600	Effet de lune – 1,600			
[Jongkind]	Les Patineurs – 2,000	Les patineurs – 2,000			
[Jongkind]	Petite marine (Dordrecht) – 1,250	Petite marine – 1,400			

[Jongkind]	Maison au bord de la rivière – 500	Petit paysage rouge – 500			
[Jongkind]		Bateaux à Dordrecht (effet de lune) – 2,000			
[Jongkind]		L'Église du Haut-Pas – 2,000		1885, no. 28, "Jongkind, *Rue de l'Abbé de l'Épée*. À l'extrémité de la rue bordée à gauche par des maisons et à droite par le mur du jardin des sourds-muets apparaît l'église du Haut-Pas; au milieu de la rue stationne une voiture. 46 × 34" (Transcript, no. 5: Fr 1,600, to Petit)	
[Jongkind]		Paysage (Environs de Nevers) – 2,000			
[Jongkind]				1885, no. 29, "Jongkind, *La rivière Merwedeen à Dordrecht (Hollande)*. Le soleil se fait jour à travers les nuages gris qui parcourent le ciel et se reflète dans la rivière. À droite, la berge est surmontée d'un moulin à vent dont les ailes se détachent sur le ciel. Quelques barques de pêche sillonnent la rivière. 24 × 34" (Transcript, no. 8: Fr 1,450, to Desfossés)	
[Jongkind]				1894, no. 56, "Jongkind, *Paysage aux environs de Nevers*, aquarelle, 27 × 45" (Transcript, no. 8: Fr 215, to Tempelaere)	
[Jongkind]				1894, no. 57, "Jongkind, *Vue de Nevers (rue Creuse coin de la rue Fonmorigny)*, signé à droite et daté: *Jongkind 24 Oct 1873*, aquarelle, 42 × 27" (Transcript, no. 9: Fr 580, to Tempelaere)	
[Jongkind]				1894, no. 58, "Jongkind, *Environs de Dordrecht*, signé à droite: *Jongkind*, aquarelle, 25 × 41" (Transcript, no. 9: Fr 360, to Tempelaere)	
[Jongkind]				1894, no. 59, "Jongkind, *Canal à Rotterdam*, signé à gauche: *Jongkind*, et daté à droite: *Rotterd. 16 sept 68*, aquarelle, 26 × 43" (Transcript, no. 14: Fr 550, to Tempelaere)	
[Jongkind]				1894, no. 60, "Jongkind, *Vue aux environs de Nevers*, signé à droite et daté à gauche: *Nevers sept 71*, aquarelle, 28 × 44" (Transcript, no. 13: Fr 260, to Tempelaere)	
[Félix Ziem, 1821–1911]				1894, no. 45, "Ziem, *Pivoines et roses*, signé à droite: *Ziem*, bois, 49 × 50" (Transcript, no. 49: Fr 680, to Oudin)	On Oudin see under Harpignies.

REFERENCES AND EXHIBITIONS

A

Adhémar 1978 Hélène Adhémar. "La Danse à la ville de Renoir." *Revue du Louvre et des Musées de France*, 3 (1978), 201–204.

Adler 1995 Kathleen Adler. "Renoir's *Portrait of Albert Cahen d'Anvers.*" *The J. Paul Getty Museum Journal* XXIII (1995), 31–40.

Adriani 1996 *Renoir*. Exhibition catalogue by Götz Adriani. Cologne, 1996.

Akiko 1983 Mabuchi Akiko. "Notes sur les lettres inédites à Hayashi Tadamasa." In *L'Âge du Japonisme: La France et le Japon dans la deuxième moitié du XIXᵉ siècle*, 47–59. Tokyo, 1983.

Alcouffe 1993 Daniel Alcouffe. "La Société des Amis du Louvre offre le diadème de l'impératrice Eugénie." *Revue du Louvre et des Musées de France*, February 1993, 11–13.

Alexandre 1892 Arsène Alexandre. Preface to *Renoir 1892*, 3–36.

Alexandre 1911 Arsène Alexandre. *Durand-Ruel: Portrait et histoire d'un "marchand."* Paris, n.d. Originally published in *Pan* (Berlin), November 1911.

Alexandre 1933 Arsène Alexandre. "Propos inédits de et sur Renoir." *Les Nouvelles Littéraires, Artistiques et Scientifiques*, 26 August 1933, 8.

Amaya and Zafran 1978 *Veronese to Franz Kline: Masterworks from The Chrysler Museum at Norfolk*. Exhibition catalogue by Mario Amaya and Eric Zafran. Wildenstein and Co., New York, 1978.

Amornpichetkul 1989 Chittima Amornpichetkul. "Berthe Morisot: A Study of Her Development from 1864 to 1886." Ph.D. diss., Brown University, 1989.

Amsterdam 1912 *Stedelijke Internationale Tentoonstelling van Kunstwerken van Levende Meesters*. Exhibition catalogue. Stedelijk Museum, Amsterdam, April–July 1912.

André 1923 Albert André. *Renoir*. Paris, 1923.

André 1928 Albert André. *Renoir*. Paris, 1928.

André and Elder 1931 Albert André and Marc Elder. *L'Atelier de Renoir*. Catalogue by Messrs. Bernheim-Jeune. 2 vols. Paris, 1931.

Anonymous 1877 "Exposition des impressionnistes." *La Petite République Française*, 10 April 1877.

Antoine 1921 André Antoine. *"Mes souvenirs" sur le Théâtre-Libre*. Paris, 1921.

Antoine 1928 André Antoine. *Mes souvenirs sur le Théâtre Antoine et sur l'Odéon*. Paris, 1928.

Apollinaire 1960 Guillaume Apollinaire. *Chroniques d'art, 1902–1918*. Edited by L.-C. Breunig. Paris, 1960.

Art for the Nation **1991** *Art for the Nation*. Exhibition catalogue by Charles S. Moffett et al. National Gallery of Art, Washington, 1991.

Artiste **1880** "Les Impressionnistes." *L'Artiste*, February 1880, 140–142.

Assouline 1984 Pierre Assouline. *Gaston Gallimard: Un demi-siècle d'édition française*. Paris, 1984.

Athanassoglou–Kallmyer 1990 Nina Athanassoglou-Kallmyer. "An Artistic and Political Manifesto for Cézanne." *Art Bulletin* LXXII:3 (September 1990), 482–492.

Aubrun 1985 Marie-Madeleine Aubrun. *Jules Bastien-Lepage 1848–1884: Catalogue raisonné de l'oeuvre*. Paris, 1985.

Auvers 1993 Jean-Michel Puydebat et al., ed. *Impressionists around Paris: A Portrait of Suburbs and Painters*. Auvers-sur-Oise, 1993.

B

Bab 1926 Julius Bab. *Schauspieler und Schauspielkunst*. Berlin, 1926.

Baedeker 1876 Karl Baedeker. *Paris and Its Environs*. 5th ed. Leipzig, 1876.

Baedeker 1884 Karl Baedeker. *Paris and Environs*. 8th ed. Leipzig, 1884.

Baignères 1879 Arthur Baignères. "Le Salon de 1879 (deuxième article)." *Gazette des Beaux-Arts*, 2nd series, XX (July 1879), 35–57.

Baignères 1883 Arthur Baignères. "Beaux-Arts: Exposition des portraits du siècle." *Revue Politique et Littéraire*, 12 May 1883, 595–596.

Bailey 1995 Colin B. Bailey. "Renoir's Portrait of His Sister-in-law." *Burlington Magazine* CXXXVII:1111 (October 1995), 684–687.

Bailey and Rishel 1989 *Masterpieces of Impressionism and Post-Impressionism: The Annenberg Collection*. Exhibition catalogue by Colin B. Bailey, Joseph J. Rishel, and Mark Rosenthal, with the assistance of Veerle Thielemans. Philadelphia Museum of Art, 1989.

Ballu 1877 Roger Ballu. "L'Exposition des peintres impressionnistes." *La Chronique des Arts et de la Curiosité*, 14 April 1877, 147–148.

Banville 1879 Théodore de Banville. "Salon de 1879, III." *Le National*, 16 May 1879, 1–2.

Barbier 1964 Carl Paul Barbier, ed. *Correspondance Mallarmé–Whistler*. Paris, 1964.

Bardi 1956 Pietro Maria Bardi. *The Arts in Brazil: A New Museum at São Paulo*. Milan, 1956.

Barlach 1968–69 Ernst Barlach. *Die Briefe*. Edited by F. Dross. 2 vols. Munich, 1968–69.

Barnes **1993** *Great French Paintings from the Barnes Foundation: Impressionist, Post-Impressionist, and Early Modern*. Exhibition catalogue by Richard J. Wattenmaker, Anne Distel, et al. New York, 1993.

Basel 1906 *Catalogue des peintures, dessins, sculptures, gravures et objets d'art décoratif de l'école française contemporaine*. Exhibition catalogue. Société des Beaux-Arts de Bâle, Kunsthalle Basel, March–April 1906.

Bataillard 1867 Paul Bataillard. "Les Bohémiennes ou Tsiganes à Paris." In *Paris: Guide par les principaux écrivains et artistes de la France*, II, 1107–1124. Paris, 1867.

Bataille 1955 Georges Bataille. *Manet*. Lausanne, 1955.

Bataille and Wildenstein 1961 Marie-Louise Bataille and Georges Wildenstein. *Berthe Morisot: Catalogue des peintures, pastels et aquarelles*. Paris, 1961.

Baubérot 1953 René Baubérot. "Le Génial Peintre limousin Renoir à sept expositions, notamment celle de Limoges en 1951 et 1952." *Bulletin de la Société Archéologique et Historique du Limousin* LXXXIV (1952–53), 261–272.

Baudelaire 1961 Charles Baudelaire. *Oeuvres complètes*. [Paris], 1961.

Baudelaire 1964 Charles Baudelaire. *The Painter of Modern Life and Other Essays*. Translated and edited by Jonathan Mayne. London, 1964.

Baudot 1949 Jeanne Baudot. *Renoir, ses amis, ses modèles*. Paris, 1949.

Baudry 1986 *Baudry 1828–1886.* Exhibition catalogue by Yves-Michel Bernard et al. Musée d'Art et d'Archéologie, La Roche-sur-Yon, 1986.

Bazille *Correspondance* Frédéric Bazille. *Correspondance.* Edited by D. Vatuone. Montpellier, 1992.

Bazille 1992 *Frédéric Bazille: Prophet of Impressionism.* Exhibition catalogue by Aleth Jourdan et al. Brooklyn Museum, 1992.

Bazin 1942 Germain Bazin. *Corot.* Paris, 1942.

Bazin 1958 Germain Bazin. *Impressionist Paintings in the Louvre.* London, 1958.

Beachboard 1952 Robert Beachboard. *La Trinité maudite: Utter, Valadon, Utrillo.* Paris, 1952.

Becker 1980 Colette Becker. *Trente Années d'amitié 1872–1902: Lettres de l'éditeur Georges Charpentier à Émile Zola.* Paris, 1980.

Bénédite 1907 Léonce Bénédite. "Madame Charpentier and Her Children, by Auguste Renoir." *Burlington Magazine* XII (December 1907), 130–135.

Bénédite 1923 Léonce Bénédite. *Albert Lebourg.* Paris, 1923.

Berard 1937 Maurice Berard. *Une famille du Dauphiné: Les Berard – Notice historique et généalogique.* Paris, 1937.

Berard 1938 Maurice Berard. *Renoir à Wargemont.* Paris, [1938].

Berard 1956 Maurice Berard. "Un diplomate, ami de Renoir." *Revue d'Histoire Diplomatique,* July–September 1956, 239–246.

Berard 1968 Maurice Berard. "Lettres à un ami." *Revue de Paris,* December 1968, 54–58.

Bergan 1994 Ronald Bergan. *Jean Renoir: Projections of Paradise.* New York, 1994.

Berger 1994 Harry Berger, Jr. "Fictions of the Pose: Facing the Gaze of Early Modern Portraiture." *Representations,* 46 (Spring 1994), 87–120.

Bergerat 1877 Émile Bergerat. "Revue artistique: Les impressionnistes et leur exposition." *Journal Officiel de la République Française,* 17 April 1877, 2917–2918.

Bergerat 1911 Émile Bergerat. *Souvenirs d'un enfant de Paris.* Paris, 1911.

Bergeron 1978 Louis Bergeron. *Les Capitalistes en France (1780–1914).* Paris, 1978.

Berhaut 1983 Marie Berhaut. "Le Legs Caillebotte: Vérités et contre-vérités." *Bulletin de la Société d'Histoire de l'Art Français,* 1983, 209–239.

Berhaut 1994 Marie Berhaut. *Gustave Caillebotte: Catalogue raisonné des peintures et pastels.* Revised ed., with Sophie Pietri. Paris, 1994.

Berlanstein 1984 Lenard R. Berlanstein. *The Working People of Paris, 1871–1914.* Baltimore / London, 1984.

Berlin 1883 Exhibition of Impressionist paintings. Fritz Gurlitt, Kunsthandlung, Berlin, October 1883.

Berlin 1900 *Der Zweiten Kunstausstellung der Berliner Secession.* Exhibition catalogue Galerie Paul Cassirer, Berlin, 1900.

Berlin 1912 *Ausstellung Auguste Renoir.* Exhibition catalogue Galerie Paul Cassirer, Berlin, February–March 1912.

Berman 1993 Patricia G. Berman. "Edvard Munch's Self-Portrait with Cigarette: Smoking and the Bohemian Persona." *Art Bulletin* LXXV:4 (December 1993), 627–646.

Bernheim de Villers 1940 Gaston Bernheim de Villers. *Petites Histoires sur de grands artistes.* Paris, 1940.

Bernier 1959 Rosamond Bernier. "Dans la lumière impressionniste." *L'Oeil,* 53 (May 1959), 38–47.

Bernier 1984 *Sarah Bernhardt and Her Times.* Exhibition catalogue by Georges Bernier. Wildenstein, New York, 1984.

Bernstein Gruber and Maurin 1988 Georges Bernstein Gruber and Gilbert Maurin. *Bernstein le magnifique: Cinquante ans de théâtre, de passions et de vie parisienne.* Paris, 1988.

Bertall 1879 Bertall [Charles-Albert d'Arnoux]. "Souvenirs du Salon de 1879: Tableaux d'histoire – grands tableaux." *L'Artiste,* August 1879, 83–87.

Bertrand 1870 Karl Bertrand. "Salon de 1870: Peinture." *L'Artiste,* 1 June 1870, 293–320.

Besnus 1899 Émile Besnus. *Le Navire d'Isis.* Paris, 1899.

Besson 1921 Georges Besson. "Renoir, par Ambroise Vollard." *Les Cahiers d'Aujourd'hui,* 5 (July 1921), 1–4.

Bibesco 1899 Prince Georges Bibesco. *Prisonnier: Coblence 1870–1871.* Paris / Geneva, 1899.

Bigot 1877 Charles Bigot. "Causerie artistique: L'exposition des 'impressionnistes.'" *Revue Politique et Littéraire,* 28 April 1877, 1045–1048.

Billy 1947 André Billy. *Les Beaux Jours de Barbizon.* Etrépilly, 1947.

Billy 1960 André Billy. *The Goncourt Brothers.* London, 1960.

Blanc 1860–77 Charles Blanc. *Histoire des peintres de toutes les écoles.* 14 vols. Paris, 1860–77.

Blanc 1880 Charles Blanc. *Grammaire des arts du dessin.* Paris, 1880.

Blanche 1915–20 Jacques-Émile Blanche. *Cahiers d'un artiste.* 6 vols. Paris, 1915–20.

Blanche 1921 Jacques-Émile Blanche. "La Technique de Renoir." *L'Amour de l'Art* II:2 (February 1921), 33–40.

Blanche 1922 Jacques-Émile Blanche. *Aymeris.* Paris, 1922.

Blanche 1927 Jacques-Émile Blanche. *Dieppe.* Paris, 1927.

Blanche 1928 Jacques-Émile Blanche. *Mes modèles.* Paris, 1928.

Blanche 1931 Jacques-Émile Blanche. *Les Arts plastiques.* Paris, 1931.

Blanche 1933 Jacques-Émile Blanche. "Renoir portraitiste." *L'Art Vivant,* 174 (July 1933), 292.

Blanche 1937 Jacques-Émile Blanche. *Portraits of a Lifetime.* London, 1937.

Blanche 1949 Jacques-Émile Blanche. *La Pêche aux souvenirs.* Paris, 1949.

Blémont 1876 Émile Blémont. "Les Impressionnistes." *Le Rappel,* 9 April 1876.

Blot 1934 Eugène Blot. *Histoire d'une collection de tableaux modernes.* Paris, 1934.

Bodelsen 1968 Merete Bodelsen. "Early Impressionist Sales 1874–94 in Light of Some Unpublished 'Procès-verbaux.'" *Burlington Magazine* CX:783 (June 1968), 331–350.

Boggs 1955 Jean Sutherland Boggs. "Edgar Degas and the Bellellis." *Art Bulletin* XXXVII:2 (June 1955), 127–136.

Boime 1969 Albert Boime. "The Salon des Refusés and the Evolution of Modern Art." *Art Quarterly* XXXII:4 (1969), 411–426.

Boime 1971 Albert Boime. *The Academy and French Painting in the Nineteenth Century.* New Haven / London, 1971.

Boime 1995 Albert Boime. *Art and the French Commune: Imagining Paris after War and Revolution.* Princeton, 1995.

Borcoman 1993 *Magicians of Light: Photographs from the Collection of the National Gallery of Canada.* Exhibition catalogue by James Borcoman. National Gallery of Canada, Ottawa, 1993.

Bouguereau 1984 *William Bouguereau 1825–1905.* Exhibition catalogue edited by Louise d'Argencourt. Montreal Museum of Fine Arts, 1984.

Bouillon et al. 1990 Jean-Paul Bouillon et al. *La Promenade du critique influent: Anthologie de la critique d'art en France, 1850–1900.* Paris, 1990.

Brade 1994 Johanna Brade. *Suzanne Valadon: Vom Modell in Montmartre zur Malerin der Klassischen Moderne.* Stuttgart / Zurich, 1994.

Brame and Reff 1984 Philippe Brame and Theodore Reff. *Degas et son oeuvre: A Supplement.* New York, 1984.

Braun 1932 "L'Impressionnisme et quelques précurseurs." *Bulletin des Expositions* (Galerie d'Art Braun, Paris), III (1932).

Breeskin 1970 Adelyn Dohme Breeskin. *Mary Cassatt: A Catalogue Raisonné of the Oils, Pastels, Watercolors, and Drawings.* Washington, 1970.

Bréon 1988 Emmanuel Bréon. *Claude-Marie, Édouard et Guillaume Dubuffe: Portraits d'un siècle d'élégance parisienne.* Paris, 1988.

Brettell 1984 Richard Brettell. "The Cradle of Impressionism." In *A Day in the Country: Impressionism and the French Landscape*, exhibition catalogue by Richard Brettell et al. Los Angeles County Museum of Art, 1984.

Brettell 1987 Richard Brettell. *French Impressionists: The Art Institute of Chicago.* New York, 1987.

Brettell and Selz 1991 *Impressionism and European Modernism: The Sirak Collection.* Exhibition catalogue with essays by Richard Brettell and Peter Selz. Columbus Museum of Art, 1991.

Brilliant 1991 Richard Brilliant. *Portraiture.* Cambridge, Mass., 1991.

Brown 1985 Marilyn R. Brown. *Gypsies and Other Bohemians: The Myth of the Artist in Nineteenth-Century France.* Ann Arbor, 1985.

Brown 1994 Marilyn R. Brown. *Degas and the Business of Art: A Cotton Office in New Orleans.* University Park, Pa., 1994.

Brown 1995 Frederick Brown. *Zola: A Life.* New York, 1995.

Brühl 1991 Georg Brühl. *Die Cassirers: Streiter für den Impressionismus.* Leipzig, 1991.

Brussels 1886 *Les XX – 3ᵉ exposition annuelle.* Brussels, February–March 1886.

Brussels 1904 *Exposition des peintres impressionnistes.* La Libre Esthétique, Brussels, February–March 1904.

Buisson 1881 J. Buisson. "Salon de 1881 (deuxième article)." *Gazette des Beaux-Arts*, 2nd series, XXIV (July 1881), 29–81.

Bürger 1870 W. Bürger [Théophile Thoré]. *Salons de W. Bürger, 1861 à 1868.* 2 vols. Paris, 1870.

Burke's Peerage (1967) Peter Townend, ed. *Burke's Peerage, Baronetage and Knightage.* 104th ed. London, 1967.

Burty 1874 Philippe Burty. "Salon de 1874 – VI (Portraits)." *La République Française*, 28 May 1874, [3].

Burty 1876 Philippe Burty. "Fine Art: The Exhibition of the 'Intransigeants,'" *The Academy* (London), 15 April 1876, 363–364.

Burty 1877 Philippe Burty. "Exposition des impressionnistes." *La République Française*, 25 April 1877.

Burty 1879 Philippe Burty. "Le Salon de 1879 – III: Les portraits." *La République Française*, 27 May 1879, 3.

Burty 1882 Philippe Burty. "Les Aquarellistes, les indépendants, et le cercle des arts libéraux." *La République Française*, 8 March 1882.

Burty 1883 Philippe Burty. "Les Peintures de M. P. Renoir." *La République Française*, 15 April 1883.

C

Cahen d'Anvers 1994 Comte Gilbert Cahen d'Anvers. *Mémoires d'un optimiste.* Paris, 1994.

Cahiers d'aujourd'hui 1921 "L'Éternel Jury." *Les Cahiers d'Aujourd-hui*, 2 (January 1921).

Caillebotte 1994 *Gustave Caillebotte, 1848–1894.* Exhibition catalogue by Anne Distel, Douglas Druick, Gloria Groom, and Rodolphe Rapetti. Grand Palais, Paris, 1994.

Callen 1995 Anthea Callen. *The Spectacular Body: Science, Method, and Meaning in the Work of Degas.* New Haven, 1995.

Carré 1912 Jean Carré. "Notes sur Renoir." *La Vie* (Paris), 13 (18 May 1912), 408–410.

Castagnary 1892 Jules Castagnary. *Salons (1857–1870).* 2 vols. Paris, 1892.

Castets 1890 H. Castets. "Art dramatique: Biographie – Jeanne Samary." *La Revue Encyclopédique*, 15 December 1890.

Catinat 1952 Maurice Catinat. *Les Bords de la Seine avec Renoir et Maupassant: "L'École de Chatou."* Chatou, 1952.

Cézanne 1995 *Cézanne.* Exhibition catalogue by Françoise Cachin and Joseph J. Rishel. Grand Palais, Paris, 1995.

Cézanne Correspondance John Rewald, ed. *Paul Cézanne: Correspondance.* Revised and enlarged ed. Paris, 1978.

Champa 1973 Kermit S. Champa. *Studies in Early Impressionism.* New Haven / London, 1973.

Chassagnol 1881 Chassagnol. "Le Salon de 1881: Les portraits." *Gil Blas*, 10 June 1881, [1–2].

Chaumelin 1876 Marius Chaumelin. "Actualités: L'exposition des intransigeants." *La Gazette*, 8 April 1876.

Chemetov and Marrey 1984 Paul Chemetov and Bernard Marrey. *Architectures à Paris, 1848–1914.* Paris, 1984.

Chesneau 1874 Ernest Chesneau. "À côté du Salon, II: Le plein-air, Exposition du boulevard des Capucines." *Paris-Journal*, 7 May 1874.

Chesneau 1878 Ernest Chesneau. "Exposition universelle: Le Japon à Paris (1ᵉʳ article)." *Gazette des Beaux-Arts*, 2nd series, XVIII (September 1878), 385–397.

Chesneau 1879 Ernest Chesneau. "Le Salon de 1879." *Le Moniteur Universel*, 160 (13 June 1879), 810–811.

Chicago 1961 *Paintings in the Art Institute of Chicago: A Catalogue of the Picture Collection.* Chicago, 1961.

Chirac 1883–86 Auguste Chirac. *Les Rois de la République: Histoire des juiveries.* 2 vols. Paris, 1883–86. Reprint 1987.

Chronique des Arts 1873 "Exposition des oeuvres non classées au Salon de 1873." *La Chronique des Arts et de la Curiosité*, 10 May 1873, 185–186.

Chu 1992 Petra ten-Doesschate Chu, ed. and trans. *Letters of Gustave Courbet.* Chicago / London, 1992.

Cincinnati 1984 C.M. Schoellkpof, ed. *Masterpieces from the Cincinnati Art Museum.* Cincinnati, 1984.

Cirque Fernando 1875 Gladiateur II. *Le Cirque Fernando.* Paris, 1875.

Claretie 1874 Jules Claretie. *Peintres et sculpteurs contemporains.* Paris, 1874.

Claretie 1876 Jules Claretie. *L'Art et les artistes français contemporains.* Paris, 1876.

Claretie 1889 Jules Claretie. *Catalogue de l'exposition de portraits installée dans les galeries du Théâtre d'application: Auteurs et acteurs.* Paris, 1889.

Clément 1878 Charles Clément. *Gleyre: Étude biographique et critique.* Paris, 1878.

Clément 1886 Charles Clément. *Gleyre: Étude biographique et critique.* 2nd ed. Paris, 1886.

Cooper 1954 Douglas Cooper. *The Courtauld Collection: A Catalogue and Introduction.* London, 1954.

Cooper 1959 Douglas Cooper. "Renoir, Lise and the Le Coeur Family. A Study of Renoir's Early Development." *Burlington Magazine* CI (1959), 163–171, 322–328.

Coquiot 1910 Gustave Coquiot. "Des Monet, des Renoir pour cinquante francs." *L'Excelsior*, 13 (28 November 1910), 3–4.

Coquiot 1925 Gustave Coquiot. *Renoir*. Paris, 1925.

Coston 1975 Henry Coston, ed. *Dictionnaire des dynasties bourgeoises et du monde des affaires*. Paris, 1975.

Courtauld 1994 *Impressionism for England: Samuel Courtauld as Patron and Collector*. Exhibition catalogue by John House. Courtauld Institute Galleries, London, 1994.

Cowart 1982 Jack Cowart. "Impressionist and Post-Impressionist Paintings." *Bulletin of the Saint Louis Art Museum*, new series, XVI:2 (1982).

Crespelle 1969 Jean-Paul Crespelle. "Trois Portraitistes mondains de la Belle Époque." *Jardin des Arts*, 173 (April 1969), 74–85.

Crespelle 1990 Jean-Paul Crespelle. *Guide de la France impressionniste*. Paris, 1990.

Curinier 1899–1905 C.-É. Curinier, ed. *Dictionnaire national des contemporains*. 5 vols. Paris, 1899–1905.

D

Dacier 1905 Émile Dacier. *Le Musée de la Comédie-Française 1680–1905*. Paris, 1905.

D'Albis 1969 Jean d'Albis. "Histoire de la fabrique Haviland de 1842 à 1925." *Bulletin de la Société Archéologique et Historique du Limousin* XCVI (1969), 193–225.

D'Albis 1988 Jean d'Albis. *Haviland*. Paris, 1988.

D'Albis and d'Albis 1974 Jean and Laurens d'Albis. "La Céramique impressionniste: L'atelier Haviland d'Auteuil et son influence." *L'Oeil*, 223 (February 1974), 47–51.

D'Argencourt 1987 *1912: Break Up Of Tradition*. Exhibition catalogue by Louise d'Argencourt. Winnipeg Art Gallery, 1987.

Dargenty 1883 G. Dargenty. "Exposition des oeuvres de M. P.A. Renoir." *Courrier de l'Art*, 12 April 1883, 171–172.

Darragon 1989 Eric Darragon. "Pégase à Fernando: À propos de *Cirque* et du réalisme de Seurat en 1891." *Revue de l'Art*, 86 (1989), 44–57.

Dauberville 1965–74 Jean and Henry Dauberville. *Bonnard: Catalogue raisonné de l'oeuvre peint*. 4 vols. Paris, 1965–74.

Dauberville 1967 Henry Dauberville. *La Bataille de l'impressionnisme*. Paris, 1967.

Daudet 1879 Alphonse Daudet. "Un Bohème." *La Vie Moderne*, 10 April 1879, 10–11.

Daudet 1910 Madame Alphonse Daudet [née Julia Allard]. *Souvenirs autour d'un groupe littéraire*. Paris, 1910.

Daudet 1992 Léon Daudet. *Souvenirs et polémiques*. Paris, 1992.

Daulte 1952 François Daulte. *Frédéric Bazille et son temps*. Geneva, 1952.

Daulte 1959a François Daulte. *Pierre-Auguste Renoir: Water-colours, Pastels and Drawings in Colour*. London, 1959.

Daulte 1959b François Daulte. *Alfred Sisley: Catalogue raisonné de l'oeuvre peint*. Lausanne, 1959.

Daulte 1960 François Daulte. "Le Marchand des impressionnistes." *L'Oeil*, 66 (June 1960), 54–61, 75.

Daulte 1964 François Daulte. "Renoir, son oeuvre regardé sous l'angle d'un album de famille." *Connaissance des Arts* (Paris), November 1964, 75–81.

Daulte 1969 François Daulte. "Vive Renoir." *Artnews* LXVIII:2 (April 1969), 30–33.

Daulte 1971 François Daulte. *Auguste Renoir: Catalogue raisonné de l'oeuvre peint*, I, *Figures 1860–1890*. Lausanne, 1971.

Daulte 1974 François Daulte. "Renoir et la famille Berard." *L'Oeil*, 223 (February 1974), 4–13.

Daulte 1978 François Daulte. "Une grande amitié: Edmond Maître et Frédéric Bazille." *L'Oeil*, 273 (April 1978), 36–43.

Daulte 1984 *L'Impressionnisme dans les collections Romandes*. Exhibition catalogue by François Daulte. Fondation de l'Hermitage, Lausanne, 1984.

Daulte 1992 François Daulte. *Fréderic Bazille et les débuts de l'impressionnisme: Catalogue raisonné de l'oeuvre peint*. Paris, 1992.

Daulte and Marandel 1978 *Frédéric Bazille and Early Impressionism*. Exhibition catalogue by J. Patrice Marandel and François Daulte. Art Institute of Chicago, 1978.

Davies 1970 Laurence Davies. *César Franck and His Circle*. London, 1970.

Dax 1876 Pierre Dax. "Chronique." *L'Artiste*, 1 May 1876, 347–349.

Dax 1877 Pierre Dax. "Chronique." *L'Artiste*, April 1877, 316–327.

Dax 1879 Pierre Dax. "Chronique." *L'Artiste*, March 1879, 286.

DBF *Dictionnaire de biographie française*. 18 vols. Paris, 1933–94.

Debans 1889 Camille Debans. *Les Plaisirs et les Curiosités de Paris*. Paris, 1889.

Degas 1988 *Degas*. Exhibition catalogue by Jean Sutherland Boggs, Henri Loyrette, Gary Tinterow, Michael Pantazzi, and Douglas Druick. National Gallery of Canada, Ottawa / Metropolitan Museum of Art, New York, 1988.

Degas Portraits 1994 *Degas Portraits*. Exhibition catalogue by Jean Sutherland Boggs, Felix Baumann, Marianne Karabelnik, et al. London, 1994.

Delacroix Journal *Journal de Eugène Delacroix, 1853–1856*. Foreword by Jean-Louis Vaudoyer, introduction and notes by André Joubin. 3 vols. Paris, 1932.

Delevoy 1985 et al. Robert Delevoy et al. *Rops*. Lausanne/Paris, 1985.

Delhuis 1888 Albert Delhuis. "Le Portrait de Mlle Darlaud." *La Vie Moderne*, 11 March 1888.

Denis 1930 Maurice Denis. "Henry Lerolle et ses amis." *Revue de Paris* XXXVII:6 (November–December 1930), 91–107.

Denis 1957–59 Maurice Denis. *Journal*. 3 vols. Paris, 1957–59.

Descharmes 1911 René Descharmes. "Flaubert et ses éditeurs Michel Lévy et Georges Charpentier." *Revue d'Histoire Littéraire de la France*, 18 (1911), 627–665.

Detroit 1976 *Arts and Crafts in Detroit 1906–1976: The Movement, the Society, the School*. Exhibition catalogue. Detroit Institute of Arts, 1976.

Deuchler 1990 Florens Deuchler. *Die französischen Impressionisten und ihre Vorläufer, Stiftung "Langmatt," Sidney und Jenny Brown, Baden*. Baden, 1990.

Devillers 1886 Hippolyte Devillers. *Jean-Jacques Henner*. Grands peintres français et étrangers, II. Paris, 1886.

D'Heylli 1880 *La Comédie-Française à Londres (1871–1879)*. Introduction by Georges d'Heylli. Paris, 1880.

Disdéri 1862 A.A.E. Disdéri. *L'Art de la photographie*. Paris, 1862.

Disdéri 1864 A.A.E. Disdéri. *The Universal Text Book of Photography*. 2nd ed. London, 1864.

Distel 1989a Anne Distel. "Charles Deudon (1832–1914), collectionneur." *Revue de l'Art*, 86 (1989), 58–65.

Distel 1989b Anne Distel. *Les Collectionneurs des impressionnistes: Amateurs et marchands*. Düdingen, 1989.

Distel 1990 Anne Distel. *Impressionism: The First Collectors.* Translated by B. Perroud-Benson. New York, 1990.

Distel 1990–91 Anne Distel. "Il y a cent ans ils ont donné l'*Olympia.*" *Quarante-huit/Quatorze, Conférences du Musée d'Orsay,* 4 (1990–91), 44–50.

Distel 1993 Anne Distel. *Renoir: "Il faut embellir."* Paris, 1993.

Distel 1995 Anne Distel. "Invitation à la visite." *Revue du Musée d'Orsay,* 1 (September 1995), 42–43.

Dorment and Macdonald 1994 *James McNeill Whistler.* Exhibition catalogue by Richard Dorment and Margaret F. Macdonald. Tate Gallery, London, 1994.

Doty 1978 Robert Doty. *Photo-Secession: Stieglitz and the Fine-Art Movement in Photography.* New York, 1978.

Doucet 1896 Jérôme Doucet. "Eugène Murer." *Les Hommes d'Aujourd'hui* IX:433 [c. 1896].

Dresden 1904 *Offizieller Katalog der Grossen Kunstausstellung.* Dresden, August 1904.

Dresden 1926 *Internationale Kunstausstellung.* Exhibition catalogue under the direction of Hans Posse. Städtischen Ausstellungspalaste, Dresden, 1926.

Dresden 1930 *Katalog der modernen Galerie.* Staatliche Gemäldegalerie, Dresden, 1930.

Dreyfous 1913 Maurice Dreyfous. *Ce qu'il me reste à dire.* Paris, 1913.

Drucker 1944 Michel Drucker. *Renoir.* Paris, 1944.

Druick and Hoog 1983 *Fantin-Latour.* Exhibition catalogue by Douglas Druick and Michel Hoog. National Gallery of Canada, Ottawa, 1983.

Du Barail 1898 Général du Barail. *Mes souvenirs,* III, *1864–1879.* 12th ed. Paris, 1898.

Dumas 1924 Paul Dumas. "Quinze Tableaux inédits de Renoir." *La Renaissance de l'Art Français et des Industries de Luxe* VII:7 (July 1924), 361–368.

Dumaurier 1894 Georges Dumaurier. *Trilby.* New York, 1894.

Duparc 1873 A. Duparc, ed. *Correspondance de Henri Regnault.* Paris, 1873.

Durand-Gréville 1925 Émile Durand-Gréville. *Entretiens de J.J. Henner.* Paris, 1925.

Durand-Ruel Paris 1888 *Exposition des impressionnistes.* Exhibition catalogue. Galeries Durand-Ruel, Paris, May–June 1888.

Durand-Ruel Paris 1899 *Exposition de tableaux de Monet, Pissarro, Renoir et Sisley.* Exhibition catalogue. Galeries Durand-Ruel, Paris, April 1899.

Durand-Ruel Paris 1910 *Tableaux par Monet, C. Pissarro, Renoir et Sisley.* Exhibition catalogue. Galeries Durand-Ruel, Paris, 1–25 June 1910.

Duranty 1876 Louis Émile Edmond Duranty. *La Nouvelle Peinture: À propos du groupe d'artistes qui expose dans les Galeries Durand-Ruel.* Paris, 1876. Reprinted in Moffett 1986, 477–484, and in English translation, 37–49.

Duret 1867 Théodore Duret. *Les Peintres français en 1867.* Paris, 1867.

Duret 1878 Théodore Duret. *Les Peintres impressionnistes.* Paris, May 1878.

Duret 1919 Théodore Duret. *Histoire d'Édouard Manet et de son oeuvre.* 2nd ed. Paris, 1919.

Duret 1922 Théodore Duret. *Histoire des peintres impressionnistes.* 3rd ed. Paris, 1922.

Duret 1924 Théodore Duret. *Renoir.* Paris, 1924.

Durieux 1954 Tilla Durieux. *Eine Tür steht offen: Erinnerungen.* Berlin, 1954.

Durieux 1964 Tilla Durieux. *Eine Tür steht offen: Erinnerungen.* Berlin/Munich/Vienna, 1964.

Durieux 1971 Tilla Durieux. *Meine ersten neunzig Jahre: Erinnerungen.* Munich/Berlin, 1971.

Dussaule 1995 Georges Dussaule. *Renoir à Cagnes et aux Collettes.* Cagnes, 1995.

E

Elder 1924 Marc Elder. *À Giverny, chez Claude Monet.* Paris, 1924.

Enault 1876 Louis Enault. "Mouvement artistique: L'exposition des intransigeants dans la galerie de Durand-Ruelle." *Le Constitutionnel,* 10 April 1876.

Éparvier 1933 Jean Eparvier. "Claude Renoir, céramiste et directeur de cinéma, cadet de la dynastie des Renoir, va copier sur terre cuite les oeuvres de son père." *Paris-soir,* 30 June 1933, 3. Hand-dated clipping in Dossier Renoir, Bibliothèque Historique de la Ville de Paris.

Ephrussi 1886 Charles Ephrussi. "Paul Baudry." *Gazette des Beaux-Arts,* 2nd series, XXX (February 1886), 106–107.

Ephrussi 1887 Charles Ephrussi. *Paul Baudry, sa vie et son oeuvre.* Paris, 1887.

Escoffier Robida 1968 Françoise Escoffier Robida. "Jombert, libraire de roi." *Miroir de l'histoire,* 217 (June 1968), 99–107.

***Exposition Centennale* 1900** *Exposition centennale de l'art français de 1800 à 1889.* Exposition Universelle, Grand Palais, Paris, 1900.

F

Faison 1973 S. Lane Faison, Jr. "Renoir's Hommage à Manet." In *Intuition und Kunstwissenschaft: Festschrift für Hanns Swarzenski,* edited by Peter Bloch, 571–578. Berlin, 1973.

Fantin-Latour 1911 Madame Fantin-Latour. *Catalogue de l'oeuvre complet (1849–1904) de Fantin-Latour.* Paris, 1911.

Farr 1992 Margaret Fitzgerald Farr. "Impressionist Portraiture: A Study in Context and Meaning." Ph.D. diss., University of North Carolina at Chapel Hill, 1992.

Feilchenfeldt 1988 Walter Feilchenfeldt. *Vincent van Gogh and Paul Cassirer, Berlin: The Reception of Van Gogh in Germany from 1901 to 1914.* Cahier Vincent no. 2. Zwolle, Netherlands, 1988.

Fénéon 1920 Félix Fénéon. "Les Grands Collectionneurs – II: M. Paul Durand-Ruel." *Bulletin de la Vie Artistique,* 15 April 1920, 262–271.

Fénéon 1921 Félix Fénéon. "Les Grands Collectionneurs – VIII: M. Raymond Koechlin." *Bulletin de la Vie Artistique,* 15 March 1921, 165–171.

Fénéon 1970 Félix Fénéon. *Oeuvres plus que complètes.* 2 vols. Geneva, 1970.

Fenton 1996 James Fenton. "Degas in the Evening." *New York Review of Books,* 3 October 1996, 48–53.

Fernier 1977 Robert Fernier. *La Vie et l'oeuvre de Gustave Courbet: Catalogue raisonné,* I, *1819–1865.* Lausanne/Paris, 1977.

Ferry 1879 Jules Ferry. "Distribution des récompenses aux artistes exposants du Salon de 1879." *Le Journal Officiel,* 28 July 1879. Reprinted in *Explication des ouvrages de peinture, sculpture, architecture . . . exposés au Palais des Champs-Élysées, le 1er mai 1880* (catalogue of the Salon of 1880), v–xiv.

Fezzi 1985 Elda Fezzi. *Tout l'oeuvre peint de Renoir.* Translated and updated from the Italian by Jacqueline Henry. Paris, 1985.

Fichtre 1882 Fichtre [Gaston Vassy]. "L'Actualité: L'exposition des peintres indépendants." *Le Réveil*, 2 March 1882.

Finsen 1983 *Degas og familien Bellelli/Degas et la famille Bellelli*. Exhibition catalogue edited by Hanne Finsen. Ordrupgaardsamlingen, Copenhagen, 1983.

Flaubert Correspondance Gustave Flaubert. *Oeuvres complètes de Gustave Flaubert*, I–IX, *Correspondance*. Paris, 1930.

Flint 1931 Ralph Flint. "The Private Collection of Josef Stransky." *Art News Supplement* XXIX:33 (May 1931), 86–117.

Florisoone 1938 Michel Florisoone. "Renoir et la famille Charpentier: Lettres inédites." *L'Amour de l'Art* XIX:1 (February 1938), 31–40.

Fosca 1923 François Fosca. *Renoir*. Paris, 1923.

Fosca 1961 François Fosca. *Renoir: His Life and Work*. Translated by M.I. Martin. London, 1961.

Fouché 1989 Pascal Fouché, ed. *Marcel Proust–Gaston Gallimard: Correspondance 1912–1922*. Paris, 1989.

Fourcaud 1883 Louis de Fourcaud. "Beaux-Arts: Exposition d'oeuvres de M. P.A. Renoir, 9, boulevard de la Madeleine." *Le Gaulois*, 270 (12 April 1883), 3.

Fox 1909 John Shirley Fox. *An Art Student's Reminiscences of Paris in the Eighties*. London, 1909.

Francis 1943 H.S. Francis. "Mlle Romaine Lacaux by Renoir." *Bulletin of the Cleveland Museum of Art* (1943), 92–98.

Frédérix 1959 Pierre Frédérix. *Un siècle de chasse aux nouvelles: De l'Agence d'Information Havas à l'Agence France Presse*. Paris, 1959.

Freeman 1990 *The Fauve Landscape*. Exhibition publication by Judi Freeman et al. Los Angeles County Museum of Art/Metropolitan Museum of Art, New York, 1990.

Frost 1944 Rosamund Frost. *Renoir*. New York, 1944.

Fry 1907 Roger Fry. "The Charpentier Family." *Bulletin* (Metropolitan Museum of Art) II (1907), 102–104.

G

Gachet 1956 Paul Gachet. *Deux Amis des impressionnistes: Le docteur Gachet et Murer*. Paris, 1956.

Gachet 1957 Paul Gachet. *Lettres impressionnistes: Pissarro, Cézanne, Guillaumin, Renoir, Monet, Sisley, Vignon, Van Gogh*. Paris, 1957.

Galassi 1977 Peter Galassi. "Paul Haviland 1880–1950" and "A Note on Haviland and Clarence H. White." In *Catalogue 6: Photo-Secession*, 5–11, 152–154. Lunn Gallery Graphics International Ltd., Washington, D.C., 1977.

Galerie Charpentier 1962 *Chefs-d'oeuvre de collections françaises*. Exhibition catalogue. Galerie Charpentier, Paris, 1962.

Gallimard 1912 Gaston Gallimard. "Exposition de portraits de Renoir (Galeries Durand-Ruel)." *La Nouvelle Revue Française*, 44 (August 1912), 371–374.

Gangnat 1925 *Catalogue des tableaux composant la collection Maurice Gangnat: 160 Tableaux par Renoir*. Prefaces by Robert de Flers and Élie Faure. Hôtel Drouot, Paris, 24–25 June 1925.

Garb 1985 Tamar Garb. "Renoir and the Natural Woman." *Oxford Art Journal* VIII:2 (1985), 3–15.

Gasnault 1980 François Gasnault. "Les Bals publics parisiens sous la Seconde République." *Revue Internationale de Musique Française* I:3 (1980), 395–402.

Gasnault 1982 François Gasnault. "Les Salles de bal du Paris romantique: Décors et jeux des corps." *Romantisme* XII:38 (1982), 7–18.

Gasnault 1986 François Gasnault. *Guinguettes et lorettes: Bals publics à Paris au XIXᵉ siècle*. Paris, 1986.

Gasquet 1921 Joachim Gasquet. *Cézanne*. Paris, 1921.

Gassies 1907 Jean-Baptiste Georges Gassies. *Le Vieux Barbizon: Souvenirs de jeunesse d'un paysagiste 1852–1875*. Paris, 1907.

Gauguin 1921 Paul Gauguin. *Lettres de Gauguin à André Fontainas*. Paris, 1921.

Gauguin 1988 *The Art of Paul Gauguin*. Exhibition catalogue by Richard Brettell et al. National Gallery of Art, Washington, 1988.

Gauguin Correspondance *Paul Gauguin: Correspondance*. Edited by Victor Merlhès. Paris, 1984.

Gaulois 1895 "Dans le monde." *Le Gaulois*, 22 March 1895, 2.

Gaunt and Adler 1982 William Gaunt and Kathleen Adler. *Renoir*. Oxford, 1982.

Gauthier 1976 Maximilien Gauthier. *Renoir*. Paris, 1976.

Geffroy 1884 Gustave Geffroy. "Salon de 1884 – 7ème article: Le portrait." *La Justice*, 7 June 1884.

Geffroy 1894 Gustave Geffroy. *La Vie artistique*, III. Paris, 1894.

Geffroy 1900 Gustave Geffroy. *La Vie artistique*, VI. Paris, 1900.

Geffroy 1920 Gustave Geffroy. "Renoir, peintre de la femme." *L'Art et les Artistes*, new series, 4 (January 1920), 151–162.

Geffroy 1922 Gustave Geffroy. *Claude Monet, sa vie, son oeuvre*. Paris, 1922.

Geffroy 1924 Gustave Geffroy. *Claude Monet, sa vie, son oeuvre*. 2 vols. Paris, 1924.

George 1965 Waldemar George. *Aristide Maillol*. London, 1965.

George and Bourgeois 1932 Waldemar George and Stephan Bourgeois. "L'Art français du XIXᵉ et du XXᵉ siècles à la collection Adolphe et Samuel Lewisohn." *Formes*, 28–29 (1932), 300–307.

Georgel 1988 Chantal Georgel. *L'Enfant et l'image au XIXᵉ siècle*. Paris, 1988.

Georgel 1994 *La Jeunesse des musées: Les musées de France au XIXᵉ siècle*. Exhibition catalogue edited by Chantal Georgel. Musée d'Orsay, Paris, 1994.

Georgel and Lecoq 1983 *La Peinture dans la peinture*. Exhibition catalogue by Pierre Georgel and Anne-Marie Lecoq. Musée de Beaux-Arts de Dijon, 1983.

Georges Petit Paris 1886 *5ᵉ exposition internationale de peinture et de sculpture*. Exhibition catalogue. Galerie Georges Petit, Paris, June–July 1886.

Gere 1989 Charlotte Gere. *Nineteenth-Century Decoration: The Art of the Interior*. New York, 1989.

Gerstein 1989 *Impressionism: Selections from Five American Museums*. Exhibition catalogue by Marc S. Gerstein. New York, 1989.

Gétreau 1996 Florence Gétreau. *Aux origines du musée de la musique: Les collections instrumentales du Conservatoire de Paris, 1793–1993*. Paris, 1996.

Gide 1951 André Gide. *Journal, 1889–1939*. Paris, 1951.

Gifts to Galleries 1968 *Gifts to Galleries: National Art-Collections Fund for Galleries outside London*. Exhibition catalogue. Walker Art Gallery, Liverpool, 1968.

Gilot 1965 Françoise Gilot. *Vivre avec Picasso*. Paris, 1965.

Gimpel 1963 René Gimpel. *Journal d'un collectionneur, marchand de tableaux*. Paris, 1963.

Girard 1988 Paul Girard. *Firmin-Girard 1838–1921*. Luchon, 1988.

Giraudon 1993 *Les Arts à Paris chez Paul Guillaume 1918–1935*. Exhibition catalogue by Colette Giraudon. Musée National de l'Orangerie, Paris, 1993.

Glaeser 1878 Ernest Glaeser. *Biographie nationale des contemporains.* Paris, 1878.

Gleyre **1974** *Charles Gleyre ou les illusions perdues.* Exhibition catalogue. Zurich, 1974.

Godfroy 1988 Caroline Durand-Ruel Godfroy. "Les Ventes de l'atelier Degas à travers les archives Durand-Ruel." In *Degas inédit: Actes du Colloque Degas, Musée d'Orsay, 18–21 avril 1988,* 263–275. Paris, 1989.

Godfroy 1995 Caroline Durand-Ruel Godfroy, ed. *Correspondance de Renoir et Durand-Ruel.* 2 vols. Lausanne, 1995.

Goncourt 1867 Edmond and Jules de Goncourt. *Manette Salomon.* Paris, 1867.

Goncourt 1879 Edmond de Goncourt. *Les Frères Zemganno.* Paris, 1879. Reprint [1924].

Goncourt 1881 Edmond de Goncourt. *La Maison d'un artiste.* New ed. 2 vols. Paris, 1881.

Goncourt 1930 Jules de Goncourt. *Lettres.* Paris, 1930.

Goncourt 1956 Edmond and Jules de Goncourt. *Journal: Mémoires de la vie littéraire.* 4 vols. Paris, 1956.

Goya to Matisse **1991** *Goya to Matisse: Paintings, Sculpture and Drawings from the Wadsworth Atheneum of Hartford, Connecticut.* Exhibition catalogue. Kanazawa, Japan, 1991.

Green 1973 Jonathan Green, ed. *Camera Work: A Critical Anthology.* Millerton, N.Y., 1973.

Grimal 1963 Pierre Grimal. *Dictionnaire de la mythologie grecque et romaine.* 3rd ed. Paris, 1963.

Grimm 1877 Baron Grimm [Albert Millaud]. "Lettres anecdotiques du Baron Grimm: Les impressionnistes." *Le Figaro,* 5 April 1877.

Groom 1993 Gloria Lynn Groom. *Édouard Vuillard, Painter-Decorator: Patrons and Projects, 1892–1912.* New Haven/London, 1993.

Grove **1980** Stanley Sadie, ed. *The New Grove Dictionary of Music and Musicians.* 20 vols. London, 1980.

Gruber 1994 Alain Gruber, ed. *L'Art décoratif en Europe.* Paris, 1994.

Gueullette 1891 Charles Gueullette. *Répertoire de la Comédie-Française 1890,* VII. Paris, 1891.

H

Haesaerts 1947 Paul Haesaerts. *Renoir, Sculptor.* New York, 1947.

Halévy 1964 Daniel Halévy. *My Friend Degas.* Translated and edited by Mina Curtiss. Middletown, Conn., 1964.

Harrison 1986 *French Paintings from The Chrysler Museum.* Exhibition catalogue by Jefferson Cabell Harrison. Chrysler Museum of Art, Norfolk, Va., 1986.

Harrison 1991 Jefferson Cabell Harrison. *Handbook of European and American Collections: Selected Paintings, Sculpture and Drawings.* Chrysler Museum of Art, Norfolk, Va., 1991.

Hartnoll 1967 Phyllis Hartnoll. *The Oxford Companion to the Theatre.* 3rd ed. London, 1967.

Haskell 1972 Francis Haskell. "The Sad Clown: Some Notes on a 19th Century Myth." In *French 19th Century Painting and Literature,* edited by Ulrich Finke, 2–16. Manchester, 1972.

Haskell 1976 Francis Haskell. *Rediscoveries in Art: Some Aspects of Taste, Fashion and Collecting in England and France.* Ithaca, N.Y., 1976.

Haskell 1982 Francis Haskell. "A Turk and His Pictures in Nineteenth-Century Paris." *Oxford Art Journal* V:1 (1982), 40–47.

Hauptman 1985a William Hauptman. "Delaroche's and Gleyre's Teaching Ateliers and Their Group Portraits." *Studies in the History of Art* (National Gallery of Art, Washington) XVIII (1985), 79–119.

Hauptman 1985b William Hauptman. "The Artist and the Master." *FMR,* 15 (October 1985), 45–66.

Havard 1881 Henry Havard. "Le Salon de 1881 (deuxième article)." *Le Siècle,* 14 May 1881, [1–2].

Havemeyer 1993 Louisine W. Havemeyer. *Sixteen to Sixty: Memoirs of a Collector.* Edited by S.A. Stein. New York, 1993.

Heilbrun 1996 *Paul Burty Haviland (1880–1950), photographe.* Exhibition catalogue by Françoise Heilbrun and Quentin Bajac. Musée d'Orsay, Paris, 1996.

Heilbrun and Néagu 1986 *Portraits d'artistes.* Exhibition catalogue by Françoise Heilbrun and Philippe Néagu. Musée d'Orsay, Paris, 1986.

Henderson 1971 John A. Henderson. *The First Avant-Garde 1887–1894: Sources of the Modern French Theatre.* London, 1971.

Herbert 1970 Robert L. Herbert. "City vs. Country: The Rural Image in French Painting." *Artforum* VIII:6 (February 1970), 44–55.

Herbert 1988 Robert L. Herbert. *Impressionism: Art, Leisure and Parisian Society.* New Haven, 1988.

Herbert 1994 Robert L. Herbert. *Monet on the Normandy Coast: Tourism and Painting, 1867–1886.* New Haven/London, 1994.

Hermant 1933 Abel Hermant. *Souvenirs de la vie frivole.* Paris, 1933.

Hermitage Masterpieces **1994** *The State Hermitage: Masterpieces from the Museum's Collections.* 2 vols. London, 1994.

Higonnet 1989 Anne Higonnet. *Berthe Morisot: Une biographie.* Paris, 1989.

Hillairet 1964 Jacques Hillairet. *Dictionnaire historique des rues de Paris.* 2nd ed. 2 vols. Paris, 1964.

Hills 1986 *John Singer Sargent.* Exhibition catalogue by Patricia Hills et al. Whitney Museum of American Art, New York, 1986.

Hitchcock 1896 Ripley Hitchcock, ed. *The Art of the World Illustrated in the Paintings, Statuary, and Architecture of the World's Columbian Exposition.* 2 vols. New York, 1896.

Hohenzollern and Schuster 1996 *Manet bis van Gogh: Hugo von Tschudi und der Kampf um die Moderne.* Exhibition catalogue edited by Johann Georg Prinz von Hohenzollern and Peter-Klaus Schuster. Munich/New York, 1996.

Homer 1983 William Innes Homer. *Alfred Stieglitz and the Photo-Secession.* Boston, 1983.

Hong Kong 1975 *Exhibition of Chinese Blue and White Porcelain and Related Underglaze Red.* Exhibition catalogue. City Museum and Art Gallery/Oriental Ceramic Society, Hong Kong, 1975.

Hoog and Guicharnaud 1984 Michel Hoog and Hélène Guicharnaud. *Catalogue de la collection Jean Walter et Paul Guillaume, Musée de l'Orangerie.* Paris, 1984.

Hoschedé 1960 Jean-Pierre Hoschedé. *Claude Monet, ce mal connu.* 2 vols. Geneva, 1960.

Hours-Miedan 1957 Madeleine Hours-Miedan. *À la découverte de la peinture par les méthodes physiques.* Paris, 1957.

House 1978 John House. "New Light on Monet and Pissarro in London in 1870–71." *Burlington Magazine* CXX:907 (October 1978), 636–642.

House 1992 John House. "Renoir's *Baigneuses* of 1887 and the Politics of Escapism." *Burlington Magazine* CXXXIV:1074 (September 1992), 578–585.

House 1994 *Renoir: Master Impressionist.* Exhibition catalogue by John House, with essays by Kathleen Adler and Anthea Callen. Art Gallery of New South Wales, Sydney, 1994.

House and Distel 1985 *Renoir.* Exhibition catalogue by John House and Anne Distel. Hayward Gallery, London, 1985. Also exhibited at the Grand Palais, Paris, and the Museum of Fine Arts, Boston.

Houssaye 1877 Arsène Houssaye. "Salon de 1877." *L'Artiste*, July 1877, 417–444.

Howard-Johnston 1969 Paulette Howard-Johnston. "Visite à Giverny en 1924." *L'Oeil*, 171 (March 1969), 28–33, 76.

Hubbard 1959 Robert H. Hubbard. *The National Gallery of Canada Catalogue of Paintings and Sculpture*, II, *Modern European Schools*. Ottawa, 1959.

Hughes 1981 Peter Hughes. *The Founders of the Wallace Collection*. London, 1981.

Hugon 1935 Henri Hugon. "Les Aïeux de Renoir et sa maison natale." *La Vie Limousine*, 118 (25 January 1935), 453–455.

Hutin 1882 A. Hutin. "L'Exposition des peintres indépendants." *L'Estafette*, 3 March 1882.

Hutton 1986 Patrick H. Hutton, ed. *Historical Dictionary of the Third French Republic, 1870–1940.* 2 vols. New York/Westport, Conn., 1986.

Huygue 1952 René Huygue. *Le Carnet de Paul Gauguin*. Paris, 1952.

Huysmans 1883 Joris-Karl Huysmans. *L'Art moderne*. Paris, 1883.

I

***Impressionist Drawings* 1986** *Impressionist Drawings from British Public and Private Collections.* Exhibition catalogue by Christopher Lloyd and Richard Thomson. Ashmolean Museum, Oxford, 1986.

Isaacson 1972 Joel Isaacson. *Monet: Le Déjeuner sur l'herbe*. New York, 1972.

Isaacson 1982 Joel Isaacson. "Impressionism and Journalistic Illustration." *Arts Magazine* LVI:10 (June 1982), 95–115.

J

Jacques 1877a Jacques [pseud.]. "Menu propos: Salon impressionniste." *L'Homme Libre*, 11 April 1877.

Jacques 1877b Jacques [pseud.]. "Menu propos: Exposition impressionniste." *L'Homme Libre*, 12 April 1877.

Jahyer 1880 Félix Jahyer. "Jeanne Samary." *Camées artistiques*, 10 (1880), 1–2.

Jamot 1923 Paul Jamot. "Renoir." *Gazette des Beaux-Arts*, 5th series, VIII (November and December 1923), 257–281, 321–344.

***Japonisme* 1988** *Le Japonisme.* Exhibition catalogue. Grand Palais, Paris, 1988.

Jellema-van Woelderen 1966–67 E. Jellema-van Woelderen. "De Clown Van Renoir In Het Museum Kröller-Müller." *Simiolus* I:1 (1966–67), 46–50.

Joëts 1935 Jules Joëts. "Lettres inédites: Les impressionnistes et Chocquet." *L'Amour de l'Art* XVI:4 (April 1935), 121–125.

Johnson 1975 Christopher H. Johnson. "Economic Change and Artisan Discontent: The Tailors' History, 1800–48." In *Revolution and Reaction: 1848 and the Second French Republic*, edited by Roger Price, 87–114. New York/London, 1975.

Johnson 1977 Una E. Johnson. *Ambroise Vollard, Éditeur: Prints, Books, Bronzes.* New York, 1944. Reprint 1977.

Johnson 1981–89 Lee Johnson. *The Paintings of Eugène Delacroix: A Critical Catalogue.* 6 vols. Oxford, 1981–89.

Jones 1984 Louisa E. Jones. *Sad Clowns and Pale Pierrots: Literature and the Popular Comic Arts in 19th-Century France.* Lexington, 1984.

Jourdain 1896 Frantz Jourdain. "L'Art au jour le jour: L'exposition de M. Renoir." *La Patrie*, 23 June 1896, 2.

Jourdain 1953 Francis Jourdain. *Sans remords ni rancune: Souvenirs épars d'un vieil homme "né en 76."* Paris, 1953.

Jullian 1962 Philippe Jullian. "'Rose' de Renoir, retrouvée par Philippe Jullian." *Figaro Littéraire*, 22 December 1962, 6.

K

Kansas City 1959 *Handbook of the Collections in the William Rockhill Nelson Gallery of Art and Mary Atkins Museum of Fine Arts.* Kansas City, Mo., 1959.

Katow 1882 Paul de Katow. "L'Exposition des peintres indépendants." *Gil Blas*, 1 March 1882.

Kelder 1980 Diane Kelder. *The Great Book of French Impressionism.* New York, 1980.

Kern 1996 *A Passion for Renoir: Sterling and Francine Clark Collect, 1916–1951.* Exhibition catalogue by Steven Kern et al. New York, 1996.

Kessler 1971 Harry Kessler. *In the Twenties: The Diaries of Harry Kessler.* New York/Chicago/San Francisco, 1971.

Kete 1994 Kathleen Kete. *The Beast in the Boudoir: Petkeeping in Nineteenth-Century Paris.* Berkeley/Los Angeles, 1994.

Kokoschka 1974 Oskar Kokoschka. *My Life.* Translated by David Britt. London, 1974.

Kolb 1953 Marcel Proust. *Correspondance avec sa mère.* Edited by Philip Kolb. Paris, 1953.

Kolb and Adhémar 1984 Philippe Kolb and Jean Adhémar. "Charles Ephrussi (1849–1905). Ses secrétaires: Laforgue, A. Renan, Proust. 'Sa' Gazette des Beaux-Arts." *Gazette des Beaux-Arts*, 6th series, CIII (January 1984), 29–41.

Kosinski and Pissarro 1995 *From Manet to Gauguin: Masterpieces from Swiss Private Collections.* Exhibition catalogue by Dorothy Kosinski, Joachim Pissarro, and Maryanne Stevens. Royal Academy of Arts, London, 1995.

Kostenevich 1987 Albert Kostenevich. *L'Ermitage: Peintures XIX^e et XX^e siècles.* Paris, 1987.

Kostenevich 1995 Albert Kostenevich. *Hidden Treasures Revealed: Impressionist Masterpieces and Other Important French Paintings Preserved by the State Hermitage Museum.* Saint Petersburg/New York, 1995.

Kostenevich and Bessonova 1986 *Impressionist to Early Modern Paintings from the U.S.S.R.: Works from the Hermitage Museum, Leningrad, and the Pushkin Museum of Fine Arts, Moscow.* Exhibition catalogue by Albert Kostenevich and Marina Bessonova. Metropolitan Museum of Art, New York, 1986.

Kristeva 1980 Julia Kristeva. "Motherhood according to Bellini." In *Desire in Language: A Semiotic Approach to Literature and Art*, edited by Leon Roudiez, translated by Thomas Gora et al., 237–270. New York, 1980.

Kuznetsova and Georgievskaya 1979 Irina Kuznetsova and E. Georgievskaya. *French Painting from the Pushkin Museum: 17th to 20th Century.* New York, 1979.

L

Lablaude 1983 Pierre-André Lablaude. "La Maison Fournaise à Chatou." *Monuments historiques, Île-de-France*, 129 (October–November 1983), 68–70.

Laclotte 1989 Michel Laclotte et al. *Les Donateurs du Louvre.* Paris, 1989.

La Fare 1882 La Fare. "Exposition des impressionnistes." *Le Gaulois*, 2 March 1882.

Lafenestre 1877 Georges Lafenestre. "Le Jour et la Nuit." *Le Moniteur Universel*, 8 April 1877.

Laffon 1981–82 Juliette Laffon. *Palais des Beaux-Arts de la Ville de Paris, Musée du Petit Palais: Catalogue sommaire illustré des peintures*. 2 vols. Paris, 1981–82.

Laforgue 1896 Jules Laforgue. "Lettres d'Allemagne (1881–1882)." *La Revue Blanche* XI (1896), 221–228, 271–276, 313–320.

Laforgue 1922–30 Jules Laforgue. *Oeuvres complètes de Jules Laforgue*. 6 vols. Paris, 1922–30.

Lamathière 1875–1911 T. Lamathière. *Panthéon de la Légion d'honneur*. 22 vols. Paris, 1875–1911.

Lambotte 1913 Paul Lambotte. *Les Peintres de portraits*. Brussels, 1913.

Larousse 1866–90 Pierre Larousse. *Grand Dictionnaire universel du XIXᵉ siècle*. 17 vols. Paris, 1866–1890.

Larousse 1898–1904 C. Augé, ed. *Nouveau Larousse illustré: Dictionnaire universel encyclopédique*. 7 vols. Paris, 1898–1904.

Laurence 1965–88 D.H. Laurence, ed. *Collected Letters of Bernard Shaw*. 4 vols. London, 1965–88.

Lavergnée, Foucart, and Reynaud 1979 Arnauld Brejon de Lavergnée, Jacques Foucart, and Nicole Reynaud. *Catalogue sommaire illustré des peintures du musée du Louvre*. 5 vols. Paris, 1979.

Laÿ 1993 Jacques and Monique Laÿ. "Rediscovering La Grenouillère: *Ars longa, vita brevis*." *Apollo* CXXXVII:375 (May 1993), 281–286.

Leclercq 1899 Julien Leclercq. "Alfred Sisley." *Gazette des Beaux-Arts*, 3rd series, XXI (March 1899), 227–236.

Le Coeur 1996 *Charles Le Coeur (1830–1906), architecte et premier amateur de Renoir*. Exhibition catalogue by Marc Le Coeur. Musée d'Orsay, Paris, 1996.

Lecomte 1892 Georges Lecomte. *L'Art impressionniste d'après la collection privée de M. Durand-Ruel*. Paris, 1892.

Le Curieux 1923 Le Curieux. "Le Carnet d'un Curieux: Collection Ch. Haviland, Tableaux modernes." *La Renaissance de l'Art Français et des Industries de Luxe* V:1 (January 1923), 69–70.

Lefort 1875 Paul Lefort. "Francisco Goya (1ᵉʳ article)." *Gazette des Beaux-Arts*, 2nd series, XII (December 1875), 506–514.

Lermina 1884 Jules Lermina. *Dictionnaire universel illustré, biographique et bibliographique de la France contemporaine*. Paris, 1884.

Leroy 1876 Louis Leroy. "Choses et autres." *Le Journal Amusant*, 15 April 1876, 2, 6–7.

Leroy 1877 Louis Leroy. "Exposition des impressionnistes." *Le Charivari*, 11 April 1877, 2.

Leymarie and Melot 1972 Jean Leymarie and Michel Melot. *The Graphic Works of the Impressionists: Manet, Pissarro, Renoir, Cézanne, Sisley*. New York, 1972.

Lhote 1883 Paul Lhote. "Mademoiselle Zélia." *La Vie Moderne*, 3 November 1883, 707–708.

Lightbown 1978 Ronald W. Lightbown. *Sandro Botticelli*. 2 vols. London, 1978.

Lindsay 1985 *Mary Cassatt and Philadelphia*. Exhibition catalogue by Suzanne G. Lindsay. Philadelphia Museum of Art, 1985.

London 1883 *Catalogue of Paintings, Drawings and Pastels by Members of "La Société des impressionnistes."* Dowdeswell and Dowdeswell, London, 1883. Unpublished exhibition listing.

London 1905 *Pictures by Boudin, Cézanne, Degas, Manet, Monet, Morisot, Pissarro, Renoir, Sisley, Exhibited by Messrs. Durand-Ruel & Sons of Paris.* Exhibition catalogue. Grafton Galleries, London, January–February 1905.

Lora 1877a Léon de Lora [Louis de Fourcaud]. "Exposition d'oeuvres d'art au Cercle artistique et littéraire." *L'Artiste*, March 1877, 213–215.

Lora 1877b Léon de Lora [Louis de Fourcaud]. "L'Exposition des impressionnistes." *Le Gaulois*, 10 April 1877.

Lorr 1879 Jean de Lorr. "Le Jour du vernissage." *La Vie Moderne*, 15 May 1879, 82–84.

Los Llanos 1992 *Fragonard et le dessin français au XVIIIᵉ siècle dans les collections du Petit Palais*. Exhibition catalogue by José-Luis de Los Llanos. Musée du Petit Palais, Paris, 1992.

Loyrette 1991 Henri Loyrette. *Degas*. Paris, 1991.

Lucas 1979 George A. Lucas. *The Diary of George A. Lucas, 1857–1909*. Transcribed by L.M.C. Randall. 2 vols. Princeton, 1979.

Lumet 1903 Louis Lumet. "La Pouponnière." *La Petite République*, 19 October 1903, 86–89.

Luxenberg 1991 Alisa Luxenberg. "Léon Bonnat (1833–1922)." Ph.D. diss., New York University, 1991.

Lyonnet 1911–12 Henry Lyonnet. *Dictionnaire des comédiens français*. 2 vols. Paris, 1911–12.

M

Mainardi 1988 Patricia Mainardi. "The Eviction of the Salon from the Louvre." *Gazette des Beaux-Arts*, 4th series, CXII (July–August 1988), 31–40.

Mainardi 1993 Patricia Mainardi. *The End of the Salon: Art and the State in the Early Third Republic*. New York, 1993.

Maison 1968 K.E. Maison. *Honoré Daumier: Catalogue Raisonné of the Paintings, Watercolours and Drawings*. Paris, 1968.

Mallarmé 1876 Stéphane Mallarmé. "The Impressionists and Édouard Manet." *The Art Monthly Review and Photographic Portfolio* 1:9 (30 September 1876), 117–122. Reprinted in Moffett 1986, 27–35.

Mallarmé *Correspondance* Stéphane Mallarmé. *Correspondance*. Edited by Henri Mondor and A.J. Austin. 11 vols. Paris, 1959–85.

Mander and Mitchenson 1977 Raymond Mander and Joe Mitchenson. *Theatrical Companion to Shaw*. Norwood, Pa., 1977.

Manet 1979 Julie Manet. *Journal (1893–1899)*. Paris, 1979.

Manet 1983 *Manet 1832–1883*. Exhibition catalogue by Françoise Cachin and Charles S. Moffett. Grand Palais, Paris, 1983. English edition, Metropolitan Museum of Art, New York.

Manet 1987 Julie Manet. *Journal 1893–1899*. Introduction by Rosalind de Boland Roberts and Jane Roberts. Paris, 1987.

Marguillier 1905 Auguste Marguillier. "Charles Ephrussi." *Gazette des Beaux-Arts*, 3rd series, XXXIV (November 1905), 353–360.

Martin 1895 Jules Martin. *Nos artistes: Portraits et biographies*. Paris, 1895.

Martin 1897 Jules Martin. *Nos auteurs et compositeurs dramatiques: Portraits et biographies*. Paris, 1897.

Mathews 1984 Nancy Mowll Mathews, ed. *Cassatt and Her Circle: Selected Letters*. New York, 1984.

Mathieu 1976 Pierre-Louis Mathieu. *Gustave Moreau, sa vie, son oeuvre*. Paris, 1976. Published in English as *Gustave Moreau, with a Catalogue of the Finished Paintings, Watercolors and Drawings* (Boston, 1976).

Matisse 1992 *Henri Matisse: A Retrospective*. Exhibition publication by John Elderfield. Museum of Modern Art, New York, 1992.

Matisse 1993 *Henri Matisse 1904–1917*. Exhibition catalogue. Centre Georges Pompidou, Paris, 1993.

Mauclair 1902 Camille Mauclair. "L'Oeuvre d'Auguste Renoir." *L'Art Décoratif*, 41 (February 1902), 173–230.

Maugham 1992 W. Somerset Maugham. *Of Human Bondage*. London/New York, 1915. Reprint, New York, 1992.

Maupassant 1973 Guy de Maupassant. *Bel Ami*. Paris, 1885. Reprint 1973.

Maupassant 1988 Guy de Maupassant. *Contes et nouvelles 1884–1890; Bel-Ami*. Paris, 1988.

Maupassant *Correspondance* Guy de Maupassant. *Correspondance*. Edited by J. Suffel. 3 vols. Geneva, 1973.

McCauley 1985 Elizabeth Anne McCauley. *A.A.E. Disdéri and the Carte de Visite Portrait Photograph*. New Haven/London, 1985.

McCauley 1994 Elizabeth Anne McCauley. *Industrial Madness: Commercial Photography in Paris, 1848–1871*. New Haven/London, 1994.

McQuillan 1986 Melissa McQuillan. *Impressionist Portraits*. London, 1986.

Meier-Graefe 1911 Julius Meier-Graefe. *Auguste Renoir*. Munich, 1911.

Meier-Graefe 1912 Julius Meier-Graefe. *Auguste Renoir*. Paris, 1912. French translation of the 1911 edition.

Meier-Graefe 1929 Julius Meier-Graefe. *Renoir*. Leipzig, 1929.

Meilhac and Halévy 1884 Henry Meilhac and Ludovic Halévy. *La Cigale*. New ed. Paris, 1884.

Merriman 1985 John M. Merriman. *The Red City: Limoges and the French Nineteenth Century*. New York/Oxford, 1985.

Milan 1996 *Da Monet a Picasso: Capolavori impressionisti e postimpressionisti dal Museo Pushkin di Mosca*. Exhibition catalogue by Marina Bessonova. Palazzo Reale, Milan, 1996.

Milner 1988 John Milner. *The Studios of Paris: The Capital of Art in the Late Nineteenth Century*. New Haven/London, 1988.

Mirbeau 1990 Octave Mirbeau. *Correspondance avec Claude Monet*. Edited by Pierre Michel and Jean-François Nivet. Tusson, Charente, 1990.

Mirbeau 1993 Octave Mirbeau. *Combats esthétiques*. 2 vols. Paris, 1993.

Mitterand 1986 Henri Mitterand, ed. *Carnets d'enquêtes: Une ethnographie inédite de la France par Émile Zola*. Paris, 1986.

Miura 1994 Atsushi Miura. "Un double portrait par Carolus-Duran: Fantin-Latour et Oulevay." *Gazette des Beaux-Arts*, 6th series, CXXIV (July–August 1994), 25–33.

Moffett 1973 Kenworth Moffett. *Meier-Graefe as Art Critic*. Munich, 1973.

Moffett 1986 *The New Painting: Impressionism 1874–1886*. Exhibition catalogue edited by Charles S. Moffett. Fine Arts Museums of San Francisco, 1986.

Moncade 1904 C.-L. de Moncade. "Le Peintre Renoir et le Salon d'Automne." *La Liberté*, 15 October 1904.

Monet 1980 *Hommage à Claude Monet (1840–1926)*. Exhibition catalogue by Hélène Adhémar, Anne Distel, and Sylvie Gache. Grand Palais, Paris, 1980.

Monet et ses amis 1977 *Monet et ses amis, le legs Michel Monet, la donation Donop de Monchy*. Musée Marmottan, Paris, 1977.

Mongan 1949 Agnes Mongan. *One Hundred Master Drawings*. Cambridge, 1949.

Monneret 1978–81 Sophie Monneret. *L'Impressionnisme et son époque*. 4 vols. Paris, 1978–81.

Monneret 1986 Sophie Monneret. "'Voir l'univers avec les yeux d'un autre . . .' Proust et Renoir." *Bulletin de la Société des Amis de Marcel Proust et des Amis de Combray*, 36 (1986), 469–476.

Monneret 1989 Sophie Monneret. *Renoir*. Paris, 1989.

Montalant 1985 Delphine Montalant. "Une longue amitié: Berthe Morisot et Pierre-Auguste Renoir." *L'Oeil*, 358 (May 1985), 42–47.

Montégut 1884 Émile Montégut. *Nos morts contemporains*. 2nd series. Paris, 1884.

Monval 1897 Georges M. Monval. *Les Collections de la Comédie-Française: Catalogue historique et raisonné*. Paris, 1897.

Moreau-Nélaton 1926 Étienne Moreau-Nélaton. *Manet raconté par lui-même*. 2 vols. Paris, 1926.

Moreau-Vauthier 1901 Charles Moreau-Vauthier. *Les Portraits de l'Enfant*. Paris, [c. 1901].

Morel 1883 Henry Morel. "P.-A. Renoir." *Le Réveil*, 2 July 1883, 1–2.

Morisot *Correspondance* Denis Rouart, ed. *Correspondance de Berthe Morisot*. Paris, 1950. Published in English as *Correspondence of Berthe Morisot*, translated by Betty W. Hubbard (London, 1957).

Moss and Marvel 1946 Arthur Moss and Evalyn Marvel. *The Legend of the Latin Quarter*. New York, 1946.

Mottez 1911 Cennino Cennini. *Le Livre de l'art ou Traité de la peinture*. Translated by Victor Mottez. New ed., with foreword by Renoir. Paris, 1911.

Mozley 1972 *Eadweard Muybridge: The Stanford Years, 1872–1882*. Exhibition catalogue by Anita Ventura Mozley. Stanford University Museum of Art, 1972.

Munhall 1995 Edgar Munhall. *Whistler and Montesquiou: The Butterfly and the Bat*. New York/Paris, 1995.

Munich 1912 *Ausstellung Auguste Renoir*. Exhibition catalogue. Moderne Galerie Heinrich Thannhauser, Munich, January–February 1912.

Munich 1958 *Auguste Renoir*. Exhibition catalogue. Städtische Galerie, Munich, 1958.

Murer Collection 1896 *Magnifique collection d'impressionnistes dont 30 toiles du grand artiste Renoir* [Murer Collection]. Hôtel du Dauphin et d'Espagne, Rouen, May 1896.

N

Nadar 1995 *Nadar*. Exhibition catalogue by Maria M. Hambourg, Françoise Heilbrun, and Philippe Néagu. Metropolitan Museum of Art, New York, 1995.

Naef 1978 Weston J. Naef. *The Collection of Alfred Stieglitz: Fifty Pioneers of Modern Photography*. New York, 1978.

Nash 1979 Steven A. Nash. *Albright-Knox Art Gallery: Painting and Sculpture from Antiquity to 1942*. New York, 1979.

Natanson 1900 Thadée Natanson. "De M. Renoir et de la Beauté." *La Revue Blanche* XXI (March 1900), 370–377.

National Gallery of Art 1978 *Small French Paintings from the Bequest of Ailsa Mellon Bruce*. Exhibition catalogue by David E. Rust. National Gallery of Art, Washington, 1978.

National Gallery of Canada 1962 *European Paintings in Canadian Collections: Corot to Picasso*. Exhibition catalogue by R.H. Hubbard. National Gallery of Canada, Ottawa, 1962.

Néagu and Poulet-Allamagny 1979 Philippe Néagu and Jean-Jacques Poulet-Allamagny. *Nadar*. 2 vols. Paris, 1979.

Near 1985 Pinkney L. Near. *French Paintings: The Collection of Mr. and Mrs. Paul Mellon in the Virginia Museum of Fine Arts*. Richmond, 1985.

New York 1886 *Works in Oil and Pastel by the Impressionists of Paris.* Exhibition catalogue. American Art Galleries, New York, 1886.

New York 1921 *Loan Exhibition of Impressionist and Post-Impressionist Paintings.* Exhibition catalogue. Metropolitan Museum of Art, New York, May–September 1921.

Nicolescu 1964 Remus Nicolescu. "Georges de Bellio, l'ami des impressionnistes." *Revue Roumaine d'Histoire de l'Art* 1:2 (1964), 209–278.

Nochlin 1987 Linda Nochlin. "Degas and the Dreyfus Affair: A Portrait of the Artist as an Anti-Semite." In *The Dreyfus Affair: Art, Truth, and Justice*, edited by Norman Kleeblatt, 96–106. Berkeley, 1987.

Nochlin 1988 Linda Nochlin. "Morisot's *Wet Nurse:* The Construction of Work and Leisure in Impressionist Painting." In *Women, Art, and Power and Other Essays*, 37–56. New York, 1988.

Nochlin 1992 Linda Nochlin. "A House Is Not a Home: Degas and the Subversion of the Family." In *Dealing with Degas: Representations of Women and the Politics of Vision*, edited by Richard Kendall and Griselda Pollock, 43–65. New York, 1992.

Norman 1973 Dorothy Norman. *Alfred Stieglitz: An American Seer.* New York, 1973.

Notin 1991 Véronique Notin. "Le Portrait de Mademoiselle Laporte par Auguste Renoir au musée municipal de l'Évêché." *Revue du Louvre et des Musées de France*, 5–6 (December 1991), 12.

O

O'Brian 1988 John O'Brian. *Degas to Matisse: The Maurice Wertheim Collection.* New York, 1988.

Olivier 1973 Fernande Olivier. *Picasso et ses amis.* Paris, 1973.

Orientalistes français 1906 *L'Exposition rétrospective des orientalistes français.* Exhibition catalogue. Exposition Nationale Coloniale, Marseilles, 1906.

Osborne 1980–81 Carol M. Osborne. "Stanford Family Portraits by Bonnat, Carolus-Duran, Meissonier, and Other French Artists of the 1880s." *The Stanford Museum* X–XI (1980–81), 3–12.

O'Squarr 1877 Ch. Flor O'Squarr [Oscar-Charles Flor]. "Les Impressionnistes." *Le Courrier de France*, 6 April 1877.

P

Pach 1912 Walter Pach. "Pierre Auguste Renoir." *Scribner's Magazine* LI (1912), 606–615.

Pach 1958 Walter Pach. "Renoir, Rubens and the Thurneyssen Family." *Art Quarterly* XXI:3 (Autumn 1958), 279–282.

Paintings from the U.S.S.R. 1973 *Impressionist and Post-Impressionist Paintings from the U.S.S.R.* Exhibition catalogue. New York, 1973.

Paret 1981 Peter Paret. "The Tschudi Affair." *Journal of Modern History* LIII:4 (December 1981), 589–618. Revised version in Hohenzollern and Schuster 1996, 396–401.

Parker 1984 Rozsika Parker. *The Subversive Stitch: Embroidery and the Making of the Feminine.* London, 1984. Reprint, New York, 1989.

Patrick 1886 Emmanuel Patrick. "Les Bals de Paris." *Le Courrier Français* III:39 (26 September 1886), 6–7.

Patterson 1981 Michael Patterson. *The Revolution in German Theatre, 1900–1933.* Boston/London/Henley, 1981.

Paulin 1983 *Paul Paulin, sculpteur impressionniste.* Exhibition catalogue. Musées d'Art de la Ville de Clermont-Ferrand, 1983.

Peintres actuels 1909 *Les Cinquante Meilleurs Tableaux des peintres actuels.* Exhibition catalogue. Petit Musée Baudoin, Paris, 1909.

Perruchot 1964 Henri Perruchot. *La Vie de Renoir.* Paris, 1964.

Pesquidoux 1874 Dubosc de Pesquidoux. "Les Peintres du XIXᵉ siècle: Gleyre." *L'Artiste*, September 1874, 158–162.

Peter 1945 René Peter. *Le Théâtre et la Vie sous la Troisième République.* Paris, 1945.

Petit Moniteur Universel 1876 "L'École des Batignolles." *Le Petit Moniteur Universel*, 1 April 1876.

Pétridès 1971 Paul Pétridès. *L'Oeuvre complet de Suzanne Valadon.* Paris, 1971.

Pickvance 1980 Ronald Pickvance. "Monet and Renoir in the mid-1870s." *Japonisme in Art: An International Symposium.* Tokyo, 1980.

Pissarro Correspondance Janine Bailly-Herzberg, ed. *Correspondance de Camille Pissarro.* 5 vols. Paris, 1980–91.

Pissarro and Venturi 1939 Ludovic Rodo Pissarro and Lionello Venturi. *Camille Pissarro, son art, son oeuvre.* 2 vols. Paris, 1939.

Plaut 1937 James S. Plaut. "A Great Renoir." *Bulletin of the Museum of Fine Arts* (Boston) XXXV:209 (June 1937), 30–33.

Pollock 1988 Griselda Pollock. "Modernity and the Spaces of Femininity." In *Vision and Difference: Femininity, Feminism, and Histories of Art*, 50–90. London/New York, 1988.

Porcheron 1876 Émile Porcheron. "Promenades d'un flâneur: Les impressionnistes." *Le Soleil*, 4 April 1876.

Porkert 1986 Hans Porkert. *Am Wesslinger See: Ein Heimatbuch in Wort und Bild.* Wessling, 1986.

Portraits du siècle 1883 *Portraits du siècle (1783–1883).* Exhibition catalogue. École des Beaux-Arts, Société Philanthropique, Paris, April 1883.

Posse 1927 Hans Posse. "Einige Neuerwerbungen der Dresdner Gemäldegalerie." *Zeitschrift für Bildende Kunst* LXI:6 (15 September 1927), 244–248.

Pothey 1876 Alexandre Pothey. "Chronique." *La Presse*, 31 March 1876.

Poulain 1932 Gaston Poulain. *Bazille et ses amis.* Paris, 1932.

Preuss 1965 Joachim Werner Preuss. *Tilla Durieux – Porträt der Schauspielerin: Deutung und Dokumentation.* Berlin, 1965.

Prinsep 1904 Val Prinsep. "A Student's Life in Paris in 1839." *The Magazine of Art*, new series, II (May 1904), 338–342.

Proust 1954 Marcel Proust. *À la recherche du temps perdu.* 3 vols. Paris, c.1919–27. Reprint 1954.

Proust 1981 Marcel Proust. *Remembrance of Things Past.* Translated by C.K. Scott Moncrieff, Terence Kilmartin, and Andreas Mayor. 3 vols. New York, 1981.

Prouvaire 1874 Jean Prouvaire [Pierre Toloza]. "L'Exposition du boulevard des Capucines." *Le Rappel*, 20 April 1874.

Puvis de Chavannes 1977 *Puvis de Chavannes 1824–1898.* Exhibition catalogue by Louise d'Argencourt, Marie-Christine Boucher, Douglas Druick, and Jacques Foucart. National Gallery of Canada, Ottawa, 1977.

R

Rathbone et al. 1996 *Impressionists on the Seine: A Celebration of Renoir's Luncheon of the Boating Party.* Exhibition catalogue by Eliza Rathbone, Katherine Rothkopf, Richard Brettell, and Charles Moffett. The Phillips Collection, Washington, 1996.

Read 1926 H.A. Read. "The Exhibition Idea in Germany." *The Arts* (New York), X:4 (October 1926), 201–216.

Reed and Shapiro 1984 *Edgar Degas: The Painter as Printmaker.* Exhibition catalogue by Sue Welsh Reed and Barbara Stern Shapiro. Museum of Fine Arts, Boston, 1984.

Reff 1964 Theodore Reff. "Copyists in the Louvre, 1850–1870." *Art Bulletin* XLVI (December 1964), 552–559.

Reff 1975 Theodore Reff. "Manet's Portrait of Zola." *Burlington Magazine* CXVII:862 (January 1975), 34–44.

Reff 1976 Theodore Reff. *Manet, Olympia*. London, 1976.

Régnier 1923 Henri de Régnier. *Renoir, peintre du nu*. Paris, 1923.

Reigl 1964 Alois Reigl. *Das holländische Gruppenporträt*. Vienna, 1931. 3rd ed., Darmstadt, 1964.

Reiley Burt 1975 Marianna Reiley Burt. "Le Pâtissier Murer, un ami des impressionnistes." *L'Oeil*, 245 (December 1975), 54–61, 92.

Rembrandt to Renoir 1992 *Rembrandt to Renoir: European Masterpieces from the Fine Arts Museums of San Francisco*. Exhibition catalogue by Steven A. Nash, Lynn F. Orr, and Marion C. Stewart. Australian National Gallery, Canberra, 1992.

Renoir [Edmond] 1879a E.R. [Edmond Renoir]. "Le Salon de 1879." *La Presse*, 11 May 1879, [2].

Renoir [Edmond] 1879b Edmond Renoir. "Cinquième exposition de La Vie Moderne – P.-A. Renoir." *La Vie Moderne*, 19 June 1879, 174–175.

Renoir [Edmond] 1883a Edmond Renoir. "Un tour aux environs de Paris." *La Vie Moderne*, 1 September 1883, 556–557.

Renoir [Edmond] 1883b Edmond Renoir. "Un tour aux environs de Paris (suite)." *La Vie Moderne*, 15 September 1883, 589–590.

Renoir [Edmond] 1883c Edmond Renoir. "Un tour aux environs de Paris (suite)." *La Vie Moderne*, 29 September 1883, 621–622.

Renoir 1879 5ᵉ exposition de La Vie Moderne, P.-A. Renoir. La Vie Moderne, Paris, June 1879.

Renoir 1883 *Exposition des oeuvres de P.-A. Renoir*. Exhibition catalogue. Galeries Durand-Ruel, Paris, 1–25 April 1883.

Renoir 1892 *Exposition A. Renoir*. Exhibition catalogue. Galeries Durand-Ruel, Paris, May 1892.

Renoir 1896 *Exposition Renoir*. Galeries Durand-Ruel, Paris, 28 May–20 June 1896. Unpublished exhibition listing, Archives Durand-Ruel, Paris.

Renoir 1900 *Exposition A. Renoir*. Exhibition catalogue. Galeries Bernheim Jeune et fils, Paris, 25 January–10 February 1900.

Renoir 1902 *Tableaux par A. Renoir*. Exhibition catalogue. Galeries Durand-Ruel, Paris, June 1902.

Renoir 1912 *Portraits par Renoir*. Exhibition catalogue. Galeries Durand-Ruel, Paris, 5–20 June 1912.

Renoir 1913 *Exposition Renoir*. Exhibition catalogue, with preface by Octave Mirbeau. Galeries Bernheim-Jeune, Paris, 10–29 March 1913.

Renoir 1933 *Exposition Renoir 1841–1919*. Exhibition catalogue. Musée de l'Orangerie, Paris, 1933.

Renoir 1941 *Renoir: Centennial Loan Exhibition 1841–1941*. Exhibition catalogue. Duveen Galleries, New York, 1941.

Renoir 1944 *Paintings by Pierre Auguste Renoir: An Exhibition Commemorating the Twentieth Anniversary of the Opening of the Museum*. Exhibition catalogue. California Palace of the Legion of Honor, San Francisco, 1944.

Renoir 1948 Claude Renoir. "Souvenirs sur mon père." In *Seize Aquarelles et sanguines de Renoir*. Paris/New York, 1948.

Renoir 1952 Jean Renoir. "My Memories of Renoir." *Life* XXXII:20 (19 May 1952), 90–99.

Renoir 1952 *Renoir*. Exhibition catalogue. Musée de Nice, April–June 1952.

Renoir 1969 *Renoir intime*. Exhibition catalogue. Galeries Durand-Ruel, Paris, 1969.

Renoir 1973 *Paintings by Renoir*. Exhibition catalogue by John Maxon. Art Institute of Chicago, 1973.

Renoir 1974 Jean Renoir. *Ma vie et mes films*. Paris, 1974. Published in English as *My Life and My Films*, translated by Norman Denny (New York, 1974, reprint 1991).

Renoir 1979 *Exposition Renoir*. Exhibition catalogue by Yomiuri Shimbun Sha. Isetan Museum of Art, Tokyo, 1979.

Renoir 1981 Jean Renoir. *Pierre-Auguste Renoir, mon père*. Paris, 1962. Reprint 1981. Published in English as *Renoir, My Father*, translated by Randolph and Dorothy Weaver (London, 1962).

Renoir 1988 *Renoir Retrospective*. Exhibition catalogue by Alexandra R. Murphy et al. Nagoya City Art Museum, Japan, 1988.

Renoir 1991 *Pierre Auguste Renoir: Photographien aus seinem Privaten Leben/Photographies de sa vie privée*. Exhibition catalogue, with texts by Paul Renoir. Das Grafische Kabinett, Galerie Utermann, Dortmund, 1991.

Renoir 1993 *Exposition Auguste Renoir*. Exhibition catalogue. Tobu Museum of Art, Tokyo, 1993.

Renoiriana 1919 "Renoiriana." *Bulletin de la Vie Artistique*, 15 December 1919, 32–36.

Reutersvard 1952 Oscar Reutersvard. "Renoir ou le triomphe du refus." *Les Arts* (Paris), 29 February 1952.

Révérend 1897 Albert Révérend, ed. *Annuaire de la noblesse de France*, LIII. Paris, 1897.

Revue Philanthropique 1897 "La Pouponnière de Porchefontaine et la question des crèches internes." *Revue Philanthropique*, 10 November 1897, 5–11.

Rewald 1945 John Rewald. "Auguste Renoir and His Brother." *Gazette des Beaux-Arts*, 6th series, XXVI (March 1945), 171–188.

Rewald 1958 John Rewald. *Renoir Drawings*. New York/London, 1958.

Rewald 1969 John Rewald. "Chocquet and Cézanne." *Gazette des Beaux-Arts*, 6th series, LXXIV (July–August 1969), 33–96.

Rewald 1973 John Rewald. *The History of Impressionism*. Revised and enlarged ed. New York, 1973.

Rewald 1985 John Rewald. "Cézanne and His Father." In *Studies in Impressionism*, 69–102. New York, 1985.

Rewald 1986a John Rewald. *Histoire de l'impressionnisme*. Paris, 1986.

Rewald 1986b John Rewald. *Studies in Post-Impressionism*. London, 1986.

Rey 1922 Robert Rey. *Suzanne Valadon*. Paris, 1922.

Rey 1926 Robert Rey. "Renoir à l'École des Beaux-Arts." *Bulletin de la Société d'Histoire de l'Art Français* 1 (1926), 33–37.

Richardson 1991 John Richardson, with M. McCully. *A Life of Picasso*, 1, *1881–1906*. New York, 1991.

Riopelle 1990 Christopher Riopelle. "Renoir: The Great Bathers." *Bulletin* (Philadelphia Museum of Art) LXXXVI:367–68 (Fall 1990).

Rishel 1987 Joseph J. Rishel. *The Henry P. McIlhenny Collection: An Illustrated History*. Philadelphia, 1987.

Rivière 1877a Georges Rivière. "L'Exposition des impressionnistes." *L'Impressionniste*, 1 (6 April 1877), 2–6.

Rivière 1877b Georges Rivière. "Aux femmes." *L'Impressionniste*, 3 (21 April 1877), 2.

Rivière 1877c Georges Rivière. "Les Intransigeants et les impressionnistes, souvenirs du Salon libre de 1877." *L'Artiste*, 1 November 1877, 298–302.

Rivière 1921 Georges Rivière. *Renoir et ses amis*. Paris, 1921.

Rivière 1925 Georges Rivière. " Renoir." *L'Art Vivant* 1 (1 July 1925), 1–6.

Rivière 1926 Georges Rivière. "Les Impressionnistes chez eux." *L'Art Vivant* II (15 December 1926), 925–926.

Robaut 1965 Alfred Robaut. *L'Oeuvre de Corot: Catalogue raisonné et illustré.* Paris, 1965.

Robert 1877 Jules Robert. "La Journée – Échos et nouvelles." *Paris-Journal*, 7 April 1877, 2.

Robert and Cougny 1889–91 Adolphe Robert and Gaston Cougny, ed. *Dictionnaire des parlementaires français comprenant tous les membres des Assemblées françaises et tous les ministres français (1789–1889).* 5 vols. Paris, 1889–91.

Robida 1955 Michel Robida. *Ces bourgeois de Paris.* Paris, 1955.

Robida 1958 Michel Robida. *Le Salon Charpentier et les impressionnistes.* Paris, 1958.

Robida 1959 Michel Robida. *Renoir: Enfants.* Lausanne, 1959.

Roger-Marx 1933 Claude Roger-Marx. *Renoir.* Paris, 1933.

Roger-Milès 1905 *Catalogue des tableaux modernes, aquarelles, pastels, objets d'art et d'ameublement provenant de la collection de feu M. Paul Berard.* Sale catalogue, with preface by L. Roger-Milès. Galerie Georges Petit, Paris, 9 May 1905.

Romane-Musculus 1974 Paul Romane-Musculus. "Généalogie des Sisley." *Bulletin de la Société de l'Histoire du Protestantisme Français,* July–September 1974, 458–463.

Roosval 1913 Johnny Roosval. "Om herr Klas Fåhraeus konstsamling." *Konst och konstnärer* IX (1913), 97–108.

Rosenberg and Grasselli 1984 *Watteau, 1684–1721.* Exhibition catalogue by Pierre Rosenberg and Margaret Morgan Grasselli. Grand Palais, Paris, 1984.

Rosenberg Paris 1917 *Exposition d'art français du XIXᵉ siècle au profit de l'Association générale des mutilés de la guerre.* Exhibition catalogue. Galeries Paul Rosenberg, Paris, June–July 1917.

Rosenblum 1988 Robert Rosenblum. *The Romantic Child from Runge to Sendak.* London, 1988.

Rosenblum 1989 Robert Rosenblum. *Paintings in the Musée d'Orsay.* New York, 1989.

Rosenfeld 1991 Daniel Rosenfeld, ed. *European Painting and Sculpture, c. 1770–1937, in the Museum of Art, Rhode Island School of Design.* Providence, 1991.

Rosinsky 1994 Thérèse Diamand Rosinsky. *Suzanne Valadon.* New York, 1994.

Rouart 1952 *Berthe Morisot and Her Circle: Paintings from the Rouart Collection, Paris.* Exhibition catalogue, with introduction by Denis Rouart. Art Gallery of Toronto, [1952].

Rouart and Wildenstein 1975 Denis Rouart and Daniel Wildenstein. *Édouard Manet: Catalogue raisonné.* 2 vols. Lausanne/Paris, 1975.

Rousset-Charny 1990 *Les Palais parisiens de la Belle Époque.* Exhibition catalogue by Gérard Rousset-Charny. La Délégation à l'Action Artistique de la Ville de Paris, 1990.

Rubin 1980 *Pablo Picasso: A Retrospective.* Exhibition publication edited by William Rubin. Museum of Modern Art, New York, 1980.

Rubin 1983 William Rubin. "From Narrative to 'Iconic' in Picasso: The Buried Allegory in *Bread and Fruitdish on a Table* and the Role of *Les Demoiselles d'Avignon.*" *Art Bulletin* LXV:4 (December 1983), 615–649.

Rubin 1989 *Picasso and Braque: Pioneering Cubism.* Exhibition publication by William Rubin. Museum of Modern Art, New York, 1989.

Russell 1996 John Russell. "Renoir's Paradise, and Those Who Loved It." *New York Times*, 29 September 1996, 37.

S

Sabartés 1949 Jaime Sabartés. *Picasso: An Intimate Portrait.* London, 1949.

Saint Petersburg 1912 *Centennale de l'art français.* Exhibition catalogue. Institut Français, Saint Petersburg, 1912.

Sallanche 1882 Armand Sallanche. "L'Exposition des artistes indépendants." *Journal des Arts*, 3 March 1882.

Salmon 1956–61 André Salmon. *Souvenirs sans fin.* 3 vols. Paris, 1956–61.

Samary 1931 Marie Samary. *Les Brohan.* Paris, 1931.

Sarcey 1884 Francisque Sarcey. *Théâtres divers, comédiens et comédiennes.* Paris, 1884.

Saur 1992–96 *Saur Allgemeines Künstlerlexikon.* 14 vols. Munich/Leipzig, 1992–96.

Savy 1989 Nicole Savy, ed. *Les Petites Filles modernes.* Paris, 1989.

Schapiro 1940–41 Meyer Schapiro. "Courbet and Popular Imagery: An Essay on Realism and Naïveté." *Journal of the Warburg and Courtauld Institutes* IV:1–2 (1940–41), 164–191.

Scharf 1962 Aaron Scharf. "Painting, Photography, and the Image of Movement." *Burlington Magazine* CIV:710 (May 1962), 186–195.

Scheen 1981 Pieter A. Scheen. *Lexicon Nederlandse Beeldende Kunstenaars 1750–1880.* The Hague, 1981.

Schneider 1945 Marcel Schneider. "Lettres de Renoir sur l'Italie." *L'Âge d'or* I (1945), 95–99.

Schneider 1992 Pierre Schneider. *Henri Matisse.* Paris, 1992.

Schnell 1993 Werner Schnell. "Renoirs Versuch, über den Orient in den Salon zu kommen." In *Begegnungen: Festschrift für Peter Anselm Riedl zum 60. Geburtstag,* edited by Klaus Geuthlein and Franz Matsche, 216–231. Worms, 1993.

Sébillot 1877 Paul Sébillot. "Exposition des impressionnistes." *Le Bien Public*, 7 April 1877.

Second Empire 1978 *The Second Empire 1852–1870: Art in France under Napoleon III.* Exhibition catalogue by Joseph J. Rishel et al. Philadelphia Museum of Art, 1978.

Seigel 1986 Jerrold Seigel. *Bohemian Paris: Culture, Politics, and the Boundaries of Bourgeois Life, 1830–1930.* New York, 1986.

Sennett 1994 Richard Sennett. *Flesh and Stone: The Body and the City in Western Civilization.* New York, 1994.

Seurat 1991 *Georges Seurat 1859–1891.* Exhibition catalogue by Robert L. Herbert, Anne Distel, et al. Metropolitan Museum of Art, New York, 1991.

Shapiro 1991 *Pleasures of Paris: Daumier to Picasso.* Exhibition catalogue by Barbara Stern Shapiro. Museum of Fine Arts, Boston, 1991.

Shaw 1955 Bernard Shaw. *Pygmalion: A Romance in Five Acts.* London, 1912. Reprint 1955.

Sheldon 1940 William H. Sheldon. *The Varieties of Human Physique: An Introduction to Constitutional Psychology.* New York/London, 1940.

Shone 1992 Richard Shone. *Sisley.* London/New York, 1992.

Sidlauskas 1993 Susan Sidlauskas. "Resisting Narrative: The Problem of Edgar Degas's *Interior.*" *Art Bulletin* LXXV:4 (December 1993), 697–712.

Silvestre 1879 Armand Silvestre. "Le Monde des arts: Demi-dieux et simples mortels au Salon de 1879." *La Vie Moderne*, 29 May 1879, 116–118.

Silvestre 1882 Armand Silvestre. "Septième exposition des artistes indépendants." *La Vie Moderne*, 11 March 1882.

Silvestre 1883 Armand Silvestre. "Le Monde des arts." *La Vie Moderne*, 14 April 1883, 242–243.

Simon 1995 Marie Simon. *Mode et Peinture: Le Second Empire et l'impressionnisme*. Paris, 1995.

Simond 1901 Charles Simond. *La Vie parisienne à travers le XIXᵉ siècle: Paris de 1800 à 1900 d'après les estampes et les mémoires du temps*. 3 vols. Paris, 1901.

Sisley 1949 Claude Sisley. "The Ancestry of Alfred Sisley." *Burlington Magazine* XCI:558 (September 1949), 248–252.

Sisley **1992** *Alfred Sisley*. Exhibition catalogue edited by Mary Anne Stevens. Royal Academy of Arts, London, 1992.

Sitte 1945 Camillo Sitte. *The Art of Building Cities*. New York, 1945.

Smith 1987 David R. Smith. "Irony and Civility: Notes on the Convergence of Genre and Portraiture in Seventeenth-Century Dutch Painting." *Art Bulletin* LXIX:3 (September 1987), 407–430.

Spinazzola 1928 Vittorio Spinazzola. *Le arti decorative in Pompei e nel Museo nazionale di Napoli*. Milan, 1928.

Stein 1933 Gertrude Stein. *The Autobiography of Alice B. Toklas*. New York, 1933.

Stemmler 1993 Joan K. Stemmler. "The Physiognomical Portraits of Johann Caspar Lavater." *Art Bulletin* LXXV:1 (March 1993), 151–168.

Sterling and Salinger 1967 Charles Sterling and Margaretta M. Salinger. *French Paintings: A Catalogue of the Collection of the Metropolitan Museum of Art*, vol. 3, XIX–XX Centuries. New York, 1967.

Stevenson 1991 Lesley Stevenson. *Renoir*. London, 1991.

Stockholm 1917 *Fransk Konst Från 1800–Talet*. Exhibition catalogue. Nationalmuseum, Stockholm, March–April 1917.

Storey 1978 Robert F. Storey. *Pierrot: A Critical History of a Mask*. Princeton, 1978.

Stuckey 1987 *Berthe Morisot, Impressionist*. Exhibition catalogue by Charles F. Stuckey, William P. Scott, and Susan G. Lindsay. New York, 1987.

Stuckey 1995 *Claude Monet 1840–1926*. Exhibition catalogue by Charles F. Stuckey. Art Institute of Chicago, 1995.

Stuttgart 1913 *Grosse Kunstausstellung*. Königlichen Kunstgebäude, Stuttgart, May–October 1913.

Suzanne Valadon **1996** *Suzanne Valadon*. Exhibition catalogue directed by Daniel Marchesseau. Fondation Pierre Gianadda, Martigny, Switzerland, 1996.

Syène 1879a Frédéric de Syène [Arsène Houssaye]. "Salon de 1879, II." *L'Artiste*, July 1879, 9–18.

Syène 1879b Frédéric de Syène [Arsène Houssaye]. "Les Beaux-Arts en 1879." *L'Artiste*, December 1879, 416–420.

T

Tabarant 1921 Adolphe Tabarant. "Suzanne Valadon et ses souvenirs de modèle." *Bulletin de la Vie Artistique*, 15 December 1921, 626–629.

Tabarant 1922 Adolphe Tabarant. "Quelques souvenirs de Théodore Duret." *Bulletin de la Vie Artistique*, 15 January 1922, 31–33.

Tabarant 1947 Adolphe Tabarant. *Manet et ses oeuvres*. Paris, 1947.

Taboureux 1880 Émile Taboureux. "Claude Monet." *La Vie Moderne*, 12 June 1880, 380–382.

Takashina 1995 Erika Takashina. "Un décor japonais en Bretagne." *Revue de l'Art*, 109 (1995), 60–62.

Terrasse 1983 Antoine Terrasse. *Degas et la photographie*. Paris, 1983.

Thompson 1980 *The Peasant in French 19th Century Art*. Exhibition catalogue by James Thompson. Douglas Hyde Gallery, Trinity College, Dublin, 1980.

Thompson and LoBianco 1994 David Thompson and Lorraine LoBianco, ed. *Jean Renoir: Letters*. London, 1994.

Thornton 1983 Lynne Thornton. *The Orientalists: Painter-Travellers, 1828–1908*. Paris, 1983.

Thurneyssen 1897 Fritz Thurneyssen. "Das Münchener Schreinergewerbe: Eine Wirtschaftliche und Soziale Studie." In *Münchener Volkswirtschaftliche Studien*, 21, edited by L. Brentano and W. Lotz. Stuttgart, 1897.

Tinterow and Loyrette 1994 *Origins of Impressionism*. Exhibition catalogue by Gary Tinterow and Henri Loyrette. Metropolitan Museum of Art, New York, 1994.

Toulouse-Lautrec **1991** *Toulouse-Lautrec*. Exhibition catalogue by Richard Thomson, Claire Frèches-Thory, and Anne Roquebert. Hayward Gallery, London, 1991.

Toussaint 1985 Hélène Toussaint. *Les Portraits d'Ingres: Peintures des musées nationaux*. Paris, 1985.

Troyat 1989 Henri Troyat. *Maupassant*. Paris, 1989.

Tucker 1982 Paul Hayes Tucker. *Monet at Argenteuil*. New Haven, 1982.

Tucker 1995 Paul Hayes Tucker. *Claude Monet: Life and Art*. New Haven, 1995.

Tuleu 1915 Jane Tuleu. *Souvenirs de famille*. Paris, 1915.

Turszinsky 1910 Walter Turszinsky. "Tilla Durieux." *Bühne und Welt* XII (1910), 604–610.

V

Valiere 1992 Nathalie Valiere. *Un Américain à Limoges: Charles Edward Haviland (1839–1921), porcelainier*. Tulle, 1992.

Vallès 1971 Jules Vallès. *Le Tableau de Paris*. Paris, 1971.

Vanier 1960 Henriette Vanier. *La Mode et ses métiers: Frivolités et luttes des classes 1830–1870*. Paris, 1960.

Vapereau 1893 Louis Gustave Vapereau. *Dictionnaire universel des contemporains*. 6th ed. Paris, 1893.

Varnedoe 1990 Kirk Varnedoe. *A Fine Disregard: What Makes Modern Art Modern*. New York, 1990.

Vauxcelles 1908 Louis Vauxcelles. "Collection de M. P. Gallimard." *Les Arts*, 81 (September 1908), 2–32.

Venice Biennale **1910** *IX Esposizione Internazionale d'Arte della città di Venezia*. Exhibition catalogue. Biennale Internazionale d'Arte, Venice, April–October 1910.

Venturi 1939 Lionello Venturi. *Les Archives de l'impressionnisme*. 2 vols. Paris/New York, 1939.

Véron 1877 Paul Véron. "Les Impressionnistes." *Le Petit Journal*, 7 April 1877.

Vlaminck 1943 Maurice Vlaminck. *Portraits avant décès*. Paris, 1943.

Vollard 1918a Ambroise Vollard. "La Jeunesse de Renoir." *La Renaissance de l'Art Français et des Industries de Luxe* III (May 1918), 16–24.

Vollard 1918b Ambroise Vollard. *Tableaux, Pastels et Dessins de Pierre-Auguste Renoir*. 2 vols. Paris, 1918.

Vollard 1919 Ambroise Vollard. *La Vie et l'oeuvre de Pierre-Auguste Renoir*. Paris, 1919.

Vollard 1920 Ambroise Vollard. *Auguste Renoir*. Paris, 1920.

Vollard 1924 Ambroise Vollard. *Degas*. Paris, 1924.

Vollard 1925 Ambroise Vollard. *Renoir: An Intimate Record*. Translated by H.L. Van Doren and R.T. Weaver. New York, 1925.

Vollard 1936 Ambroise Vollard. *Recollections of a Picture Dealer.* Translated by V.M. MacDonald. London, 1936.

Vollard 1937 Ambroise Vollard. *Souvenirs d'un marchand de tableaux.* Paris, 1937.

Vollard 1938a Ambroise Vollard. "Mes portraits." *Arts et Métiers Graphiques,* 64 (15 September 1938), 39–44.

Vollard 1938b Ambroise Vollard. *En écoutant Cézanne, Degas, Renoir.* Paris, 1938. Reprint 1994.

Vollard Collection 1950 *Paintings from the Vollard Collection.* Exhibition catalogue. National Gallery of Canada, Ottawa, 1950.

W

Wadley 1987 Nicholas Wadley, ed. *Renoir: A Retrospective.* New York, 1987.

Wadsworth Atheneum 1992 Linda Ayres, ed. *"The Spirit of Genius": Art at the Wadsworth Atheneum.* New York/Hartford, 1992.

Wagner 1986 Anne M. Wagner. *Jean-Baptiste Carpeaux, Sculptor of the Second Empire.* New Haven, 1986.

Wagner 1994 Anne M. Wagner. "Why Monet Gave Up Figure Painting." *Art Bulletin* LXXVI:4 (December 1994), 613–629.

Walter 1966 Rodolphe Walter. "Les Maisons de Claude Monet à Argenteuil." *Gazette des Beaux-Arts,* 6th series, LXVIII (December 1966), 333–342.

Ward 1991 Martha Ward. "Impressionist Installations and Private Exhibitions." *Art Bulletin* LXXIII:4 (December 1991), 599–622.

Waxman 1926 S.M. Waxman. *André Antoine and the Théâtre Libre.* Cambridge, Mass., 1926.

Weber 1922 V.-F. Weber. *"Ko-ji hô-ten": Dictionnaire à l'usage des amateurs et collectionneurs d'objets d'art japonais et chinois.* 2 vols. Paris, 1922.

Weinberg 1991 Barbara H. Weinberg. *The Lure of Paris: Nineteenth-Century American Painters and Their French Teachers.* New York, 1991.

Weisberg 1980 *The Realist Tradition: French Painting and Drawing 1830–1900.* Exhibition catalogue by Gabriel P. Weisberg. Cleveland Museum of Art, 1980.

Weisberg 1993 Gabriel P. Weisberg. *The Independent Critic: Philippe Burty and the Visual Arts of Mid-Nineteenth-Century France.* New York, 1993.

Weitzenhoffer 1986 Frances Weitzenhoffer. *The Havemeyers: Impressionism Comes to America.* New York, 1986.

Welsh-Ovcharov 1976 Bogomila Welsh-Ovcharov. *Vincent van Gogh: His Paris Period, 1886–1888.* Utrecht, 1976.

Wemaëre-de Beaupuis 1992 *Vente inaugurale.* S.C.P. Wemaëre-de Beaupuis, Rouen, 31 May 1992.

Wentworth 1984 Michael Wentworth. *James Tissot.* Oxford, 1984.

Werth 1921 Léon Werth. "À propos des maîtres disparus." *Journal du Peuple,* 30 August 1921.

Weston 1971 Pamela Weston. *Clarinet Virtuosi of the Past.* London, 1971.

Westphal 1871 Carl F.O. Westphal. "Die Agoraphobie: Eine neuropathische Erscheinung." *Archiv für Psychiatrie und Nervenkrankheiten* 3 (1871), 136–161.

Westphal 1988 Carl F.O. Westphal. *"Die Agoraphobie" – The Beginnings of Agoraphobia.* Translated by Michael T. Schumacher. Commentary by Terry J. Knapp. Lanham, Md., [1988].

White 1969 Barbara Ehrlich White. "Renoir's Trip to Italy." *Art Bulletin* LI (December 1969), 333–351.

White 1984 Barbara Ehrlich White. *Renoir: His Life, Art, and Letters.* New York, 1984.

Whiteley 1979 Linda Whiteley. "Accounting for Tastes." *Oxford Art Journal* II:1 (1979), 25–28.

Whiteley 1995 Linda Whiteley. "Painters and Dealers in Nineteenth-Century France, 1820–1878, with Special Reference to the Firm of Durand-Ruel." D. Phil. thesis, University of Oxford, 1995.

Wildenstein 1964 Georges Wildenstein. *Gauguin.* Exhibition catalogue. Paris, 1964.

Wildenstein 1974–91 Daniel Wildenstein. *Claude Monet: Biographie et catalogue raisonné.* 5 vols. Lausanne/Paris, 1974–91.

Wild 1987 Nicole Wild. *Décors et costumes du XIXᵉ siècle,* I, *Opéra de Paris.* Paris, 1987.

Willett 1978 John Willett. *The Theatre of Erwin Piscator.* London, 1978.

Winterthur 1916 *Französische Malerei.* Exhibition catalogue. Kunstmuseum Winterthur, October–November 1916.

Wolff 1879a Albert Wolff. "Le Salon." *Le Figaro,* 11 May 1879.

Wolff 1879b Albert Wolff. "Les Dessins des maîtres anciens à l'École des Beaux-Arts." *Le Figaro,* 13 May 1879, 1.

Wolff 1886 Albert Wolff. *La Capitale de l'art.* Paris, 1886.

Wolff 1990 Janet Wolff. "The Invisible *Flâneuse*: Women and the Literature of Modernity." In *Feminine Sentences: Essays on Women and Culture,* 34–50. Berkeley, 1990.

Wolff 1995 Janet Wolff. "The Artist and the *Flâneur*: Rodin, Rilke and Gwen John in Paris." In *Resident Alien: Feminist Cultural Criticism,* 88–114. New Haven/London, 1995.

Wyzewa 1890 Téodore de Wyzewa. "Pierre-Auguste Renoir." *L'Art dans les Deux Mondes,* 3 (6 December 1890), 27–28.

Z

Zeldin 1973 Theodore Zeldin. *A History of French Passions.* 2 vols. Oxford, 1973.

Zola 1983 Émile Zola. *L'Oeuvre.* Paris, 1886. Reprint 1983.

Zola 1990 Émile Zola. *La Curée.* Paris, 1871. Reprint 1990.

Zola 1991 Émile Zola. *Écrits sur l'art.* Edited by Jean-Pierre Leduc Adine. Paris, 1991.

Zola *Correspondance* Émile Zola. *Correspondance.* General editor, B.H. Bakker. 9 vols. Montreal/Paris, 1978–93.

Zurich 1917 *Französische Kunst des 19. und 20. Jahrhunderts.* Exhibition catalogue. Kunsthaus Zurich, October–November 1917.

INDEX

372

PHOTOGRAPH CREDITS